Art and Activism

Projects of John and Dominique de Menil

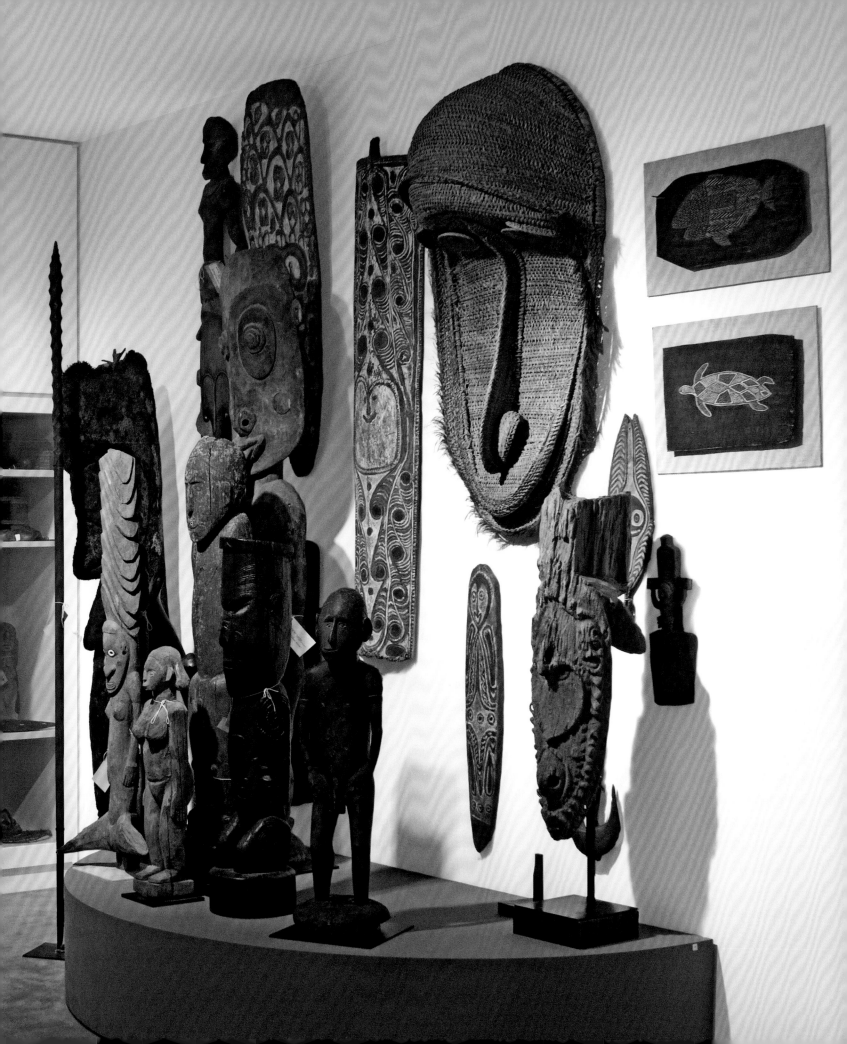

Art and Activism
Projects of John and Dominique de Menil

Edited by

Josef Helfenstein and Laureen Schipsi

Suzanne Deal Booth

William A. Camfield

Annemarie Weyl Carr

Mel Chin

Bertrand Davezac

Christophe de Menil

Clare Elliott

Stephen Fox

Pia Gottschaller

Walter Hopps

Richard Ingersoll

Thomas McEvilley

Gerald O'Grady

Deloyd Parker

Francesco Pellizzi

Renzo Piano

Pamela G. Smart

Simone Swan

Dorothea Tanning

Kristina Van Dyke

Alvia J. Wardlaw

Paul Winkler

THE MENIL COLLECTION
Houston

Distributed by
YALE UNIVERSITY PRESS
New Haven and London

This publication is generously supported by:

The Brown Foundation, Inc.
Mr. and Mrs. Peter Hoyt Brown
The Hobby Family Foundation
Sara Dodd-Spickelmier and Keith Spickelmier
Jeffery and Toni Beauchamp
H. Fort Flowers Foundation

Front cover: Dominique and John de Menil, Rice Media Center,
Rice University, Houston, 1971

Back cover (*top to bottom*): John and Dominique de Menil and
Willem De Kooning at the artist's studio, Long Island, New York, 1970;
Dominique de Menil at the dedication of the Rothko Chapel, Houston, 1971;
John de Menil and Andy Warhol in Buckminster Fuller's geodesic dome for
Expo 67, Montreal, 1967; and north portico of the Menil Collection, Houston

Frontispiece: Oceanic art in a storage room of the Menil Collection, Houston

Epigraphs (*opposite*): Dominique de Menil, "Minutes of the Annual Meeting
of the Arts Council of the University of St. Thomas, June 11, 1962," Menil
Archives; and letter from John de Menil to Philippa de Menil, August 10, 1970,
Menil Archives

The Menil Archives and the Menil Object Files, cited throughout this book,
are housed in the Menil Collection, Houston.

Persons or elements in illustrations are identified from left to right.

What counts is the intensity of the quest,
the thirst of the soul, the curiosity of the mind,
the enjoyment of the eye.

Dominique de Menil

[The Menil Foundation] is not a tomb but
a reincarnation, not sclerosis but continuity—
a word bigger than it looks, because
worthwhile projects die hard.

John de Menil

Contents

MIXED MASTERS: CORRESPONDENCE WITH ARTISTS

BUILDERS AND HUMANISTS: ARCHITECTURE

PERSONA GRATA: POINTS OF VIEW

LOOK BACK: CHRONOLOGY AND HISTORY

Foreword

By 1941 John and Dominique de Menil had left Nazi-occupied Paris destined for Houston, the headquarters of their family business, Schlumberger Ltd. John was thirty-six years old and Dominique thirty-two, and they had three small children. Very little before this moment had indicated that they would build a world-famous art collection housed in a critically acclaimed museum building, itself comprising the heart of a larger campus. Four additional sites in the Menil neighborhood—the Rothko Chapel, Dan Flavin Installation, Cy Twombly Gallery, and Byzantine Fresco Chapel—speak to the couple's ecumenicism, commitment to human rights, devotion to individual artists, and prescient leadership in exploring issues of cultural heritage. These sites are only a few of the tangible results of a visionary program of art and activism the two developed and executed from their adopted city. Less visible are the art history and film departments, major research and publication projects, and international conferences they established over six decades.

This book documents the widespread accomplishments of the de Menils and their collaborators, exploring the remarkable turn the couple's lives took upon arriving in the United States and the momentum with which they realized their visionary projects. While their art collection and architectural commissions have received significant scholarly attention, the focus here is on the de Menils as patrons and their evolving philosophy. This publication seeks to provide a rich and nuanced picture of the de Menils' well-known projects, correct certain misperceptions, and bring new details to light. It also aims to produce a record of lesser-known endeavors or those undertakings that did not find permanence in material form.

From the 1950s on, the de Menils worked with a carefully selected team of individuals to accomplish their goals, looking for certain qualities in their colleagues—intelligence, openness, passion, and single-mindedness of purpose. They encouraged the talents of others, built lifelong partnerships, and created networks in Houston, New York, and Paris. The essays collected here are a testament to those relationships, giving voice to many of the de Menils' collaborators, including family members, foundation staff members, former students, scholars, activists, and artists, who either recount the devel-opment of projects or provide insight into the de Menils' motivations and working style. In addition, the perspectives of a subsequent generation—those of us who are charged with carrying forward the de Menils' vision and mission as employees of the foundations they established—are included. The de Menils' confidence in the abilities of those who would follow them is one of the most remarkable and generous aspects of their legacy: despite having developed and implemented a unique vision and made a commitment to the relationship between art and activism, they did not leave behind rigid directives; rather they viewed their collections, projects, and foundations as living and organic, elastic enough to adapt to changing circumstances. Because they did not see these works as monuments to themselves, little attention has been paid heretofore to the de Menils as individuals and patrons. This is particularly true of John de Menil, whose death in 1973 occurred long before some of the projects the couple had planned were realized. Fortunately, the de Menils bequeathed meticulous records documenting events and their own thought processes, which have enabled us to discover and present their many stories.

The challenge was deciding what to include and what, by default, to omit. This book is not a biography; however, given that most of the authors worked with the de Menils, their essays provide insight into the couple's personalities and the special relationships they developed with those around them. This publication addresses the lore that has built up over time—the many stories about the couple that circulated through the years, filled with a mix of fact and speculation. Grounding their accounts in archival documentation and oral history, the authors brought together in this volume have fleshed out historical accounts, corrected misconceptions, and, in adding their own engaging reminiscences, provided a textured tribute to the de Menils. The few contributors who did not know John and Dominique are associated with them through two institutions: Rice University, in which the de Menils were deeply involved, and the Menil Collection, the culmination of a lifelong pursuit. It was a significant challenge for the writers as well as the editors to know where to stop—though not end—the story. One underrepresented colleague, Walter Hopps, was a close associate of Dominique de Menil and

became the founding director of the Menil Collection. Walter had planned to write an in-depth analysis of the de Menils' collecting philosophy, but he died before he could do so. Though a text from 1984 represents him here, he would have had much more to say.

A constant theme throughout this publication is the pioneering spirit with which John and Dominique de Menil approached their many projects. It seems the freedom they discovered in Houston afforded them the confidence to act independently and take repeated risks. An early example is their commissioning Philip Johnson to design their home, one of the first modernist residences in the city. At the time, Johnson was a well-known curator at the Museum of Modern Art in New York but a relatively unestablished architect. The de Menils were demanding and engaged clients who worked closely with the architect, initiating a lasting relationship. This early instance of identifying, then nurturing, talent would distinguish their lives as patrons of both architecture and art. The de Menils continued championing new approaches to architecture even as they commenced a vigorous involvement with the city's arts community.

Naturally gifted intellectuals, they pursued their interests with a scholarly intensity and unrelenting curiosity. Their deep belief in the importance of education led them to establish the Art Department and the Media Center at the University of St. Thomas, and the Institute for the Arts and Rice Media Center at Rice University. In addition to building up the infrastructure of area universities, they sponsored individual scholarships for higher learning at various institutions in the United States, some privately and others through their foundation. They commissioned diverse scholarly projects and publications, including catalogues raisonnés, in-depth studies, and exhibition catalogues. International luminaries working in art, music, and film—many of whom were personal friends of the couple—came to Houston to join the de Menils' effort in educating their students and the public.

The de Menils believed and professed that human beings are universally entitled to basic rights, and they geared much of their effort toward ensuring those rights. Acting on their conviction that art is essential to all people, they developed projects that combined the two principles. In 1960, for example, they merged their interest in art historical scholarship with their commitment to civil rights by initiating a unique, decades-long research project that documents representations of Africans and the African Diaspora in Western art from antiquity to the present. In another notable undertaking, they organized and presented in 1971 one of the first racially integrated exhibitions of contemporary art in the United States, at the De Luxe Theater in Houston's largely African American Fifth Ward. On a more general level, the couple saw film's potential as a catalyst for social change. This is particularly true of John de Menil, whose passion for documentary film and film education lay in his recognition of that medium's capacity to communicate effectively to the disenfranchised and build awareness of their plight to a broader audience.

John and Dominique de Menil's zeal for civil rights extended beyond Houston to victims of oppressive governments worldwide. The de Menils—John was raised a Catholic and Dominique converted from Protestantism to Catholicism—long shared an interest in ecumenism, but they were inspired to take action by the inclusive reforms of Vatican II, which called for a modernization of the Church. While they saw the Rothko Chapel, commissioned in 1964, as an ecumenical place of worship, they further envisioned it as an active center of exchange for people of diverse backgrounds. Talented facilitators, they brought together international scholars and religious leaders, not only for interfaith dialogues but also for discussions of world poverty, the political suppression of ethnic minorities, and the relationship between socioeconomic status and human rights.

The de Menils' commitment to peace and justice is equally evident in their role as art collectors. The idea that art connects people across time and place was one of the motivating factors in the building of their collection. For them, art links individuals to a collective human past and provides a deeply personal experience with the sublime in the present day. Sensitive to the profound connections, both formal and spiritual, between works of contemporary art and those of ancient, medieval, and indigenous cultures, the de Menils built a collection in which modern and contemporary art came together with works from classical-age Mediterranean civilizations and the

Byzantine era, as well as objects from Africa, the Pacific Islands, and the Pacific Northwest. They did not simply amass art; they lived and worked with it, and in the process established a teaching collection for their students and became accomplished scholars, archivists, and curators in their own right. Dominique de Menil learned curatorial skills from her gifted mentor, Jermayne MacAgy, and soon produced memorable exhibitions that similarly brought together unexpected groups of artwork crossing temporal, geographical, and stylistic boundaries. John de Menil carefully documented and researched the collection, producing notes that are both lively and poetic. He, together with Dominique and Jermayne MacAgy, created simple and evocative titles for their exhibitions, many of which are used as the section headings in this book.

The de Menils deepened their appreciation of art through the personal relationships they forged with artists, developing lifelong bonds in which patron and artist were often muse to each another. Such mutual inspiration is also evident in the relationships they fostered with young people. John and Dominique de Menil believed that the younger generation would build upon and expand the work they had begun. The de Menil children—Christophe, Adelaide, Georges, Francois, and Fariha, formerly Philippa—continue to honor and expand the legacy of their parents through their own ongoing commitment to, and visionary leadership in, art, architecture, film, and educational and humanitarian pursuits. In addition to the siblings, the students and others with whom the de Menils worked constitute a group of individuals who have gone on to swell the cultural tide in arts, religion, and social activism.

Building such a legacy required drive, determination, initiative, and a willingness to take risks. Reflecting that determination, the de Menils developed projects that often arose through serendipitous encounters and associations. By leaving the door open to such opportunities, they discovered innovative and exciting ways to approach the monumental goals they set for themselves. Such independence and confidence, as well as visionary foresight, are constant themes of John and Dominique de Menil's achievements. The high standards they expected from themselves and others demonstrate the power and profundity of simple ideas executed with quality and passion. This book is a testament to the work they accomplished over six decades. Dominique de Menil may have said it best: "Dynamism is contagious."

Josef Helfenstein
Director

Laureen Schipsi
Publisher

Acknowledgments

In January 2004 we began to conceptualize and work on this project, realizing how little had been published about the remarkably wide range of intellectual, artistic, and spiritual endeavors initiated by the founders of the Menil Collection. To secure this vast legacy, we sought firsthand recollections from many of John and Dominique de Menil's colleagues. Our undertaking became even more urgent as a growing number of their closest associates either had left the institution or, given the decades encompassing the de Menils' work, died. Gathering the individual viewpoints became the starting point for this publication. It is with a sense of relief and gratitude that we see this endeavor, after more than six years, come to fruition.

As one might imagine with a publication of this size and scope, many people were involved in making it a reality. In addition to the contributing authors, there are those who worked on the book's conceptualization, development, and production. Graphic designer Don Quaintance deserves special recognition. He not only produced the thoughtful design of this publication but also undertook rigorous research, drafted captions, and offered meaningful and informative editing of the texts and invaluable insight and advice throughout the long process of bringing the book into being. Don first encountered John and Dominique de Menil as a student at Rice University in 1969, and his personal association with the couple and their projects put him in a unique position to contribute to their story. Don's dedication to this project and his demanding standards demonstrate his exceptional character and are a tribute to the de Menils. Two other key participants stand apart: Geraldine Aramanda, Archivist, and Mary Kadish, Collections Registrar, both of the Menil Collection. (Geraldine Aramanda established the Menil Archives in 2000.) Having worked with the de Menils for decades, they possess the institutional memory essential to documenting and verifying this history. Energetic and creative researchers, they combed foundation files, documents, photographs, and external sources, unearthing much of the reference information published at the back of the book in addition to providing invaluable assistance to the volume's contributors. Most important, their enthusiasm for this project and the de Menils' vision imbued the process with thoughtful perspectives. Special acknow-

ledgment must also be given to Elsian Cozens who, having served as longtime assistant first to John de Menil and then to Dominique, was an indispensable source of firsthand information, guiding wisdom, and insight. Her ongoing commitment to John and Dominique de Menil and the bonds she formed with them are evidenced in her work as Manager of Special Events at the Menil Collection. Kristina Van Dyke, Curator of Collections and Research, also deserves our particular appreciation for giving her astute and informed perspective and lending a deft eye to the texts.

The family of John and Dominique de Menil was extremely helpful in providing information, particularly on the couple's early years. We wish to express our utmost appreciation to Christophe de Menil, Adelaide de Menil Carpenter, Georges de Menil, Francois and Susan de Menil, Fariha Friedrich, and Bénédicte Pesle for their many contributions. In 2010 the de Menil family donated the papers of John and Dominique de Menil to the Menil Archives. The generous gift of the de Menil Family Papers has proven to be an invaluable resource in the production of this publication and will continue to amplify the work of future researchers.

Many thanks go to Menil staff members Clare Elliott, Assistant Curator, and Vance Muse, Director of Communications. They spent considerable time and effort reading every text and offering valuable feedback. We also benefited from the insightful comments and suggestions of Emily Todd, Deputy Director; Karl Kilian, Director of Public Programs; Lisa Barkley, Archival Assistant; and Ralph Ellis, Real Estate Manager. In addition, thanks go to Suna Umari, Chapel Services Coordinator at the Rothko Chapel, who responded quickly, adeptly, and cheerfully to our many requests.

We wish to express our deep appreciation to Kathryn Davidson, Helen Winkler Fosdick, and Mary Jane Victor, who were closely associated with John and Dominique de Menil. They reviewed texts and supplied information to help flesh out the stories contained herein. Other individuals also helpful with research, securing illustrations, or other support were Gertrude Barnstone, Katherine Barr, Jody Blazek, Tripp Carter, Colleen Casey, Rose-Marie Cavazzini, Heidi Colsman-Freyberger, Ron Drees, Leslie Elkins Sasser, Sissy Farenthold,

Paul B. Franklin, Anthony E. Frederick, Marta Galicki, Dr. Curtis M. Graves, Gina Guy, Phil Heagy, Glenn Heim, Lynn M. Herbert, Gabriel García Higueras, Kirk Hopper, Caroline Huber, Nancy James, Pamela Johnson, Rita Jules, Charles Lamb, John Linden, Wolfgang Lubitz, Elisabeth Malaquais, Carol Mancusi-Ungaro, Margit Mason, Alexander McLanahan, Andrea Mihalovic-Lee, Benoit Moritz, Mary Ann Pack, Bruce Pavlow, Father Jean-Michel Potin, Caitlin Stepan, Will Taylor, Esteban Volkov, Chris Warde-Jones, Paula Webb, David White, Walter Widrig, Paul Winkler, and Geoff Winningham.

Our sincere gratitude goes to those photographers who have documented Menil exhibitions and events over the decades: David Crossley, Adelaide de Menil, Lisa Hardaway, Paul Hester, the late Blaine Hickey, the late Ogden Robertson, and John Lee Simons.

We are thankful for the resources provided by Susan Dam, Calder Foundation, New York; Lesley Trites, Centre Georges Pompidou, Musée National d'Art Moderne, Paris; Cheryl Blissitte and Justine Waitkus, Contemporary Arts Museum Houston; Leo Boucher, Da Camera of Houston; Tiffany Bell, Dan Flavin Ltd., New York; Tanja Narr, Fondation Beyeler, Riehen / Basel, Switzerland; Christopher Linnane, Harvard Art Museum, Cambridge, Massachusetts; Michelle Dass Pickard, Institute of International Education (IIE), Houston; Patricia Virasin, Kimbell Art Museum, Fort Worth; the staff of the Mickey Leland Archive on World Hunger and Peace at Texas Southern University, Houston; Galia Bar-Or, Museum of Art, Ein Harod, Israel; Anne Mobley and Lorraine Stuart, Museum of Fine Arts, Houston; Philip Hunt, National Gallery of Scotland, Edinburgh; Trish Waters, The Phillips Collection, Washington, D.C.; Francesca Bianchi, Stefania Canta, and Giovanna Giusto, Renzo Piano Building Workshop, Genoa, Italy; Amanda Focke, Rice University, Houston; Pamela Yates, Skylight Pictures, New York; Stephen James, University of Houston; and Betty L. Fischer and Betty Kaffenberger, University of St. Thomas, Houston.

It has been extremely satisfying to work with the authors of this book. It would have been both a pleasure and a great addition to this collection if Walter Hopps and Jim Love, both of whom died in 2005, had been here to tell their stories about John and Dominique. We are fortunate, however, to include in these pages an inspired piece Hopps wrote about the de Menils in 1984, never before published in English, as well as an excerpt from a letter Love wrote to Dominique. We are sincerely grateful for the contributions of authors Suzanne Deal Booth, William A. Camfield, Annemarie Weyl Carr, Mel Chin, Bertrand Davezac, Christophe de Menil, Clare Elliott, Stephen Fox, Pia Gottschaller, Richard Ingersoll, Thomas McEvilley, Gerald O'Grady, Deloyd Parker, Francesco Pellizzi, Renzo Piano, Pamela G. Smart, Simone Swan, Dorothea Tanning, Kristina Van Dyke, Alvia J. Wardlaw, and Paul Winkler. In addition to his text, Mel Chin created an original drawing to accompany his piece. Bringing all of these texts together with diligence, expertise, and elegance was editor Polly Koch. Her perseverance, cheerful attitude, and abundant skill never faltered as she pored over hundreds of pages of draft texts. The development and production of this publication have also been the focal point for Menil staff members Sarah Robinson, Editorial Assistant, and Erh-Chun Amy Chien, Rights and Reproductions Manager, as well as for Sean Nesselrode who, as Publications Department Intern, devoted nearly a full year to this book, fact checking and gathering illustrations. Others helpful in the process include Laura Fletcher, Jennifer Hall, and Nancy O'Connor. At Yale University Press, we would like to acknowledge the assistance of Patricia Fidler and Lindsay Toland. Thanks also are owed to translators Marina Harss and Marie-Pascale Rollet-Ware, design assistant Elizabeth Frizzell, indexer Becky Hornyak, and editor Jane McAllister for proofreading.

Our thanks go to the Menil Collection's Board of Trustees, especially Board President Harry Pinson and Board Chairman Louisa Stude Sarofim, for their continued and enthusiastic support of this publication.

Finally, we express our deepest gratitude to our sponsors, who made this publication possible: The Brown Foundation, Inc., Mr. and Mrs. Peter Hoyt Brown, The Hobby Family Foundation, Sara Dodd-Spickelmier and Keith Spickelmier, Jeffery and Toni Beauchamp, and the H. Fort Flowers Foundation.

J. H. and L. S.

La rime et la raison

INTENTIONS

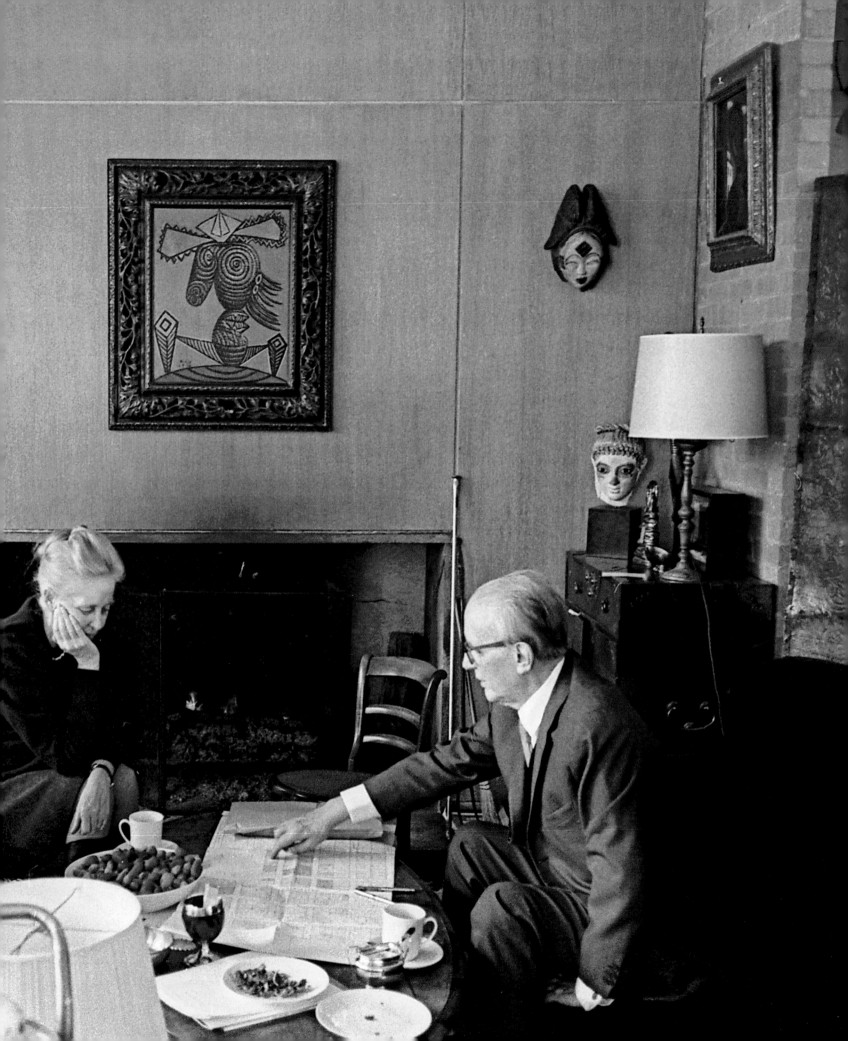

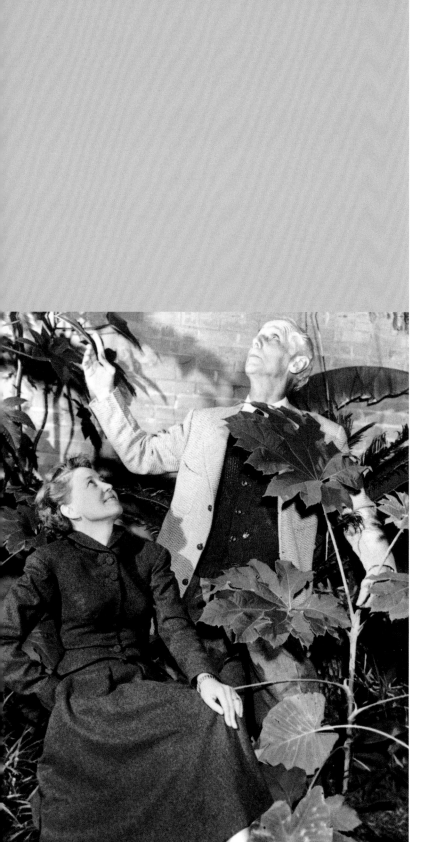

Living to Create: A Memoir

DOROTHEA TANNING

The times were always right, so right
it was as if they had been waiting
to happen. The places, too, were right
for us. We were four and we were
complete in all these times and places,
they two and we two, together.

Houston. A giant Quonset hut
has traded its military drab for
a mantle of miracle: the colors of
visual art. Could it have forgotten
its purpose, changed its mind about
war's way to change the world?
No bomber lurks in this cathedral
space. Here there is no more war.
War is sad and has no color. These
walls bloom with paintings. Colors
riot, soar, and spin. Sculptures
claim the cement floor. Another
world has entered here. Another
world invites you in.

pages 16–17
Edmund Carpenter and Dominique
and John de Menil at the de Menils'
home, Houston, 1973

Fig. 1.1
Dominique de Menil and Max Ernst in the
atrium garden of the de Menils' home,
Houston, 1952

Two imaginations become as one:
John and Dominique de Menil
have found a way to hold the artists'
vision like a mirror up to the gazers'
eyes that they might see, along with
so much else, themselves not as they
were before. The Menil Collection is
born. This is our south, a little exotic,
a little antebellum, eloquent…
An evening at Miss Ima's, where
sunset's glare competes with lighted
candelabra in all eight windows.
Such times gather us, they two
and we two, four to be complete.

Our Huismes, France, sees Dominique
under wisteria's white clusters—not
unlike Miss Ima's candelabra.
In New York, we are again four, they
two and we two to be complete,
John telling us about the big business
world he finds himself sharing with
its tough-talking tycoons. "They don't
paint pictures, carve stone. They
don't even put a bicycle wheel on
a pedestal," he assures us. And in Paris,
at l'Orangerie (did it ever grow oranges?)
John and Dominique have masterminded
a Max Ernst exhibition. How to realize
everything is beautiful when you're in it?

Other times, other places. Provence:
The old chateau eyes red-tiled roofs,
along with our hill, olives, lavender.
They two have come for a pair of days.
Here moments of exhilaration
last for hours. We are still miraculously
four complete, as if forever.

Yet again on San Felipe Road,
John, quiet and knowing so privately
that he will leave us all, not to be
four anymore, or even three
for soon, oh, too soon, Max will be
gone, and we are just two to
continue, each in her own domain.

Finally, in the wide gray nest,
so startling in its unpretentious
elegance, Dominique with her
artists and her architects will have
achieved the ends and permanence
of what they two had begun together.
Always consorting with those who live
to create, so they created their own
masterpiece. It is all here. Spanning
ages, gods, icons, totems, and isms.
(A tribal something made of nothing
is as immediate as this very moment
and as fraught with content … or portent.)

Here she is, easy among her painted
canvases, carvings, marbles, bronzes,
wood, paper, and, yes, even cloth,
transformed by the artist's hand
and eye to reveal what she called
"a truth of sight." Had they two not
sought such truths all their years together?

Drifting away, Dominique left
her starlight to those who are here,
to those who are not here, and
to the ones who will come. Stars
do that: leave trails of themselves
along the way and, you, Dominique,
perhaps, a faint footprint
of your passage.

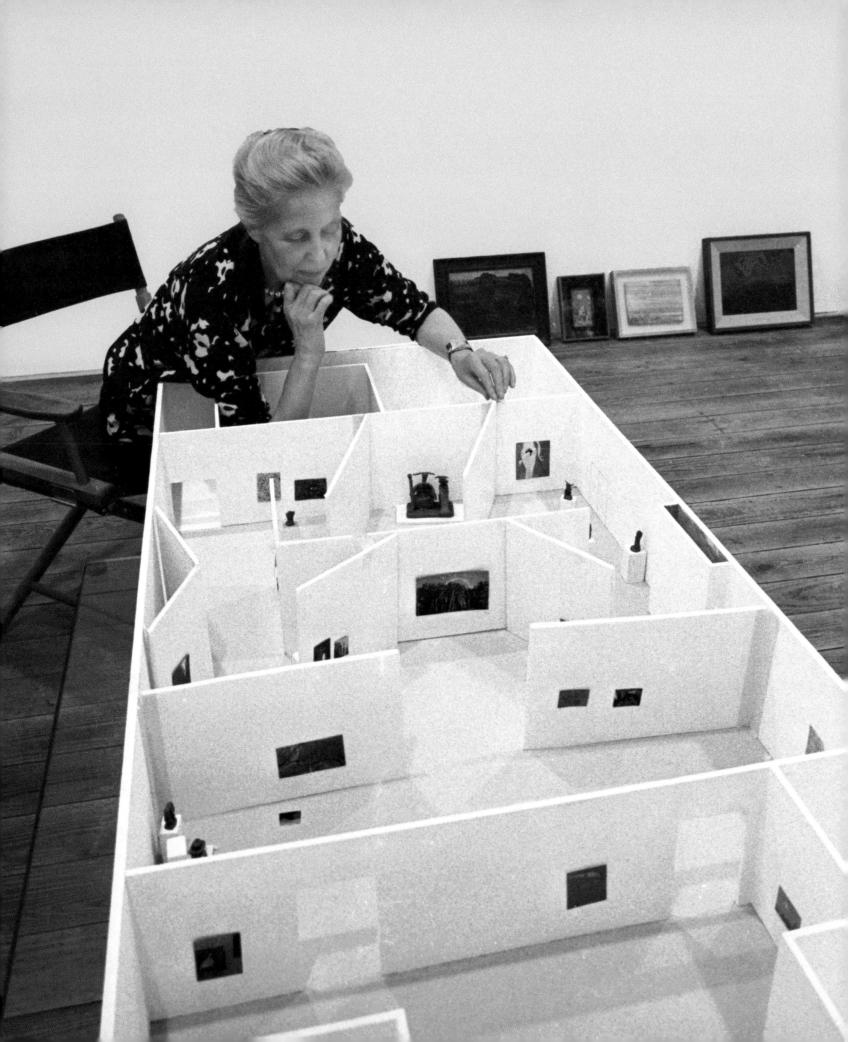

Aesthetics as a Vocation PAMELA G. SMART

Fig. 2.1
Dominique de Menil with gallery model
for "Max Ernst: Inside the Sight," Rice
Museum, Rice University, 1973

Experimentalists

Dominique de Menil died at the close of 1997, in her ninetieth year. Unlike the founders of the Barnes Collection, the Isabella Stewart Gardner Museum, and many other once-private collections, she did not leave a restrictive set of directives that would govern the future of her art collection. This was no oversight. Given her energetic engagement with the management of the Menil Collection at every level and her high degree of certitude as to how things should be done, one might have expected the collector to stipulate a regime of practice to continue after her death. Instead, she deliberately left to the Menil Foundation, under whose aegis the Menil Collection is funded and managed, the responsibility for interpreting the legacy that she and her husband had crafted.

In August 1970 John de Menil was diagnosed with the cancer that would take his life three years later. As he worked to put the foundation that he and his wife had established in 1954 on a firmer financial footing and to clarify its objectives, he sought advice from the foundation's board members. His youngest daughter, Philippa, wrote to him: "I'm glad you leave flexibility—so it's not a tomb but a reincarnation. I would dislike being on the board of something which acts like an undertaker carrying out minutely the last wishes of you and mother."[1] He replied, "You're right…not sclerosis but continuity."[2] "The Foundation must be kept alive and non-conformist," he elaborated later, "taking risks on pioneering endeavors. The founders therefore prefer that loyalties to them be waived in order that the board members not be trammeled in tradition."[3]

John and Dominique de Menil (fig. 2.2) were both experimentalists. They pursued a radical project of patronage, directing their financial resources, along with their considerable energy, intelligence, and charisma, to projects by which the "disenchantments of modernity"[4] might be overcome. While an eclipsing of the mythical and the sacred by science, the exercise of reason over faith, and confidence in the idea of progress over tradition are widely considered to be defining features of the modern period, John and Dominique de Menil, like the French Catholic intellectuals in whose circles they began to move in the 1930s, sought to reclaim space for faith and the mystical *without* turning their backs on science and innovation. In doing so, they resisted the modern tendency to "quarantine the sacred,"[5] to render it peripheral, irrelevant to the mainstream of social life, but they also positioned themselves against the Church's insistence upon convention, tradition, and the verities of an enduring past.

Fig. 2.2
John and Dominique de Menil, Bucharest, ca. 1938–39

Seeking to recuperate spirituality while at the same time exercising a commitment to a social activism oriented to the future, the de Menils pursued a critical project that would bind the sacred and the modern. The challenge, as they saw it, was to create conditions under which faith would have relevance, not as a regressive refusal of modernity, but as a source of meaning that was both resonant and absolute, that would sustain ongoing humanistic innovation across multiple endeavors. This pursuit of a "sacred modern"[6] resonates powerfully with Stephen Schloesser's characterization of the "off-modern" commitments adopted by many French intellectuals in the interwar years, whom he described as "anti-modernist in their adhesion to tradition and ultra-modernist in their embrace of time's forward motion."[7] The challenge for the Menil Collection now, in the absence of its charismatic founder, is to institutionalize the spirit of a project that cannot be pinned down—one that is "fundamentally an ambivalent synthesis of past and present" as Schloesser describes "off-modern" projects.[8]

An overview of this intellectual movement and how it underscored the de Menils' religiosity, their aesthetic commitments, their political activism, their patronage practices, and, above all, their disciplined experimentalism should not merely trace their intellectual biographies or identify their key philosophical influences. Indeed, the story of the Menil Collection far exceeds the personal biographies of its founders and patrons. It illuminates an important strand of modernism that took shape in perhaps unlikely and

unpredictable ways in Houston. An understanding of this form of modernism establishes an intellectual orientation for the present and future stewardship of the Menil Collection.

Called upon to advance a complex set of commitments, the Menil Collection presents its holdings in a manner that is unusual among museums of art, establishing an engagement with its works that is acutely aesthetic rather than didactic, eschewing the usual rendering of art as history. Dominique de Menil's ambition in crafting the Menil Collection was to create a space in which "poetry would be allowed to prevail over pedagogy,"[9] and in which visitors would engage with artworks not as an act of admiration or passive consumption, but as interlocutors actively participating with the artwork in what she called a process of "mutual interrogation."[10] In its architecture, through the installation of its exhibitions, and throughout its organizational structure and institutional practices, the Menil Collection seeks to produce an affecting interaction between people and objects in order to create the possibility for a personal, resonant encounter that rehabilitates our sensibilities, a resolutely aesthetic experience that overcomes the flattening and distancing of modernity.[11] The character of this engagement and its ongoing effects upon the viewer were central elements of Dominique de Menil's radical project of patronage, which she and her husband embarked upon soon after they and their children left Europe in 1941 and took up residence in Houston.

New World

In his essay "New York in 1941," Claude Levi-Strauss characterized the sense of possibility that this New World city presented: "New York (and this is the source of its charm and peculiar fascination) was then a city where anything seemed possible. Like the urban fabric, the social and cultural fabric was riddled with holes. All you had to do was pick one and slip through it if, like Alice, you wanted to get to the other side of the looking glass and find worlds so enchanting that they seemed unreal."[12] John and Dominique de Menil by all accounts also found it beguiling, traveling there often from the home they established in Houston, where John de Menil initially served as the head of Schlumberger operations in South America, the Middle East, and East Asia. He is widely held to have been a major force in the emergence of Schlumberger in the 1970s as one of the world's largest corporations, which provides to drilling companies throughout the world oil-detection technology that had been developed by Dominique de Menil's father, Conrad Schlumberger, and her uncle, Marcel Schlumberger.[13]

In New York they moved among exiled French intellectuals, artists, and dealers, furthering their friendship with Jacques and Raïssa Maritain,[14] whose philosophical efforts to reconcile a commitment to the eternal verities of Catholic doctrine with an embrace of modernity were deeply influential. They developed a particularly close friendship, indeed a defining one, with the Maritains' friend the Dominican priest Father Marie-Alain Couturier (fig. 2.3). Couturier had traveled to New York late in 1939 to give a series of Lenten sermons, and unable to return to France during war, he stayed on for some five years, circulating among exiled artists and working on the intellectual refinement of his own project concerned with the spiritual restoration of French liturgical art, contributing centrally to what became known as the Sacred Art Movement.[15]

But Houston in the 1940s was another story. Couturier visited the de Menils in Houston after the war, staying with them in their first house, and wrote on his return to Paris: "Naturally, when I was in Houston, I had to admit that you were right about being there, but now, when I think of your little patch of green grass and the unbearably small rooms that are privileged to house you, I wonder at the degree of absurdity to which our world has come that people like you are reduced to living in such circumstances, so far removed from all civilization."[16] Certainly Dominique de Menil expressed this sense of being cast adrift from Europe in a talk she gave some years later: "In Europe the poorest person can enjoy the most beautiful works of art without having to spend a cent—art is everywhere—there is not a village that doesn't have a lovely old church, an impressive castle. In Paris there is Notre Dame and the Louvre available for everybody. Art is … just like the air one breathes. We become conscious

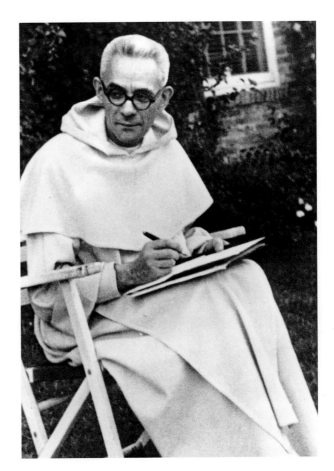

Fig. 2.3
Father Marie-Alain Couturier, Houston, 1947

of it when we lack it. I became conscious of art and particularly of beautiful architecture when we made our home in Houston."[17]

But for John de Menil, who formally anglicized his name when he and his wife were granted United States citizenship in 1962, Houston suited his sensibilities. He is fondly remembered for his enthusiasms. As Morton Feldman recalled, "He had a gentle radar for the unusual. A crazy idea, a beautiful idea, an irreverent or a religious idea, as long as it had some 'guts and personality' behind it, it got immediate attention and, many times, immediate support."[18] In New York in the 1960s, John de Menil listened to the Velvet Underground and enjoyed the company of artists and filmmakers. And in Houston, too, he and and his wife were renowned for their dinners and parties to which they invited artists, poets, students, and political activists. These Houston occasions, however, were not merely social amusements—they served to develop a critical mass of people who could be called upon in the defense of various progressive agendas, whether in the domain of art, politics, or religion. They also served in the construction of the de Menils' singular public profile. To their disruptive cultural and social agendas—most notably, perhaps, their championing of modern art and civil rights—they brought the authority of European culture and wealth. This authority was certainly furthered by John de Menil's notable acumen in the oil business, Houston's premier industry.

In 1924 John de Menil received a Polignac Foundation Fellow-

ship, awarded on the completion of his degree at l'Ecole des Sciences Politiques, where he had studied as a night-school student while working in a low-level position at the Banque de l'Union Parisienne. Born to a titled Catholic family in Paris whose fortune had been lost, John de Menil left school at seventeen determined to work to recover the estate of his family. This fellowship afforded him a round-the-world trip; on his return he wrote a report in which, his son Georges recounted, he "describes in detail the wool and sugar markets of the Pacific and the West Indies." The report brought him to the attention of bank officials and, Georges continued, "marked the beginning of what then became a meteoric career."[19] In 1931, when John and Dominique de Menil got married, John was in charge of investment services at one of the largest French banks and under considerable pressure from Conrad and Marcel Schlumberger to join the family company.[20]

John de Menil outlined his reluctance to leave the bank: "There are also—and I think this is what matters to me—the 600 people I have under me. What a wonderful adventure it would be if I succeeded in establishing friendly relations with them, breaking through their distrust and resentment. The feeling of being one of the rare ones who approach this job with a new heart. Desire to have a part, there or elsewhere, in the quest for a harmony cruelly absent from the life of these great anthills. Now you will understand, I am sure, that if Prospection [Schlumberger] proposed purely a financial and fiscal post to me, I would be very reluctant to accept it."[21] Here we get a sense not only of his frustrations with the confinements of conventional depersonalized management practices, but also of his own desire to make his mark. In light of what John and Dominique de Menil together achieved in Houston, however, the ambitions expressed here are strikingly modest. Houston, by contrast, allowed an unusual degree of proximity of action to ideas.

In Houston the de Menils radicalized a French intellectual discourse with which they had become engaged in Paris and subsequently in New York, pursuing their intellectual and religious commitments through projects that extended across a range of domains: social justice, spirituality, education, and the arts. And notwithstanding their internationalist commitments and their enduring distaste for parochialism, they became tireless champions of Houston's development as a modern, vibrant city. This was no doubt in the interest of making Houston less alien to their sensibilities, as is suggested in Dominique de Menil's early assessment of the city: "I would never have started collecting so much art if I had not moved to Houston.... Houston was a provincial, dormant place, much like Strasbourg, Basel, Alsace. There were no galleries to speak of, no dealers worth the name, and the museum ... that is why I started buying; that is why I developed the physical need to acquire."[22] But while John and Dominique de Menil might have effected a transfor-

mation of Houston that was congenial to their own tastes, they did so also with a strong sense of civic duty.[23] Indeed, their patronage took the form of a vocation—both a duty and a compelling desire.

After reading the article "Metropolis USA" in an in-flight magazine on Swiss Air in 1962, John de Menil wrote to the *Swiss Air Gazette* to point out lacunae in their treatment of Houston. The article omitted mention of the Space Center, he noted, and of the developing importance of Houston's chemical industry. But most centrally he drew attention to the author's neglect of Houston's "remarkable cultural development." He mentioned the high caliber of the symphony and the theater,[24] but focused on the visual arts with which he was most involved. He singled out the Museum of Fine Arts, Houston (MFAH), with its Ludwig Mies van der Rohe–designed addition and its director James Johnson Sweeney, "one of the most famous museum directors, nationally and internationally" (fig. 2.4). And he also highlighted the University of St. Thomas campus then being built by Philip Johnson, with an art history department headed by Jermayne MacAgy (fig. 2.5), whose attributes he went on to extol: "Such a two as Sweeney and MacAgy is quite exceptional, and I do not believe that many cities have the like of it."[25] A letter he had written just two weeks earlier to *Houston Town & Country* voiced similar concerns, again noting the particular distinction of Sweeney and MacAgy: "What city in this country can boast to that equivalent?"[26]

What is striking in this is the degree to which John de Menil

established himself as an "ambassador for Houston," promoting his projects without using it as an occasion to promote himself, but equally noteworthy is his habit of asserting the distinction of the city in terms of the quality of the people attracted to it—albeit often with the de Menils' help. To secure Sweeney for the MFAH, they made a significant contribution to his salary, and just a few years earlier at the Contemporary Arts Association of Houston (CAA, now the Contemporary Arts Museum Houston), they had engineered the hiring of MacAgy from the California Palace of the Legion of Honor in San Francisco, where she had the distinction of being the youngest museum director in the country and had become known for her highly theatrical installations.[27] When she took up her position with the CAA in 1955, with her salary paid by the de Menils, she did much to further this reputation. She organized thirty shows during her four years as director, many of which drew national attention.[28] She also curated and installed "Paul Klee" and "From Gauguin to Gorky," both 1960, under the auspices of the Modern Art Committee of the MFAH on which Dominique de Menil served, as well as the inaugural exhibition "Totems Not Taboo," 1959, for Cullinan Hall, the new Mies van der Rohe addition to the MFAH. It was widely considered to be the most spectacular show ever presented in Houston.[29]

When MacAgy's contract was not renewed at the CAA in 1959, John and Dominique de Menil saw the opportunity to establish a position for her as chair of art history at the University of St. Thomas,

a small Catholic university founded in 1947 by the Basilian Fathers. Throughout the 1950s and 1960s, the de Menils stewarded the development of the school. They bought land around the single-building campus and proposed to donate it to St. Thomas for the school's expansion. They offered to cover the architect's fees as long as they could specify the architect, Philip Johnson, who was at that time a modernist disciple of Mies van der Rohe. The Basilians welcomed the proposal, and Johnson produced a plan for the campus that would be built in increments, with several buildings completed in the late 1950s; there was also talk of building a chapel in the spirit of the French chapel projects of Couturier. The de Menils went on to subsidize not only MacAgy's salary but also those of several other professors in theology, economics, and art history.

In addition to teaching art history, MacAgy curated, installed, and produced a catalogue for a show each semester, and in conjunction with the de Menils worked on putting together what became known as the "young teaching collection," numbering some five hundred objects by 1968.[30] It was MacAgy's facility for the conceptualization and installation of exhibitions—her ability to produce enthrallment—that defined her tenure at St. Thomas. "No one could be expected to love art," Dominique de Menil wrote of the alchemy that MacAgy's installations achieved, "unless seduced." She continued, "Jermayne MacAgy was a master at seduction. She could cast a spell on practically anything. If she decided an object should be raised to the dignity of an art object, an art object it became. Nothing was too humble, too banal or too corny to be excluded from her phantasmagorias…. Her exhibitions seemed to prove Marcel Duchamp right. The spectator completes the creation. Without his cooperation, there is no work of art. Her talent insured that cooperation. Each of her installations produced an atmospheric miracle, which set the work of art in such a light that it would shine and talk to anyone who would care to look and listen."[31]

"My Career, the Installation of Shows"

It was a huge loss to Dominique de Menil when MacAgy died suddenly in 1964. It was also a great loss to MacAgy's students and associates and to Houston's increasingly energetic art scene, which she had been profoundly instrumental in fostering. "Whoever accepted her leadership," Dominique de Menil wrote, "became a new and talented person,"[32] and so it was that Dominique de Menil herself took over as head of the Art Department. "I finished her shows and tried to keep things going," she said, "and that was when I was led to my career, the installation of shows."[33]

While it may have appeared at the time that Dominique de Menil had simply adopted the incantatory modes of MacAgy, it soon became clear that she was recasting these newly acquired skills to

serve a distinctive Catholic aesthetic and moral temperament. The shows she mounted were, like MacAgy's, thematic; they did not attempt to give an art historical narrative but instead put together often rather unlikely objects in such a way that they would command fresh attention. What Dominique de Menil sought in her installations were "incantations,"[34] provoking a visceral response that would exceed, and perhaps subvert, intellectual readings. Using what she had learned from MacAgy, Dominique de Menil began experimenting with the religious and philosophical elements of the off-modern. This marked the beginning of her career of aesthetic activism.

In addition to producing an ambitious schedule of exhibitions and guest speakers, she continued with her husband to build the teaching collection, not only contributing works bought with particular exhibitions in mind and donating some from their own collection, but also encouraging contributions from other collectors, and especially from artists and dealers. In the foreword to the catalogue for "A Young Teaching Collection," an exhibition of 252 works from the collection shown at the MFAH in 1968 to mark the tenth anniversary of the St. Thomas Art Department (fig. 2.6), Dominique de Menil invoked Couturier to explain the importance of such a collection:

> "When you love a painting you want to touch it," once wrote Marie-Alain Couturier…. He believed a work of art needs intimacy to be understood and loved. It is precisely this intimacy that a teaching collection provides. The student can look at a painting day after day; he can observe a sculpture from all angles, feel its weight, smell it, caress it. A work of art has invaded its territory and demands a response.
>
> This challenge is never offered by slides and photographs. They are superb tools, indispensable tools, but they are only tools. They are remote from the original and this very remoteness leaves us emotionally distant. Scholarly judgments can be passed without involvement.[35]

Here, in Dominique de Menil's characterization of the significance of intimacy in generating an affecting engagement with art, we see an early articulation of what was to become an enduring preoccupation.[36] In public exhibitions, where objects cannot be handled freely in the way that they could be in the context of a teaching collection, the challenge is to produce the artifice of intimacy.

The Menil Collection has pursued this effect in a variety of ways. The museum's galleries are constructed as more or less discrete domains that may be reached independently of one another from a central promenade. The large galleries are themselves subdivided, some temporarily in response to the requirements of specific shows, others more or less permanently to create more modestly proportioned rooms for some installations. What Dominique de Menil sought in the arrangement of the museum's galleries were intimate spaces wherein a person might experience a visceral engagement, in

Fig. 2.6
"A Young Teaching Collection," The
Museum of Fine Arts, Houston, 1968

which "one's territory is invaded." The intimate character of these spaces relies not only on their architectural form but also on a range of more ephemeral evocations. It has been the museum's practice to pay careful attention to the effects achieved through lighting and to avoid placing physical barriers between the artworks and the viewer: no lines are drawn on the floor, and Plexiglas has been used sparingly, and inevitably with regret. There are no didactic wall panels, and labeling is minimal; docents and audio guides are absent. Moreover, there are no crowds. Works are hung considerably lower than at many museums,[37] so one is not obliged to gaze up at them in a stance of veneration. Walter Hopps (fig. 2.7), the founding director of the Menil Collection who, like MacAgy, had an extraordinary facility for the installation of exhibitions (see fig. 2.8)—and who also shared with MacAgy, and with John and Dominique de Menil, a respect for artists that is strangely muted in most art museums— described it this way: "Jerry [MacAgy] used to say she wanted the center of the paintings to 'hit the tits'.... Anyway, that's what we work with here. It's a somewhat lower hanging point than you'll see at the National Gallery or the Metropolitan. With those museums, you get

Fig. 2.7
Walter Hopps, The Menil Collection,
Houston, 1997

Fig. 2.8 *opposite*
"Robert Rauschenberg: The Early 1950s,"
The Menil Collection, Houston, 1991

heavier traffic, acoustiguides, and so forth, and you tend to hang higher, so that people can see over other people's heads. Here we can create a greater feeling of intimacy with the work hanging lower."[38]

Throughout Dominique de Menil's insistence on an intimate, poetic experience of art can be heard the voice not only of MacAgy but of Couturier also. Writing to Father Pie-Raymond Régamey, his co-editor of the journal *L'art sacré*, which became a defining instrument of the French Sacred Art Movement, Couturier stated his position emphatically: "I insist on the primacy I will give, as far as I possibly can, to 'poetry' over pedagogy. You tell me that the two are reconcilable; but you know perfectly well that concretely that is not so: poetry is always sacrificed to pedagogy.... [F]or once it is going to be the other way round: pedagogy will be sacrificed to poetry."[39]

Couturier pursued this expressly nondidactic mode of engagement, later conjured in the Menil Collection, not only in the pages of *L'art sacré* but also in his collaborations in the design of the churches of Assy, 1950, and Audincourt, 1951, and of the chapels of Vence, also 1951, and Ronchamp, 1955.[40] It also informed his negotiation of highly controversial commissions for artworks for these sanctuaries from leading modernist artists, among them Henri Matisse, Fernand Léger, Georges Rouault, Marc Chagall, and Jean Lurçat. Writing of La Chapelle du Rosaire in Vence, the chapel that Matisse described as his "crowning achievement" and that is now

commonly known as the Matisse Chapel, Couturier noted, "It was not to be a place where stained-glass windows and paintings would describe and teach complex things that people already knew anyway, but a place which by its beauty would change their hearts—a place where souls would be purified by the purity of its forms."[41]

These Dominican projects were sufficiently controversial to provoke a response from Rome. What offended the Church was not so much the *look* of the modern works that Couturier commissioned, though that was indeed a fraught issue, but the fact that (with the exception of Rouault) none of the major artists were Catholics; indeed, among them were the Jewish Jacques Lipchitz and the atheist Léger.[42] Couturier admitted that this was not ideal, but that under the circumstances it "would be safer to turn to geniuses without faith than to believers without talent."[43] "Trusting in Providence," he noted in a 1947 interview, "we told ourselves that a great artist is always a great spiritual being, each in his own manner."[44] By contrast, modest talents in the "deplorable" conditions of the day "create, as it were, a slope on which everything goes downhill, inexorably, turns to mediocrity."[45] Couturier was then, as Robert Schwartzwald so astutely characterized him, "resolutely democratic on issues of *access* to the means of artistic creation and especially art appreciation," but "aristocratic when it came to hierarchy of artistic quality," and certainly both John and Dominique de Menil shared that disposition.[46]

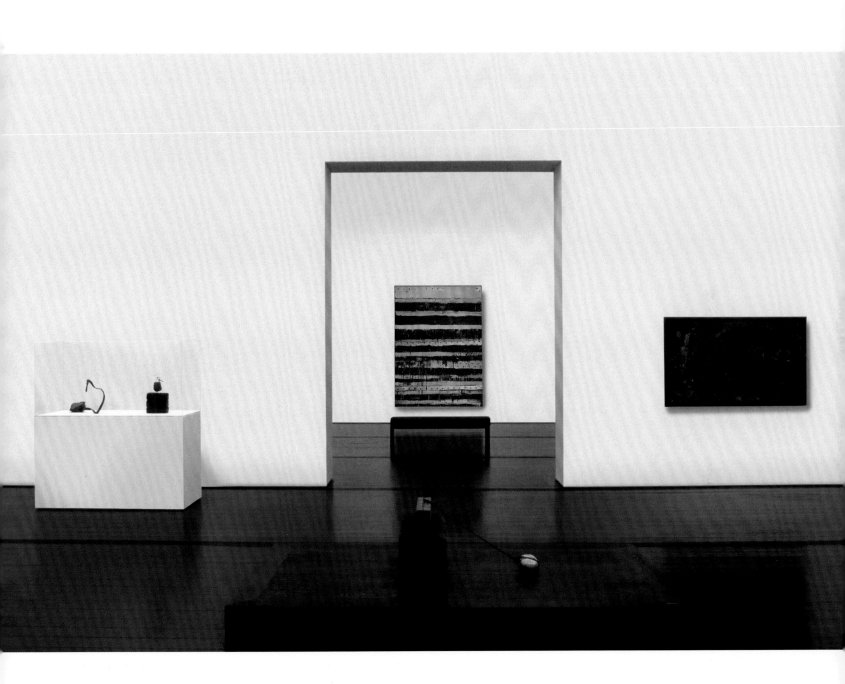

Faith

When MacAgy died, it was, for Dominique de Menil, "as if the floor had opened up under my feet."[47] It is such moments, she explained, that call for "an act of faith."[48] John and Dominique de Menil's resolve to build the chapel that they had been thinking of for some time was such an act. They called on Philip Johnson, whose design for the University of St. Thomas campus was already partially completed, to design the structure and commissioned Mark Rothko to make a series of paintings for the interior.[49]

In her opening address at the dedication of the Rothko Chapel in February 1971, Dominique de Menil recalled two events that had been decisive for her and her husband:

> In January 1936 Father Congar delivered eight lectures on ecumenicism which marked the beginning of his ecumenical career. I had the privilege to hear him and it marked me for life.
>
> In the summer of 1952 we visited with Father Couturier, another Dominican, the churches where Léger and Matisse, two towering artists of their time, had contributed their greatest work. We visited also the site where Le Corbusier was going to build his famous Chapel at Ronchamp. We saw what a master can do for a religious building when he is given a free hand. He can exalt and uplift as no one else.
>
> The influence of those events was lasting. If we played a part in the birth of this chapel, which indeed we did, it stems from the orientation we received those early days, through those two men.
>
> But this chapel has deeper roots than our own involvement.... It is rooted in the growing hope that communities who worship God should find in their common aspiration the possibility to dialogue with one another in a spirit of respect and love. This hope, this nostalgia, explains the Chapel, as it explains many spontaneous initiatives of brotherhood coming up all over the world today among religious people.
>
> The rest is good will and circumstances.[50]

Though Dominique de Menil described her aspiration for genuine respect and dialogue among people of all faiths in terms of "nostalgia," her project was clearly not fed by the kind of nostalgia that sustained the activities of Catholic traditionalists for whom Catholicism stood, by definition, "over and against modernity."[51] Both Couturier and Yves Marie Joseph Congar (fig. 2.9), in their respective efforts to reconcile the Church with contemporary society, saw the future of the Church in its ability to reorient itself to contemporary conditions, rather than in the attempt to reclaim some past historical moment, and John and Dominique de Menil shared this view. Their enthusiastic support of John XXIII makes this abundantly clear,[52] but it can be observed also throughout their endeavors. While Couturier focused primarily on freeing liturgical art from the confines of academicism, fostering instead the work of contemporary artists, Congar, the leading Catholic proponent of ecumeni-

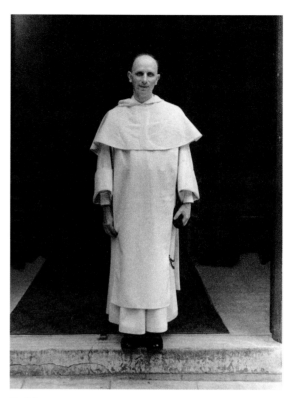

Fig. 2.9
Father Yves Marie Joseph Congar, 1947

cism, argued for "greater attention to the experiencing subject, whose needs and concerns shift with the contours of history itself."[53] Dominique de Menil and Congar both felt deeply the desire for the reunification of the Church, East and West,[54] which they sought not through a return to orthodoxy but through a set of contemporary reconfigurations.

The respective preoccupations of the two Dominicans developed within the context of the *renouveau catholique*, a Catholic revivalism that emerged in the interwar years in response to two particular conditions that had a profound effect on a generation of French intellectuals: "First, seeing the postwar epoch as a time of bereavement in need of creative synthesis of both tradition and present; and second, rethinking the 'modern' as ambivalently *off-modern* in its nostalgic futurism. Catholic revivalism became a salient influence in postwar France because it was an act of memorialization, an attempt to restore meaning and self-identity to a traumatized culture. Its actors accomplished this through a creative recasting of traditional Catholic tropes as the ultimate expression of postwar modernity."[55]

Raïssa and Jacques Maritain (fig. 2.10) were central to this effort to come to terms with the contemporary. They, like many of their circle, returned to the Church or converted to it, to a faith that offered

a meaningful alternative to the rationalism of the Enlightenment that had ceased to seem plausible in the devastation of the war. The doctrinal problem that they, along with many other French intellectuals, faced was to reconcile the traditional Church, committed as it was to the absolutism of eternal truths,[56] with the constantly changing character of the contemporary. The Maritains pursued this through a creative reworking of Thomas Aquinas, arguing that contemporary reality, and specifically modern art, might serve as a vehicle by which the ineffable could be reached.[57]

This argument on behalf of modern sacred art was controversial enough, but it was further radicalized by Couturier in his insistence that great art, even great religious art, was not the exclusive domain of the faithful. The notion that the ineffable might not be exclusively the domain of Catholics also, of course, underpinned Congar's ecumenicism outlined in his 1936 lectures delivered in the basilica of Montmartre, anticipating by some thirty years the papal focus on ecumenicism that was to find expression in the Second Vatican Council.[58] When John and Dominique de Menil heard him speak in 1936, "It wasn't any particular thing he said," Dominique de Menil recounted. "It was like a little seed deposited. There was some receptivity. The seed grew like the mustard seed mentioned in the Bible."[59] One imagines that just as appealing as his ecumenicism was his enthusiasm for reform—and more particularly for reform that did not turn its back on the present.

The Rothko Chapel gives form not only to Couturier's understanding of the sacred in relation to art, but also to Congar's ecumenicism; residing at the chapel's core is his injunction to take other faiths seriously. Indeed, the nondenominational Rothko Chapel goes beyond an embrace of diverse religions to also engage secular forms of spirituality. It operates not only as a space of contemplation, but also as the institutional hearth for those projects pursued by John and Dominique de Menil that came together under the rubrics of social justice, world peace, and spirituality, albeit initiated with an iconic aesthetic and architectural statement. The Rothko Chapel has been host to a series of colloquia, bringing together people of various faiths from around the world, but also bringing into conversation intellectuals from a range of perspectives, and it has taken a number of initiatives to recognize and support the work of human rights activists.

The first of the Rothko Chapel colloquia, "Traditional Modes of Contemplation and Action,"[60] a collaboration between John and Dominique de Menil, was convened in July 1973 just weeks after John de Menil's death. That Dominique de Menil insisted that everything should go ahead as planned, notwithstanding her grief, was testament to the centrality of their work to their lives.

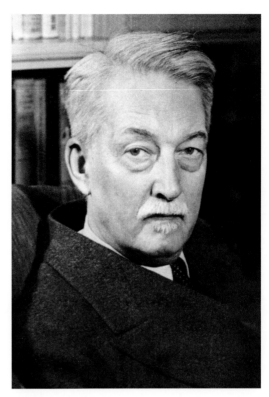

Fig. 2.10
Jacques Maritain, ca. 1951

Patronage as Activism

Issues of social justice had taken form early in the activism of John and Dominique de Menil with their efforts on behalf of the civil rights movement. As was characteristic of their patronage, they became involved with specific projects in response to particular individuals.[61] John de Menil had taken a special interest in the young student activist Mickey Leland (fig. 2.11) when they met around 1970. Art critic Ann Holmes wrote of the significance of this association:

> Knowing that one person can spark a reform, he gave Mickey the encouragement and financial help necessary to get his education. Racial tensions were running high at the time, remembers Richard Murray, a political scientist at the University of Houston: "Mickey Leland was considered the most dangerous political leader. But John taught Mickey, and Mickey was like his son. That frightened some people who thought the de Menils limousine liberals."

> As Chandler Davidson, a sociologist at Rice University, recalls it, "The de Menils were looked on as people who broke ranks with the city's top society. To them, the de Menils may have seemed like traitors to their class." Dominique de Menil counters, "A *lot* of people stood for civil rights and human causes—Oveta Hobby, the George and Herman Brown families, Nina Cullinan and many others."[62]

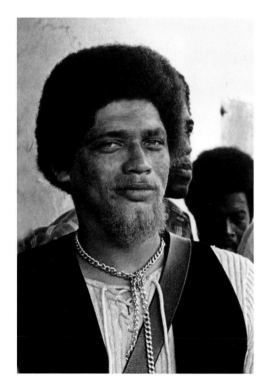

Fig. 2.11
Mickey Leland,
Houston, 1971

Fig. 2.12 *opposite*
"The De Luxe Show,"
De Luxe Theater,
Houston, 1971

It is indicative of their willingness to engage the politics of race in Houston that when they commissioned Philip Johnson to design their new home in 1948 in the wealthy River Oaks neighborhood, they had him orient its main entrance to San Felipe, a street that had hitherto only been used for rear service entrances for the comings and goings largely of African American and Hispanic employees.[63]

Leland worked closely with the de Menils in negotiating the complicated political terrain of "The De Luxe Show," the 1971 exhibition initiated and sponsored by the Menil Foundation, mounted in the building of a long-defunct cinema in the Fifth Ward, a poor black inner city neighborhood in Houston (fig. 2.12).[64] "The De Luxe Show," one of the first racially integrated exhibitions of contemporary artists in the United States, was mounted in response to a nationwide controversy over barriers to black artists and, more proximally, perhaps in response to criticism that the de Menils' exhibition "Some American History" of February–April 1971, examining slavery and black life in America, had focused primarily on the work of white artist Larry Rivers.[65] After "The De Luxe Show," works from the de Menils' collection continued to be shown in the space over the next three years. Having been groomed by John de Menil for a career in politics, Mickey Leland served Houston as a state representative and later as a congressman until his untimely death in 1989.

The Menil Foundation developed a scholarship program for promising black students that would prepare them for college and support them through the completion of their academic training, and it gave ongoing support to SHAPE (Self-Help for African People through Education). Two preoccupations recurred throughout these projects: the significance of access to good quality education and the recuperative potential of art, demonstrated through the de Menils' endeavors to give African Americans access to their distinctive aesthetic heritage, exhibiting both African art and the work of contemporary African American artists such as Peter Bradley and Joe Overstreet.

But perhaps the most enduring of their projects concerned with race relations is the Image of the Black in Western Art. Dominique de Menil had been shocked by what she recounts as her first exposure to sanctioned racial segregation: "I was startled once to be removed from my seat on a train between Houston and New York. I had sat in a car with blacks because it was not crowded and seemed comfortable. I did not consider the people there one way or another. The conductor ordered me to move."[66] This is the incident that is recounted as the provocation for the Image of the Black in Western Art, a project of extraordinary scope that the Menil Foundation financed from its inception in 1960 until 2005, when Harvard University assumed full responsibility for the archive and its publications.[67] Like other de Menil benefactions, this was not something they had charted in advance, but rather, it emerged in response to the enthusiasms and expertise of a particular individual, in this case art historian Ladislas Bugner, who was initially merely to curate an exhibition on this topic. An appealing idea pursued with excellence was allowed to take on a life of its own under the stewardship of John and Dominique de Menil.

This was always a central element of their experimentation. While the apparently disparate aspects of their work in fact form a remarkably coherent expression of their religious and moral commitments—the crafting of a sacred modern—they never adopted a long-range program. They were, in each articulation of the foundation's mission, very clear about the spirit of its work—"pioneering and unconventional"[68]—but unwilling to specify its content, since they were intent on retaining the flexibility to be responsive to unfolding circumstances, able to take up an unanticipated opportunity, equally free to abandon a project that ceased to be compelling and, more fundamentally, to embrace change and the future. This is captured in a memo that Dominique de Menil wrote to members of the Menil Foundation board in 1976, which she circulated again to board members more than a decade later, in 1989, with a note appended, explaining that she had happened upon the original memo, "which appears to me a bit naïve.... Yet, the ideas expressed remain pertinent.":

> We are often asked what ... are the basic ideas behind our projects, which cover such a wide range of activities? Jean used to say: "We do what others don't do." This is not just a provocative remark. It is a whole program.

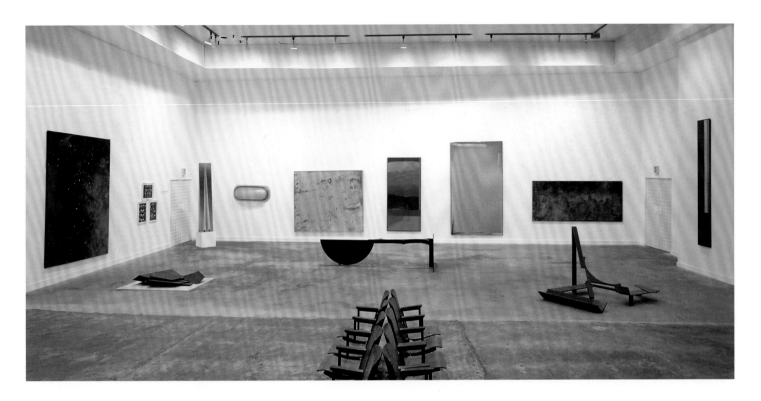

Of course we could join hands with others who do excellent work, but somehow the vocation of this foundation is elsewhere. We are in a position to be more creative and more daring. We should try to discern the men that are the greatest, and hopefully at an early stage in their career when it is not yet obvious that they are great, and when a small help can be crucial, and we should try to do what is not yet perceived as important, but will be.

This policy of independence of mind involves higher risks than conformity to established programs, and it obligates us to surround ourselves with people of great discernment, people who have an instinct, a natural taste for the highest quality.

We face a world in chaos. The problem is both a moral failure and a failure of intelligence—morality and intelligence being the two sides of the coin. It would be exhilarating if within the limited means of this foundation we would encourage ideas capable of making a breakthrough, works of a redeeming quality and far reaching consequences.[69]

There were indeed risks involved in this kind of activist patronage. Having invested considerable financial resources, and even more impressive measures of time, energy, and enthusiasm, John and Dominique de Menil would have dearly liked to extend their stewardship of St. Thomas, which, it seemed to them, had the potential to become a stellar liberal arts college. Given their commitment to the kind of informed, disciplined, critical thinking that such a school could foster in its students, the de Menils saw access to this kind of intellectual training as a consequential element of social reform. In the late 1960s it became clear, however, that St. Thomas would not concede to admitting laity to their board. Their vision for the school thwarted, the de Menils resolved with considerable regret to transfer their programs and their modified ambitions to Rice University, taking with them students and faculty, along with most of the teaching collection and the art library that they had created for St. Thomas. At Rice they established the Institute for the Arts, which allowed them to pursue their projects—lecture series, guest speakers, exhibitions, film studies, collection management—with the participation of university faculty and students, but without any obligation to align these activities to the requirements of accredited university programs. On a far-flung corner of the Rice campus, they built what became known as the "Art Barn," a temporary structure to house the Rice Museum (established by the de Menils independently of Rice's own Sewall Art Gallery), as well as the Rice Media Center for the pursuit of film studies.[70]

At Rice, Dominique de Menil continued to create shows that received considerable attention (see fig. 2.1), a number of which traveled to major museums internationally. Students and graduates hired to staff the Rice Museum worked on much of the organizational detail of putting together exhibitions, assisted in the production of exhibition catalogues, took artworks and slideshows to elementary schools, and did research on the teaching collection. And many migrated between Rice and the Menil Foundation, housed in the de Menil residence on San Felipe, since the boundaries between these operations were far from distinct.

Fig. 2.13
John de Menil, Alexander Iolas, and René
Magritte at the opening of "René Magritte"
at the Museum of Modern Art, New York, 1965

Islands Beyond

The collection, which now numbers some sixteen thousand pieces, was central to John and Dominique de Menil's project and was an abiding passion. Unlike many collectors who characterize themselves as having always had a special appreciation for art, Dominique de Menil described herself as having been awakened to it under the guidance of Couturier who, she repeated in a variety of ways, "opened her eyes" and "taught her to see." Couturier not only fostered her ability to "see" art, but encouraged her to buy it also. On their frequent business trips to New York, John and Dominique de Menil would accompany Couturier in tours around the New York dealers. Dominique de Menil, however, was not immediately seduced by the work she was being shown and was anyway initially uncomfortable with the idea of spending significant sums of money on art, a reticence informed in large measure by her Alsatian Protestant upbringing. (It was not until after her marriage, and very much moved by the intellectual milieu of the *renouveau catholique*, that she converted to Catholicism.) "Father Couturier relieved me of my *latent Puritanism* I had inherited as a tradition," Dominique de Menil wrote. "For many years I felt that purchasing art was a *slightly bad* action, too pleasure seeking, too hedonistic. Father Couturier made it almost a duty to buy art we could afford" [emphasis in original].[71] Her reticence resolved, she joined her husband in actively acquiring works and continued to do so passionately for some fifteen years after her husband's death in 1973. "We try not to stop collecting," she commented. "Once we stop, we belong to history."[72]

What they collected was a thoroughgoing expression of their off-modern commitments. They viewed (however naively) the antiquities, Byzantine and medieval art, and "tribal" objects, *particularly* from Africa and Oceania, as "pure" expressions of tradition and humanity, innocent of the secular rationalism ushered in by the Enlightenment, embodying a nostalgia for an imagined pre-modern past. The twentieth-century art they collected was, of course, a reflection of their embrace of the new, while the Surrealism in which they had developed a special interest manifested the dissonant, apparently incompatible elements of the off-modern. While the various areas of collecting cohere insofar as they materialize their off-modern commitments, the de Menils never acquired works with an overarching plan in mind. "So many people want to know my policy of buying for the collection. My policy of buying is having no policy," Dominique de Menil insisted. "There is no special theme for the permanent collection because you don't buy with ideas in your head."[73] Indeed, for Dominique de Menil, acquisitions should properly be informed by "instinct" and "love." But the idea that one should select works purely on the basis of desire does not mean, however, that the choice could simply be a matter of personal gratification. Insofar as aesthetic engagement was for Dominique de Menil a matter of ethics—a task to which one should apply oneself in the training of one's sensibilities—

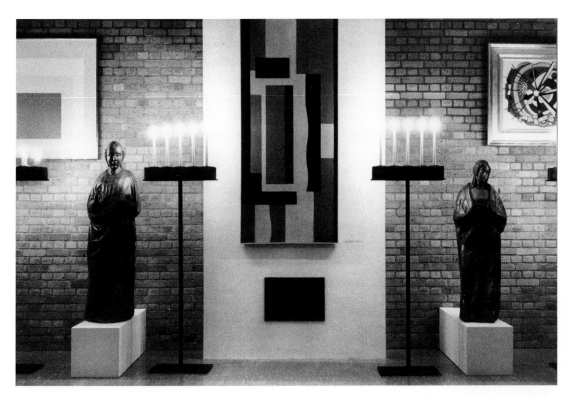

Fig. 2.14
"Islands Beyond: An Exhibition of Ecclesiastical Sculpture and Modern Paintings,"
University of St. Thomas, Houston, 1958

Fig. 2.15
Giorgio de Chirico, *Hector and Andromache*,
1918. The Menil Collection, Houston

effort is called for, and faith. The dealer Alexander Iolas (see fig. 2.13), whom she identified along with MacAgy and Couturier as the most influential on her practices of collecting and exhibiting art, had drawn the de Menils' attention to the work of the Surrealists, for which they initially did not care. Dominique de Menil explained: "At first I resisted Surrealism; it was such a strange world. I felt outside of it. But Iolas kept showing us great works. He was so convincing; he was himself so convinced of the importance of what he was showing. I remember my skepticism in front of our de Chirico, *Hector and Andromache* (fig. 2.15). I was not taken in; I bought it on his word, on faith."[74] But while this work may have seemed initially beyond Dominique de Menil's purview, it embodies preoccupations central to her aesthetic. For, as Hal Foster has pointed out, Giorgio de Chirico "works to depict the world as 'an immense museum of strangeness,' to reveal the 'mystery' in insignificant things."[75]

MacAgy's first St. Thomas show, "Islands Beyond: An Exhibition of Ecclesiastical Sculpture and Modern Paintings," was a moody, partially candlelit installation of paintings by Max Ernst, Paul Klee, Fernand Léger, René Magritte, Mark Rothko, Rufino Tamayo, and others, juxtaposed with medieval ecclesiastical sculptures, very much in the spirit of Couturier's reaching back to medieval forms as an antecedent to modern art (fig. 2.14).[76] In the foreword to the catalogue for the show, the Very Reverend G. B. Flahiff spoke of the invisible realms to which the show gave access:

The significant word is "beyond," for the pieces have been selected with a view to manifesting the power of art to evoke what lies beyond the world of the senses.... The work itself is more than a material thing. It is a veritable "incarnation" of a glimpse of reality that the artist has caught and that he has to express not in a logical statement but only in a work of art through a material medium like sound, lines, colors or masses. It is for this reason that the deepest joy attendant upon the experience of contact with a work of art is not that of the senses or the emotions, but that of the intelligence as it grasps intuitively rather than rationally realities beyond the senses and reacts to their beauty.[77] For some, these realities float like distant islands on the horizon of another world: for others, they constitute but a single all-embracing realm: for all, they are, willy-nilly, a part of the Reality beyond, in leading us to which, art has intrinsically an affinity with religion.[78]

In this description of the structuring principles of "Islands Beyond," Flahiff gives a characterization that speaks to the redemptive possibilities of art, an understanding that is central to the aesthetic projects of John and Dominique de Menil and which, of course, evokes fundamental Catholic preoccupations.

While still with the California Palace of the Legion of Honor, MacAgy wrote of her approach to installation: "To create an aura, an atmosphere belonging personally to the objects, rather than merely building an edifice against which the objects look well, is the purpose of the Museum's installation plans. And yet this is not to say that the settings should not look well ... but [they should be] at all times subservient—acting with and always evoking the innateness of the things exhibited."[79]

While this passage, which is concerned with the full presence of objects, may seem at odds with Flahiff's characterization of their referential force, the point of both comments is to stress that the exhibition itself is not the primary object, but a means by which attention to its constituent objects (or to what might be glimpsed through them) might be focused and refined. MacAgy's close attention to exhibition design, then, was not in the interest of creating spectacle for its own sake, but as a technique by which the ineffable is made present. This point is worth noting since it reveals a very particular relation to art objects that resists their reduction to mere art historical artifacts, or to spectacles of surplus value. It is a view that recurred among those whom the de Menils sought out to work with them on their various projects and was fostered in the students of MacAgy and later of Dominique de Menil.[80] Paul Winkler, who had been Dominique de Menil's student at St. Thomas and was centrally involved in the conception and construction of the Menil Collection as its assistant director, learned this lesson well under her tutelage. When Walter Hopps stepped down as director to focus his attention on the curation of shows as the Menil Collection's consulting curator,

Winkler became the museum's director; he, Hopps, and Dominique de Menil were the museum's informal management team.

For many Menil staff, this particular regard for the object and for the sensibilities it might conjure not only has defined their practices within the museum but has also resided at the heart of their deep personal investment in the Menil Collection. What is expressed and reproduced through the alchemy of Menil Collection exhibitions is a longing that is not necessarily strictly religious (of the sort expressed by Flahiff and held dear by Couturier and by Dominique de Menil), but takes a secular form in the desire to maintain the conditions of possibility for experience that is irreducibly aesthetic in character. This calls for the conjuring of aesthetic experience not only through the crafting of exhibitions but also through a constellation of details that underpin the exhibition—from the architectural elaboration of luminous work spaces, attentive maintenance, intelligent and seductive exhibition design and installation, beautiful and scholarly publications, and meticulous attention to conservation and to the storage of works in the "treasure house." But most crucially it refers to the disposition toward the collection's objects. To treat artworks as ordinary things is to compromise their aura—to make them banal. The practice of care that has been cultivated at the Menil Collection is not just a set of injunctions to do things in a manner that is excellent, but rather, it amounts to the maintenance of an aesthetic disposition, a careful mode of engagement that sustains the affecting force of the artworks.

The daily work of crafting the Menil aesthetic was not taken up as a set of techniques or procedures designed to achieve a specific outcome, but rather as a response to a series of ethical injunctions, to do things in "the Menil way." At the heart of these practices lay the care of the art object—not the empty proceduralism of merely following professional codes of practice, but the task of the exercise of judgment, of care, that ethical conduct calls for. While these ethical imperatives were perhaps intensified by the charisma of Dominique de Menil and of the privilege of working with such a splendid collection, much of what has impelled Menil Collection staff has been their own longing for an enchanted experience of art—and their abiding anxiety that such an experience might not be sustainable in a public art museum. This recognition that an aesthetic involvement calls not only for evocative exhibitory practices but also for an exercise of care toward artworks has been taken up by many Menil staff as well as by members of the public to which the museum presents itself.

The elegance and calm that the Menil Collection exudes belies its radical character. Certainly it is more like a conventional museum than the suite of buildings drawn for the same site by Louis Kahn in 1973 and abandoned on Kahn's death in 1974.[81] There are significant

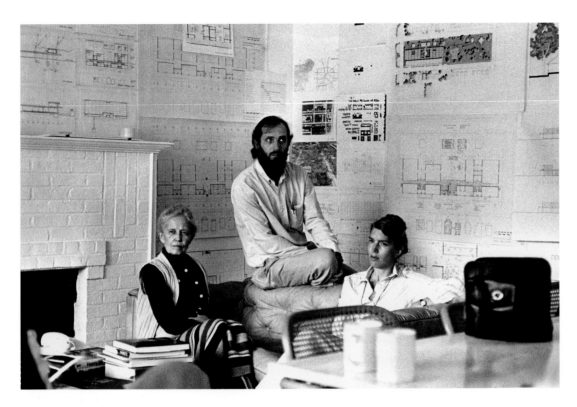

Fig. 2.16
Dominique de Menil, Renzo Piano, and
Kathryn Davidson viewing plans for the
Menil Collection, Menil Foundation office,
Houston, 1984

continuities, however, between Kahn's drawings and Renzo Piano's design, most notably the use of natural light and a scale that enables the museum to appear to fit into its neighborhood of modest bungalows.[82] More significant, however, than the form of the architecture, though this was of by no means incidental importance, was the *practice* of the architect—and the alignment of this practice with the commitments of his client and collaborator, Dominique de Menil.

The *Architectural Review*'s special issue "Architecture of Commitment" featured a cover story on Piano, giving special attention to the Menil Collection project (see fig. 2.16). Its opening portrayal of Piano mirrors the terms of Dominique's enthusiasm for him: "Renzo Piano is an architect well known—and regarded in some quarters as almost puritanical—for his continuing polemical advocacy of such notions as client participation, interdisciplinarity, the mastery and *use* of technology, and an experimental 'hands-on' approach to design.... For Piano these are moral issues, more important and more interesting than questions of personal style or form.... [It is his] commitment to *idea* above ego—that gives his built work its distinctive gentle confidence."[83] In a manner that resonates with Dominique de Menil's own practice, Piano stresses that his advocacy of participation does not amount to a democratization of the process of architecture: "Certainly, you have to try to understand people, their needs, but you are still the architect, you still have to make the decisions, you still retain control."[84] The contribution of the client then should

be "treated with respect, not submission."[85] Similarly, by eschewing the popularizing practices that other museums have adopted under the rubric of "democratization"—practices that Couturier would surely have characterized as a submission to mediocrity—the Menil Collection treats its public with respect. But more than respect is at stake. More important is the museum's crafting of circumstances that can foster and sustain resolutely aesthetic commitments that are not simply vested in a longing for an imagined past of authentic experience, but instead are oriented to the future.

It is Piano's experimental practice, not his buildings, that so distinctively bears his signature. Likewise, John and Dominique de Menil's work can most fundamentally be characterized by the experimental practice that has sustained it and that is imbued with what Schloesser describes as the off-modern "cultural Catholicism" that "refuses to quarantine the sacred."[86] The Menil Collection has sought to produce a sacred modern, and in a sense it is this sacred modern project, rather than the museum itself, that is its legacy. However, for those charged with charting the museum's future, the substance of this project and the manner by which it should be pursued are by no means obvious. It is in the character of off-modern endeavors to resist such specification, since they are inherently experimental and innovative, engaging the unfolding present as a critical, creative task that is a responsibility as much to the future as to the past.

NOTES

1. Philippa de Menil to John de Menil, undated, Menil Archives.

2. John de Menil to Philippa de Menil, August 10, 1970, Menil Archives.

3. John de Menil, Draft for the Statement of Purpose, July 27, 1970, Menil Archives.

4. Sociologist Max Weber coined this term, which has become a defining rubric for the analysis of modernity.

5. See Thomas Ferraro, ed., *Catholic Lives, Contemporary America* (Durham, N.C.: Duke University Press, 1997).

6. See Pamela G. Smart, "Sacred Modern: An Ethnography of an Art Museum" (PhD diss., Rice University, Houston, 1997); Pamela G. Smart, "Art of Transport," *Southern Review* 33, no. 3 (2000): 292–307; and Pamela G. Smart, "Crafting Aura: Art Museums, Audiences, and Engagement," *Visual Anthropology Review* 16, no. 2 (Fall/Winter 2001): 2–24.

7. Stephen Schloesser, *Jazz Age Catholicism: Mystical Modernism in Postwar Paris 1919–1933* (Toronto: University of Toronto Press, 2005), 14. Schloesser adopted the term *off-modern* from Svetlana Boym's work on the aftermath of the Soviet collapse; see Svetlana Boym, *The Future of Nostalgia* (New York: Basic Books, 2001).

8. Schloesser, *Jazz Age Catholicism*, 13.

9. Quoted in Marie-Alain Couturier, *Sacred Art*, ed. Dominique de Menil and Father Pie Duployé, trans. Granger Ryan (Austin: University of Texas Press, 1989), 10–11. This is a phrase that Dominique de Menil used frequently, drawing on the words of Couturier, her close friend and advisor.

10. Dominique de Menil, interview with the author, February 1994, Houston.

11. In museums, this "flattening" can be observed in the cumulative effects of conformity to institutionalized professional codes, submission to the criteria of funding agencies, routinized procedures for showing art, and bureaucratized management practices. In short, conformity to "best practice," codified by such organizations as the American Association of Museums in their criteria for accreditation, flattens differentiation across the museum field. The consequence, of course, is that each museum comes to feel like every other museum, and indeed like many other public institutions, thereby flattening the experiential terrain. In relation to museums, "distancing" refers to the kind of relationship between viewers and artworks that museums tend to foster; whether the viewers are experts assimilating artworks to their art history knowledge or "outsiders" looking upon artworks in admiration or bafflement, there is a notable sense of estrangement between the museum's public and its art, absent the active "mutual interrogation" that Dominique de Menil sought to recuperate.

12. Claude Levi-Strauss, "New York in 1941," in *The View from Afar*, trans. Joachim Neugroschel and Phoebe Hoss (New York: Basic Books, 1985), 258–67.

13. Dominique de Menil's sister, Anne Gruner Schlumberger, gives an account of the Schlumberger corporation in her book *The Schlumberger Adventure* (New York: Arco, 1982). A more technical account appears in Louis Allaud and Maurice H. Martin, *Schlumberger: The History of a Technique* (New York: Wiley, 1977). But perhaps the richest narrative is to be found in Ken Auletta's two-part *New Yorker* profile of Jean Riboud, former chairman and CEO of Schlumberger: "Profiles: A Certain Poetry–1," *New Yorker*, June 6, 1983, 46–49, 102–109; and "Profiles: A Certain Poetry–2," *New Yorker*, June 12, 1983, 50–91.

14. Jacques and Raïssa Maritain, raised in Protestant and Jewish faiths, respectively, were among the many French intellectuals to convert to Catholicism in the interwar period. Although they worked outside official Church institutions, their theological work positioned them as central figures in the Catholic revival of the interwar years and has afforded them enduring stature both in France and in the United States, where they were exiled during World War II. Jacques Maritain held teaching positions at Columbia and Princeton, and with the exception of a period in Rome when he served as French ambassador to the Vatican, the Maritains stayed on at Princeton until 1960, when they again took up residence in France.

15. See William Rubin, *Modern Art and the Church of Assy* (New York: Columbia University Press, 1961), for an historical account of the Sacred Art Movement; and Smart, "Sacred Modern," for a fuller analysis of the movement in relation to the Menil Collection. Also see Robert Schwartzwald, "The 'Civic Presence' of Father Marie-Alain Couturier, O.P. in Québec," *Québec Studies* 10 (Spring/Summer 1990): 133–52, for a discussion of the significance of Couturier's periodic presence in Quebec during the war years, as well as Schwartzwald's introduction to the unpublished English translation of *La vérité blessée* (Paris: Plon, 1984), a selection of Couturier's writings from 1939 to 1953, drawn from the Archives Marie-Alain Couturier, Paris, established by the Menil Foundation in 1975. The unpublished English text is in the Menil Archives.

16. Father Marie-Alain Couturier to John and Dominique de Menil, January 19, 1948, Menil Archives. Translation from French by the author with assistance of Ed Shephard.

17. Dominique de Menil, undated handwritten notes for a talk to a group of architects' wives in Houston, Menil Archives.

18. Morton Feldman, "Obituary for John de Menil," *Art in America* (November/December 1973).

19. Georges de Menil, draft of letter to Ken Auletta for Auletta's *New Yorker* article on Jean Riboud, May 1, 1982, de Menil Family Papers, Menil Archives.

20. Dominique de Menil studied physics and mathematics at the Sorbonne. There is no indication, however, that her father or uncle saw her as having a future in the company as a scientist, though she did briefly work on the company's in-house newsletter.

21. John de Menil, quoted in Schlumberger, *Schlumberger Adventure*, 120.

22. Dominique de Menil, quoted in Dominique Browning, "What I Admire I Must Possess," *Texas Monthly*, April 1983, 192.

23. Dominique de Menil, commenting on the extent and style of their engagements with Houston's cultural and social development, characterized it this way: "Yes, it is a fantastic amount of time and money and energy we spend," Dominique de Menil admits. "But Houston is becoming a great city and we must do all we can, as it grows, to help in its design, its art, and awareness. We came here, we became involved, and now we are prisoners of our own very great interests." Dominique de Menil, quoted in Ann Holmes, "A Law Unto Themselves: John and Dominique de Menil," *ARTgallery Magazine* 8 (May 1970): 36.

24. Early in their residence in Houston, John and Dominique de Menil supported the establishment of a professional theater company, underwriting the salary of Nina Vance, who directed the Alley Theatre.

25. John de Menil to *Swiss Air Gazette*, November 6, 1962, Records of the Office of the Director, James Johnson Sweeney, Correspondence and Miscellaneous Subjects, 1961–1967, Archives, Museum of Fine Arts, Houston, microfilmed by Archives of American Art Texas project, Smithsonian Institution, reel 1580.

26. John de Menil to *Houston Town & Country*, October 24, 1962, Records of the Office of the Director, James Johnson Sweeney, Correspondence and Miscellaneous Subjects, 1961–1967, Archives, Museum of Fine Arts, Houston, microfilmed by Archives of American Art Texas project, Smithsonian Institution, reel 1580.

27. Walter Hopps, the late director of the Menil Collection, once commented that the theatrical and thematic character of MacAgy's exhibitions was distinctive in that it did not compromise a primary focus on the individual works of art: "I've known a lot of design and installation people since who do not put the art first." See Walter Hopps, quoted in Calvin Tomkins, "A Touch for the Now," *New Yorker*, July 26, 1991, 37. This concern for the integrity of the object is voiced repeatedly throughout the discourse of the Menil Collection.

28. See Browning, " What I Admire," 194–96.

29. Toni Beauchamp, "James Johnson Sweeney and the Museum of Fine Arts, Houston: 1961–1967" (master's thesis, University of Texas, Austin, 1983), 21.

30. These pieces have subsequently been incorporated into the Menil Collection itself.

31. Dominique de Menil, "Introduction," in *Jermayne MacAgy: A Life Illustrated by an Exhibition*, exh. cat. (Houston: University of St. Thomas, 1968), 10.

32. Ibid., 12.

33. Dominique de Menil, quoted in Browning, "What I Admire," 198.

34. This term was widely circulated in press coverage of the 1961 de Menil–sponsored show "René Magritte," curated by Jermayne MacAgy for the Contemporary Arts Association in association with the Museum of Fine Arts, Houston, and it has since been repeated by Dominique de Menil in numerous interviews in which she discusses the art of installation.

35. Dominique de Menil, "Foreword," in *A Young Teaching Collection*, exh. cat. (Houston: University of St. Thomas, 1968), 10.

36. See Pamela G. Smart, "Possession: Intimate Artifice at The Menil Collection," *Modernism/Modernity* 13, no. 1 (Spring 2006): 19–39.

37. The "MacAgy rule" is "fifty-six inches from the floor to the center of the painting, for works of moderate size." See Tomkins, "Touch for the Now," 37.

38. Hopps, quoted in ibid.

39. Quoted in Couturier, *Sacred Art*, 10–11.

40. See Rubin, *Modern Art and the Church of Assy*; Henri Matisse, Marie-Alain Couturier, and L.-B. Rayssiguier, *The Vence Chapel: The Archive of a Creation*, ed. Marcel Billot, trans. Michael Taylor (Houston: Menil Foundation; and Milano: Skira Editore, 1999).

41. Couturier, *Sacred Art*, 94. In the late 1940s and until his death in 1954, Couturier went on to elaborate an account of these initiatives in the pages of *L'art sacré*, in which he defended his judgments with arguments concerning the relation between art and spirituality or faith, in so doing elaborating a broader treatise on the character of the aesthetic.

42. Marie-Alain Couturier, "Religious Art and the Modern Artist," *Magazine of Art* 44, no. 7 (November 1951): 268–72.

43. Ibid., 269; see also Couturier, *Sacred Art*, 52. For a discussion of the position of the Sacred Art Movement on the issue of the faith of artists, see Rubin, *Modern Art and the Church of Assy*. On Maritain's position on this issue, see Schloesser, *Jazz Age Catholicism*. Before agreeing to accept his commission, Lipchitz insisted that his sculpture of the Madonna bear the inscription: "Jacob Lipchitz, Jew, faithful to the religion of his ancestors, has made his Virgin to foster understanding between men on earth that the life of the spirit may prevail" (Rubin, *Modern Art and the Church of Assy*, 126–27).

44. Couturier, interview in *Harper's Bazaar*, December 1947, quoted in Robert Schwartzwald, "Father Marie-Alain Couturier, O.P., and the Refutation of Anti-Semitism in Vichy France," in *Textures and Meanings: Thirty Years of Judaic Studies at the University of Massachusetts Amherst*, ed. Leonard Ehrlich, Shmuel Bolozky, Robert Rothstein, Murray Schwartz, Jay Berkovitz, and James Young (Amherst: University of Massachusetts, 2004), 140, available at http://www.umass.edu/judaic/anniversaryvolume/ index.html (accessed September 25, 2006).

45. Couturier, *Sacred Art,* 119. This view is posed in opposition to the teachings of the Ateliers d'Art Sacré where Couturier trained as an artist priest. Drawing on Jacques Maritain's Neo-Thomist *Art and Scholasticism*, 1917, it was understood that "the maker of sacred art must first live a sacred life before picking up a paintbrush." See J. Weber, Archival Register, 1994, 2, Couturier Collection at Yale University, New Haven, Conn (the collection was moved to the Menil Archives in 2008). This is a point that many readers of Couturier's *L'art sacré* were unwilling to concede (Rubin, *Modern Art and the Church of Assy*, 64–73).

46. Robert Schwartzwald, introduction to the unpublished English translation of *La vérité blessée*, xxiv, Menil Archives.

47. Dominique de Menil, interview with the author, February 1994, Houston.

48. Ibid.

49. In the end, intractable differences between Johnson and Rothko over the height of the building and the manner in which it was to receive light led Johnson to withdraw from the project, leaving it in the hands of Howard Barnstone and Eugene Aubry, who had worked as supervising architects on a number of Johnson projects in Texas and had done considerable work for the de Menils. It was their task, in accordance with Dominique and John de Menil's wishes, that they complete the building as Rothko conceived of it. All the plans, including the specifications of the materials used, were approved by Rothko.

50. "Address by Mrs. John de Menil at the Opening of the Rothko Chapel, February 27, 1971," Menil Archives.

51. Schloesser, *Jazz Age Catholicism*, 4.

52. From 1981 through 2001, the Menil Foundation contributed significantly to the Instituto per le Scienze Religiose of Bologna, essentially to ensure that John XXIII's legacy would be properly appreciated and disseminated. With the foundation's assistance, the institute established a papal archive and research facility, and it has since then produced a significant body of scholarship, including a multivolume *History of Vatican II 1995–2006*, edited by J. A. Komonchak and translated into six languages.

53. Quoted in Aidan Nichols, *From Newman to Congar: The Idea of Doctrinal Development from the Victorians to the Second Vatican Council* (Edinburgh: T & T Clark, 1990), 250.

54. See particularly Yves Marie Joseph Congar, *Divided Christendom: A Catholic Study of the Problem of Reunion* (London: G. Bles, 1939).

55. Schloesser, *Jazz Age Catholicism*, 14.

56. The Church was also committed, it has to be said, to a past in which it had enjoyed considerably more stature than it was able to sustain in republican France.

57. Schloesser in *Jazz Age Catholicism* (p. 7) characterizes Maritain's deft reinterpretation of Aquinas this way: "The modern world had excluded religious belief; Catholicism had excluded the modern world. However, by recovering and recasting its dialectical tradition—in other words, through using the Church's own heritage—Catholic revivalists could re-imagine the relationship between religion and culture. Catholicism and 'modern civilization'—eternal and avant-garde, grace and grotesque, mystical and dissonant—could now be seen in categories other than simple competition: form actualizing matter, grace perfecting nature, substance underlying surface."

58. It was not until John XXIII's papacy, particularly with the Second Vatican Council in which Congar was a central participant, that his preoccupations gained legitimacy.

59. Dominique de Menil, quoted in Ann Holmes, "Dominique," *Town & Country* 145 (September 1991): 228.

60. Published as *Contemplation and Action in World Religions: Selected Papers from the Rothko Chapel Colloquium*, ed. Yusuf Ibish and Ileana Marcoulesco (Houston: Rothko Chapel; and Seattle: University of Washington Press, 1978).

61. Edmund Carpenter, husband of the de Menils' daughter Adelaide, pointed this out, prompting John de Menil to write: "In fact most projects stem from one individual: the negro iconography could not have been without Bugner; the Institute of Religion would not have been worth supporting if it weren't for Tom Shannon. Our small contribution to Masters Nursery actually is Margaret Mahler, etc." John de Menil to Philippa de Menil, August 28, 1970, Menil Archives.

62. Holmes, "Dominique," 230.

63. Stephen Fox, conversation with the author, 1998, Houston.

64. The show was curated by the New York artist Peter Bradley. As a measure of the stature of Menil endeavors, art critic Clement Greenberg came into town for the opening, and in an interview published in the catalogue, he notes, with more than a hint of surprise, the "attentiveness" of its neighborhood audience. See *The De Luxe Show*, exh. cat. (Houston: Menil Foundation, 1971).

65. See Joseph James Akston, editorial, *Arts* 45 (May 1971); Maurice Berger, "Are Art Museums Racist?" *Art in America* 78 (September 1990); George Davis, "The De Luxe Show," *Art and Artists* 6 (February 1972); and Jan Butterfield, "The Deluxe Show," *Texas Observer*, September 24, 1971.

66. Dominique de Menil, quoted in Holmes, "Dominique," 228.

67. See Francesco Pellizzi, "The Menil Advocacy for Human Rights: A Personal Account," and Alvia Wardlaw, "John and Dominique de Menil and the Houston Civil Rights Movement," in this book, pp. 93 and 103 respectively.

68. These terms recurred throughout a series of memos from John de Menil to board members in 1972 in which he outlined the Menil Foundation's purpose (Menil Archives).

69. Dominique de Menil to Menil Foundation board members, memo, November 2, 1989 [October 16, 1976], Menil Archives.

70. The Art Barn, designed and built by Howard Barnstone and Eugene Aubry in 1968–69, still stands, home now to Rice's Susanne M. Glasscock School of Continuing Studies. The Rice Media Center continues to operate, though it cannot be said to command anything like the presence that it had under de Menil leadership.

71. Dominique de Menil, written answers to questions posed by Julia Brown and Bridget Johnson for the 1983 catalogue *The First Show: Painting and Sculpture from Eight Collections 1940–1980*, Menil Archives.

72. Dominique de Menil, quoted in Ann Holmes, "Dominique de Menil: A New Kind of Patroness in a Changing Art Scene," *Houston Chronicle*, May 26, 1968.

73. *Houston Post*, November 3, 1968.

74. Dominique de Menil, quoted in Julia Brown and Bridget Johnson, eds., *The First Show: Painting and Sculpture from Eight Collections, 1940–1980* (Los Angeles: Museum of Contemporary Art; and New York: Arts Publisher, 1983), 38.

75. Hal Foster, *Compulsive Beauty* (Cambridge: MIT Press, 1993), 62.

76. "Islands Beyond: An Exhibition of Ecclesiastical Sculpture" was installed in Jones Hall at the University of St. Thomas through October 1958.

77. Flahiff's privileging of "intuitive" intellect over other modes of experience expresses Aquinas's articulation of the hierarchy of faculties, wherein intellect (not to be confused with learning or reason) reigns supreme. Dominique de Menil also subscribed to this Catholic valorization of the intellect.

78. Very Reverend G. B. Flahiff, "Foreword," in *Islands Beyond: An Exhibition of Ecclesiastical Sculpture and Modern Paintings*, exh. cat. (Houston: University of St. Thomas, 1959), 5.

79. Jermayne MacAgy, *Bulletin* (California Palace of the Legion of Honor) 2, nos. 1–2 (May/June 1953); reprinted in *Jermayne MacAgy*, exhibition catalogue for the homage to Jermayne MacAgy mounted by the University of St. Thomas Art Department.

80. Among these students was Charles W. (Mark) Haxthausen, who became chair of the graduate program in the history of art at Williams College; Helen Winkler, who worked closely with both Jermayne MacAgy and Dominique de Menil, and went on to collaborate with Philippa de Menil and Heiner Friedrich in establishing the Dia Art Foundation; Fredericka Hunter, who became a pioneering and influential Houston gallery owner; and Fred Hughes, who went from his studies at the University of St. Thomas to work for the de Menils' dealer Alexander Iolas in Paris, and later to manage Andy Warhol's activities.

81. The storage is less of an open and integral aspect of the building's public activities, as was envisaged with the Kahn plans, and the idea of the facility operating as a lively forum of exchange across a range of domains has been somewhat muted in deference to the museum's exhibition function. See Patricia Cummings Loud, *The Art Museums of Louis I. Kahn* (Durham, N.C.: Duke University Press, 1989).

82. See Richard Ingersoll, "Pianissimo: The Very Quiet Collection," *Texas Architect* (May/June 1987): 40–46, for a discussion of the museum in relation to its neighborhood.

83. E. M. Farelly, "Piano Practice," *Architectural Review* 181 (March 1987): 32.

84. Piano quoted in ibid., 33.

85. Ibid., 34.

86. Ferraro, *Catholic Lives, Contemporary America*, 9.

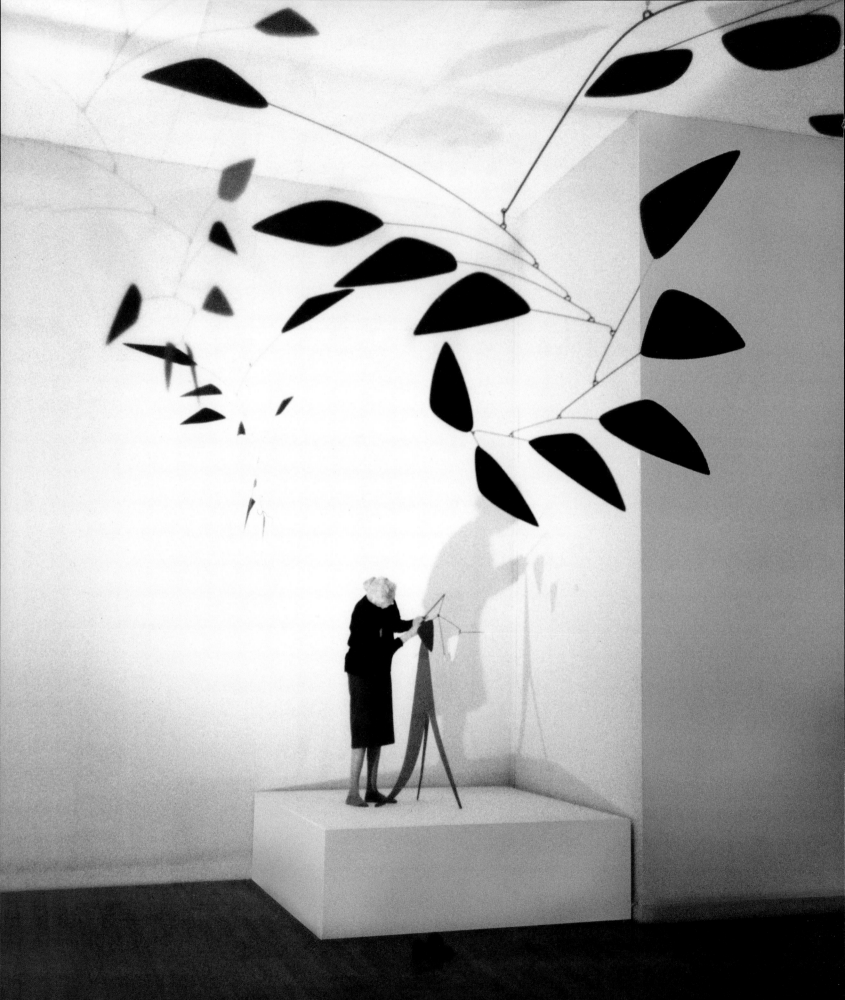

On the Nature of the de Menil Collections WALTER HOPPS

To understand both the nature and the achievement of the de Menil family collections generally, one must consider them in the context of certain pioneering and analogous American collectors. Prior to the watershed of the 1913 Armory Show, among the first collections of modern art in America were those established by the Stein family (Gertrude and her brothers Leo and Michael), by Alfred Stieglitz, and by John Quinn. These three collections embody aspects of everything that was to follow. All represent a new breed of bourgeois collector. They were pioneers whose advocacy of the "new" relied not upon the support of large fortunes or institutional backing, but on energy, ingenuity, and daring. Forging the initial aesthetic bonds between America and France in the twentieth century, the extraordinary Stein family, expatriated primarily in Paris, in many ways aped the traditions of the cultured continental family. On the contrary, Stieglitz, whose family emigrated from Europe, was an artist and an entrepreneur. Quinn, a New York lawyer, helped organize the Armory Show and was one of the first to collect and display together both modernist and indigenous artists.

The Armory Show in New York, which gathered a vast array of international avant-garde art under a single roof, had an immediate impact on American artists and collectors, and its consequences were felt on both sides of the Atlantic. Following the show, there emerged two essential positions taken toward the art of one's time. Each of two great American collections, which were directly inspired by the exhibition and were begun immediately thereafter, embodies one

Fig. 3.2
Marjorie and Duncan Phillips in the Main Gallery,
Phillips Memorial Art Gallery (later the Phillips
Collection), Washington, D.C., ca. 1922

Fig. 3.3
Walter and Louise Arensberg and Marcel Duchamp,
Arensberg residence, Hollywood, 1936

of these positions: the collections formed by Duncan Phillips in Washington, D.C. (fig. 3.2), on the one hand, and by Walter Conrad Arensberg, now part of the Philadelphia Museum of Art, on the other.

At the time of the Armory Show, both Phillips and Arensberg were young, well-educated men of relatively independent means, fascinated with the new European art appearing so dramatically in the United States. Phillips pursued and amassed a collection that rationalized the impulse of the new art in terms of its continuity with the past and its links to the traditions of European art, from Gustave Courbet and Édouard Manet through Post-Impressionism. When he founded the Phillips Collection in Washington, in 1921, the first public museum of modern art in America, he made this point of view explicit. Arensberg, a poet and a man of arcane intellectual pursuits, incisively caught the spirit of radical departure—the notion of the revolutionary break with the past—that began in the twentieth century. Arensberg and his wife, Louise (fig. 3.3), embraced the disruptive and the unsettling in the ideas and new work of their time, making immediate and major commitments to the radical art of Constantin Brancusi and Marcel Duchamp.

Looking at the grand procession of American collections that have followed across the twentieth century, one can relate them to the traditions associated either with Phillips or with Arensberg subsequent to the Armory Show. In the former case, one can identify the collections of Dr. Alfred Barnes, sisters Claribel and Etta Cone, Chester Dale, the Havermeyer family, the earlier efforts of Abby Rockefeller (leading to the Museum of Modern Art by way of its founding director Alfred H. Barr Jr.), and Gertrude Vanderbilt Whitney. In the latter case, the collections established by Katherine Dreier and her Société Anonyme under the guidance of Duchamp and Man Ray, by Albert E. Gallatin, by Solomon R. Guggenheim and separately by his niece Peggy Guggenheim, and later by William Copley share the point of view suggested by the collection of the Arensbergs. The de Menil family collections respond unequivocally to this latter spirit. When they began seriously acquiring art in the late 1940s, Dominique and John de Menil started with no preconceived program or point of view. It was not until almost twenty years later that the consequences and the directions of their collecting activities were to become clear to them.

At present, the de Menil family collections comprise either art individually owned by family members, works held by the Menil Foundation (created by Dominique and John de Menil), or art belonging to foundations established by other members of the family. If the teachings and the example of Father Marie-Alain Couturier and Jermayne MacAgy were beacons to Dominique and John de Menil, the couple's own fervor for art was communicated to their children and several immediate relatives in the Schlumberger family. Of the five

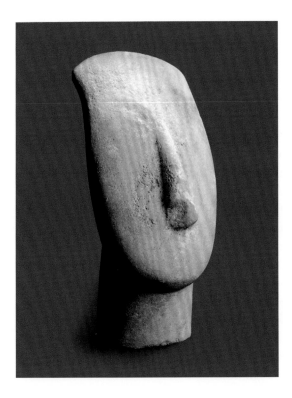

Fig. 3.4 *left*
Head of a Canonical Figure, early Cycladic II,
late Spedos variety, 2500–2400 BC.
The Menil Collection, Houston

Fig. 3.5
Paul Cézanne, *Montagne* (*Mountain*), ca. 1895.
The Menil Collection, Houston

children of Dominique and John de Menil—Christophe, Adelaide, Georges, Francois, and Philippa—and their respective families and companions, all have been involved with collecting, studying, and supporting the arts. Together, their various interests have extended the range and the depth of their parents' collection.

The divergent and individual concerns of the second generation can be seen in several special facets of their lives. An enthusiasm for contemporary performance and contemporary music is shared by Christophe and Philippa de Menil. Film and architecture are professional pursuits of Francois de Menil. The lyrical painterly abstract art collected by Georges and Lois de Menil is complemented by the systemic and minimalist art sponsored by the Dia Art Foundation, created by Philippa de Menil with her former husband, Heiner Friedrich. Important collections of the indigenous arts of the Pacific Northwest, the Inuit, and the Pacific Islands have been assembled by Adelaide de Menil and Ted Carpenter, while a significant aspect of former son-in-law Francesco Pellizzi's collection juxtaposes the atavistic imagery and markings that unite indigenous arts with the most recent contemporary art. The art housed and displayed in the Menil Collection draws from all of the aforementioned collections. Together, they consist of more than ten thousand works, of which approximately three thousand are paintings, sculptures, and objects. The remaining works comprise drawings, photographs, prints, and rare books.[1]

The de Menil family collections focus on three essential areas:

antiquities from Western civilizations prior to the Renaissance, modern and contemporary European and American art, and the arts of indigenous cultures from across the globe.[2] The concentration of art made in the twentieth century reflects the contemporaneity of the de Menils' collecting impulses. Post-Renaissance European art and artifacts representing the specialized concerns of fantasy and allegory; colonial and pre-Columbian art from the "New World"; the indigenous arts of the American Southwest and Northwest, of the Old Bering Sea cultures and the Inuit, and of Pacific Island and African cultures; and the pre- and postclassical antiquities originating in Europe and Asia Minor prior to the twelfth century—all embody individual cultural densities, and all resonate with affinities across time and cultures.

The Menil Collection brings together, under one roof, idiosyncratic and disjunctive bodies of material not usually found together in either a single exhibition or collection. It presents an important alternative regarding the meanings of art and culture, one that runs counter to the conventional chronological exposition of Western art. For example, the emphasis on indigenous arts has made them equal in importance to the presentation of Western art. Furthermore, seemingly disparate views of Western culture, from the most distant past and the most recent present, have been conspicuously chosen. With such material, it has not been possible nor has it been desired to present a developmental picture. Rather, the links are conceptual,

Fig. 3.6
Barnett Newman, *Ulysses*, 1952. The Menil
Collection, Houston, formerly in the collection
of Christophe de Menil

iconographic, and formal. The collection's raison d'etre suggests the profound ties between aesthetic and spiritual values among peoples of diverse times and places.

The variety of connective elements across temporal and cultural boundaries is strongly seen and intensely felt. In some instances works from disparate cultures are presented side by side. A vitrine within the Surrealist gallery resembling a wonder cabinet documents the manifestations of the movement by exhibiting objects made by the Surrealists alongside the kind of objects collected by them.[3] In a similar spirit, a number of modern artworks reflect on the holdings of ancient and indigenous art. For example, looking at Victor Brauner's *Séparation d'Irschou* (*Weaning of Irschou*), 1947, with the art of the Pacific Northwest, or at Max Ernst's *Le ciel épouse la terre* (*The Sky Marries the Earth*), 1964, with African art, or at Paul Cézanne's study of the colored facets composing a mountain seen in the clear light of the Mediterranean (fig. 3.5) among the art of the Cycladic Islands (fig. 3.4) invites an order of visual association that is evocative and not historically inappropriate. Such examples suggest their ability to "rhyme."

With frequency, recurring images and motifs repeat across the collections in a series of morphological permutations. The preponderance of images of beasts, for example, may be followed from the Paleolithic cave to the sensuous dynamism of a Bamana antelope; from the flamboyance and power of a Tlingit raven headdress, depicting the mythological god who brought humans to earth, to the post-Yeatsian irony of Jean Tinguely's *M.O.N.S.T.R.E.*, 1964, clanking and humming as it "slouches toward Bethlehem." Visual rhymes of this order punctuate the collections, revealing through abiding forms aspects of a shared attitude or an individual style. "La rime et la raison" ("The Rhyme and the Reason"), the exhibition title Dominique de Menil chose for the first collective showing of art owned by the family (fig. 3.1), is a notion flexible enough to apprehend the contradictions and consistencies within the collections. It countenances the irrational with the rational, consulting the incongruities of René Magritte as well as the pragmatism of Piet Mondrian.

The single most enduring factor among the works in the collections is a special feeling for the refinements of primary form, whether it represents the simple silhouettes of a gut scraper from an archaic culture near the Bering Sea, or a violin-shaped idol from Bronze Age Anatolia, or the geometric reductivism of twentieth-century art. A painting, however, like Barnett Newman's *Ulysses*, 1952 (fig. 3.6), is more than a declaration of pure form. With his overtly classical reference to the journeys in *The Odyssey*, Newman is encouraging an exploration into the unknown. The rigor of such a formal structure may frame the gateway to a reverie on metaphysical contradiction, as in Magritte's *La lunette d'approche* (*The Telescope*), 1963,

or a formal system may accommodate an increasing complexity of structure and sensation, as in Frank Stella's *Takhti-i-Sulayman I*, 1967. Released from the service of determining form, line can manifest itself as expressing a particular delight in the elaboration of surface pattern, equally in evidence in a male figure from the Trobriand Islands and the terra-cottas of the Djenné culture of Africa. The rhymes are stunningly visible; they reveal the reason behind this particular collection.

The elliptical cross-conjunctions between past and present, and the circulation between occurrence and reoccurrence within the linearity of the exhibition "La rime et la raison" indicate a structure of which Jean-Pierre Raynaud's *Espace zéro* (*Zero Space*), 1984 (fig. 3.7), is the foreshortened symbol. The work, a white-tiled corridor that forms an entranceway into the exhibition, was commissioned by Dominique de Menil expressly for the occasion. Raynaud's space thus becomes its newest work, bringing the chronology of the exhibition forward to its present moment. In addition, the four works selected by the artist from the de Menil collections to articulate this space respond to the concerns of the whole collection. An engraved Paleolithic bone, an African ancestor figure, a gold Byzantine reliquary box, and an Yves Klein blue sponge formed in the shape of a crown, all presented in a conventional chronological sequence, bring together time past and time present and suggest a beginning and a culmination.

Art has been made, as it has been collected, in response to a variety of motives. The psychic and physical fulfillment derived from creating something has its counterpart in the spectrum of pleasure involved in experiencing that creation. The metaphysical aspect of art, as a bearer of spiritual values, has similarly motivated its being made and its being kept and revered. Art also functions, and continues to function, as a prime embodiment of treasure and as a currency of trade. The de Menil family collections have inherited another tradition—the ideals of study and connoisseurship that are the particular legacy of the Enlightenment in eighteenth-century Europe. Since the Enlightenment and in accord with its principles, art may now be seen, beyond delectation and embellishment, as a significant carrier of visual knowledge. Ideas and history have come to be found not only in exposition and chronicles but also in images and things; artworks have come to be collected for the information they hold and can reveal. In this spirit, the works in this collection have been assembled rather like books in a personal library—a reference body of objects and images open to the scrutiny of the intellectually curious.

The nineteenth-century porcelain miniature of a woman's brown eye selected by Dominique de Menil as the signifying image for "La rime et la raison" underscores this notion. A modest yet mystical object and an arresting image, the eye is understood here to represent the primary instrument of the mind.

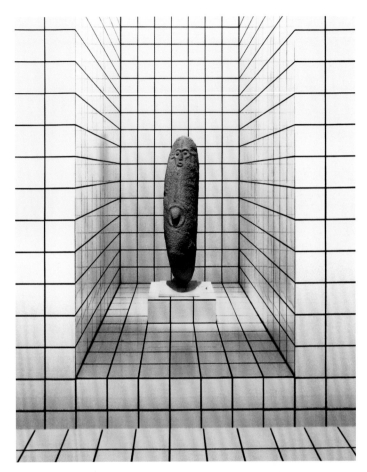

Fig. 3.7
Jean-Pierre Raynaud, *Espace zéro* (*Zero Space*) (detail), 1984. Encloses a monolith from Nnam or Nselle, Nigeria, ca. 16th–19th century. The Menil Collection, Houston. Installed in "La rime et la raison: Les collections Ménil (Houston–New York)," Grand Palais, Paris, 1984

EDITOR'S NOTE

Walter Hopps, who died in 2005, was planning to write an introduction to this book, describing the development and content of the collection. In its place, an abridged and adapted version of the introduction Hopps wrote on the subject for the 1984 exhibition of the de Menil family collections in Paris, "La rime et la raison," published only in French, appears here for the first time in its original English.

NOTES

1. As of the printing of this book, the number of works in the Menil Collection has increased to approximately seventeen thousand, more than six thousand of which are paintings, sculptures, or objects.

2. In 1985 the Menil Collection acquired an important group of Byzantine icons, which formed an additional area of focus.

3. The vitrine was replaced by an expanded exhibition, "Witnesses to a Surrealist Vision," which opened August 4, 1999, in a room adjoining the Surrealist galleries. It was conceived by anthropologist Edmund Carpenter as a tribute to Dominique de Menil.

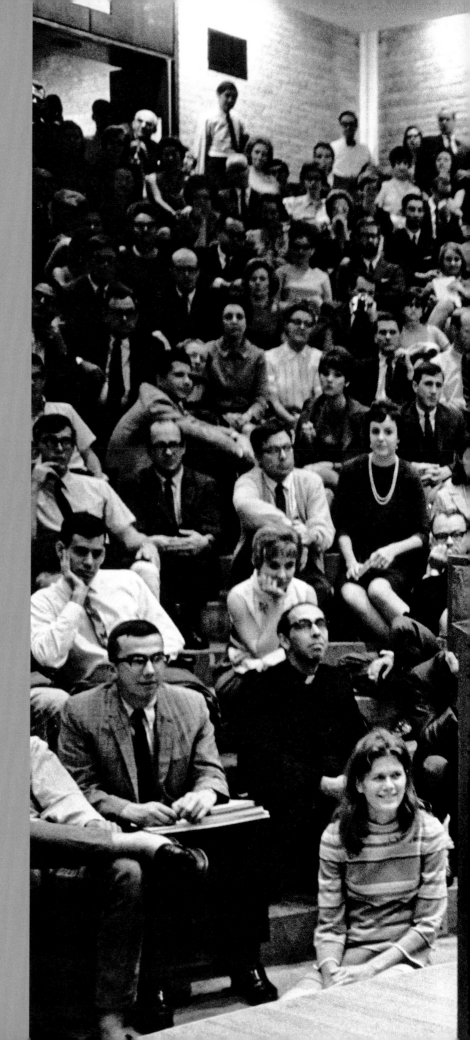

The Visage of Culture

EDUCATION

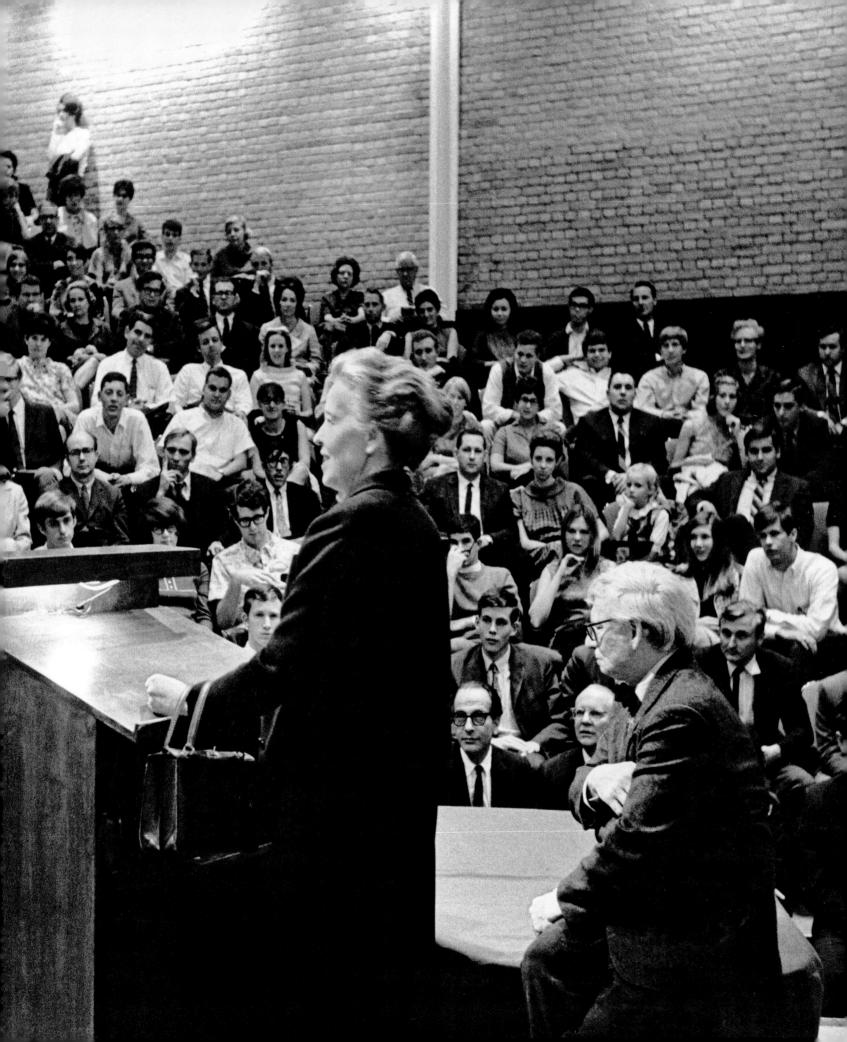

Two Museums and Two Universities:
Toward The Menil Collection WILLIAM A. CAMFIELD

In the course of almost forty years, four institutions became principal sites for John and Dominique de Menil's momentous commitment to Houston. None of those institutions—the Contemporary Arts Association of Houston; the Museum of Fine Arts, Houston; the University of St. Thomas; nor Rice University—became the ultimate site of their commitment, but each benefited enormously from its association with the de Menils, and each contributed to the final realization of the Menil Collection. I was fortunate to work with John and Dominique de Menil for more than twenty years of that unmapped journey.

John and Dominique fled France as refugees from World War II, their destination Houston, owing to the location of the overseas headquarters of Schlumberger, the oil field services company founded by Dominique's father and uncle. In 1941 Houston was a provincial, segregated southern city with 390,000 citizens; one university, William Marsh Rice Institute (now Rice University); and one museum, the Museum of Fine Arts, Houston. Why the de Menils chose to remain in the city puzzled some of their cosmopolitan visitors, but that decision was made by the late 1940s. The importance of John's work for Schlumberger at that time was the crucial factor, but they also seem to have been motivated by a sense of Houston's potential, by admiration for some Houstonians, and by an awareness of their unique ability to contribute to the city.

The war and the burgeoning petroleum industry—plus air-conditioning—were catalysts for the population growth and industrial development of Houston, and John, as president of Schlumberger's

overseas operations based in Houston, became a presence among the industrial leaders of the city. He and Dominique also became a joint force in the extraordinary cultural transformation of the city that began during the late 1940s with the founding of the University of St. Thomas, the Alley Theatre, and Texas State University for Negroes (now Texas Southern University) in 1947, the Contemporary Arts Association in 1948, and the University of Houston in 1949.

The de Menils did not arrive fully prepared for what was to become their role in the maturing of Houston. They grew with the city, nourished by their unique ties to the cultural elites of New York and Europe, and stimulated by the opportunities and challenges of Houston. Foremost among those ties was their friendship with Father Marie-Alain Couturier, then a war exile in New York. In Paris before the war, he had introduced them to his passion for the spiritual values of modern art. Now, during their stays in New York, he introduced them to modern art galleries, and to European artists and writers in exile, further opening their eyes and helping Dominique overcome what she described as her "Puritanical tendency, ancestry, that one shouldn't buy art, that it's something too magnificent, too frivolous." He convinced her, she said, that it was "a duty for me and my husband to buy art—a moral duty."[1] Dominique de Menil also gave Houston some backhanded credit for sparking her passionate desire to collect art: "When I arrived in Texas there was not much you could call art. Houston was a provincial, dormant place, much

like Strasbourg, Basel, Alsace. There were no galleries to speak of, no dealers worth the name, and the museum… [she trails off helplessly]. That is why I started buying."[2]

John and Dominique engaged with Houston in two ways in the late 1940s: with the construction of their new home and with their participation in the Contemporary Arts Association. Both involved expanding the thinking and taste of their fellow Houstonians and an insistence on quality. For the design of their home, they selected Philip Johnson, who was generating attention with the construction of his International Style Glass House in New Canaan, Connecticut. Nothing in Houston resembled the home Johnson designed with the de Menils (fig. 4.2). It was a challenge to their neighbors in the august River Oaks section—and it proved to be of enormous significance for architecture in Houston and for Johnson's career.[3]

The Contemporary Arts Association, 1948–53

The Contemporary Arts Association of Houston (CAA) was organized by a group of architects, artists, and collectors eager to educate Houstonians as to the value of contemporary art and design in daily life, and frustrated by the paucity of resources and leadership directed to those ends at the Museum of Fine Arts, Houston, then operating with a part-time director, Rice University professor James Chillman.[4] The CAA began as an enthusiastic, volunteer-run organization supported by membership dues and in-kind services, includ-

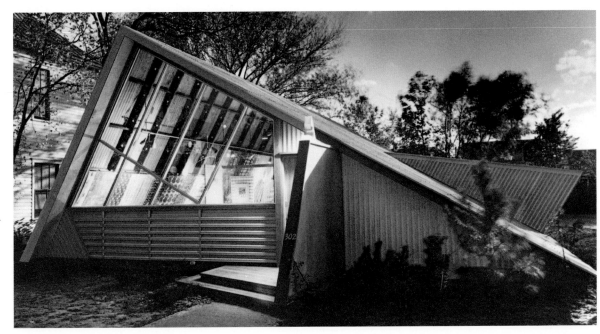

Fig. 4.2 *opposite*
The de Menils' home, Houston.
Philip Johnson, architect,
completed 1951

Fig. 4.3
Contemporary Arts Museum
Houston (CAA). MacKie &
Kamrath, architects,
completed 1949

ing an A-frame building designed in the mode of Frank Lloyd Wright by Karl Kamrath of MacKie & Kamrath (fig. 4.3).[5] John de Menil accepted an invitation to serve on the first CAA board in 1948.

Responsibility for exhibitions was rotated among the members, whose proposals usually relied on local art collections and their personal experiences as collectors, artists, or architects. A proselytizing spirit characterized some exhibitions, particularly those by Robert Preusser, a founding member of the CAA and an artist-teacher trained in the Bauhaus tradition. Preusser demonstrated that tradition in the CAA's first exhibition, a didactic presentation of contemporary household objects titled "This Is Contemporary Art," held October–November 1948.[6] Dominique de Menil later contributed an exhibition titled "Interiors 1952: Beauty Within Reach of Hand and Budget" that was ostensibly compatible with Preusser's philosophy but also a critique, distinguished by the imagination and aesthetics evident in both her selection and presentation of the objects.[7]

Moreover, the de Menils had already exhibited a totally different mind-set on the occasion of their first turn as CAA curators in 1951. Dominique recalled that John "felt we must put on a really first class show. We decided on van Gogh."[8] Houston might have been provincial, but neither the city nor the CAA had to acquiesce to that status. Quality and significance on an international scale was the challenging model they set. As described by Dominique, they plunged into the exhibition: "[John] with his incredible energy and I with my incredible naiveté.… I went straight to Theodore Rousseau at the Metropolitan Museum of Art and asked to borrow his van Gogh sunflowers. And then I asked him to write something for the catalogue and I never offered him any honorarium because I didn't know you were supposed to!"[9] Following hundreds of letters and personal meetings with private collectors, they assembled an astonishing exhibition that attracted international attention and an overwhelming response in Houston. CAA's little building was inundated by six thousand visitors in the first week alone, and before the exhibition was over Mr. and Mrs. John Hay Whitney had decided to give their Vincent van Gogh painting to the CAA "for its permanent collection." Whitney, chairman of the board of the Museum of Modern Art, New York, wrote John de Menil that "knowledge of your efforts to fill a niche that heretofore has been somewhat by-passed has given Mrs. Whitney and myself the desire to assist you in developing a collection which we hope will ultimately assume the stature that is appropriate to the great forward strides that have taken place in Texas in other fields."[10]

It is not clear from available documents if the de Menils' vision for Houston included a museum of contemporary art or if the CAA collection simply began with this gift. But gifts continued—some from the de Menils—until 1954, when the CAA's patent inability to care for a permanent collection prompted the board to begin deaccessioning its collection.

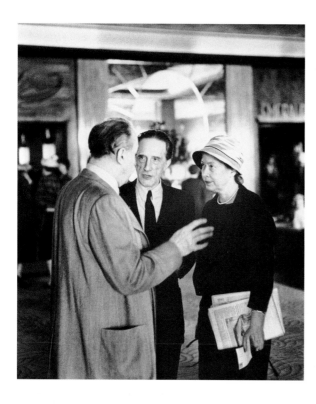

Fig. 4.4 *left*
Stuart Davis and Marcel and Teeny
Duchamp at the American Federation of
Arts Convention, Shamrock Hilton Hotel,
Houston, 1957

Fig. 4.5
Meyer Schapiro, Randall Jarrell, Stuart Davis,
and James Johnson Sweeney at the American
Federation of Arts Convention, Shamrock
Hilton Hotel, Houston, 1957

John and Dominique followed the van Gogh show with the exhibitions "Calder–Miró: Exhibition of Paintings and Sculpture" in October–November 1951 and "Max Ernst" in January–February 1952. Alexander Calder and Max Ernst—both friends of the de Menils— were invited to Houston, supervised the installations of their exhibitions, and engaged with local citizens. Once more the de Menils generated excitement in the local art community and garnered national attention.

By 1952 the CAA had reached a moment of reassessment. As chairman of the board, John de Menil expressed the situation concisely: "It has been obvious for some time that we cannot carry on this kind of program…without a stronger organization. Thus, the Association is faced with two alternatives: to raise funds and hire a first-class director in an endeavor to become one of the leading contemporary art centers in the country; or to pull in the horns somewhat and, relying on income from members, strive to encourage local appreciation of contemporary art, as well as local artists."[11] He and Dominique were leaders among those members who favored the ambitious professional route, which was vigorously opposed by members loyal to the original concept of a volunteer organization focused on Houston.

The board sought evaluation from an outside reviewer, Douglas MacAgy, director of the California School of Fine Arts in San Francisco. When illness prevented him from conducting the evaluation, the invitation went to his wife, Jermayne MacAgy, assistant director of the Palace of the Legion of Honor in San Francisco. She

submitted a lengthy report to the board in April 1952, recommending the direction advocated by the de Menil group.[12] The board rejected her recommendation, however, and the CAA continued to operate as a volunteer organization with an emphasis on educational exhibitions and local resources. One popular feature in this fare was the annual Art Rental Service, a juried exhibition that simultaneously benefited regional artists and cultivated collecting by providing a way for people who had never owned an artwork to savor the experience for a modest rental fee with the option to purchase or try another. John and Dominique continued to participate at the CAA in a somewhat less active role, but the debate continued, and three years later the board reversed its position. In the meantime, John de Menil had become more involved at the Museum of Fine Arts, Houston, where major developments were under way.

The Museum of Fine Arts, Houston, 1953–59

In May 1953 the Museum of Fine Arts, Houston (MFAH), hired its first full-time director, Lee Malone, who soon began to compete with the CAA by showing and acquiring modern art. Nina Cullinan— who was active on the boards of both the MFAH and the CAA—provided funds for an addition to the MFAH, specifying that it be designed by an architect of outstanding reputation and that space be made available in it for CAA exhibitions. Anderson Todd, a professor of architecture at Rice University and the husband of Cullinan's niece Lucie Wray, steered the MFAH's choice toward Ludwig Mies

van der Rohe. Attracted by the MFAH's new vigor, John de Menil agreed to serve on its board; he was elected a trustee in 1954 and joined the Executive Committee in 1955. He and Dominique promoted the Collectors' Society to encourage the development of private art collections, and they gave Ernst's sculpture *Moonmad*, 1944, to the MFAH in 1957. John's trenchant criticism came along with his participation. When geographic and historical criteria were proposed as guides for building the collection, he shot back:

> [This approach] will lead us to nothing but the status of a third-rate museum. The geographic criterion would have us concentrate a good deal of our resources on Mexican art because we are close to the border.... My opinion is that we should specialize on quality, wherever it comes from. I dream of a museum where everything would be so beautiful—were it Mexican or not—and so well arranged, that, walking into it one would be carried away. The Mies Van der Rohe building is a challenging shell for such a program. Let's not fill it with Mexican bric-a-brac.
>
> For the same reason, I am quite opposed to the historical approach, which would have us spread our effort over periods and styles in an endeavor to have them all represented in the Museum. This is the "kunst historische" approach, or the Encyclopedia Britannica approach, or perhaps the bookkeepers approach. I do not believe it is an exciting approach and further it is an impossible one.[13]

This response to the proposed museum policy represents the process of acquiring art that rules in the Menil Collection to this day.

John's service to both the MFAH and the CAA was actually part of his broader advocacy for Houston. Most revealing of him as art impresario and booster extraordinaire was his execution of the MFAH's responsibilities as host for the 1957 convention of the American Federation of Arts. In 1957 the American Federation of Arts was a major national arts organization. Cities competed for its annual conventions. Houston had never hosted such an event, and John seized the opportunity to direct a national spotlight on the city. Participants on the program included artists Marcel Duchamp and Stuart Davis, art historian Meyer Schapiro, art collector Vincent Price, and museum leaders James Johnson Sweeney and William Seitz (figs. 4.4–5). Attendance in Houston far surpassed that in other cities. Exhibitions were timed to coincide with the convention—MacAgy's "Pacemakers" at the CAA and Sweeney's "Jacques Villon, Raymond Duchamp-Villon, Marcel Duchamp" at the MFAH. John de Menil commissioned Henri Cartier-Bresson to photograph Houston and the convention, and he secured the Schlumberger jet to ferry distinguished visitors on art tours of San Antonio and Dallas. No publicity opportunity was overlooked.[14]

Fig. 4.6
Dominique de Menil and Jermayne MacAgy
at the de Menils' home, Houston, ca. 1960

Renewed Commitment to the CAA, 1954–58

In 1954 the CAA lost its lease on the property it was occupying near downtown Houston, but the Prudential Insurance Company came to the rescue with a dollar-a-year site just south of the Texas Medical Center on Fannin Street near Holcombe Boulevard. The CAA building was cut in half and moved on flatbed trucks to the new location during a celebratory late-night parade. There it was enlarged and provided with a sculpture garden. The move revived thoughts of a professional director, and the de Menils' candidate, Jermayne MacAgy (fig. 4.6), was hired with a three-year contract beginning September 1955. That decision changed the course of the arts and art history in Houston.[15]

MacAgy brought unprecedented professional experience and gifts as a museum director and curator renowned for installations that seduced the spectator. Clyfford Still and Mark Rothko were her personal friends, and insofar as I know, MacAgy's doctorate from

Fig. 4.7
"The Sphere of Mondrian," Contemporary Arts
Museum Houston, 1957

Western Reserve made her the first professionally trained art historian in the city. And her personality! Dominique described her as someone who was "rarely met with indifference. She either aroused hostility or passionate devotion.... Her pronouncements were final, her likes and dislikes not open for discussion.... Yet they always were tempered by her sense of humor." MacAgy, she concluded, "had the gift to discover untapped possibilities in people. Whoever accepted her leadership became a new and talented person."[16]

Having conducted the CAA review in 1952, MacAgy was familiar with the faction opposing her, and during her inaugural year she worked as best she could with the volunteer program she had inherited. Relatively free to create her own program in the following years, MacAgy soon made her mark. While retaining such popular favorites as the Art Rental Service show and the Modern House Tour, she captivated the art community with exhibitions focused variously on individual artists—"The Sphere of Mondrian" (fig. 4.7) and "Mark Rothko"—or on enchanting themes. Those exhibitions included

"The Disquieting Muse: Surrealism," a haunting juxtaposition of Surrealism and fantastic art of the fifteenth and sixteenth centuries, and "The Trojan Horse: The Art of the Machine," which mingled machine parts and images of machines from many periods of art history. Most praise focused on those exhibitions, but she injected energy into every facet of the CAA and challenged the board to think of the approaching tenth anniversary year, 1958–59, as a time to consider acquiring its own land and building. Despite this professional maturation, MacAgy felt that "Inventiveness, trial and error, experimentation, high spirit—these should always, as in the past, be our key-notes."[17] That call did not resonate with the volunteer faction nor with local artists who felt marginalized.

Nevertheless, 1958 was a gratifying year for John and Dominique de Menil: MacAgy's achievements embodied the quality and excitement they had endeavored to inspire in the CAA; the MFAH was finally contributing substantially to modern art in the city; John had become an influential member of the MFAH board; and as Cullinan Hall (the Mies van der Rohe–designed wing of the MFAH) neared completion, MacAgy was planning for the new space a dazzling exhibition that would represent the expanded collaboration between the MFAH and the CAA. Additional developments of consequence involving the de Menils were also afoot at the University of St. Thomas.

The University of St. Thomas, ca. 1956–63

Notwithstanding their substantial engagement with the CAA and the MFAH, John and Dominique de Menil made a small Catholic school, the University of St. Thomas, the principal site of their commitment to art and education from 1958 to 1969. John later described that commitment as "the wildest, indeed the most hallucinatory sort of a gamble."[18] At the time he made that statement in 1967, the risks of their "gamble" were beginning to show. But until then the de Menils—devout Catholics imbued with a belief in the spiritual and educational values of art—strove without reserve to develop their educational ideals *and* to enlarge the Basilian Fathers' vision of the university.

The Congregation of St. Basil had opened St. Thomas in September 1947 with the encouragement of Bishop Byrnes of Galveston and the Pontifical Blessing of Pope Pius XII. The university's beginnings were modest. The Lee Mansion at the corner of Montrose and Alabama contained the administration offices and library. The carriage house was converted into a cafeteria, and six scattered houses served as academic departments and residences for four priests, six lay professors, and approximately seventy students. The gentle but indomitable Father Vincent J. Guinan was its first president (see fig. 4.8).[19]

Dominique and John had served on the university's Social Arts Committee as early as 1951, but more significant contact followed

Fig. 4.8
James Johnson Sweeney, Father Edward Lee,
Father Vincent Guinan, and Dominique de Menil
at "The Trojan Horse: The Art of the Machine,"
Contemporary Arts Museum Houston, 1958

their unsuccessful attempt in 1953 to retain Philip Johnson for the design of the parish complex of St. Michael's Catholic Church, where they worshiped.[20] That project was too costly for St. Michael's, but it emboldened the Basilians to approach the de Menils.

By 1956 the university had taken root, but it needed a lot of help. The Southern Association of Universities had just reevaluated it on the basis of a review in 1954 that cited (among other things) "the need to stabilize regular income and endowment, to make long range plans for the physical plant … [and] to consider instruction in art and music."[21] The de Menils responded to Guinan's call. They began with the physical plant, stressing the need to select a distinguished architect to design the new campus. The Fathers chose Johnson from several suggested architects, and in July 1956 the General Council of the Basilian Congregation approved the university's request to accept the de Menils' offer to pay Johnson for his services. Those services included working plans for the first building and a general plan for expansion of the university over the next ten years. Johnson proposed a quadrangle plan based on Thomas Jefferson's layout of the University of Virginia. Construction began in 1957 on two halls, Jones and Strake, while John de Menil quietly acquired the additional property needed for the master plan.[22] The acquisition of property in the Montrose district eventually included the land that came to house the Rothko Chapel and the Menil Collection.

The de Menils' commitment soon expanded from architecture and real estate into the educational program of the university. They had worked closely together throughout their lives, but until now Dominique had been a silent partner. John had been the one on the boards or committees, and the one likely to be cited in the press. Dominique de Menil's leadership emerged when she joined the Arts Council at St. Thomas in 1957. At its second meeting on May 9, 1958, she proposed to give the de Menil art collection to the university on extended loan, expressing her conviction that there was no substitute for the impact of a really good painting or piece of sculpture.[23] From this point on, the de Menils referred to their collection as a "teaching collection." Their mission to educate by means of "really good" art took several forms, primarily temporary exhibitions and installation of objects from the teaching collection in buildings on the campus. Beyond that, Dominique, as a member of the Arts Council, deflected gifts of mediocre art and fostered a personal investment in high-quality works by establishing an inexpensive rental plan that made prints and posters available for loan—like books—to all members of the university. Finally, Dominique stressed the need for a department of art history, lamenting, "In the whole southwest there is no good art department or art historian to be found." Guinan acknowledged the need, but council members expressed concern about finding the right person to establish the department and "getting non-Catholics to donate to an art department."[24]

The first Philip Johnson buildings, Jones Hall and Strake Hall, opened with a series of events over the nights of October 3–5, 1958, which included a blessing by the Bishop of the Galveston Diocese;

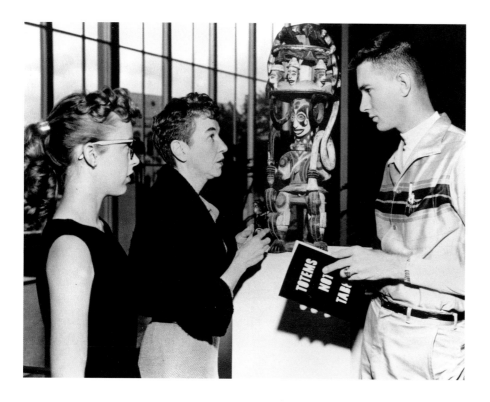

Fig. 4.9
Jermayne MacAgy (*center*) with students
at "Totems Not Taboo: An Exhibition of
Primitive Art," Cullinan Hall, The Museum
of Fine Arts, Houston, 1959

Fig. 4.10 *opposite*
"Totems Not Taboo: An Exhibition of
Primitive Art," Cullinan Hall, The Museum
of Fine Arts, Houston, 1959

a huge reception; a lecture by James Johnson Sweeney, then director of the Solomon R. Guggenheim Museum, New York; and an art exhibition organized by MacAgy titled "Islands Beyond: An Exhibition of Ecclesiastical Sculpture and Modern Paintings." MacAgy combined medieval religious sculpture and twentieth-century paintings to evoke a universal spiritual resonance in artworks across time and cultures. That opening scooped the MFAH's dedication of Cullinan Hall by a week, attracting extensive local and national attention and prompting Guinan to write Dominique de Menil: "Without your interest and assistance, the buildings would not have been possible … You successfully launched the University on a second decade of growth…. [E]xhibitions of outstanding artists will be a powerful factor in achieving [our aims]."[25]

The celebratory occasion was threatened, however, by Norman Sulier, a Houston sculptor distinguished by his commission for a portrait bust of the Pope in 1955 and his ability to discern nonexistent Communist symbols in modern art, in this instance a hammer and sickle in a painting by Mark Tobey. Sulier denounced MacAgy's exhibition in letters to Guinan, the Bishop, and George Strake (an influential supporter of the university whose name graced Strake Hall and whose service for the Church had been awarded with the honorary office of Chamberlain to the Pope). Charges that may seem preposterous today were a genuine menace in the 1950s, when fear of Communist subversion was pervasive in American society. Republican Congressman George Dondero of Michigan specialized in denounc-

ing modern art as un-American and therefore Communist, while Republican Senator Joseph McCarthy of Wisconsin became so notorious for his baseless denunciations that the term "McCarthyism" was coined to describe such tactics. Although McCarthy had been discredited in December 1954 before a national audience, the tactics of "McCarthyism" continued, and right-wing organizations active in Houston could have turned this incident into a scandal capable of devastating the fledgling art program at St. Thomas.[26]

According to Dominique de Menil, the Fathers "right away felt they were in front of a rabid 'McCarthyist,'" but George Strake "wanted the show closed down instantly."[27] She acted immediately to counter Sulier's inflammatory accusations, urging the Fathers to examine the paintings to develop their own opinion and assembling a dossier for Guinan that traced the history of similar attacks on modern art. Sweeney (also a target of such smear attacks) provided moral support for the de Menils, which stirred Dominique to write: "We are more grateful to you than we shall ever be able to express. We have been fighting for quality, Jean and I, for ten years here. At times, it was so depressing that we were about to give up. The opening of St. Thomas University, with Jerry's exhibit and your lecture … has again given us a great deal of courage. De tout Coeur: merci."[28]

Dominique's actions defused the Red Scare, and the coming year looked promising with the new campus under way and prospects for an art history department on the horizon. That moment was shattered in January 1959 when MacAgy learned from two of her most

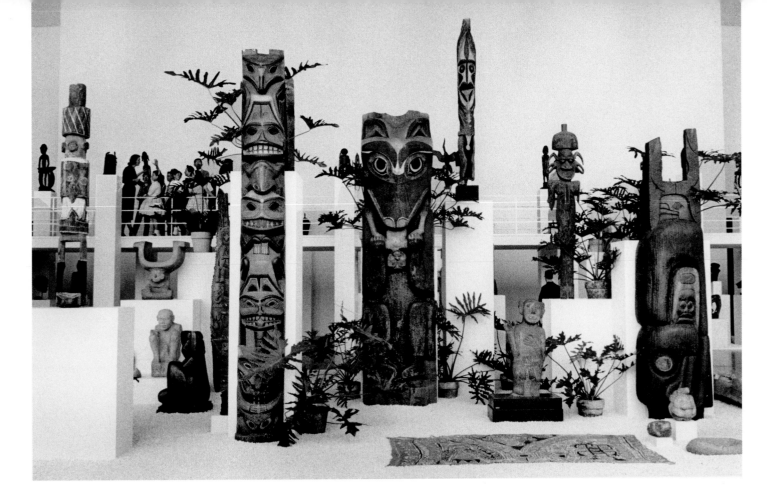

ardent supporters on the CAA board, John de Menil and Carol Straus, that her contract would not be renewed. Insufficient financial support was the public reason for letting her go, but once again the advocates for a volunteer organization had prevailed, augmented by conservative local artists, who felt slighted, and by those members irritated by MacAgy's undiplomatic manner and/or John de Menil's dominance on the board.

Anticipating this situation, a group of MacAgy supporters (known as the Menil group) sought to keep her in the city by asking the MFAH to consider her appointment as curator of modern art with an initial three-year contract underwritten by the group. The MFAH Executive Committee did not accept the offer. Malone's contract was not going to be renewed either, and committee members did not want to make such a decision without a new director.[29]

The de Menils next approached St. Thomas, proposing that MacAgy lead the Art Department that had been under discussion in the spring of 1958. With an enthusiastic response from the Basilian Fathers, John returned to the MFAH to propose that MacAgy—while based at St. Thomas and teaching courses there—would also organize three exhibitions per year, one linked to a course at the university and two in Cullinan Hall. A group called "Friends of Modern Art," formed within the MFAH, would help with the funding of MacAgy's exhibitions.[30] At that moment in the spring of 1959—in the museum's Cullinan Hall—MacAgy was dazzling the city with "Totems Not Taboo" (figs. 4.9–10), her exhibition of the arts of

indigenous peoples, which reigns in the memory of those who experienced it as the benchmark for installations in that grand but difficult space. The MFAH signed on.[31]

The appointment of Father John Murphy as president of St. Thomas beginning July 1959 prompted a meeting to review the de Menils' entire engagement with the university—from matters of architectural design and real estate, to their ambitious vision for the Art Department and the university's future. Murphy's follow-up letter to the de Menils exhibits his excitement: "If this institution should blossom into *the* Catholic Cultural Center of the South West (and at present these are my dreams) then the entire area indicated on your map would be needed. Meantime our efforts must be directed to developing an outstanding College of Arts and Sciences."[32] Murphy's dreams for the university meshed with those of John and Dominique de Menil, and at that moment their wild "gamble" must have looked like a winning venture.

The program worked well from the beginning. MacAgy, who moved to St. Thomas in fall 1959, organized exhibitions for both the MFAH and the university, supported (as she had been at the CAA) by Louise Ferrari as office manager and by sculptor Jim Love for installations. Some of the exhibitions were coordinated with her art history classes—a totally new addition to the curriculum, which quickly became popular. Fully half of the exhibitions continued in some way the inclusive, thought-provoking spiritual themes of the inaugural exhibition for Jones and Strake Halls in 1958. As one

example, in "Other Voices" during the fall of 1962, MacAgy presented art from Africa, Oceania, pre-Columbian America, the Orient, and the ancient Mediterranean as religious objects "voicing" the supernatural beliefs of other cultures. The all-inclusive religious nature of that exhibition was wholly compatible with the values embraced by John and Dominique de Menil and with the progressive spirit of the Vatican Council then convening in Rome. That ecumenical spirit likewise imbued Dominique's proposal for a university chapel after her passionate response to paintings in Mark Rothko's studio in 1959. She wrote Father Flahiff, Superior General of the Basilians: "The minute I entered Rothko's studio and was faced with the double series of dark, dark red paintings, I felt immersed in blood, sacrificial blood—and all of a sudden it occurred to me that the paintings would make a remarkable decoration for a chapel—so beautiful and so religious."[33]

As chair of the Arts Council at St. Thomas, Dominique pursued fundraising and publicity, facilitated collaboration with the MFAH, and worked to integrate art into the life of the university—not only through MacAgy's exhibitions, but also by installing art in public buildings and expanding the Art Rental Service. By 1962 she reported proudly to the Arts Council that the Art Department had blossomed on the campus, thanks to many people but especially to MacAgy and the Basilian Fathers. In words that seem to be both exhortation and confession, she wrote:

> Living daily with the great mysteries of faith, the Fathers cannot have but a humble attitude toward teaching. They know that however much one learns, however much one understands, what remains to be learned and understood is greater…. And let's face it: there is no such thing as teaching faith because there is no such thing as learning faith. People could be made to rattle away all the answers to the most elaborate catechism and they still might not have faith…. Along similar lines of thinking it is quite obvious that people could be made to rattle away the names of all the painters from Giotto to Picasso with their dates and the list of their works, and they still might know nothing about art…. Somehow it is stimulating that neither faith nor art can be taught. It leaves the door wide open to grace and to God's gifts…. So, finally, it is not encyclopedic knowledge that counts. What counts is the intensity of the quest, the thirst of the soul, the curiosity of the mind, and the enjoyment of the eye.[34]

Dominique de Menil's belief in the power of art to stimulate the intellect, the eye, and the soul became a driving force in her commitment to the educational program of the university as well as to the development of the de Menils' personal collection.

The Sweeney Years at the Museum of Fine Arts, Houston, 1961–67

John de Menil was having less success during 1959–60 as de facto chair of the MFAH's Search Committee for a new director. Houston was still viewed as a remote outpost, and despite enormous efforts, it was difficult to attract distinguished candidates. The candidate who was finally offered the position declined to accept in June 1960—providentially. One month later James Johnson Sweeney resigned as director of the Guggenheim Museum as a consequence of objectionable trustee interference in his management of the museum.

Until that moment not even the de Menils had dreamed that Houston could aspire to a director of Sweeney's stature, but they and the trustees seized the opportunity, reaching an agreement with him in January 1961. John and Dominique were exhilarated by his presence—a friend who embodied their insistence on quality and shared their convictions about the fundamentally spiritual nature of art, especially modern and "primitive" art.[35] With MacAgy at St. Thomas and Sweeney at the MFAH, their fourteen-year effort to make Houston a national center for the arts was on the threshold of realization. They were Sweeney's primary patrons throughout his tenure, writing letters and organizing dinners to introduce him to potential supporters, making incredibly generous gifts of art, and collaborating on projects. Sweeney also joined the de Menils in a vast study of images of blacks in Western art,[36] and he and Dominique coordinated to an extent their programs of exhibitions and distinguished visitors. Duchamp, for example, met with students and faculty in the Art Department while attending the opening of an exhibition of his work at the MFAH.[37]

Gifts and purchases for the MFAH poured in during Sweeney's tenure as director, especially during the first years. Several families and individuals made substantial gifts, but the de Menils led the way in year one with a breathtaking selection—a stunning Roman bronze figure of a ruler, third century AD; Calder's *International Mobile*, 1949; a Roman marble of Aphrodite, first century AD; and a huge wooden bowl by the Matankor people of the Admiralty Islands, late nineteenth century. In subsequent years they added major examples of African art; Jackson Pollock's painting *Number 6*, 1949; Niki de Saint-Phalle's *Gorgo in New York*, 1962; Claes Oldenburg's *Giant Soft Fan, Ghost Version*, 1967; and an entire exhibition of constructions by Jean Tinguely (see fig. 4.11).[38]

Sweeney used funds earmarked for his control to acquire additional examples of African, Oceanic, pre-Columbian, modern, and contemporary art, and he, indeed, caught the anticipated international attention with such exhibitions as "The Olmec Tradition," 1963, and "Three Spaniards: Picasso, Miró, Chillida," 1962.[39]

Fig. 4.11
Jean Tinguely, *M. K. III*, 1964. The Museum of Fine Arts, Houston, Gift of J. and D. de Menil

The University of St. Thomas, 1964–69

During 1963 MacAgy and Dominique de Menil revived the search for additional art history teachers.[40] As recruiters, they went in person directly to distinguished art historians known or recommended to them: Meyer Schapiro, Robert Goldwater, Rudolf Wittkower, George Heard Hamilton, and others. I received a call from Hamilton, my mentor at Yale, who knew I was Texas born and planning to explore opportunities for a teaching position there. He told me about a museum director from Texas I should meet. I found MacAgy in the Yale Art Gallery on her hands and knees under a display case, studying its construction. A lively conversation led to a meeting in New York with a couple identified as supporters of the mysterious little university in Houston. My wife, Ginny, and I were curious but expecting little, so we were totally unprepared for a five-story townhouse in the East 70s filled with African and Oceanic sculpture, as well as works by Matisse, Ernst, Picasso, Rothko, and more. We were utterly charmed by John and Dominique de Menil. Because we were returning late to New Haven, Dominique asked her cook to prepare us a picnic dinner. It fed us for three days. John offered to pay for our job-hunting trip to Texas if we would reserve two days to visit St. Thomas. That spring trip confirmed that Texas had nothing to lure anyone away from the East Coast. Even St. Thomas looked like a bizarre choice for someone accustomed to the major universities of the northeast—a very small, unknown school with no art history colleagues, an art library that could fit into a small closet, and a slide collection that consisted of two partly filled, three-drawer metal cabinets. But we liked the people. They conveyed a sense of excitement and pride in their work, and I was captivated by MacAgy's current exhibition, "Art Has Many Facets." We decided to give it a try for three to five years. That decision led to a lifetime in Houston.

Six weeks after I began to teach in January 1964, the Art Department was devastated by MacAgy's death. The de Menils embraced that dark moment by asking Rothko to design a chapel for the university. Dominique was appointed chair of the department and assumed responsibility for the exhibitions MacAgy had begun. I took over all the art history courses while finishing my dissertation. We only passed each other in the night until we came up for air that summer and agreed that we needed reinforcements. In her customary direct approach, Dominique knocked unannounced on the door of Rudolf Wittkower, chair of art history at Columbia University, in search of a scholar of "primitive art." He recommended Mino Badner, who subsequently regaled us with his story of that unorthodox interview, reduced by pressing schedules to a walk along the street near Columbia with an elegant lady in a fur coat who was being trailed by her taxi. Badner—a city boy who had hardly left Manhattan, much less gone to Texas—also rolled the dice in 1965. Philip Oliver-Smith and Walter Widrig, doctoral students at New York University, arrived in 1965 and 1967, respectively. Both were art historians and archeologists, Philip in Greek art and Walter in late Roman, early Christian, and Byzantine architecture.

Fig. 4.12
"Made of Iron," University of St. Thomas,
Houston, 1966

With the addition of those art historians, St. Thomas developed the first art history department in Houston (fig. 4.13) and for several years the most substantial such department in Texas. A generous budget permitted a rapid buildup of books and slides, which soon required an addition to the Art Department building: the Bartlett House. The new faculty multiplied the number and range of courses, expanded evening lectures, and opened new community contacts. Oliver-Smith established the Houston chapter of the Archaeological Institute of America, and the de Menils assisted Oliver-Smith and Widrig in their search for an archeological site, first in Tunisia and then in Libya. Aware of Houston's isolation from research centers, they were touchingly generous in supporting research in the form of travel grants or, more often for me, providing the best bed-and-breakfast available in New York and Paris. The question there was not "who's coming to dinner?" but "who's coming to breakfast?" Guests from other bedrooms in the de Menil residences typically included museum curators and directors from Europe, priests, professors, and

grad students. Conversation was stimulating, the food good, and the price right.

Dominique finally reserved time for herself to teach some courses. The relentless academic schedule was not compatible with her life, but she persevered. Letters from her students—lamenting the difficulty of her course requirements or the grade on a paper—indicate that she was a demanding teacher. Her thoughtful responses reveal that she was also a conscientious teacher, who sought the same quality in thinking and writing that she did in every other aspect of her commitment to art.[41] Moreover, she was concerned about the whole student, not simply the student in class. I received a letter from a Yugoslavian student in England seeking a scholarship to study painting in the United States. We did not have painting classes, and he had a mediocre record, so I wished him well in his search elsewhere. But Goran Milutinovic continued to write, and when I mentioned him in a meeting, Dominique de Menil immediately said, "Bill, anyone who is so persistent has character. Write him that he has a scholarship." Goran was a lethargic and unorganized guy, and his initial work was as mediocre as his record. But he was a lovable person, and each art historian quietly went out of his way to help him improve his study habits. By the end of the year, Goran had markedly advanced, and we were congratulating ourselves for the efficacy of our special help when Dominique interrupted us to say that the credit was all hers. We were indignant. Goran had not even been one of her students. But she wagged her finger at our mere academic concerns. "I," said she, "have been giving him vitamins."[42]

Dominique de Menil's forte in teaching lay outside the classroom—in her life, the programs of the Art Department, and the larger, public realm of exhibitions. As a curator of exhibitions, she quickly demonstrated that she had been a superb, silent student of MacAgy's—more scholarly and less dramatic, but in her own way the equal of her teacher. In the fall of 1964, for her first exhibition after MacAgy's death, Dominique offered a fascinating collection of monsters across art history. She titled it "Constant Companions: An Exhibition of Mythological Animals, Demons and Monsters, Phantasmal Creatures and Various Anatomical Assemblages." She reveled in the search for the objects, her research on them, and her quest for an installation that quickened both the mind and eye of the spectator.[43] That was true for every exhibition she organized for St. Thomas, some of the most extraordinary being "Builders and Humanists: The Renaissance Popes as Patrons of the Arts," 1966; "Made of Iron," 1966 (fig. 4.12); and "Visionary Architects: Boullée, Ledoux, Lequeu," 1967. She provided pithy essays for some exhibitions; in other instances, she commissioned notable scholars to write the texts. Impressive lecture series also accompanied most exhibitions. "Builders and Humanists" brought to Houston Janos Scholz, Rudolf Wittkower,

Fig. 4.13

Dominique de Menil (*center*) with students, faculty, and staff of the Art Department, University of St. Thomas, Houston, 1968. *Back row:* Pat Toomey, Rodney Marionneaux, Betsy McMillan, Susan J. Barnes, Fredericka Hunter, Philip Oliver-Smith, Kathryn Davidson, Elsa Ross, Edith Coles, Mary Jane Victor, Arthur Courtmanche, Shelby Miller, unidentified person, and Goran Milutinovic; *front row:* Helen Winkler, L. D. Dreyer, Kathy La Roche, Geraldine Aramanda, Elizabeth Donaldson, William A. Camfield, Lois Thornhill, Zorina Najarian, and Barry Kaplan

Milton Lewine, David Coffin, Donald Posner, and James Beck; "Visionary Architects" scheduled Louis Kahn, Buckminster Fuller, Robert Rosenblum, and Jacques de Caso.

Every exhibition and lecture was followed by a dinner, often at Maxim's, which John proclaimed as the only acceptable restaurant in town. He and Dominique were prone to issuing impromptu invitations to students to join the table, and they regularly included students in receptions and dinners at their home. Dominique was quick to identify students with the brightest minds and most engaging personalities to assist her with the research and installations for her exhibitions or to squire around a visiting artist. The year 1965 was a stellar one for visiting artists, as students and faculty gathered to meet informally with Marcel Duchamp, René Magritte (fig. 4.14) Roberto Matta (fig. 4.15), and Jean Tinguely. These experiences were multiplied for some students at St. Thomas (and later at Rice University) who went to New York for graduate studies, sometimes lodging

Fig. 4.14
Cowboys, Father John Meyer, René
Magritte, and Dominique de Menil
at the rodeo, Simonton, Texas, 1965

awhile in the de Menil residence. Virtually all of them have honored that de Menil generosity by enriching the cultural life of this nation; among them are Paul Winkler, Fred Hughes, Helen Winkler Fosdick, Susan J. Barnes, Karl Kilian, Fredericka Hunter, Suzanne Deal Booth, Glenn Heim, and Charles (Mark) W. Haxthausen.

The department's physical and psychological closeness created a memorable sense of community. Classrooms, offices, the slide room, and the art library were all housed in an artfully remodeled two-story home—and it felt homey, filled with friends and graced by art. For my office, I first chose Rothko's *Astral Image*, 1945. Later I lived with Magritte's *Les origines du langage* (*Origins of Language*), 1955. They were—and remain—ineffable sources of pleasure and mystery. As Ginny and I discovered that we shared political and social values with John and Dominique at a time when the country was struggling with civil rights and the Vietnam War, our relationship extended into community affairs. We enlisted them in the cause of Citizens for Good Schools, an upstart political group that defeated a school board opposed to integration of the public schools. They invited us to join them in fundraising events for liberal Democrats, and John gave me a hand when I clashed with the Houston Police Department over a racial issue.[44]

The post-MacAgy 1960s were heady, gratifying times for the de Menils. It must have seemed that Houston was back on track to become the art center they had worked so hard to achieve—and they were poised to expand substantially their commitment to St. Thomas. They had to proceed, however, without the company of their kindred spirit Sweeney.

Sweeney's local reception never matched his international stature. He had offended conservative museum members and many regional artists when he discontinued the MFAH's participation in the inveterate "Texas General" and "Houston Artists" exhibitions.[45] Still other members—who had never been fans of modern art to begin with—were dissatisfied with his acquisitions and totally undone by the works of Jean Tinguely and Niki de Saint-Phalle. As gifts tailed off, Sweeney became discouraged, and after income dropped, the trustees informed Sweeney in May 1967 that they were being forced to reduce his position to that of a guest director responsible for one show per year. Sweeney declined.

The de Menils' sorrow over Sweeney's departure was subsumed in their enlarged commitment to St. Thomas, triggered by the new president, Father William Young. During a meeting with the de Menils in early 1967, Young observed that the heavily subsidized Art Department was "wagging the dog" at the university while other faculty and programs struggled. John and Dominique promptly established a fund for increasing faculty salaries throughout the university and "expressed a desire to recruit faculty of high quality."[46]

John de Menil drafted a personal statement describing the educational philosophy he and Dominique shared and the measures

they thought the university should undertake.[47] At stake from the beginning was the balance between the university "as a Christian institution," which "aims to have its students live in an environment where spiritual values are stressed," and "as a liberal arts college," which "exists to cultivate in its students the habit of learning, of open inquiry,... and free personal decision." To bring the entire university up to the performance level of the Art Department, he listed specific goals: a better library, more scholars "chosen for their talent irrespective of their religious persuasion," and eventually some selective graduate programs. Funding those goals would require help from people in Houston and beyond, "who will see in St. Thomas an important precedent in privately sponsored urban renewal, in imaginative education and in the endeavor to stress spiritual values without encroaching on personality and with total respect for all convictions." John and Dominique believed that the crucial step to those ends was a redefinition of the board of trustees, which then consisted solely of Basilian Fathers. The timing was fortuitous. Mindful of directives from Vatican II, the Fathers had already discussed broadening the university's base by inviting to its board "six lay people of various convictions who will share the college government with the present board of six Basilian fathers."[48] John and Dominique began in early 1967 to compile a list of lay candidates for the board.

Disagreements over the concepts and pace of this change in the board flared briefly in September 1967. Father Patrick Braden, the newly appointed president replacing Young, had not been privy to previous discussions. He was less comfortable with John de Menil's direction and style, and did not endorse the wording John proposed for a text on "Aims and Purposes" for the 1967–68 university catalogue. That caused John to write Young: "The Basilians today have undivided authority, but it is their intention—or is it—to share it with civilian Christians (whether or not Catholic) and possibly Jews."[49]

Tensions aside, John and Dominique continued their commitment to an expanded university by funding several new positions over 1967–68 and exploring potential candidates for the board: artist John Cage, Houston businessman Reuben Askanase, Houston developer Gerald Hines, statesman Archibald S. Alexander, and Houston attorney St. John Garwood. New faculty hires included Father Pie Duployé, a Dominican priest from Paris who was secured to teach in the French Department, James Land to chair a Department of Economics, and Thomas McEvilley to teach in the Department of Greek and Latin. The flurry of hires was topped off with that of Gerald O'Grady, who established the Media Center, a totally new program that soon added to the faculty filmmaker James Blue and photographer Geoff Winningham.[50]

Concurrent with those new activities, the "regular" program flourished, enriched by a popular Print Club that supplanted the Art

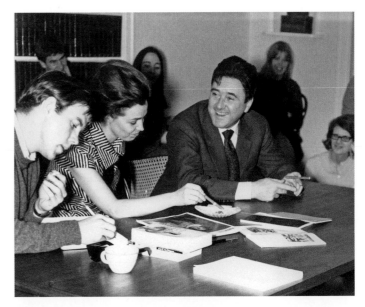

Fig. 4.15 *top*
Roberto Matta (*right*) conducting a student seminar, University of St. Thomas, Houston, 1965

Fig. 4.16
Claes Oldenburg conducting a student seminar, University of St. Thomas, Houston, 1968

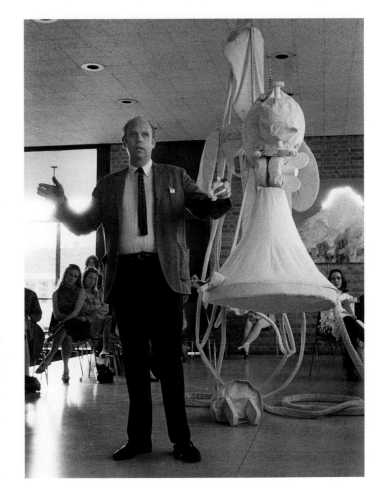

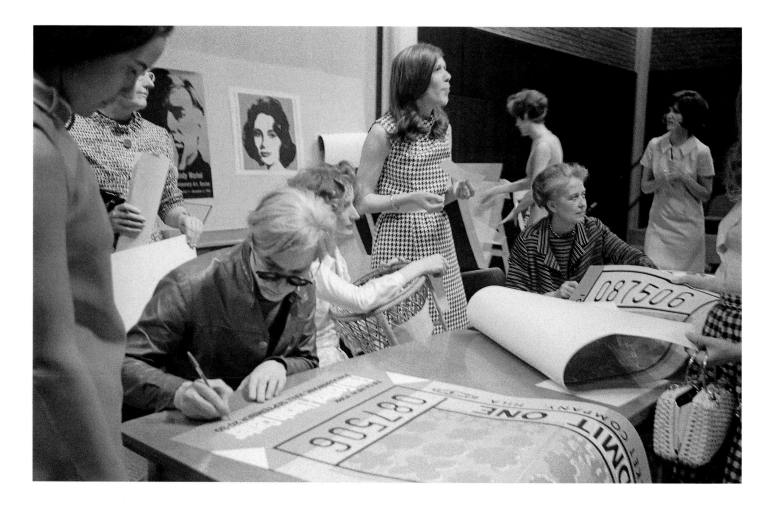

Rental Service and by a flow of visitors and lecturers that would have been exceptional at any major university in the country.[51] Guests for the opening of the "Six Painters" exhibition in February 1967 included composer Morton Feldman and distinguished curators and writers Alfred H. Barr Jr., Dorothy Miller, Tom Hess, and Brian O'Doherty. Artist Niki de Saint-Phalle was a guest in May for "Mixed Masters," an exhibition that featured diverse contemporary artists. Claes Oldenburg talked about his work in March 1968 (fig. 4.16); and Stan VanDerBeek was hired to teach a six-week seminar on filmmaking in the summer. Andy Warhol (accompanied by Viva and Paul Morrissey) spent several days at the university in May for film screenings and the premiere of his film *Imitation of Christ* (fig. 4.17). The program of Warhol films was a courageous step. The provocative, sexually charged films were challenging, even for an eager audience, not to mention an audience at a Catholic university. They were venturesome for Dominique de Menil herself. The day after Warhol left, she came up to me with a face and voice filled with a mingling of joy and relief, saying, "Bill, I must tell you that Andy is a wonderful person. Such substance!" I think she must have been uncertain about him and anxious about his visit. But she wanted to know him, took the risk, and was overjoyed by the results.[52]

Behind the scenes, relations between the de Menils and St. Thomas were deteriorating. Braden received complaints about the Warhol films and some aspects of the Media Center program, and he wondered at times whether it was he or John de Menil who was president of the university. John and Dominique, in turn, were disillusioned by the lack of any initiative for over a year to redefine the board. When no action was taken at the trustees' meeting on July 15, 1968, the de Menils decided it was time to consider separation from the university. The issues are clear in minutes of a meeting between the de Menils and members of the Congregation of St. Basil on August 26 at St. Michael's College in Toronto. John de Menil's vision of the future of St. Thomas was reported as follows: "[He supported a] college dedicated to the liberal arts with a special emphasis on the importance of religion ... [which] would be assured ... by the presence of Basilians on the Board of Directors, and ... by a first-rate Theology department which would not be restricted to the Study of Catholic Theology alone. He also envisaged Graduate Studies or Special Institutes in selected areas.... To best achieve this end ... Mr. de Menil believed that the Board of Directors should have *two* aspects to its make-up: (1) The assured presence of four members of the Congregation of St. Basil (2) a majority of non-Catholic members."[53]

Fig. 4.17
Andy Warhol signing posters, with Viva
and Dominique de Menil (*seated at table*),
University of St. Thomas, Houston, 1968

The Very Reverend Joseph Wey, Superior General of the Basilians, was reported as commenting that "the important aspect of the University should be teaching.... Any other aims, such as research and graduate studies, should not be allowed to overshadow this primary aspect.... [A] good University must offer direction to its students. One cannot teach everything from all points of view. The students really need and want some direction in the learning process."[54]

Conversations continued back at the university, and once or twice it seemed that a solution was possible. But John de Menil was resolute, and both parties realized—sadly—that they could not reconcile their philosophical differences. Years later, Young reflected on the situation then facing St. Thomas: "[The de Menils'] vision for the University was more like what the Rothko Chapel became: a meeting place for all faiths where people could pray and worship and share their concept of God. This is not what the Basilian charism of education entails. Moreover, the Basilian Fathers are part of the Church, not a free enterprise organization which can do what it wants with regard to the enterprise it directs. The Church of Vatican II gave the green light to have laymen and women in decision-making positions, such as on the Board. It did not endorse the secularization or ecumenization of Catholic Universities."[55]

In the meantime, John and Dominique approached Rice University about transferring the entire program there. By November 1968 memos were being circulated about that shift, and in December the move to Rice University was reported in the local and national press.[56] Ironically, these events were unfolding while Dominique de Menil's exhibition "A Young Teaching Collection"—organized for the University of St. Thomas—was on view in Cullinan Hall at the MFAH.[57]

The separation took about a year to complete. The de Menils retrieved their art collection in exchange for real estate crucial for the expansion of the university. They continued to support the architectural program and made up a deficit for a new dormitory. A core selection of art books and slides remained at St. Thomas, and arrangements were made for art majors to complete their studies at Rice University. Sadness permeated the separation, not bitterness. John de Menil told Ginny and me that he and Dominique had been ready to devote the rest of their lives and the whole of their fortune to St. Thomas. Some friends of the de Menils have said they thought Dominique de Menil might have preferred to remain there.[58] Young described the de Menils' contributions to the university as "immeasurable," and wrote, "One may well wonder if it could have survived without them."[59]

Rice University, 1969–85

To begin operating at Rice University in the fall of 1969, John and Dominique and Rice officials had about seven months to negotiate the de Menil shift. Conditions were less than ideal. First, Rice began the conversations with a major gap in leadership, namely, the absence of a president. Negotiating for Rice were Malcolm Lovett, chair of the trustees, and Virgil W. Topazio, dean of humanities and social sciences.[60] Second, Rice and the de Menils came to the table with incompatible philosophies regarding the funding of new programs. Rice's policy was to accept only endowed programs. John and Dominique de Menil were opposed to endowing a program. They offered instead a seed program—funded for a specified number of years after which the host institution would assume responsibility if it really wanted to keep the program. Two other factors in the larger Rice community—not voiced in the two sessions I attended with John de Menil—were a concern for the de Menils' modus operandi within institutions, and the opinion of a few prominent faculty members and administrators that the arts in general did not belong in an academic program. Notwithstanding these obstacles, Rice and the de Menils reached an agreement for the full package of de Menil programs and personnel for a five-year period, from July 1, 1969, to June 30, 1974.

That agreement included two basic components: an academic component integrated into Rice's department structure, and the Institute for the Arts at Rice, under the direction of Dominique de Menil, that would accommodate the de Menil art collection along with a program of exhibitions, distinguished visitors, and community outreach activities. The academic component included the four art historians, a slide library (with curator Pat Toomey), an art library (with librarian Shelby Miller), the Media Center with Blue and Winningham, and four additional professors: classicist McEvilley, linguist Douglas Mitchell, economist Land, and French professor Duployé.[61]

The de Menils assumed all expenses initially. They further offered to pay for a building that would have been compatible with the campus' Romanesque style of architecture and large enough to house the entire transplanted program. That idea was dropped. Rice was poised to break ground on Sewall Hall—a building partially designed for the Department of Fine Arts—and conversations were under way between Rice and Louis Kahn regarding a school of the arts.[62] John and Dominique de Menil were keenly interested in that project but more urgently concerned about another building to accommodate their first exhibition at Rice. While still at St. Thomas,

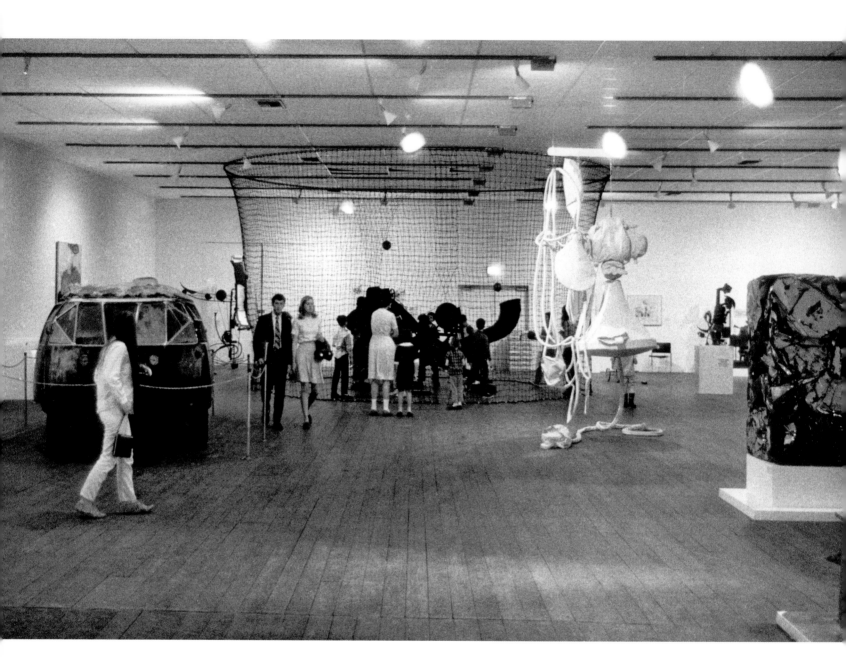

they had managed to schedule the university as one of only three venues for the extraordinary exhibition "The Machine As Seen at the End of the Mechanical Age" (figs. 4.1 and 4.18), organized by Pontus Hulten for the Museum of Modern Art, New York. With their shift to Rice, the de Menils sought immediate permission to construct an exhibition hall, and three months later "The Machine" inaugurated a corrugated metal building named the Rice Museum that came to be called the "Barn" or "Art Barn." The exhibition was enormously popular—and spectacular in the flexible twelve-thousand-square-foot space provided by that humble, industrial-looking structure. The Art Barn chaffed some in the academic community, and the neighbors across the street, but it became a symbol of something special at Rice and, eventually, an object of affection.

There was, however, an unfortunate drawback to erecting the Art Barn so quickly. Owing to its "temporary," industrial aesthetic, there was no place for it among the substantial buildings that graced the central campus. So the Art Barn was relegated to the edge of the campus where it was soon joined by a twin corrugated metal building to house the Rice Media Center. Like the Institute for the Arts, media studies was a wholly new program without an established departmental home. Notwithstanding the extraordinary activities generated by the Institute for the Arts and the Rice Media Center, their location tended to isolate them physically and psychologically from the central campus. The sense of intimacy and unity that had prevailed in the Art Department at St. Thomas was elusive in the context of a far more substantial university on a three-hundred-acre campus.

The art historians from St. Thomas worked at establishing themselves within the well-developed academic program at Rice and melding with the Department of Fine Arts, chaired by artist John O'Neil and composed of four artists, a drama teacher, and one art historian. The new crew was welcomed, and with little fanfare, art history became a more prominent and respected part of the established academic program.[63]

High spirits attended the new programs of the Institute for the Arts at Rice and the Rice Media Center. Dominique and John worked to assure that year one at Rice was spectacular. Prior to their arrival, art exhibitions at Rice had consisted of tasteful but modest shows installed in a small lobby area of the Fine Arts Department building. Following the prodigious prelude of "The Machine," Dominique deluged the campus with diverse exhibitions. These included the quirky "Raid the Icebox" show, initiated by John de Menil and conceived and installed by Warhol (fig. 4.19); to "Seventeenth-Century Dutch Masters," loaned by the Metropolitan Museum of Art, New York; to "Ten Centuries That Shaped the West," comprising Greek and Roman art from Texas collections (fig. 4.20). Members of the Rice community had to go a little out of their way to see such exhibitions at the

Fig. 4.18 *opposite*
"The Machine as Seen at the End of the Mechanical Age," Rice Museum, Rice University, Houston, 1969

Fig. 4.19
"Raid the Icebox 1 with Andy Warhol," Rice Museum, Rice University, Houston, 1969

Fig. 4.20
"Ten Centuries That Shaped the West: Greek and Roman Art in Texas Collections," Rice Museum, Rice University, 1970

Fig. 4.21
Full-size maquettes for Tony Smith sculptures
New Piece, Marriage (*center*), and *The Snake
Is Out* (*foreground, detail*), Hamman Hall
quadrangle, Rice University, Houston, 1969

Fig. 4.22 *opposite*
"Some American History," Rice Museum,
Rice University, Houston, 1971

Barn, but everyone on campus experienced the six full-scale wood maquettes of sculptures by Tony Smith prominently installed on the lawn in front of Hamman Hall (fig. 4.21). A hugely popular collection of prints and posters was made available for loan to offices all across the campus. Art historian Leo Steinberg was retained for a scintillating series of lectures on Michelangelo. Composers La Monte Young and Marian Zazeela presented their mesmerizing composition *Dream House* at the Rice Museum, and Dominique attended to publicity with an open house, a semiannual newsletter, and mailings to individual members of the university.

From the beginning, the Rice Media Center occupied a unique hybrid position in the de Menil transplant. On the one hand, it was an academic program, a section of the Fine Arts Department, offering Rice's first classes in film and photography. On the other hand, it was a semi-independent operation that enjoyed the favor of John de Menil and benefited from dedicated funds for a community outreach program—photography exhibitions, distinguished visiting filmmakers and photographers, an evening film program open to the public, a high school film festival, and more.[64] The filmmakers actively cultivated interdisciplinary projects within the university, particularly among scientists, anthropologists, and sociologists whose projects might profit from the Media Center's focus on documentary film. John de Menil encouraged such connections by commissioning Roberto Rossellini to explore a series of films and television programs on science projects then under way at Rice.[65] The program

hired two additional documentary filmmakers, David MacDougall and Mark McCarty, and retained Colin Young, director of the British National Film School, as an advisor and occasional teacher.

Norman Hackerman assumed the presidency of Rice at the end of the first year of the de Menil transplant. He was immediately concerned about Rice's responsibility for the security of the art collection.[66] The de Menils' focus, however, was on the program. Dominique urged movement toward a future graduate program in art history and described her vision for the Institute for the Arts as something akin to a continuing adult education program with more experimental courses taught by stellar professors. Within the Institute for the Arts, she wrote, "such people as high school teachers, career men and women, housewives, in brief anybody eager to invest their spare time in continuing education" could "develop their special talents in the demanding climate of a great University" and "be recognized by a certificate of some sort."[67]

The de Menils' concern for civil and human rights was a prominent theme in their second year at Rice. Dominique's first exhibition at the Institute for the Arts, "Conversations with the Dead," September 1970, featured Danny Lyon's wrenching photographs of inmates in the Texas prison system. She followed that in February 1971 with "Some American History," a provocative presentation of slavery in the United States featuring the work of artist Larry Rivers but bolstered by the work of several African American artists (fig. 4.22). That exhibition attracted numerous visitors from Houston's black

community, who would continue to come to the Institute for the Arts exhibitions. Their turnout two months later for the enchanting exhibition "For Children" prompted literary agent and John de Menil confidant Ronald Hobbs to suggest mounting exhibitions in one of the black areas of Houston. John and Dominique took that idea to Peter Bradley, a respected African American artist in New York, who accepted the task. Bradley rejected an exclusively black show as patronizing and instead specified two conditions: the inclusion of white artists and presentation in a building—in a poor neighborhood—totally unrelated to the local black art establishment. Mickey Leland, a de Menil friend and civil rights activist in the black community, proposed the De Luxe Theater, a historic but closed movie house on Lyons Avenue in the heart of the Fifth Ward. The transformed De Luxe Theater opened in August 1971 with a series of memorable exhibitions conceived to "show the black community in Houston that there are black artists of quality who compete on equal terms with white artists of their generation," to stimulate the local artists, and to challenge the black community to support them.[68] The model for this commitment to Houston goes back to the de Menils' participation in the CAA and the commission of their home.

Although preoccupied at Rice, John and Dominique always had multiple projects in the works—not only the De Luxe Theater shows, but the Image of the Black in Western Art project, catalogues raisonnés of the work of Max Ernst and of René Magritte, their involvement at the MFAH, and work on the Rothko Chapel. The Basilian Fathers had never been comfortable with the Rothko Chapel, and, indeed, it did not lend itself to being *the* chapel serving a Catholic university. Dominique and John explored other sites and worked to define a mission commensurate with the unique nature of the chapel. It was dedicated February 27–28, 1971, on property adjacent to St. Thomas and incorporated the following year as a chapel "to provide a place of worship, a place of meditation and prayer, … to discuss human problems of world-wide interest, and also share a spiritual experience, each loyal to his belief, each respectful of the beliefs of others."[69] As for the MFAH, Sweeney's successor, Philippe de Montebello, reclaimed the de Menils' service and financial support with a substantial pledge early in his tenure from September 1969 to January 1974.[70] John de Menil reduced his commitments to the MFAH after he was diagnosed with cancer in 1970, but Dominique de Menil replaced him on the Accessions Committee, then agreed to serve on the board. She continued to serve the MFAH on various committees into the 1990s, including assuming a major role in the hiring of the next director, William C. Agee.

As the de Menil program at Rice moved into the third year of the five-year agreement, the de Menils initiated discussions with Hackerman about the future. Basically they proposed that Rice assume the

entire support for the academic program and share expenses for the Institute for the Arts, which would be reconstituted as a Center for the Study of Man. The new center would be physically located in a building that it would share with their art collection near the Rothko Chapel, and it would have a changing cadre of distinguished scholars offering challenging, experimental courses for Rice students as well as a certificate for adult students in the community at large. In brief, the de Menil presence at Rice would be reduced to an innovative form of continuing education with a link to Rice that served the university while also validating the proposed Center for the Study of Man. Hackerman responded positively—and artfully—with proposals that the Center for the Study of Man be on the Rice campus with resident scholars representing science and the humanities as well as the arts. His proposals appealed to both John and Dominique, but John's death in June 1973 put an end to the conversation.[71]

John's death was a profound loss for Dominique. They had always worked as a team. She described him as "the mover," and now she was without her mover and life partner with whom to share the momentous decisions yet to be made regarding their life's work, work bound up in a host of projects and the lives of people committed to those projects. Continuing that life's work became part of coping with her loss.

When conversations between Rice and Dominique resumed in the fall of 1973, there was no further talk of a Center for the Study of Man, but a second five-year plan was negotiated, with Rice absorbing proportionately more of the budget, thanks in large part to the Brown Foundation.[72] Around this time, the long-range prospects for the de Menil relationship with Rice were addressed. Hackerman, who had inherited the de Menil challenge and a commitment to the Shepherd School of Music, was approached by separate groups proposing professional schools in law, medicine, and management. He agreed that it was appropriate for Rice to consider professional schools, but unrealistic to pursue more than two. The two approved were the Shepherd School of Music and the Jesse H. Jones Graduate School of Administration. According to Hackerman, the trustees were not opposed to the de Menil collection nor to the envisioned Center for the Study of Man and a graduate program in art history— but neither were they enthusiastic. Hackerman did not think (correctly, in my opinion) that the de Menil collection would be given to Rice. So he asked Dominique de Menil if she had considered forming her own museum.[73] That idea may have existed in embryo form for John and Dominique from the moment of their initial lukewarm reception at Rice; it was clearly present in their proposal for the Center for the Study of Man prior to John's death.

Activity at the Institute for the Arts continued in the second five-year commitment, but human rights issues and the Rothko Chapel now occupied much of Dominique's time. Only a Rice outreach program to the Houston Independent School District continued apace.[74] Lectures, concerts, and special events declined in number. Exhibitions were somewhat reduced in number also, and they were more likely to be loan shows or small in-house shows. Nevertheless, the major exhibitions—among them, "Marden, Novros, Rothko: Painting in the Age of Actuality," April 1975; "Form and Freedom: A Dialogue on Northwest Coast Indian Art," October 1975 (fig. 4.23); "Art Nouveau: Belgium, France," March 1976; and "Secret Affinities: Words and Images by René Magritte," October 1976—were extraordinary.

The Rice Media Center, once blessed with generous funding and separatist goals, fell upon hard times, with its funding reduced and restraints imposed by Rice that led to the resignation of Blue in 1977. It continued, however, to provide stimulating classes and an evening film series that for several years was Houston's only vital site for alternative film programs.

The de Menil vision of a larger art department, with a graduate program in art history and museum studies, did not materialize. Instead it settled into a popular and effective teaching department, handicapped by the perception that no funds were needed for special lectures or visiting artists, given the programs at the Institute for

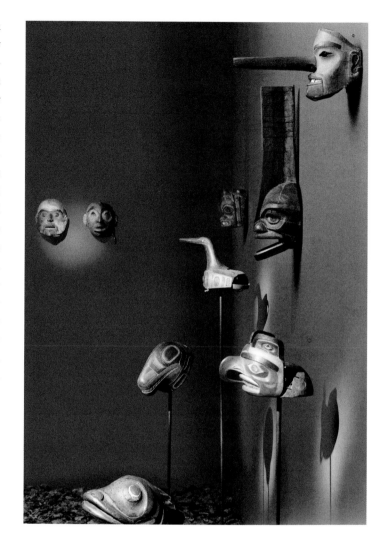

the Arts. In 1976, however, the de Menils helped finance an excavation in Latium near Rome, opened by Oliver-Smith and Widrig, which provided memorable work experiences for over two hundred Rice students until the site was covered in 1989.

In 1979 a third five-year plan was initiated as both the Menil and Brown foundations renewed their commitments. A small master's program in art history was finally opened—with Dominique de Menil's support for a fellowship honoring Jermayne MacAgy and for Bertrand Davezac as a part-time faculty member. Activities at the Institute for the Arts continued to trail off as Dominique devoted more time to thinking through the task of building her own museum on property adjacent to the Rothko Chapel. She wrote Hackerman in August 1981 that her plans to house the collection were coming to fruition and would soon be announced publicly. Although she would no longer be at Rice after the end of the third five-year com-

Fig. 4.23 *opposite*
"Form and Freedom: A Dialogue on
Northwest Coast Indian Art," Rice
Museum, Rice University, Houston, 1975

Fig. 4.23 *opposite*
"Form and Freedom: A Dialogue on
Northwest Coast Indian Art," Rice
Museum, Rice University, Houston, 1975

Fig. 4.24
"Edward and Nancy Reddin Kienholz:
The Art Show," Rice Museum, Rice
University, Houston, 1984

mitment, she wanted him to know that "special emphasis is being placed on making the collection accessible to professors and students."[75] Significant activities by no means ceased at the Institute for the Arts. The exhibition "Black Folk Art in America: 1930–1980" from the Corcoran Gallery of Art, Washington, D.C., March 1983, was particularly relevant for the de Menil history in Houston, and two shows organized by Dominique de Menil count among her best—"Yves Klein 1928–1962: A Retrospective," February 1982, and "Edward and Nancy Reddin Kienholz: The Art Show," November 1984 (fig. 4.24).[76]

Final arrangements between the Menil Foundation and Rice were concluded at a meeting on May 10, 1985.[77] Relationships continued, however, as they had at St. Thomas. The substantial de Menil art and slide libraries were given to Rice, and Dominique continued to support the master's program in art history, the excavation in Latium, and a grant for a scholar in religious studies.[78] She also arranged to pay the salaries for professors Bertrand Davezac and Thomas McEvilley until their retirements in 1993 and 2005, respectively. Rice, in turn, maintained contact with Dominique and honored her with an annual presidential lecture in her name, which continues to this day.

The Menil Collection

The departure of Dominique de Menil from Rice was as quiet and prolonged as the beginning had been sudden and spectacular. At Rice—as at the CAA, St. Thomas, and the MFAH—the de Menils had attached themselves to an institution not only to bring something vital to it but also to advance a mission for Houston. None of these attachments lasted, but each institution was better for the de Menil commitment, and each experience led John and Dominique closer to their only viable solution. They had steadfastly resisted invitations from other cities interested in their collection, and they had run out of time and Houston institutions. Dominique de Menil had to form her own.

Much that occurred in the de Menils' decades-long effort to make Houston an international center for the arts had been unforeseen, none more so than the prospect that the Menil Collection itself would become an international pilgrimage site. And so it remains today, a manifestation of their dedication to the city and a testament to Dominique's belief that neither faith nor art can be taught, but they can be exhibited with grace and power.

NOTES

Many individuals have contributed to my research for this essay. I particularly wish to thank the archivists for the four institutions: Geraldine Aramanda at the Menil Collection; Father George Hosko, Betty Kaffenberger, and Betty Fischer at the University of St. Thomas; Lee Pecht and Phil Montgomery at the Woodson Research Center of Rice University; and Lorraine Stuart, who is in charge of the archives for both the Museum of Fine Arts, Houston, and the Contemporary Arts Museum Houston. My thanks also to the following individuals who consented to an interview: William C. Agee, William Akers, Gertrude Barnstone, Preston and Pauline Bolton, Jack Boynton, Father Patrick Braden, Franz Brotzen, Katherine Brown, Helen Winkler Fosdick, Dr. Norman Hackerman, Clovis Heimsath, Melissa Kean, Karl Kilian, Douglas Mitchell, Robert Morris, Gerald O'Grady, James Sims, Richard Stout, Carol Straus, Anderson Todd, Walter Widrig, Paul Winkler, Geoff Winningham, and Father William J. Young, who shared with me portions of his unpublished manuscript on the history of the University of St. Thomas.

1. Dominique de Menil, interview with Paul Winkler and Carol Mancusi-Ungaro, September 25, 1995, Menil Archives, Film and Media Collection.

2. Dominique Browning, "What I Admire I Must Possess," *Texas Monthly* (April 1983): 192. Observation in brackets by Browning, who interviewed Dominique de Menil.

3. See Frank D. Welch, *Philip Johnson and Texas* (Austin: University of Texas Press, 2000), 40–57. The five de Menil children (two born in Houston) were reminded that they, too, had to "live with" as well as live within this "strange" home when playmates arrived.

4. The Contemporary Arts Association of Houston called its first building the Contemporary Arts Museum in 1949. The organization itself came to be known informally as the Contemporary Arts Museum Houston (CAMH), but it was not until 2003 that it officially changed to this name.

5. *In Our Time: Houston's Contemporary Arts Museum, 1948–1982*, exh. cat., essays by Cheryl A. Brutvan, with Marti Mayo and Linda L. Cathcart (Houston: Contemporary Arts Museum, 1982), 6–11.

6. Ibid., 6.

7. Welch, *Philip Johnson and Texas*, 53. See also exhibition file and documentary film in Menil Archives.

8. Quoted in Marguerite Johnston, "The De Menils," *Houston Post*, Today section, January 9, 1977.

9. Ibid.

10. John Hay Whitney to John de Menil, February 16, 1951, Menil Archives. The painting was *Woman Reading a Novel*, 1888, which subsequently was deaccessioned.

11. Annual Report from the Chairman of the Board, quoted in *In Our Time*, 13–14.

12. Jermayne MacAgy, "Report to the Board of the Contemporary Arts Association," April 24, 1952, Menil Archives.

13. John de Menil to Frank Coates, April 21, 1958, box 1, folder 25, Museum of Fine Arts, Houston, Archives.

14. Clippings on this event are in the Menil Archives. On this occasion, Duchamp read his important statement "The Creative Act."

15. *In Our Time*, 16–17.

16. Dominique de Menil, *Jermayne MacAgy: A Life Illustrated by an Exhibition*, exh. cat. (Houston: University of St. Thomas, 1968).

17. Jermayne MacAgy, Director's Report, Contemporary Arts Museum, August 13, 1957, MacAgy papers, Menil Archives. For more information on these years, see *In Our Time*, 22–26.

18. John de Menil, untitled statement, February 17, 1967, Menil Archives.

19. University of St. Thomas catalogue, 1947–48, 3. The current campus is a testament to the efficacy of the Basilians' faith, work, and good fortune, beginning with Guinan's service as president from 1947 to June 1959.

20. Welch, *Philip Johnson and Texas*, 57, and Father William Young, manuscript on the history of the University of St. Thomas, personal papers, 47–48. I am grateful for Father Young's generous help in my research.

21. "Special Study of the University of St. Thomas, Houston, Texas, October 21–24, 1956, by Dean E. B. Robert, Louisiana State University, and Dean Herman E. Spivey, University of Kentucky," Menil Archives.

22. Welch, *Philip Johnson and Texas*, 60–66.

23. "Minutes of the Arts Council Meeting, May 9, 1958," Menil Archives. The first meeting was October 23, 1957.

24. Quotes and comments in above paragraph are taken from ibid.

25. Father Vincent J. Guinan to John and Dominique de Menil, October 29, 1958, Menil Archives.

26. Dominique de Menil's concern about the destructive potential of Sulier's charge is reflected in a substantial file of letters, research notes, and articles in the Menil Archives.

27. Dominique de Menil to James Johnson Sweeney, November 3, 1958, Menil Archives.

28. Ibid. Dominique also expressed gratitude for the support of Father G. B. Flahiff and Lee Malone.

29. "Minutes of the Executive Committee of the Museum of Fine Arts, January 28, 1959," box 1, folder 39, Museum of Fine Arts, Houston, Archives. John de Menil was subsequently asked to be a member of the search committee for a new director and soon established himself as its leader.

30. John de Menil to Father Vincent J. Guinan, May 13, 1959; and S. I. Morris to the Museum of Fine Arts, Houston, Board of Trustees, May 29, 1959, Menil Archives.

31. Leaders of the CAA viewed some comments by the MFAH at that time as disparaging toward the CAA. John de Menil and the MFAH addressed those strained relations. Artist Robert Morris, who succeeded MacAgy as director of the CAA, expressed gratitude for John's help in an interview with the author, April 21, 2006.

32. Father John Murphy to John and Dominique de Menil, August 27, 1959, Menil Archives.

33. Dominique de Menil to Father Flahiff, December 4, 1959, Menil Archives.

34. Dominique de Menil, "Minutes of the Annual Meeting of the Arts Council of the University of St. Thomas, June 11, 1962," Menil Archives.

35. For values shared by Sweeney and the de Menils, see Marcia Brennan's essay "Seeing the Unseen: James Johnson Sweeney and the de Menils," in *A Modern Patronage: de Menil Gifts to American and European Museums*, exh. cat. (Houston: Menil Collection, 2007).

36. In 1960 John and Dominique de Menil initiated a study that led to *The Image of the Black in Western Art*, ed. Ladislas Bugner, 4 vols. (New York: William Morrow and Company; and Houston: Menil Foundation, 1976 to present). Initial research was conducted jointly with Sweeney. Dominique de Menil stated in her acknowledgments that the project did not proceed from any clear plan, but "was an impulse prompted by an intolerable situation: segregation as it still existed in spite of having been outlawed by the Supreme Court in 1954" (ix).

37. "NOT SEEN and / or LESS SEEN of / by MARCEL DUCHAMP / RROSE SELAVY," February 1965. The exhibition originated at Cordier & Ekstrom, New York.

38. "Jean Tinguely Sculptures," April 3–May 16, 1965. For an insightful discussion of this exhibition and other art given by the de Menils to the MFAH during Sweeney's tenure, see Brennan, "Seeing the Unseen," op. cit., 25–35. See also Toni Beauchamp, "James Johnson Sweeney and the Museum of Fine Arts, Houston: 1961–1967" (master's thesis, University of Texas at Austin, 1983).

39. Sweeney's acquisitions included Constantin Brancusi's *A Muse*, 1917; Calder's *The Crab*, 1962; Robert Motherwell's *Black on White*, 1961; and Eduardo Chillida's *Abesti Gogora*, 1966. *Time* magazine devoted almost a full page to Sweeney's exhibitions and acquisitions; see *Time* (June 14, 1963): 74.

40. Temporary help was provided by Wellesley graduate Jeanette Favrot, architect Howard Barnstone, Father Sullivan, who taught philosophy of art, and Marc Moldawer, MD.

41. Dominique taught in the spring and fall semesters of 1968 and the spring of 1969. See Menil Archives.

42. Milutinovic later explained his persistence. Out of more than two hundred universities he contacted, I was the only person who responded. Dominique's instincts were good, and we began to give other scholarships.

43. Dominique de Menil's respect for scholarship came from her rigorous training at the University of Paris (Sorbonne), including postgraduate work in mathematics and physics.

44. John provided an attorney reference and a letter to the mayor when I could not distinguish between the "cops and robbers" in a street-corner beating and, innocently, took on one of the plainclothes police officers instead of the guy being arrested.

45. These annual exhibitions had been mainstays in the art community for decades, but Sweeney viewed them as venues dominated by conventional art that poorly served the museum, the community, and ultimately, the artists themselves. He proposed instead an exhibition of art of the Southwest, which he defined as everything west of the Mississippi from Arkansas, Louisiana, and Texas to Los Angeles. Only eight area artists made the cut by a jury composed of Sweeney, Alexander Calder, and James Brooks.

46. Young, manuscript, 63.

47. John de Menil, untitled statement on the status of the University of St. Thomas, February 17, 1967, Menil Archives. All quotes in this paragraph are taken from this statement.

48. Young discusses the impact of the Second Vatican Council convened in four sessions from October 11, 1962,

to December 8, 1965. Religious orders were obliged to implement directives of the Council that specified an emerging role for lay men and women, and the University of St. Thomas discussed such profound changes in meetings (chapters) during the summers of 1966 and 1967. Young, manuscript, 58–59, 64–65.

49. John de Menil to Father William Young, September 11, 1967, Menil Archives.

50. In the early summer of 1967, the de Menils asked O'Grady, former professor of English at Rice University, to submit a proposal for a program in media studies. He proposed developing instruction in photography, cinematography, and television that explored the aesthetic, psychological, and social impact of those art forms within the humanities. The program began that fall with O'Grady as director of the new Media Center. Photographer Winningham joined the faculty in the summer of 1968. Filmmaker Blue assumed leadership in the fall of 1970.

51. The Print Club offered not only inexpensive lithographs, but also numbered and sometimes signed editions of fine prints by modern and contemporary artists. Prints were sold at cost to encourage people with modest means to live with original art. Public sales of the prints became popular events.

52. On this occasion, John de Menil purchased Warhol's films.

53. Minutes of a meeting at St. Michael's College, Toronto, on the future orientation of the University of St. Thomas, September 11, 1968, Menil Archives. Attending the meeting were John and Dominique de Menil; Fathers Patrick Braden, Edward Lee, and Victor Brezik of the University of St. Thomas; and Fathers Joseph Wey, James Hanrahan, William Young, and James Wilson of the General Council of the Basilian Fathers.

54. Ibid.

55. Young, manuscript, 74–75.

56. John and Dominique de Menil, unsigned memo produced for Rice University, November 23, 1968; and John de Menil's letter to Malcolm Lovett, chairman of the board, Rice University, November 30, 1968, Menil Archives. This letter reflects the memo of November 23 and summarizes a conversation with Lovett earlier in the day on November 30. See also Ann Holmes, "De Menils May Shift Patronage to Rice," *Houston Chronicle*, December 17, 1968; Grace Glueck, "Art Benefactors Shift Their Field," *New York Times*, December 19, 1968.

57. See *A Young Teaching Collection*, introduction by Walter Widrig, exh. cat. (Houston: Museum of Fine Arts, Houston, 1968); the exhibition dates were November 7, 1968–January 12, 1969.

58. Douglas Mitchell, interview with the author, July 12, 2006, Houston.

59. Young, manuscript, 76.

60. Kenneth Pitzer resigned as president of Rice in the fall of 1968 to become the president at Stanford. The trustees appointed William H. Masterson as the new president on February 21, 1969, without the participation of faculty and student representatives on the search committee. Masterson had been a respected faculty member of Rice, but neither faculty nor students viewed him as what the university needed in a president. They protested and Masterson resigned. On March 20, 1969, Frank Vandiver, professor in history, was appointed acting president of the university—too late to be much of a factor in negotiations. See Nancy Boothe, "The Masterson Controversy: A Five-Day Presidency" (paper presented at the Society of American Archivists Annual Meeting, Birmingham, Alabama, August 2002), Woodson Research Center, Rice University, Houston (hereinafter Woodson Research Center).

61. All faculty members were incorporated into existing departments except McEvilley. Because his interests had expanded from classics into the visual imagery of world mythology, art history, and art theory and criticism, he did not fit within departmental structures, but he resided comfortably in the Institute for the Arts and later worked within the Department of Art and Art History (formerly the Department of Fine Arts).

62. Information on this project is inconclusive. John O'Neil, chair of the Rice Department of Fine Arts, attributed the initiative to the de Menils; see his essay "Beginnings: Personal Notes About Art at Rice University (1965–1970)," *Rice Sallyport* (Fall 2005): 40. However, Board Chairman Lovett indicated to Stephen Fox that he initiated the contact with Kahn, and Professor Anderson Todd thinks the idea originally came from the Rice School of Architecture (Stephen Fox, conversation with the author, January 20, 2007; Anderson Todd, conversation with the author, May 1, 2006). Kahn was warmly received at Rice in October 1969, and he wrote Acting President Vandiver that he "was very pleased to receive your gracious letter appointing me architect of the art center" (Louis Kahn to Frank Vandiver, November 18, 1969, President's Papers, Box 6.3, Woodson Research Center). In March 1970 the *Houston Chronicle* announced, "Louis Kahn Planning Possible Arts Complex, Theatre at Rice" (ibid.). However, when Kahn returned on June 29, 1970, with extremely sketchy drawings of a vast complex, the project quietly died (Todd, conversation with the author). John and Dominique de Menil participated to some extent in this visit, but Rice was in charge.

63. For an account of the Fine Arts Department at Rice at this time, see John O'Neil, "Beginnings: Personal Notes About Art at Rice University (1965–1970)," *Rice Sallyport* (Fall 2005): 37–41.

64. Activities in 1970 alone included the exhibition "25 Photographs by Aaron Siskind," a presentation by photographer Duane Michaels, a seminar and film presentation by Richard Leacock, a high school film festival, and an African film festival.

65. Rossellini was a frequent visitor to Rice University in the 1970s, presenting lectures, classes, and screenings, as well as meeting with scientists there to open a dialogue about possible films on science. See *Newsletter, Institute for the Arts, Rice University*, no. 2 (spring 1970). A documentary that he was working on (*Science*, also known as *Orrizzonti 2000*) was never produced. The rough footage is in the Menil Archives, Film and Media Collection.

66. More secure storage for the collection was finally made available in Sewall Hall, but it was not configured to work as a teaching collection.

67. Dominique de Menil to Dr. Norman Hackerman, November 26, 1971, Menil Archives.

68. Unsigned memo (probably John de Menil), July 1971, Menil Archives.

69. Susan J. Barnes, *The Rothko Chapel: An Act of Faith* (Austin: University of Texas Press, 1989), 108.

70. The de Menils pledged $500,000 over a five-year period at a time when they were spending almost $1 million per year at Rice. Philippe de Montebello papers, Museum of Fine Arts, Houston, Archives.

71. Unsigned (John and Dominique de Menil), "A Proposal to Rice University," November 27, 1972, Menil Archives. See the letters of John and Dominique de Menil to Norman Hackerman, April 4, 1973, and May 5, 1973, and a Rice proposal, in President Gillis Papers, Box 71.3, Woodson Research Center. In 1977 Rice established the Program in Continuing Education (now the Susanne M. Glasscock School of Continuing Studies). It did not derive from the de Menils' concept for a Center for the Study of Man, but shared their educational vision, especially in the Master of Liberal Studies begun in 2005. Edgar Odell Lovett, Rice's first president, expressed similar values in his speeches at the opening of the university in 1912.

72. Dominique proposed a three-year commitment (Dominique de Menil to Norman Hackerman, September 12, 1973). Hackerman proposed a five-year contract (Hackerman to de Menil, November 6, 1973) that Dominique accepted (de Menil to Hackerman, December 20, 1973). See President Gillis Papers, Box 71.3, Woodson Research Center. Hackerman requested $1 million over five years from the Brown Foundation (Norman Hackerman to George Brown, February 15, 1974, Vandiver/Hackerman Papers, Box 86, Woodson Research Center).

73. Norman Hackerman, interview with the author, September 1, 2006.

74. The Art to Schools program was established in 1971 to engage yet another population with the pleasures, power, and relevance of art. Sandra Curtis and her small staff trained volunteer docents who carried carefully crafted slide talks to students in the Houston Independent School District, primarily to schools in African American and Hispanic neighborhoods. Some topics—for example, "Traditional Art in Africa" and "Art of Mexico Before Cortés"—were geared to those audiences. The program prospered, and for the school year 1973–74 Curtis reported that they delivered 340 talks to about thirteen thousand students in thirty-eight elementary schools, three middle schools, and three high schools.

75. Dominique de Menil to Norman Hackerman, August 12, 1981, Vandiver/Hackerman Papers, Box 88.6, Woodson Research Center.

76. The Ed and Nancy Reddin Kienholz exhibition was basically the work of Walter Hopps, Dominique's associate and the future director of the Menil Collection. She had also hired Paul Winkler, a former student from the University of St. Thomas, who would succeed Hopps as director.

77. The written agreements following the meeting on May 10, 1985, are formalized in two letters; see Scott W. Wise to Paul Winkler, June 25, 1985, and Miles Glaser to Scott W. Wise, July 3, 1985, President Gillis Papers, Box 71.3, Woodson Research Center.

78. Two unfulfilled goals of the de Menils were realized in the fall of 2009. Rice University opened a PhD program in art history, and Rice University Press published the final report of the excavation in Latium: Walter M. Widrig, *The Via Gabina Villas: Sites 10, 11, and 13*. The PhD program was enriched by a grant from the Brown Foundation and the support of individual donors that will fund graduate fellowships and foster a collaborative research partnership with the Museum of Fine Arts, Houston, and the Menil Collection.

Living and Learning with Mrs. D.

SUZANNE DEAL BOOTH

Fig. 5.1
Walter Hopps, Suzanne Deal Booth, and
Dominique de Menil at the studio of Mel
Chin and William Steen, Houston, 1978

My story begins in 1975 when, at age twenty, I transferred to Rice University in Houston to major in art history. I needed to take a work/study job, and a potential assignment was to assist one of Rice's art patrons, Dominique de Menil. I drove my beat-up pink 1964 Rambler to my interview at the de Menil home on San Felipe. My first encounter with Dominique de Menil was startling. She was tall and elegant, in her late sixties, and spoke sophisticated English with a strong French accent. She often paused, glancing around quickly as if searching for exactly the right word. When she spoke directly to me, however, her gaze was riveting, and she wasted no time in getting to the point. After a few introductory questions, she leaned forward and asked, "Would you do *anything* I need you to do?" When I said, "Probably, but could you give me an example?" she replied with a fixed stare, "Well, if the toilet broke, what would you do?" I nervously answered, "I would first turn off the water, if I could, and then find a way to clean it up." Dominique smiled and asked me when I could begin.

John de Menil had passed away in 1973, and two years later his files remained much as he had left them. His office was small and intimate, with a large floor-to-ceiling window. This is where I worked, poring over his handwritten notes, looking for any information about the works of art the de Menils had collected, and transcribing this information for the files. Later, after graduating from Rice, I was hired by the Menil Foundation to work as an assistant registrar at the Rice Museum. I learned a great deal from Dominique, who had a profound way of combining art, aesthetics, and memory with experience to create exhibitions that both illuminated and educated. For me, the process of putting together the exhibition was the most significant—the exercise of dynamic placement. For this, Dominique was a wonderful teacher as she supervised us during the installation process. I believe her love of teaching stemmed from her training under Jermayne MacAgy. Dominique once shared with me that it was Jermayne who had been instrumental in enabling her to see art, space, and light differently.

When a Parisian publisher I met while working at the Menil Foundation offered me a part-time research position, Dominique encouraged me to go. So in 1978 I moved to Paris. During this time

I kept an ongoing correspondence with her, and I often spent time with her when she visited Paris. She loved the city, telling me she found it to be "much more civilized than most cities." While I was there I became interested in pursuing a career in art conservation. Again Dominique was very encouraging. In 1980 I was awarded a graduate fellowship in art conservation and art history at New York University's Institute of Fine Arts. Dominique insisted that I live at her home in New York while attending the two-year program. That fall, I moved into her five-story townhouse on East 73rd Street, between Park and Lexington. One of the first works of art to greet me was an unusually large fur sculpture by Dorothea Tanning, placed in the main entrance at the base of the stairs—if ever an object signified that time and place to me, it was this furry thing! Life in the townhouse was interesting, to say the least—from studying and writing, to spending valuable moments with Dominique, to meeting art historians, writers, and curators, to encountering other protégés.

Sometimes I would help Dominique move works of art around the house. She would explain why certain pieces worked better with others in their vicinity, pointing out how they played off one another in complementary ways. She told me that dynamic relationships existed between works of art, even in the empty spaces between them. These were special moments—when she would impart her insight about the power of art and objects. Dominique was usually quite reserved and certainly never a superficial conversationalist. For me, this one-on-one time with her was much too precious to interrupt by asking questions. I just quietly observed as we rearranged the objects and paintings. One of my favorite places was the living room on the second floor. Occupying the space was *Voice*, 1964–67, a large, gray Jasper Johns painting with a fork and a spoon hanging from it. On a table next to the painting was a stunningly simple Cycladic vase, which sat in front of a wall where a small jewel-like Renaissance gouache glimmered. The townhome was filled with such magical objects and paintings. My studio apartment opened out to an interior garden that had several Max Ernst bronze sculptures installed. These, too, became my daily companions. At times I would find items left on my bed when I returned home from class. They would always be useful things that Dominique had noticed that

I needed: winter coats, blankets, and art books. Once an electric correcting typewriter—the most sophisticated office tool of that era—appeared on my work desk. All of these things were there for my use, and Dominique made sure that I had all that I needed for my studies.

In New York I discovered I was not the only one to have traveled this path with Dominique de Menil, though I may have been one of the last. I got to know some of the others. I had known Helen Winkler in Houston; when I arrived in New York she was mostly working on the construction of Walter De Maria's *Lightning Field* in rural New Mexico. Another former Menil student was Glenn Heim, who had designed the most exquisitely tranquil loft in SoHo. Through Glenn I met Fred Hughes. He had been enrolled at the University of St. Thomas, studying with Jermayne MacAgy, and was later Andy Warhol's business manager and eventual executor of his estate after his death. Fred was at the center of all that happened with Andy and the Factory, sporting his signature cowboy boots and speaking with a deep Texas drawl. Through these other former students I met the light-and-space artist James Turrell. I became his assistant on the sky spaces he was creating at P.S.1 in Queens and later assisted him with his first retrospective, which was held at the Whitney Museum of American Art.

When Walter Hopps, then director of the Menil Collection, came to New York, he and I spent hours discussing my thesis topic on the early works of Georgia O'Keeffe that were influenced by the great American landscape tradition and by her teacher Arthur Wesley Dow. Our conversation changed the way I would proceed with my research, and I spent days reworking my paper in a totally new direction due in great part to his "out of the box" insights. Encounters like this were indirectly made possible by my connection with Dominique, for without her influence, generosity, and vision I would not have met any of these people.

Dominique's personal legacy is an amazing one, as her legions of colleagues, admirers, students, and protégés will attest. But for me the importance of our relationship was more than having a mentor who believed in me. It was having been part of the landscapes she inhabited.

Lessons in Development:
John and Dominique de Menil and the Media Arts GERALD O'GRADY

This essay is based on recollections of my relationship with John and Dominique de Menil and my research into their lives. Since the former moves backward and the latter moves forward, each is inevitably interpreted in the light of the other. What follows is a chronological record of when I came to know what.

Summer 1967

I was working at the Butler Library at Columbia University, completing research for a book on medieval literature and preparing to teach in the Graduate School of English at the State University of New York at Buffalo. John and Dominique de Menil, whom I had never met, invited me to their home in New York at 111 East 73rd Street. John explained that he was a member of the board of trustees at the University of St. Thomas in Houston and that Dominique had recently become chair of the school's Art Department. Unknown to me, our mutual friends Gertrude Barnstone and her husband, the architect Howard Barnstone, had informed the de Menils of my other interests—early education and cinema. Film, however, was a field in which I had never taught and had no professional training.

In response to their invitation that I teach an undergraduate course in the history and interpretation of cinema, I stated that I was under contract at SUNY at Buffalo, mentioned that I was a lapsed Catholic, and as politely as I could, informed them that I had no interest in the University of St. Thomas. It was an awkward moment. The meeting was but ten minutes old, too early to leave or be dismissed. Coffee was served, and the de Menils courteously turned the conversation to my postgraduate experience at St. Antony's College in Oxford, where I had lived with seventy students from fifty different countries for three years (1958–61). Except for me, all had been pursuing graduate work in history and politics. When I mentioned that the book that had been most widely debated there was

Fig. 6.1
John and Dominique de Menil with
Roberto Rossellini, Rice Media Center,
Rice University, Houston, 1971

Fig. 6.2
Gerald O'Grady, Houston, 1965

W. W. Rostow's *The Stages of Economic Growth: A Non-Communist Manifesto*, 1960, I was surprised that John was well aware of it, and I listened carefully as he took exception to many of Rostow's proposals.

The de Menils then turned to my research in medieval literature, which involved the "patristic method," using a thousand years of commentaries on the Church Fathers, from Origen and Augustine to Bonaventure and Aquinas, to interpret the Bible. I mentioned the importance of Henri de Lubac's four-volume *Exégèse médiévale: Les quatre sens de l'écriture*, 1959–64. Dominique said she and John had known Père de Lubac and asked if I had read his book *Catholicism: A Study of Dogma in Relation to the Corporate Destiny of Mankind*, 1950. (That afternoon I acquired it from the Butler Library and read it.)

When the discussion turned to Rice University, where I had taught from 1962 to 1967 (fig. 6.2), both expressed great interest in the fact that one of my motivations to go to the South to teach had been to help persuade the university's trustees to admit black students. That battle was eventually won, and Rice integrated in 1965, the last private university in the United States to do so. They closely questioned me on many details. I knew nothing of their own political convictions—and, I might add, did not know that John was an executive of Schlumberger Ltd, of which I had never heard. After talking for three hours, we had spent fewer than fifteen minutes on the teaching of film. But our thoughts and convictions resonated on a variety of strategies for developing "the corporate destiny of mankind."

At the end of the meeting, I expressed my admiration for their own vision in beginning to think about film education and asked that I be allowed to send them what I called a white paper on the development of film studies in Houston. Within a week I wrote what was more of a manifesto, arguing for the use of film to (1) educate college students to become the field's first cohort of academics, (2) initiate experiments in teaching elementary, junior high, and high school students, and (3) provide continuing education courses for their parents and the general public.[1] It was an abstract design for development. It never occurred to me that I would be involved in carrying it out.

The de Menils summoned me again and indicated that they would be prepared to implement my plan, but only on the condition that I be involved. I received Buffalo's permission to take a leave of absence for the fall semester of 1967 to enable me to set the program in motion. I spent the rest of the summer devouring the basic scholarship on film. At that time, beyond the works of Sergei Eisenstein, Rudolf Arnheim, André Bazin, and Jean Mitry, it was not voluminous. I saw as many as six films a day—classic and contemporary at the Museum of Modern Art, and foreign and American experimental at the Black Gate Theater on 2nd Avenue at 10th Street. At the end of August, I attended, as did the de Menils, Expo 67 in Montreal, which presented the then most important international exhibition of new media technologies in human history.

1967–68

In fall 1967 I became the director of the Media Center at the University of St. Thomas, though I was effectively "teacher in residence to the City of Houston" as well.[2] Houston was then the sixth largest city in the United States. In its 240 primary and secondary schools, there was no instruction in film. No college or university in Houston had a curriculum for developing filmmakers or scholars. No screening programs or any forum for continuing education was available to adults. Our design was to serve these three groups.

From September to December 1967, facilitated by Gertrude Barnstone, film screenings and discussions were held for forty public schools: Monday mornings at elementary schools, Friday mornings at junior highs, and Friday afternoons at high schools. More than five thousand students and teachers participated. On Saturdays students from fifteen different high schools saw feature films as members of the Young Cinematographers Club, and filmmaking workshops drew as many as 130 students. My first undergraduate course at the university, "Contemporary Styles in World Cinema," included films by Ingmar Bergman, Michelangelo Antonioni, and Alain Resnais, and college students in Houston wrote research papers on film for the first time. A thirteen-week series of screenings and discussions,

"The History of Cinema" was held on Tuesday evenings for interested adults. On Thursday evenings, more than a hundred enrolled for thirteen weeks of discussions of over a hundred experimental films by makers such as Stan Brakhage, Bruce Conner, Maya Deren, Marie Menken, and Peter Kubelka. The Media Club on Friday evenings presented the best foreign films then available to an audience of adults and students in college and high school.

I myself curated, taught, and administered all of these programs from a small white bungalow at 3812 Mt. Vernon Street, which the de Menils had renovated for my live-in office. We shared a missionary spirit, which they encouraged.

During the spring semester of 1968, when I taught at both SUNY at Buffalo and the University of St. Thomas, commuting each week (a pattern that continued in the following year), the de Menils financed my visits to the twelve American colleges and universities that then taught courses in film. We were at the forefront of a revolution in the arts and humanities. (Six years later, more than six hundred colleges would be offering at least one course in film.) While in Los Angeles, I discovered the Larry Edmunds Bookstore, the only one in the country that exclusively sold new and used books on film. When I told the de Menils about the store, they responded by purchasing copies of almost every new and used book offered, including back runs of rare journals and magazines, many of them foreign. Houston suddenly had one of the largest and best film book collections in the United States.

In March I initiated a new series of lectures on twenty-one films by Ingmar Bergman on KHTV, Channel 16 (now CW, Channel 39), one of the newly legislated UHF channels. The station was located at 7700 Westpark Drive, far from downtown Houston. Station manager James Page and I could look out the huge plate-glass windows of its new building at cows grazing in adjacent fields. The Swedish films with English subtitles, followed by my lectures, telecast live, were the first such programming in the United States.

Later that spring we were unexpectedly caught up in the historical events of that period. The de Menils were attending my screening of Laurence Olivier's version of Shakespeare's *Hamlet* on April 4 when news came that Martin Luther King Jr. had been shot. We shut off the projectors and adjourned to their home to keep vigil.[3] On June 5 Robert Kennedy was shot. Two days earlier an attempt had been made on Andy Warhol's life. The de Menils were collectors of Warhol's paintings and silkscreens, and were among the few patrons to support his attempts to make an entirely new kind of film. His films centered on the life of real people performing unrehearsed, often mundane actions, and on superstars like Viva and Ultra Violet playing out their fantasies. Warhol and his retinue of actors and actresses often flew to Houston to show his films. After he was shot,

Fig. 6.3
John de Menil (*left*) in a scene from Norman Mailer's film *Maidstone*, 1968

the de Menils helped assemble his medical team, and when he recovered from his wounds and made his famous *Lonesome Cowboys*, he premiered it in Houston at Rice University on November 17, 1968.

That summer the novelist Norman Mailer conceived of *Maidstone*, a film shot over four days in East Hampton, Long Island. He directed the scenes in which he played the main character, Norman T. Kingsley, a candidate for the American presidency whose murder was being plotted by secret police. Meanwhile, various other actors directed their own scenes without revealing them to him. John de Menil acted in the film in the role of a foreign agent (fig. 6.3). *Maidstone* premiered in New York at the Whitney Museum of American Art, showing for two weeks in September 1971 and selling out its entire run. Mailer had spent part of that year in the de Menils' Houston home while writing *Of a Fire on the Moon*, an account of the launching of the Apollo mission to the moon.

For the summer session in 1968, I invited the animator Stan VanDerBeek, then artist-in-residence at both the Center for Advanced Visual Studies at MIT and Bell Telephone Labs, to teach the Media Center's first course in filmmaking. VanDerBeek responded to that summer's shockwaves by animating drawings of human heads being blown apart. On the soundtrack a human voice cried, "Oh! Oh! Oh!"—Robert Kennedy's last words. VanDerBeek was then deeply involved in the flowering of the experimental film movement, for which he coined the phrase "American underground," a movement that I championed as "poetic film." The de Menils met with him several times in Houston and later asked me to invite twenty-five members of "The New Underground" for dinner at their home in New York. Jonas Mekas, Ed Emshwiller, Shirley Clarke, and others were soon brought to Houston to screen their films as the de Menils eagerly embraced the most radical elements of the New American Cinema.

The de Menils were also affected by the spring 1968 student riots in Paris and the stunning announcement by President Charles de Gaulle's Minister of Culture André Malraux that he was removing Henri Langlois as director of the Cinémathèque Française because of alleged fiscal mismanagement. The legendary Langlois was then the most revered cinema archivist in the world (fig. 6.4), having amassed a collection of more than twenty-five thousand films. His screenings had served as a classroom for the filmmakers Jean-Luc Godard (see fig. 6.5), François Truffaut, and Alain Resnais, who led protests and were joined by students, the French film industry, foreign direc-

Fig. 6.5
Jean-Luc Godard (*background center*) at a lunch held in his honor at the de Menils' home, Houston, 1968

tors, and intellectuals, a harbinger of the historic student revolution and union strikes in May. Among John de Menil's papers, I later found, torn from the international edition of *Life Magazine* (March 8, 1968), was a photograph of Godard's head bloodied by a gendarme's truncheon. Langlois was reinstated, but de Gaulle cut all promised government funding to Cinémathèque Française.

Soon after, I attended a meeting at the de Menils' home in which Godard pleaded for John de Menil's support. John and his counterpart at Schlumberger's Paris office, Jean Riboud, then met with Langlois and Truffaut in New York on June 21. John's response was immediate, a ten-page draft document, "Langlois–USA," which projected a way for Langlois to share his archival resources with a consortium of American film museums in return for funding. It also proposed the incorporation of a foundation, New Wave, Inc., to be housed at the University of St. Thomas with the de Menils providing one-third of the budget. John de Menil worked with Langlois and German director Fritz Lang to rally support for Langlois from the greatest film directors, including John Ford, Jean Renoir, George Stevens Sr., and King Vidor. John called them "the heroes of cinema." During that period, I attended meetings between John and Langlois at the Salisbury Hotel opposite Carnegie Hall in New York. Because of ownership issues, however, sharing his archives proved impossible. Although New Wave, Inc. did not become operative, the concept was not forgotten, and it prepared the way for John's later projects with Langlois. In the meantime he and Riboud helped raise money from French corporations to make up the budget shortfall, effectively saving Langlois.

Fig. 6.4
Henri Langlois, ca. 1960

1968–69

On October 18–20, 1968, the Media Center held the Houston Film Conference at the Shamrock Hilton Hotel, attracting three hundred teachers from the state of Texas. Its thirty-two sessions aimed to raise consciousness about the role of film in schools at all levels of the state's academic system. We invited the nation's leading exponents of teaching film in primary and secondary schools, and one panel, "Film Study on the Gulf Coast," featured professors who were beginning to teach film courses in San Antonio, Dallas, and Austin. We later worked to develop a statewide plan for film education.

The last event listed in the conference program was "Films for All Mankind, Miller Theater, Hermann Park," a presentation of ten films featuring the artists of five continents in Houston's new outdoor theater. Three months earlier the de Menils had asked me to head up the United Nations Committee of Houston, which was organizing a series of events to celebrate the twentieth anniversary of the UN's Universal Declaration of Human Rights of 1948. The screenings of those ten films, designed as a climax to the conference on film teaching, represented but one event in that yearlong endeavor, collectively called Project Houman (Houston + Human). Another was the Photographic Self-Expression Program for the Disadvantaged Youth of Harris County, which trained and paid sixty high school students to make photographs of other students' interpretations of human rights in chalk drawings, wood carvings, weaving, and other media, as well as portraits of these students at work. The photographs were presented in slide shows throughout the city so that, as I wrote in a funding proposal, "Houston's young and old would find themselves in a variety of environments in which the faces of the city's children and their artistic depictions of human rights would suddenly flash around them in all the colors of the rainbow."

Other screenings later that fall were also related to international human rights. On November 15 Jan Neméc introduced his *Oratorio for Prague*, which documented Russian tanks rolling into Czechoslovakia in August 1968.[4] It had been financed by Houston businessman Miles Glaser, who later became chief financial officer of the Menil Foundation. On November 21 Roberto Rossellini appeared for a premiere screening of a selection from his twelve-hour film series *Lotta dell'uomo per la sua sopravvivenza* (*Man's Struggle for His Survival*), 1967–69, intended to act as a spur for economic development through its distribution on television in recently decolonized African countries. Its purpose was to "show people how man can tame his environment with advanced technology."[5]

While concerns for the international cause of freedom and development permeated our program at the Media Center, the main focus at this time was to develop an academic faculty for the department. Geoff Winningham accepted an appointment to teach the first classes in photography, which he had begun in the summer of 1968. While earning his master's degree at the Illinois Institute of Technology's Institute of Design, founded by László Moholy-Nagy, Winningham had studied with photographers Aaron Siskind, Harry Callahan, and Wynn Bullock.[6] At the Media Center, he inaugurated a series of lectures by photographers Frederick Sommer, Robert Frank, Lee Friedlander, and Jerry Uelsmann, and by curators Nathan Lyons of George Eastman House and Peter Bunnell of the Museum of Modern Art in New York. A detailed memorandum he wrote to Dominique de Menil, providing a list of sixteen established photographers and ten younger ones, became a basis of subsequent photography acquisitions of the Menil Collection.[7]

The de Menils were essential to the development of photography in Houston. Their exhibitions stimulated the founding of the city's first photographic galleries; they invited leading practitioners to Houston; and they financed the publication of related books and catalogues. In conjunction with Winningham's lecture series, the de Menils sponsored the first exhibition of photography as an art form in the history of Houston. "Images by Light," featuring more than a hundred photographs from the daguerreotype to the present, on loan from the Museum of Modern Art in New York, appeared in Jones Hall at the University of St. Thomas from January 17 to March 2, 1969; curator John Szarkowski of the Museum of Modern Art lectured at its opening. The de Menils also supported the work of Danny Lyon, exhibiting his Texas prison photographs in "Conversations with the Dead," 1970 (see fig. 6.7). "Frederick Baldwin, Wendy Watriss: Photographs from Grimes County, Texas" was exhibited in 1977 at Rice Museum and traveled to nine other Texas institutions in 1979 (see fig. 6.6). The show documented the "old South" part of Texas: the descendants of Anglo-American plantation owners, the children and grandchildren of black slaves, the sons and daughters of German and Polish immigrants, and the growing numbers of Mexican Americans.[8] Baldwin and Watriss founded FotoFest in 1983, which in 1986 evolved into the first international biennial of photography and photo-related art in the United States. The dedication of its seventh catalogue in 1998 reads: "We want to remember an extraordinary humanitarian and patron of the arts, Dominique de Menil, without whose vision and presence we would not be in Houston today."[9]

The de Menils had brought Henri Cartier-Bresson to Houston and America for the first time in 1957.[10] Many of Cartier-Bresson's photographs from that time appeared in Howard Barnstone's classic and now twice-reprinted *The Galveston That Was*, first published by the Museum of Fine Arts, Houston, in 1966 with funding help from John de Menil. Barnstone began his acknowledgments: "Most of all to my friend, patron, critic, spur, and my strongest support, John de Menil." Later, in John's obituary, Barnstone wrote that "it was John de Menil

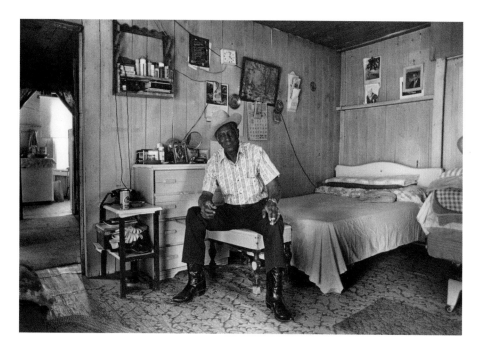

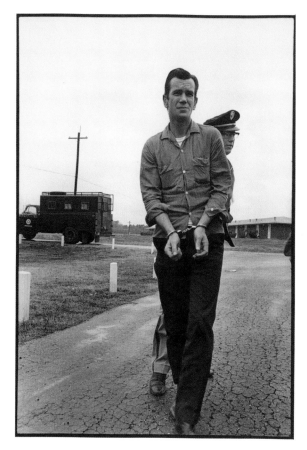

who made available a relatively large sum, through the Museum of Fine Arts in Houston. In that copyright was given to the museum,… the amount of the grant has been matched again and again [through sales], as the book goes into its third printing."[11] In 1974, the Menil Foundation acquired an archival set of 385 black-and-white photographs by Cartier-Bresson, which he himself had selected as being representative of his best works. Sets were subsequently acquired by the Bibliothèque nationale in Paris, the Victoria and Albert Museum in London, and the Osaka University of Arts in Japan.

In spring 1969 Winningham was joined by filmmaker James Blue (fig. 6.8). Blue had graduated first in his class in film production from the prestigious Institut des hautes études cinématographiques (IDHEC) in Paris. He personally knew all the young film directors of the French New Wave and used the first grant given in support of film by the Ford Foundation to interview many of them, as well as other international directors including Rossellini. His first feature, *Les oliviers de la justice* (*The Olive Trees of Justice*), 1963, the only film made in Algeria during its war with France, won the Critics' Prize at the Cannes Film Festival. In the mid-sixties, he had made films on five continents for President John F. Kennedy's Agency for International Development. On August 28, 1963, he directed *The March*, the primary documentation of Martin Luther King Jr.'s "I Have a Dream" speech.

As our program expanded to include professionally trained teachers, John de Menil asked me to join him in raising funds for it. He explained that his and Dominique's basic philosophy was to provide seed money to programs that would prove their worth by becoming self-sustaining; if we could attract other sources of funding, the de Menils' resources could be used to support other innovative projects. John then incorporated the Media Center, declaring the purposes for which it was organized: "To establish, create, maintain, and staff schools or colleges with regularly scheduled curricula, regular faculties, and a regularly enrolled body of students; to teach and promulgate information concerning, among other things, the aesthetics, psychology, and social impact of modern technological art forms, such as photography, cinematography and television."[12] Soon John hired a fundraiser, William Allen, and what had been my sitting room in the bungalow became his office.

In 1970, redefining the Menil Foundation, John de Menil listed

Fig. 6.6 *top*
Frederick Baldwin and Wendy Watriss,
Green Valley Community, ca. 1971–72

Fig. 6.7
Danny Lyon, *Entering Prison, Texas*,
1967. The Menil Collection, Houston,
Gift of Leon and Ginette Henkin Family

"Media Studies" third among its eight purposes, just after "The Menil Art Collection" and "The Negro Iconography in Western Art Project." Arguing that media studies are "a valid discipline," citing film's accessibility, simulation, scientific rigor, and encouragement of self-expression and insight, John then concluded that film and photography "are as effective in the study of the humanities as the written word." His strong interest in the myriad possibilities of film found expression in his hope "that the traditional dogmatic approach to the humanities will thereby develop into an approach that is increasingly scientific and exploratory."[13]

While I was absorbed in faculty recruitment and fundraising, the de Menils, it subsequently came to light, had been discussing with the Basilian Fathers their role in the future of the University of St. Thomas. From the outset the de Menils had always shown in my presence respect and admiration for the clerics and had never uttered a word of criticism. In mid-December 1968, however, I attended a meeting of the Art Department at which Dominique solemnly announced, in a voice I would always remember as saddened, that our program would move to Rice University in fall 1969.

Some at Rice were not interested in my returning, and I myself felt that my design for developing the Media Center was not consonant with Rice's history. I had now been commuting between Houston and Buffalo for three semesters. SUNY at Buffalo had always been sympathetic to, and supportive of, my activities in Houston, and I was an excited participant in the Buffalo English Department's efforts to challenge and renovate education in the humanities. In deciding whether to follow the de Menils to Rice, I had to consider the question of fairness to Buffalo but, more important, the imperative not to impede in any way the de Menils' relationship with a new set of administrators.

One Sunday morning in spring 1969, I met with John and Dominique de Menil at their home to discuss a final decision. While we worked to maintain an atmosphere of devoted comrades discussing the best strategy for our revolution, emotions rose and tears were shed. I said it seemed best for me to remain under contract at SUNY at Buffalo. John offered an apology for diverting me from my research in medieval literature and offered to commit $50,000 to support my initiation of a media project in Buffalo or elsewhere. I persuaded them that I had been a more-than-willing co-conspirator and that it would be awkward for all of us if it seemed that I was competing for funds with my former colleagues, Winningham and Blue. During the years immediately following my departure, I discussed the Rice Media Center with John de Menil at many lunches in New York, and I frequently visited my former colleagues in Houston.

1969–79

During this decade of the 1970s, Blue was the leader at the Media Center at Rice. His belief that the central goal of a college education was the creation of citizens concerned about their communities, both local and global, resonated with the de Menils' thought. He believed that media should not be a department of its own and so cross-listed media courses with anthropology, architecture, and biology classes. Some student films concentrated on the careful observation and recording of scientific processes, while reflecting upon the social circumstances of the humans involved in them. Blue also became a leader in technical innovations involving low-end Super-8mm equipment, and he employed gifted engineers such as Layne Whitehead and A. C. Conrad to create the synchronization of image and sound, and enhance image projection. Both de Menils—one, the daughter and niece of the Schlumberger inventors, and the other, the current administrator of Schlumberger innovations in oil-drilling technologies—understood the implications of this thrust better than any university administrators.

In a new building on Rice's campus completed in 1970, Blue and his staff screened daily programs of feature films from all countries, documentaries on social issues, and films from the cutting edge of experimental cinema. These programs kept alive the spirit of the screenings first launched for college students and the public at the University of St. Thomas in 1967; still continuing in 2009, the weekly film series is part of the de Menil legacy to Houston.

Blue also continued the initial outreach to Houston schools,

Fig. 6.8
David MacDougall with James Blue, Rice Media Center, Rice University, Houston, ca. 1970

joining Shirley Wiley and Helen Foley to found the Houston High School Film Teachers Association, which was active for almost a decade. Drawing on his experience with showing films to Arabs in Algeria, he outfitted a media van for teaching film to groups in small towns throughout Texas. The van's resources also enabled local groups to produce films—the Chicano Casa de Amigos on Houston's north side on housing aid, for example, or the ACLU on the city's prison conditions. From 1971 to 1976, Blue's filmmaker colleague Ed Hugetz produced 160 films on social change in Texas towns. Blue persuaded the Houston PBS station, Channel 8, to broadcast "The Territory," the first American television program on local independent filmmakers, which is still on the air today. When *Le Monde* (Paris) published a Special Bicentennial Salute to the United States on July 4, 1976, critic Louis Marcorelles called "The Territory" a significant blow in the struggle for the independence of filmmakers.

These widespread activities did not always mesh with Rice's traditional sense of an academic program. Thus, in 1977 Dominique de Menil put her support behind the incorporation of the Southwest Alternate Media Project (SWAMP) by Blue, Hugetz, and Brian Huberman, and housed its offices in a converted garage apartment on the site of what is now the Menil Collection. SWAMP today supports the creation and appreciation of media as art within a multicultural community. It focuses on helping regional filmmakers get their projects financed, produced, and shown. It continues producing "The Territory," has established numerous media literacy programs, and engages in a plethora of community media services.[14]

To help in developing the academic program in media at Rice, the de Menils provided Blue with a team of internationally renowned advisors and collaborators, starting with San Francisco film artist Bruce Baillie. Colin Young commuted from UCLA, where he was chair of the Department of Theater Arts, and later from London after he founded the National Film School there. He brought with him David MacDougall, who later headed the Australian Institute of Ethnographic Studies and became the leading international scholar in that field. Other teachers were Mark McCarty and Roger Sandall. The de Menils gave financial support to two Nigerian filmmakers: Moustapha Alassane, who visited the Media Center, and Ola Balogun. Another frequent visitor was František Daniel, former dean of the Prague Film and Television Academy. An interested visitor from the beginning was Roberto Rossellini, the founder of Italian Neorealism, who had become the director of the Italian National Film School, Centro Sperimentele, in 1970.

Between 1970 and 1976, Rossellini frequently traveled from Rome to Houston (fig. 6.1). He stayed at the de Menils' home and, encouraged by John, worked with Rice faculty members on a project to introduce the language of film into scientific education.[15] His film *Rice University*, 1971, contains two fifty-minute segments of his interviews with these scientists. While at Rice, he also wrote a script, never produced, on the Industrial Revolution.

In addition to Rossellini, John de Menil also hoped to bring Henri Langlois to Rice. In a letter to Fritz Lang, he first voiced his hope that Langlois might share his archives by teaching at an American university. On February 3, 1970, on behalf of the Menil Foundation, John executed a contract whereby it would receive two 16mm prints of excerpts from 121 significant classics housed at the Cinémathèque Française, the purpose being "to support the teaching of the history of cinema in the context of a liberal education."[16] The collection would include excerpts from films by the Lumière brothers, Georges Méliès, Carl Dreyer, Dziga Vertov, Fernand Léger, Fritz Lang, and other classic filmmakers. John's great ambition was to have Langlois conduct a summer school at Rice University for film teachers from throughout the United States. His goal was to secure a place for film in the arts and humanities curricula of American universities, similar to his parallel wish to teach professors of science a new language. (One of the other names that he had suggested for New Wave, Inc. was "Language of Our Century.") The project languished with John's death in 1973, but Dominique reminded Langlois of his commitment, and the Menil Foundation received excerpts of all 121 films by 1976. They are now in the Film and Media Collection of the Menil Archives.

1987

In October 1987 SWAMP and the Rice Media Center held the conference "A Tribute to Roberto Rossellini in Recognition of the Contributions of Dominique and John de Menil to the Media Arts." It was the twentieth anniversary of my first meeting with the de Menils, and in preparing a paper for that occasion, I read a file of correspondence between Roberto Rossellini and John de Menil.[17]

My first discovery in the file was a copy of one of the first essays ever published on how sound technology worked in film: "Les divers procédés du film parlant," *La revue du cinéma* (April 1, 1930). This essay on the invention of the "talkies" was written and illustrated with drawings by a woman who had taken her degree in physics at the Sorbonne—Dominique Schlumberger (see figs. 6.9–10). That same issue included Sergei Eisenstein's essay "Les principes du nouveaux cinéma russe," and *La revue* had recently published essays by Méliès, Charlie Chaplin, Luigi Pirandello, Luis Buñuel, Salvador Dalí, and other pioneers of cinema. This aspect of Dominique de Menil's life had been entirely unknown to me, to her academic colleagues, and to her children.

An earlier issue of *La revue du cinéma* (March 1, 1930) featured another essay by Dominique Schlumberger, "Courrier de Berlin," on

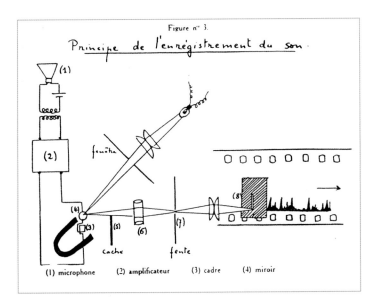

Figs. 6.9–10
Diagram of optical sound on film
by Dominique de Menil for
La revue du cinéma, April 1930

the production of *The Blue Angel*. Years later in an interview, Dominique would recall that when she was in her early twenties, she had sought and gained permission from her father, Conrad, to learn about moviemaking, not as an actress but as a production assistant, and she started by training in studios near Paris. There she met Karl Vollmoeller, who had written a script for *The Blue Angel*.[18] He invited her to observe its production at the former UFA studios in Berlin. Her experience in Germany, she remembered, led her to realize that the French movie industry did not offer much in the way of prospects compared to her work at the infant Schlumberger company. In my later investigation of her personal papers, I found that she had been an avid reader and collector of film magazines of that period. I found her own signature ("D. Schlumberger") on the cover of *Cinéa*, no. 1, from 1930, which featured a photograph of Greta Garbo and her autograph.

My second discovery was that John de Menil had filed to incorporate a private foundation, Horizon Two Thousand, in Houston in 1966. Its primary activity was "the aid of large segments of [the] underprivileged and ill-educated … throughout the world by means of furnishing motion picture educational films in different languages in efforts to teach literacy and the latest trade skills … [through] the illustration of the newest farming and mechanical techniques."[19] Its first project was to raise funds to produce Rossellini's television series *Man's Struggle for His Survival*. John's correspondence revealed letters attracting pledges of $100,000 each from the American corporations General Electric, Gulf, IBM, and Upjohn. On April 25, 1969, Rossellini wrote to say that all twelve hours were complete and transmission rights had been secured in eighty-two underdeveloped countries ("pays sous développés").

Rossellini's own commitment to social justice was evident in the work he did at Rice. While there, he wrote scripts for films on the student revolution of 1968 and on the American Revolution, the latter to be produced for the bicentennial in 1976. In May 1971 he flew from Houston to Santiago to interview the Socialist president of Chile, Salvator Allende. *Force and Reason* (*Interview with Salvator Allende*) has rarely been shown; the original version of the film is preserved in the Menil Collection. It appeared on Italian television on September 15, 1973, the night of Allende's overthrow and assassination, and it was screened at two Rothko Chapel colloquia in 1973 and 1977.[20]

After Rossellini's death in 1977, Dominique de Menil wrote a eulogy: "We will greatly miss Roberto Rossellini on the Board of the Rothko Chapel." She went on to say: "He dreamt of a better mankind, where men would be liberated from oppression, from misery and from ignorance." She related his vision to the "idealism of the Italian socialists and communists like Gramsci and Tagliatta," recalled his deep interest in Karl Marx, and revealed that "he was about to shoot a film on Marx when he died."[21]

Dominique de Menil was determined that all of Rossellini's Houston materials be preserved in the Menil Collection. In addition to the films he made during his stay at Rice, nine videotapes now housed in the Menil Archives Film and Media Collection include Rossellini discussing *Open City*, *Paisan*, and *Voyage to Italy* (January 22, 1973); Blue's interview of Rossellini on *Louis XIV* (January 30, 1973); and three tapes on filmmaking, education, and Rossellini's work in Houston (October 22, 1970). All of these were also made at Rice. With this first public acknowledgment of their existence, we can look forward to having researchers incorporate them into future Rossellini scholarship, as Dominique would have wished.

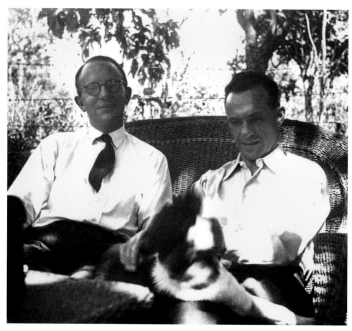

Fig. 6.11
John de Menil and Jean Malaquais, La Ciénega,
near Caracas, Venezuela, ca. 1942

2002–06

In 2002 I read that Leon Trotsky's widow had deposited his papers at the Houghton Library at Harvard University. Because I had once corresponded with Trotsky's biographer, Isaac Deutscher, I went to look at them. I discovered that Trotsky had written to the French writer Jean Malaquais (fig. 6.11).[22] John de Menil had once given me Malaquais's 1947 novel, *Planète sans visa* (*World Without Visa*); the author was his close personal friend and had dedicated it to Dominique and John. It was about a group of leftist émigrés from all over Europe surviving in Marseille under the Vichy regime. I knew almost nothing about Malaquais, but a little research established that in his correspondence with André Gide, he described his first meeting with the de Menils in Caracas, Venezuela, in 1942: "It was then that, completely by chance, we made the acquaintance of a young French couple, the de Menils…. Practicing Catholics, the de Menils enlightened me for the first time as to what Christian souls could be in a world that would not ring false. What allowed for the start of our mutual friendship was the exceptional heart of these two beings; what strengthened it was that none of us felt bound to make concessions of an intellectual or moral nature."[23]

Malaquais was born a Polish Jew, Vladimir Malacki, in 1908 and later emigrated to France. He translated works by Karl Marx, played an important role in the Communist movement in France (and internationally), and escaped from Marseille to become an exile in Mexico during World War II. He died in Geneva in 1998. The only available summary of his life was by Philippe Bourinnet, a member of the Centre d'histoire du syndicalisme at the University of Paris I–Sorbonne, who thus described his escape from Marseille: "Gide, particularly, arranged his passage on a trip to Venezuela. In October, 1942, Jean Malaquais went to Spain; from Cadiz, with Galy [his wife], he managed to arrive by boat in Venezuela. By chance, he found help from a wealthy Catholic philanthropic family, the Schlumbergers, who anonymously contributed to a fund for Spanish anti-Franco refugees, and also subsidized the needs of the widow of Trotsky, who was without resources. From Caracas, he left for Mexico."[24]

In a long interview with Adelaide de Menil on June 6, 1985, Malaquais recounted how he took the de Menils to meet Mrs. Trotsky at her home when they visited him in Mexico in the spring of 1943, and also that John de Menil gave money to another Mexican émigré, Victor Serge.[25]

The de Menils' friendship with Malaquais in Venezuela suggests that their experiences in Latin America were formative to their encouragement of social change through film. They lived from 1941 to 1944 in Caracas, where John managed Schlumberger Surenco, traveling to Argentina, Brazil, and Colombia.[26] From our conversations, I knew that they were well aware of the leftist worker-priest movements in Latin American countries and supportive of the controversial doctrine, "the preferential option for the poor," that originated there. They were further energized by the famous Second Vatican Council of the Roman Catholic Church of 1962–65, which issued a statement about the liberalization of Christian doctrine in the light of justice.

As early as 1975, Dominique de Menil provided support for American filmmaker Danny Lyon's *Los niños abandonados* (*The Abandoned Children*), a documentary about orphaned street children in Colombia.[27] In 1983 she helped fund Pamela Yates, Deborah Shaffer, and Tom Sigel's *Nicaragua: Report from the Front*, an examination of United States military aid to General Anastasio Somoza Debayle's contras (fig. 6.12), and, in the following year, another film in Argentina, Susana Muñoz and Julia Maline's *Las Madres de la Plaza de Mayo*, completed in 1985. It told about how the notorious Juan Perón government had systematically kidnapped children of the opposition to be given to childless families of the repressive regime.

In a note accompanying a check of $10,000 in support of *Nicaragua: Report from the Front*, Dominique de Menil wrote: "I would very much like to help Skylight Pictures complete the film they are now making on Nicaragua, which will point out, in an objective manner, that countries in Central America should be able to determine their own future without United States involvement."[28] She also wrote to Andrea Primdahl about Primdahl's film on the border patrol and detention activities of the United States, primarily in the

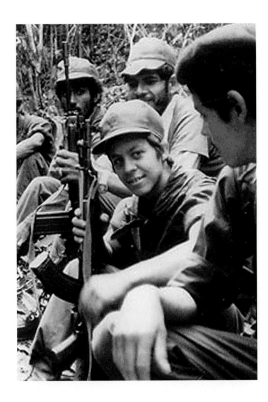

Fig. 6.12
Film still from
*Nicaragua: Report
from the Front*, 1983

treatment of Salvadoran and Guatemalan refugees, as well as the efforts by churches and human rights organizations to create sanctuaries for them: "Although our foundation is small and our 1985/86 budget spoken for (and, I might add, cut drastically because of the present economic situation everyone is facing), we will contribute $10,000 towards your film, *The Stranger in Our Midst*. The sanctuary movement touches my heart. The courage of the people involved in helping the refugees reach a safe harbor is heroic."[29] Dominique may have been recalling her own experience as a French refugee in Venezuela.

Often as revealing of the de Menils' thinking as the grants awarded are the discussions of projects not funded. In early 1973 Brazilian filmmaker Glauber Rocha requested $200,000 for a four-hour film *The History of Brazil*, describing it as "an inquiry into the economic, social, political and cultural background of one of the most important countries in the Third World."[30] While the request was finally turned down as too expensive given the resources of the Menil Foundation at the time, John de Menil wrote: "*The History of Brazil* presented by a Brazilian would certainly provide an interesting opening on the roots of the Latin American problems today. We are inclined to see these problems from our western point of view with traditional western solutions at the back of our minds—such solutions are not necessarily what Latin America needs or wishes."[31]

2010

This essay is the first presentation of John and Dominique de Menil's engagement with the new technologies and languages of film, photography, and media—the art forms of our century. One of the de Menils' main goals was to re-envision education in the arts, the humanities, and the sciences by incorporating these new disciplines. As in all of their other activities, this desire was embedded and enmeshed in their yearning to enrich the development of each individual, the local community, and the third world. The de Menils were expatriates from occupied Europe and its World War II destruction. Causes to which they were committed were the Universal Declaration of Human Rights, the Vatican II reformation of the Roman Catholic Church, the civil rights movement in the United States, and the creation of an interdenominational and ecumenical spirit. The development of the media arts in Houston reinforced those impulses. When John de Menil became ill and knew he was going to die, he wrote out a plan for his funeral, deliberately designed as a spiritual and a media event to summarize and symbolize (and celebrate) his lifelong commitments and concerns. The Celebrant at John's funeral Mass at St. Anne's Church in Houston was a Lebanese priest and Islamic scholar who sang verses from the Koran and burned incense from friends in India. A Jewish rabbi read Psalm 15 in Hebrew; a black pastor from a Houston Baptist church read passages from St. John's Epistle; a French Dominican priest chanted the Veni Creator; and Bob Dylan's "Girl from the North Country" served as the recessional song.[32]

The de Menils' venture with the Media Center at the University of St. Thomas and later at Rice was grounded in Houston—the Apollo trip to the moon, heart transplants in the Texas Medical Center, the conditions of the city's prisons, and the cause of integration. They were also citizens with a global vision who brought to Houston both the issues and the cinematographic expertise of Paris, Prague, Rome, London, and Latin America. Their engagement was interracial, international, and interdenominational. In particular, with their championing of film in education and the Media Center, John and Dominique de Menil brought to two of the city's universities a vision, a generosity, an engaged conversation, and a pervasive hope for the world that was the direct outgrowth of their passionately committed lives.

NOTES

This essay benefited from Father George Hosko, archivist at the University of St. Thomas, who assisted my access to that university's records; Philip Montgomery, archivist and Special Collections librarian, who assisted my access to the Rice University papers at Fondren Library's Woodson Research Center; Ron Drees at the Houston Public Library's Metropolitan Research Center; and, most important, the generous and informed assistance over many months by Geraldine Aramanda, archivist at the Menil Collection.

1. At that time I was greatly influenced by two books by Marshall McLuhan: *The Gutenberg Galaxy*, 1962, and *Understanding Media*, 1964. They argued that the inventions of the alphabet, the printed book, and then television had restructured the psychic and social development of humankind, and that it was imperative to teach media in the classroom.

2. The following paragraphs are based on copies of two typed drafts I wrote: "Proposal for a Cinema Center at the University of St. Thomas—Houston, Texas," June 22, 1967, and "Media Center at St. Thomas in Houston, Texas," December 1967, both in the Menil Archives. I also had privileged access to the unpublished history *The Basilian Fathers and the University of St. Thomas*, 2003, by the late Father William Young, with its chapter on "The de Menil Years (1955–1968)," and Father Victor Brezik's "University of St. Thomas' Quadragesima Anno—Some Personal Reflections," 1987. I had conversations as well with Father Patrick Braden, president of the university when I taught there.

3. For a fuller account, see my article in *Southwest Alternate Media Project Bulletin* (Winter/Spring 1998): 3. Dominique de Menil later acquired for the Menil Collection a video copy of Sidney Lumet and Joseph L. Mankiewicz's documentary *King: A Filmed Record … Montgomery to Memphis*, 1970, and on January 16, 1984, for the annual celebration of Martin Luther King Jr. at the Rothko Chapel, she requested that I send a print of James Blue's *The March*, 1964, for screening in the chapel.

4. Neméc stayed on in Houston and developed a scenario for a feature film about the heart transplants by Michael DeBakey and Denton Cooley that were then making medical history at the Texas Medical Center; at Neméc's request, I invited a young Czech playwright, Václav Havel, to develop the script. Havel, future president of Czechoslovakia and later the Czech Republic, was in prison at the time, but he and Neméc communicated by mail and wrote the script, called *Heart-Beat*.

5. Roberto Rossellini, quoted in an interview with Nathan Fain, *Houston Post*, November 17, 1968.

6. Over the next thirty years, Winningham would produce an unparalleled series of photographic studies of Southwestern popular culture, including *Friday Night in the Coliseum* (on wrestling); *Going Texan: The Days of the Houston Livestock Show and Rodeo; In the Eye of the Sun: Mexican Fiestas; Rites of Fall: High School Football in Texas*; and *Along Forgotten River*, the last published by the Texas Historical Association in 2003.

7. Geoff Winningham to Dominique de Menil, memo, May 26, 1970, Menil Archives.

8. See Harris Rosenstein's essay introducing the works in the catalogue *Frederick Baldwin, Wendy Watriss: Photographs from Grimes County, Texas, An Exhibition by the Institute for the Arts, Rice University, Houston, 1977* (Houston: Institute for the Arts, 1977), 2.

9. This dedication appears on the inside front cover of *The Seventh International Festival of Photography* (Houston: Masterpiece Litho, 1998). Geoff Winningham had founded Houston's first gallery of photography, The Latent Image, in 1970. In 1974 a major show of his work at the Museum of Fine Arts, Houston, was "the first exhibition of photography organized by the Museum's new Department of 20th Century Art"; see E. A. Carmean Jr., ed., *Geoff Winningham: Photographs* (Houston: Museum of Fine Arts, Houston, 1974), 9. The museum appointed Anne W. Tucker its first curator of photography in 1976. In "Only Sixteen Years," an introductory survey of photography in Houston, 1970–86, Tucker wrote: "Perhaps Houston's most rapid transformation occurred in photography. At one time, fine arts photography played no role in Houston's cultural life…. The Menil Foundation, directed by John and Dominique de Menil … was the only institution in Houston which then purchased photographs." See *Houston FotoFest 1986: The Month of Photography* (Modena, Italy: Edizione Panin, SpA, 1985), n.p. While Tucker did not record that the de Menils commissioned "Transfixed by Light: Photographs from the Menil Collection Selected by Beaumont Newhall" in 1981, she did report that a collective of photographers formed the Houston Center for Photography in 1981. A year later, they moved the center to its current location on West Alabama Street on the Menil Collection's extended campus.

10. His photographs from this visit, including some of the Houston Ship Channel, were later published in Henri Cartier-Bresson, *America in Passing* (Boston: Little, Brown, 1991). For a full description of the visit, see Lauri Nelson, "Cartier-Bresson in Houston, 1957," *Cite* (Fall 1995–Winter 1996): 27–31; the article features fourteen of the 114 photographs that Cartier-Bresson took.

11. Howard Barnstone, "John de Menil and His Architects," original typescript, June 2, 1973, 4, in Howard Barnstone Papers, Box 46, File Folder 10, Houston Metropolitan Research Center, Houston Public Library.

12. Article IV, Media Center incorporation papers, August 2, 1968, Menil Archives. Relating to John's hope for the promulgation of information on technological art forms, a hundred pages of selected essays by both James Blue and Gerald O'Grady were published in Woody Vasulka and Peter Weibel, eds., *Buffalo Heads—Media Study, Media Practice, Media Pioneers, 1973–1990* (Cambridge: MIT Press, 2008).

13. John de Menil, document relating to the redefining of the Menil Foundation, October 1, 1970, Menil Archives. The foundation was originally incorporated on March 19, 1954.

14. See Marian Luntz, "Media as Art: Towards an Appreciation in Texas," *Texas Association of Museums Quarterly* (Winter 1984): 19–21; *The Official SWAMP Handbook*, ca. 1995; Mary M. Lampe, "The Origins of Southwest Alternate Media Project and the Development of a Texas Film Community," in Helen de Michiel and Kathy High, eds., *A Closer Look: Hidden Histories* (San Francisco: National Alliance for Media Arts and Culture, 2005), 42–53.

15. See Edward Hugetz and Brian Huberman, "The Memory of Rossellini in Texas," in *Roberto Rossellini* (Rome: Edizione Ente Autonomo Gestione Cinema, 1987), 107–15. The book was published by the Ministero del Turismo e della Spettacolo for the multimedia project "Rossellini in Texas," October 1987.

16. John de Menil to Fritz Lang, November 20, 1968; John de Menil to La Cinémathèque Française, February 3, 1970; John de Menil, memorandum, "Conversation with Henri Langlois," December 4, 1969, all Menil Archives. In this last, a memorandum to himself, John noted that Langlois had delivered a series of lectures at the University of Paris-Nanterre, "The Discovery of Cinematic Expression," which were based on excerpts from the Cinémathèque collection. See also Dominique de Menil to Dean V. P. Topazio of Rice University, July 30, 1969, Menil Archives.

17. The correspondence had been directed to and from John de Menil's Schlumberger office at 277 Park Avenue, New York.

18. Dominique de Menil, interview by Adelaide de Menil, September 5, 1984, transcript translated from the French by Marie-Pascale Rollet-Ware, "Souvenirs," Film and Media Collection, Menil Archives.
 While Robert Liebmann and Karl Zuckmayer wrote the screenplay for *The Blue Angel*, Dominique's memory was not wrong. Director Josef von Sternberg, in both *Fun in a Chinese Laundry* (New York: Macmillan, 1965), 137, and in his introduction to *The Blue Angel: A Film by Josef von Sternberg: An Authorized Translation of the German Continuity* (New York: Simon and Schuster, 1968), 11–12, explains why he asked his good friend Karl Vollmoeller to lend his name to the script. It was Vollmoeller who suggested Marlene Dietrich for a role in the film and who introduced her to von Sternberg.

19. "Articles of Incorporation of Horizon Two Thousand, Inc.," April 22, 1966, Menil Archives.

20. In the papers of the second colloquium, which were published in 1979 as *Toward a New Strategy for Development: A Rothko Chapel Colloquium*, Rossellini was thanked in the acknowledgments (xii). W. W. Rostow's *The Stages of Economic Growth: A Non-Communist Manifesto*, 1960, which I had discussed in my first meeting with the de Menils, was cited in six papers.

21. Dominique de Menil, "Roberto Rossellini," unpublished eulogy, delivered at the Rothko Chapel Board Meeting, Houston, Texas, October 8, 1977, Menil Archives.

22. See Douglas W. Bryant, "The Travels of the Trotsky Archive (bMS Russian 13)," in Rodney G. Dennis with Elizabeth Falsey, eds., *The Marks in the Fields: Essays on the Use of Manuscripts* (Cambridge, Mass.: Houghton Library, 1992), 138–40. For Jean Malaquais, see *The Exile Papers of Leon Trotsky*, part 2, 331, items 8987 and 8988, Houghton Library, Harvard University, Cambridge. From his home in Coyoacán, Mexico, on August 9, 1939, a year before his assassination on August 20, 1940, Trotsky wrote: "Mon cher Malaquais… I see by your letters that you have not abandoned the project to come to Mexico…. You ask me about my book on Lenin. It is put aside. I am actually writing a book on Stalin, after which I shall return to the biography of Lenin."

23. Pierre Masson and Geneviève Millot-Nakach, eds., *Andre Gide / Jean Malaquais Correspondance, 1935–1950* (Paris: Éditions Phébus, 2000), 168, author's translation.

24. Philippe Bourrinet, *La gauche communiste italienne 1926–1945 (Ébauche d'une histoire du courant "bordiguiste")—Memoire de maitresse* (Paris: Université de Paris I –Sorbonne, 1980), 118. Later Malaquais served as a mentor of Norman Mailer's and translated his fiction into French; see J. Michael Lennon, *Conversations with Norman Mailer* (Jackson: University Press of Mississippi, 1988), 30, 85.

On August 28, 1968, Mailer wrote to Malaquais: "J'ai fin fait la connaissance de Jean de Menil et nous sommes de grands copains"; see *Correspondance 1949–1986 Jean Malaquais, Norman Mailer*, trans. Hélène Ancel, ed. Elisabeth Malaquais and Geneviève Millot-Nakach (Paris: Le Cherche Midi, 2008), 217.

25. Between 1984 and 1985, Adelaide de Menil filmed in 16mm a series of interviews with eighty-two relatives, friends, and associates of her father. She titled her project *Souvenirs* and there are approximately three hundred hours of image and sound preserved in the Menil Archives. I am grateful to Adelaide de Menil for permission to consult *Souvenirs*, and also to her brothers and sisters for permission to quote from that collection of interviews.

Victor Serge, born Victor Lvovich Kibalchich in Belgium in 1890, went to Petrograd to join the Russian Communist Party in 1919. He became critical of Joseph Stalin, remaining loyal to the Bolsheviks and Trotsky. Imprisoned in both France and Russia, he escaped to Mexico when the Germans invaded France in 1940, dying there in 1947.

26. On the de Menils' life in Venezuela, see Anne Gruner Schlumberger [Dominique's sister], *The Schlumberger Adventure* (New York: Arco, 1982). For Dominique de Menil's own account of the early years of the company, see Jean Schlumberger and Dominique de Menil, *Conrad Schlumberger, sa vie, son oeuvre* (Paris: Editions hors commerce, 1949), reprinted in Jean Schlumberger, *Oeuvres*, vol. 5 (Paris: Gallimard, 1960), 260–81. On page 360, her uncle explains that this short biography was originally written for the funeral of Dominique's father in 1936. In addition to his scientific genius, Conrad de Menil was a pacifist, a socialist, and a financial backer of the French Communist newspaper *L'humanité*. The de Menils once suggested to Rice that the Institute for the Arts, which they had founded there, be reorganized and renamed the Center for the Study of Man to honor Conrad Schlumberger. They proposed to create near the Rothko Chapel a new building for the center, which would also house their art collection ("A Proposal to Rice University," November 17, 1972, Menil Archives).

27. In his autobiography, *Knave of Hearts* (Santa Fe: Twin Palms, 1999), Lyon recalls: "At the time, Dominique de Menil and Dr. Gerry O'Grady had created one of the first media centers in the country" (60).

28. Dominique de Menil to Glenn Silber, July 29, 1983, Menil Archives.

29. Dominique de Menil to Andrea Primdahl, August 26, 1985, Menil Archives.

30. Glauber Rocha to the Menil Foundation, January 10, 1973, Menil Archives.

31. John de Menil, "Memo on Glauber Rocha," February 12, 1973, Menil Archives. In the 1960s and 1970s, Glauber Rocha and his compatriot Nelson Pereira dos Santos were the founders of Cinema Novo. These filmmakers were disciples of Roberto Rossellini.

32. The funeral was recounted in the *Houston Chronicle*, June 6, 1973, and in Father Victor Brezik's memoirs (note 2 above). John de Menil's plan for his funeral, written as a codicil to his will on December 13, 1972, was reproduced in Kim Shkapich and Susan de Menil, eds., *Sanctuary: The Spirit In/Of Architecture* (Houston: Byzantine Fresco Foundation, 2004), 2, and in Matthew Drutt, *Robert Gober: The Meat Wagon* (Houston: Menil Foundation, 2006), 24. A full ten-page transcript of the proceedings, "Funeral Services of John de Menil," is in the de Menil Family Papers, Menil Archives.

Some American History

SOCIAL AND POLITICAL ACTION

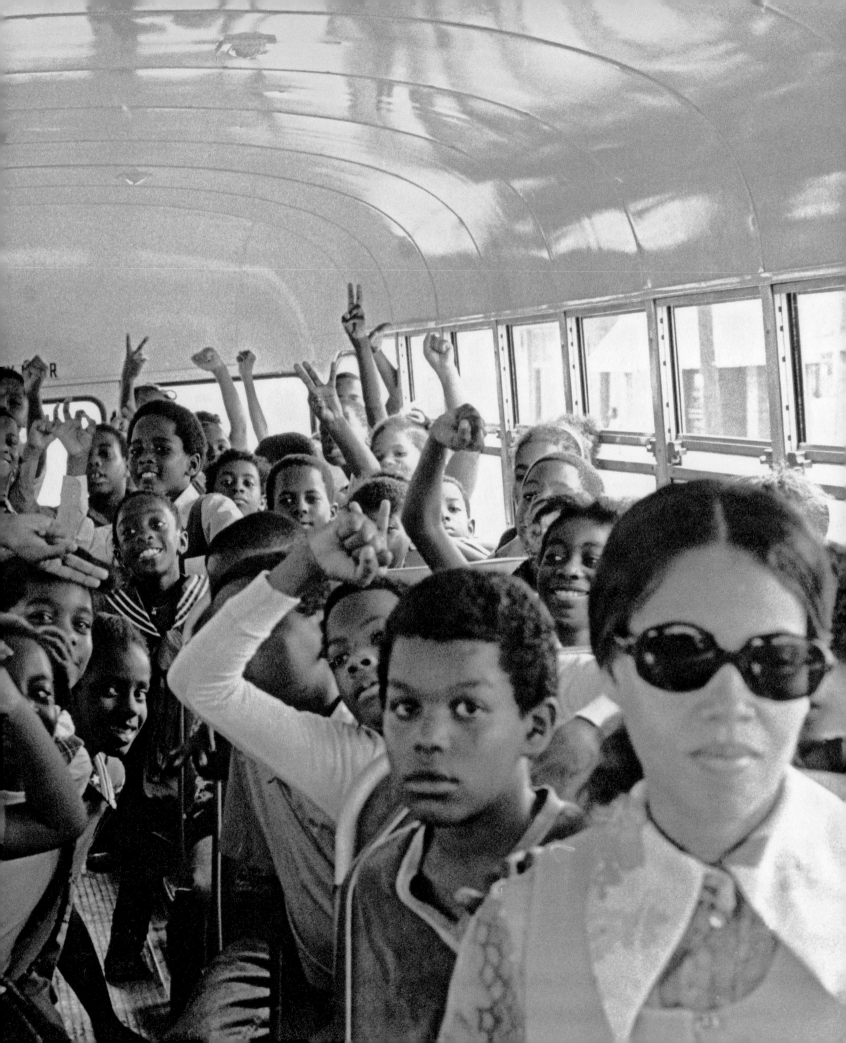

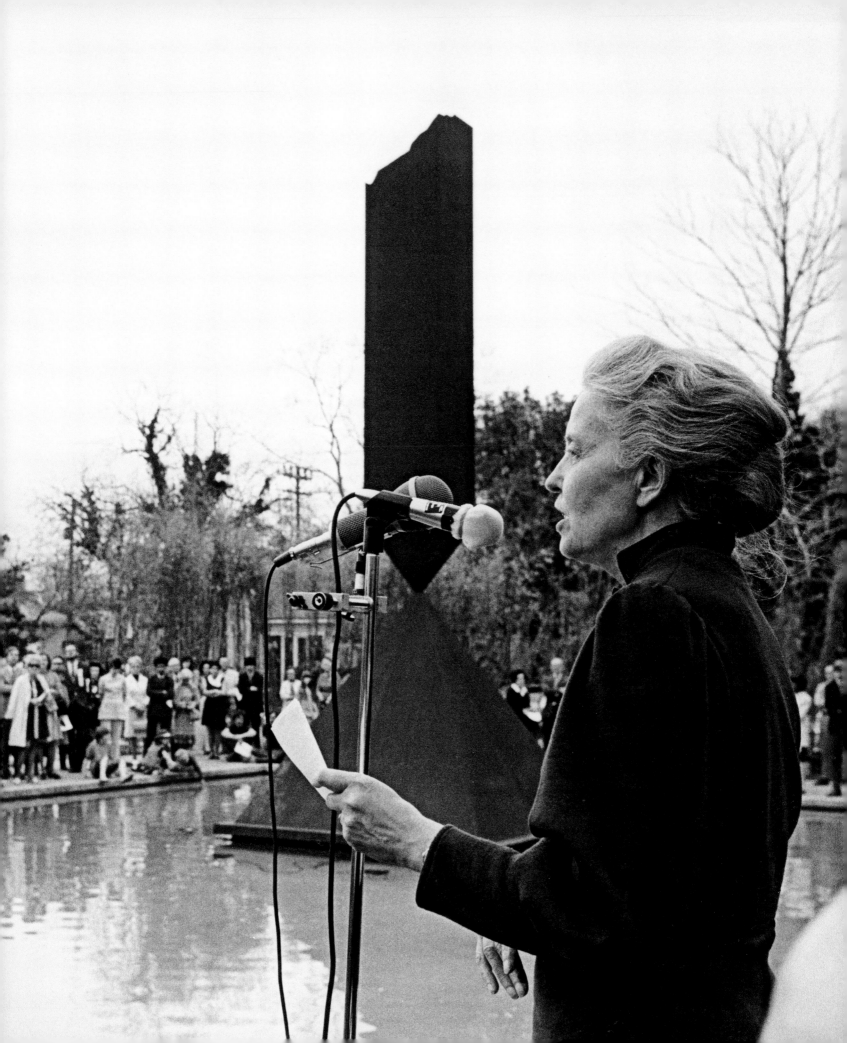

The Menil Advocacy for Human Rights:
A Personal Account FRANCESCO PELLIZZI

Nos idées, nos goûts, nous cachent le monde. Or le monde est plus vaste, plus divers que nous. Que le passé ne nous cache pas le présent.[1]

Marie-Alain Couturier, *La vérité blessée*, 1943

[I]t will be the day not of the white man, not of the black man, it will be the day of man as man.

Rev. Dr. Martin Luther King Jr.
(Montgomery, Alabama, Sunday, March 1, 1963)

pages 90–91
Students on a school bus en route to
"The De Luxe Show," Houston, 1971

Fig. 7.1
Dominique de Menil at the dedication of the
Rothko Chapel, Houston, 1971

When I first visited John de Menil in June 1968,[2] a time when riots had sprung up in several cities in the wake of the struggle for civil rights on the part of African Americans, he insisted that I familiarize myself with aspects of Houston that are not often visited by tourists, such as its black neighborhoods. He also wanted me to see features that directly related to his and Dominique de Menil's involvement in local cultural and political affairs, including the campus of the University of St. Thomas, designed by Philip Johnson, and the Harris County Center for the Retarded, designed by Howard Barnstone.[3] While I had been somewhat prepared for the Old World refinement and understated cosmopolitan atmosphere of the de Menils' home, I was surprised in our first long conversations by John's intense commitment to American society, to the idea of its openness and seemingly unlimited potential, to the principles embedded in its founding documents, but especially to the distinctive—and at times irreverent—flavor of the Texan expressions of these New World qualities and values, even in their sometimes startling contradictions.

It was immediately evident to me on that first encounter that the de Menils (particularly John) viewed, and had seized on, the controversial complexities of the Texan and American social fabric as fertile ground for novelty and experimentation. But the "Menil ethos" that informed their social action came with a distinctive aesthetic connotation—one grounded in an original synthesis between the iconoclastic, anti-establishment, and anti-bourgeois tradition of Dada and Surrealist modernism that emerged around the First World War

Fig. 7.2
John and Dominique de Menil with Archbishop
George Khodr, Metropolitan of Byblos and
Batroun (Mount Lebanon), and Nizar Raslan,
Beirut, 1971

Fig. 7.3 *opposite*
"Traditional Modes of Contemplation and
Action in World Religions," colloquium at
the Rothko Chapel, Houston, 1973

and the radically new forms of creative engagement developed in America by native and immigrant artists right after the Second World War. Suddenly, while staying at the de Menils' home, not only did Mark Rothko and Barnett Newman seem much less remote from Max Ernst and René Magritte, but their profound kinship revealed a *political* undertone—in terms of both the social engagement implied by their art practice and their shared pursuit of a vision free of traditional European representational canons. For the de Menils the neo-utopian modernist dream of a brave new world was still worth pursuing—especially in America. So it did not surprise me, three years later, when John promoted a contemporary art exhibition of the most exacting quality in an abandoned and readapted cinema right in the middle of Houston's African American Fifth Ward: the famous "De Luxe Show."[4]

Visiting this exhibition with him, I witnessed both the affection with which he was received by local residents and his satisfaction at having (not for the first time) defied local and national conventions. John was clearly unwilling to accept, as something one would simply have to live with, the social conditions of the city and country he had otherwise wholeheartedly embraced ("love it or leave it," trumpeted the conservative slogan of the time). For him, to live in the United States as a new American (he even changed his name from Jean to John) was to be civically—i.e., *humanly*—engaged in its reality. Well aware of the thorny questions regarding the appalling conditions in which people are all too often compelled to live, depending

on the forms of social organization and power relations they are subject to—i.e., their *political* setting, so that in this respect "human rights" becomes equivalent to "civil/civic rights"—John felt that he must try to transform what he could not agree with, ideally through *persuasion*. This meant seeking and transmitting an ever-broader awareness of the specific limitations under which individuals and groups are allowed to act in shaping the conditions of their own *social* existence.[5]

Such an orientation is also what may have first inspired the ambitious and original research project launched by John and Dominique de Menil in the early 1960s called the Image of the Black in Western Art. While undoubtedly prompted by their acute awareness of the still unresolved racial rifts in American and European societies, this research project went deeper into the study of racism's origins: the de Menils sought to compile a complete visual archive of the representation of sub-Saharan Africans in European, Middle Eastern, and American arts from antiquity to the beginning of the twentieth century, and in the process to produce a series of in-depth studies on the implications of this iconography for race relations in Western cultural history. It was typical of the de Menils' constructive and thoughtful approach to social and historical issues that they did not limit themselves to pursuing what could easily have become a superficial (if harrowing) documentation of how black Africans had been consistently degraded in Western representation (even, and often especially, when "beautified" and idealized). They instead encouraged and supported distinguished scholars, who had never before thought the question relevant to their pursuits, to investigate it, period by period, in great historical and hermeneutic depth, thereby establishing a whole new field of legitimate study that had not previously existed in academic or any other settings, but whose human and civil rights implications were (and are) of the greatest urgency.[6] For John and Dominique de Menil, there were no barriers—rather, essential connections—between art and vital social concerns, nor between social concerns and the loftiest scholarly pursuits.[7]

John and Dominique de Menil made a remarkably harmonious team, acting in concert on most issues. Yet, if one were to make a distinction between them, one could say that John was somewhat more inclined to focus on the civil rights concerns, and Dominique, on the human side of social issues.[8] In general John's involvement in public affairs tended to be more pragmatic, and hence "political," than Dominique's, driven by an overriding interest in what could be *done* about certain specific conditions and situations in the short and longer term. Dominique's civic as well as aesthetic concerns often had more of a religious undertone, guided by her paramount preoccupation with the possibility of a true dialogue among the great spiritual traditions of the world (including those primarily relying on *oral* transmission).[9] I am, of course, speaking of nuances here, not

of divergent aims; after all, Dominique converted to Catholicism in part as a consequence of marrying John. However, in progressively distancing themselves from the University of St. Thomas (of which they had been major supporters) as they developed their ideas for the Rothko Chapel, John and Dominique acted on *principal* motivations that were perhaps not identical. John appeared more concerned with the limitations on civic activism that such a close association with this then somewhat conservative institution of the Catholic Church might entail for the Rothko Chapel (especially in the promotion of civil rights), while Dominique's chief dissatisfaction at least initially seemed to be with the perceived reluctance on the part of St. Thomas's governing Basilian Order to fully embrace the new ecumenical principles and Church reforms championed by Pope John XXIII and the Vatican Council II.[10]

John's penchant for pragmatic action in the cause of civil rights was in evidence when the Houston City Council refused the de Menils' proposed gift of Barnett Newman's *Broken Obelisk*, which came with the condition that it be placed in front of City Hall and dedicated to the memory of Dr. Martin Luther King Jr. John was the one who decided to acquire the work and install it, with that same dedication, in front of the Rothko Chapel. Further, on the day of the chapel's inauguration, when it was announced that an all-black choir would perform, and a disgruntled neighbor called threatening to shoot any "negroes" he could spot from his windows, it was John who drove

over and managed to calm him down.[11] But the unprecedented feat of gathering together religious leaders from different faiths, which had all too often been bloodily at war throughout their history, to celebrate the chapel's opening in February 1971 was largely Dominique's doing (fig. 7.1).[12]

A similarly dual inspiration presided over the first colloquium held at the Rothko Chapel (fig. 7.3), the result of careful planning by John, Dominique, and others, which included extensive international travel to meet with leaders of diverse faiths (fig. 7.2).[13] Held on July 22–30, 1973, only seven weeks after John's death, it was an attempt—quite novel in America at the time—to lift the discussion about the role of religion in contemporary society above the limitations and conflicts of established institutions, while equally avoiding the pitfalls of well-meaning platitudes, New Age vagaries, and abstruse neo-esotericisms. The challenge was to revisit the sources of many different spiritual traditions to see what they could still teach us about our spiritual survival and coexistence in today's world. Some participants in the colloquium had a personal bearing on the de Menils' lives. Father Youakim Moubarac, a Lebanese Maronite theologian living in Paris, had spiritually assisted John at the time of his last illness. And the Christian Orthodox theologian and philosopher Father André Scrima was close to Dominique until her death. All these and other intensely felt relationships, such as those with HH the 14th Dalai Lama (fig. 7.4) and Bishop Desmond Tutu, testify to Dominique's

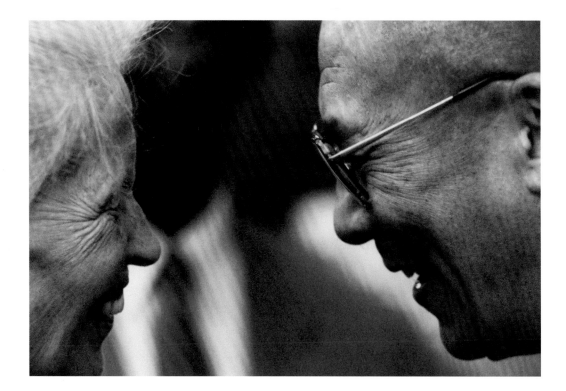

Fig. 7.4
Dominique de Menil and HH the 14th Dalai Lama, Prayer for World Peace program at the Rothko Chapel, Houston, 1991

unending search for the common roots of spirituality, which she saw as an essential underpinning for her advocacy of "human rights," despite the fact that she remained to the very end a practicing Catholic.

The colloquium's title, "Traditional Modes of Contemplation and Action in World Religions," points to a venerable dichotomy in Christian thought between active (Martha) and contemplative (Mary) engagements in religious and communal participation (fig. 7.5). These two forms of spiritual practice would be equally important to Dominique throughout her life, and it is perhaps in their precarious balance that one finds a profound motivation for her continued involvement with the gathering and experiencing of works of art after John's death. Even as she felt—both personally and in representing him—an ever-keener sense of the urgency of standing up and speaking out against the world's worsening inhumanities, she recognized the regenerating potential of unfettered creative action, a promise stemming from the freedom of contemplative spirits. Both John and Dominique valued the moment of wonder at the outcome of the word joined with the deed, evoked most profoundly in *Genesis*, as well as the importance of making it possible for anyone to mimetically experience such a conjunction of action and contemplation: this they perceived as art's true generosity and ethical substance.[14]

A more overt conjunction of religious and political concerns came about through the de Menils' connection with Dom Hélder Câmara, Archbishop of Olinda and Recife, in the very poor and racially divided northeastern Brazilian state of Bahia. Dom Hélder, a diminutive man of boundless energy, was a fiery and fearless champion of the rights of the poor and the forgotten, and throughout the time of Brazil's oppressive military dictatorship and afterward, he foreshadowed in his religious practice what came to be called "Liberation Theology." The archbishop, who appeared to echo the de Menils' new perspectives on the workings of faith in the world, was, from their first encounter, a man well to their liking: despite his caution in strictly doctrinal matters, Dom Hélder not only was deeply engaged as an advocate for the dispossessed (and for political freedoms) in Brazil, but also showed remarkable flexibility in accommodating in his dioceses the practices of the transatlantic African religion of Candomblé (fig. 7.6), which incorporates aspects of Catholicism into its pantheon and rituals. Dominique demonstrated tangible appreciation for this advocacy and embrace of diversity through her support for charities overseen by the archbishop in the state of Bahia and for the ministry of Father François de l'Espinay. L'Espinay was initiated with Dom Hélder's consent into the Candomblé devotional practices of one such community, thus affirming the deep kinship among all the world's spiritual traditions.[15]

As the Image of the Black project, the Rothko Chapel colloquia, Dominique's editing of the books written by the de Menils' longtime art advisor Father Marie-Alain Couturier, and several learned and imaginative art exhibition catalogues prove, Dominique was by temperament and training a studious person, much given to immersing herself in the work of scholars and thinkers in many fields. Despite

Fig. 7.5 *left*
Johannes Vermeer, *Christ in the House of Martha and Mary*, ca. 1654–56. National Gallery of Scotland, Edinburgh

Fig. 7.6
Candomblé devotees in a ceremony, Salvador, Bahia, Brazil, 1985

her relative shyness, she also tried whenever possible to meet intellectuals and learn from them in person. She was not able to do so in the case of Jean Mettas, the valiant young historian of the eighteenth-century French slave trade, because of his untimely death, but she generously sponsored through the Menil Foundation the publication of his extraordinary record of all slave ships and their human cargo from 1707 to the French Revolution.[16] In 1982 she readily accepted the proposal to sponsor the fifth Rothko Chapel colloquium, in which anthropologists and political scientists assembled to explore the looming conflicts in several areas of the postcolonial world. Participants specifically examined tensions between groups newly conscious of their ethnic roots and identity and the often authoritarian and neomodern nation states within which they had found themselves.[17] Held in 1983, "Ethnicities and Nations" was sadly prophetic, like so many other undertakings by the de Menils, in its anticipation of the bloody ethnic conflicts and outright genocides that have erupted around the world from the late 1980s to our day.[18]

Dominique's commitment to human rights worldwide gained intensity, if that were possible, after her husband's death. It was as if she felt the need to continue to carry the torch for John, to the point that she briefly considered abandoning her plans to create a new museum for the collection so as to dedicate all her energy to the Rothko Chapel and its advocacy of human rights.[19] In her ever-growing preoccupation with world conditions, and even in aspects of her personal history and relationship to her husband, Dominique bore

an uncanny resemblance to Eleanor Roosevelt.[20] Both women greatly admired their fathers (who died relatively young), married talented, strong-willed, and charismatic men who encouraged them to develop their own potential, had five children, battled with deep insecurity and self-doubt, but found within themselves seemingly boundless energy that led them to visit peoples across the world to learn first-hand about their plights. And both established lasting alliances and quasi-filial relationships with many gifted friends. They also shared a common ethical fiber—perhaps rooted in their similar Protestant upper-class education—and common concerns in the American civil rights movement and the broader issue of "universal human rights."[21] Dominique seldom mentioned the reluctant First Lady, but she made sure that the anniversary of the United Nations' Universal Declaration of Human Rights was celebrated at the Rothko Chapel every year by holding a significant event relating to some critical issue of the moment, and she insisted that such a commemoration become a permanent feature of the Rothko Chapel programming for the future.

Coming from a European background—with its long history of social struggle, political revolutions, and manifestos, endowed with a keen appreciation of communal rather than individual rights and duties—John and Dominique de Menil were perhaps initially more open to collectivistic sociopolitical experiments than average American liberals were inclined to be.[22] Dominique seemed to have a soft spot for the writings of the most radical ideologues of the French Revolution, and she paid tribute to that French tradition of intellectual

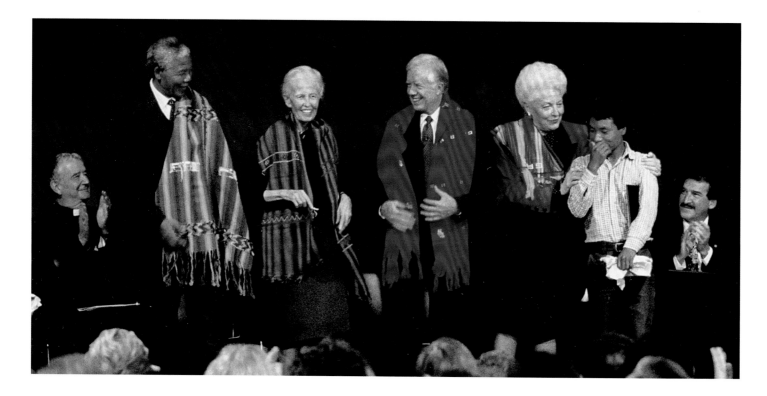

engagement by privately supporting for several years the aperiodic publication of *L'antenne*, a pamphlet dedicated to an in-depth and irreverent analysis of current sociopolitical events and ideological trends. Yet her familiarity with the writings of secular thinkers such as Jean-Jacques Rousseau, Benjamin Franklin, and Thomas Paine (particularly his *Rights of Man*) did not pull her from her fundamental pursuit of human rights in a *spiritual* realm, one shielded from the partisanship and vagaries of political conflict. She did not try to be neutral in the face of many of the struggles of the times, but believed, rather, that a deep and far-reaching sense of right and wrong could be promoted more effectively by not losing sight of the *transcendent* dimension of the human condition, even when and where she felt compelled to intervene on behalf of the oppressed. It was in this spirit that Dominique instituted the biannual Rothko Chapel Oscar Romero Award in 1986 (to coincide with the first Carter-Menil Human Rights Prize (fig. 7.7), established by Dominique de Menil and President Jimmy Carter, and with the second Rothko Chapel Award for Commitment to Truth and Freedom).[23]

Like her, Bishop Oscar Romero of El Salvador had been a convert of sorts: he moved from an early conservatism, both doctrinal and social, to a commitment to the disenfranchised of his country along with a new sense of the Church's role in opposing oppressive regimes and defending civil and human liberties.[24] The award, in turn, recognizes individuals and groups who have risked their lives, and often suffered torture and imprisonment, in similar struggles.[25]

The idea is not just to reward them, but to strengthen their causes and afford them a measure of protection through their new international visibility. The announcement of the third Rothko Chapel Oscar Romero Award on the tenth anniversary of Bishop Romero's assassination was in fact rather dramatic. To lend it maximum force, Dominique traveled to El Salvador in the company of a small Rothko Chapel contingent in a visit that coincided with a rather tense march through the center of San Salvador attended by many religious and civil international delegations (in which, of course, those of us traveling with Dominique took part).[26] Not long before these events, the massacre of six priests, all professors at a local Jesuit university, by paramilitary agents of the Salvadoran government lent renewed relevance to the figure of Bishop Romero, as well as urgency to the efforts of many organizations to address the plight of his people.

I believe it was through her tireless, at times exhilarating, but also stressful process of researching potential candidates for these human rights awards, which often involved long and difficult travel (always in economy class), that Dominique developed her ever-stronger concern about the widespread use of torture as an instrument of coercion all over the world. Be it in South Africa, the Middle East, the Balkans, Algeria, Latin America, China (with regard to Tibet), or Southeast Asia—and on occasion in the West—a recurrent pattern of torture was, and still is, disturbingly prevalent.

As a deeply religious Christian, informed by both Protestant and Catholic teachings, Dominique was all too aware of the grave European

Fig. 7.7 *opposite*
Carter-Menil Human Rights Prize ceremony
with Monseñor Rodolfo Quezada Toruño,
Nelson Mandela, Dominique de Menil,
President Jimmy Carter, Governor Ann
Richards, Sebastian Suy Perebal, and
Ramiro de León Carpio at the Rothko
Chapel, Houston, 1991

Fig. 7.8
Tony Smith, *Marriage*, 1961. Oslo, Norway

heritage of religious and political strife, but she also knew that critical knowledge of this very history could make us all the more keen to expose, denounce, and fight against violence and torture.[27] History has shown that torture, in all its grotesquely twisted logic, is invariably an instrument of unbridled power, and that any struggle against it is implicitly a struggle for liberty and equality under the law.[28] But the spiritual dimension of her human rights engagement made Dominique also see that sometimes a strategic advantage could be gained by reserving comment on specific political conflicts in order to call attention to the broader repressive behavior of those able to both apply coercion and suppress public knowledge of their actions. Although the announcements of the Rothko Chapel Oscar Romero Awards and the Carter-Menil Human Rights Prizes proved quite effective in countering individual and collective victimizations, the thought of torture's persistence was intolerable to Dominique, particularly in her later years, and she showed unbounded admiration for those who rose up against it. As she wrote on the program for the second Rothko Chapel Awards for Commitment to Truth and Freedom: "Millions are left to sink. They are asphyxiated, starved, tortured, reduced to silence. Yet, at great risk, a few men and women refuse to bow down in front of hypocrisy, pseudo-truths, and inflated authority. Loud or silent, their testimony sends endless echoes around the world. To such heroic people, many of them anonymous, we dedicate this ceremony."[29]

As in the case of Newman's *Broken Obelisk*, there were instances when John and Dominique de Menil sent pointed and straightforward political messages. One such intervention occurred toward the end of Dominique's life, once more in the form of the donation of a monumental work of art for public display (one is tempted to think that John's spirit was again calling her to action). On May 18, 1994, a large "architectural" sculpture was installed on top of a hill overlooking the city of Oslo in recognition of the imaginative and courageous work carried out by the Norwegian government in promoting a truce (and possible future peace accord) between the Israeli and Palestinian peoples.[30] The dedication event, with Foreign Minister Shimon Peres and Chairman Yasser Arafat shaking hands (for the first and only time) at the foot of the monument while Dominique looked on, might well be seen as the crowning achievement of her forty-year involvement with the cause of world peace and all issues relating to human rights. It is a rather extraordinary coincidence that it was also to Oslo (as Dominique certainly knew) that the novice Dominican monk and painter Marie-Alain Couturier—John and Dominique's earliest mentor on their artistic-spiritual path—had been sent by his superiors, almost seventy years before, to paint a fresco in the local chapel of his order. And in fitting expression of the profound unity between the artistic and human rights passions of Dominique (and possibly also in silent memory of her husband), the work she donated to Norway (fig. 7.8)—created by Tony Smith, an artist whose philosophical, spiritual, and multidisciplinary interests were very much in tune with John's and her own—was called *Marriage*.[31]

NOTES

I wish to thank Josef Helfenstein, director of the Menil Collection, and Sissy Farenthold, until recently chairman of the board of the Rothko Chapel, for asking me to provide this personal account. Having served simultaneously for close to thirty years on the boards of both the Menil Foundation and the Rothko Chapel, I was blessed with a rather privileged insider view of the interconnections among the de Menils' various "philanthropic" engagements—a trust for which I am forever grateful to Dominique de Menil. I also wish to especially thank Suna Umari, head of the Rothko Chapel Archives, for kindly refreshing my own memory of key people and events, as well as Geraldine Aramanda for doing the same from her invaluable Menil Archives. Gini Alhadeff patiently revised my English form.

1. "Our ideas, our tastes, hide the world from us. Now the world is vaster, more diverse than we are. Don't let the past hide the present from us." Author's translation.

2. Our common friend, the composer Morton Feldman, had suggested I visit the de Menils on my drive through Texas to join the Harvard Chiapas Project in southern Mexico as a visiting anthropologist for the summer. At the time only John de Menil was there; Dominique was in France.

3. The Harris County Center for the Retarded, completed in 1966, has since been renamed the Center Serving Persons with Mental Retardation.

4. The de Menils' interest in African American culture and civil strife may have had some roots in the French interest in "Negritude" in 1920s–30s Paris. This literary and ideological movement of black intellectuals included the American entertainer Josephine Baker and the radical activist and heiress Nancy Cunard, who published the substantial and politically pioneering anthology *Negro* in 1934. Cunard was very close to Louis Aragon and other Surrealists at around the same time that the de Menils first met Max Ernst at the Café de Flore (as Dominique herself recounted to me), which led to the painting of his striking portrait of Dominique de Menil (now at the Menil Collection). But it is certainly upon their coming to the American South and settling there that the de Menils encountered the African American civil and human rights question in all its explosive urgency.

5. I must confess here that I have always thought the term "human rights" somewhat pleonastic, since "rights" are juridical-ethical constructs that necessarily pertain to the human realm. In our long association, I never raised this question with John and Dominique de Menil, however, considering that all they stood for "humanly" and "civically" far transcended any terminological quibble. The historical underpinnings of the issue have been recently and provokingly discussed by UCLA Professor Lynn Hunt in her book *Inventing Human Rights: A History* (New York: W. W. Norton, 2007), in which she critically unravels the relations between the 1776 American Declaration of Independence, the 1789 French Declaration of the Rights of Man and of the Citizen, and the United Nations' 1948 Universal Declaration of Human Rights. One of her controversial contentions, which may be relevant to a discussion of "civil/civic" versus "human" rights, is that "the utterly dehumanizing crimes of the twentieth century only became conceivable once everyone could claim to be an equal member of the human family" (quoted by Sylvana

Tomaselli, "Where Rights Go Wrong," *Times Literary Supplement*, July 20, 2007).

Dominique of course must have known how problematic the French Revolution's own "human rights" record was, including the fact that Olympe de Gouges, the royalist author of *Déclaration les droits de la femme et de la citoyenne*, 1791, was herself guillotined (Tomaselli, op. cit.), but I distinctly remember a conversation in the last years of Dominique's life, when, after rereading some of the revolutionary leaders' fiery writings, she said to me emphatically, "*C'était des saints! (They were saints!)*"

6. Francis Haskell, late professor of art history at the University of Oxford, conversation with the author, 1992. Onetime painter Ladislas Bugner was the general editor of the project until his retirement in 2005, and Karen C. C. Dalton acted for several years as the project's editorial assistant from Houston. I served for about ten years (1992–2002) as the project's editorial coordinator and promoted the transfer of the project's visual archives and library from Paris to the Warburg Institute at London University. The Houston copy of the archives has been given to a special research institute at Harvard University, affiliated with both its Center for African American Studies and its Department for the History of Art and Architecture, under Dalton's direction and Professor Henry Louis Gates Jr.'s supervision. Professor David Bindman of University College, London, is currently editing the third volume of the series, covering Western representations of sub-Saharan Africans in the sixteenth, seventeenth, and eighteenth centuries.

7. John visited his daughter Philippa and me while I was conducting fieldwork in the Chiapas Highlands in Mexico. (Philippa's parents had introduced us in January 1969, and we were married later that same year until our de facto separation in 1976, followed by divorce in 1980.) After watching me listen sympathetically to a Tzotzil woman's lengthy complaints, John said, "Now I understand what you are doing here." He made me aware of the fact that an anthropologist is first of all a listener.

8. John's basic attitude in these matters was reinforced by his close friendship with Simone Swan, a Belgian American public relations expert who served for a while as public relations advisor to the Menil Foundation and the Rothko Chapel, and who was very keen on civil rights and racial issues. Equally important, in John's last years, was his association with Miles Glaser, a younger Houston businessman similarly inclined in political matters, who went on to valiantly serve Dominique after John's death, and until hers, as personal advisor and chief financial officer of the Menil Foundation and as an engaged supporter for several of Dominique's human rights initiatives. He in fact nurtured the connection between Dominique de Menil and President Jimmy Carter that led to the establishment of the Carter-Menil Human Rights Prize at the soon-to-be-dedicated Carter Center, then at Emory University's Human Rights Center in Atlanta. Last but not least, it is important to remember the role played by Nabila Drooby, who was for more than twenty years Dominique's closest associate in developing the Rothko Chapel's goals and programs, and who served as its director after the Rev. Thompson L. Shannon retired from that position in 1990, until her own retirement in 1997.

9. I met Dominique in Houston at the end of the summer of 1968. It was while we were examining together a new translation of a St. Augustine tract that we established a connection, which lasted to the end of her days and beyond.

10. With the separation from the University of St. Thomas, the Rothko Chapel became part of Houston's Institute of Religion and Human Development, headed by Rev. Thompson L. Shannon, and was still under its aegis at its dedication in 1971. In 1972 the chapel was incorporated (and eventually endowed) as an independent institution.

Dominique, through the Rothko Chapel and the Menil Foundation, long supported the editing and publishing of Angelo Roncalli's monumental correspondence, carried out by Giuseppe Alberigo, professor of history of the church at the University of Bologna and director of the "Istituto per le Scienze Religiose" in that same city, and his research team at the University of Bologna as well as the Instituto's monumental five-volume work on the history of Vatican Council II. The inspiration of Pope John XXIII remained central to Dominique's thought and actions to the end of her life.

11. We remained rather nervous throughout the afternoon proceedings. The man's house, adjacent to the Rothko Chapel's grounds, was one of the few that the de Menils had not yet been able to acquire for their foundation.

12. Among the celebrants were the Right Rev. Scott Field Bailey, DD, Protestant Episcopal Church of America, New York; the Right Rev. Kenneth W. Copeland, STD, Bishop Texas Conference, United Methodist Church, Houston; Shukri M. el-Khatib, PhD, Islamic Society of Greater Houston; Bishop John, Titular Bishop of Thermon, Greek Orthodox Archdiocese of North and South America, Brookline, Massachusetts; Rev. William Lawson, DD, Wheeler Avenue Baptist Church, Houston; Rabbi David L. Lieber, PhD, University of Judaism, Los Angeles; the Most Rev. John L. Markovsky, STD, Co-adjutor Bishop of Galveston-Houston; Rabbi David Polish, PhD, Central Conference of Rabbis, Evanston, Illinois; Rev. Eugene S. Smith, PhD, DD, World Council of Churches, New York; Rev. Thompson L. Shannon, PhD, DD, and Rev. Donald S. Williamson, PhD, Institute of Religion and Human Development, Houston; and Jan Cardinal Willebrands, Secretariat for the Promotion of Christian Unity, Vatican City.

13. See *Contemplation and Action in World Religions,* ed. Yusuf Ibish and Ileana Marcoulesco (Houston: Rothko Chapel; and Seattle: University of Washington Press, 1978) and *Traditional Modes of Contemplation and Action*, ed. Yusuf Ibish and Peter Lamborn Wilson (Tehran: Imperial Iranian Academy of Philosophy, 1977). Professor Yusuf Ibish from the American University in Beirut played a key role in seeking out the potential speakers for this first colloquium and bringing them to Houston; he remained a trusted advisor to Dominique de Menil, the Menil Foundation, and the Rothko Chapel until his death. For my part, I secured the participation of Professor Elémire Zolla, one of my former mentors at the University of Rome and an inspired explorer of the less-frequented reaches of "comparative religions."

14. A strong and lasting influence on John and especially Dominique in regard to this view of the role of art in spiritual, social, and political action was that of a Dominican friar, Father Marie-Alain Couturier. Dominique spent innumerable hours in the late 1970s and early 1980s personally editing and revising French and English editions of Couturier's posthumous journals, published as *La vérité blessée* in 1984, as well as the priest's other writings. He was certainly not a moderate nor a quietist—among the books he wrote was one called *L'evangile est à l'extrème* (*The Gospel Is at the Edge*). Christophe de Menil, John and Dominique's eldest daughter, recalls that her father asked

Couturier to take her to look at important art and that this had a profound effect on her capacity to approach art with unconventional eyes. The de Menils' youngest daughter, Philippa, would move more decisively toward an outright "spiritual" understanding of the art of our time, cofounding the Dia Art Foundation and funding its many projects throughout the 1970s and early 1980s. Now called Fariha, she is the recognized leader of the Nur Ashki Jerrahi Order, a Sufi congregation. Dominique, who was spiritually, intellectually, and emotionally very close to her daughter, would occasionally attend religious services at the Sufi center.

15. In a clear indication that the somewhat rarefied spiritual concerns of the first Rothko Chapel colloquium were not to determine all that the institution stood for, a second colloquium—planned since before John's death— called "Human Rights / Human Reality," soon followed in December 1973. It was attended by a small panel of speakers who had distinguished themselves as advocates for pressing socioethical causes, including Archbishop Dom Hélder Câmara, Jonas Salk, Joel Elkes, John Calhoun, and Giorgio La Pira. In this same vein, though with an even stronger empirical bent, a third colloquium at the Rothko Chapel, "Toward a New Strategy for Development," was led in 1977 by Nobel Prize–winning economist Albert Hirschman.

16. Jean Mettas, *Répertoire des expéditions négrières françaises au XVIIIme siècle,* ed. Serge Daget, 2 vols. (Paris: Société française d'histoire d'outre-mer, 1978–84). For a recent account of the British side of the trade in that same preabolitionist period, see Marcus Rediker, *The Slave Ship: A Human History* (New York: Viking, 2007).

17. See *Ethnicities and Nations: Processes of Interethnic Relations in Latin America, Southeast Asia, and the Pacific,* ed. Remo Guidieri, Francesco Pellizzi, and Stanley J. Tambiah (Houston: Rothko Chapel; and Austin: University of Texas Press, 1988).

18. An earlier colloquium, "Islam: Spiritual Message and Quest for Justice," October 21–25, 1981, had been equally prophetic. Its aim was to provide among specialists a free and open discussion of various aspects of Islam. The close connections in Islam between values and action, the transcendental and the everyday, and the metaphysical and the physical were stressed, pointing to the central principle of unity that is an essential aspect of this faith. The participants represented many geographical regions of the Islamic world, scholarly disciplines, and viewpoints.

19. I was among those who strongly advised her against taking such a course, believing that she should strive to preserve and leave to the world the gift of her and her husband's understanding of the role of art in civilization and its deep connection to human rights.

20. Indeed, one can even discern a certain physical resemblance between them, or at least something of an *air de famille.*

21. Eleanor Roosevelt had promoted civil rights since at least the 1930s, and she was, of course, responsible for negotiating the promulgation of the Universal Declaration of Human Rights by the newly formed United Nations in 1948. Like the de Menils, she had also been deeply concerned by the lingering racial rifts within American society: for instance, she advocated equal rights for black workers in the industrial war effort (and their partial implementation actually resulted in the Detroit white race riots of 1943).

22. Early on, Dominique had traveled to the still young Soviet Union as a personal assistant to her father, Conrad, in his work to help the Communist regime modernize its search for new oil reserves. One of John and Dominique's closest friends from their years in Venezuela during World War II, the French writer Jean Malaquais, was an outspoken Communist.

23. On this occasion, as well as in 1991, all three awards were given at the same time for practical purposes. Dominique could not be in two places at once, and this was a way to share two important keynote speakers: Archbishop Desmond Tutu and President Nelson Mandela.

The Rothko Chapel Awards for Commitment to Truth and Freedom had been started as a way to mark the Rothko Chapel's tenth anniversary in 1981. As Dominique said in her speech at that ceremony, "It is a good time to reaffirm its vocation and question our faithfulness to it." These awards were given twice after that, at an interval of five years. The 1981 awardees were Giuseppe Alberigo, Italy; Amadou Hampate Ba, Ivory Coast; Balys Gajauskas, USSR; Douglas and Joan Grant, USA; Las Madres de la Plaza de Mayo, Argentina; Ned O'Gorman, USA; Warren Robbins, USA; Sakokwenonkwas (Chief Tom Porter), Mohawk Nation; Zwelakhe Sisulu, South Africa; Socorro Juridico, El Salvador; Tatiana Velikanova, USSR; and Jose Zalaquett, Chile.

The 1986 awardees were Charter 77, Czechoslovakia; Myles Horton, USA; Helen Joseph, South Africa; Anatoly Koryagin, USSR; Jonathan Kuttab, Occupied West Bank; Sanctuary, USA; Raja Shehadeh, Occupied West Bank; and Albertina Sisulu, South Africa. The 1991 awardees were Conavigua; Ramon Custodio Lopez and CODEH; Ramiro de León Carpio and Cesar Alvarez Guadamuz; Sebastian Suy Perebal; Maria Mirtala Lopez and CRIPDES; and Juan Guillermo Cano Busquets and Ignacio Gomez Gomez. On this occasion, Nelson Mandela from South Africa was the recipient of a Special Rothko Chapel Award (given one time only).

The Carter-Menil Human Rights Prize had a limited lifespan (1986–1994) and is now no longer being given. Awardees were Yuri Orlov, USSR, and Gupo de Apoyo Mutuo, Guatemala (1986); La Vicaria de la Solidaridad, Chile (1987); Sisulu Family, South Africa (1988); Al-Haq (Law in the Service of Man), West Bank, and B'Tselem (Israeli Information Center for Human Rights in the Occupied Territories), Israel (1989); Consejo de Comunidades Ethnicas Runujel Junam, Guatemala, and Civil Rights Movement of Sri Lanka (1990); University of Central America in San Salvador in honor of the six Jesuit priests who were murdered (1991); Haitian Refugee Center, Miami, and Native American Rights Fund, Boulder, Colorado (1992); and Norwegian Institute of Applied Science, Oslo (1994).

24. Archbishop Oscar Romero was shot to death on the front steps of his cathedral in San Salvador in 1980 by government-sponsored (or tolerated) assassins—very much like his medieval predecessor Thomas Becket, about whom T. S. Eliot wrote a drama that Dominique admired.

25. Originally, starting in 1986, the Oscar Romero Award was given more or less biannually, but after Dominique's death in 1997, because of budgetary restrictions resulting from necessary and costly restoration work on its main building, the Rothko Chapel had to wait a few years before resuming the awards in 2003. Awardees have been Bishop Leonidas Proaño Villalba, Ecuador (1986); Cardinal Archbishop Paulo Evaristo Arns, Brazil (1988); Bishop

Medardo E. Gomez Soto and Maria Julia Hernández, El Salvador (1990); Monseñor Rodolfo Quezada Toruño, Guatemala (1991); Oslobodjenje, Bosnia (1993); Selima Ghezali and Abdennour Ali-Yahia, Algeria (1997); Ishai Menuchin, Israel (2003); Torture Abolition and Survivors Support Coalition, International, USA (2005); and Shanti Sellz and Daniel Strauss, No More Deaths, Arizona (2007).

26. As the only fluent Spanish speaker in the group, I was asked to announce the award on Salvadoran television.

27. Some of her own Huguenot ancestors after all had narrowly escaped the horrors of the sixteenth-century St. Barthélemy massacre (while others may have perished in it).

28. For a profound discussion of the history and philosophy of torture in Western civilization, see Elaine Scarry, *The Body in Pain: The Making and Unmaking of the World* (New York: Oxford University Press, 1985).

29. Dominique de Menil's speech at the second Rothko Chapel Awards for Commitment to Truth and Freedom, Menil Archives.

30. Dominique's donation occurred in conjunction with the award of the Carter-Menil Human Rights Prize to the Norwegian Institute for Applied Social Sciences "in recognition for the inspirational work and leadership of Norwegians in laying a foundation for peace between Israel and the Palestinian Liberation Organization." It may very well have been her determination to personally see this highly significant symbolic gesture to its conclusion and the attendant exhaustion that precipitated the illness from which she never fully recovered.

31. Joan H. Pachner from New York University's Institute of Fine Arts wrote, "In *Marriage*… [Smith] wanted to incorporate an intuitive sense of scale so self-evident and familiar as to be almost invisible. Smith's sensitivity to the role of the body in sculpture stems … from architectural proportion, *which used man as measure* [emphasis mine].… His idea of the 'monumental' … evokes the strength of a religious experience, when one is transfixed by a vision or, potentially, equally moved by the abstract sublime of a painting by Barnett Newman or Mark Rothko." From the pamphlet for the monument's dedication in Oslo, 1996, Menil Archives.

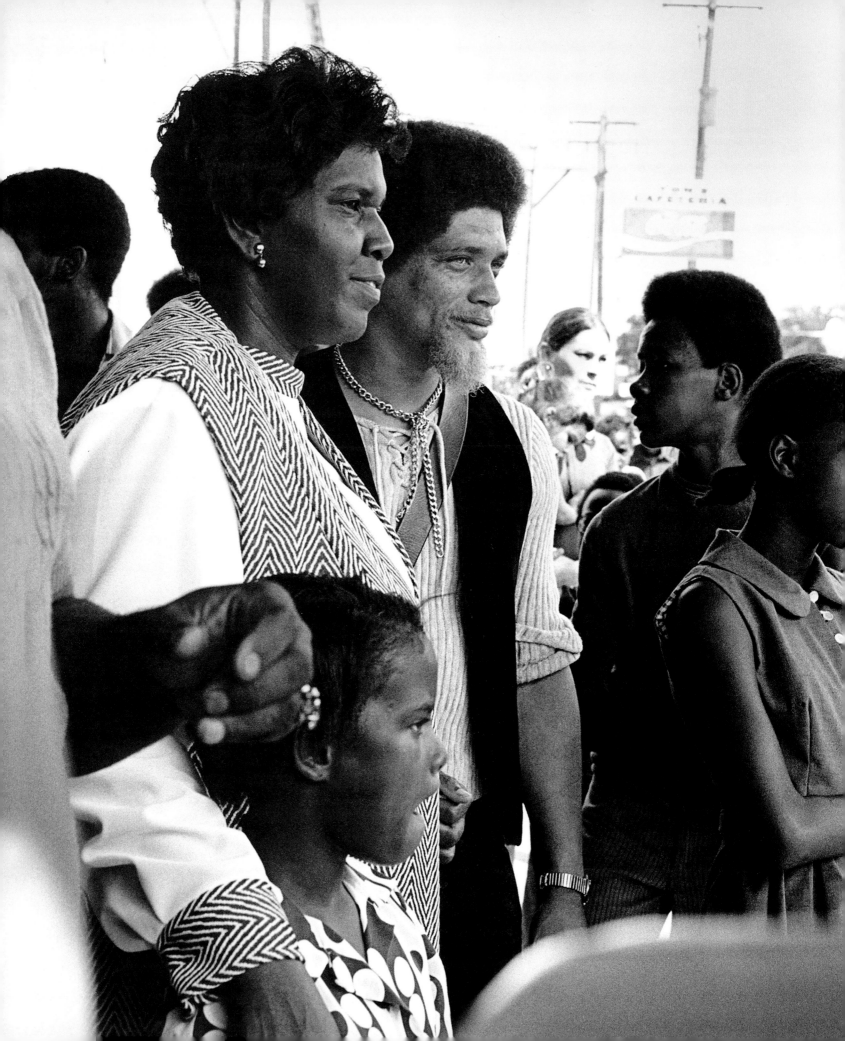

John and Dominique de Menil and the Houston Civil Rights Movement ALVIA J. WARDLAW

Shot Kills Texas Policeman in a Riot at a Negro College

HOUSTON, May 17—A policeman was killed and two other policemen and a student were wounded early today in an exchange of rifle fire during a five-hour riot at Texas Southern University, a predominantly Negro school.

New York Times, May 18, 1967

Fig. 8.1
Congresswoman Barbara Jordan and Mickey Leland at Wheatley High School Alumni Day at "The De Luxe Show," De Luxe Theater, Houston, 1971

On May 17, 1967, one of the most horrific events in the history of Houston race relations occurred on the campus of Texas Southern University (TSU), with its all-black enrollment. After demonstrating for weeks about the heavy traffic on Wheeler Avenue, a street that split the campus, as well as the common occurrence of whites hurling insults at the TSU women from cars as they sped by, the students had had enough. A few young men set fire to the contents of a trash can in the middle of the street to slow down the traffic, after which the Houston Police Department stormed the campus, shot hundreds of rounds into the men's dormitory, and forced students and their housemothers out into the night air in nothing but nightclothes (fig. 8.2). Scores of male students from the Lanier Hall for Men were taken en masse down to the city jail and booked, while HPD officers trashed their possessions. Harvey Johnson, an art major at the time who would later become a professor of painting at the university, was swept up in the arrest at the dorm:

> The next thing we knew, we were surrounded by HPD, and we could hear gunshots and breaking glass. They made us lie in the broken glass on the floor in our underwear. Then they had us run through them; the student in front of me got hit on the head with the butt of a gun. They piled us into a paddy wagon. As we were driving to the police station, the officers talked about how they were going to throw us in the bayou…. At the station, the officer questioned me using the term "nigger."… He insisted that I answer him with "Yes, sir" and "No, sir."

Fig. 8.2
Students held by police, Texas Southern
University, Houston, May 17, 1967

The next day we were let go in our underwear. My friend and her mother came to pick me up. I was in shock, like I didn't know where I was. All this time my mother was trying to find me. People came from out of state—Chicago, Tennessee—trying to find their children. They tore the dorms up so much that we didn't go back until September.[1]

The altercation was broadcast throughout the country. (I sat in shock in my New England dormitory as I watched the campus that I literally grew up on turn into a war zone.)[2] In the barrage of gunfire, one officer was killed by a ricocheting bullet from a fellow officer's weapon, and five students who came to be known as the "TSU Five" were charged with murder.[3]

John and Dominique de Menil also watched the unfolding events. Anonymously, John de Menil paid the legal fees for these young men and rented buses to take students and community members to Victoria, Texas, where the trial was being held.[4] This is but one instance of the de Menils' support for a fundamental change in the Jim Crow environment that defined Houston at mid-century. The city back then was effectively segregated by a division into wards that were largely black or white, a pattern that held in its educational systems, social circles, and religious practices. Connection between blacks and whites was limited largely to black domestics who worked in white homes or to black men and white men who worked together at places such as the Port of Houston. Though the city was beginning to attract cultural celebrities, police brutality under Chief Herman Short often supplanted accounts of the city's growing sophis-

tication on the front pages of the papers, especially the *Forward Times* and the *Informer*, the two major local African American newspapers of the time.

Through graphic photographs and editorial commentary, black journalists reported the many abuses of the HPD toward the black community. The de Menils responded to this state of affairs in numerous ways. Their efforts included the documentation project showing blacks in Western art, the dedication of a sculpture to Martin Luther King Jr., the fostering of black cultural expression and education, the organization of art exhibitions in the Fifth Ward, the support of black political candidates and Black Panther projects, and the provision of seed money for black-run initiatives. Often anonymously, the de Menils sought to encourage citizens both to examine their racial biases and to help rectify the injustice that occurred too often in the city that the couple had adopted as home.

I met Dominique de Menil not in Houston but in Brooklyn, while I was a student at the Institute of Fine Arts, New York University, in 1970. I was studying Egyptian art with Bernard von Bothmer, curator at the Brooklyn Museum and a personal friend of Dominique's. Bothmer shared with the de Menils the results of his excavations and research of Nubian culture and advised them on their acquisition of the Nubian head now in the Menil Collection. A few months later, I received a call from Dominique de Menil asking me to write an essay for an exhibition she was curating for the Black Arts Gallery in Houston. On my next trip home, I visited the de Menils, and she shared with me—with much enthusiasm and excitement—the hundreds of images that she had collected of blacks in Western art. It was the beginning of a long and intermittent conversation that spanned years and topics; we discussed professional matters, such as questions of connoisseurship in African art, and more personal ones, such as the raising of my then-toddler son.

Moving to the United States from wartime France had been a major adjustment for John and Dominique de Menil. They brought with them not only a European aesthetic, but also the very real memory of what war can do and the terrible costs of oppression. That they were contemporary art collectors was extreme enough for many in Houston, who tended to prefer Frederic Remington to René Magritte, but their unapologetic concern for the welfare of Houston's disadvantaged African Americans further distinguished them from the city's old guard. Still, not only did the de Menils find common ground with those art patrons who wished that Houston could gain more prominence as a cultural nexus, elevating its status in the visual arts on a par with that of iconoclastic conductor Leopold Stokowski's grand presence at the Houston Symphony, but they also touched many with their global vision and the importance they accorded the contributions of Africans and African Americans to world culture.

Fig. 8.3
Aelbert Cuyp, *The Baptism of the Eunuch*, ca. 1642–43.
The Menil Collection, Houston

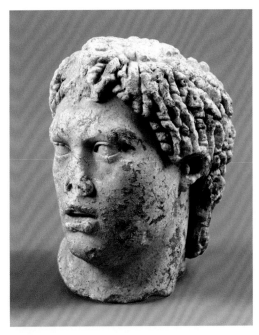

Fig. 8.4
Portrait Head, Asia Minor, Hellenistic, 1st century AD.
The Menil Collection, Houston

The de Menils' decades-long visual archive and publications project, the Image of the Black in Western Art, now housed at Harvard University, is a testament to their determination to right the language of art regarding the presence and contributions of Africans and African Americans. Dominique de Menil explained: "The decision in 1960 to launch a systematic investigation of the iconography of blacks in Occidental art did not proceed from any clear plan. It was an impulse prompted by an intolerable situation: segregation.... Many works of art ... reveal a depth of humanity beyond any social condition, race, or color. So why not assemble these works in an exhibition or a book? With such a naïve approach, a serious enterprise was started. It ... uncovered the breadth and complexity of problems, which had their roots in history, in myths, in the collective unconscious."[5] Understanding, however, that the intellectual nature of the project was not a panacea for race relations, Dominique de Menil noted, "Such a large effort and such an abundance of collected material bring sobering reflection. Undeniably, we are confronted with a gallery of blacks ... some plain, some beautiful, some even quivering with life.... Though whites are invisible ... it is their customs, their tastes, their prejudices, their phantasms, and their romanticism that have been captured in these images.... The past is heavy. To face it, to assume it, facts must be brought candidly to light. The making of a more human world requires rigorous studies."[6]

For over forty years, the Menil Foundation funded the endeavor; the archive at present comprises thirty thousand images, and three of four multipart volumes chronicling the history of blacks in Western art have been published. The couple also acquired many artworks relating to this research (see figs. 8.3–4). The care the de Menils gave to the study of the perception and representation of people of African descent demonstrates their belief in art as a social force. In the 1960s the art world was as political as any other, and to show the cultural presence of blacks during the Renaissance was very much a statement of civil rights. In a just world, all have a right to recognize and celebrate their cultural splendor. The first volume of *The Image of the Black in Western Art* was a groundbreaking publication in the art world, while in the civil rights arena, the images pictured in those pages were food for the soul.

John and Dominique de Menil's actions were not always so academic or behind the scenes. A year after the assassination of Dr. Martin Luther King Jr., they offered to match a federal grant to secure Barnett Newman's *Broken Obelisk* as a gift to the City of Houston. Initial press coverage of the gift was glowing. Ann Holmes, art critic for the *Houston Chronicle*, observed that the work of art had "already attained an unusual fame," having been installed outside the Seagram Building in New York and the Corcoran Gallery of Art in Washington, D.C.[7] Then the de Menils announced that they wished to dedicate the work of art to the memory of Dr. King.[8] Polite consternation ensued among city leaders and the Municipal Art Commission. Holmes sounded almost plaintive as she wrote, "The commission has recommended that the piece be given as a work of art, solely. The complexity now

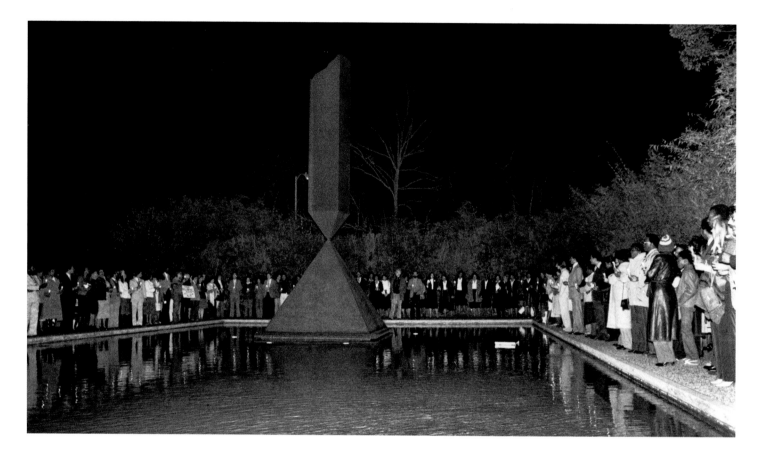

surrounding it, because of the dual grant and other considerations, could conceivably place the whole gift in jeopardy. There is no reason why a Martin Luther King memorial should not be raised here—but either project is lessened by playing in tandem with something else."[9]

The project moved like a hot potato from the nervous members of the Municipal Art Commission—who claimed that weighing in on the dedication was outside their jurisdiction—to the mayor's office. When the de Menils appeared before the city council to argue for the gift, John de Menil was pointedly direct: "We understand you want to know why we have asked for this dedication. We ask, 'Why not?' We cannot understand your objections and we were deeply surprised when the proposed dedication was not approved."[10] In the end, the city council under then Mayor Louis Welch rejected the gift. Holmes seemed to echo the dismay of the city leaders at being forced to admit the relationship of art to the real world: "It's all a monumental headache. Hopefully donors, art commissions, and the public will realize that quality, imagination, and implicit design are essential beyond the consideration of current matters, if we're to be dealing with art as opposed to politics."[11] Newman supported the de Menils' decision: "I am very moved by what you have done and I feel with you, I am sure, a very special sense of happiness. After all, it is not every day that we can stand up to the Philistines and win."[12] However,

both the artist and his patrons saw meaning in *Broken Obelisk* beyond its association with Dr. King. Newman wrote to the de Menils, "I hope that my sculpture goes beyond only memorial implications. It is concerned with life and I hope that I have transformed its tragic content into a glimpse of the sublime."[13] The de Menils purchased the work themselves, donated it to the Institute of Religion and Human Development, and installed it in a reflection pool (fig. 8.5), created for that purpose, in front of the Rothko Chapel in October 1970.

Similar objections arose when in spring 1970 the Menil Foundation worked with Rice University students to bring poet LeRoi Jones (now Amiri Baraka) to Houston to speak on campus and then suggested a venue change to TSU (see fig. 8.6).[14] Jones was a fierce speaker and proponent of the Black Arts Movement whose writing and activism were raising the awareness of audiences on the East Coast regarding the brutality of life for blacks in America. This engagement would represent his first appearance in a public forum in Houston, and it seemed appropriate to hold his lecture at a black university. When it was suggested to make the appearance a joint sponsorship with TSU, Rice University administrators responded that it was "against their policy to make any payment for a function that wasn't taking place on their campus."[15] Jones's speaking engagement became an issue and once again the parties involved looked to the

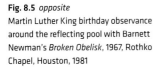

Fig. 8.5 *opposite*
Martin Luther King birthday observance around the reflecting pool with Barnett Newman's *Broken Obelisk*, 1967, Rothko Chapel, Houston, 1981

Fig. 8.6 *right*
Poster advertising visit by LeRoi Jones (Amiri Baraka) to Texas Southern University, Houston, 1970

Fig. 8.7 *far right*
Mickey Leland, Granville Sawyer, and John de Menil at the opening of "Some American History," Rice Museum, Rice University, Houston, 1971

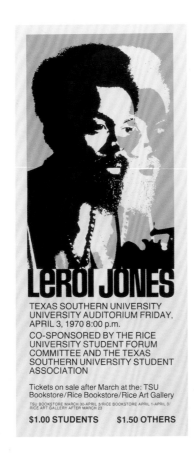

Menil Foundation to make things happen. The foundation finally ended the back-and-forth discussion by paying Jones directly for his TSU appearance. A. L. Palmer, then TSU fiscal vice president, later expressed his gratitude to Dominique de Menil, saying, "Many… activities would be impossible without your generous support."[16]

In the early 1970s, John and Dominique de Menil funded numerous other programs in the arts, humanities, sciences, and education at TSU. They had contact with artists John Biggers and Carroll Harris Simms, who had established an impressive studio art program at the school, a lively presence as early as 1952 when Dominique de Menil brought Max Ernst there to meet the professors and their students. (Ernst was so impressed with Biggers's drawings that the de Menils purchased one for him.) The de Menils' involvement in the community went beyond the promotion of an aesthetic awareness; they believed equally in the importance of training African Americans in the sciences and education. In July 1971 the Menil Foundation began discussions about expanding the undergraduate program within the School of Pharmacy and four months later committed to supplying significant seed money to develop a $750,000 campaign to that end.

TSU pharmacy student Mickey Leland was the force behind this initiative. John de Menil had contacted Leland at the suggestion of the university's president, Granville M. Sawyer, who touted the bril-

liant young man (fig. 8.7).[17] Soon to become an instructor at the school, Leland had ambitious plans to "develop a truly effective program in clinical pharmacy… to enable advanced students to learn how to practice and refine their professional skills… by working in hospitals, health service clinics, [and] nursing homes," as he wrote to John de Menil. He added, "At the present time, there is, to our knowledge, no school of pharmacy which now includes this type of program in its curriculum."[18] Thus began a long and fruitful relationship between the young activist and the de Menils, especially John. They responded to Leland's energy and enthusiasm: "We asked Mickey whether or not he would be willing to face the sweat of raising that kind of money…. Mickey gladly accepted the challenge."[19] Remaining behind the scenes, the Menil Foundation provided money to hire a fundraising consultant and public relations firm to work directly with TSU to get the campaign off the ground. After several months, TSU was pleased with the publicity effort but expressed disappointment with the fundraising results, and Leland left the School of Pharmacy to pursue a political career; concurrently the de Menils ended their support of the project.

After he became a Texas State representative, Leland continued to have a role in Menil Foundation projects. He passed along a request from Reverend William Lawson in April 1972 to help fund a trip

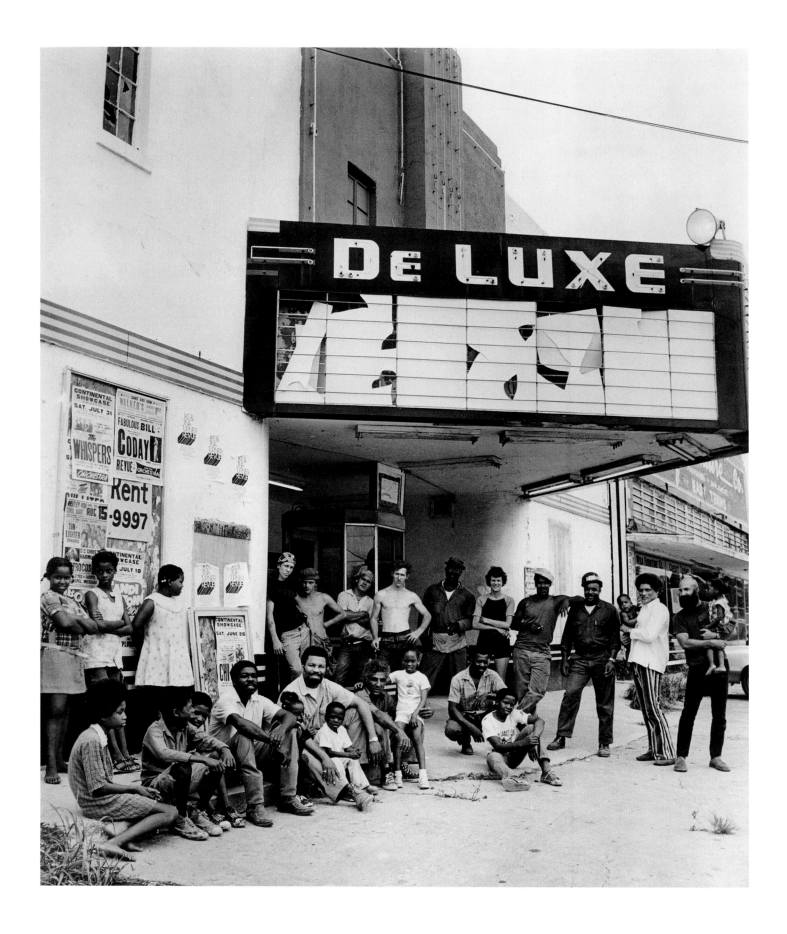

to Europe for the TSU dance group, choir, and opera workshop.[20] John de Menil, who was very moved by the efforts of the faculty to take TSU students on the concert tour, expressed his personal support for the project: "It will be an eye and mind opener. I am writing this of experience because I remember what a similar experience meant to me when I was the same age," [21] referring to the travel grant he received in college that enabled him to visit several countries around the world. The group sent a postcard to him while overseas, signed by all participants, saying, "Our first concert (in the Netherlands) was well received. Thanks a million for helping to make it possible."[22]

In 1975 the foundation contributed to an innovative program developed by the TSU School of Education that focused on the preparation of teachers in a newly integrated school system for assignment to schools that were different from their own cultural environment. Created by Launey F. Roberts Jr., the Suburban Teacher Education Program (STEP) sought to "assist students in gaining additional understanding and insight in bridging the socio-cultural gap that exists between life in suburbia and the central city."[23] The foundation supported this research for two consecutive grant cycles.

In addition to working within the university setting, the de Menils looked for ways to extend their community involvement into the neighborhoods where African Americans lived. In July 1971, in collaboration with Leland and others, the de Menils embarked upon the whirlwind creation of an exhibition in the predominantly African American Fifth Ward: "The De Luxe Show." In an effort to bring contemporary art to the black community, this exhibition— one of the first interracial shows of contemporary art in the United States—was housed in an abandoned movie theater called the De Luxe. Leland, a resident of the Fifth Ward, became the primary liaison, moving between the exhibition's artists (both black and white), the Fifth Ward black community, and the Menil organization. As coordinator of "The De Luxe Show," he had the daunting task of translating the visual language of contemporary art for the African American community of Houston.

Fewer than six weeks transpired from the conception of the exhibition to the opening night. The show galvanized the Fifth Ward community and created a rare interface between blacks and whites, one that was productive and goal driven. In preparation for the exhibition, the Menil Foundation worked in partnership with local (black) businesses to renovate the space in a record thirteen days

Fig. 8.9
Peter Bradley and John de Menil at "The De Luxe Show," De Luxe Theater, Houston, 1971

(fig. 8.8).[24] Curated by New York artist Peter Bradley (fig. 8.9), the show opened on August 22, 1971, featuring the work of an integrated roster of contemporary artists including Bradley, Anthony Caro, Sam Gilliam, Robert Gordon, Daniel Johnson, Kenneth Noland, Larry Poons, and William T. Williams. "The De Luxe Show" was a novel idea that set the Houston art world on its heels, even as the art baffled some Fifth Ward residents. Noted New York art critic Clement Greenberg assessed the show's importance:

> In my experience the effect of an art show, and especially of a group show, hardly ever becomes clear until six months or more afterwards. Far be it from me to know what the people in the Fifth Ward are going to conclude from what they saw at the De Luxe. That they will conclude something, I'm sure, simply because of the attention with which I saw them looking…. The De Luxe Show shouldn't be permitted to be a one-time thing; it should be followed up; otherwise it will lapse, in retrospect, to the status of a gesture. And I know that it wasn't meant as that…. It was meant, by those who put the show on, as seriously as it was taken by most of those who visited it.[25]

Greenberg's hopes were partly answered: when "The De Luxe Show" closed, the de Menils worked with community leaders to put the space—which became the Black Arts Gallery of the Black Arts Center—to new uses, paying the lease and utilities on the building and lending part of their African collection for an installation that

Fig. 8.8
Menil staff and neighborhood volunteers, including community coordinator Mickey Leland and Menil exhibition assistant Helen Winkler (*standing second and fifth from right*) and building contractor Sawyer Bynam (*sitting fifth from right*), De Luxe Theater, Houston, 1971

Fig. 8.10
Visitors to "Tribal Art of Africa," Black Arts
Gallery, De Luxe Theater, Houston, 1973

Fig. 8.11 *opposite*
Students at the Free Breakfast for School
Children program sponsored by the Black
Panthers, Houston, 1973

remained on view there for over two years. The installation was drawn from the exhibition "Tribal Art of Africa" (fig. 8.10), which the de Menils had organized, opening the show at the Black Arts Gallery on April 22, 1973. (It was for this exhibition that I wrote the essay that Dominique de Menil requested.[26]) The works were some of the best from the collection, and Dominique de Menil created an installation that drew the viewer in, attracted by the beauty of the forms and the magnificence of the artistry. As was always her way, she left much for the viewer to interpret rather than create a didactic presentation. It was like a wordless introduction for African Americans to a past that they could now celebrate. Students from local schools came to see the exhibition by the busload. That this installation followed edgy exhibitions of contemporary art—"The De Luxe Show" and "Joe Overstreet" in 1972—is an indication of the de Menils' commitment to making available to the black community art experiences that were rich and varied. They sought as well to make the space that they had created move forward in meaningful ways: during the same period, works from the permanent collection along with terracottas by Professor Carroll Harris Simms and his TSU students were displayed in the gallery space.

The interaction between the Menil Foundation and the Black Arts Center was not always smooth. On the one hand, some felt that the de Menils should allow local black arts advocates to take more of a leading role in selecting the types of shows to be presented, while providing support indefinitely to the Black Arts Gallery. The de Menils, on the other hand, regarded their efforts for the gallery—as was the case with many of their projects—as being catalytic rather than perpetually sustaining. Also, perhaps because he was used to running a large corporation, John de Menil wanted to see quick results, perhaps sooner, in some cases, than might be reasonable. Ultimately, the de Menils concluded that the leaders of the African American community should carry the initiative forward in all aspects, and they ended their lease on the space in January 1976. Not long afterward, the doors of the De Luxe Theater closed.

The ups and downs regarding the De Luxe project did not affect the de Menils' admiration and support for Mickey Leland, whose efforts in organizing the community and creating an audience for "The De Luxe Show" foreshadowed his future career in politics. John and Dominique de Menil went on to support Leland in his successful congressional run to replace the retiring Barbara Jordan (fig. 8.1), representing residents of the Fifth Ward in the U.S. House of Representatives.[27] Leland was not the only politician who received backing from the de Menils (they were lifelong political supporters): African American politicians, including Jordan, presidential candidate Jesse Jackson, U.S. mayoral candidate Curtis Graves, and Texas Representatives Senfronia Thompson and Sheila Jackson Lee, were

also a major focus of their efforts. The couple remained particularly close to Leland over the years. About John de Menil's influence on him, Leland said, "He took me, a militant who hated all white people, and made me into a humanitarian."[28] Leland's ability to connect with people and to get things done was something he had in common with John de Menil. He became an advisor and a voice for the black community within the Menil Foundation, serving on its board.

Farther out on the political spectrum, John de Menil also engaged with the Houston chapter of the Black Panthers. The link between the de Menils and the Panthers was Charles Freeman, a native of Port Arthur, Texas, who was one of two students to desegregate Rice University in 1965. John de Menil helped him for several years as Freeman sought to find a place for his intellectual rage against the "system." After leaving Rice, Freeman extended his activism to include a place

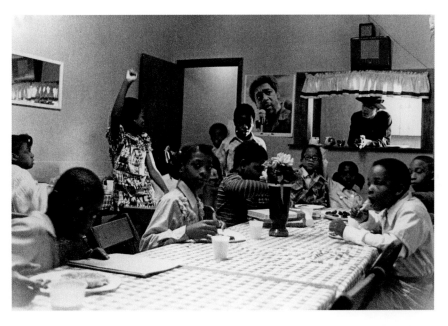

of leadership in the Black Panther Party, and in a continuation of his earlier support, John de Menil in January 1973 led the Menil Foundation to aid the Black Panthers in their efforts to establish a free breakfast program (fig. 8.11), a hallmark of the Panther Party that had begun in Oakland, California. A flyer advertised "Free Breakfast for School Children," and meals were served on weekdays at the Do Drop Inn, a Third Ward restaurant for home-style cooking near Dodson Elementary School. Known as "the bottom" by most Third Ward residents, this area still houses some of the neighborhood's poorest families.

The de Menils also contributed to other "survival projects" initiated by the Panthers, including the purchase of two hundred bags of groceries for free distribution at a spring 1973 rally supporting James Aaron, a convicted party leader who was believed to be a victim of racist police policies.[29] Stephen Edwards, information officer of the Panthers, wrote to Dominique de Menil shortly after her husband's death that June: "The late John de Menil, who made some very decisive steps towards helping to alleviate hunger, poverty and the many social obstacles, which dim our view and impede our growth, ushered in a whole new galaxy of social accomplishments and brought the Black Panther Party and the Menil Foundation together as a community-wide social force."[30] In 1974, after supporting a "no-cost" transportation program for the elderly, the foundation discontinued support of Black Panther programs. While the reasons remain unclear, it could have been a reaction to the City of Houston's implementation of a free breakfast program for children or the foundation's concern regarding the Panthers' management of its fiscal affairs. Either way, following John de Menil's death Dominique de Menil began to devote her attentions to the broader focus of human rights.

While the de Menils were eager to contribute to community projects, they funded them with the idea that their support should provide a jump-start and avoid becoming an overextended commitment to any one organization. The desire to provide aid to civil rights groups while also encouraging their autonomy was often a delicate balancing act. Such was the case when the de Menils set about to help students of color when they found out that local black-designated scholarships, such as the Jones and the Worthing scholarships, were being dissolved or opened up to white students because of the issue of "reverse discrimination," leaving many graduating African American seniors in need.

To keep the decision making within the black community, they insisted on their own anonymity. As John de Menil stated in the initial planning memorandum, "The program being for blacks must be handled by blacks. The white sponsors and the foundation will remain in the background."[31] The de Menils established the Committee for Upgrading Black Scholars (CUBS) in January 1973, which over a two-year period provided numerous scholarships to black high school students. Leland served as chair of the committee; Houston public school administrator Lawrence Marshall was designated the point person for the school district channels making these awards; and civic leaders Reverend William Lawson, pastor of Wheeler Avenue Baptist Church, and Robbie Hayes, a community activist for schools, were committee members. It was the intent of the foundation to provide initial support for the project, expecting CUBS to find sufficient outside income to become largely independent. When it became apparent that the committee was generating plenty of applicants but not raising enough additional money to sustain the scholarship fund,

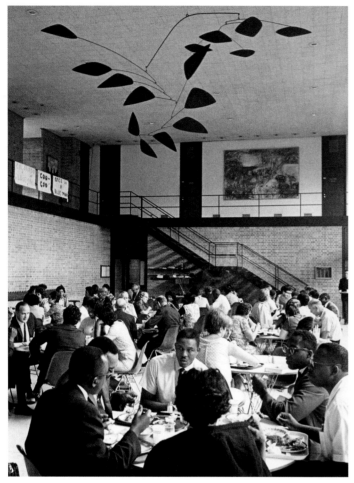

Fig. 8.12
Luncheon meeting of the Special Training Institute on
Problems of School Desegregation in the Houston Area,
Welder Hall, University of St. Thomas, Houston, 1967

the foundation grew discouraged. By May 1975 CUBS was being re-evaluated, and at some point shortly thereafter, the committee disbanded, but not before awarding a number of scholarships to African American students in the Houston area. Those students went on to study in a variety of disciplines, including law, accounting, and nursing, at institutions such as Michigan State University, the University of Houston, Rice University, and West Point.[32]

John de Menil often opted for anonymity, but when he chose to exert a public presence, he did not mince words. He believed especially in holding politicians to follow through on their promised actions rather than engage in empty posturing, as when in 1972 he questioned the mayoral candidate Fred Hofheinz's commitment to a climate of inclusion in Houston city government. Before offering his

endorsement, John de Menil asked a Hofheinz operative pointedly, "Will he undertake to have on his staff, at all levels, blacks and Chicanos in the proportions of 25% and 7% of the population? Will he seek actively decentralization of the police force under local community control, and with black and Chicano officers in the majority in their neighborhood?"[33] This sort of direct "man-to-man" conversation was John de Menil's trademark means of communication. Over the years he sustained an immediate and open dialogue with a network of African American men who pointed him to the needs of their community. Even more impressive was his relationship with the many young African American men whom he quietly mentored in exchanges based upon an unusual mutual trust: they gave him access to their own thoughts on the revolution they saw happening in the country in a way that was rare at the time. "He was not simply content to write a check to buy into the movement," states Deloyd Parker, an associate of John de Menil's who received ample support from the Menil Foundation for his important work in establishing SHAPE (Self-Help for African People through Education) a community center in the Third Ward.[34] For a wealthy European entrepreneur to sit down often with young black community activists and arrive at a common course of action, not once but many times, is notable.

The de Menils' civil rights activities were the precursors of later alliances, such as the one that developed between former President Jimmy Carter and Dominique de Menil, who learned from her husband to leverage her personal wealth and power to encourage a dialogue between disparate communities. And to some extent, the de Menils' actions, such as their support of public school desegregation programs (see fig. 8.12), contributed to the reputation that Houston gained for facing the challenges of the civil rights era and its own ingrained segregation (and police aggression) in a relatively peaceful fashion compared to other large cities. Despite the traumatic events of the TSU incident and other occasions of police violence, negotiations and dialogue were the more typical response to civil rights sit-ins and marches. In addition, discussions between black and white student leaders, moderated by such organizations as the NAACP and the Houston Council on Human Relations, were arranged in an effort to bring together the young to bridge their cultural and racial divide.

John and Dominique de Menils' greatest gift to Houston was their emphasis on creativity, social responsibility, imagination, and human interaction. Their positive acts prompted open and free discussions about art and education, racism and injustice. By promoting an inclusive social climate, the de Menils helped shape an atmosphere of community and the sense that all things are indeed possible for everyone.

NOTES

1. Harvey Johnson, interviews with the author, Houston, August–October 2008.

2. My father began teaching at TSU when I was four and continues to work at the university today as director of budgets. When I returned to Houston after completing work for my master's degree in art history, I began to teach art history in the TSU Art Department at the request of John T. Biggers.

3. Prosecutors decided to hold the students, rather than the police officers, responsible for the violence that ensued that day.

4. Deloyd Parker, interview with Laureen Schipsi, Houston, August 29, 2007, Menil Archives. The "TSU Five" were ultimately acquitted of all charges, and today that part of Wheeler Avenue is permanently closed.

5. Dominique de Menil quoted in Jean Vercoutter, Jean Leclant, Frank M. Snowden Jr., and Jehan Desanges, *From the Pharaohs to the Fall of the Roman Empire*, vol. 1 of *The Image of the Black In Western Art* (Houston: Menil Foundation, 1976), ix.

6. Ibid., x–xi.

7. Ann Holmes, *Houston Chronicle*, May 2, 1969.

8. According to the *Houston Post*, the de Menils decided on the dedication "because the sculpture—an obelisk with its top torn away—seemed to typify a life abruptly ended." See "An Obelisk for Houston," *Houston Post*, August 27, 1969.

9. Ann Holmes, "Heroic Storm Centers, Those Public Sculptures," *Houston Chronicle*, August 10, 1969.

10. John de Menil, "Why Not Dedicate Art to King, De Menil Asks City Council," *Houston Chronicle*, August 20, 1969.

11. Holmes, "Heroic Storm Centers."

12. Barnett Newman to John and Dominique de Menil, August 26, 1969, Menil Archives.

13. Ibid.

14. "Memo for LeRoi Jones Lecture File," Menil Foundation, Inc., April 8, 1970, Menil Archives.

15. Ibid.

16. A. L. Palmer to Mrs. John de Menil, April 6, 1970, Menil Archives.

17. "Miles Glaser and Dominique de Menil on Mickey Leland," transcript of interview with Adelaide de Menil, Houston, February 16, 1993, Menil Archives.

18. Mickey Leland to John de Menil, October 6, 1971, Menil Archives.

19. "Memorandum re: Grant to Texas Southern University, Pharmacy Department," Menil Foundation, Inc., October 13, 1971, Menil Archives.

20. "Memorandum to the Advisory Committee," Menil Foundation, Inc., April 10, 1972, Menil Archives.

21. John de Menil to Billye Batiste, April 11, 1972, Menil Archives.

22. TSU students to John de Menil, May 1972, postcard, Menil Archives.

23. Launey F. Roberts Jr. and Jacqueline Giles, *STEP: A Report on the Suburban Teacher Education Program* (Houston: Texas Southern University, undated), Menil Archives.

24. Simone Swan to Frances Stamper, August 15, 1971, Menil Archives.

25. "De Luxe Interview with Clement Greenberg," in *The De Luxe Show*, exh. cat. (Houston: Menil Foundation, 1971), 65.

26. Alvia J. Wardlaw, "Tribal Art of Africa: Selected from the Menil Foundation Collection" (photocopied typescript for exhibition "Tribal Arts of Africa," Black Arts Gallery, April 22– May 20, 1973), Menil Archives.

27. Leland served the 18th District in the U.S. House of Representatives from 1979 until his death in an airplane crash in 1989, which occurred while he was on a famine-relief mission to Ethiopia.

28. Mickey Leland, quoted in Marguerite Johnston, "De Menils' Driving Energy Was Key to IIE Success," part 3 of "The de Menils: They Made Houston a More Beautiful Place in Which to Live," *Houston Post*, January 11, 1977.

29. See Simone Swan to Charles Freeman, February 15, 1973, Menil Archives.

30. Stephen Edwards to Dominique de Menil, August 30, 1973, Menil Archives.

31. John de Menil, "Memo to the Committee for Grants and to the Members of the Board," January 16, 1972, Menil Archives.

32. The de Menil's financial support of African American students extended beyond high school seniors in Houston. For example, they provided funding to a doctoral candidate studying urban planning at Massachusetts Institute of Technology and, notably, to Sylvia Ardyn Boone, a doctoral student in art history at Yale University, whom they supported significantly from 1972 to 1979. Boone became the first tenured African American woman on the Yale faculty. For more information on Menil Foundation support of African American scholars, consult the Menil Archives.

33. John de Menil to Reuben Askanase, November 27, 1972, Menil Archives.

34. Parker, interview with Schipsi.

In Good Faith:
Remembering John de Menil

DELOYD PARKER

Fig. 9.1

Deloyd Parker with local children,
Dar es Salaam, Tanzania, 1973

Charles Freeman, one of the "TSU Five,"[1] introduced me to John de Menil in the summer of 1971. Charles told Mr. de Menil about SHAPE (Self-Help for African People through Education), the community center I started in Houston's Third Ward in 1969, and set up a meeting for us at the de Menils' house in River Oaks. I'll never forget going there: John, Charles, and Helen Winkler and I sat down in the front room and began to talk. Mr. de Menil wanted to find out who I was. Since he had heard about me from people he trusted—Charles and Mickey Leland—he didn't have a lot of questions. He just wanted to know about SHAPE, so I told him about it.

We ended up having a long talk about human rights issues. After a while he asked me, "Well, what do you need? The Menil Foundation would like to give some help with no strings attached." It threw me. I was hesitant, and he said again, "What do you need?" It was obvious we were struggling. I didn't have to worry about a place to stay, but all of us who worked at SHAPE at the time were volunteers. My wife and I were getting by on her small salary. Since I hadn't come there to ask him for money, I didn't know exactly what we needed, so Mr. de Menil asked me to think about it and come back in a few days. I started thinking: "Let me see now, my rent is this. I need food to eat. There's the free breakfasts we serve to kids every morning before school, the after-school classes on black history, and the tutoring in math and science by TSU students." When I met with Mr. de Menil again, I said, "We need $240, which will cover the rent, utilities, and telephone." And that was that. We received that much or more every month. I bet if I had said more, he would have given it. But I didn't think that way. I was just a young brother wanting to get something to keep the program going. And he read that.

Beyond the regular payments, Mr. de Menil would give us money for such things as books for our library, office supplies, and audio equipment. We didn't have any transportation, so he gave us a van they had been using at Rice. When we grew out of our main center

and needed more space, he bought a building for us and continued to pay rent on the other one. Jody Blazek, who worked as the treasurer at the Menil, began donating her time to help us at SHAPE with our 990 tax returns. All of these things were done in a very low-key manner—he didn't want to tell us how to run anything. I'd say, "You know, whatever you give us, we'll still be doing what we're doing. We can't be controlled by anybody. That's why we don't get funds from foundations, corporations, or the government, because they are going to tell us what to do with the money." And he understood that.

In January 1973 the Menil Foundation increased its monthly contribution to SHAPE, paying a salary for me so that I could quit my night job, and paying the salaries of the two teachers who taught at the center's no-cost, all-day preschool for children of working parents. John de Menil had cancer, and he knew he was dying, so I think he was looking out for SHAPE, giving it high priority so that it could live on after his death.

I was always talking about Africa, Africa, Africa, and one day in the spring of 1973 Simone Swan, who worked for the Menil Foundation and was very involved in community-based grants, said, "Deloyd, why don't you go?" She said that she had discussed this with the de Menils; they thought it would be good for me, for my colleagues, and for the children at the center, and they wanted to help. The next thing I knew, my wife and I had our tickets. In the following August, we were on our way to Kenya and Tanzania.

John de Menil was very quiet in many of his actions. He was involved in more things than anyone realized—including financing and funding human rights issues. Once, he helped finance a major fundraising event for Martin Luther King Jr. in Houston. It was a concert, 1967, given by Harry Belafonte and Aretha Franklin, followed by a speech by Dr. King. At first tickets for the event were being sold through an agency, but it stopped selling when the employees received death threats, and a smoke bomb was thrown into one of their stores. So, on the day before the concert, only one-third of the tickets had been sold. The organizers were afraid they were going to lose money and that the press would have a field day because of the small turnout. When Dr. King heard the news, he got down on his knees and prayed. Then he said, "Give away the tickets," so the concert hall would be full. On the day of the concert, a car drove up, and the driver got out and handed the organizers an envelope, saying, "This is from my boss, John de Menil." None of them had heard of Mr. de Menil at the time. Inside was a check that paid for all of the tickets and expenses.[2] Then there was Lee Otis Johnson. He was a member of the Student Nonviolent Coordinating Committee and an activist in the sixties and seventies at Texas Southern University. He was like the Malcolm X of the movement in the Third Ward. In 1968 he got arrested and convicted for one marijuana cigarette and was given thirty years. His sentence was politically motivated. Mr. de Menil helped with his legal fees.

One of the best qualities about John de Menil was his open mind and commitment to individual people and a cause. Either he trusted you or he didn't; once he made the decision, that was it. No questions asked. You didn't have to go through an act of Congress to get what you needed. When he and Dominique de Menil opened the De Luxe Theater in the Fifth Ward, bringing their African collection for people in the neighborhood to see, it was a great act of faith in the community. The De Luxe was in a poor neighborhood, which at the time was so crime ridden it was called "Pearl Harbor." What impressed us even more than the art was the fact that the de Menils trusted it to be shown in our neighborhood. We understood that they were leaving it in our hands.

I think John de Menil and I got along so well because he looked to me and others within the black community for our views on human rights. I couldn't see him being comfortable in the African American arena without making contacts and interacting with those who were important parts of that experience. I think our views had some impact on him. Frankly, at the time I was not used to speaking to Europeans the way I spoke to him; I didn't have much use for them. I was and am very involved in the African American community in Houston, and I didn't exactly see how John de Menil fit in. But I thought a lot about our discussions, and I got comfortable talking to him—to a white man about the black community. It worked with him because he was very interested, open, and honest, and he didn't want anything. So I didn't feel like I had to keep anything back. He loved people. He believed in fairness, and he used his role to help, to whatever degree he could, to pursue justice.

After Mr. de Menil's death, I didn't have as much close contact with the Menil Foundation. My relationship was with him. Even still, maybe as a tribute to him, the foundation continued to contribute monthly to the center until 1989. I don't even know if SHAPE would still be here, if we would have lasted, without John de Menil's early support and enthusiasm. We were young, and it benefited tremendously. It helped open up the doors to more communication between blacks and whites as well. He brought us together.

NOTES

1. See Alvia J. Wardlaw's "John and Dominique de Menil and the Houston Civil Rights Movement" in this volume.

2. Memorandum, "Conversation with Curtis Graves about John de Menil Donation for MLK Visit to Houston," Menil Foundation, Inc., December 2, 2008, Menil Archives. See also Curtis Graves, "Help from on High," in Juan Williams, *My Soul Looks Back in Wonder: Voices of the Civil Rights Experience* (New York: AARP and Sterling Publishing, 2004), 150–51.

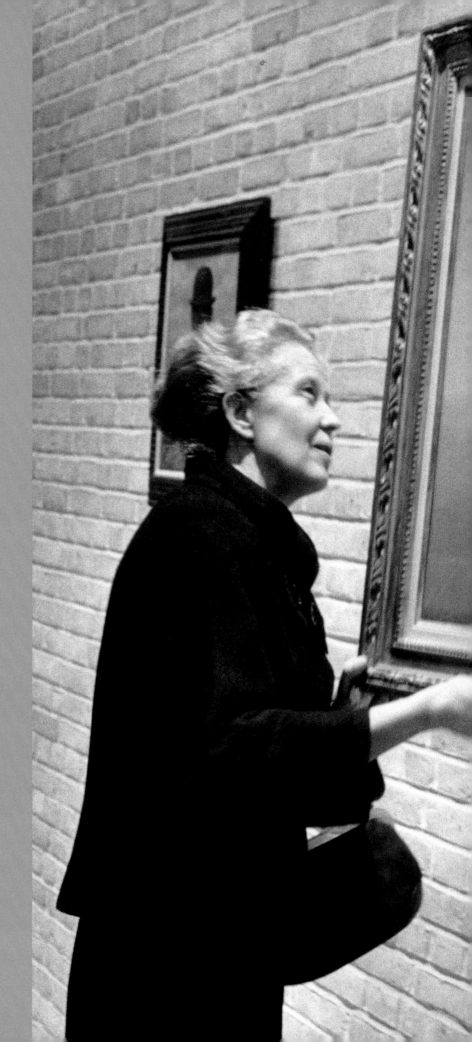

Art Has Many Facets

COLLECTING AND COMMISSIONS

Losing One's Head:
John and Dominique de Menil as Collectors KRISTINA VAN DYKE

pages 116–17
Dominique de Menil and René Magritte installing works, University of St. Thomas, Houston, 1965

Fig. 10.1
Study, de Menils' home, Houston, ca. 1972

John and Dominique de Menil built their collection on the simple but profound premise that art is not the preserve of the elite but rather a basic human necessity—if not fully on par with food, water, and shelter, then certainly a vital complement to these essentials. For them, a work of art expresses something of what it means to be human in the world, and as such contributes to our own search for meaning. The couple was energized and humbled by the works they encountered. Keenly aware that their collection would outlive them, the de Menils did not conceive of acquiring in terms of possession or property.[1] The artist Roberto Matta, who became a close friend of the de Menils', said that they did not collect or amass art so much as experience a sense of self-awareness as a result of their encounters with it. Collecting, for the de Menils, was "a way to know oneself, like a mirror, a way of seeing oneself."[2]

Little in the first years of their marriage indicated that the de Menils would build an outstanding art collection, much less develop such a strong humanist argument about its importance. During the 1930s, the couple lived in Paris, where the demands of John de Menil's career and their growing family occupied them. As Dominique de Menil once said, "We had not bought any paintings in Paris before the war because we did not have the means but also because it did not even occur to us."[3] Lack of funds and interest were not the only things preventing them from becoming collectors. They had to unlearn biases. For Dominique, this was a Protestant prejudice against the perceived luxury or frivolity of art, which she often

Fig. 10.2 *top*
Barkcloth, Humboldt Bay, Papua Province,
Indonesia, ca. 1929. The Menil Collection,
Houston

Fig. 10.3
Max Ernst, *Portrait of Dominique*, 1934.
The Menil Collection, Houston

spoke of in later years: "To collect paintings … I really had to overcome a block, a Puritanical block. In my family, … it was considered slightly immoral to spend on art…. Alsatian Protestants thought that indulging in the good things of life was definitely dissolute."[4] Nonetheless, she recalled having a deep yearning to collect even as a child. She said that she had "inherited the craving, the unfulfilled craving of my mother and grandmother," suggesting that they had been frustrated collectors.[5]

It is interesting to note how the couple retrospectively framed some of their earliest acquisitions as guilty indulgences or pleasures justified by helping out the seller. For example, they acquired two barkcloths in 1932 from Jacques Viot (fig. 10.2), a field collector working for the Parisian dealer Pierre Loeb. Explaining this purchase, Dominique de Menil said, "Here and there, you know, something came our way and we did buy, without collecting…. Then this tapa from New Guinea just fell into our lap. The man who had brought it back needed money, so we bought it."[6] A similarly oblique charitable impulse informed the couple's commissioning of a portrait of Dominique de Menil by Max Ernst in 1934 (fig. 10.3). They had intended to ask the artist, introduced to them by an acquaintance, to paint a decorative mural in their apartment, but decided against moving forward when they saw his work. To save face and help the artist, they commissioned a portrait, the significance of this decision and acquisition itself dawning on them only much later. Returning to Paris after the war, they discovered the painting wrapped in paper and left on top of a cupboard. As Dominique de Menil recalled, "We opened it and then we screamed, because by that time our eyes were open and maybe there is still not a resemblance, but the colors … and the whole composition is really so imaginative. So ever since, we've liked it enormously and it was this extraordinary feeling that our eyes were different, we hadn't seen something, and now we could see it."[7]

It seems that only after they had acquired a number of works of art and begun to live with them could they start to see art as a transformative agent. John de Menil described the way art could affect one's thinking in terms of an ever-evolving relationship: "And then there is that extraordinary companionship with that painting on your wall or that beautiful object on your table. And it's immensely valuable; it's the right kind of companionship…. [You have] to sit and do nothing, just let your mind get disconnected and then it starts meander-

ing around new ideas. It starts being sensitive to new feeling.... There you sit.... Every day you look at them and you find something else in them."[8] Once they recognized this potential in art, however, the de Menils felt not only justified in building a personal collection, but also compelled to use the collection to affect the lives of others. Given that the origins of their collection were rooted in this emotional and spiritual relationship to art, it is little wonder that their history as collectors can be framed in terms of a near religious conversion and an accompanying desire to evangelize.

The de Menils began collecting seriously in the mid-1940s and within five years had become increasingly confident, acquiring works of art at an impressive rate. The vast majority of the nearly seventeen thousand objects housed at the Menil Collection today were acquired by the couple over six decades, either privately or by the foundation they would establish in 1954, with significant gifts from family members and friends adding to the total. The objects the de Menils collected span centuries, from the Paleolithic era (22,500 BC) to works made in the 1990s, and cover a vast swathe of the globe, including Africa, the Americas, Europe, and the Pacific Islands. They collected works of all kinds, including painting, sculpture, drawings, prints, and photography, as well as folk art, vernacular objects, and curiosities. Despite the wide range of art history the de Menils' collection covers, it was not, nor did they intend it to be, encyclopedic. In fact, it was decidedly idiosyncratic. As Dominique de Menil said, "One of the characteristics of my collection is its partiality.... I feel a private collection does not have to be comprehensive."[9] She also noted that she and her husband had no collecting plan: "We did not go by theories. When you love something you just buy it—if you can afford it."[10]

Although they allowed themselves to be open to new discoveries and passions, they did not leave everything to chance. They relied on the advice of a core group of dealers and advisors, and made a commitment to particular artists. When they began mounting exhibitions and developing scholarly projects under the auspices of their foundation, or engaging in social activism, their collecting interests moved in tandem. The couple was candid about their learning curve, acknowledging that every work they acquired was not a masterpiece. As John de Menil said, "So there are fakes. There are the lemons. Then there is the total involvement and the engulfing passion. But frankly it's worth it."[11]

Fig. 10.4
Georges Braque, *Vase et poisson noir*
(*Pitcher, Candlestick, and Black Fish*), 1943.
The Menil Collection, Houston

Beginnings of the Collection

The de Menils acquired diverse and relatively unimportant objects on occasion in the early years of their marriage. Their first significant step toward becoming serious collectors took place at the end of the war, by which time they had established their main residence in Houston and a townhouse in New York while maintaining family homes in France. In 1941, during one of their frequent visits to New York, they had become reacquainted with Father Marie-Alain Couturier, the French Dominican priest they had met in Paris who held pronounced views on the need to integrate contemporary art into the Catholic Church; he later initiated projects incorporating the work of modernist artists into churches at Assy and Audincourt and a chapel at Vence.[12] The de Menils credited Couturier with opening their eyes, in essence converting them to the power of art. Dominique de Menil said, "He had a really decisive influence on us.... He took us to galleries and museums and it was the first time that we really looked at paintings seriously. I remember our first visit to the Museum of Modern Art with him. We had finally been able to appreciate the Cubists. At least we thought that made sense. But then ... he showed us the Mondrian, and I still remember very clearly I said to him, 'Oh, Father, no, this is really going too far.' And each time we couldn't accept something, well, we finally got to appreciate Mondrian."[13]

Given this tutelage, it is unsurprising that Couturier was instrumental in the couple's first serious purchase, in 1945. After the war the couple had put aside money, thinking they would owe taxes to the U.S. government. When that was not the case, Dominique de Menil suggested they do something special with the money (yet another example of a kind of justified indulgence). Around this time John de Menil took a trip to New York and, while visiting galleries with Couturier, used the earmarked money on the "spur of the moment" to buy three paintings—one by Dufy, one by Chaïm Soutine, and a watercolor by Paul Cézanne—without consulting his wife.[14] He said, "Those things arrived and very promptly Dominique showed her disapproval and promptly she proceeded to trade them out. And against the Dufy we got a beautiful [Fernand] Léger and I'm very happy with it. And against the Soutine we got this [Georges] Braque, which is a great painting (fig. 10.4). And on the Cézanne watercolor, there was no compromise possible. I just stuck to my guns and now she loves it.... That set us on the road. That's really how it all started."[15] At the time, John de Menil was forty-one and his wife was thirty-seven. They had four of their five children, had just been through a war, and were transitioning to their new lives in Houston. It seems remarkable that their collection was born in this hectic moment and all the more so that they would establish such a large and important collection with such a late start in a matter of decades.

From Modernists to Surrealists

Having set off on their path, the de Menils acquired a number of important paintings in the final years of the 1940s. These included works by Giorgio de Chirico, Yves Tanguy, Victor Brauner, Georges Rouault, Jean Hugo, Renzo Vespignani, and Christian Bérard, as well as additional works by Braque, including *Poisson, hûitres et pichet* (*Fish, Oysters, and Pitcher*), 1941, and Léger, such as *Étude en violet et jaune* (*Study in Violet and Yellow*), 1944. Though clearly focused on painting, they occasionally added a work from antiquity, a pre-Columbian artifact, or a religious sculpture to their growing modern collection. While in the early days of their marriage they had acquired pre-modern works from time to time, they were now more deliberate in their purchases.

At New York's Hugo Gallery, they encountered another figure who would come to have a strong influence on their collection and become a close personal friend, Alexander Iolas.[16] A former ballet dancer of Greek origin who had immigrated to the United States in 1933, Iolas directed the gallery on 55th Street. In 1953 he relocated it to 57th Street between Park and Madison Avenues, renaming it the Alexander Iolas Gallery. The de Menils were undoubtedly sympathetic to his views on art as something that can possess collectors, as opposed to being possessed by them. Iolas said, "A beautiful painting is beyond pricing ... because if we love them, we can love them without even seeing them [in front of us.... The art] stays within you, it enriches you.... The artwork is what makes you rich."[17] He, in turn, appreciated their willingness to take risks and to support and promote artists in his gallery who were not widely known at the time. For example, Iolas believed strongly in the German-born artist Wols (Alfred Otto Wolfgang Schulze) and was frustrated that his work met with indifference or outright hostility from viewers in the gallery. The de Menils were the exception, purchasing two paintings and fifteen drawings by Wols between 1950 and 1954. Iolas admired the de Menils' approach to collecting: "[F]or them, it was not the knowledge [of art history]... because most of the things that they bought, nobody had ever heard of. Nobody wanted them, even.... It was not the knowledge that helped them, you understand. It was instinct, and maybe something subconscious."[18] He also noted the couple's chemistry as collectors and patrons: "She was the motivation, the big precursor. But Jean [John] finished things from every point of view: materially, financially, everything, you understand."[19] Iolas was the source of over 350 works of art that would find their way into the collection between the 1940s and 1970s, including important paintings by Pablo Picasso, Braque, Joán Miró, and other modernists, as well as Egyptian, Greek, and Roman pieces. Perhaps more importantly, he was the source of more than thirty works by Max Ernst and more than fifty by René Magritte, artists to whom the de Menils would become famously devoted.[20]

Fig. 10.5
René Magritte, *L'alphabet des révélations*
(*The Alphabet of Revelations*), 1929.
The Menil Collection, Houston

The year 1949 marked a significant stage in the couple's relationships with these two major Surrealist artists. That year Iolas gave them two paintings: Ernst's *Design in Nature*, 1947, and Magritte's *L'alphabet des révélations* (*The Alphabet of Revelations*), 1929 (fig. 10.5). After these initial gifts, the de Menils would add to their collection over thirty works by Ernst and fifteen by Magritte in the 1950s, the decade in which they made their decisive turn toward Surrealism. Although collecting Surrealist works in hindsight seems as wise a move as collecting those by Picasso, Braque, Léger, and other modern masters, conventional art market wisdom at the time did not agree. As Dominique de Menil said, "In those days Surrealism was totally obscured by abstract painting. I always had the feeling that Surrealism was looked upon as one looks upon a member of the family who has gone astray: an unsavory character one does not mention too often."[21] She herself was hesitant: "At first I resisted Surrealism; it was such a strange world. I felt outside of it. But Iolas kept showing us great works, and he was, as I said, extraordinarily convincing."[22]

In time, however, Dominique de Menil warmed to Surrealism, and the couple moved firmly against the anti-representational trend of a market then dominated by Abstract Expressionism. (They would warm to artists associated with that movement in the following decade.) In their lifetimes they assembled the largest private collection of Ernst's work in the world, totaling well over one hundred paintings, sculptures, and prints, and a significant Magritte collection numbering more than fifty works of art. Their interest in Surrealism proved expansive, extending to include the work of de Chirico, Miró, and Man Ray, among the earlier Surrealists, and Joseph Cornell, Matta, and others, who came later. In addition, they built an important collection of two Surrealists who were then relatively unknown in the United States: Victor Brauner and Louis Fernandez, artists who had emigrated from Romania and Spain, respectively, to Paris, where they became friends of the de Menils'.

There is little concrete evidence about what exactly attracted the de Menils so strongly to Ernst's work. Months before she died, though, Dominique de Menil gave members of the Menil collections committee a glimpse into her sense of Ernst, using the framework of spiritual belief to characterize her appreciation. In reference to Ernst's 1941–42 painting *Day and Night* (fig. 10.6), which was purchased with funds provided by her daughter Adelaide de Menil, she said, "If you were to ask me the essence of my belief, I would name *Day and Night*. I believe things exist, but we see them only as flashes sometimes."[23] Even though the de Menils championed Ernst, they did not do so wholesale. It seems that while the couple found some of his paintings and sculptures immediately accessible, they struggled to appreciate others. Such was the case with his large-scale painting *Le surréalisme et la peinture* (*Surrealism and Painting*) from 1942. Iolas had offered it to the de Menils, but they refused, which he attributed to their discomfort with the work's eroticism; he sold it to

the collector William Copley instead.[24] Over time, however, Dominique de Menil grew to appreciate the work and eventually acquired it in 1979 from the Sotheby's sale of Copley's holdings, paying considerably more than Iolas's initial asking price.

In the 1960s and 1970s, the relationship between the de Menils and Ernst grew stronger. The couple continued to acquire his work for their collection and others, giving gifts of his paintings and sculptures to individuals and institutions.[25] Much of his work from the 1960s and 1970s was featured in exhibitions they organized at both the University of St. Thomas and Rice University, where they developed art history programs.[26] As a further testament to their engagement, the Menil Foundation financed Ernst's catalogue raisonné, directed by the German scholar Werner Spies, beginning in 1969. Their willingness to take on such a long-term project reveals the depth of their commitment to Ernst as well as their desire to see his work better known and understood. Writing to Spies in 1975 about the pending publication of the first volume, Dominique de Menil gave full credit for this project to her husband, who had died two years earlier: "Obviously a catalogue raisonné is not the kind of work that can be commissioned. It takes devotion, intelligence, and a great deal of work that must be carried out with enthusiasm. A collaboration of an exceptional nature is necessary between the person who assumes the responsibility of putting together the catalogue raisonné, and the person who assumes the expenses—which are great and always more than anticipated.... I want all the credit to be given to Jean. It was he—not me—who had the vision and the courage to launch the catalogue raisonné of Max Ernst."[27] While Dominique de Menil suggested that she and her husband were no more than silent financial backers, they were in fact deeply involved in this project. They were active participants in the cataloguing and research of Ernst's work, as evidenced by the catalogue raisonné archives, which are rife with letters to Spies about problematic titles or translations of Ernst's work, gaps in the exhibition history, and formatting inconsistencies. This project also resulted in further acquisitions for the collection, as well as recommended acquisitions for others, as the catalogue raisonné team discovered many works for sale in the course of its research.

Just as the de Menils discovered Ernst through Iolas, so too was the case with Magritte. However, they seemed slower to appreciate the Belgian artist. As Dominique recalled, Iolas encouraged the de Menils to collect Magritte, saying, "One day the force of these images will appear to everybody, you'll see."[28] Iolas gave them their first Magritte painting in 1949 and followed it with another four paintings over the next few years. The de Menils finally made their first purchase of a Magritte work in 1953—Le chant des sirènes (The Sirens' Song), 1952—and steadily acquired the artist's paintings and sculptures from this period onward.[29] As with Ernst, the de Menils

did not collect certain periods of Magritte's work, such as his "Impressionist" stage of the early 1940s. Dominique de Menil's thoughts on La lunette d'approche (The Telescope), 1963, reveal something of what ultimately attracted her to Magritte's work; after describing the enigmatic image, she wrote, "There is no answer, no possible explanation. All our certainties are shattered. We know only that we do not know."[30]

Once won over to Magritte, the de Menils became dedicated evangelists and endeavored to promote his oeuvre. They made his work the subject of exhibitions they organized in Houston and beyond,[31] and they supported scholarship on the artist, underwriting his catalogue raisonné, as they did for Ernst, also beginning in 1969. In their promotion of Magritte, the de Menils were as concerned with nuanced details as they were with the larger goal. A note in the object file for Le soir qui tombe (Evening Falls), 1964, shows John de Menil searching for the best English translation of the title, considering "Dusk," "In the Dusk of the Evening," "The Evening Falls," and "The Sun Sets Down" before settling on Evening Falls. Object files on the Menil's Magritte holdings also reveal a lively correspondence with David Sylvester, the British scholar who spearheaded the catalogue raisonné, including queries about translations, attributions, and titles, once again showing the de Menils to be impressive researchers in their own right. In a letter to Sylvester the year before his death, John de Menil wrote, "I feel like shouting hurray and shooting fireworks in every direction. I'm sending you, as a heavy brick, the files of our Magritte collection.... You will notice that there is a style to my entries.... I am sure there are other ways of doing it which are as good, but this happens to have become our style.... I am so proud of having laid my egg that I feel like asking you about your own. If I am correct in my recollection, you announced in recent correspondence a first volume out in 1974. My health has deteriorated and I would like to see that."[32]

Throughout the 1950s, then, the de Menils were actively building their Surrealist and other modern holdings while adding a scattering of pre-antiquity, Greek, Roman, and non-Western works. As the collection started to take shape, the de Menils began to give thought to the nature of their collecting. In Dominique de Menil's words, "One day, we realize we have a lot of things and start thinking about what a collection is and what we have to do."[33] This pause to reflect seemingly led the couple to experience the desire, akin to a calling, to build a collection and disseminate it to a larger audience as part of a general humanist endeavor. Dominique de Menil often attributed this sense of being morally "obliged" to collect to Couturier's influence: "He made us consider it our duty.... He was the one who pushed us."[34] She also once said, "He sort of made it a moral duty to buy good paintings."[35]

Fig. 10.6
Max Ernst, *Day and Night* (formerly "Night and Day"),
1941–42. The Menil Collection, Houston, purchased
with funds provided by Adelaide de Menil Carpenter

Fig. 10.7
Bu Gle Mask, Dan, Liberia, 19th century.
The Menil Collection, Houston

Engaging the Public in the Collection

In 1958 the de Menils founded the Art Department at the University of St. Thomas to provide a strong art history curriculum for students in Houston. This was part of their larger goal of providing public guidance and education in art to the surrounding community. They invited Jermayne MacAgy, who had been the director of the Contemporary Arts Association, Houston, to be their founding department chair the following year. MacAgy had spent the majority of her career prior to Houston in San Francisco at the Palace of the Legion of Honor, where she was known for her theatrical installations.[36] With Couturier and Iolas, she was often cited by the de Menils as a pivotal influence. Paying homage to her friend and mentor after MacAgy's untimely death in 1964, Dominique de Menil described MacAgy's purpose in life as "keeping art permanently alive."[37]

MacAgy's exhibitions often brought together a range of artworks from different times and places to explore a particular theme, allowing conversations to develop among various parts of the de Menils' growing collection as well as objects loaned from private and public collections. Her approach to installation resonated with the Surrealist practice of putting unlike things together in order to produce new and unanticipated associations. This inclination was unsurprising given MacAgy's love of Surrealism, and she found the de Menils, who shared her affection for the Surrealists, sympathetic to it. She not only led the couple to discover the power of provocative arrangements of works from diverse periods and cultures, but perhaps even more significantly also helped them to realize their goal of bringing the collection to a wide audience.

With their arrival at St. Thomas, the de Menils had offered the university the nucleus of their collection on extended loan for teaching purposes. MacAgy encouraged them to expand this into a teaching collection that reflected the wide range of her own interests, which ran the gamut from folk art, Spanish colonial art, and antiquities to African, Native American, and contemporary art, to give but a few examples. Dominique de Menil said of MacAgy, "She always insisted that a collection—even a small one—was indispensable for teaching. She felt the need to have artworks, for students should not only look at slides and book illustrations, but should be able to touch real works of art. This approach to teaching played an important part in the formation of my own collection. At that time I started to buy more systematically in certain fields, such as African and Cycladic."[38] Dominique de Menil also acknowledged Couturier's influence on the development of a teaching collection: "He believed a work of art needs intimacy to be understood and loved. It is precisely this intimacy that a teaching collection provides.... [T]he work of art is aggressively present. It forces our reaction. It puts us on the spot."[39]

During the years at the University of St. Thomas, the collection

Fig. 10.8
Funerary Vessel, Northwestern Iran,
ca. 1000 BC. The Menil Collection, Houston

grew broadly, and new areas of strength developed. While the couple had acquired around two hundred objects a year in the late 1950s, by the early 1960s that number had leaped to over three hundred a year and included African (fig. 10.7), Pacific Islands, Native American, and pre-Columbian artworks, as well as objects from antiquity (fig. 10.8).[40] Many of these acquisitions were made from the New York dealer J. J. Klejman, who became a significant source and advisor for the couple in non-Western and pre-modern art.[41] The de Menils' interest in these areas was probably affected by their developing Surrealist holdings: many of the African and Pacific Islands pieces resonated with themes and imagery found in the work of Ernst and others.[42] They also benefited from the counsel of family members interested in these areas, including Adelaide de Menil and her husband, Edmund Carpenter, particularly in Northwest Coast and Pacific Islands art, and former son-in-law Francesco Pellizzi, whose interests encompassed the art of Africa, the Pacific Islands, and Native America.

During this same period, the de Menils' views began to solidify on the distinction between, and the complementary nature of, experiencing art and learning art history. Years later Dominique de Menil summarized it succinctly: "Events, people, situations, and works of art most of all are always beyond what may be said of them. Language restricts, limits, impoverishes…. And yet words can be illuminating. They may put you in a frame of mind that the invisible becomes visible…. Roland Barthes helped me to love Cy Twombly's

work; Leo Steinberg led me to see Jasper Johns's more fully; and my daughter Christophe revealed many a painting to me with just a few remarks…. Books, catalogues, lectures, informal talks, panel discussions, all have their privileged and welcomed place. But discourse must not take the place of art itself."[43] The productive tension between the direct personal encounter with art and the scholarly research on art that is produced (nonetheless informing what is seen on exhibit) characterized the couple's approach to collecting and provides the reasoning behind the purposefully limited pedagogic material in the galleries today at the Menil Collection.

Interest in Contemporary American Art

From the late 1950s, the de Menils began expanding their holdings in contemporary, especially American, art. MacAgy had pointed them in this direction, drawing on her own strong relationships with Abstract Expressionists like Clyfford Still and Mark Rothko. But the shift was not without effort, and Dominique de Menil would comment at various times on the ways in which contemporary art stretched her and her husband as collectors: "The greatest challenge for a collector is to buy works by contemporary artists…. Paintings by pioneering artists are not attractive right away. Anything important is going to be so radically new that it will be disconcerting at first."[44] She was especially eloquent in describing the challenge of new artists: "When they appear, great artists are not easily recognizable. They use a new language that we have to learn before we can understand

Fig. 10.9 *opposite*
Mark Rothko, *The Green Stripe*, 1955.
The Menil Collection, Houston

Fig. 10.10
Andy Warhol, *Flowers*, 1964. The Menil
Collection, Houston

them. They are at the heart of life, in tune with its poignancy, express-ing the inexpressible. They are the explorers of the unknown, the ministers of a mystery which cannot be fathomed, the mystery of the world."[45] One such artist was Mark Rothko, whose work would come to have a prominent place in their collecting and patronage history (see fig. 10.9). In 1955 Dominique de Menil recalled, "I fell in love with Rothko when I first saw his work at the Sidney Janis Gallery…. [Many] could not believe that these canvases with large blotches of color, one on top of the other, were also paintings, and beautiful ones at that."[46] MacAgy's ex-husband, curator Douglas MacAgy, suggested in 1959 that the de Menils go visit the artist, who had just completed panels for the Seagram Building.[47] This meeting would set the stage for the commissioning of a suite of paintings by Rothko for a planned chapel, which got fully under way as a memorial to Jermayne MacAgy following her death in 1964.[48]

In the 1960s the couple added multiple works by American artists, including Claes Oldenburg, Robert Rauschenberg, Jasper Johns, Wayne Thiebaud, John Chamberlain, and Alexander Calder, developing personal relationships with many of them. Calder, Olden-burg, and Thiebaud, for example, visited Houston, where they were feted in the de Menils' home and at the art institutions with which the couple was affiliated, receiving the same warm welcome that was extended to the many other artists who visited the family. In addi-tion, the de Menils purchased works by Christo and Yves Klein, as well as numerous sculptures by their Houston friend Jim Love, who collaborated in the installation of their exhibitions. And at the begin-ning of the decade, the couple added the work of three female artists to the collection: Chryssa [Vardea], Lee Bontecou, and Niki de Saint-Phalle. These acquisitions were somewhat exceptional, as Dominique de Menil was known to have remarked that women were not equipped to be great artists. That she was herself a strong and vision-ary woman and that Jermayne MacAgy played such a forceful role in the development of the collection make her stance one of the greatest paradoxes of the de Menils' patronage.

The de Menils took a particular interest in Andy Warhol dur-ing this decade. In 1965 they purchased two silkscreens by Warhol from Leo Castelli (both titled *Flowers*, 1964 [see fig. 10.10]), and two years later they acquired *Little Electric Chair*, 1965, a work of which they were particularly fond. The next year, they commissioned a por-trait of MacAgy, which was followed by one of Dominique de Menil. The couple developed a personal relationship with Warhol, to whom John de Menil was especially attracted, both as an artist and film-maker; he invited Warhol to the University of St. Thomas and later to Rice University on multiple occasions.

Fig. 10.11
Sir Joshua Reynolds, *A Young Black*, ca. 1770.
The Menil Collection, Houston

Fig. 10.12 *opposite*
Antimenes Painter (attributed), Black-Figured
Psykter, Greece, Attic, ca. 530–520 BC. The Menil
Collection, Houston

Influence of Civil Rights Activism on the Collection

The de Menil's strong behind-the-scenes support of civil rights in Houston at this time also impacted their collecting focus. In 1960 they undertook a massive archival and publication project referred to as Image of the Black in Western Art. In the same way that the Ernst and Magritte catalogues raisonnés attempted to develop a resource for informed scholarship on these artists, the Image of the Black project gave scholarly support to the history of depictions of Africans and people of the African Diaspora in Western art. It also spoke to the de Menils' belief that art could be a vehicle—either positive or negative—for social change. It was important to them that the public recognize the prominent presence of Africans and those of the African Diaspora within an art largely viewed as separate from them. But it was equally important to preserve the negative imagery and the implications of its widespread dissemination. The couple's collecting addressed both dimensions. The de Menils added to their collection ennobling depictions of black people, such as a portrait by Gabriel Mathias of William Ansah Sessarakoo, a West African prince who visited London in the eighteenth century. Dominique de Menil acquired the painting in 1980, following it three years later with another important portrait, this one of an unidentified black man by Sir Joshua Reynolds (fig. 10.11).[49] They also added a group of some forty Egyptian miniature terra-cotta heads depicting sub-Saharan Africans from the Greco-Roman period (acquired in 1972)—some of which are dignified representations, others caricatures—and a large collection of black memorabilia, which included toys, games, advertisements, and various artifacts of popular culture from the nineteenth and twentieth centuries, most depicting people of African descent in stereotypical and racist roles. These objects came as a gift from their daughter Adelaide de Menil and her husband, Edmund Carpenter, in 1972, followed by similar gifts in the 1990s. Dominique de Menil responded enthusiastically to the gifts, writing to her daughter, "Your interest in searching for these pieces and collecting them in a selective and yet comprehensive way is of great value to us and to the future studies to be made in this area."[50]

Fascination with "Ancient Pieces"

John and Dominique de Menil acquired more than three hundred objects from antiquity in the 1960s, particularly Cycladic, Greek, and Roman art, representing their most intense period of collecting in this area. They bought a number of important Cycladic figures; Greek objects including a black-figured psykter (fig. 10.12) and a funeral stele; and Roman works such as a bust of either Apollo or Dionysus, a vase depicting an African head, and a bronze bull sculpture, to give but a few examples. Until this time they had made only a handful of such purchases. The sudden increase can be attributed to the demands of forming a teaching collection, but also to Dominique de Menil's passion for the material. In 1964 she said, "John is mostly interested in contemporary art. I too like contemporary art, but I am a frustrated archeologist. I am fascinated by ancient pieces—by their beauty and by what they reveal of their time. John dreams of living in one large room with just a few paintings on the walls…. [But] his study is cluttered with objects, all my archeological purchases, which he has to catalogue…. It seems there is no end to my archeological purchases. It's like buying books. One book leads to another. If you start on a certain type, you want as many examples as possible. John is not crazy about pots, but beautiful is beautiful."[51]

Pursuing this archeological interest, the de Menils in 1964 and 1979 acquired over eight hundred small objects of daily piety and living from the Byzantine empire of the third to twelfth centuries. Foregoing icons or other objects produced for the Church, as well as monumental or imperial arts of the Byzantine period, the de Menils concentrated instead on the art of the merchant class. These objects, originally assembled by a focused collector in Istanbul, included glass and metal weights, signet rings used to impress wax seals, a wide assortment of cross-shaped pendants in a variety of metals, oil lamp elements, bronze keys and buckles, stamps, and other miniature items. The couple's interest in these more modest art forms stemmed from their curiosity about how people from other times and places incorporated art into their daily lives.

In 1966, two years after this large acquisition of mostly metalwork, Dominique de Menil mounted an exhibition called "Made of Iron." One of the most ambitious exhibitions staged at the University of St. Thomas, the show included more than five hundred objects ranging from the utilitarian to the fanciful, and spanning eras (antiquity to recent times) as well as continents. It not only put vastly different art traditions together in conversation, reflecting the tutelage of Jermayne MacAgy, but also demonstrated Dominique de Menil's own idiosyncratic penchant for metalwork. More than a hundred objects from the de Menils' collection were included in the exhibi-

tion, among them, numerous works of art acquired in the years just prior to the exhibition.

Prompting additions to the couple's collection in a similar way, the exhibition "Ten Centuries That Shaped the West" brought together Greek and Roman art from Texas collections, including objects from the eighth century BC to the fourth century AD. This exhibition was in the planning stages by 1965, and the de Menils made numerous acquisitions for the exhibition before its opening in the fall of 1970. Herbert Hoffmann, curator of ancient art at the Museum für Kunst und Gewerbe in Hamburg, wrote an essay for the catalogue and advised on a number of the pieces that would find their way onto the exhibition checklist. In 1970 he urged the couple to purchase an Attic black-figured psykter, ca. 530–520 BC. Responding as the exhibition neared completion, Dominique de Menil cabled back to Hoffmann, "Thank you for pushing us. We are now gratefully happy to have the psykter in our foundation and in Houston."[52] A couple of months later, he recommended another acquisition, a Daedalic pithos fragment from 625–600 BC. Again, John and Dominique de Menil took his advice, but their cable reveals that the rapidly approaching exhibition deadline would not allow for other additions: "Okay Herbert we take that fantastic buy for Menil Foundation but let it be the last. We are snowed under with work and are panicky about the catalogue not being ready on time. Trust you are sending us entry for this last purchase."[53]

A Museum for the Collection

By the time John de Menil died in 1973, the couple had amassed thousands of objects in their personal and foundation collections and assembled a team of dedicated scholars and employees to support their projects. They had also begun to explore the creation of an independent museum that could more fully implement their philosophy and vision for their collection. Following her husband's death, Dominique de Menil quietly continued formulating plans for a museum, and with the help of Menil Foundation staff members Mary Jane Victor and Kathryn Davidson she began defining the functions of such a building. In 1974 she started to work closely with Houston architect Howard Barnstone on drawings for several different structures, including a conference center and what was broadly called the "Art Storage Building" on Branard Street, which included registration, conservation, and storage facilities. This early planning became the basis for the architectural program launched in 1980, when she engaged Italian architect Renzo Piano to design a building to house the collection. As these plans got under way, more of her personal and foundation resources were reserved for the building project, causing the rate of acquisitions to slow considerably.

Throughout the 1970s and early 1980s, however, Dominique de Menil continued to add to the collection, purchasing for the most part in areas that were already established. Acquisitions included a number of African and classical pieces as well as modern and postwar works by artists such as Klein and Willem De Kooning. But she also opened up new spheres of collecting. In the late 1970s, for example, she took an interest in kilims and rugs, building a modest collection, which was displayed in her San Felipe home as well as in some of the bungalows in the neighborhood where the museum building would be sited. In 1985 she acquired an important group of fifty-eight Byzantine icons that had been assembled by British collector Eric Bradley (see figs. 10.13–14). She purchased this collection on the advice of Bertrand Davezac, the foundation's curator of medieval and Byzantine art, who had a significant impact on the shape of the collection during his tenure from 1979 to 2000. This art form had never before been a priority for the de Menils, a surprising fact given the couple's spiritually grounded collecting impulses.[54] London art dealer Yanni Petsopoulos, who brokered the deal, said once that Dominique de Menil purchased the group of icons in hopes of changing what she perceived as an American bias against icons as art, based on the erroneous idea that they were formulaic compositions. Clearly even during this period of intense activity around the construction of the museum, her intellectual and aesthetic interests continued to grow.

Renewed Focus on Postwar American Artists

Even though the de Menils had added to their existing holdings of Rauschenberg and Johns over time, it was not until 1979 that Dominique de Menil purchased two Cy Twombly works at auction, adding two more in the following few years. Then, in the early 1990s, Twombly made an unparalleled gift of art to the museum in response to the Menil Foundation's proposal to establish the Cy Twombly Gallery.[55] Spearheaded by Paul Winkler, then director of the Menil Collection, this was a joint project of Twombly, the foundation, and the Dia Art Foundation. The last was created in 1974 by the de Menils' youngest daughter, Philippa de Menil (after converting to Sufi Islam in 1979, she changed her name to Fariha), art dealer Heiner Friedrich, and Helen Winkler, onetime assistant to the de Menils. Dia concentrated on a small group of artists, including Chamberlain (see fig. 10.15), Dan Flavin, Donald Judd, and Twombly, and collected their work in depth while underwriting the development of new work on a grand scale. Dominique de Menil shared an admiration for, and commitment to, many of the artists Dia supported. Paul Winkler also championed the acquisition of works by Twombly and other artists originally the focus of Dia, such as Michael Heizer and Walter De Maria.

The renewed attention paid to postwar art during this period was attributable as well to the presence of Walter Hopps, who became founding director of the Menil Collection in 1981. Hopps and Dominique de Menil enjoyed a close relationship over the time they worked together. When first engaged as a consultant to the foundation in 1980, Hopps used one of the children's rooms in her Houston residence as both home and office for two years, and he quickly became one of her closest advisors as plans for the museum building took shape. Throughout his curatorial career, Hopps demonstrated a prescient awareness of contemporary trends in mid-twentieth-century art. His organization of Marcel Duchamp's first museum retrospective in 1963 at the Pasadena Art Museum in California remains a watershed moment of art history. After founding Ferus Gallery in Los Angeles with Edward Kienholz, he became, like the de Menils, an early champion of Warhol, mounting the artist's first solo gallery exhibition of Pop images. Hopps recalled that when he began working for the foundation, he immediately got involved in increasing the representation of Barnett Newman, De Kooning, Frank Stella, Rauschenberg, and Johns.[56] He organized Rauschenberg's mid-career traveling retrospective in 1976 to celebrate the American Bicentennial and, with curator Susan Davidson, a massive second retrospective in 1997. Hopps's close friendship with the artist fostered a continuing focus on Rauschenberg's work within the collection.

Fig. 10.13 *opposite top*
Saint Marina, Crusader-Byzantine, 13th century. The Menil Collection, Houston

Fig. 10.14 *opposite bottom*
Follower of Andrei Rubliov, *Archangel Michael*, Moscow-Suzdal region, mid-15th century. The Menil Collection, Houston

Fig. 10.15
John Chamberlain, *Rooster Starfoot*, 1976. The Menil Collection, Houston, Gift of Heiner and Fariha Friedrich

Fig. 10.16
William Christenberry, *House and Car, near Akron, Alabama*, 1981. The Menil Collection, Houston, Gift of Gerard Junior Foundation

Hopps's range of interests in contemporary art was famously far-reaching and eclectic, and he continued to have a significant impact on the collection after he stepped down as director in 1989 and became the Menil's consulting curator of twentieth-century art. Just as he had proved influential in establishing the West Coast in the 1950 and 1960s as an alternate center for American art, his presence at the Menil brought increased visibility to the artists and projects with which he was associated in Texas and on the Gulf Coast. He had an unwavering commitment not only to well-established artists but also to lesser-known artists, young artists, and those whom the market no longer deemed fashionable. During his tenure in Houston, he took a serious interest in art produced by Texas artists Ben Culwell, James Surls, Richard Stout, Michael Tracy, and David McManaway, much as he had done for the California artists he had long-championed, including Ken Price, Kienholz, Bruce Conner, John McLaughlin, and others. He significantly increased the presence of photography in the collection as well, adding a major group of photographs by Walker Evans and the work of William Christenberry (fig. 10.16) and William Eggleston. While Hopps is best known for his exhibitions and publications on modern and contemporary art, his impact on the collection and foundation extended far beyond these areas. He was passionate about antiquities and Byzantine art, for example, playing a leading role in securing the thirteenth-century dome and apse frescoes that would ultimately be housed, with the permission and on behalf of the Holy Archbishopric of Cyprus, in the Byzantine Fresco Chapel on the Menil campus.

A Collection Built on Relationships

Though John and Dominique de Menil developed their own tastes as collectors over time, they deliberately remained open to the insights and ideas of others throughout their lives. The list of people includes those the de Menils encountered in their engagement with art, such as Couturier, MacAgy, Davezac, Winkler, and Hopps, as well as their children, who as adults would make their own contributions to their parents' collection. Throughout their lives, the couple made gifts of art to their children, and they in turn donated art to the collection and provided generous support to the museum that housed it. While some of these gifts were the very objects the de Menils had chosen for their children, in other cases they were works of art purchased to expand the museum's holdings or introduce a new artist. Georges de Menil gave works by Ernst, adding to the museum's important collection, and Francois de Menil contributed works by Magritte, Jean Tinguely, Johns, Rauschenberg, and others, enhancing areas of long-standing interest. Alternatively, in some of the first forays into these artists' oeuvres, Christophe de Menil donated works by De Kooning, James Rosenquist, and Price, and Fariha (with Friedrich) gave a number of sculptures by Chamberlain. Adelaide de Menil and Edmund Carpenter broadened the de Menils' interest in and collection of the arts of the Pacific Islands and Northwest Coast America, among other areas. The de Menil family continues to be actively involved in the museum, generously underwriting programs and giving gifts of art and donating their time. Family members serve on the board of trustees, including the collections committee, which sets the future direction of acquisitions.

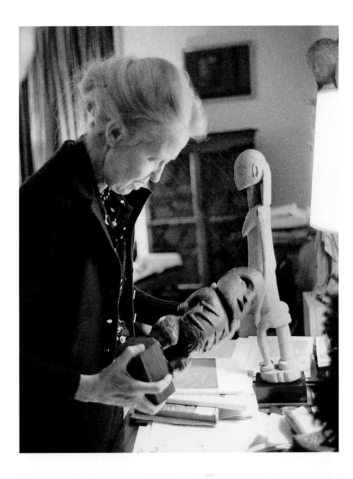

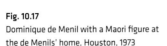

Fig. 10.17
Dominique de Menil with a Maori figure at
the de Menils' home, Houston, 1973

Fig. 10.18
John de Menil at "Through the Porthole,"
University of St. Thomas, Houston, 1965

The relationships that John and Dominique de Menil built and maintained over the course of their lives effectively led to the creation of a museum where, as Couturier had expressed it, one loses one's head in an ecstatic and participatory response to the works of art.[57] In her introduction to *La rime et la raison*, Dominique de Menil wrote, "We all have this miraculous power to give life to the work of art. Everything is given, yet everything has to be discovered, to be experienced. Everything."[58] The de Menils felt a responsibility to set up conditions that could bestow the fullest lives possible to the objects they collected. In their many museum exhibitions, they ensured that the individual could discover the works they had assembled with minimal impediment, placing a premium on the immediacy of the encounter.

As Dominique de Menil once said, "Sharing spiritual food is indeed the artist's deep wish, but proper space and time are needed. Without space and time the radiance and the power of the work cannot be experienced."[59] While art historical study of an object could enrich one's experience of it—and the de Menils clearly valued research and art education—they felt this activity was not a prerequisite to communing with art. The distinction they made between experiencing art and acquiring a knowledge of art came to frame the formation and deployment of their collection and became a hallmark of their patronage. It is the intangible dimension of the visitor's experience in the museum—the immediacy of one's encounter with works of art in the light-filled space of the galleries—that constitutes the greatest and most vital legacy of the de Menils' vision and gift to Houston.

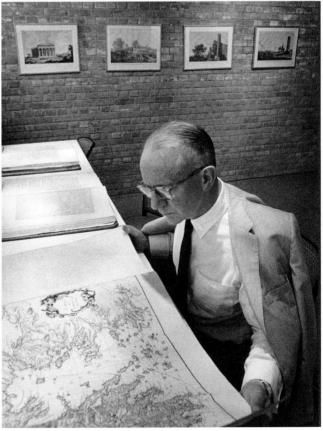

NOTES

I extend profound gratitude to my colleagues at the Menil Collection for their assistance with the research and development of this essay, most especially Geraldine Aramanda, Amy Chien, Elsian Cozens, Clare Elliott, Mary Kadish, Karl Kilian, Mary Lambrakos, Vance Muse, Laureen Schipsi, and Michelle White. I am also grateful to Polly Koch, Don Quaintance, Caroline Huber, and Susan and Francois de Menil for their help.

1. About the predella *St. John in the Desert* by Domenico Veneziano at the National Gallery of Art, Washington, D.C., Dominique de Menil wrote, "I am so fond of this strange and miraculous little painting that I experience it as totally mine when I stand in front of it. And I think that in years ahead there will be those, unknown to me, who will take and 'possess' works that I have acquired." Dominique de Menil, foreword, *The Menil Collection: A Selection from the Paleolithic to the Modern Era* (New York: Harry N. Abrams, 1987), 7.

2. Roberto Matta, interview by Adelaide de Menil, October 15, 1984, transcript translated from the French by Marie-Pascale Rollet-Ware, "Souvenirs," Film and Media Collection, Menil Archives.

3. Dominique de Menil, quoted in *The First Show: Painting and Sculpture from Eight Collections 1940–1980*, ed. Julia Brown and Bridget Johnson (Los Angeles: Museum of Contemporary Art; and New York: Arts Publisher, 1983), 36.

4. Dominique de Menil, "The Delight and Dilemma of Collecting" (lecture, University of St. Thomas, Houston, April 9, 1964), Menil Archives.

5. Dominique de Menil, quoted in *The First Show*, 36.

6. Dominique de Menil, "The Delight and Dilemma of Collecting."

7. Ibid. The de Menils paid Ernst for the painting and later made no inquiry when it was not delivered, thinking that perhaps Ernst himself was not happy with it. In reality, however, Ernst's wife had delivered the painting to a framer, and through a comedy of errors, the framer had neither her address nor that of the de Menils. About a year later, he put the framed portrait in his shop window. When the couple's priest passed by and recognized the artwork, he notified the couple, and they were once again reunited with the painting. Still unmoved by the portrait, they left it wrapped in brown paper and forgot about it until after the war.

8. John de Menil, "The Delight and Dilemma of Collecting" (lecture, University of St. Thomas, Houston, April 9, 1964), Menil Archives.

9. Dominique de Menil, quoted in *The First Show*, 47.

10. Ibid., 41.

11. John de Menil, "The Delight and Dilemma of Collecting."

12. "He was a friend of Rouault and Léger, Braque and Matisse, and Picasso…. He was a man who could not get reconciled with the fact that the world of artists and the religious world were completely apart and had absolutely no contact." Dominique de Menil, "The Delight and Dilemma of Collecting."

13. Ibid. "During that time Father Marie-Alain Couturier took us around to the New York dealers Paul Rosenberg, Valentine Dudensing, Kurt Valentine, and Pierre Matisse." Dominique de Menil, quoted in *The First Show*, 36.

14. John de Menil, "The Delight and Dilemma of Collecting." It is unknown if the Dufy painting the de Menils traded was by Raoul Dufy or his brother Jean.

15. Ibid.

16. Alexander Iolas founded the Hugo Gallery with Donna Maria Hugo. Iolas recalled meeting the de Menil family through Donna Maria Hugo, who brought the couple with their children to the gallery to see an exhibition of Jean Hugo that apparently took place in 1949. Alexander Iolas, interview by Adelaide de Menil, July 4, 1984, transcript translated from the French by Marie-Pascale Rollet-Ware, "Souvenirs," Film and Media Collection, Menil Archives. However, the de Menils had already made purchases from the Hugo Gallery in 1947 and 1948. See Menil Object Files.

17. Iolas, interview by Adelaide de Menil, 11.

18. Ibid., 14.

19. Ibid., 13

20. These figures include works by both artists that the de Menils subsequently gave to their children or deaccessioned.

21. Dominique de Menil, quoted in *The First Show*, 39. They also bought Surrealist works because they were affordable. "The Surrealists cost practically nothing." Dominique de Menil, "The Delight and Dilemma of Collecting."

22. Dominique de Menil, quoted in *The First Show*, 38.

23. Dominique de Menil, quoted in Carol Mancusi-Ungaro, memo, August 19, 1997, Menil Object Files.

24. Iolas, interview by Adelaide de Menil, 9–10.

25. *A Modern Patronage: de Menil Gifts to American and European Museums* (Houston: Menil Foundation; and New Haven and London: Yale University Press, 2007), 10. In their lifetimes the de Menils gave more than forty works by Max Ernst to family members, friends, and museums. For example, they gave sculptures, such as *The King Playing with the Queen*, 1954, to Robert Motherwell; *Moon Mad*, 1944, to the Museum of Fine Arts, Houston; and *Anxious Friend*, 1944, to the Solomon R. Guggenheim Museum.

26. Ernst's work was included in seven exhibitions organized at the University of St. Thomas and eight exhibitions at the Rice Museum, including two exclusively devoted to his work: "Max Ernst: Inside the Sight," February 7–June 17, 1973, and "Max Ernst: Illustrated Books, Writings, Periodicals, Exhibition Catalogues, Dada and Surrealist Memorabilia (Collection of Marvin Watson Jr., Houston)," February 7–May 20, 1973.

27. Dominique de Menil to Werner Spies, February 17, 1975, Max Ernst Catalogue Raisonné File, Menil Archives. Art critic Lucy Lippard did preliminary research beginning in 1964 that was intended for a catalogue raisonné, but the project gained considerable momentum when Spies was appointed to oversee it in 1969. The Menil Foundation entered into an agreement with Spies and Verlag M. DuMont Schauberg, the publisher, in 1973 to compile the complete works of Max Ernst.

28. Dominique de Menil, quoted in *The First Show*, 38.

29. Prior to John de Menil's death in 1973, the de Menils acquired fifty-six works by Magritte, to which Dominique de Menil added seventeen in subsequent decades. Of the eighty-one works they acquired in total, fifty-eight remain in the Menil Collection, including *L'evidence éternelle* (*The Eternally Obvious*), 1930; *L'empire des lumières* (*The Dominion of Light*), 1954; and *La clef de verre* (*The Glass Key*), 1959. The remaining twenty-three works were either given as gifts or deaccessioned.

30. Dominique de Menil, note, no date, 65-06, Menil Object Files.

31. At the University of St. Thomas, Magritte was included in nine exhibitions and another seven at the Rice Museum, including the single-artist exhibition "Secret Affinities: Words and Images by René Magritte," October 1, 1976–June 19, 1977. The couple also lent their support and works of art to "Magritte in America," an exhibition organized by Jermayne MacAgy for the Contemporary Arts Association and held at the Museum of Fine Arts, Houston, in 1961. Three years later they organized an exhibition of Magritte's work for Governor Winthrop Rockefeller in Little Rock, Arkansas.

32. John de Menil to David Sylvester, December 11, 1972, 65-06, Menil Object Files. Because the scope of the catalogue raisonné was reformulated and expanded, the first volume would not come out until 1992.

33. Dominique de Menil, interview by Adelaide de Menil, May 17–19, 1985, transcript translated from the French by Marie-Pascale Rollet-Ware, "Souvenirs," Film and Media Collection, Menil Archives. Dominique de Menil later acknowledged, "It was very late before we would admit we were collectors." Quoted in *The First Show*, 40. She added that "collector" had been a negative term for her (41).

34. Dominique de Menil, interview by Adelaide de Menil.

35. Dominique de Menil, "The Delight and Dilemma of Collecting."

36. Between 1941 and 1949, MacAgy curated dozens of exhibitions at the California Palace of the Legion of Honor as diverse as "Boxing and Wrestling in Art," "The Medieval City," and "French Art of the Book," as well as various single-artist shows including ones devoted to the work of Aaron Siskind, Josef Albers, and Clyfford Still. Jermayne MacAgy, Guggenheim Foundation application, October 11, 1949, Menil Archives.

37. Dominique de Menil, quoted in *Jermayne MacAgy: A Life Illustrated by an Exhibition*, exh. cat. (Houston: University of St. Thomas, 1968), 10.

38. Dominique de Menil, quoted in *The First Show*, 43.

39. Dominique de Menil, quoted in *A Young Teaching Collection*, exh. cat. (Houston: University of St. Thomas, 1968), 10.

40. Kristina Van Dyke, "*La recontre humaine*: African Art in The Menil Collection," in *African Art from The Menil Collection* (Houston: Menil Foundation; and New Haven and London: Yale University Press, 2008), 20.

41. Ibid., 20–22. Over the course of their relationship with Klejman between 1957 and 1974, the de Menils acquired over five hundred works of art from his gallery. They regularly shopped at other galleries in New York and Paris to add to these holdings, ultimately acquiring close to a thousand African objects, more than two hundred objects in each area of Pacific Islands and pre-Columbian art, and over a hundred Native American objects.

42. The de Menils were aware of this connection, as evidenced in one of John de Menil's notes for a Melanesian stone bird, in which he wrote: "Carved stone bird looks like Max Ernst." Menil Object Files.

43. Dominique de Menil, foreword, *The Menil Collection*, 7.

44. Dominique de Menil, "The Delight and Dilemma of Collecting."

45. Ibid., 110.

46. Dominique de Menil, quoted in *The First Show*, 43. Mark Rothko's first exhibition at Sidney Janis Gallery took place in 1955.

47. Rothko, eager to work on a much larger scale than he had before and with a site-specific setting, created three, dark-toned groups of paintings for the Seagram Building, then objected to their placement in the less-than-contemplative Four Seasons restaurant and withdrew them. Dominique de Menil visited Rothko's studio in the fall of 1959 and said later that she had been convinced of the religious nature of his work and its suitability for a chapel set-ting. Dominique de Menil to Father [G. B.] Flahiff, December 4, 1959, Menil Archives.

48. See *The First Show*, 43.

49. Though the painting was entitled "Portrait of Frank Barber" when it was purchased from Hotel Drouot in 1983, subsequent scholarship has questioned the sitter's identity. Menil Object Files.

50. Dominique de Menil to Adelaide de Menil, December 15, 1972, Menil Archives.

51. Dominique de Menil, "The Delight and Dilemma of Collecting." Dominique de Menil continued to add antiquities to the collection in the following decades, but at a significantly reduced rate.

52. Dominique de Menil, cable to Herbert Hoffmann, April 27, 1970, Menil Object Files.

53. John and Dominique de Menil, cable to Herbert Hoffmann, June 4, 1970, Menil Object Files.

54. Dominique de Menil recalled purchasing an icon on a trip to Russia with her father in the 1930s in "The Delight and Dilemma of Collecting."

55. Twombly gave over forty works of art to the foundation in 1994, including paintings, drawings, and sculptures spanning his career from the 1950s onward.

56. Walter Hopps, "Encountering the de Menils," in *good*, ed. Toni Beauchamp (Houston: Toni Beauchamp, 2000), 105.

57. "A museum should be a place where we lose our head," Dominique de Menil, quoting Couturier, *The Menil Collection*, 8.

58. Dominique de Menil, introduction, *La rime et la raison: Les collections Ménil* (Houston–New York), exh. cat. (Paris: Galeries nationales du Grand Palais, 1984), 12, English translation by Dominique de Menil of her original French text.

59. Dominique de Menil, remarks given at the Dia Center for the Arts (New York, October 28, 1992), Menil Archives.

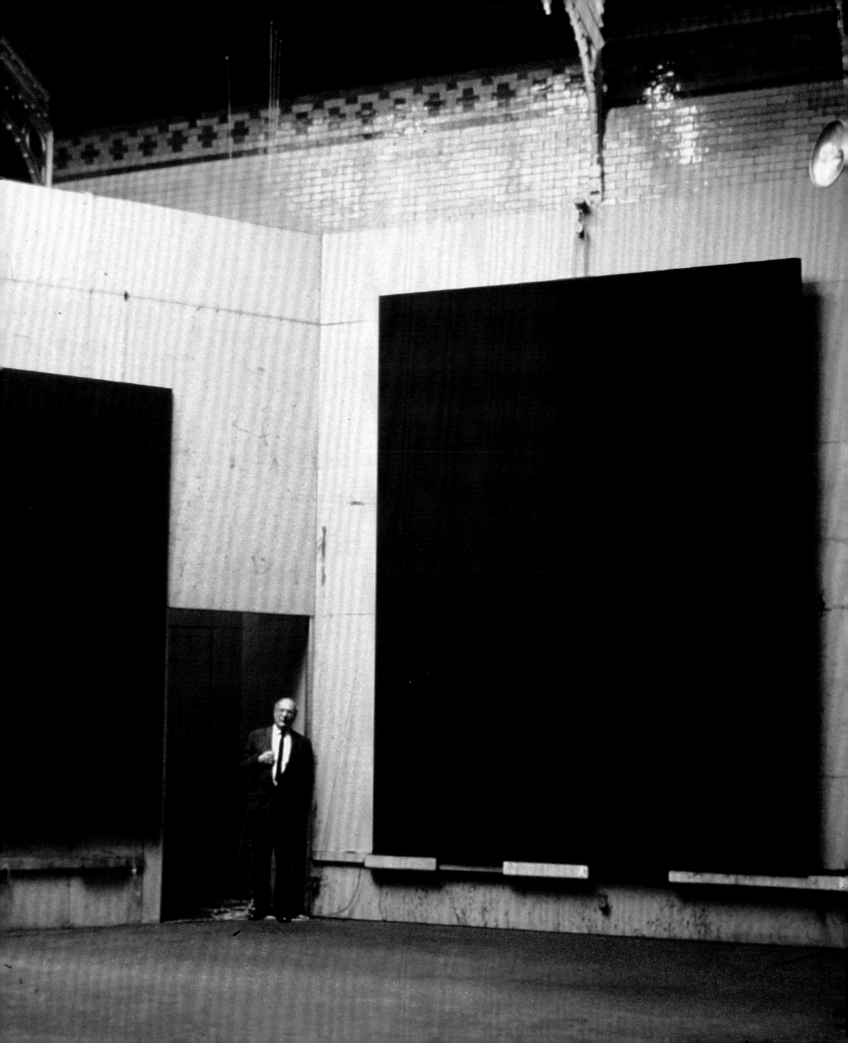

The Rothko Chapel: Toward the Infinite PIA GOTTSCHALLER

The creation of the Rothko Chapel was predicated on the confluence of several extraordinarily gifted minds: John and Dominique de Menil, Father Marie-Alain Couturier, Mark Rothko, Philip Johnson, and Barnett Newman. As is true for many outstanding acts of human accomplishment, the engagement of myriad individuals was essential to the realization of the project. However, it was the combination of these six personalities that allowed for the development of a space that has been considered one of the major contributions to twentieth-century Western art since the day of its opening in February 1971.

In 1941, due to the Nazi occupation of France, John and Dominique de Menil left for the New World and started afresh in Houston. While still in France, before the outbreak of the Second World War, they had encountered two Catholic priests whose inspiring views on the formation of a modern Catholic Church left a lasting impression: Father Yves Marie Joseph Congar and Father Marie-Alain Couturier. In 1936 the former had delivered a series of lectures on ecumenism in the basilica of Montmartre in Paris, well before the Vatican began to show even the slightest willingness to emphasize the aspects uniting the Christian faiths rather than their divisions. Congar's insistent invocation of a rapprochement between confessions would ultimately and profoundly affect the ecumenical foundation of the Rothko Chapel. The young Dominican priest Couturier had abandoned his career as a painter in 1925 to answer his religious calling. An extraordinarily spirited and spiritual man, "a transcender of boundaries," in Dominique de Menil's words,[1] he was able to

Fig. 11.2
The Church of Notre-Dame de Toute Grâce with
mosaic by Fernand Léger, Plateau d'Assy, France

bring together his two vocations, art and religion, in a way that became particularly meaningful for the development of *art sacré* in France.[2]

Couturier's deep conviction that only the greatest living masters, regardless of any personal religious inclination, should be invited to contribute to the aesthetic renewal of Catholic liturgical art took shape in the art he commissioned for churches in Assy, 1950 (fig. 11.2); Vence, 1951; Audincourt, 1951; and Ronchamp, 1955. Beginning in 1919 while studying painting in Paris, he soon had developed his appreciation for the works of Georges Braque, Fernand Léger, Georges Rouault, Henri Matisse, and other modern artists. After Couturier found himself temporarily exiled in New York at the outset of the Second World War, John and Dominique de Menil visited him often in the following five years, allowing the Dominican's infectious enthusiasm to carry them away on their discovery of the riches of contemporary art. In 1952 all three traveled together to Assy, Audincourt, the building site of Ronchamp, and Vence, which Matisse considered his greatest achievement.[3] Many years later, Dominique de Menil singled out Matisse's stained-glass windows and murals on ceramic at Vence as having a clear spiritual connection to Rothko's paintings in Houston, primarily due to the "opportunity for a new departure, a new direction in experimentation, enabling him [Matisse, and later Rothko] to eventually transcend the space offered to him."[4]

Although Couturier died prematurely, in 1954, his unswerving belief in the power of "living art," in the need for a "reform of ideas and the restoration of the sensitivity to the eye,"[5] continued to inform

the many engagements of the de Menils. Their conviction that aesthetic sensitivity has a causal relationship to ethics grew so strong that actions informed by faith followed logically. Thus, the seed of an idea for the commission of a church had already been planted in their minds when in 1964 the unexpected death of their friend and colleague Jermayne MacAgy brought it to the fore. MacAgy had belonged to the de Menils' circle of extraordinary people whom the couple managed to entice to come to Houston, some to work and others to visit, and with whom they enjoyed intimate friendships. After her arrival from California in 1955, MacAgy first worked as director of the Contemporary Arts Association, then transferred in 1959 to the Art Department at the University of St. Thomas, newly founded by the de Menils, who were longtime patrons of the small Catholic liberal arts college. MacAgy's nonconformist approach to teaching and her gift for evoking visceral responses from her students—along with her legendary, visually mesmerizing installations of countless exhibitions—were so rare that her death created a void in the Houston arts community. For John and Dominique de Menil in particular, it was as if an abyss had opened up, and they felt the right moment had arrived "to make an act of faith."[6]

Deciding on a site for the chapel was an easy task, as the de Menils had long wanted to see one built on the St. Thomas campus, which lacked both an adequately sized chapel and the art to go in it.[7] When they first began to look seriously for an appropriate site, they approached Father John Murphy, president of St. Thomas, to discuss their project. The university, founded by Basilian Fathers in 1947, had early on received support from the de Menils, who played an instrumental role in the choice of Philip Johnson as the campus' architect; he went on to design a series of strictly geometrical buildings that conveyed his intense dialogue at the time with Miesian concepts.[8] Johnson had included a place of worship in his master plan of 1957, but so far only the immediately necessary buildings for teaching had been erected in parallel rows of steel, brick, and glass. The de Menils soon settled on the two individuals to whom they wished to entrust their chapel: Johnson and the painter Mark Rothko. Before contacting Johnson, Dominique de Menil sought to ascertain Rothko's interest in creating a suite of paintings for a chapel during a visit to his New York studio on April 17, 1964, which reveals the importance the de Menils accorded the creator of the interior. Rothko had been a close friend of both Douglas and Jermayne MacAgy. The de Menils owned three of the artist's paintings before Dominique first met him in 1959, when she went to his studio to view murals he had painted for the Seagram Building in New York (see fig. 11.3).[9]

Rothko and Johnson had first become acquainted through the Seagram mural project. The architect approached the artist in the mid-1950s to invite him to paint the series of large works for the Four

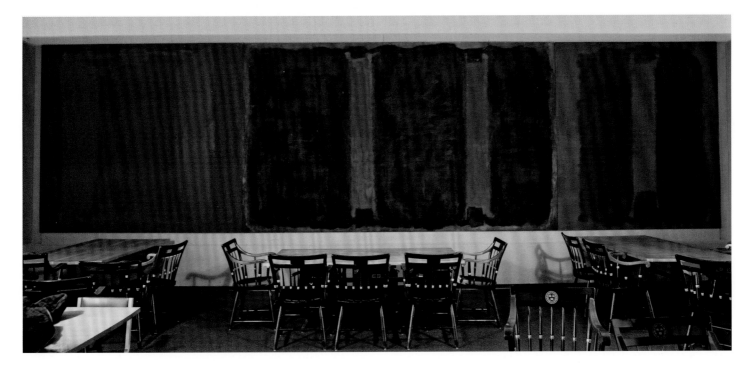

Fig. 11.3 *top*
Mark Rothko, *Seagram Mural, Section 7* (*Red on Maroon*), 1959.
Tate Modern, London

Fig. 11.4
Mark Rothko, *Panels I–III* (Harvard Mural Triptych), 1962. Installed
in the Holyoke Center, Harvard University, Cambridge, ca. 1964.
Harvard Art Museum, Fogg Museum, Harvard University, Gift
of the artist on deposit to the Harvard University Art Museums

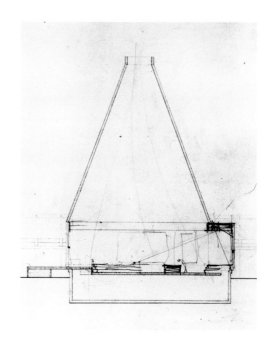

Fig. 11.5 *left*
Philip Johnson, preliminary octagonal
plan for the Rothko Chapel with steps,
1964. The Menil Collection, Houston

Fig. 11.6
Philip Johnson, preliminary section for
the Rothko Chapel with elongated
oculus (with sketches by Mark Rothko),
1964. The Menil Collection, Houston,
Gift of The Mark Rothko Foundation, Inc.

Seasons restaurant, which was going to be located in the building. Rothko at first was excited by the opportunity to work on a much larger scale than he had before and with a site-specific setting in mind.[10] But when he finished his three, somber-toned groups of paintings in 1959, he objected to their being hung in a decidedly noncontemplative setting and consequently withdrew them. A second commission of similar import that Rothko received in 1961 for another series of large paintings, the so-called "Harvard murals" (fig. 11.4), also became fraught with issues of context: the work was to hang in a meeting room that ended up being used for dining as well. This time Rothko did not withdraw the paintings, but his wish to more precisely control the creation of an enveloping ambience for a group of his works persisted.

At the start of his career in 1924, while studying at the Art Students League in New York under the charismatic teacher Max Weber (and influenced by his older painter friend Milton Avery), Rothko had first developed a representative imagery that centered on the emotional isolation of human beings in the estranging world of the interwar years. By 1939–40, Rothko's interest in creating art primarily as a means of self-expression had shifted toward a preoccupation with ancient myths and an increasing abstraction, although the human figure remained at the core of his research.[11] As Rothko drew closer and closer to the tragic, a theme that would dominate his painterly expression, he became associated with Clyfford Still and Barnett Newman, whose simultaneous concern with the tragic and with explorations in the realm of pure, abstracted forms encouraged Rothko to continue his own "process of elimination." By 1946 Rothko had set-

tled on the arrangement of what he called "multiforms," elements devoid of all figurative associations arranged in ambiguous spatial settings. At this stage, color became a much more relevant and expressive carrier of meaning.

Rothko from this moment onward insisted that his pictures contained "nothing—but content."[12] Like his colleagues working in what came to be described as the Abstract Expressionist mode, he increased the scale of his paintings in order to establish a more immediate, unmediated relationship with the viewer. His mature work from 1949 through the 1950s posits intense color planes, rectangles, and narrow bands on thinly painted backgrounds, which inquire into the proportions of space, light, and shadow. The use of dry pigments in rabbit-skin glue for the nondescript field bordering the edges permitted the creation of a receding visual effect due to the medium's matte surface appearance, while the shinier qualities of oil paint and egg tempera visually caused the color planes to float and hover.[13] Rothko's apprehensive, brooding nature found respite and inspiration in literature and music, and his quest for the depiction of what he considered "the most basic human emotions, tragedy, ecstasy and doom,"[14] was intended in fact "to raise the painting to the level of poignancy of music and poetry."[15]

The contract signed by Rothko and Father Murphy on February 13, 1965, stated that the artist agreed to "make a sufficient number of paintings to illuminate adequately the interior of the new chapel at St. Thomas, which is being designed by Mr. Philip Johnson. Since it is an octagonal chapel with an apse, it seems at present that there will be ten units—one to each of the sides, and three for the apse."

The contract also mentioned that Rothko had already spent six months on the project, including time in collaboration with Johnson.[16] In the summer of 1964, in preparation for the unprecedented scale of the paintings to be executed, Rothko had rented an old carriage house on 153 East 69th Street in Manhattan and had asked the first of three assistants to help him with the construction of a full-size mock-up of three adjacent walls of the chapel interior on which he would work out the smallest details of scale, proportion, and placement in his paintings (fig. 11.1). The dimensions of the chapel's eight walls never changed, contrary to almost every other aspect of its design. Also that summer, Rothko chose the overall dimensions of the strainers for the paintings.

As Rothko's contract noted, he and Johnson had been engaged in frequent exchanges on the design of the chapel's floor plan since the preceding October (fig. 11.5). The architect's original wish for a rectangular-shaped building quickly gave way to Rothko's desired octagon, and after further negotiations, Johnson let go of the inversely stepped base leading to the entrance in favor of a level one. Also, the three steps leading up to the apse were eliminated.[17] It seems that Johnson was originally unaware of Rothko's early voiced preference (documented in the contract stipulations) for an octagon, an architectural form central to Christian architecture beginning with the Church of the Holy Sepulchre in Jerusalem of 325–326 AD. During the increas-

ingly difficult negotiations, it became evident that Johnson intended to maintain control over the design of the chapel's exterior and the ceiling, granting Rothko domain only over the space below the ceiling line that his paintings would occupy, though Johnson did accept the octagonal plan. As the architect envisioned placing the church in a central position at the south end of the university mall, he felt justified in postulating a towering edifice: a white stuccoed octagon with a truncated, concrete pyramid and an oculus on top (fig. 11.6).

In April 1967, when Rothko had finished the paintings, he resumed his struggle with Johnson over the building plan. The two most contentious issues remained the lighting—Rothko preferred a skylight much like the one he had in his carriage-house studio—and the overall height of the building. Clearly, Rothko was concerned about having to consign his paintings to Johnson's dominating, overwhelming structure. When the two reached an impasse in late 1967, the de Menils were asked to intervene. Because they took sides with Rothko, perhaps motivated by the Second Vatican Council's declaration that the Church should aim for a less "triumphalist" mode of self-representation,[18] Johnson withdrew from the project and left it in the hands of his supervising collaborators in situ, Howard Barnstone and Eugene Aubry. With their guidance, Rothko's wishes were implemented without any further modifications, resulting in a brick-faced building with a low-hipped skylight (fig. 11.7). Since Rothko had never

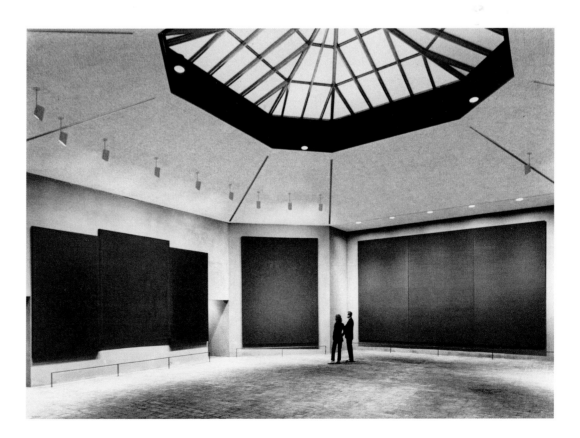

Fig. 11.7
Rothko Chapel interior with original uncovered skylight, Houston. Barnstone and Aubry, architects, completed 1972

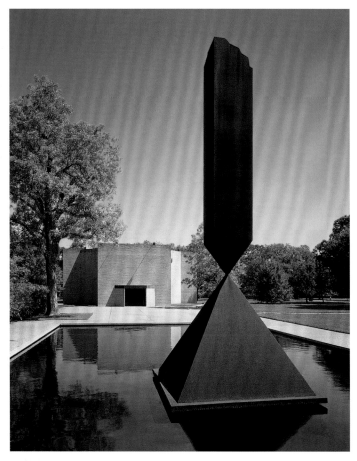

Fig. 11.8
Barnett Newman's *Broken Obelisk*, 1967, in the
reflecting pool in front of the Rothko Chapel

visited Houston, he probably underestimated the intense radiance of
Texas light. He had strong opinions about the lighting conditions of
his works, preferring his paintings to be shown under low light
using, ideally, only daylight. He envisioned a scrim for the chapel
much like the one made from parachute silk that he had had to use
even for the milder daylight in his New York studio. But the scrim,
added in 1974, proved to be an insufficient safeguard against the
scorching Houston sun. A more permanent element modifying the
ceiling was not installed in the chapel until 1976, when a baffle was
added to deflect some of the harsh light.[19] No detail of the interior
design, no matter how small, seemed too banal for Rothko's atten-
tion: he asked that the walls be a gray color, not painted but achieved
by spraying uncolored plaster on concrete blocks, and that the floor
be paved with asphalt bricks.

Construction of the building was delayed until May 1970 because
the de Menils had been obliged to find a new site for the chapel. Not
only had the Basilian Fathers made some demands regarding the
future use and site of the chapel that the de Menils considered unten-

able,[20] but philosophical differences between the de Menils and the
priests over the direction of the university itself eventually caused
the couple to move their programs to Rice University. Hence the
de Menils decided to approach the Institute of Religion and Human
Development, on whose board John de Menil served, to take on the
chapel project. The institute, an ecumenical graduate studies center
that trained pastors in clinical education, accepted the offer, and in
early 1969 ownership of the chapel was transferred. At that point,
the decision was made to turn the chapel into a nondenominational
place of worship, and after searching for an appropriate piece of land,
the trustees chose the current site. By 1972 the trustees and admin-
istration of the institute felt that the chapel's largely religious focus
was not in keeping with the institute's more academic and scien-
tific nature, so they decided to make it an autonomous entity. That
is when it became the Rothko Chapel.

Another important change to the chapel, with strong political
implications, occurred with the addition of Barnett Newman's sculp-
ture *Broken Obelisk*. Newman had conceived the sculpture in 1963,
but only found the right collaborator, the metal fabricator Don
Lippincott, for its realization in 1967. In 1969 the de Menils offered
the Cor-Ten steel sculpture as a gift to the city of Houston, under the
proviso that it should be dedicated to Martin Luther King Jr. Oppos-
ing the dedication to the civil rights leader, the city ultimately
declined, and the de Menils instead acquired it for the Institute of
Religion and Human Development and placed it on its current site
in front of the chapel in 1970 (fig. 11.8). Johnson was asked to design
a reflecting pool for the work, with Newman's participation, on a
south axis with the chapel's main entrance. The pyramid and inverted
obelisk's kindred sensibility with the spiritual context of the chapel
is striking: the collision of these two archaic, perfectly balanced, and
harmonious forms creates an enormous tension at the fine point
where they meet. The jagged edge of the obelisk directed skyward
establishes a connection with heaven, and the broad and heavy base
of the pyramid firmly roots the sculpture to the ground, while the
reflecting water confers a lightness and immateriality to the steel. The
balancing of all these variables is an extraordinary artistic achieve-
ment. Newman said of *Broken Obelisk* that "it is concerned with life
and I hope that I have transformed its tragic content into a glimpse
of the sublime."[21]

Rothko's paintings deal with similar themes. While he had set-
tled on the overall dimensions and the colors of the fourteen paint-
ings early on, every other aspect of the final design was subject to an
arduous process of gradual adjustments and eliminations: the num-
ber of paintings in the space, their arrangement, their exact position-
ing, and finally the internal balance of their picture planes. For
instance, Rothko may have considered placing small predella paint-

ings underneath the triptychs[22]—after all, he had executed the entire series based on the assumption that they would be placed in a Catholic chapel—but, he focused instead on the basic organization of the purple monochrome and the black form paintings. As finally arranged, the canvases can be divided into four sections: a purple monochrome work, with a black rectangle placed off-center toward the top, which hangs on the south entrance wall; four individual purple monochromes facing one another on the four angled walls; two sets of triptychs, consisting of purple monochrome backgrounds with centrally placed black rectangles, on the east and west walls; and an apse triptych of three purple monochromes on the north wall. The restrained, concentrated atmosphere created by the muted hues was not completely unexpected, as Rothko, beginning in 1963, had shifted his coloration toward a much more restricted palette. Yet this choice, combined with the sharp boundaries of the rectangles achieved by Rothko's unprecedented use of masking tape, took even Dominique de Menil by surprise when she saw one of the paintings for the first time: "I was taken aback. It was a very large canvas of a dark purplish color, much darker than anything I had anticipated. He did not say a word. I did not say a word. I sat and looked, and he looked at me. Gradually I began to absorb, or rather I was absorbed into, an ocean of soft, velvety, purplish-black."[23]

Considering the enormous size of the paintings, ranging from 180 x 105 inches to 135 x 245 inches, Rothko was required to work with assistants who helped not only in moving the paintings but also in stretching the cotton-duck canvas and applying the paint. Having two people work in tandem allowed for a much more even application while preserving the both unavoidable and desired traces of a human hand. All fourteen stretched panels first received a coat of blue, black, and red pigments mixed with rabbit-skin glue, followed by a modifying coat of an acrylic medium with black pigments. The surface thus achieved has a velvety quality. For the black forms, Rothko himself would daily create, without a recipe, a mixture of oil paint, whole eggs, a natural resin called Damar, and turpentine. Before applying the first coat of black paint, however, he would make a preliminary drawing of the shape on the "primed" surface with black charcoal.[24] The complex evolution of the final proportions of the black rectangles versus the background can be accurately traced in the deliberately kept pentimenti, which reveals the importance of such fine adjustments for the artist.[25] With now only a minimum number of variables at hand, Rothko had begun to focus on surface reflectance—the different, juxtaposed qualities of sheen that (in the absence of readily perceptible differences of hue) were taking on a much greater importance in his work than ever before. It is primarily due to the attention that he paid to every one of these visual components that the viewer can experience the feeling of being at once

Fig. 11.9
Last Judgment (detail), 1190. Basilica St. Maria Assunta, Torcello, Italy

enveloped by, and denied entrance to, the virtual space of his creation.

A number of factors suggest that the first paintings to be completed were the entrance wall panel and the north wall triptych.[26] The entrance wall panel bears the most direct resemblance to all the other works of Rothko's career up until that point. While he did not in general travel widely, Rothko did take three influential trips to Italy relatively late in life, and he is known to have been strongly affected by the church of St. Maria Assunta in Torcello.[27] The entrance wall and the apse wall of the twelfth-century basilica are decorated with brightly colored mosaics that depict the Last Judgment (fig. 11.9) and the Virgin and Child, respectively. While it would be a mistake to equate any aspect of Rothko's design with overtly religious imagery, he nonetheless was fully committed to creating an atmosphere conducive to contemplation. The awe and tension inspired by the strong polarity formed by the north-south axis in the Rothko Chapel, somewhat relieved by the balancing angle-wall murals that are in turn counterbalanced by the black-form triptychs, mean that the gaze of the observer is drawn into a wandering, echoing movement from unit to unit. The black-form triptychs were initially conceived as horizontally aligned at top and bottom like the north apse triptych (fig. 11.10),

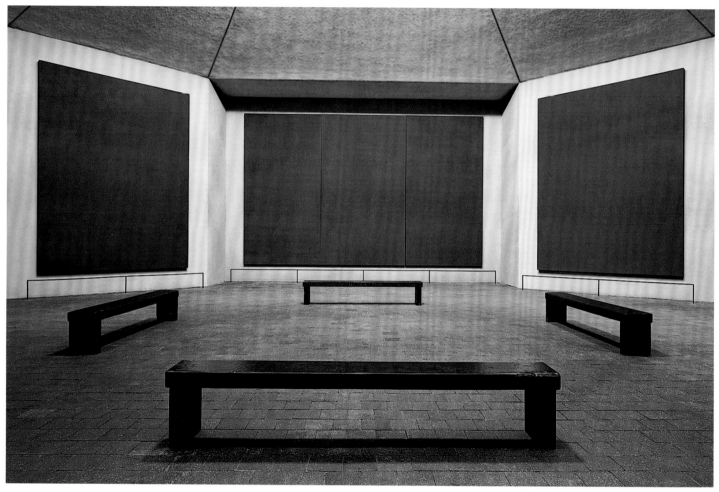

Fig. 11.10
Rothko Chapel interior, looking north toward apse triptych

but presumably to create a stronger counterbalance between the tall south wall panel and the wider north wall triptych, Rothko at the end of 1966 decided to raise both center panels of the black-form triptychs and their overall placement between the doorways. Although the various differences between the black-form triptychs are subtle indeed, Rothko nonetheless made exact provisions for varying the installation heights of the center panels, in addition to introducing compositional differences in the works themselves.

By the time Rothko was at work on the chapel paintings, he had long ceased to offer overt explanations of what his work was about. He placed his confidence in the ability of his paintings to speak for themselves and communicate with a receptive viewer. About the chapel paintings, he said that he attempted to express the "infinite eternity of death,"[28] which would be in keeping with his previously articulated preoccupation with the basic human values of tragedy, ecstasy, and doom. Instead of facilely relating his comment to his suicide on February 25, 1970, one year before the chapel opened,[29]

or to an unusually depressed outlook on life, one could see instead the choice of his subject as a courageous act in that he offered his personal view on life through the paintings as a pictorial invitation to anyone who would be able to look beyond the material surface of life. The existential experience that many visitors undergo at the chapel is possible only through their willingness to face themes such as the realization of their own mortality. But often the joy of being alive and making the most of time is ultimately intensified. Rothko challenged himself for this commission to find the most essential pictorial language imaginable to him in order to express the essential truths as he saw them. Writing to the de Menils, he described the strong personal effect this had on him: "The magnitude, on every level of experience and meaning, of the task in which you have involved me, exceeds all my preconceptions. And it is teaching me to extend myself beyond what I thought was possible for me."[30] All he could do from that moment onward was hope that visitors would be compelled to do the same.

NOTES

1. Dominique de Menil, "To Recapture the Voice of Père Couturier," in Marie-Alain Couturier, *Sacred Art* (Austin: University of Texas Press, with Menil Foundation, 1989), 9.

2. *Art sacré*, that is, art conceived for a religious context, was begun as a movement of renewal through the efforts of Maurice Denis and Georges Desvallières. Couturier joined their "Ateliers d'Art Sacré" at the end of 1919.

3. Dominique de Menil, "Preface," in Susan J. Barnes, *The Rothko Chapel: An Act of Faith* (Austin: University of Texas Press, 1989), 7.

4. Dominique de Menil, "Matisse and Rothko," in Henri Matisse, Marie-Alain Couturier, and Louis-Bertrand Rayssiguier, *The Vence Chapel: The Archive of a Creation* (Houston: Menil Foundation; and Milano: Skira Editore, 1999), 7.

5. Marie-Alain Couturier, "For the Eyes," in Couturier, *Sacred Art*, 14. Couturier was co-editor of *L'art sacré*, an influential and contentious review founded in 1935.

6. Barnes, *The Rothko Chapel*, 42.

7. A small chapel by Glenn Heim was located between the former library and what was then called the Language building. The chapel was built in a preexisting building attached to the Language building, which itself had been converted from a residential structure (the Howard Hughes House). Later the chapel was converted into an art gallery. In 1997 Johnson built a chapel in a deconstructivist style for the university; it is located on the north end of the quadrangle.

8. As early as 1949, Johnson had already upset the well-to-do Houston neighborhood of River Oaks by placing right in its midst an austere, flat-roofed building, also in the International Style, that would be the de Menils' family home.

9. At that time Douglas MacAgy had suggested that the de Menils ask Rothko to show them the "Seagram Murals," which he had finished relatively recently, with an eye to acquiring them for a chapel for St. Thomas. However, the project was delayed and was resurrected only after Jermayne MacAgy's death. See Barnes, *The Rothko Chapel*, 34.

10. See, for example, David Anfam, *Mark Rothko, Works on Canvas, Catalogue Raisonné* (New Haven, Conn., and London: Yale University Press, 2001), 91.

11. See, for example, Mark Rothko, "Subject and Subject Matter," in *The Artist's Reality: Philosophies of Art / Mark Rothko*, ed. Christopher Rothko (New Haven, Conn.: Yale University Press, 2004), 84.

12. Mark Rothko, quoted in "A Certain Spell," *Time*, March 3, 1961, 72.

13. For an in-depth discussion, see Carol Mancusi-Ungaro, "Material and Immaterial Surface: The Paintings of Rothko," in *Mark Rothko*, exh. cat. (Washington, D.C.: National Gallery of Art; and New Haven, Conn.: Yale University Press, 1998), 282–300.

14. Mark Rothko, quoted in Selden Rodman, *Conversations with Artists* (New York: Devin-Adair, 1957), 93.

15. Mark Rothko, quoted in Brian O'Doherty, *American Masters: The Voice and the Myth* (New York: Random House, 1973), 153.

16. Contract signed by Father John Murphy and Mark Rothko, February 13, 1965, Menil Archives.

17. Sheldon Nodelman, *The Rothko Chapel Paintings: Origins, Structure, Meaning* (Austin: University of Texas Press, with Menil Collection, 1997), 43–77.

18. Ibid, 70.

19. The resulting problem of overly bright illumination of the paintings at the top versus a relatively shadowy appearance at the bottom would only be resolved satisfactorily in the most recent redesign of the baffle by Ove Arup & Partners and Jim McReynolds in 2000.

20. Nodelman, *The Rothko Chapel Paintings*, 71.

21. Barnett Newman, quoted in Annalee Newman to John and Dominique de Menil, July 8, 1971, Menil Archives.

22. A predella is an integral part of a typical Gothic altar polyptych. Predellae are placed underneath the central panel and often depict a Man of Sorrows or scenes of the lives of the saints shown above them.

23. Dominique de Menil, "Acceptance Speech of the 1992 Christian Culture Award Gold Medal" (speech delivered at Assumption University, Windsor, Ontario, 1992), 2, Menil Archives.

24. For a more detailed description, see Carol Mancusi-Ungaro and Pia Gottschaller, "The Rothko Chapel: Reflectance, Reflection and Restoration," in *Zeitschrift für Kunsttechnologie und Konservierung*, vol. 2 (Worms am Rhein, Germany: Wernersche Verlagsgesellschaft, 2002), 215–24.

25. Carol Mancusi-Ungaro, "Nuances of Surface in the Rothko Chapel Paintings," in *Mark Rothko: The Chapel Commission* (Houston: Menil Collection, 1996), 25–29.

26. These factors include the development of his painting technique and the existence in the Menil Collection of five other similar, but differently sized, paintings like that for the north wall. See Nodelman, *The Rothko Chapel Paintings*, 89, 115.

27. Barnes, *The Rothko Chapel*, 67; Nodelman, *The Rothko Chapel Paintings*, 93.

28. Mark Rothko, quoted in Nodelman, *The Rothko Chapel Paintings*, 306.

29. The Rothko Chapel was solemnly dedicated in two ceremonies on February 27 and 28, 1971.

30. Mark Rothko to John and Dominique de Menil, January 1, 1966, Menil Archives.

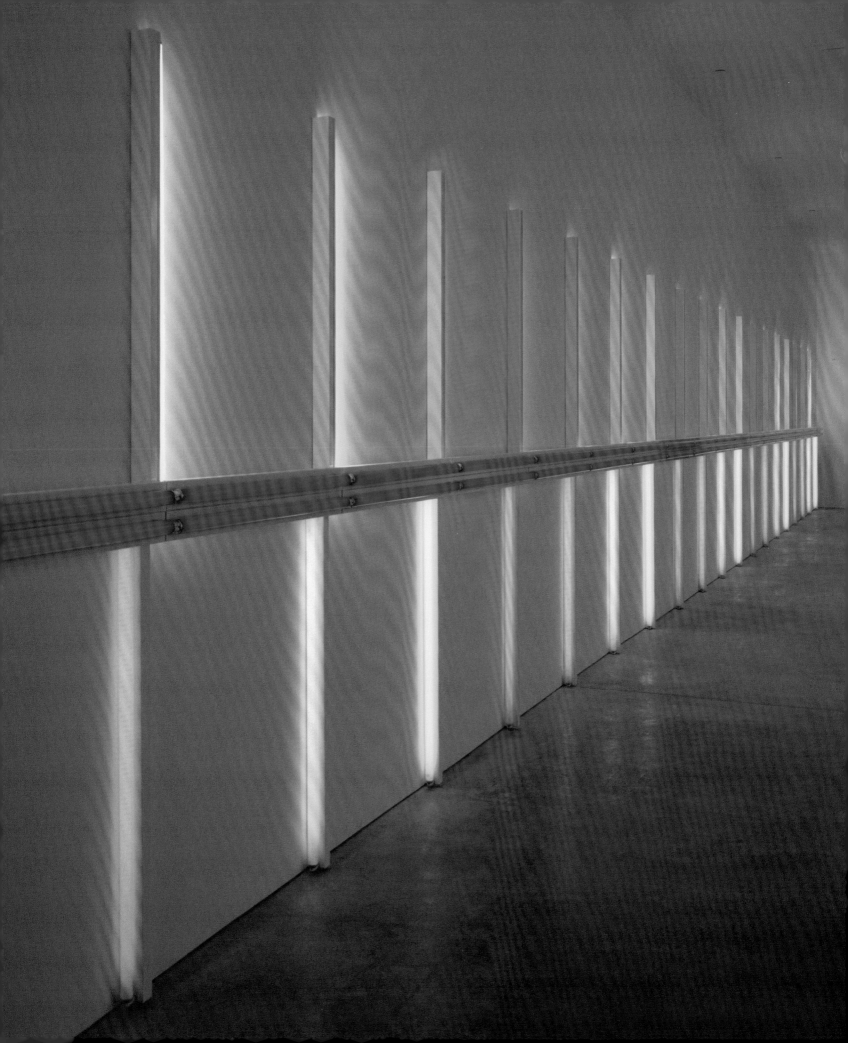

Regard the Light:
The Dan Flavin Installation at Richmond Hall CLARE ELLIOTT

You are a wonderful person, exceptionally sensitive, intelligent and generous. You are also a very good artist.... It was kind of a miracle for me to witness the birth of the show. I go there every day and its beauty strikes me anew each time.... We like the idea of some permanent Flavin show... but don't be impatient, it involves a lot of planning.[1]

Dominique de Menil

So wrote Dominique de Menil to the artist Dan Flavin in 1972, following the opening of "cornered fluorescent light from Dan Flavin," an exhibition of his work that she had organized for the Institute for the Arts at Rice University. De Menil was wise to counsel patience; she herself could not have anticipated that a permanent installation of Flavin's work would take over a quarter of a century to realize. As her letter suggests, the de Menils, Dominique in particular, had developed an intense admiration for Flavin, a feeling both personal and professional. Perhaps it was the influence of her children and colleagues, whose support bolstered her interest in the intervening years; her background in math and science, which drew her to Flavin's geometrically ordered oeuvre; or maybe simply her love of light—which she incorporated into all her building projects—that caused Flavin's aesthetic to resonate with her. Whatever its origins, her esteem for the artist, and her vision for a space dedicated to his work, finally took shape as the Dan Flavin Installation at Richmond Hall.[2]

Dan Flavin began his long relationship with the unconventional medium of fluorescent light in 1963, when he attached a single eight-foot-long yellow fluorescent light fixture to his studio wall, calling the work *the diagonal of personal ecstasy,* then renaming it one year later *the diagonal of May 25, 1963 (to Constantin Brancusi)* (fig. 12.2). Flavin discovered in what would become his signature medium an unexpected sensuousness and beauty. Ordinarily associated with the sterile glow of utilitarian lighting in mundane settings, such as warehouses and offices, fluorescent lights lack the colorful come-on of

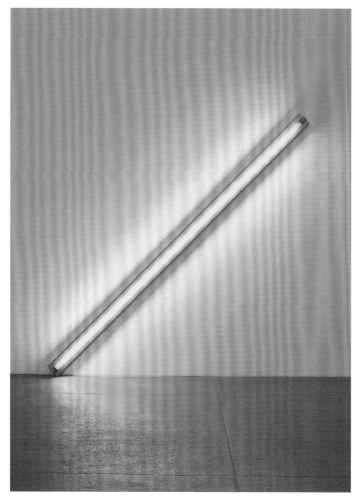

Fig. 12.2
Dan Flavin, *the diagonal of May 25, 1963*
(*to Constantin Brancusi*), 1963. Dia Art
Foundation, New York

neon: they do not advertise or entice, flicker or flash, or otherwise call attention to themselves. Available from any hardware store, they are meant to function as a practical light element, not as a source of entertainment or contemplation. More important, fluorescent lamps come in a limited range of standard lengths and colors. Like the Dutch painter Piet Mondrian, whose work inspired Flavin's passionate interest, the artist found enormous freedom in the endless combinations and recombinations of a deliberately limited visual vocabulary.

Flavin quickly grasped the potential for fluorescent light to transform the viewer's perception of interior space. In 1965, merely two years after his initial discovery, Flavin wrote:

> Regard the light and you are fascinated—inhibited from grasping its limits at each end. While the tube itself has an actual length of eight feet, its shadow, cast by the supporting pan, has none but an illusion dissolving at its ends.… Realizing this, I knew that the actual space of a room could be broken down and played with by planting illusions of real light (electric light) at crucial junctures in the room's composition. For example, if you press an eight-foot fluorescent lamp into the vertical climb of a corner, you can destroy that corner by glare and doubled shadow. A piece of wall can be visually disintegrated from the whole into a separate triangle by plunging a diagonal of light from edge to edge on the wall.[3]

In the many room-sized installations (or "situations," as he chose to call them) that he created over the course of his career, Flavin pursued a decades-long meditation on the effects of space, light, and color.

Flavin insisted that light for him was merely a medium, carrying no religious or symbolic meaning: "There is no hidden psychology, no overwhelming spirituality that you are supposed to come into contact with."[4] Despite this assertion, it seems almost instinctual for viewers to find, if not a spiritual connotation, at least a metaphysical experience in Flavin's light installations. As critic Melinda Wortz observed of his work in 1983, "Presented in a medium whose beauty is simultaneously direct and inexplicable, it embodies the potential for transcendent awareness that is inherent in ordinary experience, and that has been recognized through light in virtually all spiritual traditions."[5] John and Dominique de Menil were likewise captivated by Flavin's work. The profound beauty and otherworldly glowing colors of Flavin's sculpture appealed to the de Menils' sophisticated aesthetic and likely to their spiritual side as well. Furthermore, the fact that such a powerful experience could be evoked from a material common to the blandest of buildings would have resonated with their democratic ideals.

The de Menils' first recorded encounter with Flavin's work occurred at the 1970 exhibition "four 'monuments' to V. Tatlin 1964–

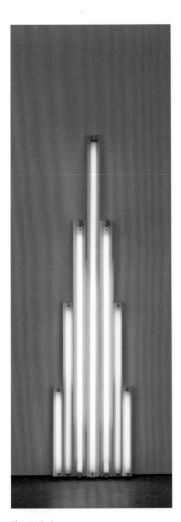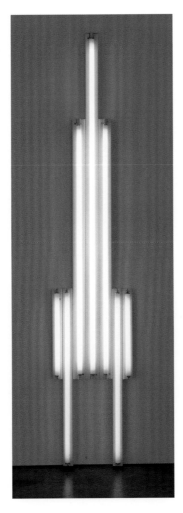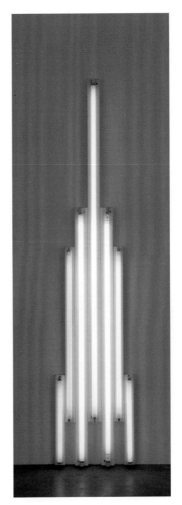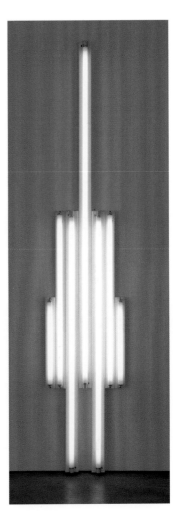

Figs. 12.3–6
Dan Flavin, *"monument" 1 for V. Tatlin*, 1964; *"monument" 7 for V. Tatlin*, 1964; *"monument" for V. Tatlin*, 1966-69; and *"monument" for V. Tatlin*, 1969. The Menil Collection, Houston

1969 from Dan Flavin" at the Leo Castelli Gallery in New York. It so moved them that they immediately bought all of the works on display. Shortly after the Castelli show, Dominique de Menil, as director of the Institute for the Arts at Rice University, invited Flavin to Houston to contribute an original work to an exhibition she intended to organize featuring the four recently acquired *"monuments"* (figs. 12.3–6). She was encouraged to do so by German art dealer Heiner Friedrich (see fig. 12.8), once married to the de Menils' youngest daughter, Philippa, whose enthusiastic support of Flavin's work began in 1968 and continues to this day. Flavin and Friedrich came to Houston several times in the autumn of 1972, working closely with de Menil and her former student and curatorial assistant Helen Winkler. The exhibition, "cornered fluorescent light from Dan Flavin," was presented October 5–November 26, 1972 (fig. 12.7).

In the main gallery, the artist placed four twelve-foot-high, X-shaped partitions, each creating four inner corners where the walls crossed. He arranged twelve circular fluorescent lamps, a variety he had begun to incorporate into his work earlier in the year, in a column on the right wall (from the viewer's perspective) of one inner corner of each partition, positioning the partitions so that the four light columns faced one another. The stacked circular lamps, which alternated cool white and daylight lamps,[6] extended a few inches above the walls. Accompanying this site-specific piece called *untitled (to Dominique and John de Menil)* were ten additional works borrowed for the exhibition.[7] In combinations of white, green, pink, yellow, and blue fluorescent tube lamps, each work was installed in one of ten of the remaining twelve corners of the four X-shaped partitions. The arrangement resulted in a stunning "core of pure white light surrounded by color."[8] The four *"monuments"* to V. Tatlin were displayed together in a separate room.

Inspired by the de Menils' art collection, Flavin asked Winkler if he could organize a selection of their drawings. She agreed, and

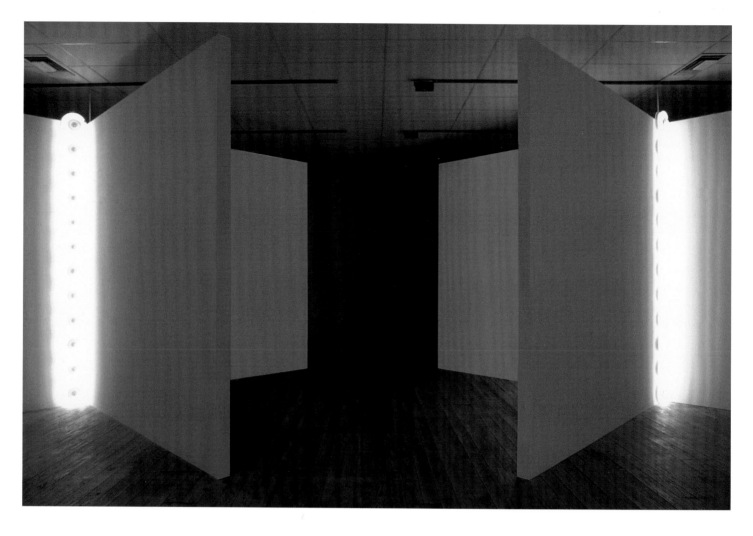

Fig. 12.7
"cornered fluorescent light from Dan Flavin,"
Rice Museum, Rice University, Houston, 1972

Fig. 12.8
Don Quaintance, Helen Winkler, Heiner
Friedrich, and Dan Flavin during installation
of "cornered fluorescent light from Dan Flavin,"
Rice Museum, Rice University, Houston, 1972

they were shown in a separate gallery in the Rice Museum (the "Print Club room") simultaneously with his exhibition.[9] Faithful to his love of seriality and logical order, Flavin hung the drawings in a strictly chronological progression, placing them edge to edge around the room. Winkler recalls that when Dominique de Menil learned of his plans, she became furious, afraid that a competing exhibition would distract from his work.[10]

Despite their disagreement over the drawings, de Menil was thrilled with Flavin's light installation, to the point that she refused to produce a publication of the exhibition "because you cannot catalogue a miracle."[11] Her refusal is particularly significant considering that she published catalogues for most of the exhibitions organized by the Institute for the Arts. Flavin likewise developed a great respect for de Menil, as a letter to Winkler testifies: "I like the way that Dominique cooperates, especially with modifying suggestions which reveal that she follows me with penetrating understanding. And she has a good humored, direct, no nonsense attitude. Her mind is well used."[12] Understanding the importance of space in Flavin's art, Dominique de Menil began to discuss with him a permanent installation of his work while the Rice exhibition was still open. Although Flavin was extremely receptive, the project was not immediately pursued, likely due to John de Menil's death in 1973 and to the increasing amount of time that Dominique de Menil devoted to human rights causes after that. She did remain acutely aware of Flavin's work and included his pieces in important European exhibitions of her collection.[13] The idea of a site dedicated to the permanent presentation of Flavin's work was formally revisited shortly after the opening of the Menil Collection in the late 1980s. At that time, the Menil Collection was investigating opportunities to collaborate with the Dia Art Foundation in an effort to find or create spaces for the display of Dia's large and for the most part unseen collection of contemporary art.[14]

Although the de Menils had been leaders in the commission of important new architecture throughout their lives, in the 1990s Dominique de Menil and Paul Winkler, Helen's brother and then director of the Menil, became interested in exploring the conversion of existing buildings into sites for the display of art; Dia in New York and Donald Judd at the Chinati Foundation in Marfa, Texas, had for some time pursued this practice.[15] The Menil Foundation already owned a suitable property—Richmond Hall, located three blocks south of the museum's main building. Built in 1930 as Weingarten's Grocery #9 (fig. 12.9), one of the city's early grocery stores, the building over time had housed a series of bars including, in its last incarnation, Van's Stampede Ballroom, a country-western dance hall. De Menil appreciated the building for its simple structure as well as

its history in the life of the neighborhood. Understanding that it would likely have been demolished if purchased by a developer, the Menil Foundation had acquired the property in 1985.

The building was renovated while the Menil Collection was being constructed, with the idea of using it as a space for performances and more experimental exhibitions. Under the supervision of Houston architect Anthony E. Frederick, the original storefront and skylight were retained, but the interior was completely reconstructed. Dominique de Menil asked Frederick to add two angled walls to the building's entryway to create a funnel-like foyer for the space.[16] Richmond Hall opened simultaneously with the Menil Collection in June 1987, showing "Warhol Shadows," an exhibition of serial paintings by Andy Warhol. Three years later, however, the museum had presented only three exhibitions, and the space was being used mainly for storage.[17] It seemed the logical choice as a site for Flavin's work, and in January 1990 Paul Winkler wrote to the artist on behalf of the Menil Foundation, outlining the foundation's vision for Richmond Hall: "This proposal was instigated by a desire to see realized the installation of the Tatlin monuments as you have envisioned for such a long time. We would approach the Dia Foundation board for the gift or permanent loan of the 21 Tatlin monuments they hold and leave it to you to add any others you feel should be included … and new work incorporating daylight from the skylight and storefront, created to your design as feasible in the remaining space. Finally, if you agreed, a small room with 'icons' and/or other early work could be extraordinary."[18]

The plan developed slowly over the next several years, having to compete for time and resources with the Cy Twombly Gallery and the Byzantine Fresco Chapel, other de Menil projects under development simultaneously with Richmond Hall. During these years de Menil and Winkler made a number of visits to the artist at his home on Long Island. At one point, Flavin did design an installation for the *"monuments" to V. Tatlin* for Richmond Hall. As discussions advanced, however, that plan was discarded for a number of reasons. For one, Winkler felt that the Dia *"monuments"* should stay in New York, while Flavin himself, for personal reasons, had grown frustrated with Dia and so less inclined to cooperate with the institution. Finally and most important, de Menil had become excited about the prospect of supporting a new work by the artist. In the end the proposal for Richmond Hall was redefined as a new, site-specific commission.[19]

By now Flavin was seriously ill due to complications from diabetes. Unable to visit the site himself, he relied on his technical assistant, Steve Morse—who traveled to Houston and videotaped the entire exterior and interior of the building—as well as his own memories of the site from his prior visits to Houston.[20] In November 1996, two

Fig. 12.9 *top*
Weingarten's Grocery #9 (now Richmond Hall), Houston, ca. 1934

Fig. 12.10
Untitled (detail, *installed along left roof line*), 1996. Exterior of Richmond Hall, The Menil Collection, Houston

days before his death, Flavin certified his design for the permanent installation in Richmond Hall. The construction was carried out posthumously by the artist's studio, supervised by Morse and Winkler.

Although Flavin was given complete creative control over the project, he chose not to alter the building's structure, instead designing three distinct but related pieces for the existing site. Flavin took advantage of the building's skylight, allowing the intensity of the Texas sun to interact with the electric light of the installation. He anticipated that the effects would vary according to the season, the weather, and the time of day, introducing an element of randomness and mutability to his otherwise carefully controlled system.

On the exterior, horizontal lines of custom-built, weatherproof housings, each fluorescent fixture containing two eight-foot green tubes, articulate the east and west top perimeters of the building (fig. 12.10). Flavin chose green lamps because they create the strongest and most far-ranging light, calling it his "gift to the neighborhood."[21] Understated on sunny days, the light illuminates the parking lot at night, tying Richmond Hall to the commercial buildings nearby by mimicking their exterior signage. On damp evenings, humidity diffuses

the light further, filling the area with an eerie green mist. The building's entrance lobby contains a second work consisting of two sets of eight-foot daylight fluorescent lamps mounted diagonally at forty-five degree angles on the foyer walls (fig. 12.12). The angles of the lamps in this work relate to the angles of the walls themselves, while recalling Flavin's seminal work *the diagonal of May 25, 1963*.

The largest and most complex of the three installations occupies the building's main interior space, an unbroken rectangular room measuring approximately 128 feet long by 50 feet wide. A dark purple line made up of filtered ultraviolet lamps (commonly known as blacklight) horizontally divides each of the building's long sides (figs. 12.1 and 12.11). Flavin included the blacklight (an element more typical of his late career) as a means to blend the light from the colored lamps in order to create in the surrounding environment a brightness approximating that of the natural light entering from the skylight.[22] Above and below that line, offset slightly from one another, a sequence of vertically oriented, four-foot, colored fixtures progresses the length of the building. The colors alternate in a repeating pattern of pink, yellow, green, and blue. In the two rows, top and bottom, the colored tubes face opposite directions so that the light reflects off the lamps' metal bases, incorporating the fixtures into the design. The colors also bounce off of the matte white wall, the ceiling above, and the polished concrete floor below. The varying consistencies and colors of light appear to change as one moves through the space—the lamps' bases obscuring, reflecting, or revealing according to one's position.

Like the angled work in the foyer, the central installation relates to an earlier work: *untitled (to Saskia, Sixtina, Thordis)*, 1973 (fig. 12.13), was created in conjunction with "Dan Flavin: Drei Installationen in fluoreszierendem Licht" (Dan Flavin: Three Installations in Fluorescent Light), held November 9, 1973–January 6, 1974, at the Kunsthalle Köln.[23] Flavin had revisited earlier work throughout his career, demonstrating that subtle variations in pattern could produce dramatically different installations. *untitled (to Saskia...)*, presented in Cologne within a very similar, though slightly larger rectilinear room (164 x 72 feet), contained the same sequence of pink, yellow, green, and blue lamps, and the same pattern of forward- and backward-facing fixtures at the same four-foot intervals as in Richmond Hall. The apparently small differences between the two, however, would produce a profound effect. In Cologne the bisecting horizontal lines of light were blue, rather than ultraviolet. Photographs of the installation reveal that without the blending effect of the blacklight, *untitled (to Saskia...)* was awash in blue tones—perhaps a nod to a wintry German sky—and as a result, the reflections so prevalent in the later Houston installation were muted. The second divergence is that, in Cologne, the repeating pattern of the fixtures

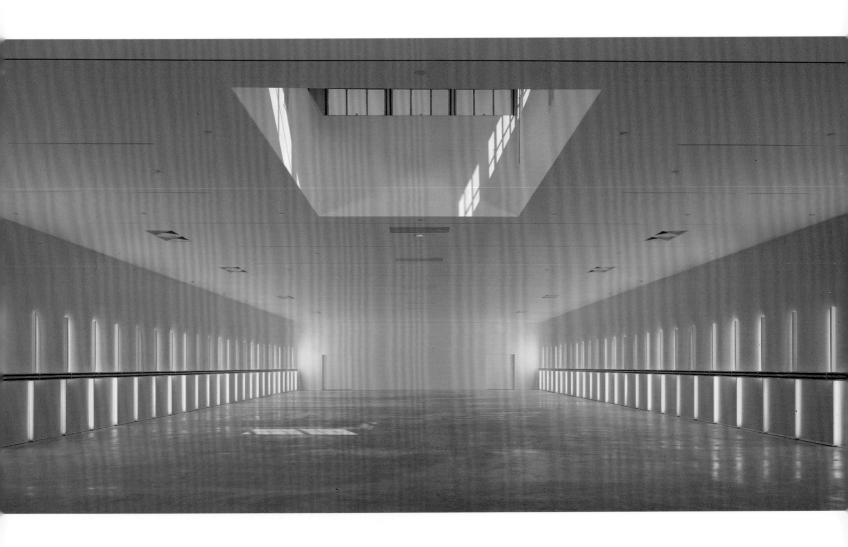

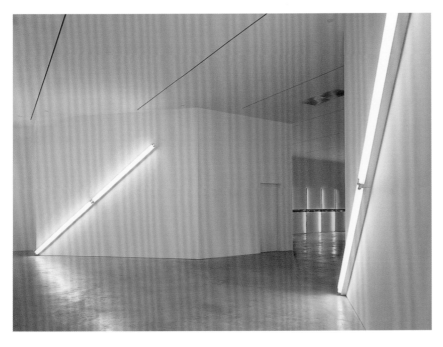

Fig. 12.11
Dan Flavin, *Untitled*, 1996. Installation view,
Richmond Hall, The Menil Collection, Houston

Fig. 12.12
Dan Flavin, *Untitled* (*foreground*), 1996.
Installation view, Richmond Hall, The Menil
Collection, Houston

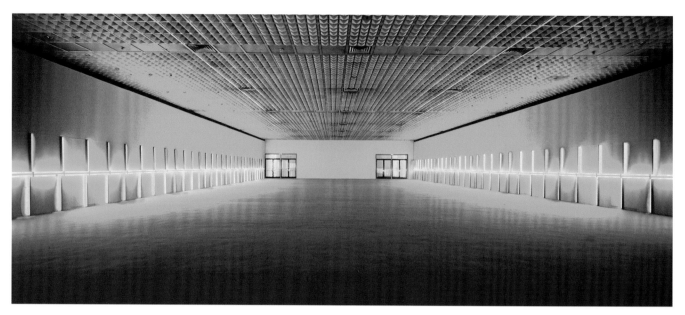

Fig. 12.13
Dan Flavin, *untitled* (*to Saskia, Sixtina, Thordis*),
1973. Installation view, Kunsthalle Köln

started on one wall and progressed back as far as the space allowed, then picked up on the opposing wall and progressed forward. This meant that although the pattern on both walls was the same, the progressions on each were staggered relative to one another. In Houston, the opposing walls have exactly the same progression of fixtures. The symmetry created in the main room at Richmond Hall echoes the symmetry of the lobby installation, as well as the outdoor frieze, "creating an interior/exterior system for the entire structure."[24] The unity of the three pieces underscores the distinction of Richmond Hall as an entire building given over to the artist rather than merely a single room or series of spaces.

In the summer of 2003, the Dan Flavin Installation came full circle when the Menil converted a storage room in Richmond Hall into a separate exhibition space to permanently display the four *"monuments" to V. Tatlin* in its collection.[25] Vladimir Tatlin (1885–1953), the father of the Russian avant-garde art movement Constructivism, had advanced a radical Marxist philosophy that art, like science and engineering, would eventually evolve to express the needs of the working class, thereby improving the condition of society as a whole. Like Flavin, Tatlin attempted to collapse the distinctions between art, design, and architecture by constructing totally abstract sculptural reliefs out of untreated, commonly available materials. Flavin appreciated the aesthetic of the Constructivists: "Thus far, I have made a considered attempt to poise silent electric light … in the box that is a room. This dramatic decoration has been founded

in the young tradition of a plastic revolution which gripped Russian art only forty years ago…. *'monument' 7* in cool white fluorescent light memorializes Vladimir Tatlin, the great revolutionary, who dreamed of art as science."[26]

He did not, however, share the Constructivists' utopian vision. By placing the titles of his *"monuments"* in quotation marks, Flavin emphasized that he intended them to be understood ironically—as temporary memorials built of mass-produced fluorescent tubes that can be switched on and off, thus only as timeless as the light fixtures themselves. The arrangement of the four *"monuments"* at Richmond Hall restages their exact configuration in the exhibition at the Leo Castelli Gallery in 1971, where the de Menils first encountered and purchased the works.

Dominique de Menil, who died in 1997, did not live to see the permanent Flavin exhibition that she had envisioned more than two decades earlier. Officially credited as her "final commission," the Dan Flavin Installation opened to the public on November 18, 1998, adding to Houston extraordinary artworks by one of the innovators of twentieth-century art. In its unobtrusive, yet spectacular, beauty Richmond Hall resembles all of the de Menils' building projects—their home, their museum, the Rothko and Byzantine chapels, and the Cy Twombly Gallery. Indeed, this humble grocery store, transformed by light, seems a fitting analogue to the many art and architectural projects the de Menils created for the city they chose to adopt.

NOTES

1. Dominique de Menil to Dan Flavin, November 18, 1972, Menil Archives.

2. Richmond Hall is one of only a few long-term installations by Flavin in the U.S. For a complete list, see Michael Govan and Tiffany Bell, *Dan Flavin: The Complete Lights 1961–1996* (New York: Dia Art Foundation and Yale University Press, 2004), 157.

3. "Dan Flavin, an Autobiographical Sketch," *Artforum* 4, no. 4 (December 1965): 24.

4. Dan Flavin, quoted in Michael Gibson, "The Strange Case of the Fluorescent Tube," *Art International,* no. 1 (Autumn 1987): 105.

5. Melinda Wortz, "Dan Flavin, E. F. Hauserman Company showroom, Pacific Design Center," *Artforum* 21, no. 5 (January 1983): 82. For more on the complicated subject of spirituality in Flavin's work, see Michael Govan, "Dan Flavin: Sacred and Profane," in *Robert Lehman Lectures on Contemporary Art* (New York: Dia Art Foundation, 2000), 181–93.

6. A variety of whites is available in fluorescent lamps: warm white, cool white, daylight, soft white, and deluxe white. Flavin mainly used cool white and daylight. See Steve Morse, "Technical Aspects and Some Sited Works of Dan Flavin," in *Light in Architecture and Art: The Work of Dan Flavin* (Marfa, Texas: Chinati Foundation, 2002), 127–46.

7. The installation included *untitled (to Janie Lee) one,* 1971; *untitled (to Janie Lee) two,* 1971; *untitled,* 1969; *untitled,* 1969; *untitled (to Virginia Dwan) 1,* 1971; *untitled (to Virginia Dwan) 2,* 1971; *untitled (to Shirley and Jason),* 1969; *untitled,* 1969; *untitled (to Helen Winkler),* 1972; and *untitled (to the "innovator" of Wheeling Peachblow),* 1966–68. The installation was reconstructed by the Flavin foundation in 2006 for "Dan Flavin: A Retrospective" at the Hayward Gallery, London.

8. Press release for "Dan Flavin: An Exposition of Light," 1972, Menil Archives.

9. The exhibition included works by Paul Cézanne, John Chamberlain, Giorgio de Chirico, Juan Gris, Paul Klee, Franz Kline, Henri Laurens, Fernand Léger, Man Ray, Henri Matisse, Amedeo Modigliani, Claes Oldenburg, Pablo Picasso, Robert Rauschenberg, Auguste Rodin, Vincent van Gogh, Andy Warhol, and Wols.

10. Helen Winkler Fosdick, notes from telephone conversation with archivist Geraldine Aramanda, March 12, 2003, Menil Archives database.

11. Dominique de Menil to Dan Flavin, November 18, 1972, Menil Archives.

12. Dan Flavin to Helen Winkler, September 18, 1972, Menil Archives. (I believe this letter is misdated and was actually written in September 1973, as it refers both to the opening, which occurred in October 1972, and to posters sent to the artist in February 1973.)

13. Friedrich suggests that her appreciation of Flavin's work actually increased in those years. Conversation with the author, August 2007.

14. In 1974 Heiner Friedrich, Helen Winkler, and Philippa de Menil established the Dia Art Foundation. Dia made a special commitment to funding permanent installations of artists' works and large-scale projects that would not normally find sponsors within the art market. It suffered from heavy financial losses starting in the mid-1980s. Dia and the Menil collaborated on the Cy Twombly Gallery in the early 1990s and remain closely allied, sharing a common desire to give primacy to the artwork and the artist's vision where possible.

15. This practice has by now become de rigueur as nonprofit spaces, such as Dia: Beacon, New York; Tate Bankside, London; and MassMoCA, North Adams, Massachusetts, have converted disused factories into huge exhibition halls, and as galleries in New York, London, and elsewhere have taken over old tenements, taxi garages, and the like.

16. Ralph Ellis to Laureen Schipsi, email, March 9, 2007.

17. Richmond Hall continued to be used as an exhibition space from 1992 until the opening of the Dan Flavin Installation in November 1998. The last temporary exhibition in the space was one component of Walter Hopps's huge "Robert Rauschenberg: A Retrospective," mounted in different venues in Houston from February to May 1998.

18. Paul Winkler to Dan Flavin, January 25, 1990, Menil Archives.

19. According to Friedrich, Flavin and de Menil also discussed a separate commission, "untitled (to dominique de menil)," a piece in white light that would have encircled the main museum building; this work has never been realized.

20. "[Flavin] was very pleased to be invited to work on this project, as he was quite familiar with this building." Morse, "Technical Aspects," 144. "[H]e had seen the building in the late 1980s." Tiffany Bell, "Dan Flavin Posthumously," *Art in America* 88, no. 10 (October 2000): 144.

21. Paul Winkler, conversation with the author.

22. Morse, "Technical Aspects," 144.

23. The work is dedicated to Heiner Friedrich's daughters Saskia and Sixtina, and to Friedrich's partner at the time, Thordis Moeller.

24. Morse, "Technical Aspects," 145.

25. Flavin made nearly fifty *"monuments"* over the course of his career.

26. Dan Flavin, "Dan Flavin über Kunst," in *Dan Flavin: Drei Installationen in fluoreszierendem Licht* (Cologne: Kunsthalle Köln, 1973), 84. Originally published in English as "The Artists Say," *Art Voices* (Summer 1965).

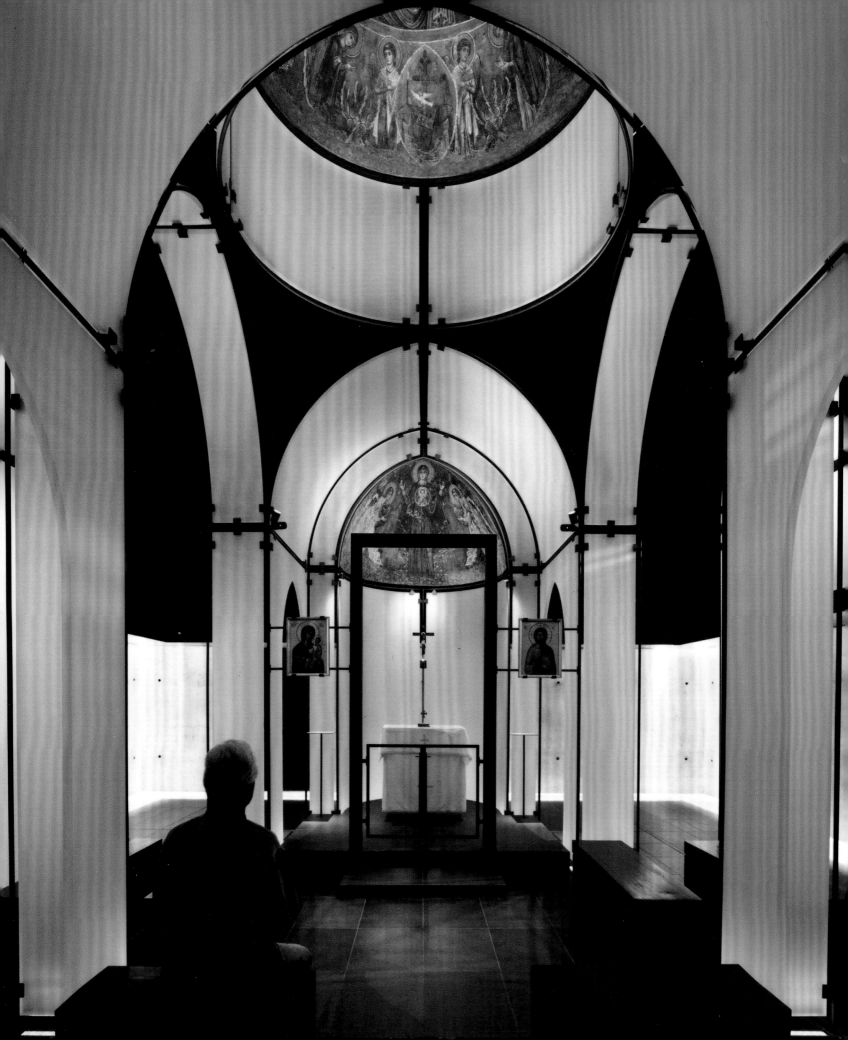

The Byzantine Fresco Chapel: Lysi in the Art History of Cyprus ANNEMARIE WEYL CARR

About 2 mi. southwest of the Village is the Church....
The interior was once completely painted, but now has
been whitewashed, and nothing remains save the paintings
in the dome and apse, which are of Christ Pantacrator [sic]
and B.V.M. in Glory; both are superbly painted and in a
marvelous state of preservation.[1]

<div align="right">Rupert Gunnis</div>

Rupert Gunnis's description was the first published response to the
church of St. Themonianos—familiarly known as St. Piphianos—
near Lysi, Cyprus (fig. 13.2). When he wrote it in 1936, the little build-
ing had not been studied. The Department of Antiquities of Cyprus
published a brief survey of the church in 1973,[2] but the Turkish inva-
sion of the island republic months later left Lysi inaccessible to fur-
ther study. Today we know only the two paintings that captured
Gunnis's eye. Retrieved in fragments from the illegal art market in
1984, they were reassembled to serve a new consecrated space in
Houston (fig. 13.1) through the determination of Dominique de Menil,
who recognized their excellence even in their shattered state.[3]

The story that brought the frescoes to Houston has, in a sense,
two beginnings. One took place in the chapel itself, as a discerning
hand traced out the lines along which the frescoes were to be dis-
membered for the European art market and recorded them in two
black-and-white photos (see fig. 13.5).[4] The other occurred in a Paris
apartment in 1983, when those same photographs captured the
equally discerning eye of Dominique de Menil and impelled her to
redeem what she saw in them. In the interim, the frescoes had been
cut from their setting and thrust into a new realm of value, governed
not by liturgical use but by aesthetic and expressive appeal—the fres-
coes in the photograph, paintings of immense human and spiritual
depth, were now in radical danger. Dominique de Menil's keen sense
of their cultural value committed her to the daunting task not so
much of putting them back as of putting them back together, and so

Fig. 13.1
Interior of the Byzantine Fresco Chapel,
Houston. Francois de Menil, architect,
completed 1997

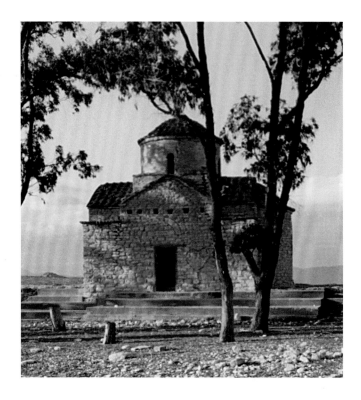

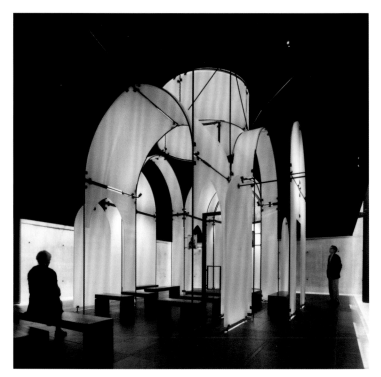

saving their exceptional beauty for the world. Her commitment was shared by Walter Hopps, then director of the Menil Collection, who would later risk personal peril in negotiating with the underworld dealer to secure the murals.

As Bertrand Davezac, the gifted medievalist who advised her as the collection's curator, later recounted, de Menil's first concern was to find the frescoes' rightful owner.[5] With the legal counsel of Herbert Brownell, former Attorney General of the United States, their origin in Lysi and their ownership by the Holy Archbishopric of Cyprus were soon established. She then arranged to negotiate covertly for the acquisition of the frescoes on behalf of the Archbishopric but at her own expense. In January 1984 she and Hopps took possession of the thirty-eight hacked and flattened fragments, moving them at once to London for safekeeping. There, with the agreement of the Archbishopric, she retained the conservator Laurence J. Morrocco to reassemble and restore the fragments. This delicate and costly project took three years and remains a triumph of deft conservational skill.[6] As the restoration approached its conclusion, the Menil Foundation and the Holy Archbishopric of Cyprus jointly signed a legal agreement that assigned ownership of the frescoes to the Archbishopric, but gave the Menil Foundation a renewable lease, beginning in 1986, for their display in a consecrated space to be built in Houston (figs. 13.3–4).

It is clear to all who had the privilege of working with Dominique

de Menil that her involvement in art went far beyond engagement, appreciation, or even—strong as it was—the exhilaration of ownership. Hers was a fundamental cultural commitment. She believed in the power of art to shape lives and even societies. This was not because art spoke of history, but because it could speak quite apart from history—directly across space, time, creed, and culture. She placed deep faith in the power of art's profundity to connect, one on one, to the viewer. As such, she affirmed both the ecumenism of culture as a globally shared tool in the human endeavor and the imperative to keep its legacy connected to the present. She shared this affirmation with major Catholic thinkers who strove to look beyond ingrained and outworn historical divisions to a spirit that superseded national or creedal myths.

At the very heart of Dominique de Menil's commitment, however, lay not the disembodied spirit, but the tangible, socially entangled human being—living in a body, in a neighborhood, and in a regime. This embodied human being, too, must have a place if culture is to connect. Few religious arts have been more absolute in their focus upon the human figure than the Byzantine. Even more deeply than the Catholicism that the de Menils espoused, Orthodox Christianity pins its theology upon the incarnation: the imperative that for man to become God, God must become man.

The non-representational imagery of modernism, a central focus of John and Dominique de Menil's collection, served well their vision

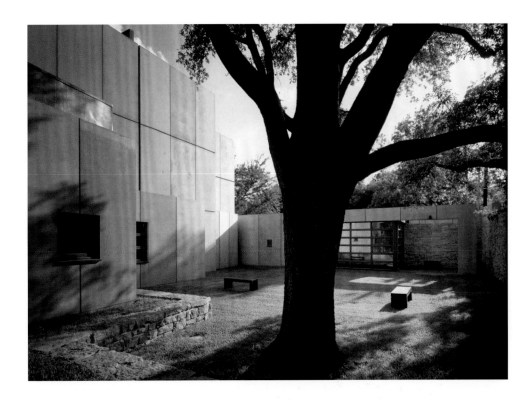

Fig. 13.2 *opposite left*
Church of St. Themonianos, Lysi, Cyprus, 1990

Fig. 13.3 *opposite right*
Glass enclosure suggesting the site of the Church of St. Themonianos, interior of the Byzantine Fresco Chapel

Fig. 13.4
Courtyard garden of the Byzantine Fresco Chapel

of a superseding spirit in art. Crucial to modernism is its iconoclasm, which strips away the codes of style and imagery that bind art to nations, faiths, and regimes. Indeed, the Rothko Chapel, for which the de Menils commissioned a set of transcendent paintings by Mark Rothko, stands as a veritable symbol of the power of non-representational art to speak across cultural boundaries and directly to the spirit. The still rectangles of Rothko's paintings, like the unprogrammed space that they enclose, invite a contemplation free of imposed ritual and a spirituality not tied to prescribed forms. By contrast, the Orthodox Church had defined itself in the face of iconoclasm, asserting its fundamental faith that humankind can know the divine because the divine makes himself known in us. To strip away his image is to strip away what makes him conceivable to us. Thus Byzantine art is in some sense the antipode of what we see in the Rothko Chapel: it is a spirituality that beholds God mirrored in the human face. The two chapels thus present two forms of religious humanism, one that sees God in the image of humankind, and one that gives the divine no definition beyond the human act of seeking it. Both belonged to Dominique de Menil's sense of responsibility as a believing person in a modern society. It was her insight to juxtapose the two visions of faith, the one that sees beyond the all-too-human story and the other that sees through it to God's own deep humanity.

That the frescoes should be accessible to the public but in the focused setting of a consecrated space dedicated to their thought-

ful contemplation, was deeply embedded in Dominique de Menil's expectations for the frescoes. The profundity of this desire emerges beautifully in the letter she sent to her son Francois de Menil, asking him to design the building for them: "Only a consecrated chapel, used for liturgical purposes, would do spiritual justice to the frescoes.… We touch here to [sic] a subtle domain involving psychology and spirituality. Consider for instance the Rothko Chapel. The commissioning went beyond the creation of an ensemble of paintings by a major artist. It had a religious purpose. You know the result and of how Rothko created a truly sacred place. Restored to a living situation the frescoes would co-respond to the Rothko panels. Seven centuries apart, Rothko and the painter of the frescoes expressed the same human aspiration to reach the ineffable."[7]

Through a major fundraising campaign launched in 1992 under the aegis of the newly founded Byzantine Fresco Foundation, organizations, families, and individuals in Houston contributed to the chapel's construction and maintenance. Five years later, the Byzantine Fresco Chapel (originally named the Byzantine Fresco Chapel Museum), endorsed by the Holy Archbishopric of Cyprus and honored in the United States with two architectural awards, was consecrated by His Beatitude, Archbishop Chrysostomos of the Holy and Autocephalous Archbishopric of Cyprus, in September 1997 (fig. 13.12), with the plea that its visitors always remember Cyprus and the despoliation of its heritage in the wake of 1974.[8] Set in the chapel,

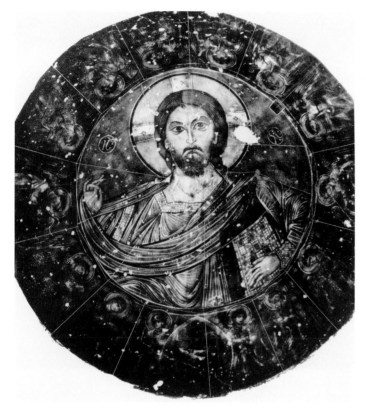

Fig. 13.5
Lysi dome fresco (Christ Pantokrator with angels)
in situ, smuggler's photograph with lines indicat-
ing the cuts made to remove frescoes, ca. 1983

the frescoes can be seen as they were intended to be, in dialogue with one another across a consecrated space of intimate and human scale.

The pulsating, centered stillness of a Byzantine church interior is an aesthetic experience rarely found outside the onetime territories of Byzantium. In the decade since the frescoes' installation in the chapel, numerous visitors have had the opportunity to experience the awe and sweetness, the purity and power that so distinguish Byzantine art. The same decade has also seen voluminous scholarship on the medieval art of Cyprus.[9] Much of that work has eddied insistently around the Lysi paintings, which continue to pose questions of both interpretation and date. Deeply Byzantine in their themes and visual strategies, the paintings are at the same time distinctive in the selection and inflection of their motifs, the rich messages of which have yet to be fully unfolded. And though they are readily recognizable as Cypriot, they are also exceptional among the surviving paintings on the island and so have eluded satisfactory dating. In each of these respects, emerging scholarship has deepened our perception of the Lysi paintings and heightened their importance in the art history of Cyprus.

Reassembled in the Byzantine Chapel, the figures play with rich responsiveness upon their three-dimensional setting. Mary extends her arms along the curving conch of the apse to embrace those who stand before her; at the same time, she draws their eyes firmly inward to the center, where the face of her son punctuates her breast (fig. 13.6). The angels flanking her surge inward, yet gaze outward toward us, too, making it clear that we share the space through which they move, and should share in their awe. Much the same animation characterizes the dome. Drawn irresistibly by the rushing throngs of angels and the glittering S-curve of Christ's gestures, the eye is at the same time brought back to the circling center of Christ himself. The pulsing interplay of movements both animates and centers the eye.

The themes displayed in the frescoes adhere to the canonical themes of Byzantine church decoration, with God in heaven in the dome and the Mother of God in the apse. At the same time, however, these themes are inflected with motifs distinctive to Cyprus itself. The Mother of God, shown orante—that is, in the Byzantine posture of prayer with her arms extended—bears upon her breast a medallion showing the infant Christ, the image of Emmanuel, which means "God with us." The figure of Christ in the dome, in the pose known as the Pantokrator, or All-Ruler, is surrounded by a surging chorus of angels. They converge upon an imperial throne, bearing the Gospel Book, dove, and Passion instruments. The praying figures of Mary and John the Baptist flank the throne. The composition of these two figures extending their hands to Christ, known as the Deesis, or Entreaty, is an image of intercession for humankind. The Mother of God with the medallion of Christ Emmanuel; the Pantokrator surrounded by angels thronging toward the charged throne; and the Deesis recur in Cypriot churches, and each image is laden with meanings.

The Mother of God with the medallion of Emmanuel was introduced to Cypriot mural painting around 1100. Outside of Cyprus, however, it was virtually unknown in monumental painting, having gained currency not in large-scale painting but in small, personal objects, especially the images with which high-placed people sealed their documents. Many seals of court dignitaries from the later eleventh and twelfth centuries display this figure, and two accompany the image with an epithet associated with the great Constantinopolitan church of Blachernai, home of the relic of Mary's veil that was believed to have protected the city from barbarian invasion. This invites an association of this figure with the theme of Mary's protection. But given that the orante Mother of God with the medallion on her breast had a wide circulation independently of Blachernai,[10] it is perhaps wiser to look for guidance in interpreting the figure's meaning to the apses that first introduced this image to the monumental art of Cyprus. We know of three examples, all by a major Cypriot painter known as the Asinou Master. Especially eloquent is the case

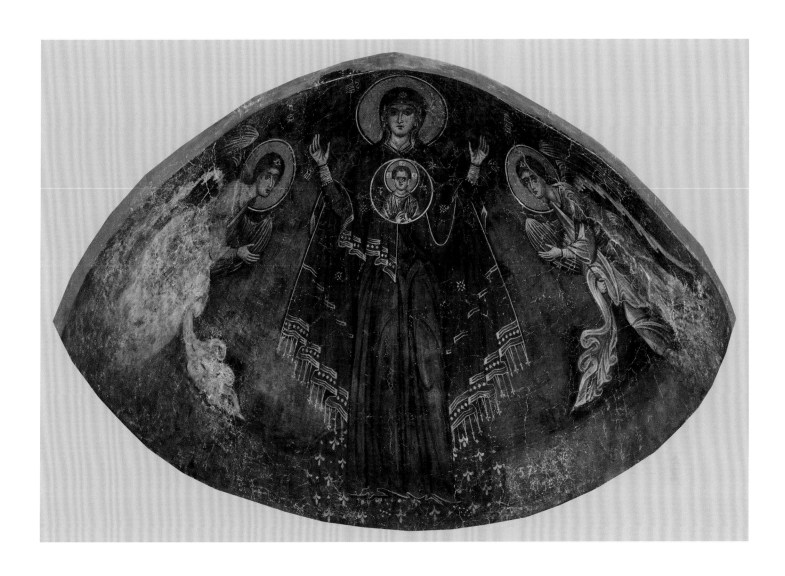

Fig. 13.6
Apse depicting the Virgin with Archangels
Michael and Gabriel (*left and right*), Lysi,
Cyprus, ca. 13th century, restored 1983–88.
Byzantine Fresco Chapel, Houston.
The Holy Archbishopric of Cyprus

Fig. 13.7
Asinou Master, detail of overdoor depicting
the Mother of God Phorbiotissa, Church of
the Mother of God Phorbiotissa, Asinou,
Cyprus, 1105–06

Fig. 13.8
Asinou Master, dome depicting Pantokrator, angels, and Etimasia, Church of SS. Joachim and Anna, Trikomo, Cyprus, ca. 1130

of the church of Asinou from 1105–06, which retains the imagery that surrounds the apse figure of Mary.

The scenes are devoted to Mary herself, emphasizing her centrality in the story of God's flesh, both Incarnation and Eucharist. To one side is the scene of her birth. The scene's inscription, inviting the world to "see its resurrection" in Mary's birth, signals the salvation that God's Incarnation in her flesh would bring. Balancing the scene of Mary's birth is her presentation in the Temple. If Mary's birth announces the body that would bear Jesus, the presentation shows it offered to its sacred use, anticipating the Eucharistic bread. Around the apse opening is the Annunciation whereby Mary receives God himself. It is in this apse that the Mother of God with the medallion of Emmanuel on her breast stood (fig. 13.7). Hovering before her like a radiance of light, the medallion suggests the presence of God, not in her arms as the Christ Child, but in her own being as the God within. She is the very image of humankind's reunion with God.

That this same message was sustained later in the apse of Lysi finds confirmation in an interesting feature in the dome. Here again, it is the Asinou Master who seems to have first formulated the dome composition with a throng of angels converging on the throne and Deesis, this time at Trikomo (fig. 13.8). In that church, he called upon verbal inscriptions to clarify his meaning. Around the Pantokrator he wrote: "You who see all from this high place, see all who enter. Mortals, have fear of the judge." And he labeled the throne the "Etimasia"—the throne prepared for the Lord at the end of time. The dome of Lysi (fig. 13.9), however, differs from the Trikomo example in the labeling of the throne. The throne had stood in early Byzantium as a sign of the presence of God and later came to serve as a summary of God's Trinitarian nature, embracing the Father (throne), the Incarnate Word (Gospel Book and Passion instruments), and the Holy Ghost (dove). It also appeared in images of the Last Judgment in which it acquired its customary name, Etimasia. But in the Lysi dome, the throne is labeled "IC XC": Jesus Christ. This shifts its emphasis. By identifying the throne specifically with the second person of the Trinity, the one who lived as both God and man, the label presents it less as the judgment seat than as the mercy seat. Thus, in the Byzantine Fresco Chapel, the radiant image of the Incarnation in the apse finds a responsive chord in the heaven of the dome, where humankind is offered the promise of the God-man's grace that accords with the poignant beauty of the Mother of God.

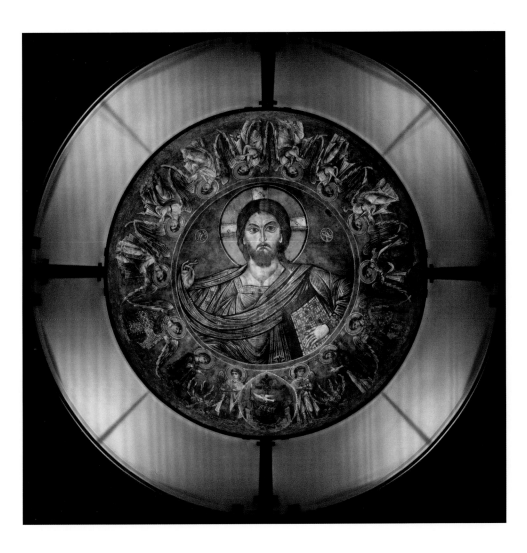

Fig. 13.9
Dome depicting Christ Pantokrator with
angels, Lysi, Cyprus, ca. 13th century,
restored 1983–88. Installation view,
Byzantine Fresco Chapel, Houston.
The Holy Archbishopric of Cyprus

A further issue that has hung over the understanding of Lysi's images is that of their date and thus of their place within the history of Cyprus's thirteenth-century art. The thirteenth was a harrowing century in Cyprus, marked by foreign domination, religious violence, endemic warfare, and mass immigration from the mainland. The native aristocracy, the dominant source of artistic patronage, who at the time of the island's conquest was being served by some of the most proficient painters in the Byzantine world, either fled the island or was reduced to poverty. The Lysi frescoes display many of the stylistic features that distinguished the work of those painters, including dynamic postures, linear drapery folds rippling into cascades at the hems, the richly fringed garments and pure oval face of the Virgin, and the finely drafted lines in the figures' facial features and hair. Differentiating the painter of Lysi from the other late twelfth-century painters, however, are the taut, relieflike density and volume in his forms. Such volumetric density is far more characteristic of the later thirteenth century and makes one question whether the Lysi painter could possibly have been working as early as the years around 1200. The combination of qualities from both the early and the late thirteenth century suggests an attribution to the period in between.

That interim period, however, was a fraught and difficult one. The earlier painters had fallen silent by about 1220, and when large-scale painting resumed in about 1270, it shared almost nothing with work from the beginning of the century, bespeaking a very different training and tradition, probably rooted in the Syro-Palestinian mainland from which Cyprus had absorbed so many artisan refugees. Only in works dating toward the end of the thirteenth century does one find painters once again borrowing from the rich repertoire of styles and images offered by Cyprus's own past monuments. Their paintings echo twelfth-century forms, though now with a heavier, less dynamic sense of form that reflects the three-dimensionality of late Byzantine art.

An earlier assignment of a mid-century date to the Lysi frescoes, arguing that they proved the ability of Cypriot painters to sustain a legacy of brilliant Byzantine painting despite foreign invasion and cultural disruption, must be seen today as implausible,[11] not simply because of the situation on Cyprus but also because of the catastrophic conquest of Constantinople in 1204 by the Fourth Crusade, which shattered the guiding Byzantine cultural dominance upon which Cyprus had depended. Cyprus's painters were forced to find

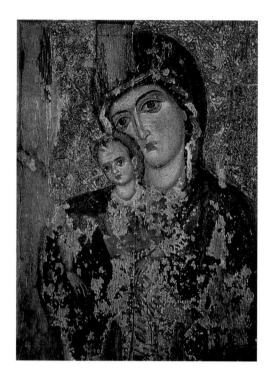

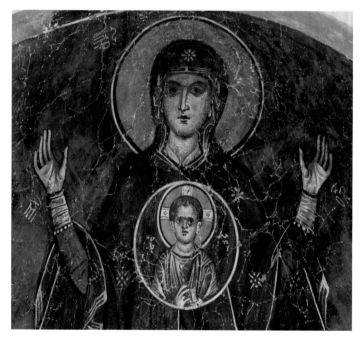

Fig. 13.10 *top*
Mother of God, Asinou, Cyprus, late 13th
century. Byzantine Museum, Nicosia, Cyprus

Fig. 13.11
Detail of apse depicting the Virgin, Lysi, Cyprus,
ca. 13th century, restored 1983–88. Byzantine
Fresco Chapel, Houston. The Holy Archbishopric
of Cyprus

new ways of working, and styles unlike Lysi's took root. Lysi's frescoes find no parallels in this period. They must belong either before or after this time.

Several panel-painted icons of the late thirteenth century do bear a striking kinship with the paintings from Lysi. One of these is the remarkable, large icon of St. Nicholas tes Steges in the Byzantine Museum in Nicosia that depicts the saint full-length with a Latin knight, his family, and his horse at the saint's feet. The face of St. Nicholas so closely resembles that of the Lysi Pantokrator in its relief-like volume, fine drafting, and knowing use of red, green, and brown lines to achieve depth, that it can only have been done by a master who practiced a style very close to that of the Lysi frescoes. The knight in the icon, identified on the basis of his heraldry as Mellours de Ravenal,[12] immigrated to Cyprus in 1295, so his icon could have been painted no earlier than the very end of the thirteenth century. A similar date is now assured for an icon of the Mother of God that comes from Asinou (fig. 13.10), in which the graceful oval of the Mother's face; the sweeping lines of her large eyes; the patterns of highlights on her cheeks and nose; the small, richly bowed mouth of both Mother and Child; and the plump painterliness of the Child's face are strikingly similar to those of the Lysi Virgin (fig. 13.11). Yet in the end, neither icon displays such thorough and excellent mastery of late twelfth-century Byzantine painting techniques as the Lysi paintings do. This difference in mastery is confirmed in the dome frescoes at the Chryseleousa church in Strovolos, which are dated, like the two icons, to the last decade of the thirteenth century.[13] They could very nearly be called a copy of Lysi's dome and, like the icons, show that Lysi was being studied closely in the late thirteenth century. Their dry and stringy imitation of Lysi's fluent linearity, however, only underscores the contrast between the known art of around 1300 and that of Lysi itself. If one attributes the Lysi frescoes to around 1300, their confident mastery of late twelfth-century art stands out as unparalleled, so it seems likely that they were painted earlier and served as a model for later painters.

Although the frescoes of Lysi can no longer be understood to demonstrate the unbroken continuity of Cyprus's excellent Byzantine artistic practice during a period of cultural disruption, their message today is no less significant. The resurgence of forms recalling those of Lysi in the later thirteenth century attests to the capacity of Cypriot painters and patrons to reconstitute a radically endangered legacy. In the silent bond between the two faces of Lysi's legacy—one in the years around 1200, the other in the years around 1300—surely lies crucial keys to our understanding of Cyprus's art in one of its most difficult and definitive periods, illuminating its stubborn continuity and determined resurgence.

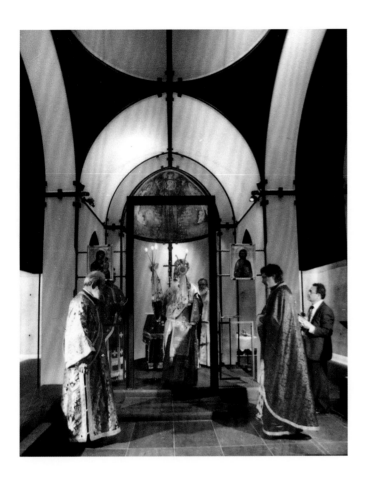

Fig. 13.12
Consecration of the Byzantine Fresco Chapel, Houston, 1997

The importance of Lysi's paintings in affording an insight into Cyprus's history has only strengthened scholars' gratitude for their preservation. Their placement in the Byzantine Fresco Chapel adds a further dimension to their art historical role, for when they came to Houston, they became, in essence, art. It is in this way that they are visited today. Yet within the ethos of the Menil Collection as assembled and housed under Dominique de Menil's direction, there is no contradiction between the space of art and the space of sacrality. Both refresh the spirit and stimulate it to reflective appreciation. The sacred space of the Byzantine Fresco Chapel invites the viewer to engage with an art dedicated, with singular focus, to depicting the face of God. The frescoes, in turn, invite reflection upon the universality of art's power, even when the work itself is deeply bound to its own place and culture. Dominique de Menil recognized the frescoes' profundity—their ability to speak not only to history but also across history's divides to the spirits of many creeds and places. How their new role can relate to their place at home is a question that lies very much at the heart of how we, today, want to shape the culture we pass on to the future.

NOTES

1. Rupert Gunnis, *Historic Cyprus* (London: Methuen, 1936), 230–31.

2. *Annual Report of the Director of the Department of Antiquities for the Year 1972* (Nicosia, 1973), 13, figs. 38–39.

3. They were the subjects of the monograph on Lysi published by the Menil Foundation in 1991. Annemarie Weyl Carr and Laurence J. Morrocco, *A Byzantine Masterpiece Recovered, the Thirteenth-Century Murals of Lysi, Cyprus* (Austin: University of Texas Press, 1991).

4. The second photograph is reproduced in Carr and Morrocco, *A Byzantine Masterpiece*, fig. 2.

5. Ibid., 6–14.

6. Ibid., 125–57.

7. Dominique de Menil to Francois de Menil, April 25, 1989, Menil Archives.

8. See Archbishop Chrysostomos's letter to Dominique de Menil, quoted in Carr and Morrocco, *A Byzantine Masterpiece*, 19: "I am sure that the people visiting the Chapel will always remember Cyprus and that in the occupied areas churches are looted and sacred vessels are stolen."

9. For an overview of this development, see Annemarie Weyl Carr, "Art," in *Cyprus: Society and Culture, 1191–1374*, ed. Angel Nicolaou-Konnari and Chris Schabel (Leiden, The Netherlands: Brill, 2005), 285–328.

10. For a recent interpretation of the image, see Bissera V. Pentcheva, *Icons and Power: The Mother of God in Byzantium* (University Park: Pennsylvania State University Press, 2006), 153.

11. See Annemarie Weyl Carr, "Perspectives on Visual Culture in Early Lusignan Cyprus: Balancing Art and Archaeology," in *Archaeology and the Crusades*, ed. Peter Edbury and Sophis Kalopissi-Verti (Athens: Pierides Foundation, 2006), 86–87.

12. David Jacoby, "Society, Culture and the Arts in Crusader Acre," in *France and the Holy Land: Frankish Culture at the End of the Crusades*, ed. Daniel H. Weiss and Lisa Mahoney (Baltimore: Johns Hopkins University Press, 2004), 119.

13. Athanasios Papageorgiou, "The Paintings in the Dome of the Church of the Panagia Chryseleousa, Strovolos," in *Medieval Cyprus: Studies in Art, Architecture, and History in Memory of Doula Mouriki*, ed. Nancy Ševčenko and Christopher Moss (Princeton, N.J.: Princeton University Press, 1999), 147–60.

Mixed Masters

CORRESPONDENCE
WITH ARTISTS

EDITOR'S NOTE

In addition to maintaining personal contacts, John and Dominique de Menil carried on both casual and lengthy correspondence with artists whose work they collected or with individuals whose projects they supported (in the case of architects and filmmakers, for instance).

Following is a selection of these communications along with related artworks or archival photographs. Though representative of the de Menils' wide-ranging network, this assemblage is only an archival sampling of the rich connections they made with the artists and critical thinkers they drew into their orbit.

The correspondence and related material are reproduced in fac-simile form except for transcriptions of one interview and the text from a drawing. A small number of multi-page letters have been excerpted; such alterations are noted in the accompanying captions. Typeset English translations are provided for texts written in French.

All correspondence is taken from the Menil Archives or the Menil Object Files (see Photography and Document Credits, pp. 338–39).

pages 168-69
Dominique de Menil and Roberto Matta at
the University of St. Thomas, Houston, 1965

Forrest Bess

What I have done in painting is this-the vision came sponaneously and I ha d to
copy it beaause therein lay my integraity .I never knew there was a clue to the
understanding of my symbol until I ran acrsoo Jung accidentally.Not only have I
found meaning in my work but I have been given another dimension and it can be
experienced by those who look at both the positive and the negative of the canvas.
The canvases tell the person much more,not only about the origin,the original picture
of the experience but how they themselves are thinking.So under separate cover I
am sending you one of these canvases.Place the negative along side and take a
pencil and paper and write down quickly everything you feel,see,do,sense within
yourself-everything.Usually the viewer,in integrating the canvas,will write about
one page,possibly two pages and then spontaneously the meaning will happen.I en-
close a separate envelope,sealed which I ask you not to open until you have found
what you think the canvas represents.

Then open the envelope and you will find that not only have you found your answer
but you have experienced the initial archtype representing the original experience.
Often I find the best time to integrate canvases are is right before I go to bed
then the intuitive response comes right before we go to sleep.But the canvas can
be integrated at any time and can be thought out in its entirety.Once integrated
you will agree with me that another dimension has been added.

I noticed in your bedroom a beautiful copy of Indian Art.I think I have some
photograps of these sculptures that may interest you very much.Your book shows
only the faces of these temples-which I believe are the temples of Love,right out
side of Calcutta.They are very sexy,but are beautiful,and I have the negatives
which I had made from a set picked up in the war in India.Would you like to see tthem,
if so I will send them on to you.

I dont know whether Meyer has told you that I am doing a ballet"Black and White"
that I believe will be so beautiful and so simple as to cause individuation within
all who see it.Your poet,Paul Valery in "La Jeune Parque",almost captured it.I have
the vision,and from all indications have been in preparation for this mission for
twelve years,and now I am putting the pieces in their place and must fulfill
Goethe's prophecy-

 All things transitory
 But as symbols are sent:
 Earth's insufficiency
 Here grows to Event:
 The Indescribable,
 Here it is done:
 The Woman-soul leadeth us
 Upward and on!

Return the canvas when you are finished.Please accept my best wishes for happiness
and understanding.

 Sincerely,

Fig. 14.1
Letter from Forrest Bess to John and
Dominique de Menil, ca. 1952 (excerpt
from two pages)

Fig. 14.2
Forrest Bess in his studio, Bay City,
Texas, ca. 1955

Victor Brauner

Fig. 14.3
Victor Brauner, *Portrait d'un paysage* (*Portrait of a Landscape*), 1956. The Menil Collection, Houston, Bequest of Jermayne MacAgy

Fig. 14.4
Letter from Victor and Jacqueline Brauner to Dominique de Menil, December 2, 1956 (excerpt from three pages). Translated by Marie-Pascale Rollet-Ware

Of course, I am always very sad to part with a painting, but in this case, I also feel a great joy because I know that it [*Portrait d'un paysage* (*Portrait of a Landscape*)] is loved and that you will also feel a great joy when looking at it and that is a feeling of creation amplifying itself and becoming radiant. Thus it informs its own necessity.

There is another problem concerning this painting. It constitutes a particular point in my investigations. It is a crossroads. It serves as a reference for me and is a key document.

This painting is the first in the series that you saw when you came to see me, in which I use this technique of applying onto the canvas squares made out of a mixture of cork and rubber, which are impregnated with colors that leave their imprint.

It was conceived directly and resolved "in one move" onto the canvas.

For me, it is one of those rare moments when a painting becomes authoritative, and it is important because of its (in my opinion) exalted quality. I mean that when looking at it one recovers the element of spontaneous "projection," which allows me to unify immediately the creative "strategy," improvisation and decision and, inversely, decision and improvisation.

Henri Cartier-Bresson

Fig. 14.5
Henri Cartier-Bresson, untitled photograph of John de Menil in the living room of the de Menils' home, Houston, 1957. The Menil Collection, Houston

Fig. 14.6
Letter from Henri Cartier-Bresson to John and Dominique de Menil, November 5, 1960. Translated by Marina Harss

Dear Jean Dear Dominique,

What a joy it was to spend the day and evening with you. What marvels you have shown me. I regret my faulty memory, but I would have liked to repeat a saying by Confucius which a Chinese friend of mine once inscribed in a book for me. It tells of the joy one feels when arriving from afar and discovering that one shares the same pleasures and feelings with friends; of course this was said with a beautiful turn of phrase, well-crafted in the Chinese manner…

Near Corpus Christi [I attended] a very traditional fiddler contest—not at all influenced by what one hears on the radio—with two groups of contestants, one made up of players over sixty and the other under sixty, both equally good.

In San Antonio [I had] an extraordinary morning at the medical center for interplanetary travelers [Mercury astronauts], which left me in a dreamy mood, and a long conversation with their P.R.O. [Public Relations Officer], who was very intelligent and very lucid. From there I arrived just in time to see a gang of local Republicans gathered in front of the Alamo, awaiting the arrival of R.N. [VP Richard Nixon], coming down from the sky. But you probably witnessed the same spectacle later in the evening.

Thank you again for your kindness. Until New York, I hope.

Affectionately,
Henri

P.S. I hope I did not tire Dominique too much.

Marcel Duchamp

November 7, 1967

Dear Dominique, Dear Jean,

 We were so touched on our arrival
ten days ago to find the two tickets you
sent us for the party at Philip Johnson's.
Even though late, we thank you and apologize
for not answering.

 Here now is the catalogue of a show
of a charming française friend of ours. We
would love to see you at the vernissage.

 Love to you both,

 Teeny-Marcel.

Fig. 14.7
Letter from Teeny and Marcel Duchamp to
John and Dominique de Menil, November 7, 1967

Fig. 14.8
Exhibition announcement for "Yo Sermayer"
(with Duchamp's printed inscription), Bodley
Gallery, New York, 1967

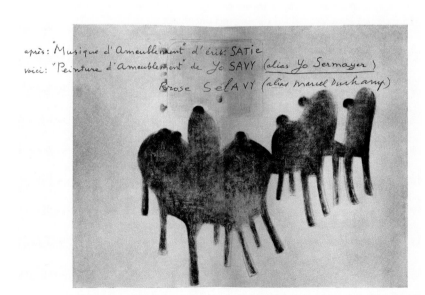

Max Ernst

Sedona. Ariz.
Jan. 25. 52

Dear Jean and Dominique,

on my long and lonesome trip back
through that vast and mad desert I could
not cease thinking about the very generous
and charming way Dorothea and I have been
recieved by you both, and also about the
most comprehensive attention which the Mus.
seum has given to my shows. Now I'm
trying hard to get accostumed to the life
of a bachelor in the wilderness — not too
successfully, I must admit — but I must
say that the magnificent drawing by
John Briggers which you offered us, is an
excellent companion.

I'm writing to Robert Motherwell à pro-
pos du King playing with the Queen.

I guess that you will be off to N.Y. pretty
soon, where you may see Dorothea (her address:
c/o Richter. 134 East 60ᵗʰ St. N.Y. 22.)

Très cordialement à vous deux.

max ernst

Fig. 14.9
Letter from Max Ernst to John and Dominique
de Menil, January 25, 1952

Fig. 14.10
Max Ernst with Dominique and John de Menil
at the opening of "Max Ernst: Inside the
Sight," Les Salles de l'Orangerie, Paris, 1971

Louis Fernandez

Fig. 14.11
Letter from Louis Fernandez to John de Menil, June 7, 1959. Translated by Marina Harss

Fig. 14.12
Louis Fernandez, Etude pour *Les chevaux en Pontpoint etable* (Study for *The Horses in Pontpoint Stable*), 1959. The Menil Collection, Houston, Gift of the artist

My dear friend,

Here is the drawing of the horses, which it is my great pleasure to give to you. I am sending it to rue Las Cases because I believe you are probably about to arrive.

We hope that you are all in perfect health and will be very happy to see you again. Sylvia is very well.

Do not think, my dear Jean, that I have forgotten the sum that I still owe you. Because, as I previously informed you, things did not work out with [Alexander] Iolas, I am trying to obtain this money elsewhere so that I may return it to you as soon as I can. I am ashamed that I have not done so already; soon it will be a year since you did me this favor, and I ask that you not hold it against me.

Please receive my profound friendship, as well as Sylvia's.

Louis

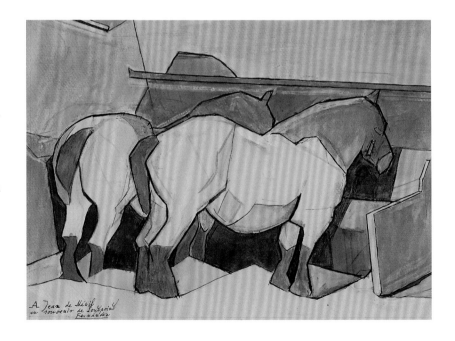

Dan Flavin

I do like the chapel. I prefer the Rothko paintings. I reiterate that, importantly, the site ought to be reorganized to equate the Newman sculpture with the Johnson building. I sense it mistaken to keep the distorted obelisk a remote subsidiary across the water and plaza. I sense, too, that the site should be controlled as mostly artificial—rational without the two present ailing trees or substitutes for them.

I like the way that Dominique cooperates especially with modifying suggestions which reveal that she follows me with penetrating understanding. And she has a good humored, direct, no nonsense attitude. Her mind is well used. Please thank her for help for me again.

And thank you, too, for being available carefully, quietly, expediting when necessary. Best regards to you, to Dominique, to Jean, to the men and women of your art department, Dan F.

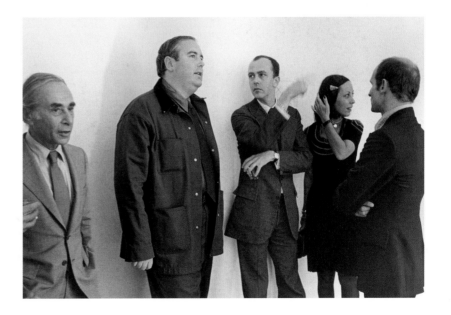

Fig. 14.13
Letter from Dan Flavin to Helen Winkler,
September 18, 1972 (excerpt from three pages)

Fig. 14.14
Leo Castelli, Dan Flavin, David Whitney, Barbara
Jakobson, and David White at the opening of
"cornered fluorescent light from Dan Flavin,"
Rice Museum, Rice University, Houston, 1972

Glenn Heim

Fig. 14.15 *right*
Letter from Glenn Heim to Dominique de Menil,
December 12, 1989

Fig. 14.16 *bottom left*
Glenn Heim, *Paysage planétaire* (*Planetary Landscape*),
1989. The Menil Collection, Houston, Gift of the artist

Fig. 14.17 *bottom right*
Letter from Dominique de Menil to Glenn Heim,
January 16, 1990 (excerpt from one page)

Dec. 12, 1989

Dear Mrs. De Menil,

I have thought of writing you many times. I have been receiving invitations to your shows in Houston, especially the Ernst & Man Ray exhibits. I'm sure they were superb! Unfortunately Judi and I are fairly grounded in New York. Judi is in law school at Columbia and I have been overly bound to my work.

I don't know how appropriate the gesture, but I would like you to have this painting. I feel that I'm beginning to reach a delicacy of control & inner life which I have been searching for over the years. As yet I do not have a significant body of work for presentation. My progress has been slow, but I feel confident of my direction. I am intent on a contemplative world and am more at peace with myself than at any time since my life with the Basilian Fathers.

I wish you the best for the new year.

Sincerely,
Glenn

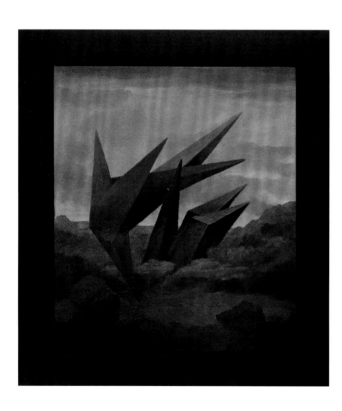

3363 San Felipe Road Houston, Texas 77019

Jan. 16 - 1990

Dear Glenn,

How can I express to you the extreme pleasure your painting has given me. I wasn't in Houston when it arrived, but when I discovered it, a few days ago, I felt like screaming with joy.

That little painting is a masterpiece. Not only does it have great beauty and poignancy, but it has reached a level of perfection. If one looks at it as a formalist, it is superb, yet it offers much more than visual satisfaction: it is mysteriously pregnant with meaning. It is not quite a night scene, but almost. The pink glow of the sky could indicate sunset, but also a distant catastrophy. Everywhere there is ambiguity - is the terrain made of bushes, rocks or clouds? whatever it is, it seems weightless and uncertain. It is the strange setting of two strange and dynamic forms, surging from and plunging into the landscape -

Jasper Johns

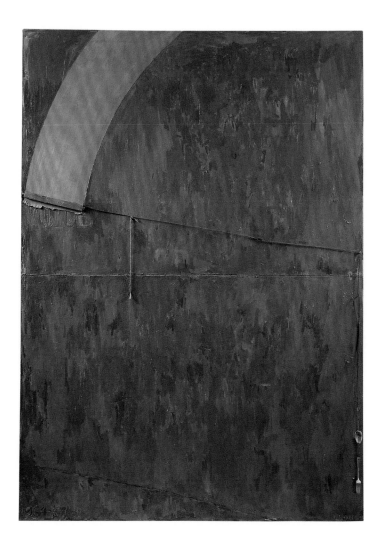

Fig. 14.18
Jasper Johns, *Voice*, 1964–67. The Menil Collection, Houston

Fig. 14.19
Letter from Jasper Johns to Dominique de Menil, 1973

225 EAST HOUSTON STREET, NEW YORK, N. Y. 10002

Dear Dominique—

Forgive my delay in replying to your letter. I've been rather disorganized trying to live in too many places at once. I'm solving everything by leaving town this week.

I thought there might be some material concerning VOICE in my sketchbook but I find none. Whatever related notes there were must have been in books that burned some years back with my Edisto Beach S.C. house.

Probably too late for

225 EAST HOUSTON STREET, NEW YORK, N. Y. 10002

your purpose, and irrelevant as well, I'm sending you photos of VOICE in an earlier state and photos of VOICE (2) and some notes which include references to the later painting.

I so much enjoyed the evening with you last October (in Houston) and think often of the pleasure of having seen you then.

With best wishes,

As ever,

Philip Johnson

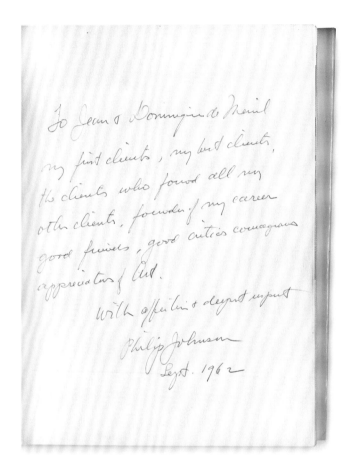

Fig. 14.20 *left*
Inscription from Philip Johnson to John and Dominique de Menil on flyleaf of his first monograph, *Philip Johnson* (New York: George Braziller, 1962), 1962

Fig. 14.21 *bottom left*
Philip Johnson, 1960

Fig. 14.22 *bottom right*
Letter from John de Menil to Philip Johnson, October 4, 1962 (two pages combined)

October 4, 1962

Mr. Philip Johnson
New York City

Dear Philip:

When I received that padded envelope and found the book in it, I felt you were very generous. Then, I opened the book and I was overwhelmed by that which you had inscribed in it. Thank you very much.

I have been leafing through it about a dozen times since this morning, and an interesting picture of your work comes out of it: past, present and future. Up to and including the synagogue, you are the great master of the style. Then, with guts and the courage without which you would not be a real artist, you go a step further and you introduce an element of fluidity in the rigid canons of proportion. Perhaps this is what we tried to do, unconsciously and inadequately, when introducing into our house the Charles James couches, the piano and the Belter furniture. Whatever it may be of that, with the hung vault of the synagogue and of the guest room of your house, you do it superbly. This is the turning point of modern architecture. Now you are at grips with that baby you have conceived and it proves to be a tough baby. In some instances, your clients do not give you freedom to let him breathe: the first project for the Asia house is the best of the three and the one chosen is not the second best. In some other cases, it looks as if you were afraid to go all the way and this, I believe, applies to the Fort Worth Museum and to the Sarah Lawrence dormitories.

In some other instances, I just do not understand. What did you mean to accomplish with the Lincoln Center Theater? With the Science Tower for Yale?

I feel free to say these things to you because you know the spirit in which I am doing it and also because such extraordinary monuments as the nuclear reactor and the church in New Harmony are there to prove that you are a great architect.

Yours sincerely,

John de Menil

JdM:cp

Jim Love

I began to realize that in certain isolated and quite rare cases, people whose own lives and intellectual curiosities are of sufficient substance as to be worth legitimate inquiry, and thus do themselves provoke the intellectual curiosity of others, have somehow added some remote and haunting something to the art that they have acquired.

What I am trying to talk about is a completely legitimate extra something that is capable of standing the test of time, just as a work of art must do. In the cases that qualify — it can in all good faith set aside any thoughts or fears that housing a collection is simply a matter of ego or a monument to self — or any of those kinds of things.

You and Jean fall very much into this feeling.

Dear Jim, Yes "a work of art ... has a right to feelings."

Those which surround me have not suffered too much from want of love — Even when not exhibited they knew they were loved.

It is this universal need for love that has turned me into a religious person. We starve without love. It is the food for the heart. Not only people need it, but animals too and of course works of art. Remember what Rothko said:

"A work of art lives by companionship..."

Museums have been notoriously necropols rather than homes — but not all.

I'm working towards a home for what I have loved — My mind is now set on that.

Thank you for reminding me that things cannot be postponed indefinitely

yours ever

Dominique

Fig. 14.23 *top left*
Letter from Jim Love to Dominique de Menil, May 4, 1979 (excerpt from eight pages)

Fig. 14.24 *top right*
Letter from Dominique de Menil to Jim Love, June 7, 1979

Fig. 14.25 *bottom right*
Jim Love and Dominique de Menil at "cornered fluorescent light from Dan Flavin," Rice Museum, Rice University, Houston, 1972

Danny Lyon

Aug. 9, 1974

Dear Mrs. De Menil,

It has not been until now that I have had the peace of mind
to be able to sit down and thank you for that wonderful moment
in your home in Houston. You are indeed an absolutely e traordinary
person. For you have permitted some young men a chance to dream
the only dreaming that makes sense, a dream of work. Our best
thanks to you will be a film that will make the world cry. We
dream of works of art and social realism that have the power to
change men and transform society. We dream of better films and
better books and finally of the use of art as a sword against
injustice.

I have enclosed a picture of Billy's, something I meant to
do years ago. 100,000 copies of his book will appear in paperback
in November. The beginning of a just revenge.

My best to you as always Danny

Danny Lyon
Bernalillo, New Mexico

September 3 1974

Dear Danny:

Thank you for your warm letter. I am very happy that
your film will be produced. It must hit people right,
in the stomach, and I know it will.

It is fabulous that 100,000 paperback copies of Billy's
book will be printed: a major step for our cause. I
suppose Bill Coats is still proceeding with the case.

The self portrait of Billy's is a beautiful present. I
will treasure it.

Yours sincerely,

Mrs. J. de Menil

Fig. 14.26 *top left*
Letter from Danny Lyon to Dominique de Menil,
August 9, 1974

Fig. 14.27 *top right*
Letter from Dominique de Menil to Danny Lyon,
September 3, 1974

Fig. 14.28 *bottom left*
Billy McCune, *A Self Portrait*, 1969. The Menil
Collection, Houston, Gift of Danny Lyon

René Magritte

RENÉ MAGRITTE
97, RUE DES MIMOSAS, BRUXELLES 3
TÉLÉPHONE 15.07.30

Nice le 21 Mai 1964

Madame,

C'est avec un grand plaisir que je viens de recevoir votre lettre qui m'apprend la réussite de mon exposition à Little Rock.

J'aurais aimé la voir, mais ce que vous m'en dites m'enchante déjà et je suis certain qu'elle est irréprochable : je suis très touché des soins que vous avez bien voulu y apporter. Le catalogue que vous m'avez envoyé est parfaitement réussi. Je vous suis reconnaissant au plus haut point de l'intérêt que vous accordez à mes travaux et grâce auquel une si grande exposition a pu s'ouvrir à Little Rock.

Monsieur Iolas, je n'en doute pas, sera heureux de recevoir votre télégramme, il m'avait d'ailleurs dit déjà que cette exposition, à Little Rock, serait, grâce à votre concours, très importante à tous points de vue.

Avec mes remerciements, agréez je vous prie, Madame, l'expression de ma considération distinguée,

René Magritte

P.S. puis-je vous prier de bien vouloir me faire envoyer quelques catalogues c/o: Berger. 44 rue Marché au Charbon Bruxelles 1. (Belgium) qui me les remettra dès mon retour de Nice ? Merci encore, MR.

Fig. 14.29
Letter from René Magritte to Dominique de Menil, May 21, 1964. Translated by Marina Harss

Fig. 14.30
René Magritte with his dog, Lou-Lou, at the rodeo, Simonton, Texas, 1965

Madame,

It was with great pleasure that I received your letter informing me of the success of the exhibition of my works in Little Rock.

I would have liked to see the exhibit, but what you tell me is already enchanting and I am certain that it was perfect. I was very touched by the care which you devoted to it. The catalog that you sent me is excellently done. I am extremely grateful for your interest in my works, thanks to which such a large exhibition was possible in Little Rock.

I have no doubt that Monsieur Iolas will be happy to receive your telegram; he had already informed me that this exhibit in Little Rock would, thanks to your involvement, be very important from every point of view.

With my great thanks, sincerely yours,

René Magritte

P.S. Might I request that you send me a few catalogues, c/o: Berger. 44 rue Marché au Charbon, Bruxelles 1. (Belgium), who will deliver them to me as soon as I return from Nice? Thanks again, RM

Man Ray

Fig. 14.31
Man Ray, *Suicide*, 1917. The Menil Collection, Houston

Fig. 14.32
Letter from Man Ray to Dominique de Menil, October 20, 1973

MAN RAY 4 RUE FEROU 75006 PARIS

Oct. 20 1973

Dear Mrs. Menil,
Excuse my delay in answering your letter- I have been under
treatment for some deficiency and mail has been piling up.

At the time I painted SUICIDE the beginning of a SERIOUSX
series done with an air-brush or compressed air instrument
I had been rather severely criticized for vulgarizing
art with mechanical tools. That and other run-ins with
galleries depressed me and I observed that I would sit behind
the painting and arrange a gun in front so that I could
pull a string and have the bullet go through to my heart.
However, I feared this would provoke further criticism in
resorting to another mechanical instrument. But there was
also the thought that my suicide might give pleasure to
some people. Just giving the title and remaining alive
was a contradiction I would enjoy alive. So here I am.

At the time I was reading a play by a Russian writer, a
melodrama called The Theater of the Soul, by N.Evreinof,
which suggested the title.

You may use this if not too late. Jolas called me and
said there was still time.

Thanking you for your kind interest and with best wishes,

Sincerely

Man Ray

Roberto Matta

Excerpt from interview of Roberto Matta by Adelaide de Menil:

Adelaide de Menil: Tell me, Matta,…how did you meet my father?

Roberto Matta: Little by little, but I don't remember exactly when…. I had seen him several times in Paris…. I remember that in 1946, I think, they gave a dinner for Camus, and I was at this dinner, Max Ernst was there too. [M]ost probably I met him through Max… and I met you as a very little girl, in a house with stairs.

AdM: Yes, in New York.

…

RM: What was interesting about all of [your family], is that your choice [in collecting art] was not a necklace. The majority of collections are pearl necklaces…. Those are *collections*. Here, we had the impression that for Dominique—I think that this is true—that [collecting art] was a sin, forbidden, dangerous; an inhibition that one must break through…. This is very interesting because it is what one does, I dare say, that changes one's relationship with an object. It is an *adoption*, more than a collection, and I think that all of you have, more or less, one way or another, grasped the essence of the object.

AdM: What kind of collectors do you think that my Dad and Mom really were, since their way of collecting was very different?

RM: They didn't *collect*! That is what I think. They didn't collect…. They came to collecting late in life and not at all with a view of doing business! For the majority of collectors, it is business! It is a business to gain prestige…but it is rarely seen as a way of understanding one's own self, as if in a mirror, a way of seeing one's self…. And I believe that Dominique was the compass in the project, but Jean was … amused by…Dominique's expedition, Dominique's sins. Ha, ha!… I am under the impression that every time she bought something, it was with fear, but in the good sense of the word "fear," that is to say, a true encounter with the unknown and the unnameable… [It] is a dialogue and the object is not only an object anymore. The object becomes a transformer of the person, and it's the person who gives the object its value— you understand, the object comes alive. We do not have the impression we usually have in a cemetery and in museums—tombs or pantheons. We have the feeling that these things had a life…and are alive!

I think there was an aspect, an "oenological" side to Jean. Jean loved these objects as one loves wine—not as one collects postage stamps. And Jean and I had a very good relationship…. We loved to laugh, and we got along very well.

The interview took place on October 15, 1984. Transcript of audiotape translated from the French by Marie-Pascale Rollet-Ware, from "Souvenirs," Menil Archives Film and Media Collection

Fig. 14.33
Roberto Matta, Untitled drawing of interior view and courtyard of the de Menils' 73rd Street townhouse in New York, 1967. The Menil Collection, Houston, Gift of the artist

Barnett Newman

August 26, 1969

Dear John and Dominique:

I am sending you the Washington Post and New York Times stories. Considering the circumstances, I think they did very well. I am, however, annoyed at the New York Times for not have made a sufficient effort to reach me, so that I could publicly express my thanks to you for your generosity and pay tribute, in particular, to your courageous act.

May I now express my appreciation and my admiration for your great courage, which it was thought I should not do in the Houston release.

When you honored your gift by dedicating it to the memory of Martin Luther King, you also honored my work by rescuing it from the Philistines, who would have destroyed it as a work of art and madeit a political "thing".

I am very moved by what you have done and I feel with you, I am sure, a very special sense of happiness. After all it is not every day that we can stand up to the Philistines and win. Bless you both for making it possible.

I hope that my sculpture goes beyond only memorial implications. It is concerned with life and I hope that I have transformed its tragic content into a glimpse of the sublime.

Annalee joins me in sending you both our love.

Cordially,
Barney

685 West End Avenue
New York, N. Y. 10025

Houston Chronicle, August 20, 1969

Why Not Dedicate Art to King, De Menil Asks City Council

Art patrons Mr. and Mrs. John de Menil today challenged City Council to tell them why a modern sculpture they propose to help the city acquire should not be dedicated to the memory of Martin Luther King Jr.

"We understand you want to know why we have asked for this dedication," de Menil said in appearance before council. "We ask, 'Why not?'"

"We cannot understand your objections and were deeply surprised when the proposed dedication was not approved."

Councilmen did not respond immediately to de Menil's challenge.

The de Menils have offered to match a $45,000 grant the city has received from the National Foundation for the Arts and Humanities to acquire the sculpture, "The Broken Obelisk," by Barnett Newman.

Fig. 14.34 *top left*
Barnett Newman with *Broken Obelisk*, 1963/67, in progress, Lippincott Foundry, North Haven, Connecticut, 1967

Fig. 14.35 *top right*
Letter from Barnett Newman to John and Dominique de Menil, August 26, 1969

Michelangelo Pistoletto

Atlanta 18, 2, 1979

Dear madame de Menil
I thank you very much for your
exquisite aspitality.
It was a very intens month in
Houston, and a beautifull raport
with people, in a perfect collaboration.
It has been a great plesure to meet
you and work with you, with a
result that makes me happy.
My hope is that every thing will
procide well till the end of the
exibition.
I hope to see you again soon.
My family loves you.
Many and best greatings from all of us.
 your. Michelangelo Pistoletto.

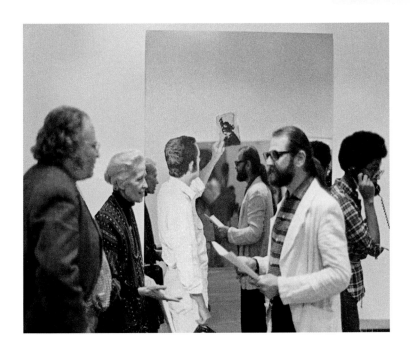

Fig. 14.36
Letter from Michelangelo Pistoletto to
Dominique de Menil, February 18, 1979

Fig. 14.37
Harris Rosenstein, Dominique de Menil, and
Michelangelo Pistoletto installing the exhibi-
tion "Michelangelo Pistoletto: Mirror-Works,"
Rice Museum, Rice University, Houston, 1979

Robert Rauschenberg

Robert Rauschenberg P.O. Box 54, Captiva, Florida 33924

FEBRUARY 19, 1996

DEAR DOMINIQUE,

I PERSONALLY, AND THE WORLD SPECIFICALLY, WILL AND DO
CELEBRATE YOUR DEVOTIONS, DEDICATIONS AND ACCOMPLISHMENTS.
I AM GRATEFUL THAT YOUR ACCEPTANCE OF MY ARTWORK --
MARKING YOUR UNIQUE CONTRIBUTIONS -- CAN BE A CONTRACT
TO OUR FUTURE SERVICES TO CONTINUE OUR UNVEERING CARE.

LET'S GET ON WITH OUR JOYOUS WORK. WE ARE NEEDED AS
NEVER BEFORE -- AGAIN.

THANK YOU FROM THE DEPTHS OF MY MIND, BODY AND HEART.

BOB RAUSCHENBERG

ROBERT RAUSCHENBERG

Fig. 14.38
Letter from Robert Rauschenberg to
Dominique de Menil, February 19, 1996

Fig. 14.39
Dominique de Menil and Robert Rauschenberg,
New York, 1991

Roberto Rossellini

ROBERTO ROSSELLINI

Via Appia Antica 230
Rome, 27th December 1967

My dear Jean,

Thank you once again for the delightful hours spent with you, also in your beautiful house.

I wish to inform you about all what I did after your departure to explore the possibilities of exploiting of our programmes in the States. As you know I have always considered it more realistic not to count upon the profits of the USA market, but in any case I have never rejected the idea of penetrating into it. The difficulty of diffusing our programmes through the three big networks NBC, ABC and CBS exists and I am not at all sure that the sacrifice of producing a programme on Sicily in order to establish cordial relations with the NBC would be fruitful in this sense. Furthermore, this is a particularly difficult moment being pre-electoral period.

I am though very much encouraged by something else which I found existing there and which I am illustrating here, in short, for you:

i) In few words, the philosophy applied by the Board of Education for developping its programmes attaches great importance to the visual means. Furthermore it gives the theory that the programmes should be developed in a way so that the pupil whether young or adult, is involved also emotionally. In addition it points out the importance of a particular representation of history in order to make the present understood humanly.

This is exactly what we are doing through our programmes.

ii) Many organizations (also the industries like Westinghouse and Time & Life) are by now dedicating their efforts seriously to Education in order to achieve the developements needed for the making of a better society.

I have discovered, as you certainly know, that very big amount of money is involved in this field. Considering the nature and quality of our programmes I am now aware of the fact that we are ahead of the others.

For example I went to see the Westinghouse Learning Corporation which has already invested 14 million of dollars in only two months of its existence. In many sectors it is still in the phase of research. Like the others (also the Board of Education is facing the same problem) it is unable to do what we are doing, due to the difficulty of involving the people of show business who are also capable of developping methods of learning.

This is only a very short account of the picture I had which I consider encouraging. I will speak to Jean about it and I hope we shall meet to discuss this in detail and to decide the line of action.

My best wishes for you for a prosperous New Year and all happiness.

Fig. 14.40
Letter from Roberto Rossellini to John de Menil, December 27, 1967

Fig. 14.41
Filmmakers William Colville and Roberto Rossellini, Rice Media Center, Rice University, Houston, 1971

Mark Rothko

Jan 1, 1966

Dear John & Dominique DeMenil,
 First,
I would like to send the season's greetings
to you and yours.

 Secondly, I would like to say
what a marvel that you exist, and that
you move about in the world as you do.
The magnitude, on every level of experience
and meaning, of the task in which you
have involved me, exceeds all my
preconceptions. And it is teaching me to
extend myself beyond what I thought
was possible for me.

 For this I thank you

 Mark Rothko

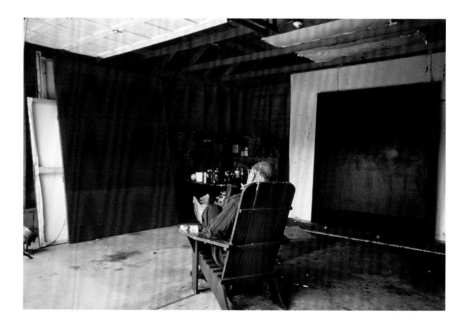

Fig. 14.42
Letter from Mark Rothko to John and
Dominique de Menil, January 1, 1966

Fig. 14.43
Mark Rothko in his garage studio,
East Hampton, New York, 1964

Lucas Samaras

Inscription on enclosed sheet:

The coming and the going was fabulous. The staying
would have been better if you had been less busy and
come with us in our excursions. I hated the exhibition
and installation with the exception of the Mexican sculp-
tures of the Madona [*sic*] and crucifixtions [*sic*]. In any
case thanks for a glimpse of Texas. Good wishes to
Dominique who still remains an unknown quantity.

<div align="center">

Peace Lucas/68

</div>

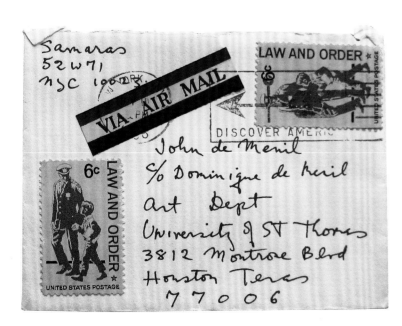

Fig. 14.44
Lucas Samaras, artist-made card with note
on reflective paper, with envelope, from Lucas
Samaras to John and Dominique de Menil, 1968.
The Menil Collection, Houston, Gift of the artist

Dorothea Tanning

June 30 1971

Miss Dorothea Tanning
Var

Dear Dorothea:

Thank you for the photos of <u>Cousins</u> which Simone
gave me last week. It is thoughtful of you to provide
us with this record of 'how it should be'. The cousins
are where you left them, and on a recent visit to New
York they kept me company: friendly and demanding at the
same time. Hey, they say, don't you start dozing in well
fed self satisfaction; life and love won't leave you alone.
And the fact is that they don't, and I'm glad of it. I
won't leave cousins alone either and we'll find a better
place for them - which they deserve.

Look, I'm sorry I missed your visit to New York.
Simone told me of your lunch together and that it was
brilliant, friendly and relaxed. While you were frolicking
together we were closing l'Orangerie with Max, and this
also was relaxed, brilliant and friendly.

Max looked happy - missing you (why is she gone so
long?), but happy. We were immensely happy also, Dominique
and I. Our friendship with you two, sunken deep in the
heart, is something very very rare for us.

With affection,

John de Menil

Fig. 14.45
Letter from John de Menil to Dorothea Tanning,
June 30, 1971 (two pages combined)

Fig. 14.46
Dorothea Tanning, *Cousins*, 1970. The Menil
Collection, Houston

Wayne Thiebaud

Feb 16, 1975

Dear Dominique;

American Hobos have a sign which they place on an especially hospitable house which looks like this ⧗ — I shall resist writing it on that pleasant little guest house — foreverafterwards you would have great hordes of tramps, hobos, bums, artists, sculptors, writers, filmmakers, poet-philosophers, itinerate illuminators, ambivalent signpainters, and transcendental conceptualists raging for your fine company.

Thank you, thank you, thank you !!! ♡

And I shall always treasure our "hands-and-knees-viewing" of Cezanne, our "raid-the ice-box" supper under those various whites in the Mondrian — and (flatteringly) your close watch over my shoe painting. You are so nice ! Thanks again and see you soon

Sincerely & fondly
Wayne Thiebaud

Fig. 14.47
Letter from Wayne Thiebaud to
Dominique de Menil, February 16, 1975

Fig. 14.48
Wayne Thiebaud, ca. 1975

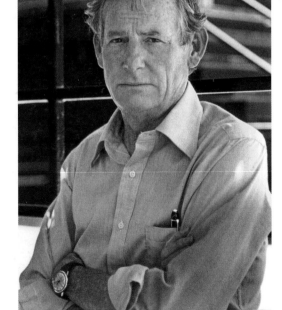

Niki de Saint-Phalle

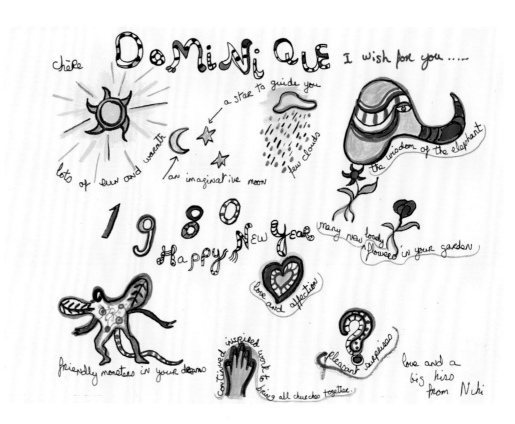

chère **DoMiNiQUE** I wish for you.....

a star to guide you

lots of sun and warmth

an imaginative moon

few clouds

the wisdom of the elephant

1980 Happy New Year

many new lovely flowers in your garden

love and affection

friendly monsters in your dreams

continued inspired work & being all churches together.

pleasant surprises

love and a big kiss from Niki

3363 SAN FELIPE HOUSTON TEXAS 77019 Jan 16. 80

Dear Niki,

what a joy to receive your fabulous message for New Year. I felt cheered up instantly. It gave me additional strength for the work to which I am committed.

In very prosaic terms. I want also to wish you a Happy New Year. Poets and artists give wings to words and a pulsating beat to feelings. The rest of us is more or less speechless No wonder we rely on artists to express our most inner feelings.

Je te remercie de tes voeux merveil et je t'embrasse dans la joie de l'amitié.

Dominique

Fig. 14.49 *top*
Niki de Saint-Phalle, untitled New Year's greeting to Dominique de Menil, 1979. The Menil Collection, Houston, Gift of the artist

Fig. 14.50 *bottom*
Letter from Dominique de Menil to Niki de Saint-Phalle, January 16, 1980

Fig. 14.51 *opposite top*
Jean Tinguely, untitled thank you card to Dominique de Menil, 1986. The Menil Collection, Houston, Gift of the artist

Fig. 14.52 *opposite left*
Jean Tinguely, Francois de Menil, and Niki de Saint-Phalle at the exhibition "The Machine," Rice Museum, Rice University, 1969

Fig. 14.53 *opposite right*
Jean Tinguely, untitled drawing to Dominique de Menil celebrating the opening of the Menil Collection, 1987. The Menil Collection, Houston, Gift of the artist

Jean Tinguely

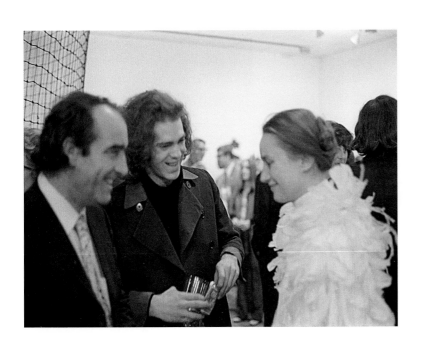

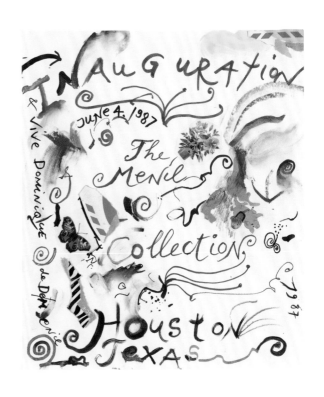

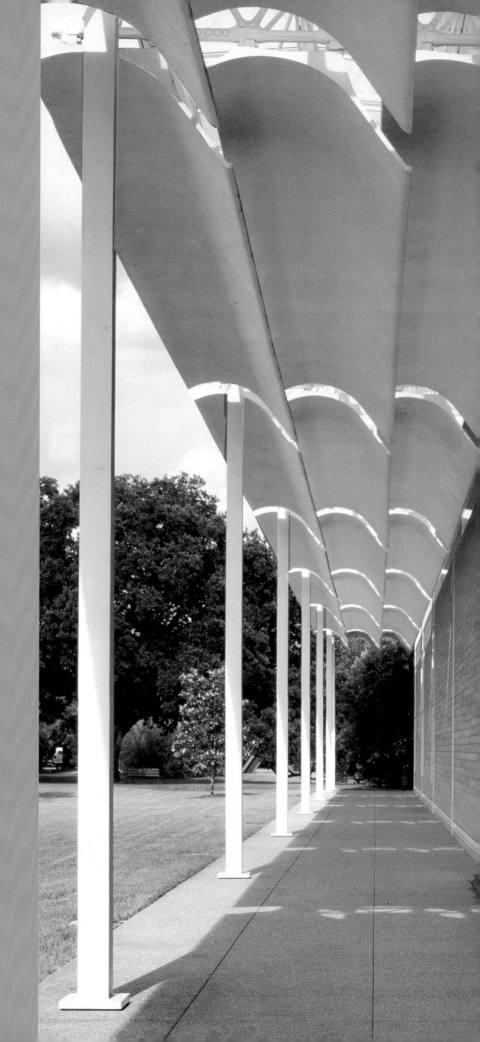

Builders and Humanists

ARCHITECTURE

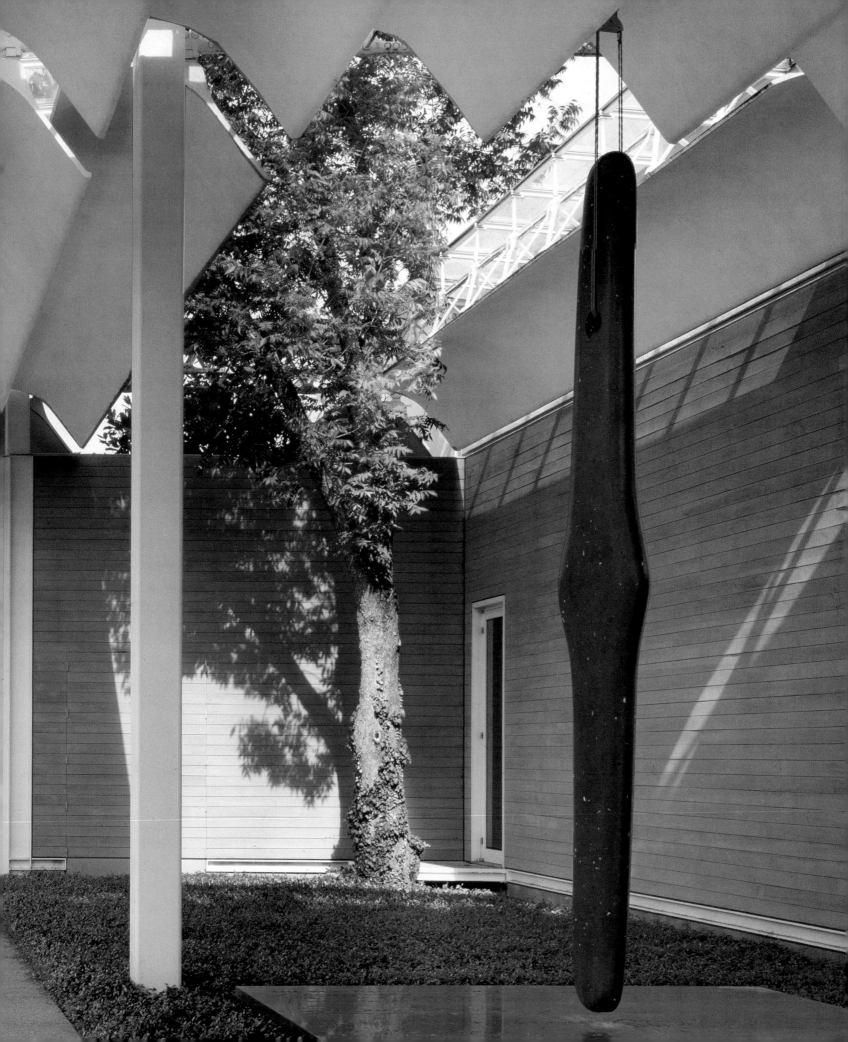

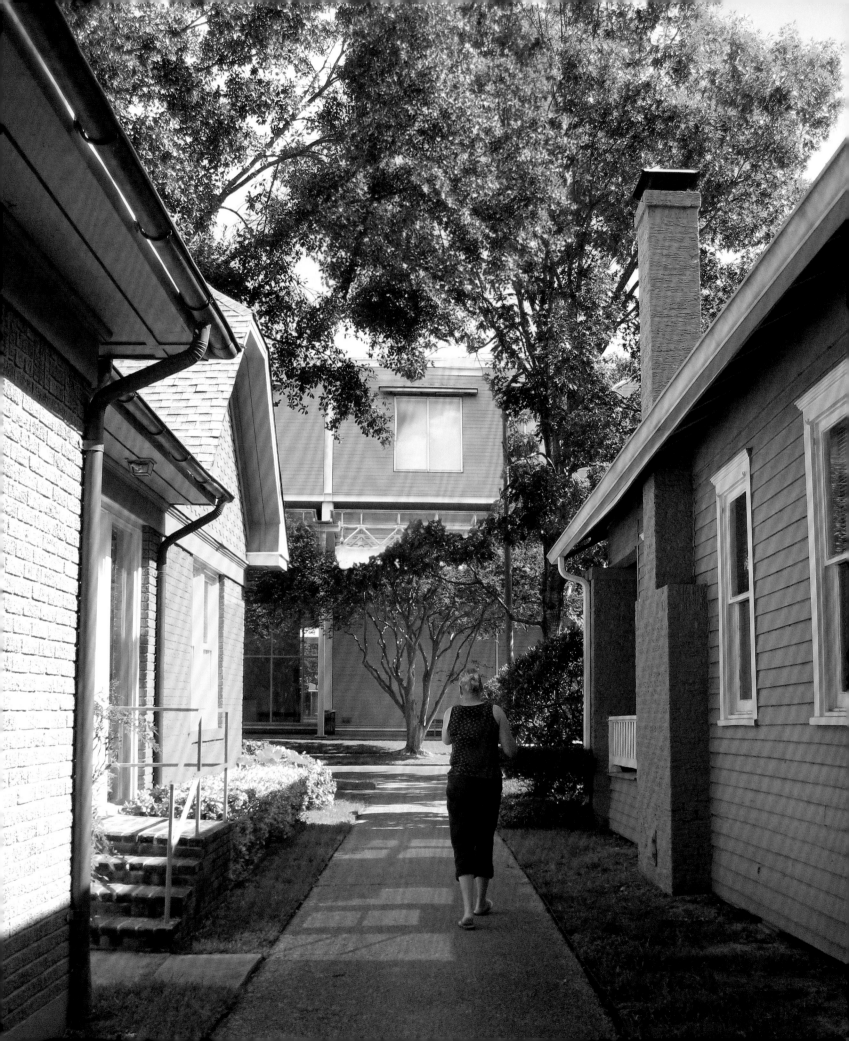

Dominique and John de Menil as Patrons of Architecture, 1932–97

STEPHEN FOX

But let us come to the point: you must not go to London, Paris, or New York to be cosmopolitan. Just open your ears and your eyes and you have it, right in Houston.

John de Menil[1]

Art never responds to the wish to make it democratic; it is not for everybody; it is only for those willing to undergo the effort needed to understand it. We hear a great deal about humility being required to lower oneself, but it requires an equal humility and a real love of truth to raise oneself and by hard labor to acquire higher standards. And this is certainly the obligation of a Catholic.

Flannery O'Connor[2]

pages 196–97
North portico of the Menil Collection, Houston.
Renzo Piano and Richard Fitzgerald &
Associates, architects, completed 1987

Fig. 15.1
Southern exterior of the Menil Collection and
bungalows

John and Dominique de Menil stand out among twentieth-century American patrons of postwar modern architecture, even though their focus was on art collecting and patronage rather than building.[3] They first asserted cultural leadership in the 1950s by persuading others to identify with their vision of modern architecture, which they positioned in the cultural politics of mid-twentieth-century Houston as the "cosmopolitan" alternative.

The de Menils, but especially Dominique de Menil, came to the modernist critique of contemporary culture through the French Roman Catholic dialectical integralist movement of the 1920s and 1930s. This progressive movement sought to redeem contemporary culture by exploring the dialectical contradictions between modernity and faith rather than rejecting either modernity (for reactionary alternatives) or faith (for utopian alternatives).[4] Dominique de Menil embraced integralism—the proposition that all cultural phenomena are systematically integrated—as a Catholic discipline, while it was the dialectical predilection that resonated with John de Menil, who constantly challenged provincial attitudes in Houston with his expansive liberality.[5] Instead of conforming to any of the competing modernist identities current in American architecture during the 1940s and 1950s, the de Menils appropriated and combined elements of these tendencies to fashion a distinctive identity that engaged a central mid-century problematic: the relationship of modernity to history.[6] Over the course of their careers as patrons of modern architecture, John and Dominique de Menil moved from a strategy of consensus building, drawing in others with the allure of cosmopolitan glamour, to one grounded in spiritual introspection

Fig. 15.2
John and Dominique de Menil's apartment in Paris, interior designed by Pierre Barbe, ca. 1930–35

Fig. 15.3 *opposite top*
Patio looking into the living room of the de Menils' house, Houston. Philip Johnson, architect, completed 1951

and social engagement. They considered the stimulation of discovery and surprise the most spontaneous, least coercive way to affect others. They also retained a commitment to standards of excellence that sometimes collided with an ingrained American suspicion of elitism.

Paris: Pierre Barbe

The de Menils' involvement with modern architecture predated their arrival in Houston. In 1931, the year of their marriage, John and Dominique de Menil commissioned the Parisian architect Pierre Barbe to redesign their apartment in the Seventh Arrondissement of Paris (fig. 15.2). The Houston architect Howard Barnstone, describing the apartment in 1973, noted Barbe's elimination of moldings, his sleek hardware, and the tranquil proportions characteristic of his restrained interpretation of rationalist architecture.[7] Had John and Dominique de Menil returned to Paris at the end of World War II, might they, too, have gravitated toward the sophisticated, but conventional, combination of classical architecture, modern art, and subdued interiors that Barbe managed so skillfully in his postwar practice?

Houston

Instead the de Menils remained in Houston. John de Menil's job as president of Schlumberger Surenco, the corporation's South American division, involved extensive travel. In 1941 he and Dominique de Menil moved temporarily to Caracas so that he could restructure Schlumberger as a corporation based in Trinidad, beyond the con-

trol of German-occupied France. It was on business trips to New York during the war years that John de Menil reconnected with Father Marie-Alain Couturier, whom the de Menils first met in France in 1931. Couturier introduced the ebullient John de Menil and a not-always-so-receptive Dominique de Menil to New York's wartime milieu of French modern art and helped the de Menils to discern their vocation as collectors.[8] One of the artists who became a friend of the de Menils in New York was Mary Callery, an American who had worked in Paris from 1930 to 1940.

In summer 1948 John de Menil asked Callery to recommend an architect to design a house that he and his wife wanted to build in Houston. When asked why they chose the New York architect Philip Johnson (fig. 15.4), Dominique de Menil always recounted the advice Callery gave John de Menil: if they were prepared to spend $100,000, they should commission Ludwig Mies van der Rohe, one of the founders of the modern movement in twentieth-century architecture, who practiced in Chicago after leaving Berlin in 1938. If they could afford to spend only $75,000, they should hire Johnson, who was then director of the Department of Architecture and Design at the Museum of Modern Art, New York.[9] In 1948 Johnson was building the Glass House, 1949, a weekend house for himself in New Canaan, Connecticut, that would establish his reputation as an architect. The Glass House paid homage to the precepts and practices of Mies van der Rohe, and through the 1950s Johnson would be known as Mies's foremost interpreter.[10]

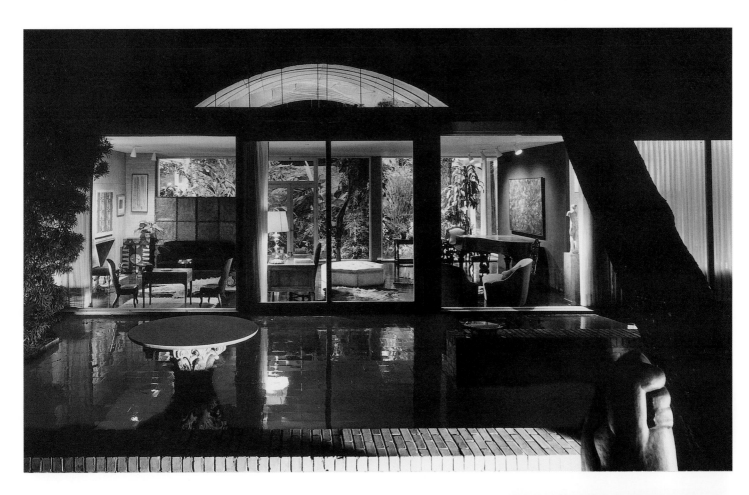

3363 San Felipe Road: Philip Johnson and Charles James

In choosing Philip Johnson as the architect for their house at 3363 San Felipe Road, John and Dominique de Menil bypassed Houston's best-known modern architects, MacKie & Kamrath and Donald Barthelme. Hiring Johnson was John de Menil's way of "cosmopolitanizing" Houston. Johnson was linked to the most important institution of modern art in the United States, the Museum of Modern Art, which the de Menils joined after hiring him and to which they began to donate works of art. John de Menil's conviction that being a provincial town in no way hindered Houston from acting as though it were a cosmopolitan city was also reflected in the de Menils' attraction to Miesian architecture. The austerity, precision, and what Johnson described as the "freedom" of Miesian architecture appealed to the de Menils in a way that the Frank Lloyd Wright–inspired architecture of MacKie & Kamrath, for instance, did not.[11] Miesian architecture was capable of inducing sensations of transcendence and elation. These qualities suffuse the flat-roofed, one-story pavilion Johnson began to design for the de Menils' 2.9-acre site in Briarwood, a small subdivision surrounded by the River Oaks neighborhood, in fall 1948.[12]

Completed in spring 1951, the de Menil house (now referred to as Menil House) is simple in appearance, yet contains startling contrasts of opacity and transparency. The transparency resulted from Johnson's use of walls of glass on the south-facing back of the house (fig. 15.3) and his incorporation of a glass-walled interior courtyard

Fig. 15.4
Dominique de Menil and Philip Johnson, River Oaks Theatre, Houston, 1949

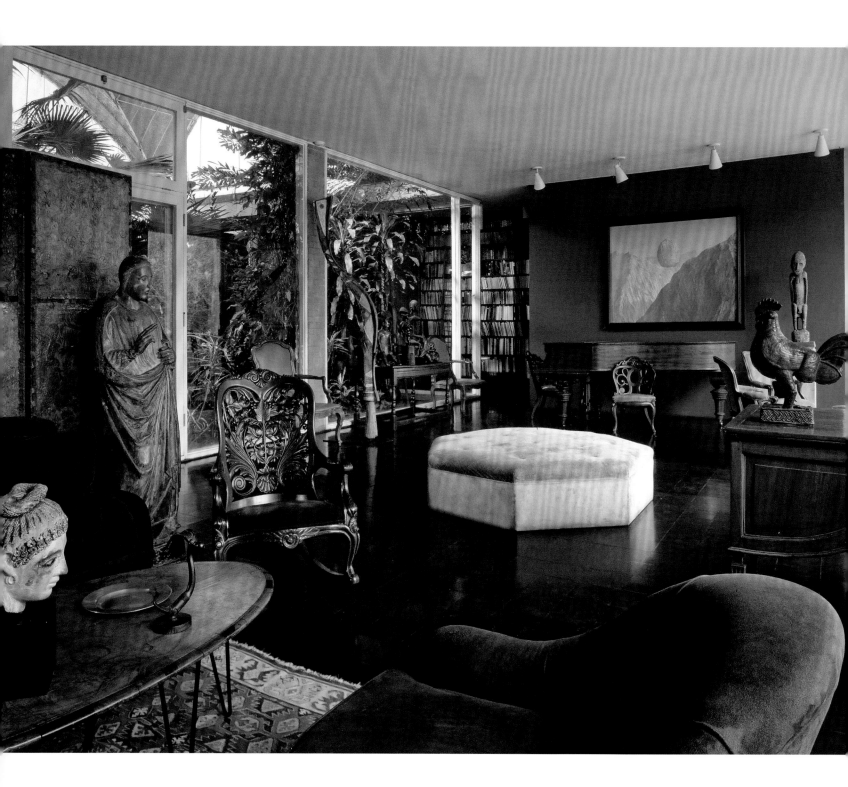

Fig. 15.5
Living room and atrium garden of the de Menils'
house, 1964, with interiors by Charles James,
completed ca. 1951

onto which the entrance hall and living room open. Dominique de Menil specified the courtyard; it reminded her of the house built around an open patio in which she and John de Menil had lived in Caracas. (According to Elsian Cozens, her assistant from 1973 to 1997, Dominique de Menil always called the courtyard the "patio."[13])

The Menil House immediately began to advance the architecture of Mies van der Rohe as the vanguard style of Houston modernism.[14] The Houston architect Hugo V. Neuhaus Jr., whom Johnson asked to supervise construction of the house, designed and built a one-story, flat-roofed, glass-walled Miesian pavilion for his own family between 1949 and 1950. Neuhaus introduced the de Menils to another young Houston architect, Howard Barnstone, and in 1952 John de Menil hired Barnstone and his partner Preston M. Bolton to carry out minor alterations to 3363 San Felipe and to oversee its maintenance. Other young Houston architects—Burdette Keeland, Harwood Taylor and J. Victor Neuhaus III, William R. Jenkins, Kenneth E. Bentsen, and Anderson Todd—established their reputations in the mid-1950s with flat-roofed, steel-framed, glass-walled pavilions incorporating interior courtyards. As the English architecture critic Reyner Banham observed in 1987, "[N]ext to Chicago itself, Houston must be the most Miesian city in the United States."[15]

Yet while adopting Miesian modern architecture, the de Menils diverged from the expected by turning to the New York couturier Charles James (fig. 15.6) to design the interiors of their house. The decor of the Menil House embodies James's sense of style: spontaneous, fantastic, inspired (fig. 15.5). Three pieces of furniture he designed—the serpentine banquette in the playroom/dining room, and the butterfly sofa and iron-framed chaise longue in the living room—engage in a dialogue on curvature with the surrounding pieces of Venetian and Belter furniture. He upholstered walls with felt, installed velvet draperies in doorways, and introduced such deep, warm colors as mustard, vermillion, and fuchsia. These lent the house unexpected nuance without subverting the clarity and dignity of Johnson's design.[16] James's involvement exemplified a distinction that the de Menils, but especially Dominique de Menil, seemed to make between architects and artists. Architects were expected to resolve practical problems with rigor and precision, while artists were geniuses who worked from inspiration.[17] The assurance with which the de Menils appropriated Johnson's Miesian architecture to frame their modern paintings and sculpture, eclectic furniture, and medieval and African and Oceanic statuary in dialectical exchanges between modernity and history exemplified their skill in managing objects

Fig. 15.6
Charles James at the Charles James Salon, New York, 1945

(and design professionals) to negotiate a modern identity that was singular and provocative. It set their house apart from the unitary, all-modern interiors characteristic of American modern houses of the 1950s (at least as photographed for architectural magazines). The house and its contents reciprocated by framing the de Menils as modernists who possessed the confidence and judgment to define their own style of representation.

A degree of tension developed between Dominique de Menil and Johnson: her methodical attention to detail and his impulsive, restless temperament were incompatible.[18] John de Menil's enthusiasm for Johnson was undiminished, however, and he was directly or indirectly responsible for getting Johnson numerous building commissions through the 1950s and 1960s.[19] One project for which John de Menil recommended Johnson that was not built was a parish complex for St. Michael the Archangel Catholic Church in Houston, 1952–53.[20] The recommendation of Johnson for the design of a church reflected the influence of Couturier.[21] Couturier's precepts also underlay Johnson's first multi-building complex, the University of St. Thomas in Houston. The aura of purposefulness and proportioned serenity that Johnson's St. Thomas buildings radiate goes beyond the cosmopolitan glamour of the Menil House. They materialize a vision of a Catholic community situated in the modern world yet committed to redeeming its alienating impulses.[22]

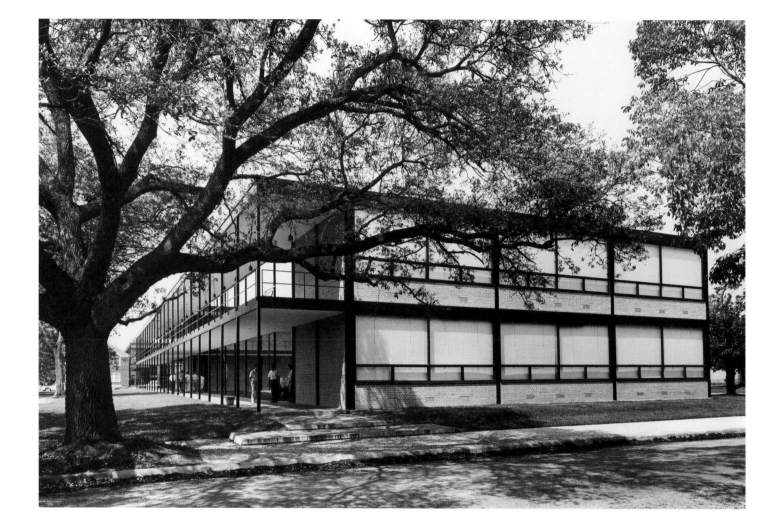

Fig. 15.7
University of St. Thomas, Houston. Philip
Johnson Associates and Bolton & Barnstone,
architects, completed 1958–59

Fig. 15.8
Dominique de Menil and Ludwig Mies van
der Rohe at the dedication of Cullinan Hall,
The Museum of Fine Arts, Houston, 1958

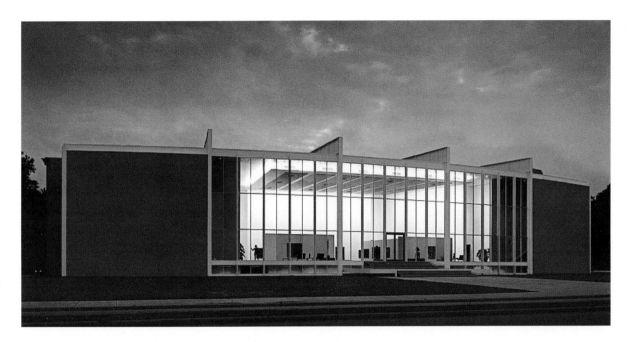

Fig. 15.9
Cullinan Hall, The Museum
of Fine Arts, Houston.
Ludwig Mies van der Rohe,
architect, completed 1958

University of St. Thomas

In 1956 the de Menils offered to pay Johnson's fee for producing a master plan for a new campus for the Catholic university on three city blocks in the Montrose neighborhood (fig. 15.7), where priests of the Congregation of St. Basil had founded the university nine years earlier. A memorandum of June 20, 1956, documenting a meeting between four university trustees and John and Dominique de Menil to discuss hiring Johnson, echoes the admonitions of Couturier. John de Menil was reported as telling the trustees, "[A]t one time the Catholic church encouraged fine architecture. Great artists built the cathedrals of Europe, many of which are still an inspiration. Many buildings were built in units, and often it took centuries to complete a building.... But the final building is a unity and a work of art because great architects of each age were employed for the various units."[23]

Johnson's first buildings for the campus—the Jones Hall auditorium and gallery building, 1958; the north half of Strake Hall, a classroom, 1958; and Welder Hall, the student center, 1959, all built with gifts from other Houston donors—were among the last he designed that adhered to the discipline of Mies van der Rohe. At the time these buildings were constructed, Johnson made the apparently shocking suggestion that the campus plan be based on a historical model—Thomas Jefferson's Academical Village for the University of Virginia, 1819.[24] Subverting the modernist rejection of historical borrowing was typical of the way Johnson intersected the mid-century discourse on the problematic relationship of modernity and history. It obscured the profound yet subtle ways in which Miesian architecture was grounded in history, specifically in the precepts of St. Thomas

Aquinas, to whom the university was dedicated.[25] The modesty, spatial subtlety, and tectonic clarity of Strake, Jones, and Welder Halls, especially evident in the ways they respect the scale of the neighborhood and compensate for the flatness of Houston with layers of outdoor courtyards and elevated pedestrian decks, make them among the most satisfying of Johnson's buildings.

Constructed at the same time as the halls at St. Thomas was the building that confirmed John and Dominique de Menil as the modern cultural arbiters of Houston: Cullinan Hall, 1954–58, the first of Mies van der Rohe's two additions to the Museum of Fine Arts, Houston (fig. 15.9). Because the de Menils were *not* involved with the project, Cullinan Hall demonstrated the extent to which younger members of Houston's elite had identified with and internalized the de Menil modern position.[26] In 1954 a building committee, on which the architects Neuhaus, Todd, and Bolton served, recommended that the museum's trustees commission Mies van der Rohe to carry out this expansion. When Cullinan Hall was dedicated in October 1958, John de Menil (who was elected a trustee of the museum in 1954) had the Magnum photographer Eve Arnold photograph guests at the festivities (fig. 15.8). One of Arnold's images depicts Dominique de Menil kneeling to converse with Mies van der Rohe, transforming their exchange into an icon of the transmission of cultural authority. This modernist spirit prevailed at the museum under the directorship of James Johnson Sweeney, whom John de Menil was instrumental in bringing to Houston in 1961. During his six-year tenure, Sweeney repeatedly installed exhibitions that performed modernity with electrifying power in the ethereal, glass-walled volume of Cullinan Hall.

Magic: Jermayne MacAgy and Howard Barnstone

Another important influence on the de Menils' formation as modern collectors was the museum director Jermayne MacAgy. The extraordinary thematic exhibitions she installed, first in MacKie & Kamrath's museum for the Contemporary Arts Association between 1955 and 1959, then at the Gallery of Fine Arts in Johnson's Jones Hall at the University of St. Thomas from 1959 to 1964, gave form to a modern identity that enticed and excited visitors by appealing, often spatially, to their sensations of curiosity and delight.[27] An exhibition of design that MacAgy and the interior designer Herbert Wells organized in 1958, "The Common Denominator: Modern Design 3500 BC–1958 AD," is intriguing because their installation evoked the interior of a Miesian courtyard house, used to frame historical and modern objects in much the same way that they were framed in the Menil House. It was MacAgy who initiated the sequence of spectacular exhibitions in Cullinan Hall, where in 1959 she would mount her most renowned show, "Totems Not Taboo: An Exhibition of Primitive Art."[28]

Howard Barnstone (fig. 15.10) also had a great effect on the de Menils. Like MacAgy, Barnstone had an infectious, stimulating spatial imagination. He possessed the instinctive ability to imbue space with the affective quality he called "magic," a term Jermayne MacAgy also used in connection with architectural space.[29] In the late 1950s, Bolton & Barnstone began to make additional modifications to the Menil House, designing a freestanding servants' house, 1960 (used primarily as a guesthouse). In 1962 Barnstone added the vaulted canopy above the interior courtyard. He even designed the de Menils' Christmas decorations. In New York Barnstone remodeled a five-story brownstone house at 111 East 73rd Street for the de Menils, designing a terraced installation of sculptures by Max Ernst in the rear courtyard in 1964 (fig. 15.11). In 1968 Barnstone and his partner of the 1960s, Eugene Aubry, converted the carport of the Menil House into the Collection Room, a home office and art storage space.[30]

Fig. 15.10
Howard Barnstone, Houston, ca. 1950

Fig. 15.11
Max Ernst installation in the courtyard of the de Menils' 73rd Street townhouse, New York. Howard Barnstone and Partners, architects, remodeled 1964

Chapels

In her history of the Rothko Chapel, Susan J. Barnes indicates how powerfully MacAgy's sudden death in February 1964 affected Dominique de Menil.[31] Two chapels constructed after MacAgy's death— a temporary student chapel for the University of St. Thomas (dedicated in 1965 and dismantled in 1997) and what was intended as a permanent chapel for the university but became the Rothko Chapel instead—demonstrate the increasing appeal of interiority and introspection to the de Menils in the 1960s. At each chapel, spatial intensity was matched by an effort to keep the exterior as undemonstrative as possible.

The student chapel (fig. 15.12) was constructed in an existing, low-ceilinged, concrete block enclosure across the street from Johnson's campus. Dominique de Menil persuaded the Basilian Fathers to allow Glenn Heim to design the chapel. Heim was an industrial design graduate of the Cleveland Art Institute who had joined the Basilian order and had been sent to St. Thomas to study philosophy before entering seminary. Exposure to Dominique de Menil in an art history class that Heim took as an elective led him to discern that his vocation was to be an artist not a priest.[32] John and Dominique de Menil paid for the student chapel, which was constructed during the summer by Heim and fellow Basilians. The artist Jim Love fabricated all the metal pieces Heim designed for the chapel.[33] Heim shaped the chapel to evoke austerity, intimacy, and purity. The design of the University of St. Thomas Student Chapel seemed less involved with advancing cosmopolitan ways than with inspiring the performance of Christian virtue.[34]

The design and construction of the student chapel coincided with the plan for a permanent chapel that John and Dominique de Menil offered to build for the university in 1964, following MacAgy's death. It was to be designed by Johnson to contain a suite of paintings by Mark Rothko, and it was to be constructed at the south end of the university's academic mall. As built in 1970, however, the chapel was neither a Catholic church nor on the St. Thomas campus nor a Philip Johnson design. Erected three blocks west of Johnson's campus, it is instead an ecumenical chapel named in memory of Mark Rothko. Johnson had resigned the commission in 1967 after a conflict with Rothko over questions of architectural design in which John and Dominique de Menil supported Rothko's vision rather than Johnson's. Barnstone & Aubry adapted Johnson's design to comply with Rothko's directives.[35]

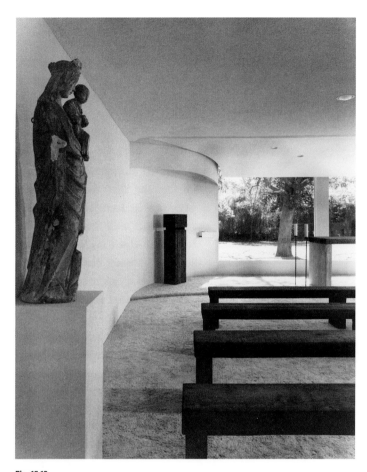

Fig. 15.12
Student chapel, University of St. Thomas, Houston. Glenn Heim, architectural designer, completed 1965

Susan Barnes in *The Rothko Chapel* and Sheldon Nodelman in *The Rothko Chapel Paintings* trace the conflicted history of the project. A consequence of these conflicts is that the architecture of the chapel does not possess the gravity of Rothko's paintings, although it is the most ambitious materialization of the de Menils' dialectical integralist convictions. Yet its architectural shortcomings do not compromise its social role as an instrument for the formation of community. The octagonal enclosure that Rothko specified, reinforced by his monumental paintings and the events that occur there, spatially frame those who gather in the top-lit chapel as a community.

Community and Work

The de Menils withdrew from St. Thomas in 1968 and organized the Institute for the Arts at Rice University, to which they brought the art and art history faculty and the teaching collection of the University of St. Thomas. A pair of temporary buildings that Barnstone & Aubry designed for the institute signaled their role as workshops rather than permanent institutions. Both buildings—the Rice Museum, also known as the Art Barn, 1968–69, and the Rice Media Center, 1968–70 (fig. 15.13)—are long, gable-roofed sheds surfaced with corrugated galvanized sheet iron and floored with pine planks. By appropriating a building type and materials so ordinary as to be considered sub-architectural, and redeeming them as architecture, Eugene Aubry produced an architectural analogue of Pop Art. Pop architecture identified the community that used the Art Barn and Rice Media Center as countercultural, anti-elitist, and performance-oriented.[36] The Art Barn and Rice Media Center marked the transition from art connoisseurship to art making, and a corollary shift in the community—from art consumers to art producers—with which the de Menils were affiliating themselves.

Aubry was also architect for a pair of attached houses that, because they were materially linked with the Art Barn and Rice Media Center, came to be identified as "art houses." They were designed and built in 1973–74 in the West End of Houston, a mixed-use,

working-class neighborhood of wood cottages and pre-engineered steel warehouses, for Aubry's sister-in-law, the art dealer Fredericka Hunter, and for Simone W. Swan, the first executive vice president of the Menil Foundation. John de Menil financed their construction. Aubry faced the houses with corrugated galvanized sheet iron, which enabled them to blend into the landscape of the West End. The "Tin Houses" (Hunter's nickname for the pair) explored the potential for constructing a community identity that affiliated artists, and those involved with art, with ordinary, working-class spatial settings. The Tin Houses redeemed an ordinary Houston neighborhood by adjusting to the landscape rather than imposing a competing identity on it.[37]

The de Menils' architectural patronage of the late 1960s and early 1970s seemed to focus on the construction of community through the practice of redeeming (rather than ignoring or displacing) existing spaces. "The De Luxe Show," an exhibition installed in the reclaimed and rehabilitated De Luxe movie theater on Lyons Avenue in the Fifth Ward of Houston in 1971, addressed community and redemption.[38] "The De Luxe Show" exemplified the efforts of John and Dominique de Menil, with the participation of artist Peter Bradley and activist Mickey Leland, to expand the art community beyond the cosmopolitan constituencies of the 1950s and 1960s while also redeeming art exhibition practices by infusing them with a sense of urgency and purpose.

Fig. 15.13
Rice Media Center and Rice Museum, Rice University, Houston.
Barnstone & Aubry, architects, completed 1970 and 1969

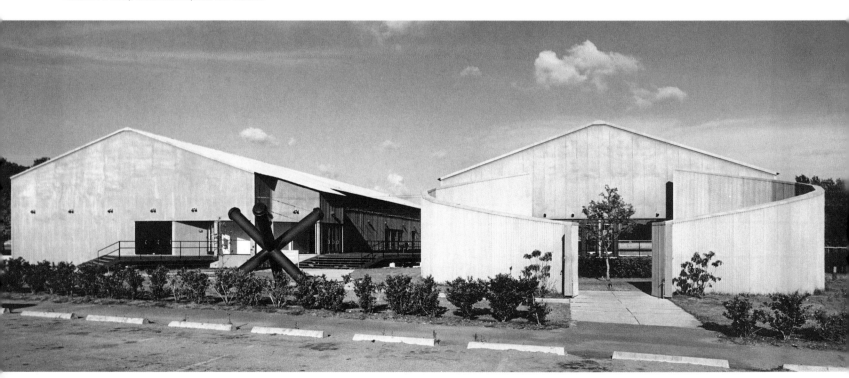

Fig. 15.14
Louis I. Kahn, site plan for the Menil campus, 1973. The Menil Collection, Houston. Includes the Rothko Chapel and reflecting pool (*right of center*), a planned collection storage building (*right of center, across the green from the chapel*), and an assembly building (*below the chapel, structure with inset circle*)

Storage Building: Louis I. Kahn

Following the dissolution of their relationship with Johnson, the de Menils gravitated to the architect who in the 1960s replaced Mies van der Rohe as the most admired architect in the United States, Louis I. Kahn of Philadelphia. Kahn's buildings of the 1950s and 1960s engaged the postwar discourse on modernity and history with constructional austerity and spatial solemnity. Their sky-lit interior spaces, enclosed with thick masonry or concrete walls, were the antithesis of Mies van der Rohe's thin, transparent, glass-walled pavilions. Six months before John de Menil's death, he and Dominique de Menil began to work with Kahn on preliminary designs for a storage building for their collection, to be built just west of the Rothko Chapel. Kahn worked on the project until his sudden death in March 1974.[39]

Kahn's site drawings (fig. 15.14) encompassed the 1300, 1400, and 1500 blocks of Sul Ross and Branard Streets, where between 1971 and 1974 the de Menils bought seventy-one lots adjacent to the Rothko Chapel.[40] Kahn proposed to transform the neighborhood, replacing almost all of its 1920s-era bungalows and duplexes. His most specific designs were for "the storage" (as it is labeled in his drawings) and for an assembly building at 1409 Branard aligned with the Rothko Chapel. Kahn's schematic drawings of the storage build-ing proposed rows of projecting, gable-roofed storage rooms clustered around a pair of interior courtyards. Although the storage building was long and wide, the drawings implied that its scale would have been intimate, like that of Kahn's Kimbell Art Museum in Fort Worth, 1972.

The deaths of John de Menil and Kahn nine months apart temporarily interrupted planning for the collection storage building, but not for smaller-scaled projects. By 1974 nearly all the buildings the de Menils had acquired on Sul Ross and Branard were painted gray with white trim under the direction of Barnstone. This transformation of the ordinary houses of the Rothko Chapel neighborhood represented a surreal diffusion of art into life: the color gray changed the subjective perceptions of an ordinary Houston landscape without spatially altering it.[41] The installation of five, large, black steel pieces by the sculptor Tony Smith in the neighborhood in 1976 added to the extraordinary/ordinary surreal dialogue. Barnstone's gift for transforming existing bungalows with touches that were modest but spatially effervescent (see fig. 15.15) gave the blocks of Sul Ross and Branard a new collective identity (what the St. Thomas graduate and Houston book dealer Karl Kilian nicknamed "Do-ville"), materializing a community that came to be peopled by the artists, architects, filmmakers, photographers, writers, and curators to whom Menil

Fig. 15.15
Menil Foundation office under construction,
Houston. Howard Barnstone, architect,
completed 1975

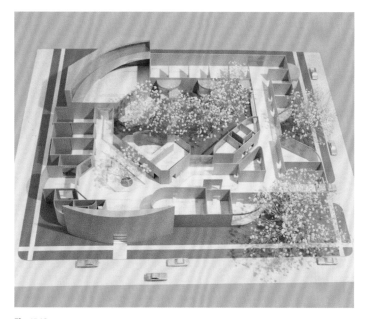

Fig. 15.16
Model of an art storage building on Mulberry
Street (*foreground*). Howard Barnstone,
architect, 1979

Fig. 15.17 *opposite*
Main entrance to the Menil Collection in 2009

Properties rented bungalows and apartments.[42] The Houston architect Anthony E. Frederick, after working for Barnstone in the first half of the 1970s, was responsible for exhilarating transformations of three bungalows: the Black Image Office, 1983–84, at 1519 Branard (now a staff office) and two houses adapted for staff offices at 1511 and 1513–1515 Branard, 1987 and 2001, respectively.[43]

In late 1974 Dominique de Menil resumed planning for a collection storage building, working with Barnstone on a number of architectural studies. One proposal for a two-story structure with basement and mezzanine was to include a workshop, conservation and registration facilities, small viewing rooms, curatorial and administrative offices, a number of public gallery spaces, gardens, a two-hundred-seat auditorium, and art storage rooms divided by genre and referred to as "treasure rooms." Another proposal, smaller in scope, involved a long storage building inserted into the backyards of houses on the south side of Branard Street. In 1979 Barnstone designed a large one-story building facing the 3900 block of Mulberry Street (fig. 15.16). This was organized around an open-air courtyard and contained curved-glass window bays, angled passageways, and broad interior concourses. Dominique de Menil disliked the curved screen used to mark the public entrance, which she criticized as ostentatious. Although Barnstone's designs were not pursued, they provided much of the preliminary information used to design the museum.[44]

The Menil Collection: Renzo Piano

In 1980, when Dominique de Menil decided to go forward with plans to make her collection the nucleus of an art museum, she hired Walter Hopps as a planning consultant and Paul Winkler, one of her former students at St. Thomas, as building coordinator. That same year, Pontus Hulten, then director of the Centre Pompidou in Paris, arranged for Dominique de Menil and Hopps to meet the Genovese architect Renzo Piano, who had designed the Centre Pompidou with the British architect Richard Rogers. Dominique de Menil retained Piano to design the building for the Menil Collection, which was completed in 1987 (fig. 15.17).[45]

Piano's methodical, problem-solving approach to architectural design fit with Dominique de Menil's propensity for focusing intently on resolving practical issues. Responding to her desire for a building that was small on the outside and big inside, Piano and his collaborators, the London engineers Peter Rice and Tom Barker of Ove Arup and Partners, the Houston architect Richard Fitzgerald, and Winkler, produced a design that affirmed the gray houses of Do-ville.[46] Piano subtly acknowledged John and Dominique de Menil's architectural patronage through his design. Gray-stained cypress clapboards and white-painted steel members affiliate the museum with the surrounding bungalows (fig. 15.18). The steel supporting

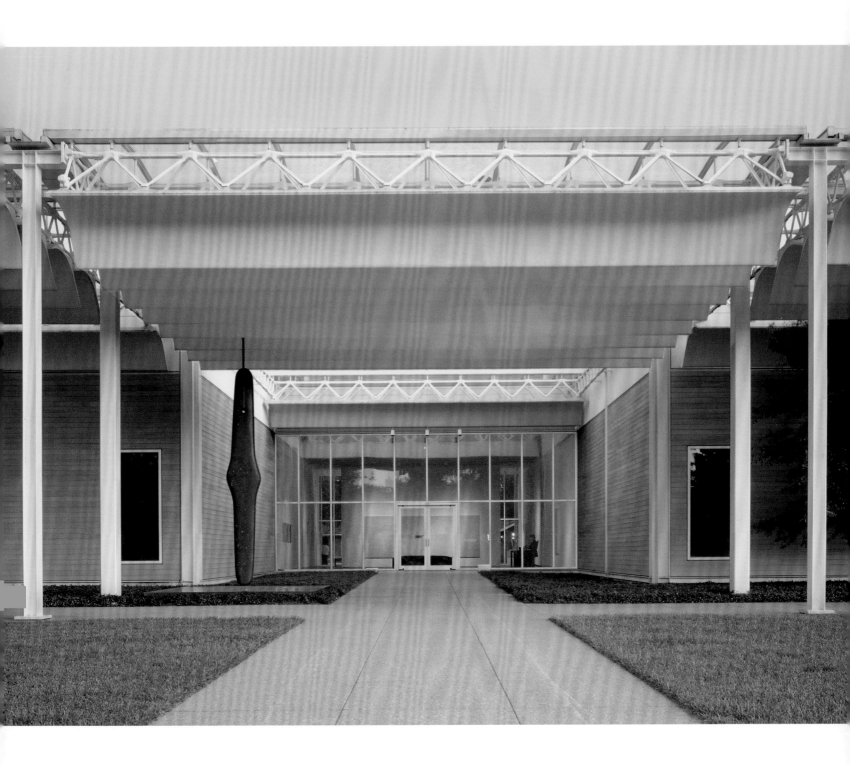

Fig. 15.18
Portico of the Menil Collection with a view
of a neighborhood bungalow

structure identifies with the University of St. Thomas, as does the encircling exterior promenade. Piano's sinuous "leaves" illuminate galleries with natural light, as at the Rothko Chapel, and the proportions of the gallery spaces, several interior garden courtyards, and even the black finish of the floors evoke the interiors of the Menil House. Vernacular cladding material and interior pine strip floors register the influence of the Art Barn, as does the fact that work being performed is visible at the loading dock and in glimpses from the promenade into the framing workshop and the conservation laboratory. The theme of perceptual exploration and discovery that was so important to MacAgy and Dominique de Menil as a way to apprehend works of art finds spatial expression in the path that visitors take from the parking lot to the museum and in the asphalt-topped path that slips between a pair of gray bungalows on Branard (fig. 15.1) and weaves through backyards to direct visitors from the museum to Richmond Hall. This former Weingarten's grocery store built in 1930 was rehabilitated in 1987 by Anthony Frederick to become the Menil Collection's alternative exhibition and performance space (it has contained the Dan Flavin Installation since 1998).

The Neighborhood of Art

The Houston architect Lars Lerup's term "metropolitan suburbanism" characterizes the paradoxical claim that the Menil Collection museum seems to make with its extraordinary/ordinary setting in what Banham called "the neighborhood of art."[47] Piano set up a spatial dialogue between the building and its surroundings, including the canopy of trees that, as Lerup observes, is the most distinctive natural feature of the flat coastal plain across which Houston sprawls.[48] Rather than architecturally proposing urbanism as an antidote to the city's sprawl, the Menil Collection museum redeems suburban space. It engages the found landscape in a dialectical exchange on site specificity, proportion, precision, and subtlety—all the "good form" phenomena whose absence makes Houston's suburban sprawl feel so monotonous and oppressive. The totalizing, competing modernist narratives of the 1950s (cosmopolitan versus provincial, Mies van der Rohe versus Frank Lloyd Wright) give way in the neighborhood of art to the construction of exchanges between architectural singularity and the commonplace.

An Ecumenical Vision

Piano and his team subsequently worked with the artist Cy Twombly and Winkler, by then director of the museum, to design the freestanding Cy Twombly Gallery, 1992–95.[49] The Byzantine Fresco Chapel, opened eleven months before Dominique de Menil's death in December 1997, is the work of her younger son, the New York architect Francois de Menil.[50] The Byzantine Fresco Chapel materializes the dialogue between modernity and history as a problematic.[51]

In the 1990s and 2000s, as in the 1950s, de Menil architectural patronage inspired new buildings in Houston, such as the Live Oak Friends Meeting House, 2001, by the architect Leslie K. Elkins, with its "skyspace" by the artist James Turrell. Project Row Houses (fig. 15.19) and the Orange Show are two alternative art sites in Houston that, as with the commissioning of Mies van der Rohe for the Museum of Fine Arts, Houston, addition in the 1950s, demonstrate the effect the de Menils' ecumenical vision has had. It has encouraged others to develop new constituencies for art and, in doing so, redeem the ordinary landscapes of Houston by perceiving what is extraordinary about them.[52] The proliferation of steel-surfaced tin houses in Houston in the 1990s and 2000s likewise demonstrates how an architectural initiative identified with the Art Barn and Rice Media Center took on a life of its own to signal the presence of artists, art dealers, and art collectors in Houston.[53]

John and Dominique de Menils' ventures in architecture dialectically exploited the phenomenon of difference to identify alternatives to cultural mainstreams in Houston. In the 1950s they used Miesian modern architecture to attract and identify a sympathetic constituency. In the 1960s the de Menils moved away from architecture with a strong formal identity to buildings that emphasized introspection, community, and the performance of work. Dominique de Menil's architectural patronage after John de Menil's death constructed a new alternative to mainstream patterns of development in Houston by focusing on a specific site with redemptive practices that constructed engagement between exceptional architecture and ordinary buildings and landscapes. What further set the de Menils apart, and what most frequently involved them in conflict with the Houston institutions with which they sought to work, was their dedication to excellence—in conception, execution, and reception. Their approach to modernism, not as a style but as a critical medium, involved paradox and contradiction. What marks the de Menil enterprise, and the architecture associated with it, is the determination to make elitism accessible, insisting on exceptional standards of excellence in service not to the few who are rich in resources and the right connections, but to those who appreciate and value the experiences these works embody and represent.[54] These are the attributes materialized in the cosmopolitan architecture associated with John and Dominique de Menil.

NOTES

Stephen Fox is a fellow of the Anchorage Foundation of Texas. For assistance in the preparation of this essay, he extends grateful thanks to the Menil Collection: Josef Helfenstein, director; Laureen Schipsi, publisher; Geraldine Aramanda, archivist; Vance Muse, director of communications; Karl Laurence Kilian, director of programs; Elsian Cozens, events coordinator; and Marta McBride Galicki, manager of special gifts. He also thanks Ralph Ellis, Menil Properties; Ron Drees, architectural archivist, Houston Metropolitan Research Center, Houston Public Library; Pamela G. Smart, assistant professor of anthropology, Binghamton University; Deborah Velders; Helen Winkler Fosdick; Glenn Heim; Frank D. Welch; William F. Stern; Ellen Beasley; Ben Koush; Stephen James; Simone W. Swan; Howard Barnstone; Anthony E. Frederick; Anchorage Foundation of Texas; Rothko Chapel; School of Architecture, Rice University; Gerald D. Hines College of Architecture, University of Houston; Rice Design Alliance; Archives Department, Museum of Fine Arts, Houston; University of St. Thomas; American Institute of Architects, Houston Chapter; Houston Mod.

1. John de Menil, "A Provincial Town," in *Houston: Text by Houstonians* (Marrero, La.: Hope Haven Press, 1949), 127.

2. Flannery O'Connor, "Catholic Novelists and Their Readers," in Flannery O'Connor, *Mystery and Manners: Occasional Prose*, ed. Sally and Robert Fitzgerald (New York: Farrar, Straus & Giroux, 1970), 189.

3. Attempting to measure mid-century modernist architectural patronage in the U.S. is complicated because the most publicized patrons acted in different contexts and at different scales.

For a discussion of postwar modern architectural patronage, see essays by Donald Albrecht and Will Miller in Eeva-Liisa Pelkonen and Donald Albrecht, eds., *Eero Saarinen: Shaping the Future*, exh. cat. (New Haven, Conn.: Yale University Press; New York: Finnish Cultural Institute in New York; Helsinki: Museum of Finnish Architecture; and Washington D.C.: National Building Museum, 2006).

4. "Redemption" is a term Pamela Smart has used to characterize a point of view toward art and the social purposes it serves that the de Menils shared with Father Marie-Alain Couturier, the most forceful advocate in postwar France of a reconciliation between the Catholic Church and modern art and architecture. See Pamela G. Smart, "Sacred Modern: The Ethnography of an Art Museum" (PhD diss., Rice University, 1997). "Redeeming" suggests critical engagement with existing circumstances rather than a utopian or eternalist denial of circumstance ("eternalist" is Stephen Schloesser's term for reactionary critiques). "Redemption" is a term that also appears in Schloesser's examination of efforts to reconcile Catholicism and modernism in interwar France; see Stephen Schloesser, *Jazz Age Catholicism: Mystic Modernism in Postwar Paris, 1919–1933* (Toronto: University of Toronto Press, 2005), 234. I am indebted to Pamela Smart for making me aware of Schloesser's book, which proposes a new and profoundly insightful understanding of the cultural matrix that so strongly affected Dominique de Menil in the 1930s.

5. Cheryl A. Brutvan has noted the mixture of enthusiasm and apprehension that John and Dominique de Menils' activities elicited among modernist advocates in Houston in the postwar 1940s, 1950s, and 1960s; see *In Our Time: Houston's Contemporary Arts Museum, 1948–1982*, essays by Cheryl A. Brutvan with Marti Mayo and Linda L. Cathcart (Houston: Contemporary Arts Museum, 1982). In December 1953 Aline B. Louchheim (subsequently Saarinen), associate art editor of the *New York Times*, wrote about the art scene in Houston. She noted the energy emanating from the "aggressively democratic" Contemporary Arts Association (CAA), on whose board John de Menil had served since the museum's organization in 1948. She also noted a "schism" within the CAA that she identified with John de Menil. His capacity to captivate and charm (as well as polarize) is evident in her description of his aspirations for the Museum of Fine Arts, Houston, including a "forthcoming Gauguin exhibition, which will show not only the influences on Gauguin but also how his work stimulated awareness of such other art as Egyptian murals and Gothic stained-glass, a show perhaps to be arranged by André Malraux" (Aline B. Louchheim, "Diverse Museums: Institutions of Our Southwest Present a Wide Variety of Aims and Outlooks," *New York Times*, December 27, 1953).

6. The postwar problematic of the relationship of modernity and history was first articulated in the milieu to which Couturier introduced John and Dominique de Menil, the wartime gathering of expatriate European modernists in New York. "Nine Points on Monumentality" of 1943, a manifesto by Catalán architect José Luis Sert, French artist Fernand Léger, and Swiss art historian Sigfried Giedion, initiated this discourse; see Paul Louis Bentel and Howard Lynn Hopffgarten, eds., *The Harvard Architecture Review*, vol. 4, *Monumentality and The City* (Cambridge, Mass.: Graduate School of Design, Harvard University, and MIT Press, 1984), in particular essays by Christiane C. and George R. Collins, and William J. R. Curtis, and reprinted texts by Sert, Léger, and Giedion. Philip Johnson was a leading voice in this discourse in the U.S. from the mid-1940s forward. What distinguished the de Menils' position was their resolve to seek out connections to, and continuity with, history rather than claim an exceptionalist stance (the classic modernist position) or, as Johnson would increasingly do in the late 1950s, inscribe historical forms in modern buildings. For the de Menils, modernism was a spiritual effort more profoundly involved in posing questions than in prescribing solutions.

7. Howard Barnstone, "John de Menil and His Architects," typescript in Howard Barnstone Papers, Houston Metropolitan Research Center, Houston Public Library. An edited version of the tribute was published as "Obit" in *Architecture Plus* 1 (August 1973): 71. See also Jean-Baptiste Minnaert, *Pierre Barbe: Architectures* (Liège, Belgium: Madaraga, 1991), 66, 112, 116, 118. Paul Winkler refers to Barbe's hardware in the de Menil apartment in his oral-history interview with Ellen Beasley on March 5, 2001, transcript, Menil Archives. Talking about Barbe, John de Menil said, "Through him we learned shape, proportion, etc." (Ellen Middlebrook, "Jean de Menil's Inspiration for Study Came Late," *Houston Post*, September 22, 1957). At the time the de Menils hired him, Barbe was a member of the Congrès Internationaux d'Architecture Moderne. In 1935 the de Menils and the writer François Mauriac launched a subscription drive to build Barbe's design for a rural chapel, Notre-Dame des Neiges, in the French department of Isère. Completed in 1938, the gable-roofed wood chapel marked the beginning of Barbe's move away from modernism toward regional vernaculars and, after World War II, classicism. Barbe worked for members of the de Menil and Schlumberger families throughout his long career. In 1962 he transformed a seventeenth-century stone building near Pontpoint (Oise) into a summerhouse for the de Menils.

8. Dominique de Menil, "Biographical Note," in Marie-Alain Couturier, *Sacred Art: Texts Selected by Dominique de Menil and Pie Duployé*, trans. Granger Ryan (Austin: University of Texas Press and Menil Foundation, 1989), 157–59; Smart, "Sacred Modern," 89–90; Frank D. Welch, *Philip Johnson and Texas* (Austin: University of Texas Press, 2000), 22–23, 34–35.

9. James Johnson Sweeney, "Collectors' Home," *Vogue* 147, April 1, 1966: 190; Rosamond Bernier, "A Gift of Vision," *House and Garden* 159, July 1987: 180; Welch, *Philip Johnson and Texas*, 40–41.

10. David Whitney and Jeffrey Kipnis, eds., *Philip Johnson: The Glass House* (New York: Pantheon Books, 1993). On Philip Johnson's devotion to Mies van der Rohe and his architecture, see Franz Schulze, *Philip Johnson: Life and Work* (New York: Alfred A. Knopf, 1994), 156–59,176–80, 185–86, 188–227.

11. Peter Blake and Philip C. Johnson, "Architectural Freedom and Order: An Answer to Robert W. Kennedy," *Magazine of Art* 41 (October 1948): 228. MacKie & Kamrath were architects of the headquarters building of the Schlumberger Well Surveying Corporation, 1951–53. The Schlumberger building, the first corporate headquarters in Houston to be built alongside a freeway, was MacKie & Kamrath's first big building in Houston. Their client was Dominique de Menil's cousin Pierre M. Schlumberger.

12. The Menil Archives contains an undated and unlabeled sketch plan on yellow tracing paper and the print of a drafted floor plan, dated October 22, 1948, along with ten letters from Johnson to John and/or Dominique de Menil, one letter from Johnson to Howard Barnstone after Bolton & Barnstone had taken on maintenance and repair work on the house in 1952, and a copy of a letter from Dominique de Menil to Johnson about the lack of stays on casement windows.

On the Menil House, see Welch, *Philip Johnson and Texas*, 36–50; Kathleen Bland, "Glass House Builder Expands on Ideas," *Houston Post*, January 11, 1950; "Art Collection and Home of the John de Menils in Houston's River Oaks," *Interiors* 123 (November 1963): 84–91; Sweeney, "Collectors' Home," 184–93; Ann Richardson, ed., *The Grand Homes of Texas* (Austin: Texas Monthly Press, 1982), 14–20; John Davidson, "Dominique de Menil," *House and Garden* 155 (March 1983): 10–12; Bernier, "A Gift of Vision," 120–29; Schulze, *Philip Johnson*, 202–03; Pilar Viladas, "They Did It Their Way," *New York Times Magazine* (October 10, 1999): 85–94; Stover Jenkins and David Mohney, *The Houses of Philip Johnson* (New York: Abbeville Press, 2001), 56–57; *The Architecture of Philip Johnson* (Boston: Bulfinch Press, 2002), 46–47; William Middleton, "A House That Rattled Texas Windows," *New York Times*, June 3, 2004; David Hay, "De Menil Reborn," *Metropolis* (August/September 2004): 98–101.

13. Elsian Cozens, interview, Menil Archives. Oral-history interviews conducted by the consulting historian and preservation specialist Ellen Beasley in 2001 prior to the restoration of the Menil House by Stern & Bucek Architects, 2002–04, are a valuable source of information about the de Menils and how they lived in the house. In their interviews with Beasley, Adelaide de Menil and Paul Winkler each mentioned the impact that living in the Caracas house had on Dominique de Menil.

14. The Menil House was one of nine houses featured on the first Modern House Tour of the Contemporary Arts Association (CAA) in April 1952; John de Menil brought Johnson to Houston to speak at the opening of the CAA's related exhibition "New Directions: Domestic Architecture," which was staged as a confrontation between the Miesians and the Wrightians. See Mary Ellen Preusser, "Nine Homes Show New Direction," *Houston Post Texas Living Magazine* (April 27, 1952): 8–9; Ann Holmes, "A Door, a Crag, a Tree May Plan Your House," *Houston Chronicle Magazine* (April 20, 1952): 2; "Texans Too Modest, Architect Claims," *Houston Chronicle Magazine* (April 20, 1952): 3.

15. Reyner Banham, "In the Neighborhood of Art," *Art in America* 75 (June 1987): 120. On Miesian examples in Houston, see "Roman House," *House & Home* 2 (July 1952): 67–73; "In Texas, an Air-Conditioned Villa," *House and Garden* 105 (February 1954): 50–53. See also Howard Barnstone, with Burdette Keeland, *Ten Years of Houston Architecture* (Houston: Contemporary Arts Museum, 1959); Nicholas Lemaan, "The Architects," *Texas Monthly* 10 (April 1982): 143–46; Mark Hewitt, "Neoclassicism and Modern Architecture, Houston Style: Or the Domestication of Mies," *Cite* (Fall 1984): 12–15; Welch, *Philip Johnson and Texas*, 47–57; Ben Koush, *Booming Houston and the Modern House: Residential Architecture of Neuhaus & Taylor* (Houston: Houston Mod, 2006), 13–18; Ben Koush, *Hugo V. Neuhaus, Jr.: Residential Architecture, 1948–1968* (Houston: Houston Mod, 2007).

16. Elizabeth Ann Coleman, *The Genius of Charles James* (Brooklyn and New York: Brooklyn Museum and Holt, Rinehart and Winston, 1982); see also "Art Collection and Home of the John de Menils in Houston's River Oaks," 84–91. In a letter thanking Johnson for sending the de Menils a copy of John M. Jacobus's book *Philip Johnson*, John de Menil wrote, "[Y]ou go a step further and you introduce an element of fluidity in the rigid canons of proportion. Perhaps this is what we tried to do, unconsciously and inadequately, when introducing into our house the Charles James couches, the piano, and the Belter furniture" (John de Menil to Philip Johnson, October 4, 1962, Menil Archives). Dominique de Menil told Rosamond Bernier that James "started from a few simple principles, such as that you should only put color on corridors and inside closets. Dark corners and passages were the places for color" (Bernier, "A Gift of Vision," 180, 182). Paul Winkler observed that Charles James was always subtle on the outside, putting his boldest colors where beholders would come upon them by surprise (Winkler, interview, Menil Archives). A *Houston Chronicle* interview of 1952 described Philip Johnson as "sitting in an easy chair and looking out over the tropical garden in the patio of one of his most famous homes, the de Menil home where he is staying while in Houston," adding that he "illustrated the trend toward mellowing the extremes by . . . putting period furniture in modern houses" ("Texans Too Modest, Architect Claims").

17. Dominique de Menil used the word "genius" in describing Charles James and said about the architectural design of her house, "I had very precise requisites for the house" (Richardson, *The Grand Homes of Texas*, 15). In another interview, she was quoted as saying, "Charlie was impossible, as we soon found out. But all that mattered was that he was a genius" (Bernier, "A Gift of Vision," 182).

18. It became part of the folklore of the Menil House that during construction Dominique de Menil compelled Johnson to insert the pair of high-set horizontal slot windows lighting the kitchen into the house's north-facing wall plane, which Johnson had wanted to be unbroken except for the entrance, and that at Charles James's insistence the ceiling height of the house was raised. However, Johnson's construction drawings show the kitchen windows in place and the ceiling height at ten and a half feet, which is also the height of the ceiling in Johnson's Glass House. Johnson did not include the Menil House in any of the authorized books on his work. Not until publication of *The Houses of Philip Johnson* by Stover Jenkins and David Mohney (New York: Abbeville Press, 2001) was the Menil House included in a survey of Johnson's work.

Jenkins and Mohney write that "Johnson was beleaguered throughout the project by the ever-changing program: the transformation of the original dining room into a playroom—a change made well into construction of the house—was one of these. . . . The plan, however, Johnson felt to be awkward. Despite the remarkable asset of major works of contemporary art, the design was vitiated by programmatic issues. Attempts to resolve questions of design and the role of art—Johnson's primary interests as a designer—were frustrated by the client's insistence on functional concerns. 'This is what happens when you wrestle with clients,' Johnson noted ruefully in a recent interview" (55–57). Johnson's preliminary drawings in the Menil Archives show that at that early stage the generous entrance hall was planned for dining when the de Menils entertained. Two spatial changes were made to the house during construction: a utility bay was added between the kitchen and the carport, and the heating and air-conditioning equipment room between the living room and the playroom was partitioned to make a cross passage connecting the children's bedroom wing to the living room.

19. Johnson inscribed the copy of John M. Jacobus's book *Philip Johnson* (New York: G. Braziller, 1962), which he sent to the de Menils in 1962: "To Jean & Dominique de Menil, my first clients, my best clients, the clients who found all my other clients, forwarder of my career, good friends, good critics, courageous appreciators of Art." Johnson's de Menil–related projects were the Schlumberger Administration Building in Ridgefield, Connecticut, 1952; two houses for Dominique de Menil's sister Sylvie Schlumberger and her husband, Eric H. Boissonnas, 1956, 1964; the Havey Hall dormitory at Seton Hill University in Greenburg, Pennsylvania, 1958; Taylor, Garrison, and Rothschild Hall dormitories at Sarah Lawrence College in Bronxville, New York, 1960; the Roofless Church in New Harmony, Indiana, 1960, an art chapel built by Jane Blaffer Owen; the Amon Carter Museum in Fort Worth, 1961; and the Art Museum of South Texas in Corpus Christi, 1972. See "This Small Suburban Administration Building is Four Things to Four Men," *Architectural Forum* 99 (September 1953): 124–29; William H. Jordy, "The Mies-less Johnson," *Architectural Forum* 111 (September 1959): 121; Jenkins and Mohney, *The Houses of Philip Johnson*, 152–59, 175–83; "Recent Work of Philip Johnson: Dormitories at Sarah Lawrence College, Bronxville, New York," *Architectural Record* 132 (July 1962): 118–19; "Shingled Shrine," *Architectural Record* 113 (September 1960): 128; "Culture, Religion, and Architecture in Indiana," *Architectural Record* 128 (October 1960): 13; "Portico on a Plaza," *Architectural Forum* 114 (March 1961): 86–88; Alan Lessoff, "An Art Museum for South Texas, 1944–1980," in *Legacy: A History of the Art Museum of South Texas* (Corpus Christi: Art Museum of South Texas, 1997), 24–53; Welch, *Philip Johnson and Texas*, 68–75, 76–84, 87–89, 92–101, 132–49; *The Architecture of Philip Johnson*, 54–55, 72–73, 108–09 (houses), and 88–90, 92–93, 142–43 (other buildings).

20. Peter C. Papademetriou, "Johnson in Houston," *Progressive Architecture* 62 (June 1981): 38. Johnson referred to the church as a new commission in his letter to Howard Barnstone of November 20, 1952, Menil Archives.

21. See Dominique de Menil, "Biographical Note," 158; Calvin Tomkins, "The Benefactor," *New Yorker*, June 8, 1998: 56–58.

22. Karl Kilian, "Flashback to the Sixties: University of St. Thomas," *Cite* 35 (Fall 1996): 22–23.

23. "Report of Meeting of Building Committee with Mr. and Mrs. de Menil," memorandum, June 20, 1956, University of St. Thomas Archives, Houston. The memorandum also cites four points that the de Menils advanced in Johnson's favor: he was "one of the few really great architects practicing today," he built economically, he was neither dogmatic nor dictatorial, and he worked quickly.

24. "The University of St. Thomas," *Architectural Record* 122 (August 1957): 138, 142–43; "First Units in the Fabric of a Closed Campus," *Architectural Record* 126 (September 1959): 180–82; Welch, *Philip Johnson and Texas*, 61–65; Welch, *The Architecture of Philip Johnson*, 78–79.

25. The systematic conception of Mies van der Rohe's architecture—its coherent, logical, and clear exposition of construction as the basis of building; its simple and lucid spaces, capable of producing emotionally intense sensations in their occupants; its integrity, truth, rigor, economy, and generosity—constitutes a built analogue of St. Thomas's discourse and methods. See Reinhold Seeberg, "Thomas Aquinas," in *New Schaff-Herzog Encyclopedia of Religious Knowledge* 11 (Grand Rapids, Mich.: Baker Book House, 1964), 426–27.

The influence of St. Thomas Aquinas on European modernist thought in the 1920s and 1930s accounts for profound commonalities between Mies van der Rohe and the de Menils. Fritz Neumeyer cites the impact of the Catholic theologian Romano Guardini on the architect's thinking in the mid-1920s in *The Artless Word: Mies van der Rohe on the Building Art*, trans. Mark Jarzombek (Cambridge, Mass.: MIT Press, 1991), 196–236. Mies van der Rohe's biographer Franz Schulze notes that although "he was indifferent to the formal church," the architect continued to acquire and read texts by Guardini and by the German modern architect of Catholic churches Rudolf Schwarz after he came to the U.S.; see Franz Schulze, Mies van der Rohe Archive of the Museum of Modern Art, *Mies van der Rohe: A Critical Biography* (Chicago: University of Chicago Press, 1985), 315–16. Stephen Schloesser notes that Jacques Maritain, whom Pamela Smart identifies as an important influence on Dominique de Menil in the 1930s, published Guardini's work in his Paris-based journal, the *Roseau d'or* (Schloesser, *Jazz Age Catholicism*, 184).

26. Anderson Todd emphasizes that John and Dominique de Menil had no involvement with the selection of Mies van der Rohe as architect for Cullinan Hall, an assertion that the museum's records support. See "The Museum of Fine Arts, Houston: An Architectural History, 1924–1986," *Bulletin* (The Museum of Fine Arts, Houston) 15, nos. 1–2 (1992): 66–90; James Johnson Sweeney, "Le Cullinan Hall de Mies van der Rohe à Houston," *L'oeil* 99 (March 1963): 38–43; "Two Ways of Looking at Art in Houston: I. The Museum of Fine Arts," *Interiors* 123 (November 1963): 92–95; Lynn M. Herbert, "Seeing Was Believing: Installations of Jermayne MacAgy and James Johnson Sweeney," *Cite* 40 (Winter 1997/98): 30–33.

27. Dominique de Menil identified MacAgy, along with Couturier and the art dealer Alexander Iolas, as the three people who had the greatest influence on the de Menils' sensibilities as collectors. See "Dominique de Menil" in *The First Show: Painting and Sculpture from Eight Collections, 1940–1980*, ed. Julia Brown and Bridget Johnson, exh. cat. (Los Angeles: Museum of Contemporary Art; and New York: Arts Publisher, 1983), 36–37, 40; Jermayne MacAgy, "Exposures and Enticements," *Art in America* 46 (Spring 1958): 40–43; Tomkins, "The Benefactor," 58; *In Our Time*, 22–31; "Two Ways of Looking at Art in Houston: II. The Gallery of Fine Arts, University of St. Thomas," *Interiors* 123 (November 1963): 92, 96–98; "Jermayne MacAgy: An Exhibition and a Tribute," *Art Journal* 28 (Winter 1968/69): 179.

28. Herbert, "Seeing Was Believing," 30–33; Eleanor C. Munro, "Totems and Taboos: Art Out of Anthropology," *Art News* 58 (April 1959): 28–29.

29. MacAgy, "Exposures and Enticements," 41. It also appears in an illustration caption in Sweeney, "Collectors' House," 184.

30. On Howard Barnstone, see Peter C. Papademetriou, "Howard Barnstone, 1923–1987," *Progressive Architecture* 68 (July 1987): 27; Stephen Fox, "Howard Barnstone (1923–1987)," in Barrie Scardino, William F. Stern, and Bruce C. Webb, eds., *Ephemeral City: Cite Looks at Houston* (Austin: University of Texas Press, 2003), 230–40.

Bolton & Barnstone's first design commission from John de Menil was to reorganize a wing of the original 1938 Schlumberger building in Houston's East End as offices for Schlumberger Surenco, 1953–54, a project on which they collaborated with the New York furniture designers Knoll Associates. In 1954 Bolton & Barnstone were commissioned by John de Menil to design staff housing and support buildings for Schlumberger Surenco at remote sites in Venezuela, Peru, Argentina, and Trinidad in collaboration with the Knoll Planning Unit and a former Knoll employee who had settled in Houston, interior designer Sally Walsh. Following Schlumberger's reorganization, Bolton & Barnstone and Walsh designed new offices for Pierre M. Schlumberger, John de Menil, and their staffs in the Bank of the Southwest building in downtown Houston, 1958. The Barnstone papers contain numerous files relating to these projects. Two of the Surenco houses were published: "House in Venezuela by Bolton & Barnstone," *Arts & Architecture* 73 (November 1956): 28–29, and "Company House in Trinidad B.W.I." *Arts & Architecture* 74 (April 1957): 28–29. On Walsh, see Gretchen Fallon, "Design Innovators: Three Houstonians Who Create Classic Looks," *Houston Home & Garden* 10 (October 1983): 142–43; Gary McKay, "Sally Walsh, 1926–1992," *Cite* 28 (Spring 1992): 8. Barnstone worked for Schlumberger for the rest of his career, thanks to the support of first John de Menil and then Jean Riboud.

31. Susan J. Barnes, *The Rothko Chapel: An Act of Faith* (Houston: Rothko Chapel, 1989), 42.

32. Glenn Heim, conversation with author, September 10, 2006.

33. Heim shaped the worship space to comply with the Apostolic Constitution on the Sacred Liturgy, formulated by the Second Ecumenical Vatican Council in 1963. Using curvature to display natural light, sectionally layering the curves of one wall plane to construct the trace of a baldachin above the tabernacle, and inserting shadow lines produced by minimally offsetting floor and ceiling slabs suggested that interior surfaces had been manipulated and worked out during construction by an artist rather than sketched, studied with scale models, and drawn by an architect, then built by a contractor. (Heim did make preparatory drawings for both chapels, however.) Heim's backless, dark-stained fir benches (which he credits Dominique de Menil with suggesting) perceptually lowered the horizon line of the space to compensate for its low ceiling. A medieval wood statue of the Virgin and Child from the de Menils' collection, stationed on a white pedestal near the rear of the chapel, subtly charged the space while affirming in dialectical integralist terms continuity with, rather than rejection of, pious devotional practices. Heim indicates that he was powerfully affected in his work with curvature by the late architecture of Le Corbusier.

34. "Prodigy in Houston," *Architectural Forum* 124 (January/February 1966): 8; "Two Chapels on the Campus of the University of Saint Thomas," *Liturgical Arts* 35 (November 1966): 34–36; Marguerite Johnston, "The Excitement, the Promise, the Charm of St. Thomas," *Houston Post Tempo Magazine*, November 3, 1968, 20.

35. "Processional Elements in Houston," *Architectural Record* 137 (June 1965): 159; Barnes, *The Rothko Chapel*, 42–43, 48–68, 77–87; Sheldon Nodelman, *The Rothko Chapel Paintings: Origins, Structure, Meanings* (Austin: University of Texas Press, 1997), 72–75; Dominique de Menil, "Rothko Chapel," *Art Journal* 30 (Spring 1971): 249; Smart, "Sacred Modern," 209.

36. Marguerite Johnston, "The Institute for the Arts Comes to Rice," *Rice University Review* 6 (Summer 1971): 6–11; Marguerite Johnston, "Rice Art Program Expansion Planned," *Houston Post*, December 18, 1968; "Machine Shop for Art," *Architectural Forum* 131 (July/August 1969): 95; Dominique de Menil, "New Art Center, New Possibilities," *Institute for the Arts, Rice University, Houston Newsletter No. 1* (Winter 1969): n.p.; and "Open House, New Media Building," *Institute for the Arts, Rice University, Houston Newsletter No. 2* (Spring 1970): n.p.

37. Aubry designed the Tin Houses as the low-rise Houston equivalent of a New York loft, according to Fredericka Hunter, speaking at a symposium on the Tin Houses moderated by William F. Stern and organized by the Rice Design Alliance, Houston, on April 19, 1994. See also Cyndy Severson, "The House That Art Built," *Texas Monthly* 5 (September 1977): 100–103; Susan Freudenheim, "Shock of the New," *Texas Homes* 10 (October 1986): 58–63. For a subsequent example of the West End Tin House, see Neal I. Payton, "Tin Houses," *Cite* (Summer 1986): 8.

38. "Adaptive Use: Renovated Movie Theater Brings Fine Art to a Depressed Neighborhood," *Interiors* 131 (January 1972): 12; George Davis, "The De Luxe Show," *Art and Artists* 6 (February 1972): 36–37.

39. Kahn was one of four lecturers who spoke, at Dominique de Menil's invitation, in connection with the "Visionary Architects" exhibition at the University of St. Thomas in fall 1967, and he contributed a poem to the catalogue *Visionary Architects: Boullée, Ledoux, Lequeu* (Houston: University of St. Thomas, 1968), 8. In 1970 Kahn produced a schematic design for an arts complex at Rice University. See Ann Holmes, "Louis Kahn Planning Possible Arts Complex at Rice," *Houston Chronicle*, March 5, 1970; "Rice Ponders Future Xanadu of the Fine Arts," *Houston Post*, March 6, 1970; David B. Brownlee and David G. De Long, *Louis I. Kahn: In the Realm of Architecture* (Los Angeles and New York: Museum of Contemporary Art and Rizzoli International Publications, 1991), 108–10. Although the Rice project has been linked to the de Menils, no such connection is evident from documents in the Menil and Rice University archives. H. Malcolm Lovett, chairman of the board of governors of Rice University in 1969, stated that he commissioned Kahn for the arts complex after encountering the library Kahn designed at Phillips Exeter Academy in Exeter, New Hampshire, which one of Lovett's sons attended (H. Malcolm Lovett, conversation with author, October 17, 1977).

On Kahn's schematic designs for the Menil Foundation, see Patricia Cummings Loud, *The Art Museums of Louis I. Kahn* (Durham, N.C.: Duke University Press and Duke University Museum of Art, 1989), 244–59, where she devotes nearly a chapter to Kahn's drawings for the Menil Foundation; Stephen James, "Treasuries for Art: Louis Kahn and the Houston Projects" (paper delivered at the Southeast Chapter, Society of Architectural Historians, 2005 Annual Meeting, Fort Worth, October 14, 2005); Brownlee and De Long, *Louis I. Kahn: In the Realm of Architecture*, 136–37.

40. Ann Holmes, "Rothko Chapel Park Expanding," *Houston Chronicle*, July 30, 1974.

41. Prior to the coordinated painting of the Menil Properties' houses, Dominique de Menil and Patrice Marandel had organized an exhibition of grisaille at the Art Barn, which seems to have inspired the choice of colors. See "Grisaille Exhibition Opens at Rice Museum," *Institute for the Arts, Rice University, Houston Newsletter* (Fall 1973): n.p.

42. Dominique Browning, "What I Admire, I Must Possess," *Texas Monthly* 11 (April 1983): 142. Barnstone expanded on the spontaneity of his urban design with his alterations of a house at 1506 Branard for the Menil Foundation in 1973–74. The house moved to 1427 Branard when construction of the Menil Collection building began, and today it contains the offices of Da Camera of Houston.

43. Andrew Bartle, "The Black Image Office of the Menil Foundation," *Cite* (Spring 1986): 22.

44. Doug Michels, best known for his association with the design collaborative Ant Farm, worked on the development of the 1979 design for Barnstone. Michels's preliminary version of this design was shown in the exhibition "Doug Michels: Beyond the Ant Farm" organized by Stephen James at the Gerald D. Hines College of Architecture at the University of Houston in March 2005.

45. Renzo Piano, *Renzo Piano: Projects and Buildings, 1964–1983*, trans. Richard Sadleir (New York: Rizzoli International Publications, 1984), 156–69; Peter Davey, "Piano Practice: Menil Collection Art Museum," *Architectural Review* 181 (March 1987): 36–42; Peter C. Papademetriou, "The Responsive Box," *Progressive Architecture* 68 (May 1987): 87–97; John Pastier, "Simplicity of Form, Ingenuity in the Use of Daylight," *Architecture* 76 (May 1987): 84–91; Richard Ingersoll, "Pianissimo: The Very Quiet Menil Collection," *Texas Architect* 37 (May/June 1987): 45–46; Reyner Banham, "In the Neighborhood of Art," 124–29; Mary McAuliffe, "The Erasure of the Canopy," *Crit 19* (Winter 1987): 32–37; "The Menil Collection Museum," *A+U 206* (November 1987): 41–70; Peter Buchanan, *Renzo Piano Building Workshop: Complete Works* (London: Phaidon Press, 1993), 1: 81–86, 140–63; Renzo Piano, *Progetti e architetture 1987–1994* (Milan: Electa, 1994), 16–29.

46. The phrase "small on the outside and big on the inside" is Ann Holmes's quotation of Dominique de Menil in her article "Dominique de Menil: From *Jeune Fille* to

'Renaissance Woman,'" *Art News* 82 (January 1983): 82. See also Shunji Ishida, "Toward an Invisible Light: Design Development," *A+U 206* (November 1987): 66.

47. Lars Lerup, *After the City* (Cambridge, Mass.: MIT Press, 2000), 80. Lerup observed that the Menil Collection neighborhood resists spatially identifying itself as a "campus" (the code word in Houston for exclusionary, defensible, single-identity precincts) in order to maintain continuity with the city, which in Houston, with only a few exceptions, is suburban space: freestanding buildings, trees, grass or paving, and infrastructure. Redemption in this context is not about giving architectural expression to the suburban city, but rather creating works of architecture that are of such singular value that they are not diminished by taking responsibility for their ordinary environs. See also Banham, "In the Neighborhood of Art," 124, and Richard Ingersoll, *Sprawltown: Looking for the City on Its Edges* (New York: Princeton Architectural Press, 2006), 55–56.

48. Lerup, *After the City*, 162.

49. Karen D. Stein, "Art House: Cy Twombly Gallery, The Menil Collection, Houston, Texas," *Architectural Record* 183 (May 1995): 80–83; Gerald Moorhead, "Softly Piano," *Texas Architect* 45 (July/August 1995): 62; William F. Stern, "The Twombly Gallery and the Making of Place," *Cite 34* (Spring 1996): 16–19; Peter Buchanan, *Renzo Piano Building Workshop: Complete Works* (London: Phaidon Press, 1997): 3: 56–73.

50. Joseph Giovannini, "Modern Reliquary: In a New Houston Museum, Francois de Menil Crafts an Authentic Setting for Two Byzantine Frescoes," *Architecture* 86 (April 1997): 68–75; Gerald Moorhead, "Glass House," *Texas Architect* 47 (July/August 1997): 44–47; Catherine Slessor, "Out of This World," *Architectural Review* 203 (May 1998): 82–85.

51. The layered wall planes, courtyards, fountains, and pools of the Byzantine Fresco Chapel are reminiscent of a 1986 proposal by the Mexico City architects Luis Barragán and Raúl Ferrera Torres for a conference building to be built for the Menil Foundation at 1304 Sul Ross. Christophe de Menil was instrumental in persuading her mother to retain Barragán. Misunderstandings about the size and scale of the conference building, as well as the need to complete the museum building before beginning any new construction, caused the project to be deferred. Work was never resumed after Barragán died. See John Clarke Ferguson, "Luis Barragán: A Study of Architect-Client Relationships" (PhD diss., University of Delaware, 1999), 140–67; "Luis Barragán: An Unbuilt House for the Menil," exhibition brochure, Menil Archives; Antonio Riggen Martínez, *Luis Barragán: Mexico's Modern Master, 1902–1988* (New York: Monacelli Press, 1996), 240; Richard Ingersoll, "In the Shadows of Barragán," in *Luis Barragán: The Quiet Revolution*, ed. Federica Zanco (Milano: Skira Editore, 2001), 221.

52. Houston art dealer Hiram Butler was instrumental in bringing James Turrell, architect Leslie Elkins, and the Live Oak Friends Meeting together to realize this project. Patrick Peters, "What Simplicity Conceals, the Light Reveals," *Cite 50* (Spring 2001): 12–14; Ned Cramer, "The Outer Light," *Architecture* 90 (June 2001): 84–89; Val Glitsch, "Opening Night," *Texas Architect* 51 (July–August 2001): 44–47; Sheryl G. Tucker, "Reinnovating the African-American Shotgun House," *Places* 10 (Summer 1995): 64–71; Jessica Dheere, "Profile: Artist Rick Lowe Preserves Humanity in Houston," *Architectural Record* 189 (February 2000): 218; Nancy Bless, "Home Equity: An Experiment in Urban Renewal Learns to Stand on Its Own," *Metropolis* 19 (May 2000): 38; David Brown and William Williams, eds., *Row: Trajectories Through the Shotgun House*, Architecture at Rice 40 (Houston: School of Architecture, Rice University, 2004); Ingersoll, *Sprawltown*, 66; William Martin, "What's Red, White, and Blue … And Orange All Over?" *Texas Monthly* 5 (October 1977): 120–24; John Beardsley, *Gardens of Revelation: Environments by Visionary Artists* (New York: Abbeville Press, 1995).

53. Among the most notable second-generation Tin Houses are Natalye Appel's house for Sarah and Ray Balinskas, 1992; Val Glitsch's house and studio for Bobby Bennett, 1992; Cameron Armstrong's house for Terrell James, 1993; Taft Architects' house and studio for Joanne and Casey Williams, 1996; and Nonya Grenader's house for Jim Love, 2004. See Emily Alexander, "Full Metal Jacket: Balinskas House, Houston," *Texas Architect* 44 (September/October 1994): 44–45; "Light and Easy," *Texas Architect* 43 (September/October 1993): 56–57; Joseph Giovannini, "Showing Their Metal," *Metropolitan Home* 27 (July/August 1995): 97–101; Terzah Ewing, "The Home Front: Houston Takes A Shine to Metal," *Wall Street Journal*, April 25, 1997; Donna Paul, "Homes of Metal: Great Shining Hope?" *New York Times*, May 14, 1998; Gerald Moorhead, "Lots of Light," *Texas Architect* 49 (September/October 1999): 44–45; Lawrence W. Speck, "Taft Architects: Williams House and Studio," *Architecture* 90 (May 2001): 140–45; Michelangelo Sabatino, "Small Houses for a Big City," *Cite 70* (Spring 2007): 27–28.

54. Anne Gruner Schlumberger, in *The Schlumberger Adventure* (New York: Arco, 1982), observed of her brother-in-law John de Menil, "[H]e cherished the dream of a life dedicated to serving the weak and rejected. A curious character! For in the end, however spontaneous may have been the movement that carried him toward others, he was nonetheless tainted with elitism. Jean believed in the demonstrative power of example, the duty of the 'chief' to preach by example" (120). In her remarks at the dedication of the Menil Collection, Dominique de Menil remembered her husband: "Through struggles and failures, John de Menil's dogged determination to strive for the highest values prepared the way we are following today. The esthetic and moral principles he fought for are embodied in the museum and in the Rothko Chapel, the buildings where the highest aspirations of humankind can be expressed." See Dominique de Menil, "The Menil Collection and Museum," *A+U 206* (November 1987): 63.

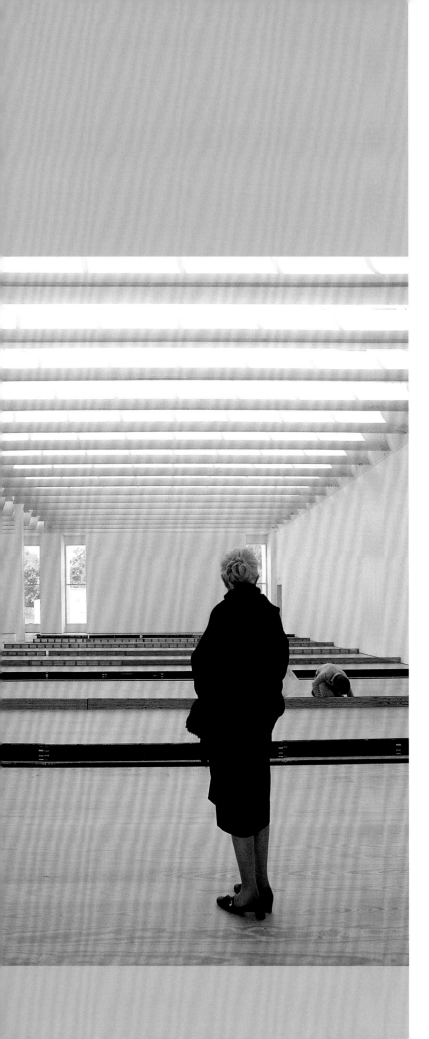

Working with Light:
A Portrait of Dominique de Menil

RENZO PIANO

When somebody asked me how I felt about coming to Houston to talk at the Menil's twentieth-anniversary party—it's been a long time—I said that there are very few things that have changed. The trees have grown. And unfortunately Dominique de Menil is no longer here. I was used to seeing her working around the museum. The clients are always the essential part of the job—you do not have good architecture without a good client. And architecture is, in some way, the mirror of the client. So this building is a portrait of Dominique de Menil.

The other thing that I notice is that you can see the trace of footsteps on the floor of the museum. People passing by have been picking up the stain, and you see the pine, and you see the trace of the steps. This was one of the discussions we used to have with Dominique de Menil. She wanted to do something like that. So you can see in the floor that it's a record of the steps of people going by. It is the kind of poetry that was in the mind of this lady.

I met Dominique de Menil for the first time in 1980. We met in her house in Paris that was a kind of *maison de tresor*—she used that word, the "treasure house." She told me immediately, "I want a building that is small outside and big inside." It was the best way to explain how to make the building here. This was an odd place to build a museum, that's for sure. She and John de Menil and the family started to acquire these properties, so that they became a little town. They were places where people were living. People who worked for the Menil. People working on everything—visual art, music, cinema, religion, social life, anthropology. That was the village.

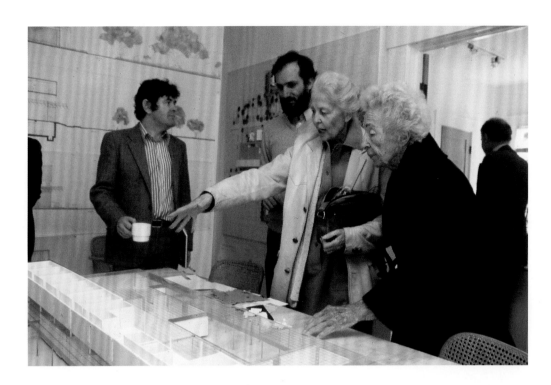

Fig. 16.1 *opposite*
Dominique de Menil in the galleries during construction of the Menil Collection, 1986

Fig. 16.2
Peter Rice, Renzo Piano, Dominique de Menil, and Nina Cullinan viewing the museum model, Menil Foundation, Houston, 1982

One of the biggest mistakes you can make as an architect is a mistake in scale. Scale is something that you cannot judge in drawings. You cannot judge it in models. Scale is something you only judge as you walk around and watch everything. You measure everything. (From time to time, policemen will try to arrest me because I measure everything!) You have to measure, because then you understand. You understand the scale of the trees, the scale of the houses. And then you work out the presence of the new building.

We made plans for the building to be here among these properties, but we didn't find enough space, so we had to move some houses. These houses are very fragile. They are actually part of the environment. We didn't keep them just because we are romantic—well, we are also a bit romantic—but because they are, in some way, what we Europeans call a historical center, if you can use that word in Houston. This is a place where these houses are part of the city's roots.

The art of making a building is the art of trying and trying again. It is a continuous struggle. It's not true that it is very harmonious. Dominique de Menil said to me immediately when we met for the first time, "Renzo, I don't like Beaubourg. Clear?" But she was not saying that she didn't like Beaubourg [Centre Georges Pompidou] as an idea. She just didn't like pipes. So she got me to swear that I will never do pipes again. But she loved the idea of a place of invention. Architecture's not just about design—it's also about inventing. It's a very funny mix between art, science, history, psychology, and sociology. She loved that. So she said, "Okay. You are probably the right guy to work with, to invent something else. Not that, but something else."

It was a very interesting struggle, with many, many things coming together. She was a stubborn lady. Everybody knows that, but she was actually the most stubborn lady I ever met in my life! But she was also a person of incredible lightness. She was tiny, skinny, physically light. Beautiful, beautiful. And she was light in the sense that she used to love to talk, to understand, to listen. Stubbornness is a great quality only on one condition: that you know how to listen to people. You are as stubborn as she was, but at the same time, you are permeable. You grab hold, and then you're still, and you think. Sometimes good people don't talk, and the wrong people talk a lot. You have to be clever enough to listen to those who are silent; it is not that easy. Places also talk. This place told me a story a long time ago, and it still tells a story to me as I walk around. Sometimes architects don't listen to those stories because the voice is normally very, very tiny. It's a little voice. But you should.

Reyner Banham, the critic that I love so much, used to come to Houston quite often with Paul Winkler, Walter Hopps, and Peter Rice. Banham wrote the famous book *The Architecture of the Well-Tempered Environment*, which says that architecture is not just made of walls and floors, but is actually made of atmosphere. It's made of light. It's made of perspective. It's made of transparency. It's made of complexity. And it is in some way a continuous Ping-Pong between the world of poetry, beauty, and abstraction and the world of construction. This is what happened at the Menil Collection.

The most important thing Dominique de Menil wanted was to work with light. She wanted to feel the clouds coming and going.

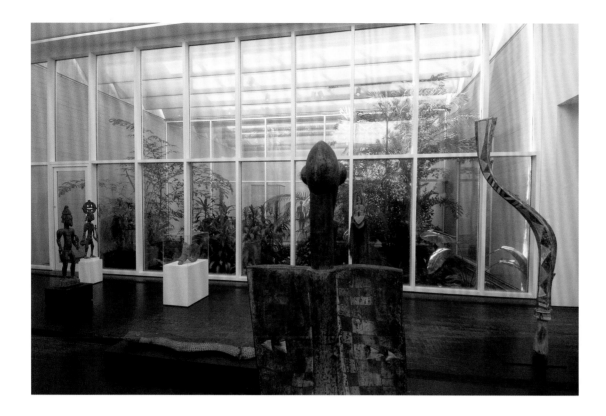

Fig. 16.3
African art gallery and atrium of
the Menil Collection, ca. 1995

She used that expression. She wanted to feel the day going away and the evening coming—that sort of sensation. Happily enough, Houston is one of those cities built in such a way where the north is north and the south is south. (Not many cities are built like that.) And that's good, because it made it easy to put the roof leaves or the visors we designed in such a way that they don't take the stronger sun from the south. They only take the light from the north. If you make the trusses very slim, very rounded white pieces, the light goes around, and it doesn't create big shadows. That is, of course, what you have to do if you want to create a good condition for museum lighting.

Also, architecture is not sculpture. That's another little mistake that often happens. Architecture is something else. Architecture is about construction. We love the idea that buildings are made up of pieces. We love the idea that these are the walls of Peter Rice, that the building shows the traces of the hands, like the floor shows the traces of the shoes. So the art of making those slim, rounded trusses, which are so precise they look like a result of industrial production, was part of this game.

At the same time, I think a museum is a place above physics. It's a metaphysical place. A place out of the world and out of time. Yet the Menil Collection is also very well connected to its environment, to the park. Some of these things are really in the spirit of Dominique de Menil. The idea of the multiple planes, different layers. You are in a room in the company of a beautiful piece of art. Then you have

an inside garden. And beyond the garden, you have another room with other works of art. And beyond that room, you have another inside garden. And finally, eventually, [an exterior] wall of wood. So this multiple-plane idea, combined with the light from the top, creates that sense of a metaphysical place. But the beauty of this is even more in that feeling of continuity between the street, the park, the building.

It's more proof that you can fertilize the life of cities, even when they are quite indifferent to art, by putting things like the Menil Collection in the middle of cities so they become a kind of reference. I think fertilizing is a good way to talk about this, because you can fertilize even the desert. And unfortunately sometimes cities that I love very much are like deserts.

The treasure house in the Menil building is the place where all the pieces of art stay. And it's an invention of Dominique de Menil. Well, of course, it was really done a long time ago in the Florentine palazzos. The *quadraria* is the room where they put the paintings, one by the other, to be safe. The Menil also has rooms where the collection is kept. All the art is carefully arranged so that it is visible, and it is very intense. These are rooms that are absolutely mad. Dominique de Menil used to say that a museum is a place where you have to be able to lose your head.

Windows looking into the conservation lab are another invention of hers. She wanted to see the backyard of the museum. She wanted the people to be able to see what is happening inside from

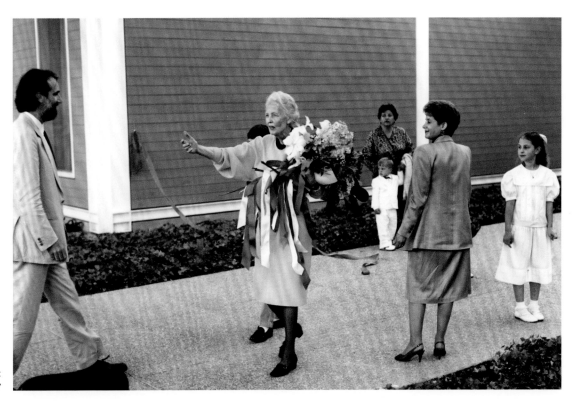

Fig. 16.4
Renzo Piano and Dominique de Menil
with Houston Mayor Kathryn Whitmire at
the opening of the Menil Collection, 1987

Branard Street. Normally people don't see matting and framing. But she wanted to do this in such a way that you can understand from the street what goes on inside.

Dominique de Menil came to my office much later, after the opening of this building, to start another job. She decided—together with Walter Hopps, Paul Winkler, and the family—to make a pavilion here for Cy Twombly, who was happy about this. We wanted to put the building in this little place. Very simple plan. Square. But also very complex. You have a filter here for the light, for the sun, then you have the glass, and you have louvers, and you have the horizontal ceiling. And finally you have here the fabric "ceiling." The fabric was done by a sailmaker. Every part was crafted—I love that.

In Dallas we have designed and built more recently the Nasher Sculpture Center, a sculpture garden plus galleries. It is done in travertine. This idea is very mad, because we water-blasted the travertine so that it looks like it is three thousand years old. So you go around in Dallas and suddenly you see this thing and think, "My God, the Romans were here." Dallas is totally torturous; the blocks are not looking north and south. So we made a screen for the roof using little rib-like forms oblique holes to let in only indirect sunlight. The ceiling is made of barrel-vaulted glass suspended above the galleries, atop narrow steel ribs and supported by thin, stainless-steel rods. You can see them through the glass. Because the Nasher is mainly about sculpture, we were able to let in more light.

Architecture is about freedom. And freedom is about not being self-referential. It's not because you don't care about style. Style or language and coherence are important parts of your history. I have spent my entire life fighting against gravity, for example. You have to be mad to fight against gravity, being an architect. If you are a poet, you may try. If you are a musician, you may try. But if you are an architect, you must be really mad. You still do it, even though this is not the way you should approach a building. You don't approach a new design by saying, "Now I will show you how well I fight gravity."

We are back in Texas to add something for the Kimbell Art Museum. We don't really know exactly what but are trying to figure it out. The Kimbell is a seminal job for me. I have visited it many times and am familiar with Louis Kahn. So in America, I started from Texas and we are back in Texas. This state is familiar to me and to us. We started with the Menil. Then Twombly. Then Nasher. Now Kimbell. My little boy here was born in Texas. It's probably a bit like a love story in some ways.

So I want to end here with this little admission of love.

This piece was adapted from a talk given by Renzo Piano at the Menil Collection on April 21, 2007, as part of a lecture series commemorating the museum's twentieth anniversary.

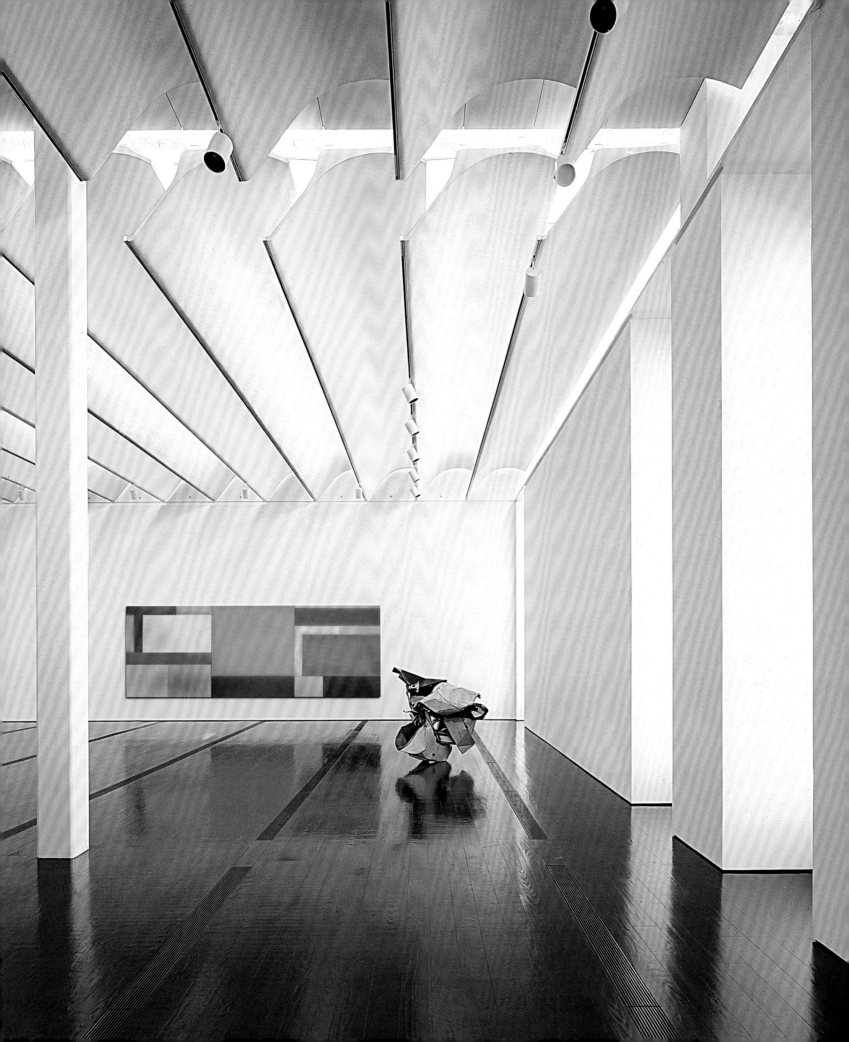

The Porosity of The Menil Collection RICHARD INGERSOLL

Of the many important museums built during the late twentieth century, the Menil Collection is one of the few that feels like a real place. This atmosphere was achieved through the creative preservation of a ten-block neighborhood in the Montrose district of Houston, where dozens of pre–World War II bungalows acquired by the Menil Foundation were painted gray with white trim in the 1970s. The substantial oblong museum structure was then stealthily inserted into the midst of the contrived uniformity of the neighborhood—cloaked in gray clapboard revetment and surrounded by spindly, white steel-frame porticoes. The building looks so familiar and unassuming that one might drive by it without taking notice, yet on closer inspection one finds it is laden with exceptional details, such as the magnificent horizontal louvers held in place by a web of intricate metal trusses. Many of the houses surrounding the museum serve auxiliary functions for administration and as spaces for other art organizations, contributing to the sense that this is not just a museum, but a productive community for the art experience. Both through the apparent lightness of its architecture and through the interaction with its setting, the Menil Collection suggests "porosity," an urban condition defined by literary critic Walter Benjamin in his description of Naples in the 1920s as existing where "building and action interpenetrate … to become a theater of new, unforeseen constellations."[1]

The late twentieth century may some day be known as a Golden Age of museum building, since almost every city in the United States and Europe, large or small, provided a home for at least one major

Fig. 17.1
West gallery of the Menil Collection, Houston.
Renzo Piano and Richard Fitzgerald &
Associates, architects, completed 1987

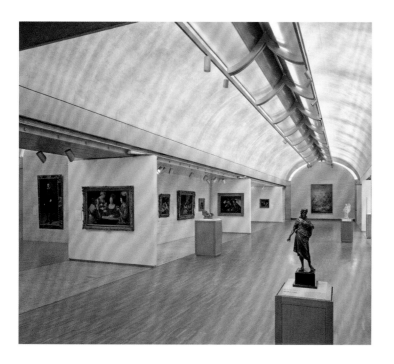
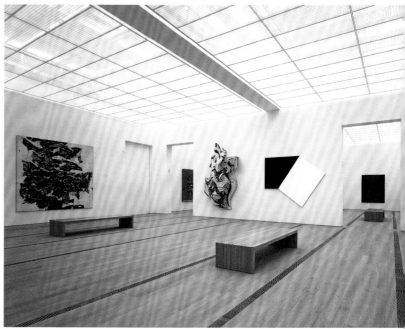

new exhibiting institution during that time; in Houston alone, seven museums spaces were built.[2] In general, the first concern of museum design from an architectural point of view is to create distinction in the quest for a masterpiece to add to a city's cultural trousseau. Today this is most commonly known as the "Bilbao Effect," referring to Frank Gehry's spectacular Guggenheim Museum in Bilbao, Spain, which during its first year of operation in 1998 attracted nearly a million tourists to a city that was previously known only for its industrial port. An early instance of this effect was the Centre Pompidou in Paris, which Renzo Piano, the Italian architect of the Menil Collection, designed and built with his English partner, Richard Rogers, in 1971–76. In time the enthusiastic reception for this brightly colored, gigantic Erector set made it the first in a new generation of museums to become a mass attraction. The rate of attendance at the Centre Pompidou was more than ten times that which had been anticipated, and only twenty years after its opening it was in sore need of renovation, requiring a complete overhaul of the museum's interior— a job overseen by Piano. Although the popular success of the Centre Pompidou can be partly attributed to its unconventional program of integrating art, music, cinema, and a public library, the architecture, with its monumental exposed mechanical parts, remains the main attraction. Nothing could be more dissimilar to the subdued, antimonumental approach of the Menil Collection built a decade later, which gains distinction by willfully attempting to remain indistinct.

Of the American museums that had the most influence on the initial architectural conception of the Menil Collection, undoubtedly

Louis I. Kahn's Kimbell Art Museum in Fort Worth, 1967–72, was central (fig. 17.2). Dominique and John de Menil were impressed with the atmosphere of the Kimbell and hired Kahn in 1973 to design a campus for their collection of, at that time, ten thousand works. Kahn's lyrical pastel drawings show an unfettered grand approach and include a Pantheon-like domed space. As at the Kimbell, Kahn envisioned a series of top-lit galleries that in section would have resembled narrowly triangular Mayan vaults with long monitor skylights at their apexes. The principal idea from his design that would be transmitted to future programs for the museum was his desire for a special interior atmosphere bathed with toplighting; as Kahn said, "Light is the theme."[3]

With the death of John de Menil in 1973, followed by that of Kahn the next year, the design never developed beyond the schematic phase, and it was both too sketchy and too ambitious, and as such was consigned to the archives. When Dominique de Menil resumed the effort to create a home for the collection, her intentions diverged greatly from what was being built at that time for new U.S. museums. The blatant epic and spectacular interiors of I. M. Pei's addition to the National Gallery of Art in Washington, D.C., 1968–78; Richard Meier's High Museum of Art in Atlanta, 1980–83; and Arato Isozaki's Museum of Contemporary Art in downtown Los Angeles, 1985, were anathema to her taste and objectives. She was after all, despite her wealth, known for such self-effacing gestures as wearing her mink coat inside out because it felt warmer that way. She shared with her husband a missionary zeal concerning the function of art as

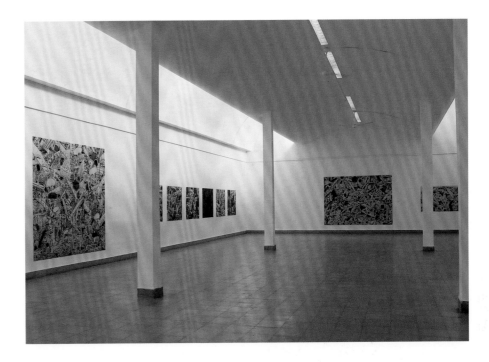

Fig. 17.2 *opposite left*
South Gallery, Kimbell Art Museum, Fort Worth, Texas. Louis I. Kahn, architect, completed 1972

Fig. 17.3 *opposite right*
The American Room of the Fondation Beyeler, Riehen/Basel, Switzerland. Renzo Piano, architect, completed 1997

Fig. 17.4
Exhibition hall of the Museum of Art, Ein Harod, Kibbutz Ein Harod, Israel. Samuel Bickels, architect, completed 1948

a spiritual enterprise that derived from their initial conversion to the appreciation of modern art by the Dominican priest Father Marie-Alain Couturier. Couturier had introduced the de Menils in Paris in the 1930s to the discourse concerning the spiritual nature of modern art.[4] Transcendent spirituality became central to the items the couple collected and the way the objects were installed.

Rather than replicate the stuffy demeanor of traditional museums, Dominique de Menil desired to maintain the manner in which she displayed art in her own home, a modernist brick and steel structure designed in 1948 by Philip Johnson. She and her husband had liked to try things out in different places and create interesting juxtapositions of works, and she hoped that the museum could avoid strict categorical organization and allow a periodic rotation of the works on display. Many of the features of the de Menil residence were carried over to the museum, including its broad, unassuming, asymmetrical exterior, its enclosed tropical garden court, and the oversized polygonal ottoman in the foyer. Her encounter with Piano in 1980 through the intervention of Pontus Hulten, then director of the Centre Pompidou, spared the patron from having to struggle with the ego of an architect intent on making a statement. Piano was instead a good listener and sympathetic to her spiritual notion of art. Above all he proved to be a superb interpreter of her goals. When Piano, who was awarded architecture's prestigious Pritzker Prize in 1998, observed that "a good project requires a good client," he included in this reference Dominique de Menil, who proved to be more than his match.

By the end of the 1970s, Piano had dissolved his partnership with Rogers and founded his own office in Genoa while maintaining a smaller office in Paris. Although he had achieved wide recognition for the Centre Pompidou, the decisive breakthrough in his career came with the completion of the Menil Collection in 1987. It led to numerous other commissions for museums in the U.S., including the Nasher Sculpture Center in Dallas, 1999–2003; the addition of four buildings to the High Museum of Art in Atlanta, 1999–2005; and the additions to the Morgan Library & Museum in New York City, 2000–2006. Indeed, one patron, Ernst Beyeler, the great art dealer of Basel, was so impressed with the Menil that he asked Piano in 1992 to make an identical museum for his personal collection of modernist treasures (the architect persuaded him to take a slightly different approach [fig. 17.3]).

The critic Reyner Banham was quick to observe that the new museum in Houston demonstrated at once Piano's appropriate attitude toward technology, his remarkable understanding of social and urban contexts, and the beginning of his fascination with filtered toplighting.[5] But Dominique de Menil played a role as well. If the architect nurtured a certain myth of collaboration by naming his office the "Building Workshop," his patron in Houston took him up on it, demanding full participation in the design process. The building's exceptional quality of interior natural light, dignified understatement, and its inimitable response to its urban situation are owed mostly to the imagination of Dominique de Menil. Piano created the tools for achieving the desired effects and, with the Houston architect Richard Fitzgerald, orchestrated the assembly.

Part of the dialectic process between client and architect involved a trip to an unlikely source of inspiration, a small museum at Kibbutz Ein Harod in northern Israel (fig. 17.4). The building, constructed in 1948 to the designs of the obscure architect Samuel Bickels, reflected the Neue Sachlichkeit (New Objectivity) attitude that prevailed among European-trained Jewish architects in Palestine during the 1930s and 1940s. The museum on the kibbutz was functionalist to a fault, barnlike in its volume, and sensible for the climate, but the section view most held de Menil's and Piano's attention. Piano's sketches show a segmental vault suspended between two pitched slopes with clerestory reveals between them. The intense sunlight of the region was bounced off the convex crest of the vault in the center and reflected through the clerestories to the pitched ceilings, spreading a diffused, natural toplighting into the gallery. Piano in a second sketch proposed an alternative that might achieve a similar effect: a series of small, curved baffles that would deflect the light from the convex back of one onto the concave belly of the next before allowing its descent into the gallery.[6]

The next step for Piano was to consult his associate, the Irish engineer Peter Rice, who had dreamed up much of the magnificent structural hardware of the Centre Pompidou and with whom Piano had a brief partnership in the late 1970s. Together they had designed several yachts to be made using molded ferro-cement, and they much admired the thinness of the shapes that could be obtained from the material. Using that experience, they executed a curious tech-

nology transfer, designing the long, suspended louvers, known as "leaves," made of the noticeably heavy and compressive material. While Kahn's concrete vaults at the Kimbell Art Museum are daringly slit down the center, contradicting their compressive logic as vaults, they nonetheless perform structurally as beams. The forty-foot-long leaves at the Menil, however, instead of providing support, needed support, leading to the invention of a complex armature of metal trusses (fig. 17.5). The resulting system of sprockets has the additional task of holding up the glass roof. Had the leaves been made of a lighter material, such as fiberglass or aluminum, they probably would have lost much of their emotional appeal. Like the heavy shapes balanced in Alexander Calder's stabiles, they are fascinating, sensuous figures caught in a web of ductile iron members—and the only disappointment, or at least surprise, is that they are not movable. The static profile of the leaves has a sinuous curve, like the serene eyebrow of a Greek goddess, while their lovely white color derives from the addition of marble powder to the cement bond. Piano admitted that the leaves were a conceit, explaining them as "an example of something that takes form half for its function and half for the function that it would like to express; there is a true ambiguity between their real and symbolic roles."[7] But without them the character of the museum would be seriously diminished.

The glowing toplighting produced by the Menil's leaves was initially intended to be uniformly distributed in all of the six gallery areas. But as the program was refined with the collection's founding

director Walter Hopps and the building's coordinator and subsequent director Paul Winkler, the two galleries flanking the entrance were given conventional flat roofs without natural lighting. These enclosed spaces were for installing the chamber works: the intimate Surrealist pieces and the delicate Byzantine and ancient artifacts that require controlled lighting. Other galleries were less constrained, and much of the freewheeling character of the Menil reflects Hopps's influence on Dominique de Menil—he was a legendary curator of contemporary art who liked to keep things unpredictable and open. As much as patron and architect had hoped for a constantly rotating installation of works—Piano's building is sufficiently flexible to allow for different orders of display—operational realities have meant that certain works in the collection have stayed in place over the years and have been organized in broad art historical categories. Thus the top-lit ceiling of the twentieth-century galleries has needed to be partially occluded to protect the more delicate drawings and watercolors that have remained on view from overexposure to ultraviolet rays. The museum adopts a similar protection, using removable white panels on the roof, for temporary exhibitions featuring these vulnerable works on paper.

Despite the modifications to the project, one still perceives the intended effect of the filtered toplighting: it begins in the exterior spaces of the porticoes surrounding the building and beneath the canopy in front of the main entrance, then continues within the foyer and along the length of the 320-foot-long corridor, until one reaches the large, eighty-by-eighty-foot, loftlike galleries at the eastern and western ends—the former for rotating modern works, the latter for temporary exhibitions. The roof is literally porous, offering a special kind of luminosity that makes one feel connected to the rest of the world. Neither a sterile white box nor an overarticulated series of spaces, Piano's galleries serve the works while providing a unique sense of depth (fig. 17.1). As he says, "You do not want to compete with art, and you still want to give character to a museum; you have to work on the immateriality of the museum—light, vibration, proportion."[8]

The trusses that are fastened to the backs of the leaves are made of cast ductile iron, using an arcane nineteenth-century technique similar to cast iron (fig. 17.7). Each of the pieces is joined to the next with a series of exposed bolts that are almost as decorative as the egg-and-dart motif in a classical cornice (fig. 17.6). To produce these pieces, which are as diminutive as the twenty-foot *gerberette* brackets supporting the steel girders of the Centre Pompidou are colossal, required a subcontractor from the auto industry in Detroit. The luxury of the Menil is in these hidden details: the eighteen different components that are repeated in its roof system were each custom-made, greatly increasing the museum's construction costs. A section through the roof shows that the flat top of each leaf acts as the hypotenuse

Fig. 17.6 *top*
Drawing of classical egg-and-dart architectural motif

Fig. 17.7
Renzo Piano, drawing for structural roof trusses and ferro-cement leaves, 1982

Fig. 17.8
Renzo Piano, section drawing for structural roof trusses and ferro-cement leaves, 1982

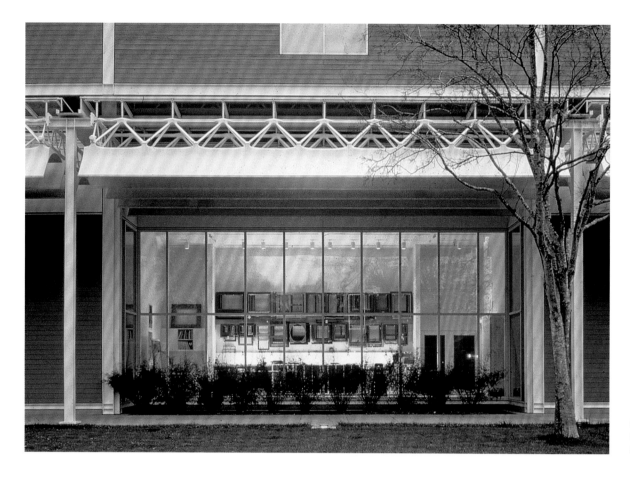

Fig. 17.9
Framing studio of
the Menil Collection

for a triangle formed by the web trusses (fig. 17.8), which are then linked in a frame. Wedged inside the trusswork above each leaf is a cylindrical duct for the return air.

The frame also carries a glazed roof on vertical rods in which the apex of a slightly pitched plane of glass over one leaf alternates with a drain gutter over the next. In any climate, a glazed roof leads to the greenhouse effect and unwanted condensation. In subtropical Houston, the potential for heat buildup can be catastrophic. The leaves were thus intended to function as their namesakes do on trees, keeping temperatures low, reflecting the heat back, and blocking its passage downward. In every museum designed by Piano since the Menil, including the Cy Twombly Gallery, 1992–95, adjacent to the museum, and his own office in Genoa, he has persevered in his obsession with glazed roofs, inventing layers and filters to attempt to reduce harmful glare and thermal excess. While the visual effect of natural light is stunning, the glass ceilings in most of Piano's projects, including the Menil, have had to address minor technical problems of leaks, excess heat, and ultraviolet exposure—a type of porosity that is not desired.

An unusual aspect of the museum's program coordinated by Winkler was the decision to put the working spaces alongside the exhibition spaces. The principal areas for framing (fig. 17.9), pack-

ing, and conservation on the southeast side, as well as a library on the southwest side, all have access to the same long corridor as the galleries. Hopps, who had enjoyed the feel of the loftlike gallery he founded in Los Angeles, promoted the idea at the Menil of keeping museum professionals and museumgoers in close proximity. This fluidity between the back office and the show space is one of the many ways that the Menil achieves a feeling of porosity. While walking around the exterior porticoes, one encounters oblique views into some of the working spaces, allowing viewers this minor invasion of privacy makes it clear to them that the service functions have the same importance as the galleries.

Such an egalitarian subtext was not an accident. Dominique and John de Menil were noted activists for social causes such as civil rights who frequently attempted to mix political and cultural agendas. That there is no admission fee to enter the museum is Dominique's personal gift to all classes. On the other hand, that the main museum building houses no bookshop or café, no knickknacks for sale, is part of her aristocratic prerogative to keep art uncorrupted by commercialization. In Piano's early sketches, he proposed auxiliary functions such as an auditorium and a bookshop between Sul Ross Street and the area now occupied by the parking lot, almost out

of view of the museum. In the end, the Menil Bookstore was put in one of the existing bungalows.

This hands-on engagement with art led to the most singular feature of the Menil Collection, its accessible storerooms on the upper level that are open by special arrangement to scholars and teachers. Kahn in his earlier plans had referred to such areas as "storage." Dominique de Menil called them the "treasure rooms." The upper level of the Menil Collection is stacked directly above the working spaces of the ground level, raised on steel columns over a hollow mezzanine with a four-foot-high crawl space left exposed for air to circulate and ducts to be hidden. Seven of the eight upper rooms are filled with items from the collection in the sort of rotating order that originally was desired for the rest of the museum. Specialists and those who have been granted permission can study most works of the collection in relative solitude. The experience is like visiting an artist's studio to select an acquisition. The south-facing windows of each room are usually kept shut by heavy sliding pocket doors unless there are visitors seeking to view works in natural light. Computerized awnings on the exterior extend over the storage room and office windows for further protection.

While the Menil Collection will never be thought of as frivolous, there is something peculiarly light about it. Piano's other museums, such as the Fondation Beyeler or the Morgan Library & Museum, which were built with costly stone surfaces, have demonstrable transparency but do not feel light. The lightness of the Menil comes from making an expensive and technically sophisticated building with unpretentious materials. The floors are made of soft pine boards stained black—an inexpensive paving material that shows the wear immediately but that can be easily replaced. The boards were expensively assembled, however: running lengthwise every ten feet is a plank that has been custom-cut with narrow vents—narrow enough to resist high heels—that open to the air plenums. On the exterior, the white steel frames encase walls made of thick concrete panels that have been masked with horizontal cypress slats—a relatively expendable siding material used on barns. Despite the slats' scoring on the back and intense priming, some of the siding has warped and been replaced on occasion. But this wear may be to its advantage, as one of the reasons the Menil feels so real is because it began to show signs of age almost as soon as it opened.

If the modest wooden clapboards are comparable to dressing down in blue jeans, the slender steel columns that carry the leaves of the porticoes of the Menil Collection are like adding an elegant string of pearls. Both Hopps, during his early career in Los Angeles, and Piano admired the Case Study Houses and other domestic architecture of Craig Ellwood built in Southern California during the 1950s and 1960s (see fig. 17.10). As director of the Pasadena Art

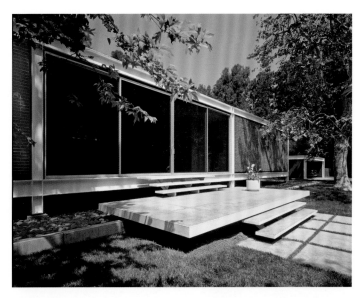

Fig. 17.10 *top*
Rosen House, Los Angeles. Craig Ellwood, architect, completed 1963

Fig. 17.11
Ospedale degli Innocenti (Foundling Hospital), Florence, Italy. Filippo Brunelleschi, architect, completed 1445

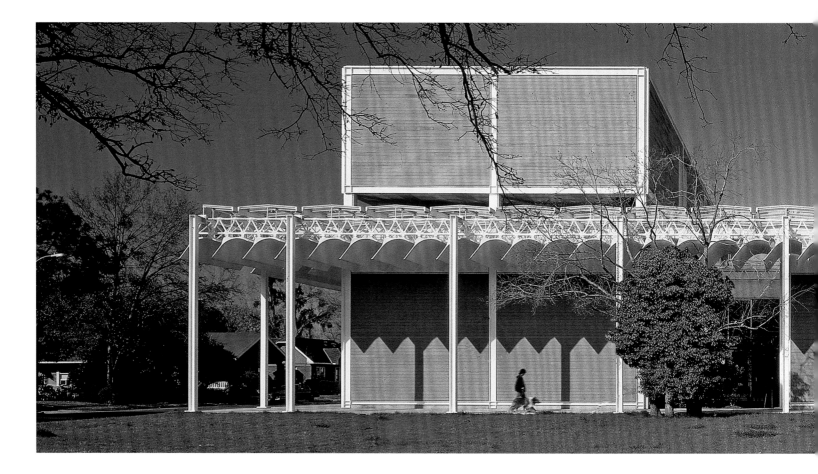

Museum in 1965, Hopps had sought out Ellwood and others working in the steel frame idiom for a proposed addition. These minimalist steel frame boxes seem to have inspired some of the museum's feeling of lightness. The Menil's columns also refer to the local modernist tradition of steel frames in such works as Philip Johnson's University of St. Thomas campus, 1957–59, commissioned by the university and funded by the de Menils, and Ludwig Mies van der Rohe's majestic two-phase addition to the Museum of Fine Arts, Houston, 1958 and 1974. The steel columns of the Menil suggest an etherealizing of the southern plantation porches framed by white classical columns, and the lively pedestrian use of the covered space as shelter from the intense Texas heat reinforces the analogy.[9] Piano's steel "H" columns are nearly twenty feet tall, and with a ratio of 1:40, they seem preposterously thin. They sit on flat square bases and terminate with a flange that carries the exterior leaves. The sheltered apron of the ten-foot-wide porticoes (fig. 17.12) proves to be as engaging as Filippo Brunelleschi's portico for the Foundling Hospital in Florence, 1419 (fig. 17.11), and as rich in stimulating one's expectation of the architecture within.

The Menil Collection is a large structure—the ground floor alone is more than forty thousand square feet—yet the way the building has been sited away from axial views makes its scale difficult to discern. The exterior is nearly impossible to photograph. The porticoes mask one's perception of the bulk of the upper story while establishing a human dimension. In a city of immense sprawl that leaves few options but to drive, many people actually choose to walk to the Menil if they can. Those who come by car still must approach on foot: the parking lot was discreetly placed a block away on a major thoroughfare to the north to keep the museum from being overwhelmed by a large adjoining stretch of asphalt. The spirit of the Menil is neutral and flexible; it is a place where many activities and walks of life intersect. Piano's thoughts about what makes a good city seem particularly influenced by the process of designing the Menil: "The experience of a place creates a certain vibration inspired by the overlapping of immaterial circumstances that will always elude the photographer's lens."[10] The balance between substance and openness, the insistence on understatement and high ideals, the mixture of common materials and great art, all make the Menil Collection feel tangible and indelibly rooted in its place. The little gray houses, the neutral gray wall slats, and the lightness of the porticoes contribute to its engaging porosity as life and art filter in, then filter out to its surroundings and beyond.

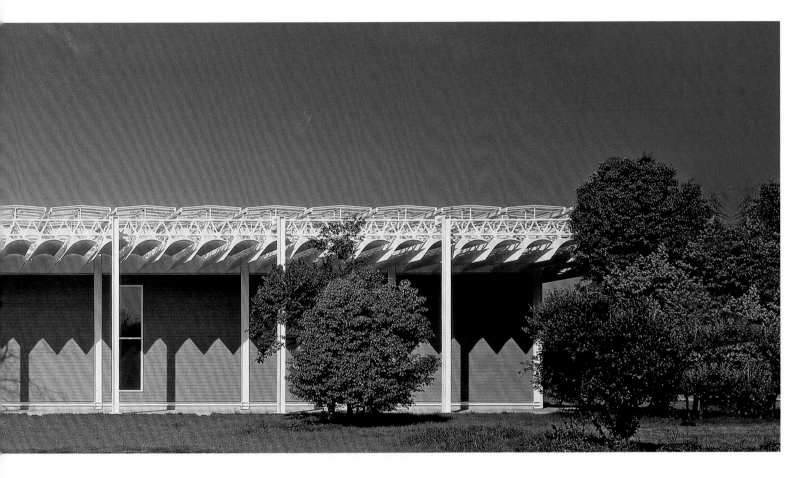

NOTES

1. Walter Benjamin, *Reflections: Essays, Aphorisms, Autobiographical Writings*, ed. Peter Demetz, trans. Edmund Jephcott (New York: Harcourt Brace Jovanich, 1978), 165–66.

2. Museums built in Houston between 1980 and 2000 include: the Children's Museum of Houston (1980), the Jesse H. and Mary Gibbs Jones Gallery of the Houston Museum of Natural Science (1982), the Menil Collection (1987), Holocaust Museum Houston (1996), Contemporary Arts Museum Houston (major renovation 1997), ArtCar Museum (1998); and the Audrey Jones Beck Building at the Museum of Fine Arts, Houston (2000).

3. Patricia Cummings Loud, *The Art Museums of Louis I. Kahn* (Durham, N.C.: Duke University Press with Duke University Museum of Art, 1989), 247–59. See also Nell E. Johnson, comp., *Light Is the Theme: Louis I. Kahn and the Kimbell Art Museum* (Fort Worth: Kimbell Art Foundation, 1975).

4. Antoine Lion, ed., *Marie-Alain Couturier (1897–1954): Un combat pour l'art sacré: Actes du colloque de Nice, 3–5 décembre 2004* (Nice, France: Serre, 2005), 51; quoted text first published in *L'art sacré*, nos. 11–12 (July/August 1950): 3–8. Couturier's statement on the quality of art used by the Catholic Church in the twentieth century could equally represent Dominique de Menil's goals: "La gloire de Dieu ne consiste pas dans la richesse et l'énormité, mais dans la perfection d'une oeuvre pure. Si nos églises étaient ainsi elles pourraient recommencer à enseigner au monde que très peu de choses suffit à l'essentiel (The glory of God is not conveyed by expensive materials or great size, but through the perfection of a pure work. If our churches were once like this, they can be so again in order to teach the world that only a few things are needed to obtain the essential)."

5. Reyner Banham, "In the Neighborhood of Art," *Art in America* 75 (June 1987): 124–29.

6. Piano's method of drawing reflects his way of listening to the client. For each project he makes hundreds of tiny sketches with a thick felt-tip pen—skeletal diagrams like the kind used for giving directions for getting from one place to another. He draws these thumbnail maps without shading or perspective, letting them serve as artless representations of ideas, neither precise in depiction nor interpretative in tone. They allow him to work in a very direct way with clients, associates, contractors, and other players in the process.

7. Renzo Piano, quoted in "The Virtue of Transparency," interview with Richard Ingersoll, *Korean Architects* 158 (January 1997): 65.

8. Renzo Piano, quoted in Jason Edward Kaufman, "Renzo Piano: The World's Leading Builder of Museums," *Art Newspaper*, April 2004.

9. See Peter Buchanan, *Renzo Piano Building Workshop: Complete Works* (London: Phaidon Press, 1997), 3: 28.

10. Renzo Piano, quoted in "The Virtue of Transparency," 65.

Fig. 17.12
East facade of the Menil Collection

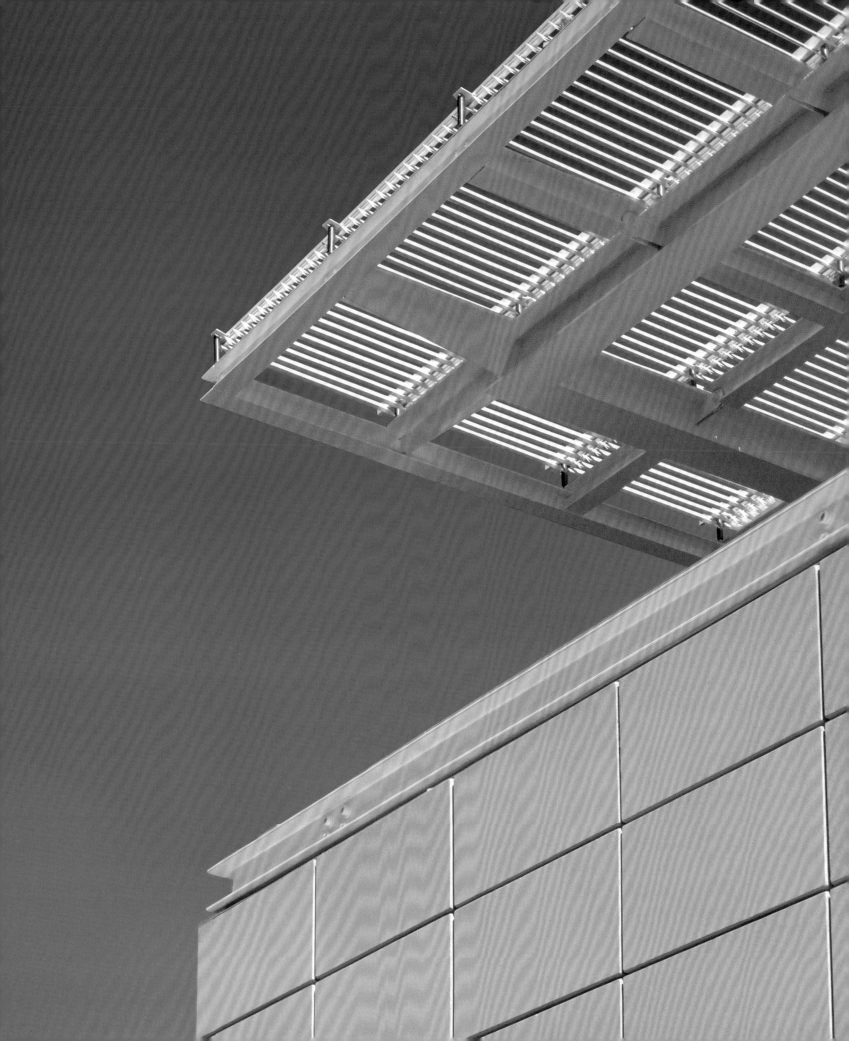

Lightness and Gravity: The Cy Twombly Gallery PAUL WINKLER

John and Dominique de Menil eschewed grand plans in favor of the less predictable, seeking adventure with an openness to the spontaneous moment. Accidental encounters; fortuitous circumstances; setbacks; conversations with artists, scholars, and colleagues; the interests of their children; and their relationship to each other—all affected their activities and their collection. The creation of the Cy Twombly Gallery came about in much the same manner.

I became involved with the de Menils and their activities while a student in the art history program at the University of St. Thomas. While there I was hired by Dominique de Menil to assist in the installation of exhibitions. During that time I had direct access to the de Menils' collection and came to learn of its breadth and to gain an understanding of the points of view and the spirit it represented. Dominique de Menil had a strong belief in the training of the "eye." It is the major reason a segment of the holdings developed as a teaching collection. In an often-repeated phrase, she would adamantly declare: "A real object puts you on the spot. One cannot remain complacent; one must respond." I gleaned much concerning the presentation of works of art while helping her hang the imaginative and thought-provoking exhibitions she conceived. She developed a confidence in my abilities, and despite my move to New Mexico to oversee the construction of a wing at the Museum of International Folk Art for the Alexander Girard Collection, I returned numerous times to Houston to help her with major installations at Rice University. In 1979, when a group of old friends and benefactors expressed an

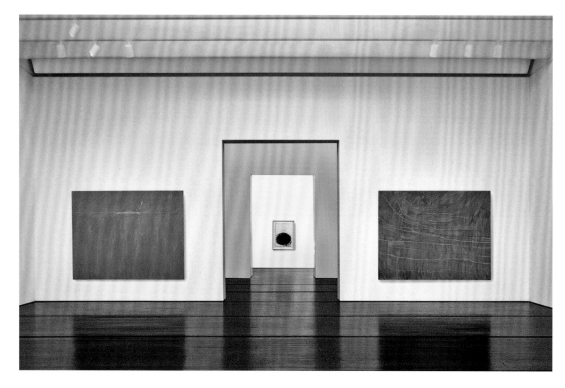

Fig. 18.2
"Cy Twombly" exhibition in west galleries
of the Menil Collection, 1989

interest in assuring that the de Menils' collection remained in Houston, she invited me to join her in planning a museum for the collection. I returned in 1980 to spearhead the museum project, becoming assistant director that year and acting director in 1989, before assuming the role of director from 1991 to 1999.

The story of the Cy Twombly Gallery begins with the Dia Art Foundation and its founders, the art dealer Heiner Friedrich, John and Dominique de Menil's daughter Fariha (formerly Philippa) Friedrich, my sister Helen Winkler Fosdick, and Dia's subsequent director Charles Wright. Dia was established in 1974 to support the realization of major site-specific works of art and to amass collections of paintings, sculptures, and drawings by a select number of artists.[1] These collections were to form the basis of a new museum in Lower Manhattan. Called the New York Museum, it was conceived as a number of individual, single-artist galleries located in buildings owned by Dia; one of these was to be dedicated to a permanent exhibition of paintings and drawings by Twombly. Unfortunately, a sharp downturn in financial resources in the 1980s curtailed the plans. As a result, the New York Museum never materialized, and Dia was forced to sell the majority of its substantial real estate holdings; it eventually sold eighteen works of art at auction in 1985. During the following year, hoping to forestall the sale of further works, the Menil board agreed to pursue discussions with Dia concerning a home for its collection. As a result, many of Dia's works were sent to Houston on loan, including more than thirty Twombly paintings and drawings, many of which

would appear in exhibitions at the Menil over the next ten years.[2]

The nascent idea for the Cy Twombly Gallery first emerged as plans were being developed for the opening of the Menil Collection in 1987. To inaugurate the large west gallery, two single-artist presentations were proposed: Cy Twombly on one side and John Chamberlain on the other.[3] Chamberlain had been long of interest to Walter Hopps, then director of the museum, and Twombly, to me. Dominique de Menil enthusiastically embraced the suggestion, and Hopps was put in charge of the Chamberlain exhibition, while I undertook the Twombly. We sent a letter to Twombly describing our plans and requesting the loan of his magnificent ten-part painting *Fifty Days at Iliam*.[4] As we learned in time, Twombly, when first approached, can be reclusive until you've gained his trust. He did not respond to our request directly, but, from word passed through a number of emissaries, I knew he had received the letter. In the end, lacking any personal response from the artist, we had to abandon the idea of the exhibition, and the museum opened instead with a large Chamberlain show in the west temporary gallery, drawn primarily from Dia's collection.

About a year later, I received a call out of the blue from Twombly, saying that he would consider an exhibition at the Menil Collection if we were still interested. He had heard good reports and was ready to work with us. In June 1989 Hopps and I went to Rome, where Twombly had been living since 1957, to meet with him and to discuss the selection for the show.[5] He was very generous of spirit and

time, and could not have been friendlier or more accommodating. During our visit he showed us areas and buildings in Rome that intrigued him, and we shared numerous meals. We discussed ideas for his exhibition, as well as those for a show of early Robert Rauschenberg works that Hopps was planning and for which Twombly proved invaluable. He was the opposite of a recluse—warm and forthcoming on many fronts.

The exhibition "Cy Twombly," consisting of works from both the Dia and the Menil collections, with a few pieces from private collectors suggested by the artist, opened in September 1989 (fig. 18.2).[6] While Twombly did not come to Houston to see the exhibition, two of his close confidants at the time, Thomas Ammann, founder of Thomas Ammann Fine Arts, Zurich, and Heiner Bastian, an independent curator from Berlin who was working on the five-volume *Cy Twombly: Catalogue Raisonné of the Paintings*, visited soon after the opening and were ecstatic about the installation and the beauty of the building. Their reports to Twombly undoubtedly helped to advance our cause in working further with him. In addition, I had established a good relationship with Twombly during the preparation of the exhibition.

Twombly and I soon began informal conversations about an ideal space for housing those of his works owned by Dia. In May 1990 I sent the artist a letter stating that movement was afoot to build a separate structure on Menil property to permanently install his works, with perhaps some pieces by Chamberlain and Dan Flavin in adjacent rooms. I added that we wanted to develop the space and make the selection of works with him—would he be interested and could he support such a proposal when we made it to Dia? He replied the following week, writing, "Naturally I would be *terribly interested* that the 'holdings' find a 'permanent' place, as they have been in storage for at least ten years except for a few moments.'"[7] This was the first confirmation of his willingness to collaborate fully with us, and it added great momentum to our adventure. In September, Dominique de Menil, Heiner and Fariha Friedrich, and I visited Twombly in Rome to discuss the proposal. He was highly receptive and so enthusiastic that by the next morning, he offered to add paintings and sculptures he owned to the project; he had even produced a simple sketch for the building.

Twombly's immediate interest in the conceptual design of the proposed gallery grew from his tremendous knowledge of, and familiarity with, architecture of all ages. He has visited many of the most inspiring sites and buildings around the world. To walk for hours through Rome with him is exhilarating, particularly while viewing the city's Baroque architecture, though the ancient is just as familiar to him. During one such visit, Twombly commented on the pretensions of most architects, saying, "A good building only needs a good

Fig. 18.3 *top*
Antonio da Sangallo, plan for Farnese Palace, Rome, showing square galleries (*lower left corner, e.g.*) and double-square galleries (*right of those square galleries, e.g.*), ca. 1513

Fig. 18.4
Cy Twombly, conceptual sketches of plans; top plan shows four square galleries and one double-square gallery, 1990

Fig. 18.5
Renzo Piano Building Workshop, south elevation drawing of
the Cy Twombly Gallery and adjoining bungalows, 1992–93

Fig. 18.6
Renzo Piano Building Workshop, conceptual
sketches of the plan and section of the
Cy Twombly Gallery, 1992

engineer and an understanding of simple space." He noted the cube-shaped rooms in his house on via de Monseratto in Rome and later, while standing in front of the Farnese Palace, mentioned that the large interior room to the left was "a double cube" (fig. 18.3). We would later see a similar room find its place in the Cy Twombly Gallery design.

Because Twombly has a strong sense of how his work should be seen, there was no doubt that he would be fully engaged, with great joy and exactitude, in the design of his gallery. His original sketch consisted of two rooms, each eight meters (twenty-six feet) square; a subsequent drawing showed six eight-meter-square rooms, two with the dividing wall removed to create a single large, double-square room (fig. 18.4). My notes from that day record the other features he desired for the building. The exterior should be of sufficient mass to form a "protection" for the more delicate works inside. It should be sky lit with no windows. The outside should be fairly abstract or neutral. He wanted wide-plank wood floors, which were not to be too yellow, with the floors for the entrance room in a different material. In the excitement of the day, Heiner Friedrich suggested that perhaps three more rooms should be added at the back. Twombly laughed, but this eventually occurred.[8]

Our first choice of an architect to realize the artist's ideas was Renzo Piano, who had designed the Menil Collection building. He was engaged in some of his largest international projects when I wrote to ask if he would entertain designing the Cy Twombly Gallery. The small size of the project, coupled with the number of conceptual ideas and preferences already agreed upon with Twombly, easily could have dampened Piano's interest in participating. But he responded immediately and accepted the job. He said he enjoyed the opportunity to focus on smaller endeavors periodically, and in addi-

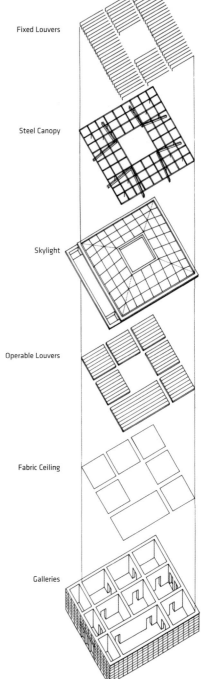

Fixed Louvers

Steel Canopy

Skylight

Operable Louvers

Fabric Ceiling

Galleries

Fig. 18.7 *right*
Renzo Piano Building Workshop,
schematic showing the configuration
of roof elements of the Cy Twombly
Gallery, 1993

tion it would allow him a fresh look at the "village museum" concept he had established with the Menil Collection.

It is rare for an architect to have the opportunity to respond to one of his own buildings and the context in which it was created. Piano understood more than anyone the delicacy of introducing a new building into the neighborhood of prewar bungalows where he had so ingeniously incorporated the comparatively large Menil building. The site selected for the Cy Twombly Gallery, three lots within a row of houses to the south of the museum on Branard Street, meant that the new building would have a side-by-side relationship with the residential structures.[9] The gallery would require its own identity, one that was neither overshadowed by the Menil Collection nor overbearing to its neighbors.

The Cy Twombly Gallery was conceived as a single-function edifice, created for the permanent installation of a known group of artworks. Since no changing exhibitions were anticipated, spaces could be fixed. Illumination was to be from natural light, as at the Menil, but with slightly different purposes. The primary role of natural light at the Menil Collection is to bring an organic quality to the space and to convey the sense of the day passing in the building. Shadows and changes in light intensity and reflection from wall to wall are part of the design solution, the light being more directional than diffused. Since the Cy Twombly Gallery would retain a relatively fixed and permanent installation, we sought to achieve a more uniform illumination across the entire surface of each wall, which would require a greater diffusion of the light, and yet still allow visitors to feel the changes of the day within the building.

At the early stages of a project, Piano often adopts a metaphor that reflects the sensibilities of his understanding of the task at hand.

The metaphor refers to a core component that drives the design solutions. "A butterfly alighting on a firm surface" was the essence of the challenge of the Cy Twombly Gallery for Piano.[10] It reflects the dynamic established between the block walls and the multilayered, light-filtering planes that form the roof system, the latter being the most inventive part of the design.[11]

Piano's schematic plan evolved quickly (fig. 18.6), based on Twombly's initial sketches. At the building's street side, the walls were aligned with the facades of the row of houses (fig. 18.5), creating a rhythmic unity with the neighborhood. And in a brilliant stroke, Piano decided to turn the building ninety degrees, moving the entrance off the street and onto a larger green to the east of the building (fig. 18.8). (This green space, with its magnificent live oak tree, has a diagonal relationship to the larger Menil park across the street.) The visitor would now walk into the actual domestic row to enter the Cy Twombly Gallery, reinforcing the neighborhood experience while simultaneously providing a greater independent identity for the building itself. The visual reference to both the houses and the Menil Collection building, seen as one approaches the gallery entrance, mediates the differences in size and scale among the three, and exposes the subtle complexities at play in the Menil properties.

Piano has spent his career, as he often says, "at the impossible task of fighting gravity." This effort has been in the service of creat-

ing lightness, one of the few common traits among his buildings. The mass of the exterior walls of the Cy Twombly Gallery may appear as a contradiction to this quest, but in fact it provides the contrast and tension needed to set off the near-floating system of planes that form the roof, which conveys the lightness—the "butterfly" barely at rest (fig. 18.1). The proportions of the custom-made concrete blocks, their integral color formed of a native sand and aggregate, and the single stepped base on which they rise create a strong yet quiet facade. Piano also prompted an engaging play between exterior and interior by introducing the blocks into the foyer of the building. A wonderful progression from outside space to inner galleries is reinforced by the transition from the triple opening of the monolithic exterior entrance to the single monolithic opening into the actual galleries. The experience is heightened by the change in light from the bright exterior, through the dimmer foyer space, to the glowing presence of the white galleries. Twombly suggested the entrance of concrete posts and beam, with their large transparent openings, and Piano refined it to fit into the block facade. Its reappearance at the rear of the building adds the only other interior transparency and acts both as a visual release and a memory of one's first experience entering the Cy Twombly Gallery.

Walking into the first gallery is a palpably uplifting event. Twombly wrote to me a week after we had visited Piano's office to

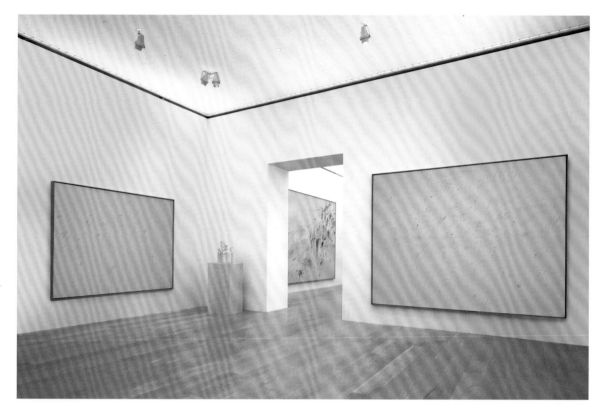

Fig. 18.8 *opposite*
Entrance view of the Cy Twombly Gallery with the Menil Collection across the street

Fig. 18.9
Installation view of the "Lexington" paintings in the Cy Twombly Gallery, The Menil Collection, Houston, 1995

review models and plans, noting, "The white cloth ceilings & wide board floors perfect proportion of windows & door openings it will be as ideal & I would say perfect in every way that one could wish for."[12]

Because the Twombly galleries are made of few parts and materials, it is essential that each reside in harmony. One of the first perceptions in the galleries is their classic proportion. The rooms are twenty-six by twenty-six feet and fifteen feet in height, while the door openings are in the old Roman ratio of two to one, height to width. Although the galleries are equal in size, with the exception of one double-square room, they are in no way static. The openings to each room are at different positions, resulting in varying wall configurations. As one progresses through the building, the spatial experience changes in each gallery. The thickness of the walls (2 ft. 9 in.), which adds to the sense of solidity of the whole, is revealed at the doorways. The wall surface is white plaster, again a material suggesting permanence. Twombly wanted plaster, but insisted that it not be opaque in appearance; he wanted it to have a sense of depth. Piano and I were intent that "the feel of the hand" be apparent in the overall application. The wide-plank floors so desired by Twombly were embraced by Piano for their lightness in color, which forms a reflective surface important to the illumination system. The white oak planks were hand-selected to ensure that they were neither too yellow nor too red and would maintain a neutral tone throughout.

While all these elements are critical to the success of the spaces, it is the quality of the light that brings the greatest richness to the galleries. Piano's solution for the natural lighting system is a series of sun-filtering planes (fig. 18.7). They form a component that simultaneously encloses the building away from the natural elements, lowers the heat load to the building, and reduces the intensity of light to acceptable levels for the illumination of the works of art. In Houston on a bright day, this means allowing in less than one percent of the available exterior light. To achieve this, the upper level consists of small, lightweight, fixed louvers placed on a grid-shaped steel frame. Their primary function is to cut the majority of daylight entering the building and to direct that which is allowed in to come from the north. Below this shading device is a double-glazed, hipped skylight of optically pure glass that contains an ultraviolet filter. This forms the enclosing element of the roof and removes harmful rays that could cause photochemical damage to the works of art. Horizontal mechanical louvers arranged in rectangular grids that mirror the footprint of each gallery have been placed below the skylight. These provide a further way to cut the intensity of natural light. They are activated by photoelectric cells and have the capability to change continuously, although we opted to adjust the openings only a few times a day to reflect the major changes in the position of the sun. Beneath the mechanical louvers is a tautly stretched, cotton duck

scrim that forms the ceiling for each room and acts as a final diffuser for the light.[13]

The physical presence of the roof platform is as important to the building as its performance. Both cantilevered from the center of the building and raised from the sloping double-truss beams, the fixed louvers appear to float above the block facade, an effect heightened by having lifted each section of louvers off their structural grid support and onto stainless-steel pins. The steel frame of the upper register is also tapered to create a thin edge at the perimeter. Inside the building, the ceiling plane of luminous, diffusing fabric is the essence of lightness. The first time I entered a gallery after a ceiling had been stretched, I had a sensation akin to levitation. Piano insisted on exposing the turnbuckle attachment system for the fabric. This creates a transition between the vertical wall and horizontal ceiling, one that is rigorous (a bit like a dentate cornice), yet airy and calm.

The Cy Twombly Gallery is a building of clarity and precision that has established what many agree is the ideal space for it's namesake's art. Twombly's work often deals with passage across time and memory. The sense of solidity in the building and its walls counterpoints the fleeting nature of the paintings' contents, not unlike the contrasts often expressed in his work: epic and intimate, dense and sparse, rising and falling, among others. Strong and ordered at the exterior, the gallery opens to rooms that are simple in appearance but dynamic in spatial quality, representing an exacting resolution of all things architectural—size, scale, proportion, materials, progression through space, and exquisite light—and providing an inspiring but unobtrusive environment in which the art is given prominence.

Nothing in a Piano design is developed in isolation. Every detail evolves in relationship to every other element, down to the air flowing through the building. His aim is always simplicity, but Piano knows that it often can be achieved only through a process of great complexity. Twombly once remarked to me in 1994, when he was completing the very large painting *Untitled Painting* (*Say Goodbye Catullus, to the Shores of Asia Minor*) (*A Painting in Three Parts*) (fig. 18.10), "You would think that you could get away with placing a mark on such a big painting that wasn't quite right, but it's not possible; it affects everything." The same is true for architecture.

Construction on the gallery began in August 1993. During the building phase, Twombly visited Houston twice to look at the materials and physical mock-ups of building parts. As the gallery neared completion, we began working out installation plans in a large-scale model and making decisions on framing, mounting, and pedestal

Fig. 18.10
Cy Twombly, *Untitled Painting* (*Say Goodbye Catullus, to the Shores of Asia Minor*), 1994.
The Menil Collection, Houston, Gift of the artist

designs with the conservation department. As he had suggested the basic floor plan and scale for his gallery, I am convinced that Twombly could envision his paintings and sculptures in these spaces from day one. Before construction on the building started, from fall 1990 to spring 1992, I visited Rome a number of times to work with him on the selection. Each time he would bring out important paintings and sets of work that he thought would be right for the gallery. Many were unknown to me, as they had rarely been exhibited, particularly in the United States, and some had been seen by only a few.[14]

In May 1992, a month after Twombly, his assistant Nicola del Roscio, and I visited Piano's office in Genoa and agreed to the basic building plans, I was accompanied to Rome by Carol Mancusi-Ungaro, then chief conservator at the Menil Collection, to organize the shipment of selected works to Houston. In addition to those works already agreed upon, Twombly offered others for consideration, now aware of the full size of the project. Among them were five works from a group painted in 1959 and known as the "Lexington" paintings (see fig. 18.9), having been made in Twombly's hometown of Lexington, Virginia. The entire group of ten canvases was to have been shown that year at the Leo Castelli Gallery in New York. When they arrived in New York, however, Castelli contacted Twombly and

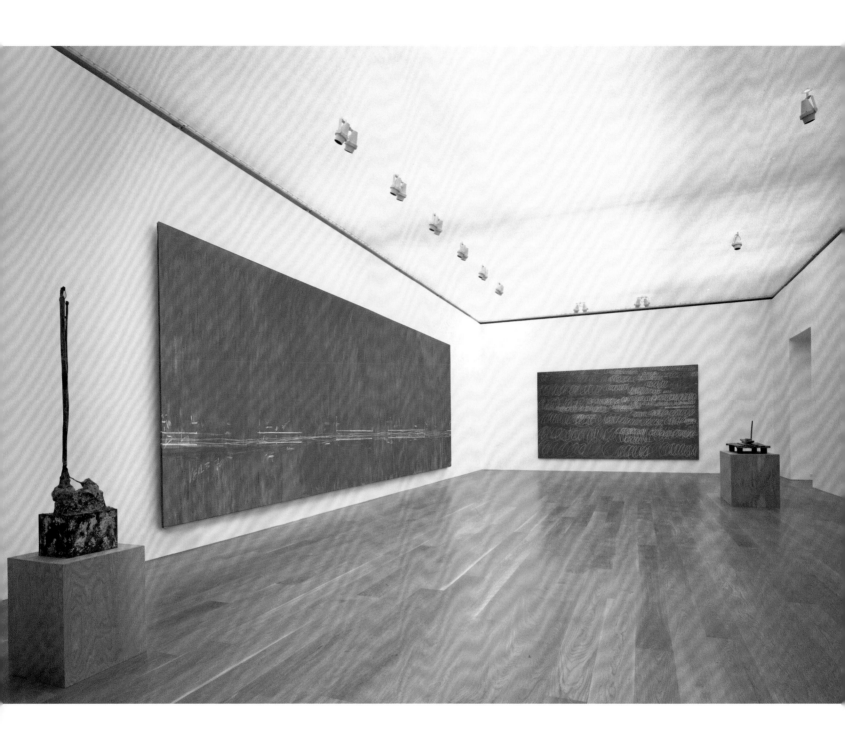

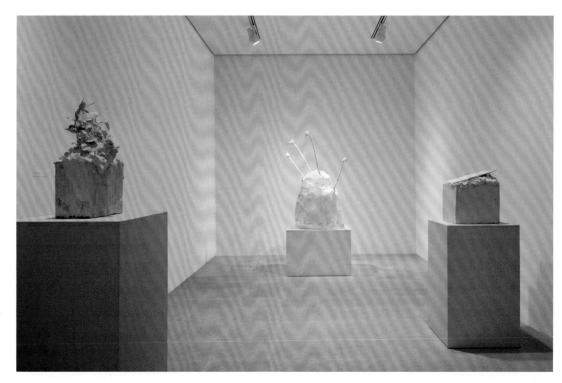

said he couldn't show them because he "didn't know what they were." So Twombly placed them in storage and eventually sent them to Rome. The larger canvases were folded for shipping ease, which affected their surface at the creases. Although they had been in-painted by Twombly's wife, Tatia Franchetti, herself a painter, they were now in need of attention. Mancusi-Ungaro assured Twombly that they could be restored to their original integrity, and they were added to the shipment. The restoration was hugely successful and established a trust between Twombly and Mancusi-Ungaro that is ongoing. The paintings constitute an entire room at the Cy Twombly Gallery. During the first private viewing of the gallery, arranged for invited guests, I entered the room of "Lexington" paintings to find Leo Castelli and his wife seated on a bench, happily looking at the pictures. Castelli turned to me and said, "Aren't they wonderful?"

One of the works that Twombly sent in 1992 was a very large unfinished painting in three parts, then known as "Anatomy of Melancholy." He began working on it in 1972, returned to it again in the early 1980s, but left it incomplete. When adding the work to the Houston consignment, he said, "Maybe I'll come down to Houston, have a good day painting, and finish it." Instead, in February 1994, he called from Lexington, where he was spending the winter, and asked if the painting could be delivered to him. He had rented half of an industrial building with a long wall on which the three canvases could be hung unstretched. He approached the work with excitement, and within two months I received a call saying he had finished and

would I like to come take a look. It was an exhilarating painting to view. The physical quality of the paint was extraordinary, and the colors, raw and rich. Twombly had renewed his painting in a very expressionistic way. He showed the newly completed work at the Gagosian Gallery in downtown Manhattan as a pendant to the retrospective exhibition organized by Kirk Varnedoe at the Museum of Modern Art. Twombly then sent the painting, renamed *Untitled (Say Goodbye Catullus, to the Shores of Asia Minor)*, to Houston, where we agreed to hang it in the double-square room on the first anniversary of the opening of the gallery; Twombly and I worked out installation changes to incorporate some of the pieces originally placed in the large room (fig. 18.11). Once it was hung, it was clear that it had found its permanent home. It completed the Cy Twombly Gallery, bringing into its sphere the full expression of Twombly's art.

As Dominique de Menil once said of Cy Twombly, he "is not an easy artist. He goes against the grain. He just scribbles and things come to his mind—and he constantly evokes the past or great prophets or religious people. He travels in history, you see. He is the opposite of a teacher who—bang, bang, bang—gives dates. But he evokes the past much better than a history teacher would—because to him it's alive."[15] The evocative nature of his work takes precedence over dates in the gallery: although the presentation of works is roughly chronological, spanning a large part of the artist's career from 1954 to 1994, the installation was devised according to Twombly's wish that each room have a different "emotional and atmospheric"

Fig. 18.13
Fariha Friedrich, Dominique de Menil,
Renzo Piano, Cy Twombly, and Paul Winkler
at the opening of the Cy Twombly Gallery,
1995

quality. His strong participation in the selection of works and his subsequent generosity in providing most of those eventually exhibited helped fulfill that wish.[16] A number of monumental paintings from different periods provide anchors for some rooms. These include *The Age of Alexander*, 1959; *Triumph of Galatea*, 1961; and the large gray loop painting *Untitled*, 1970. In each case they are joined by additional paintings of similar expression and mood. Other rooms contain groups of paintings considered as sets, including *Analysis of the Rose as Sentimental Despair*, 1985, and the nine-part green painting *Untitled*, 1988. A number of sculptures, both originals and bronze casts, complete the installation and represent a facet of Twombly's career that was little known in the mid-1990s. He has made sculpture for as long as he has painted, although, at that time, they had been seldom exhibited. He once remarked to me that for years Jasper Johns was the only person who showed interest in his sculpture. A small room to the north of the entrance foyer (fig. 18.12), a space having a tomblike presence, houses three elegiac masterworks, including *Thermopylae*, 1991, speaking to ancient conflicts, honor and courage, and loss and memory.

The Cy Twombly Gallery opened on February 10, 1995.[17] Twombly, his family, and friends from across the world arrived for the three-day event (fig. 18.13). Piano, his wife, and numerous architects and engineers who had worked on the project were also in attendance. The poet Octavio Paz spent a few moments with Twombly and Piano, and reflected on the gallery, the light, and the artist's work in an interview shortly afterward. He called Twombly "a painter who has a poetic sensibility, an intuitive grasp of the instant." In a statement that easily embodies the dreams and pursuits of Dominique and John de Menil, Paz declared,

> And this art, this artist we are talking about, is neither American nor European; that is a question for past generations, not for new generations, for my generation. This probably started at the beginning of the century, with the Cubists. In Paris and in all places the moment was international. Picasso in Spain, Kandinsky in Russia, the Abstract Expressionists in the United States changed things; they had many interests and created something very particular. It has to do with a sensibility. It is the way with Cy, Renzo, and myself. Very strange, you see, because there are different generations, different countries between us. Yet, here we are. Some coincidence.[18]

The Cy Twombly Gallery is a fusion of art, architecture, and light. Walking from room to room in the gallery, one encounters individual paintings, multipart paintings, and sculptures that excite through their boldness, their individuality, their rawness and delicacy, and their sheer beauty. The strength and clarity of the entire ensemble—works of art, building, and presentation—provide an opportunity to relish the work of an artist of our time in its fullest dimensions.

NOTES

1. The artists Joseph Beuys, John Chamberlain, Dan Flavin, Donald Judd, Imi Knoebel, Walter De Maria, Barnett Newman, Blinky Palermo, Fred Sandback, Cy Twombly, Andy Warhol, and Robert Whitman were Dia's primary focus.

2. While two Twombly paintings owned by Dia are permanently installed in the Cy Twombly Gallery, most of Dia's other collections remained intact. The vast majority found a permanent home at Dia: Beacon, which opened in 2003. The paintings and drawings of Andy Warhol, however, excluding the "Shadow" paintings, became a critical part of the formation of the Andy Warhol Museum in Pittsburgh, to which title eventually was conveyed.

3. Dominique de Menil, Walter Hopps, and I shared all decisions concerning the initial installations at the Menil Collection. Most galleries were to be dedicated to showing the permanent collection, with two exceptions: the temporary west gallery, which we envisioned as a place to coordinate with artists for extended presentations of their work (nine months being our ideal), and a one-room space in the middle of the east galleries to be used for more in-depth looks at ideas, periods, styles, or cultures stimulated by works in the collection.

4. Begun in 1977 and completed in 1978, the set of paintings reflects on incidents in Homer's *The Iliad*. It had been exhibited only once, in November 1978 in New York by the Lone Star Foundation, a precursor of the Dia Art Foundation. It was eventually acquired by the Philadelphia Museum of Art, where it is on permanent exhibition in its own room.

5. Twombly went to Rome not as an expatriate, but to embrace and immerse himself in the Mediterranean world. While Rome was a base, he made periodic sojourns to other places in Italy and far beyond, which often inspired spontaneous work on site or when he returned to one of his studios. He restored old houses to serve as studios and residences in Bassano de Teverina and later Gaeta, which has been the location of his primary studio since the mid-1980s. Twombly has never abandoned the United States and continues to work a part of each year here in Lexington, Virginia, his place of birth, where he has made many sculptures, photographs, and important sets of paintings.

6. In addition to the Dia works, the Menil had acquired two paintings and three drawings by Twombly by 1984.

7. Cy Twombly to the author, May 30, 1990, Menil Archives.

8. The final configuration is a grid of nine squares consisting of eight square galleries and one double-square gallery.

9. Two bungalows were saved and moved to other locations on Branard Street.

10. Conversation with the architect while viewing the first schematic plan at Genoa in 1991. See also "The Menil Collection, Houston," *Art Newspaper* (February 1995), clipping, Menil Archives: "Renzo Piano describes the contrast between the lightweight lighting system forming the roof and the mass of the walls as that of 'a butterfly alighting on a firm surface.'"

11. The building was designed out of the Renzo Piano Building Workshop in Genoa/Vessima. Piano was joined by engineers at Ove Arup & Partners in London; architects Richard Fitzgerald and Partners, Houston; engineers Haynes & Whaley, Houston, and Lockwood, Andrews & Newnam, Houston; and building contractor Miner-Dederick Construction, Inc., Houston.

12. Cy Twombly to the author, April 21, 1992, Menil Archives.

13. Farley Fontenot, a custom sailmaker in Seabrook, Texas, made and installed the scrims. Piano, himself an avid sailor, was delighted by this association.

14. Heiner Bastian's five-volume catalogue raisonné of the paintings (Munich: Schirmer/Mosel, 1992–2009) had not yet been published.

15. Dominique de Menil, quoted in Janet Tyson, "A Melting Pot of Paint," *Ft. Worth Star-Telegram*, March 9, 1995, A&E section.

16. In 1992–93 Twombly sent more than two dozen works to the Menil to be considered for the gallery; most are included today in the permanent installation.

17. The Menil Foundation was joined by the Brown Foundation, Inc., Charles Engelhard Foundation, Houston Endowment Inc., Wortham Foundation, and Mike and Anita Stude in providing funds for the Cy Twombly Gallery's construction.

18. Octavio Paz, interview, *RES* 28 (Autumn 1995): 181–83.

Persona Grata

POINTS OF VIEW

Matisse's Vence Chapel with John de Menil and Father Couturier

CHRISTOPHE DE-MENIL

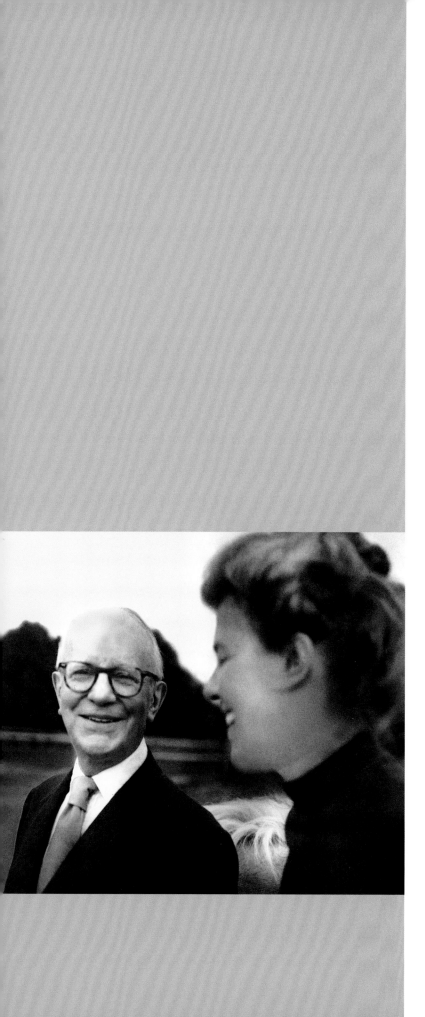

Marie-Alain Couturier, my father, and I flew from Paris to Nice in late November 1953 to visit the Vence Chapel and meet Henri Matisse. This was the year before he died, just after Eisenhower's election.

The chapel looked surprisingly glorious. One wall enhancing others, the confessional door next to the stations of the cross, the splash of blue, yellow, and green glass throughout. This had never been evident even in the wonderful photos taken by Alexander Liberman, then art director of Vogue.

Couturier told me of the search for the yellow glass Matisse was looking for to use in the chapel—no one could locate the proper tint. It was Couturier, in his splendid Dominican robes, who, traveling third class, took a train from Nice to Paris, then Paris to Lille to visit the famed glass factories there. The area is the most desolate, where wars have raged century after century. Though covered with grass, the fifty-foot earthen fortifications are visible for miles. On finding someone who would make the desired yellow, he returned to Paris, where he took another train to Nice, as there was no direct route.

page 247
Alexander Calder, sketch caricatures of John de Menil, 1959, and Dominique de Menil, 1964. Menil Archives

Fig. 19.1
John de Menil and daughter Christophe, ca. 1960

Fig. 19.2
Interior of the Vence Chapel, Vence, France.
Henri Matisse, designer, completed 1951

Couturier was profoundly close to artists; he had a great, great eye. Matisse and Couturier long had an intimate and easy rapport.

That day, wandering around the chapel, Father Couturier and my father commented on the disappointments of the architecture. Situated on an escarpment, the chapel feels spatially tight, and the altar is placed on a strange angled rise. Though designed by Brother Rayssiguier, a monk recovering from tuberculosis at the nearby Dominican convent of sisters, Matisse had not worked on that aspect until the end, when he told Rayssiguier, who was being too pushy: "This is my chapel." It seems strange that Matisse did not assert his vision earlier, given the open feeling of his paintings.

In the early evening Father Couturier and my father went up the hill to spend some time with Matisse. Feeling too awkward to say something like, "Monsieur Matisse, I like your chapel," I asked to stay in the hotel overlooking palms and sea; it was like being in one of the earlier paintings.

A bit later as I was bathing, there was a loud knock on my door.

It was Father Couturier telling me to come with him immediately. Matisse had been told there would be a young woman visiting. "Monsieur Matisse knows you don't want to make some silly statement. You don't have to say anything."

I got dressed and the two of us drove up above Nice to the Hôtel Régina. Matisse was pleased when I arrived, gracious and quiet, leaving me to walk quietly about the immense apartment. Top floor, vast space, very neat, two or three attendants (an assistant and a nurse), very little furniture; one queen-sized bed covered in white, aslant in the middle of one of the large rooms. Desk storage consisted of old crates neatly stacked by the sides of two tables. We each wandered slowly from room to room, not talking.

On the walls were placed a number of the ocean-scene paper cutouts that are now at the Museum of Modern Art. These were probably made near Nice, as they are beach scenes. It was serene. We stayed three hours, talking very little. As Mark Rothko once said, "Silence is so accurate."

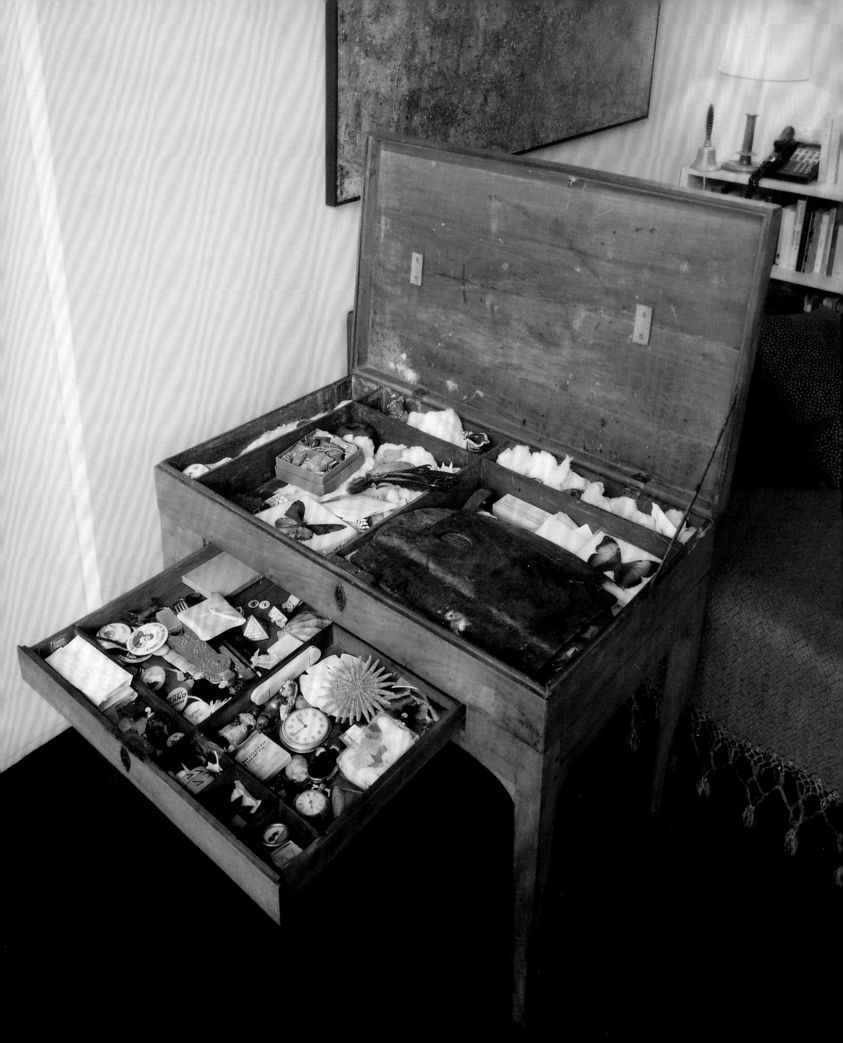

Dominique de Menil: Sketch for a Portrait BERTRAND DAVEZAC

Burial places are ultimate commitments. That John and Dominique de Menil's final resting place is Houston underscores their ultimate commitment to the city that allowed their innovative will to support the values they deemed vital to its spirit. It was no preordained call —Dominique bristled at the word "mission"—but actions called up by the circumstances of the moment that caused their collection to come into being. To John and Dominique, the priority needs of Houston were in the visual arts, human rights, and spirituality (despite its hundreds of churches). The work that Dominique accomplished together with John or alone in these fields over a period of some forty years is thrice emblematized in the Menil Collection, the Rothko Chapel, and the Byzantine Fresco Chapel. Unlike so many newcomers, unlike some of their relatives who arrived in Houston at approximately the same time, John and Dominique never considered themselves transients: their Philip Johnson–designed house attests to permanent residence as early as 1949.

Although at its inception the Menil Collection may have been mistaken for a transplanted Parisian collection owing to its modernistic determination and content, in fact it is thoroughly American in intent—it could never have come into being in France. It is indeed with Houston in mind that it was undertaken. Very early on it turned away from a strict "collector's collection." The cultural activities around the collection itself, from the Print Club created to inspire young people to collect to the teaching and exhibitions that the de Menils developed in the art department they founded at the

Fig. 20.2
François de Nomé, *A City in Ruins at Night*,
1625–30. The Menil Collection, Houston

Fig. 20.3 *opposite*
Bar adjacent to the living room of the
de Menil's home, Houston, 1964

University of St. Thomas, rooted them in Houston. In shaping their destiny, the city helped give them their identity, hence the recurrent journalistic cliché, "Grande Dame of Houston," applied to Dominique on both sides of the Atlantic. Dominique and John never felt captive in Houston but instead found there civic responsibilities that anchored them in America.

Still new to the art of connoisseurship and collecting, John and Dominique sought the tutelage of Father Marie-Alain Couturier, an unrepentant crusader for and patron of modern art, toward which the couple had cultural proclivities. Modernism therefore could not but be the cornerstone of the de Menils' collection. Chances for errors were relatively few in those days of clearer choices. Discriminating between the good and the less good within the boundaries of the School of Paris over the first two generations of modernism was verging on the self-evident: Marcel Duchamp notwithstanding, art was not yet the anything and everything that the artist chooses to call art. Images had not yet spilled out of the frame or accrued in three dimensions on the canvas. Moreover, the Museum of Modern Art in New York, at that time under the aegis of Alfred H. Barr Jr., was a reassuring inspiration.

When Dominique left France in 1941, African art was still consonant with modern art. In the United States, Nelson Rockefeller and others were juxtaposing indigenous art and modern art as the de Menils would do, while in Paris African and Oceanic art had long been collected by artists including Pablo Picasso, Le Douanier Rousseau, and Surrealists such as André Breton and Max Ernst. The same consonance appears in André Malraux's *Les voix du silence* (*The Voices of Silence*, 1951), a book that was shelved in the de Menils' private library and that Dominique pays homage to in the foreword of *La rime et la raison*. Art historian Paul Wingert, too, had subsumed Cubism in his analysis of African and Oceanic art at approximately the same time at Columbia University. It is therefore not surprising that John and Dominique embraced indigenous art, primarily from the standpoint of a purely formal connoisseurship informed by their modernist sensibility.

The obverse side of modernism is anti-classicism. Indeed, centuries of illusionistic figuration were of little consideration for the de Menils, which begs the question: why did René Magritte become such a fixture in the collection? Wit was not a de Menil family trait, and the witty foundation of Surrealism has never been a prime source of its appeal for them. It was only by fracturing the evidence of illusionism in his prima facie straightforward images that Magritte won admission in the collection, along with other figurative Surrealists who, like him, thumbed their noses at descriptive and figurative art. Put simply and absurdly, "Nature needs no duplication" could have been the collection's creed early on.

Incursions into classical and postclassical periods were nevertheless frequent. The Old Masters that seem inconsistent with the rest of the collection may be explained in several ways. Some seem to be spontaneous fancies, indulging in the domestic decorative charm

of paintings such as Tomás Hiepes's *Four Vases of Flowers in a Niche*, ca. 1660. Others, like *A City in Ruins at Night* (fig. 20.2) by François de Nomé or *Still Life with Globe*, ca. 1650, by the seventeenth-century Christian Luycks, were perceived to anticipate Surrealism. Still others entered the collection on account of their topical relationships to the exhaustive index of black iconography through the ages that the de Menils had initiated, including Aelbert Cuyp's *The Baptism of the Eunuch*, ca. 1642–43, or Sir Joshua Reynolds's superb *A Young Black*, ca. 1770. A further appeal of colonial art of the New World was how it combined spirituality with independence from normative European classicism. Another attraction, special to Dominique, was their aura of nostalgia—the nostalgia of the attic that the uncompromising "rooflessness" of Johnson's house had precluded. All her life Dominique showed a fondness for bric-a-brac, the incidental, the demure objects of desuetude (fig. 20.1), all of which touched on her childhood. The first object she collected when she was little was a pinecone. The bar off of her living room is a poetic homage to the trivial and familiar (fig. 20.3).

Finally, incursions of classicism into the collection were a reflection of the de Menils' desire to make their art available and useful to the community as a teaching collection. This pedagogical concern explains the presence of the important holdings of Greco-Roman art, the principal departure from a prehistoric ensemble that ranges from Mediterranean and Anatolian figures to objects from the Bronze Age and the Chalcolithic periods to Iron Age figures. Thus the manifold concerns that informed the de Menils' actions in Houston tended to pull the collection away from its core and shape its apparent eclecticism.

Both Dominique and her husband from the outset wanted their collection to inform young people and be enjoyed by the community. When the Basilian Fathers of the University of St. Thomas decided to enlarge their campus, the de Menils understood that this new campus by Philip Johnson, a gem of Minimalist architecture in neo-Bauhaus style, could offer their collection a role in furthering education and public enjoyment. They turned it into a teaching collection, the very title of an early exhibition organized at St. Thomas, and founded an art department on that campus, where art was studied from the perspective of its merits and its history. They mounted shows at St. Thomas featuring major contemporary artists, singly or in groups, and thematic shows reflecting contemporary tendencies, such as "Six Painters: Mondrian, De Kooning, Guston, Kline, Pollock and Rothko," and "Mixed Masters: An Exhibition Showing the Various Media Used by Contemporary Artists," both from 1967. These endeavors would provide occasional opportunities to augment the collection. This double approach of praxis and theory—here in the order of the de Menils' priority—was later carried to Rice University and the Institute for the Arts they founded there. The Rice Museum and

Rice Media Center they commissioned from architects Howard Barnstone and Eugene Aubry became the site of more contemporary art shows and exhibitions featuring the collection on a scale and in a way that anticipate those of the museum that was to come.

Thus art exhibition and art history became ideological auxiliaries of the collection. Most private collections, unlike public museums, are subjective and selective in their choices and tend to mirror the idiosyncratic predilections of their makers. Private collections have a psyche. The de Menils thought to defend and illustrate their own aesthetic spirit not only by offering shows at St. Thomas, but also through even more direct involvement. Dominique bravely jumped into the water, volunteering her help in the classroom until the teaching positions were filled. Sometimes she would call me late at night in Bloomington, Indiana, so I could assist her in organizing her lecture of the morrow on Christian antiquity. Hers were truly pioneering, ad hoc responses to needs in the absence of the more formal structures of operations to come. To ignore the creative nature of such acts of spontaneity is to altogether ignore the creative nerve and indeed the impulsive spontaneity that distinguished Dominique de Menil.

Jermayne MacAgy (fig. 20.4) played an essential role in the formative years of St. Thomas. She had come to Houston in 1955 as the director of the newly created Contemporary Arts Association where John de Menil, at the time a board member, appreciated her fiery personality and her enthusiastic engagement in the cause of modern art. Dominique fell under her spell. When the opportunity presented itself, John proposed to Dominique that MacAgy be brought to St. Thomas to head the Art Department. From her, Dominique learned the art of hanging shows and how to intuit the delicate concert among the work of art, its mural ground, and the surrounding space. MacAgy had learned it from Paul Sachs, her mentor at the Fogg Art Museum of Harvard University. Her approach became the hallmark of the Menil Collection ever after. (It is tempting to see here an instance of lineal descent over three generations.) MacAgy elicited enthusiastic admiration within the art circle of St. Thomas and around the de Menil family, an admiration that after her death neared legendary proportions. Dominique's own admiration never flagged over the years. From the start, MacAgy's persona dominated the art scene in Houston. She was a passionate—some might say biased—reformer whose commitment to modern and contemporary art matched that of James Johnson Sweeney, then director of the Museum of Fine Arts, Houston, another prize of John and Dominique's, snatched up after he left the Solomon R. Guggenheim Museum in New York. Andy Warhol's 1968 portrait of MacAgy is emblematic of the cause of modern and contemporary art that she championed

in Houston at that time. Nothing better illustrates the de Menils' engagement with Houston than MacAgy's teaching and art exhibitions at St. Thomas. Both were geared to stir the public and students alike to the cause, and it bore fruit: well-known gallery dealers, art foundation directors, and recognized art historians are among the Art Department alumni of St. Thomas.

MacAgy was an inspiring teacher. Not all of her methods were orthodox: on occasion she could stray from objective historicism when she saw the chance to win popularity and approval. At those times, foreshortened art histories were drastically construed, ideologically motivated to pitch two period styles in Manichean contrast, one illustrating "good" art, the other representing "bad" art. One of her former students told me that she once put a *Virgin and Child* by Raphael on the screen for the purpose of pillorying it in the name of the absoluteness of modern and contemporary art. She roused her young audience by saying, "Isn't it disgusting, class?" But *Qu'importe le flacon pourvu qu' on ait l'ivresse!* (Never mind the flask as long as one gets drunk!) MacAgy's influence explains Dominique's trumpet call that opens the exhibition catalogue *Builders and Humanists: The Renaissance Popes as Patrons of the Arts* (1966), "Eulogies are for the dead. The Renaissance is dead." Many years later I questioned her about this subversive one-liner. I still remember her expression as she moved her hand contritely.

Jermayne MacAgy died in 1964. Grievous though MacAgy's death may have been to those of her entourage who knew and admired her, seen through the cold eye of history, it put an end to Dominique's period of tutelage, a deferential situation incompatible with her character—that of a woman who, due to upbringing and fortune, had never experienced subordination, even in marriage. Yet the St. Thomas years are the true golden age of John and Dominique de Menil in Houston. Its air of innocence was the result as much of a light chain of command as of the unconventional procedures born out of Dominique's lack of formal art training. The academic informality, and its intercourse with the domestic environment of the de Menils' house on San Felipe in a symbiosis of the university and the home, led to the reaping of an unpredictably rich harvest of young enthusiastic students. MacAgy, Dominique, and the shooting stars who passed through St. Thomas inspired lifelong avocations amidst those crops of gifted

students. Teaching and inspiration were inseparable. Figuratively or in reality, the students huddled around the visiting masters, whether Magritte, Ernst, Duchamp, or later, filmmaker Roberto Rossellini, as others centuries earlier had done in the Islamic, Jewish, or Christian universities of the Middle Ages. These informal gatherings were oftentimes followed by a supper at the emblematic de Menil residence at 3363 San Felipe, where John would serve his best wine smuggled from New York, as Houston was in a dry state at the time.

Twenty-five years later, when the chance presented itself to join in what I considered to be an adventure by Dominique's side, it was with no hesitation that I responded to her call (albeit for a midnight appointment at her Paris apartment). In the course of this meeting, Dominique sketched out the ways in which I could assist her. This was not a situation in which the request for a formal contract would have been proper. I later discovered that, to her, positions or titles only define functions, not rank. My role at her side was never clarified. I even doubt that it was ever clear to her. Around her I felt like a chaplain or some lay counterpart at the court of a small eighteenth-century German principality. My advice was taken and given for twenty years not in the business environs of her or my office, but in the privacy of her home, mostly at dinnertime, alone in tête-à-tête or with other guests. I pressed my plea for the acquisition of the Cypriot frescoes from Lysi in the Hotel Meurisse lobby in Paris. I was similarly informal when I encouraged her to acquire Eric Bradley's icon collection. "When you return to Houston," I said, "why don't you detour by London and see the collection in Hampstead, just for the *plasir de vos yeux*?" The next time we met was at Rice, and at the end of our casual encounter she said, " By the way, I saw the collection and I bought it."

All the activities relative to the collection took place at the house (fig. 20.5). The management of the de Menils' collection had the intimacy of a family business. This woman so often rapt in unfathomable thoughts needed the tangibility of the familiar, of the domestic. To those who have partaken of lunches in the San Felipe kitchen—a downscaled convent refectory with a monumental Mexican cross embossed with the instruments of the Passion at the head of the table—amidst a handful of young women, for the most part trained at St. Thomas, sitting around the head mother, this was an indelible experience.

There could be long intervals of silence during dinners with Dominique, but her subterranean thoughts could surge up at any point of their course—text without its context. "Do you know," she once said to me after a long silence, "that Bossuet never mentioned once Joan of Arc in his writings?" (At the time the seventeenth-century Bishop of Meaux and familiar of the Court of Louis XIV was writing, Joan of Arc was not a saint to catch his attention! What reason would this great prelate theologian, author of funeral orations

for the royal and the princely, have to mention the humble "maiden of Orleans" who was not yet canonized?) Indignation and admiration she expressed loudly, but her thoughts she kept private, or she distilled them in short and dense texts. Her solitary process of communication was, I think, a further trait of her patrician, occasionally overbearing, character. Significantly enough, she was not a debater; I never heard her participate in panel discussions other than to open them or to ask about points of facts. She never descended into the arena, but she would in all likelihood have disapproved of my saying that her place was in the imperial box because, although not humble, she was simple and definitely modest.

While Dominique's style was aphoristic, her aphorisms were an essential part of that quest of the absolute that attracted her to modern forms and that she found in spirituality. The aphorism is quintessence, just as a line by Henri Matisse or a painting by Mark Rothko or Barnett Newman is. Yet the aplomb of her apothegmatic pronouncements and their lack of shading could inhibit questioning. The form is a difficult one; it demands acumen and may be hit or miss. We have seen that she could miss. Swimming against the stream of political correctness, Dominique believed that women were not as creative as men: "No woman could be a Matisse," she once told me, adding that Emily Dickinson's lines do not demand the agonizing strength that a Matisse creation does. But never mind her contradictions or her extravagant affirmations. Artists are entitled to intellectual license. Far from jeopardizing the cogency of their work,

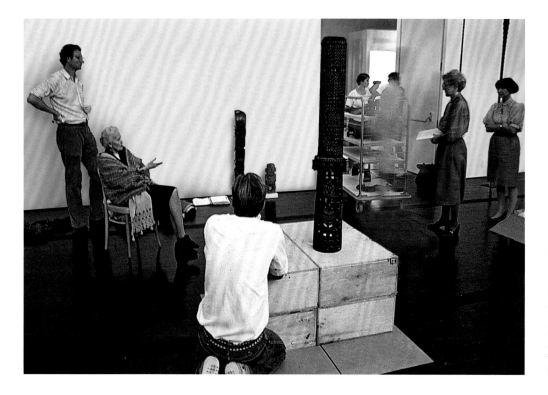

Fig. 20.6
Paul Winkler, Dominique de Menil, Gary (Bear) Parnham, Julie Bakke (in doorway), Adelaide de Menil, and Elsian Cozens installing the Oceanic Art Gallery, The Menil Collection, Houston, 1987

Fig. 20.7 *opposite*
Portrait of an Old Woman, formerly attributed to Mathieu Le Nain, 17th century. The Menil Collection, Houston

this freedom reinforces instead their creative engagement. Dominique must be regarded as an artist and her actions, not her words, as her work of art.

Early on, living in Houston developed an interesting syndrome in her, which I might compare to that which an explorer can experience far from home. It would be appropriate to call it, for the sake of argument, the Lambaréné syndrome, after the site of Albert Schweitzer's hospital in Gabon. Isolated and away from metropolitan centers of culture, Dominique developed a unexpected sense of insecurity, which sometimes made her overvalue the opinions and advice of guests passing through town. This sense of insecurity made her feel that she was missing something—removed, as she sometimes felt, from where the action was. Thus it was not business alone that motivated her frequent trips to cultural capitals where the de Menils kept residences, in Manhattan and Paris, but also opportunities to visit or be visited by authorities in a large variety of fields, whether artistic, cultural, spiritual, intellectual, or otherwise professional. Her innate enthusiasm often made her uncritically accept ideas that distance, both physical and cultural, made all the more persuasive. For instance, her assistants narrowly escaped having to redo the bibliography of the 1976 catalogue *Art Nouveau: Belgium, France*, an ambitious show organized by the Institute for the Arts at Rice University, on the strength of the intemperate advice of some French scholar passing through from Paris who told her that French footnotes were done differently.

The cultural estrangement that at times she felt in Houston made her particularly receptive to counsels she would get from specialists and dealers. The case of Charles Sterling—an eminent scholar in European painting whom Annette Schlumberger, Dominique's sister, had introduced to her—is significant. Dominique used to visit him in Launay, outside Paris, where he kept residence. One time I accompanied her. During our visit he tempted her with a nude drawing by Charles-Alexandre Lesueur and with an *Adoration of the Shepherds*, 1639, an impressive nocturnal scene with glowing light effects by Roger Baigneur, an unjustly overlooked seventeenth-century painter from Nancy. This was not a visit in an art gallery, where dealer and client are on equal ground, and the client is not inhibited by a sense of obligation toward the dealer. The situation I witnessed was indeed different. Three factors were at play to force her decision: the weight of Sterling's scholarship, the actual precariousness of his financial circumstances (a lasting effect of World War II), and Dominique's compassionate feeling, all of which influenced the purchase of both pieces. In another instance, the acquisition of Anthony van Dyck's impressive *Saint Rosalie in Glory*, 1624, was unambiguously the result not of an aesthetic interest but of a spiritual motivation. Originally acquired from, and identified by, the same Sterling, yet unlike anything else in the collection, it would be hard to arrange its place in concert with the other works. Couturier, who provided the foundations of Dominique's aesthetic ideology, and her friend Father Yves Marie Joseph Congar, a major force behind the reforms

of Vatican II who contributed to the shaping of her Catholic and ecu-
menical convictions, would have shuddered at the sight of this para-
mount statement of Counter-Reformation.

Still, John and Dominique de Menil made their decisions always,
it seems, in consensus. "Dominique is the locomotive," John is quoted
as saying, a metaphor she herself used about him. And together they
made the decision to move the Art Department from St. Thomas to
Rice University; to create the Rice Media Center with its small art and
photography exhibition space; and to build what would eventually
become an ecumenical center, the Rothko Chapel. John's death in
June 1973 did not change the character or pace of their previous joint
actions. Under the single leadership of Dominique, major decisions
were made, and in time she saw the completion of her crowning
achievement: the museum for the permanent collection and tempo-
rary exhibitions along with its offshoot, the Cy Twombly Gallery, both
commissioned to Renzo Piano, as well as the Byzantine Fresco Chapel,
designed by Francois de Menil, a shrine to thirteenth-century
Byzantine frescoes salvaged from pillage in Cyprus, which won long-
term refuge within the de Menil orbit in Houston.

With the move to Rice, however, the unique spirit of St. Thomas
Art Department seemed lost in the translation. Dominique's grip
somehow did not have the same power there. The bureaucracy was
more cumbersome, though the Art History Department benefited
from the stellar presence of the noted art historian William Camfield.
Some of the spirit of St. Thomas was preserved in the Rice Media
Center. John's interest in filmmaking thrived there, while theoretical
problems and current issues on contemporary art were presented in
class and public lectures. The shows that Dominique mounted at Rice
until the opening of her museum in 1987 were also in the same strict
orthodoxy as those at St. Thomas.

With the opening of the museum, Dominique's sovereignty was
altered. That earlier golden age was never recaptured—when possi-
bilities were within the reach of a single person, when Dominique
was the sole master of her initiatives, when she was not yet checked
by a hierarchy of museum administration, and when plans were not
impeded by inescapable realities that closed forever those years of
financial insouciance. Gone were the days when she conducted her
multiple operations from her home with the sole help of her assis-
tant and an early crop of St. Thomas students, pausing with them in
the cénacle of her kitchen at lunchtime and interrupting at any
moment the ongoing conversation to remonstrate her cook. The charm
of this domestic intimacy was definitively stifled with the emergence
of the museum, one that unquestionably flattered her ego but also,
with its cortege of problems and its financial difficulties, made her
nostalgic for the simplicity of the earlier years. "It's you all," she once
told me reproachfully, "who talked me into a museum!"

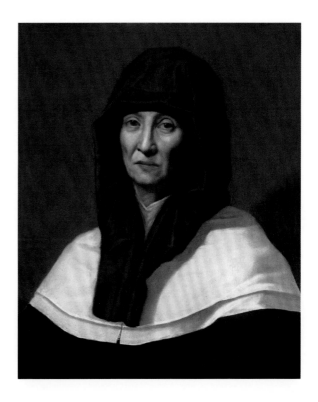

Dominique kept coming by the museum, however, meeting with
Walter Hopps, the founding director, and with Paul Winkler (see
fig. 20.6), his successor. She would occasionally indulge in small-
scale shows in the East Temporary Gallery, mainly drawn from the
collection. She would attend the staff meetings that Winkler, another
graduate of St. Thomas, called to order on Tuesdays. She would pay
visits to the business officers and staff members across the street. She
also attended public openings, functions, or lectures, where often
the flicker of a heartfelt smile would animate for one instant her well-
chiseled mask. But above all she delighted in visiting Carol Mancusi-
Ungaro, the chief conservator, for whom she had both admiration and
affection, joining her behind the monumental doors of the conser-
vation department. There she could indulge in physical contact with
individual artworks in a quasi-mystical experience of private recapture.

Vita activa and *vita contemplativa* have been the two embodi-
ments of her beliefs, each one the justification of the other. The temp-
tation of a convent retreat does not seem to have touched her, although
she may well have yearned for a chance at tranquil contemplation—
the never-never attic, the claustral bedroom in which the Picassos,
Jean Dubuffets, and African sculptures joined the crucifix as icons
of contemplation. The austere, anonymous seventeenth-century
Portrait of an Old Woman, formerly attributed to Mathieu Le Nain
(fig. 20.7), personifies to me how she may have quietly reminisced
at the close of her life.

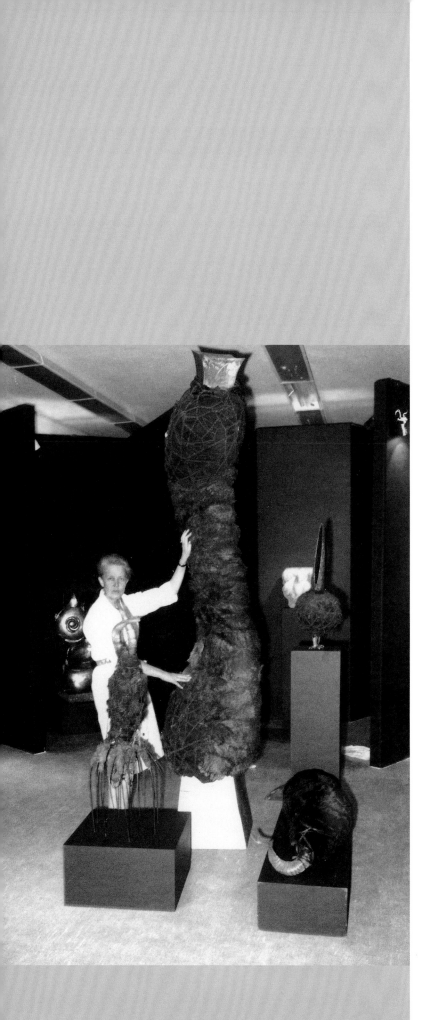

From Surprise to Marvel:
Dominique de Menil as Curator

SIMONE SWAN

I first met Dominique de Menil in New York in 1963. John de Menil had arranged for us to have lunch. I mentioned to her that her husband had shown me her office at the University of St. Thomas, where she began directing the Art Department the next year, after the death of Jermayne MacAgy. Dominique was then in mourning for Jerry, whom she admired and obviously missed. She showed me some of MacAgy's exquisite exhibition catalogues as well as a copy of her own catalogue for a small Magritte show she had organized with the artist Jim Love in Little Rock, Arkansas. When you reversed the little book, the text was in French. I was impressed by Dominique's devotion to her work and to those whom she admired, like MacAgy.

After lunch we went to my office, then in the Time-Life Building. I asked if she had done any publicity at St. Thomas—a press release, the mailing of catalogues to art magazines for review. She seemed somewhat irritated and exclaimed, "We are only two people doing all this work, maximum three when a student volunteers! Never would we have time to promote our work." I understood the stress, but nevertheless declared, "Dominique, you are cheating the art world. Your efforts and accomplishments are just too important!" We parted having covered much territory about art, her collection, and teaching students.

Fig. 21.1
Dominique de Menil in her installation of "Constant
Companions," University of St. Thomas, Houston, 1964

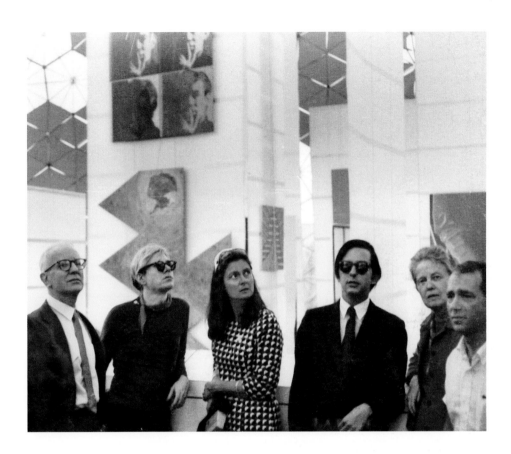

Fig. 21.2
John de Menil, Andy Warhol, Simone Swan,
Fred Hughes, Dominique de Menil, and Howard
Barnstone in Buckminster Fuller's geodesic dome
for Expo 67, Montreal, 1967

In late 1963 I left for a trip to Kenya. Upon my return, I decided to give a party to celebrate Uhuru, Kenya's independence, and called to invite Dominique. Luckily she was in Manhattan and accepted. She came to my apartment on East 79th, six blocks from her house. The next day she sent over her housekeeper, Gladys, bearing three lampshades and a note saying, "Your lampshades are all wrong. These might work." Dominique was of course right. I kept two and was more than amused by her forthrightness.

She flew back to Houston and soon called to say, "John and I would like you to handle the publicity for the Art Department of St. Thomas. Our next exhibition is 'Constant Companions.' We would like you to come here to see what's cooking."

Held in a second-story exhibition space in Jones Hall on the St. Thomas campus, the show contained books, paintings, drawings, and sculptures, all representing fictive, imagined, or mythical creatures. The rooms were kept eerily dark, with a spotlight on each work of art. You groped your way from surprise to marvel. Works were on loan from the Metropolitan Museum of Art in New York as well as from important galleries and private collectors. Dominique was especially pleased to obtain the loan of a Roman bronze from the Musée du Louvre. Aline Saarinen of NBC-TV devoted a long seg-

ment to "Constant Companions" on the nationally televised *Sunday* news show, which aired during prime time in the fall of 1964.[1] The press, local as well as national and international, featured articles and listings. We were well on our way to sparking interest in Houston's emerging art scene.

More memorable exhibitions followed, all worthy of MacAgy and all installed by Dominique with her ineffable sensitivity to objects and their history. She had a special gift for design. One delightful installation at the Museum of Fine Arts, Houston, "A Young Teaching Collection," featured the de Menils' own art collection displayed within cubic structures, each placed under the thirty-six-foot-high ceilings of Cullinan Hall. The intimate spaces were reachable by staircases. It was an amazing and innovative installation, which I will always remember.

NOTE

1. Aline Saarinen, "Monsters in Art," *Sunday*, NBC, broadcast October 15, 1964.

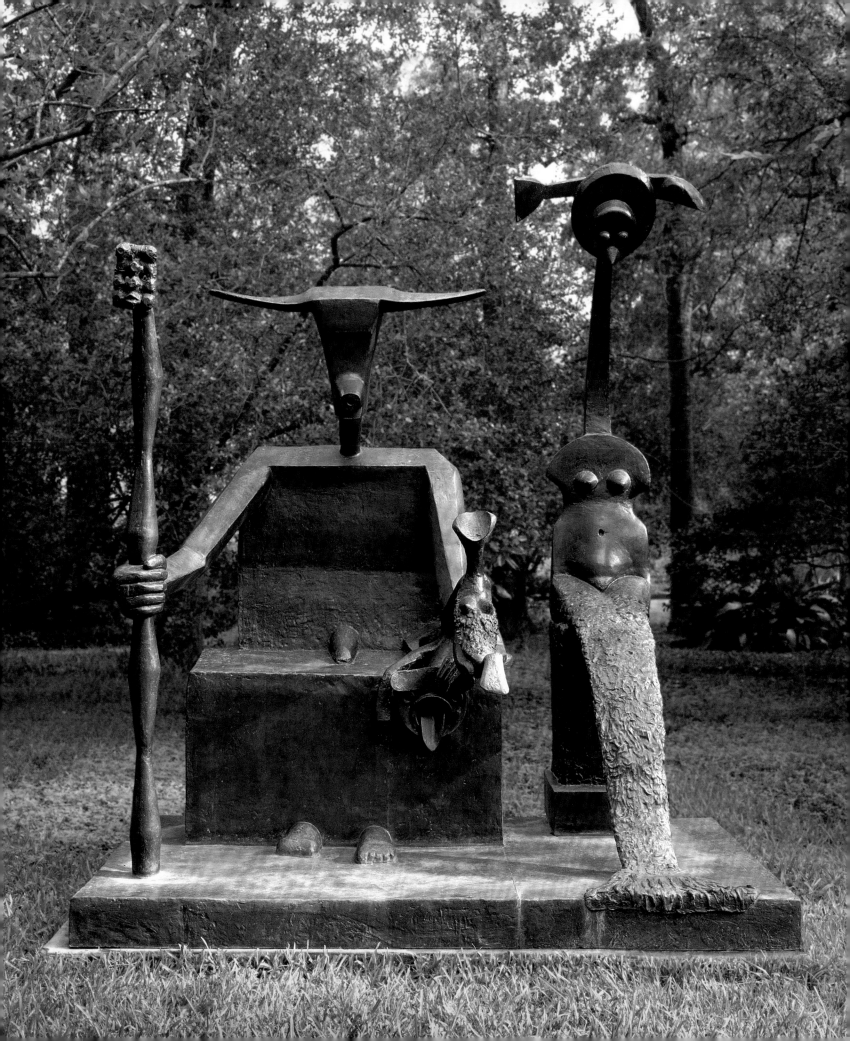

Memoranda: John and Dominique de Menil and the Dream of Black Mountain THOMAS McEVILLEY

Fig. 22.1
Max Ernst, *Capricorn*, 1948/1964. The Menil
Collection, Houston. Installed in the backyard
of the de Menils' home, Houston, ca. 1987.

The Dream of Black Mountain

The Dominican priest Marie-Alain Couturier inspired in John and Dominique de Menil a passion for a modern art that had undergone a rigorous stripping away of incident in pursuit of purity of form—art that, insofar as it succeeds, seems sacred. Think of the Rothko Chapel or Barnett Newman's Stations of the Cross series. Couturier's goal, as he wrote, was "first and foremost the restoration of people's taste and specifically their sense of poetry. Anything else is spiritual academicism."[1] John and Dominique de Menil cultivated this idea, with Couturier's goal of restoration in mind, when they adopted a small local Catholic college and patronized it so richly and artistically that it became a significant venue of the avant-garde in Houston. The conceptual parallels between the University of St. Thomas and Black Mountain College—founded in 1933 in the Blue Ridge Mountains of North Carolina using John Dewey's principles of progressive education—are basic. Committed to democratic governance and to the idea that the arts are central to the experience of learning, Black Mountain College in the postwar years attracted a number of maverick spirits. The saga of the development there of an early mixture of late modernism and postmodernism has become a kind of sacramental passage in the story of modern art. Both John and Dominique said to me, at one time or another during my first year in Houston, that Black Mountain was the model on which their patronage of the University of St. Thomas was based; indeed when proposing a lay board of directors, they thought of John Cage, no

doubt because of his role in the transfiguration of Black Mountain into a legendary center of the avant-garde.

Black Mountain College was in its early days a nexus of cultural refugees from Europe, such as faculty members Josef and Anni Albers, paralleling the similar status of the de Menils. Then in 1948 the college entered its heyday with Cage, Merce Cunningham, Charles Olson, Willem and Elaine De Kooning, Buckminster Fuller, and others joining the faculty, attracting students like Robert Rauschenberg and Cy Twombly. In 1952 Cage presented there his *Theater Piece #1*, a complicated absurdist event that is regarded as one of the forebears of the 1960s Happenings. For the performance, which incorporated some of Rauschenberg's *White Paintings* into the stage design, Olson recited poetry from atop a ladder, and Cage read either a Zen or Dada text (both are claimed).[2] Through Albers, Black Mountain was connected to the Bauhaus and, behind it, with Dada. This was the moment when the current of Western art history turned away from Europe toward America.

The same infusion of a spirit that was a bright reflection of their times attended the de Menils' involvement with the University of St. Thomas, where as Catholics they had developed a relationship with the priests, especially the president, Father Vincent J. Guinan, and later Father William Young. These men knew of the de Menils' intentions and were interested in the enterprise. Though they have come to seem like cultural institutions, John and Dominique were, as individuals, both deeply committed to the counterculture point of view. After a filmmaker whom they had brought to campus was busted for pot at the Plaza Hotel on Montrose in 1969, Dominique said to me, "There are two kinds of people, hippies and rednecks." That dichotomy was to be prominent in their lives as they attempted to open up the traditions of Texas.

Beginning in the late 1950s, significant sums of money went from the de Menils to the University of St. Thomas for the master plan and new buildings on the campus. It became a handsome and expansive academic setting. Dominique became chair of the Arts Council, and she and John began to hire new professors directly: a meeting or interview with the university administration, the Basilian priests, was not required. The overall strategy was to start with the Art Department, located in an attractively renovated house, develop it, then start on other departments. Seeking candidates at College Art Association and Archaeological Institute of America meetings, they hired Philip Oliver-Smith, a classical Greek art historian and archeologist, and Walter Widrig, an architectural historian. The idea was that the de Menils would somehow get them a site in the Mediterranean where they would conduct annual digs, taking students with them. This envisioned archeological enterprise with the de Menils' modernist focus would have been a true laurel of classicism and modernism woven

Fig. 22.2
Filmmakers Bruce Baillie and James Blue, auditorium of Rice Media Center, Rice University, Houston, 1973

together, a homage at once to each field and to the relationship between them. Also joining the faculty was William Camfield, an art historian whose thesis at Yale was on Francis Picabia, exactly the kind of ornery modernist the de Menils loved. And finally Mino Badner, a scholar of non-Western art (an area of increasing interest for the de Menil collection), completed the original core of the department.

Meanwhile John had developed the desire to found a film department. He hired Gerald O'Grady, a scholar of medieval literature with an interest in film, to set it up. The idea was to create a film school, archive, and cinematheque that were widely cultural, but would specialize in the study of avant-garde and socially engaged film. Reflecting John and Dominique's postcolonialist stance, such film interests showed the influence of the French documentarist Jean Rouch, who later visited and lectured at the Rice Media Center. I taught many courses there over a period of thirty years, alongside long-term and visiting film professors such as James Blue, Bruce Baillie (fig. 22.2), Stan Brakhage, Mark McCarty, and Brian Huberman, under whose direction John's old dream of a media center still draws breath.

It was the de Menils' particular genius, and their Old World flavor, that prompted them to turn in 1968 to the field of classics as the third department to develop after art and film. I was in my final year of doctoral studies at the University of Cincinnati, writing my dissertation on the fragments of the poems of Sappho. Oliver-Smith and Widrig directed John and Dominique to Jack Caskey, chair of the Classics Department at Cincinnati. They asked him to recommend

Fig. 22.3
John de Menil in the de Menils' 73rd Street
townhouse, New York, ca. 1960

one person coming out with a PhD in classics who he thought was especially promising. He named me. They then sent Oliver-Smith to the combined American Philological Association and Archaeological Institute of America convention in Boston with the mandate of luring me down to Houston. I agreed to go down for one night and look the situation over.

I flew from Cincinnati to Houston and got a cab to the de Menils' house in River Oaks. As I felt the warm air and saw the city through the window, I was concerned about living in the South. I asked the black driver if his life seemed constricted by race-based limitations—like where you could live. "No, man," he said, "this is the South*west*, not the South. You can live wherever you want." It's not entirely clear that history has borne out his LBJ-era idealism, but it did, perhaps deceptively, reassure me.

After dinner that night in what Jill Johnston in the *Village Voice* would call "a real fine sexy Phillip [*sic*] Johnson home,"[3] I told them that I was engaged in a longtime writing project about ancient philosophy. John and Dominique, solicitous of the requirements of a scholar (as of an artist, a poet, indeed any cultural professional contributing to the humanities), expressed concern that there might not be a library in Houston adequate for my needs. The next day Dominique took me to the Rice library, the larger holdings of which would supplement the smaller St. Thomas library, but it was closed for some reason. We stood outside in a light rain, looking in, shielding our eyes with our raised hands.

It was dusk when we turned away and went home. Later that night John asked me if I sleepwalked: the collection, much of which was spread throughout the house in tasteful confrontations, was protected by motion-detection devices in all the rooms. I didn't sleepwalk, but I rarely went to sleep before three or four a.m. and in fact often saw the dawn. When they said goodnight at about eleven, with the caveat about motion detection, I retired to my room.

After reading, with the help of a Latin dictionary, a couple of pages of Livy describing the barbarian conquest of Rome in 390 BCE, I stood gazing out the window into the darkness of the leafy yard, dotted with the black shadows of a Max Ernst sculpture. Fortunately, my room had an exterior door nearby, apparently outside the security system, which I passed through after a while to find myself facing off with Ernst's *Capricorn* in the garden (fig. 22.1). I walked to the street, then slowly around the long block in the dark and back to San Felipe, creeping in through the unlocked door two hours later. I just got a little taste that night of the loneliness living there would involve—which I saw John and Dominique as standing up to bravely for years.

Between my visit to Houston in January and my move there with my family in August, the situation changed. Young, the priest who was formerly president of the University of St. Thomas and was interested in John and Dominique's plans to open up the priestly board to include lay people, was reassigned by the order. The priest whom the Basilian Fathers chose to succeed him as president, Father Patrick

Fig. 22.4
The Whirling Dervishes of Konya, Turkey,
at the Rothko Chapel, Houston, 1978

Braden, had no interest in the arts and regarded avant-gardism as disreputable and perhaps anti-religious. The similarities to Black Mountain College began to fade. The new president refused to seat the board selected by the de Menils. The university would not be laicized after all. The Art Department the de Menils had in their grip and could retain, but the rest of the university was to revert to its pre-avant-garde form. I found myself teaching New Testament Greek to seminarians.

John still clung to the idea that progressive education in avant-garde art could be made to happen in Houston, and he came privately to an understanding with friends who were on the board of Rice University. Gathering us professors together at the house, he said, "We're going to try a heart transplant." Widrig quipped, "None has survived." John had arranged to shift ("spin off," as he put it) his faculty members to the Art Department at Rice. I could either go on my way or come along and find other things to teach compatible with an art department (mythology, iconography, and after a while film). We made the move, but the department quickly lost what vigor it had. Over a number of years, it descended into what Dominique would later describe to me as "good mediocrity." One day in 1982 or so, Virgil W. Topazio, the dean of humanities at Rice at the time, pounded his right fist on his desk while shouting at me, "You've got to choose between the de Menils and Rice!"

Rothko Chapel

When I first arrived in Houston—driving with my family in an old Mercury while our tattered possessions were hauled in a van—the Rothko Chapel was under construction. This, like the whole venture of collecting art, was modeled on the career of Father Marie-Alain Couturier, who was the art commissioner responsible for the Matisse Chapel in Vence, which Dominique once told me was the ideological (not necessarily the aesthetic) model for the Rothko Chapel. As it happened, my wife, Marion, our two sons, Thomas and Alex, and I moved into a little house within eyesight of the chapel, and it became more and more a part of our lives. For the few years we lived there, I often went over, meditated on a cushion, played the flute, strolled around, and witnessed a great series of events unfold, from Turkish Sufis whirling (fig. 22.4) to Ralph Kirkpatrick playing the *Goldberg Variations* to the Dalai Lama charming everybody. My kids would bounce a tennis ball against the outside wall till the guard asked them to desist.

While the chapel had auspicious beginnings as the brainchild of two modern masters of art and architecture, Mark Rothko and Philip Johnson, the final structure has its flaws. Rothko had insisted that the chapel have a skylight so the paintings would be lit by natural light as they were in his studio in uptown Manhattan. Johnson wanted to make a pyramid on top of the chapel, which was the far better idea because the natural light didn't work out at all. Much brighter and more glaring than New York light, the savage sacrificial Aztec sun of

the nearby Gulf of Mexico reflected violently off the paintings. In order to see the pictures at all, you had to come back around dusk. Then there are the paintings. Today the maroon monochromes, in particular, are faded due, in part, to the sun. In spite of all of this, the chapel has an aura that one must, however begrudgingly, acknowledge: it is, in a strange, cold way, a welcoming place. Early on, when Dominique was writing about Rothko's paintings for the address she would give at the chapel dedication, she quoted the French poet Charles Péguy as saying that night was the most beautiful of God's creations. I said, "But look at the north triptych—the one emphasized by a recessed bay. In the central passages of it there is a pre-dawn light glowing." She put that into her speech.[4]

For all its problems, the Rothko Chapel impresses me still as the last great monument of modernism and the most essential defining piece of John and Dominique's aesthetic.

Partying

A significant part of my job, both at the University of St. Thomas and later at Rice University, turned out to be going to parties, usually at John and Dominique's house but sometimes elsewhere (fig. 22.3). Once they invited Marion and me to a dinner for three artists who specialized in earthworks, whom they had invited to bring proposals or maquettes from New York. They were Dennis Oppenheim, Robert Smithson, and Robert Morris. I was introduced as an assistant professor of classics. I had no idea who any of them were. Dennis, I recall, was forthcoming and friendly; the other two, uptight and seemingly under stress. Morris especially was trying hard to sell John and Dominique on a ziggurat-with-moat ensemble of which he had brought a maquette. But it was no go.

As the years scrolled by, Andy Warhol and some of his associates visited Houston to work on projects with the de Menils. One occasion was the show "Raid the Icebox 1," which Andy curated for the Institute for the Arts at Rice (fig. 22.5). It should be mentioned that in these years Dominique (not unaided by others, but as the primary mover after the death of Jermayne MacAgy) produced a series of brilliant shows of modern and contemporary art. She and John carefully maintained contacts with a network of contemporary art figures, of whom Warhol was perhaps the most important—though they included a lot of critics, too, from Leo Steinberg to Gregory Battcock to Jill Johnston to Sheldon Nodelman. Warhol's business manager, Fred Hughes, a former student of Dominique's at the University of St. Thomas, was frequently around.

The shows kept rolling out, and "Raid the Icebox 1" was not the only one to leave a distinct memory. Still, occurring in 1969–70, it was a historically significant show. To create the exhibition, Warhol chose things from the storage of the Rhode Island School of Design

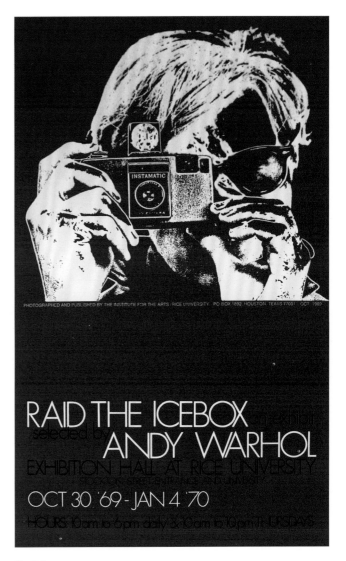

Fig. 22.5
Poster for "Raid the Icebox 1 with Andy Warhol," Rice Museum, Rice University, Houston, 1969

museum (he included a full-grown olive tree from the grounds outside that was visible from a window of the storage space). It may have been the first fully appropriationist show and the first show featuring what has come to be called "museum intervention," which ten years or more later would become characteristic of postmodernism. At the opening, every eye was out for the famous artist, who arrived late with a superstar—either Viva or Jane Forth—on his arm. He was carrying a Nagra tape recorder; she had the microphone. When anyone approached them, she would extend the microphone toward that individual's mouth and ask some unsettling question, like, "Are you a good fuck?" They stayed for perhaps fifteen minutes, never varying from that mode—he not saying a single word—then they were gone.

Over the years there were occasional dinners like the one with the earthwork artists—with Steinberg, Colin Young, Susan Sontag, and others. I was part of the furniture at those meals, and it was not a hard job. But most often there were larger parties, which John especially enjoyed. These were parties with scores of guests in the house and throughout the backyard sculpture garden, where people drank a lot and sometimes became what passed for outrageous, which delighted John, who would grow slightly red-faced and laugh aloud, throwing back his head. John's best friend in Houston was Miles Glaser who, like John, enjoyed a good time and a party that had hints of wildness. I remember a moment when Miles said to a bunch of people clustered around the piano, "Let's trash the place." Everyone laughed.

During those years John always wore a monochrome metallic-orange necktie. He told me he had them made by the dozen. It was a kind of self-expression, meaning he was unchanging: his inner world, his bearing seemed to say, was always the same, and so was his surface mood. One night before the move to Rice, there was a party at the University of St. Thomas art gallery. One of John's guests was an Italian count whose name I forget. What I do remember is a moment when the count was lying on his back on the terrazzo floor of the museum, sliding along, while John gripped him by his left ankle and dragged him, both of them laughing heartily.

John and Dominique had two ambitions: first, to collect artworks and develop over the years a collection that would shake the heart of the world. This was the legendary Couturier's legacy in their lives. Second, they had all this money and they wanted to somehow use it for what you might call social good. This ambition became intertwined with their feeling that they had come to Houston on a kind of civilizing mission. (When Confucius says he is moving to the West,

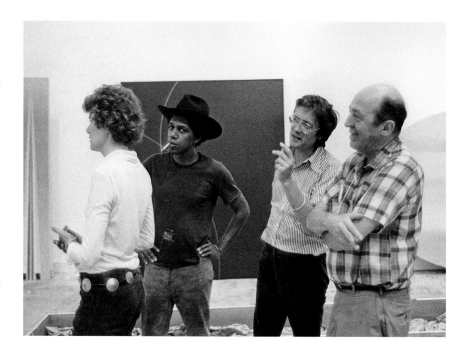

the interlocutor says, "Among those barbarians?" And he replies, "Once a civilized man lives among them, there will be no more barbarians.") The high point came when John began to give money to liberal black political candidates, first Barbara Jordan, later Mickey Leland. For a couple of years, one was apt to meet them around the dinner table.

Another sign of their interest in the black community—and a possibly overboard demonstration of their civil rights mission—was "The De Luxe Show." The De Luxe was a movie theater in the Fifth Ward, which at the time was one of Houston's black ghettos. John and Dominique renovated the old theater, which had been unused for years, removed the seats to make it an open exhibition space, commissioned African American artist Peter Bradley as curator, and somehow arranged for Clement Greenberg to come down and help in the installation (fig. 22.6), which he took over with what seemed an excess of self-confidence. Kenneth Noland and Sam Gilliam also participated in the installation. Other artists in the show included Anthony Caro, Larry Poons, Jules Olitski, and Craig Kauffman. In the catalogue Greenberg noted that the "'hard' art ... seemed to be animating that neighborhood."[5]

In the 1970s John grew increasingly interested in African American contemporary art and began collecting it. Joe Overstreet, for example, an African American artist now about seventy-six, who was the artistic director of the Black Arts Repertory Theater School in Harlem in the 1960s, was invited to have a show of his abstract paintings at the Rice Museum (fig. 22.7) and later at the De Luxe Theater. John and Dominique bought two pieces.

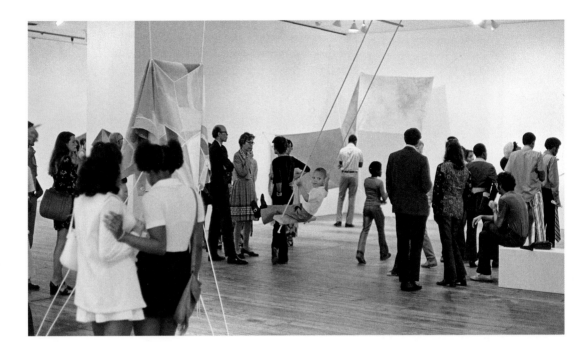

Fig. 22.6 *opposite*
Helen Winkler, Peter Bradley, Steve Cannon, and Clement Greenberg at the installation of "The De Luxe Show," De Luxe Theater, Houston, 1971

Fig. 22.7
"Joe Overstreet," Rice Museum, Rice University, Houston, 1972

John's Death and Dominique's New Life

In 1972 John became very ill with cancer, and he didn't spend long in dying. Between 1972 and 1973, when he was in his bed in the house on San Felipe with Dominique tending to him, he often asked for people to come talk. He couldn't speak, Dominique explained to me, but he still liked to hear interesting people talk and to follow the conversation. So I was brought into the room, one of the people whom John asked for. I sat there once, for example, with Adelaide de Menil and her husband, Ted Carpenter; we talked while John, seemingly bright-eyed and alert but silent, turned toward the sound of our voices. Later, Dominique recalled, with a sacramental reverence as if referring to the Last Supper, "You were in the room." John, true to his hippie dropout millionaire style, was buried in a pine coffin while a recording of Bob Dylan singing "With God on Our Side" played. Quite a throng attended.

After John's death, Dominique was very concerned with consummating the mutual dream that had come to function as part of the foundation of their marriage—the museum. This would be the culmination of Couturier's advice: to seek a sense of meaning through collaborating on a great collection that would then be left as a gift to the world. Proceeding carefully over the years, Dominique put it together, engaging Walter Hopps as the founding director of what would be called the Menil Collection and commissioning Renzo Piano as its architect. Little bungalow-style houses on a solid block were moved or torn down to make room for the museum one block west of the Rothko Chapel, with a Mark di Suvero sculpture on the lawn between them, and a Michael Heizer sculpture in front. The museum

was painted a particular gray, the official Menil gray, to fit in with the little houses for several blocks around, which had been painted gray in the 1970s. I lived in gray houses (my kids grew up in them) for years.

Meanwhile, Dominique didn't want to be stuck with a widow's isolation, but she didn't like the big semi-wild parties that John and she had given either. Instead she individually asked a small group of people if each of them would have a one-on-one dinner with her every couple of months or so. I was one of these. She would call when my time came round, and I would always be ready. I would go to the house. Dominique's cook, Mani, would let me in. Then Dominique and I would talk in the living room for an hour or so, usually about things that were on her mind and that I was supposed to counsel her about. For example, one evening she asked if I thought she should build the museum underground so it could survive World War III and, even in a difficult future, people would be able to appreciate these works. (What would Couturier have said?)

At the end of one of these datelike dinners for two, Dominique walked me to the foyer. We stood chatting near Yves Klein's anthropometry *People Begin to Fly* (fig. 22.9). Suddenly, with an impulsive excitement that seemed like a teenage girl's, she said, "I want to do a show with you. You write the catalogue; I'll make the show. Who would you like to do?" As an assistant professor of classical philology, I had not thought about it much. But that afternoon I had been reading Edward Lucie-Smith's description of Klein's work in *Movements in Art Since 1945* (1969). Looking at Dominique in surprise, I noticed that she was standing in front of the Klein work, and I said, "Why not do Yves?" She saw the sense of it immediately, as a French person and

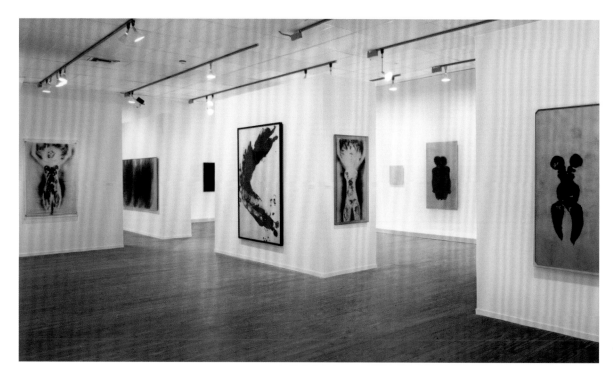

Fig. 22.8
"Yves Klein, 1928–1962:
A Retrospective," Rice Museum,
Rice University, Houston, 1982

as a collector who already owned some works of Klein's. In fact, there was a chance for the show to be a significant revival of a major French artist who had been passing out of the discourse for some time.

That was in 1977. I began studying and writing, learning what art criticism was, little by little, and I went to Paris with Marion to stay in the Schlumberger family residence and embark on a series of interviews that Dominique, or someone working for her, had arranged. We had pleasant and informative meetings with Klein's old friends Claude Pascal and Arman, art critic Pierre Restany, and numerous others.

Originally the idea was that this would be a small show in the out-of-the-way Rice Museum (fig. 22.8). But it got out of hand. First Tom Messer, then director of the Guggenheim Museum in New York, decided he wanted to take the show. Then Pontus Hulten at the Centre Pompidou wanted to take it. Everything about it got big. Dominique, as soon as the show opened, had invested in more works by Klein, knowing the show would probably increase their value. Walter Hopps signed on and became a constant watchful presence as the show grew like a mystical fever. Many nights Walter and I would sit up in Dominique's dining room until four or five a.m. dealing obsessively with pictures. After countless redealings of the deck, we ended up with fourteen images to illustrate my text, "Yves Klein, Conquistador of the Void." Only much later, at the Guggenheim opening in November 1982, did Walter remark to me that this was the same number as the Stations of the Cross.

On the morning after the opening at the Guggenheim, I sat with Dominique in her Upper East Side brownstone as she sadly said of

the press—mainly the *New York Times*—"There was high praise for you, but little else." The skepticism with which New York had greeted Klein in 1960 hadn't really gone away. But it was soon to turn around under the slightly delayed impact of our show. I had recently begun to work with Ingrid Sischy at *Artforum*, and the opening of the show was accompanied by my article, "Yves Klein, Messenger of the Age of Space" (January 1982), with a cover that featured the anthropometry *People Begin to Fly*, before which Dominique and I had first broached plans for the show about five years earlier.

Afterword

Before ground had been broken on Sul Ross Street for the beginning of the building of the Menil Collection museum, an old friend, the artist James Lee Byars, visited me in my house just a few feet away. He picked a massive old tree on the building lot, announced it to the world somehow, got my son Tom in a tux playing the violin under the tree, and then, with me as a kind of sponsor, did an art performance piece, which consisted primarily of his walking around silently in gold suit, black top hat, and black mask, distributing to the visitors tiny discs of white paper that had a message printed on them too small to read. James claimed that the tiny text said, "What do you know, Mr. Thomas McEvilley?" But I couldn't read it. Later at Dominique's house, I introduced James to Walter; they were both oddballs born in America in the same year and hit it off at once. I suggested to Walter that James's piece that afternoon was the first artwork actually installed and performed publicly in the Menil Col-

Fig. 22.9
Yves Klein, *People Begin to Fly*, 1961.
The Menil Collection, Houston

lection space. He concurred thoughtfully. It was official: the museum was inaugurated. A couple of days later they broke ground.

It may have been that first night, when John advised me about sleepwalking, that I mentioned to them that I had another life altogether. I told them that I had under way another project, a book titled *The Shape of Ancient Thought: Comparative Studies of Greek and Indian Philosophies*. Dominique immediately was enthralled by it because it seemed ideologically akin to her own adventures in ecumenism, such as the way the Rothko Chapel would be used by representatives of different faiths. My book's attempt to unify East and West had philosophical parallels to events at the Rothko Chapel with the Dalai Lama or Turkish Sufi dervishes. Dominique and I shared a nineteenth-century feeling that multiculturalism was a great adventure of the spirit. "You're lucky," Dominique said to me more than once; she couldn't believe that this great topic was just lying there for the taking.

From 1982 I spent only a few months—then weeks—each year in Houston, living for the most part in New York. I was more or less apart from the discussion but would report to Dominique from time to time on how the book was progressing. Unfortunately it was not finished and published until after her death. In the eight years that the book has now been in print, it has been written about repeatedly in scholarly journals and elsewhere. At two colleges, I know of courses that have been taught on the book. An Indian edition has been published by Motilal Banarsidass.

I wish she could have seen it.

NOTES

1. Marie-Alain Couturier, *Sacred Art* (Austin: University of Texas, 1989), 11.

2. Mary Emma Harris, *The Arts at Black Mountain College* (Cambridge: MIT Press, 1987), 228.

3. Jill Johnston, "Credo Quia Absurdum," *The Village Voice*, November 28, 1968.

4. "Address by Mrs. John de Menil, Friday, February 26, 1971, in the Rothko Chapel," Archives, The Menil Collection, Houston.

5. "De Luxe Interview with Clement Greenberg," in *The De Luxe Show*, exh. cat. (Houston: Menil Foundation, 1971), 65.

Mrs. D. and Me

MEL CHIN

Fig. 23.1
Mel Chin, *Study for a Story*, 2007.
Collection of the artist

Our dreams could have ended in the spring of 1983.

We escaped a Chamberlain moment. A jerk of the wheel in the wrong direction and the French-chocolate Mercedes would have sculpturally moshed with a faded emerald/pink-splotched Plymouth in a high-speed, head-on collision.

It would have been terrible. The empress of *Empire of Light* and high priestess of a collection holding things divine and surreal, in a demolition-derby confrontation with a wannabee museum worker chasing minimum wages to support his own grandiose ideas, sometimes mixed with meaningful aspirations. Everything almost reduced to French and Asian forensic comangling flesh, along with rubber and steel, German electronic components, and a rebuilt Detroit voltage regulator.

It was like this.

I had started work for the Rice Museum as the new prep person. I was assigned the less glamorous, non-white-glove handling jobs, like solo demolition of the drywall cathedrals of closed exhibitions. The inevitable tetanus shot was worth it for an occasional glimpse of surreal stuff. Her fabulous collection and accompanying scholarship clarified misconceptions nurtured by the dusty books of simplified college art history. The dust stirred up by my labor aroused new configurations and delusions … one day I would have walls built like this for my one-person exhibition.

That morning was a one-person unloading of massive crates, cradling the finest and most curious aged cultural artifacts. All done, I approached the crew who had been inside the museum smoking and philosophizing. I bummed a smoke as they strolled out of the museum like a Philip Morris version of Raphael's *School of Athens*… cigs dangling, making challenging statements in reference to the human condition.

I got some cold coffee, slumped on a crate, propped up my feet, and lit up. As the match sulfur lingered, she came in.

Dominique made a straight agitated gait toward me, "No, no, Noooo, NOOO.…You will burn up my entire museum!" Her small frame and massive credentials lorded over me with finger-wagging emphasis. Face to face with Dominique, I dunked the danger, stirring the coffee with the butt.

We both weren't happy, but it was almost noon and time for a beer. It was 3:30 before I came wheeling back from lunch. I wanted to stay clear of the museum until she left. I'd been dressed down by the grand dame, but I put away enough drinks to put away feeling bad. Sunglasses on and acuity off, I leaned back, rested my eyes, and started cutting across the asphalt expanse of the Rice University stadium parking lot, blind.

I opened my eyes to her oncoming car. Her mouth was a dark silent "O" that matched her green-glass specs. They formed a perfect triangulation, a geometry that reminded me of her excited exclamation at a staff meeting regarding a table, "But a plane is defined by three points!" The math of my face was not much different. Probability sided with our choices of trajectory as we slid apart without scratch or chrome souvenir scrap. I kept driving. I didn't look back; neither did she.

Assuming a pink slip the next day, I tried to avoid her when she came in. She found me. Her hard, determined look pried my downcast head up and she emphasized: "We must be vigilant!" That was it and I wasn't fired. It suggested our escape from collision would set things up for a rematch.

The exhibition she granted me in the spring of 1991 was a prodigal moment. I had abandoned my shiftless ways. It was my immersion in creating new artwork unfashionably focused on tragic political realities and arcane meanings that heralded this return to grace. It was a supreme honor that the dark light of these works was accepted into the prism held by Dominique de Menil.

Before the opening we had lunch together at her home. It was a table for four. Walter Hopps, Paul Winkler, Mrs. D., and myself. The lunch began with Mrs. D. in collector mode overdrive. An expert orchestra of actions and events had to be developed to wrest a Seurat she wanted from a reluctant-to-part-with owner. Walter laid down the hard facts as Ms. D. worked the corners for any weakness. The cost would be staggering, but the desire for the work was definitive.

She suddenly steered away from accumulation to protest against those who would engineer the paths of human misery. We spoke of the difficult job of exposing the perps of unjust sufferings.

She eyeballed me with that familiar, hard, even look. She said, "We must be vigilant!"

Her pronouncement hinted at a recollection of our crash course years earlier, but this time disapproval transmuted into a smile of elegant camaraderie and survival.

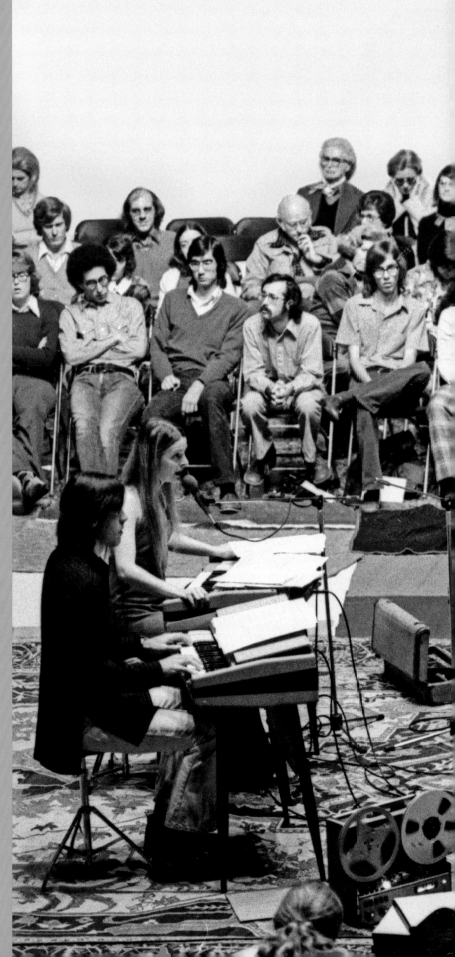

Look Back

CHRONOLOGY AND HISTORY

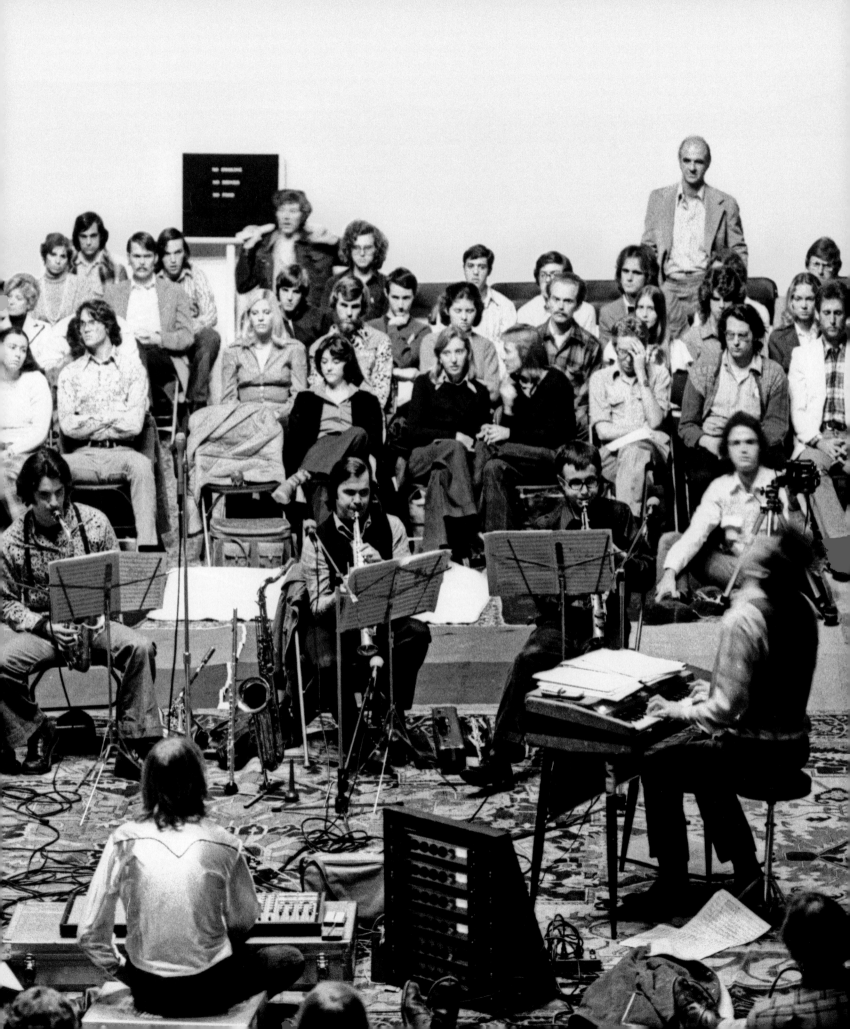

Chronology

Compiled by GERALDINE ARAMANDA,
WILLIAM A. CAMFIELD, CLARE ELLIOTT,
MARY KADISH, and DON QUAINTANCE

This chronology highlights activities in which John and Dominique de Menil were involved. Others worked behind the scenes and alongside them; space constraints made it unfeasible, however, to include every participant and event.

Entries that cannot be dated precisely are given approximate placement within the timeline. In some instances, future developments of an event or project are included in the entry of the date in which it originated. In general, titles of people frequently mentioned are only given in the first reference. Exhibitions are listed in this chronology if they are of special significance or relate to other events; for a complete exhibition history, see pages 300–19.

1904

January 4 Jean Marie Joseph Menu de Menil is born to Baron Georges Auguste and Baronne Marie Madeleine (née Rougier) in Paris. He is the sixth born of eight children. (When Jean de Menil becomes an American citizen in 1962, he officially changes his name to John de Menil. He is referred to as John de Menil throughout this chronology.)

1908

March 23 Dominique Isaline Zelia Henriette Clarisse Schlumberger is born to Conrad and Louise (née Delpech) in Paris. She is the middle born of three girls. Her father and uncles had moved to Paris from the Alsace region of France circa the 1890s in order to avoid being drafted into the German army.

1918–19

After World War I, Conrad Schlumberger, a professor of physics at the École des Mines, conducts his laboratory and field experiments using electrical measurements to map subsurface rock bodies (fig. C.2). He invents induction logging, a process that will prove essential to prospecting and drilling for oil. In 1919

Conrad and his brother Marcel start a business based on this invention, with initial funding provided by their father, Paul Schlumberger. According to their father, Marcel brings to the project his "remarkable engineering qualities and his sense of reality," while Conrad is "the inventive physicist." The following year, the Schlumberger brothers open their first office at 30 rue Fabert in Paris. In 1926 Société de Prospection Electrique (Proselec), a precursor to Schlumberger Ltd., is founded in Paris. With operations expanding worldwide, Conrad and Marcel establish Schlumberger Well Surveying Corporation in 1934. Schlumberger will become the base of John de Menil's professional life and the source of John and Dominique's wealth.

1921

John de Menil takes a job at the Banque de l'Union Parisienne. He pursues his studies while continuing to work at the bank and in 1923 receives a baccalauréat ès lettres of secondary education. He subsequently earns a degree in Finances Privées from École des Sciences Politiques, and in 1935 a degree in law from the Faculté de Droit de l'Université de Paris.

1924–25

As a student, John de Menil receives a Polignac Foundation travel grant, and in October–February he travels around the world, visiting, among other places, Australia, Caledonia, Ceylon, Egypt, Ethiopia, the Panama Canal, Somalia, and Tahiti (fig. C.3).

1925–26

During his required national military service, John de Menil is drafted to fight in the Rif Mountains of Morocco. He renounces his officer's commission and chooses to serve as an infantryman (fig. C.1).

1927–28

Dominique Schlumberger completes her secondary studies and receives her baccalauréat ès sciences in 1927 and then earns a Certificat d'Études Supérieures en Mathématiques générales from the Faculté des Sciences de l'Université de Paris in 1928.

1929

Dominique Schlumberger leaves the Sorbonne and becomes an editor of Proselec's in-house technical journal.

Interested in filmmaking, Dominique Schlumberger travels to Berlin with Karl Gustav Vollmoeller, screenwriter of *The Blue Angel*, to serve as a script assistant on the Josef von Sternberg production of the film. She writes an essay about the experience, which is published in *La revue du cinéma* in March 1930. In April of that year, she writes one of the first articles ever published about the use of sound technology in film, also published in *La revue du cinéma*.

1930

John de Menil and Dominique Schlumberger meet at a party in Versailles.

1931

May 9 John de Menil and Dominique Schlumberger marry at Saint Dominique–Saint Mathieu Chapel in Paris. They honeymoon in Morocco (fig. C.4).

As a wedding present, Dominique's parents give the couple a floor in the family's Paris apartment. John and Dominique de Menil ask French architect Pierre Barbe, whom they meet through Dominique's cousin, Antoinette Grunelius, to modernize the apartment. Barbe also designs a settee and glass-top coffee table. Barbe will continue to work for the de Menils throughout his career. Future projects include designing a wooden chapel at L'Alpe d'Huez, France, in 1939 and restoring

a seventeenth-century house in Pontpoint (Oise) into a family country home in 1962 (fig. C.5).

In Paris John and Dominique de Menil meet Father Marie-Alain Couturier, a Dominican priest whose passionate efforts to combine spirituality, worship spaces, and modern art will profoundly influence the couple's many cultural activities.

1932

Dominique de Menil converts to Catholicism.

The de Menils purchase two bark cloths from northwest New Guinea from ethnographer and art dealer Jacques Viot. Other early acquisitions include an icon, which Dominique buys while on a trip to Russia with her father in 1933, and the painting *Othello*, 1931, by Christian Bérard, which John and Dominique acquire from Viot in 1934.

1933

February 5 Marie (later called Christophe), eldest daughter of John and Dominique de Menil, is born in Paris.

1934

In Paris John and Dominique de Menil commission a portrait of Dominique from Surrealist painter Max Ernst at the suggestion of Pierre Barbe, who wants to help an artist in need. Ernst's wife, Marie-Berthe Aurenche, takes it to a local framer and, because initially John and Dominique do not care for the painting, it is forgotten. After some time, the framer, unable to recall who had brought it in, displays it in his window. The parish priest sees it and believes he recognizes Dominique de Menil, so he mentions it to her. The painting is retrieved, wrapped in brown paper, and put away on top of an armoire in the de Menils' apartment, where it is once more forgotten. It is only on returning to Paris, after the war, that the couple finds the portrait and admires it.

Fig. C.1 *opposite bottom*
John de Menil preparing for military service, France, ca. 1925

Fig. C.2
Conrad Schlumberger testing equipment, Clairac, Lot-et-Garrone, France, ca. 1918

Fig. C.3
John de Menil (second from right) aboard sea freighter during his voyage around the world, ca. 1925

Fig. C.4
Dominique de Menil on her honeymoon, Morocco, 1931

Fig. C.5
De Menil family country home, Pontpoint, France, ca. 1962

pages 272–73
Performance of *Music in Twelve Parts*, Philip Glass and Ensemble, Cullinan Hall, The Museum of Fine Arts, Houston, 1974

The de Menils eventually become close friends and principal supporters of Ernst. The Menil Collection now owns more than one hundred works by the artist.

1935

May 21 Adelaide, second eldest daughter of John and Dominique de Menil, is born in Paris.

1936

January 18–25 Dominique de Menil attends a series of lectures on ecumenism given by Father Yves Marie Joseph Congar in Montmartre, which has a profound impact on her religious philosophy. Congar will become one of the influential theologians of Vatican II (1962–65), for which he participates in the drafting of documents exploring the Church's greater tolerance and more activist role in the modern world.

1939

John de Menil joins Schlumberger, the family firm, at the insistence of Marcel Schlumberger. He formalizes the accounting practices of the still mainly family-run enterprise. He later introduces personnel procedures for the international staff, which ensure that Schlumberger engineers around the world are paid equally based on their skill level regardless of their nationality.

September 1 Germany invades Poland, marking the beginning of World War II. John de Menil, in Romania on business at the time (fig. C.7), is called to serve under the command of the Military Attaché of the French Embassy in Bucharest.

1940

Due to the war, Schlumberger moves its headquarters to Houston, a booming center for oil exploration, and members of the Schlumberger family relocate to that city.

John de Menil, accompanied, at times, by Dominique de Menil, continues to travel to Romania on business. After participating in clandestine French Underground activities, such as sabotaging oil trains leaving for Germany, he receives a citation in May for "exceptional service" as a corporal.

May Germany invades France.

June Dominique de Menil, who is pregnant, returns to France, where she joins her two children at Val Richer, a Schlumberger family property in Normandy. With her daughters, Christophe and Adelaide; her mother; her sister Sylvie Boissonnas, also pregnant; and Sylvie Boissonnas's daughter, Catherine, she goes to Roche, the home of Dominique's maternal grandmother, Henriette Delpech, just outside of Clairac, Lot-et-Garonne, France.

June 28 On orders of the Military Attaché, John de Menil leaves Romania for Istanbul, where he is notified of his demobilization. He heads east for the United States, making several necessary business stops along the way in the Middle East and Southeast Asia, arriving in San Francisco on October 19.

December 4 Georges, eldest son of John and Dominique de Menil, is born in Clairac, Lot-et-Garonne, France.

1941

Seeking to join her husband in the United States, Dominique de Menil finds she is unable to book passage on a boat without first obtaining an American visa, nor could she secure a visa without having first booked passage. In desperation, she looks through the then-small Marseille telephone directory hoping to come across the name of someone who might help her. She recognizes the name of a family in the diplomatic service and, with their help, she secures visas for the United States.

Dominique de Menil takes her three children and British nanny, Evelyn Best, to Bilbao, Spain, where they set sail aboard *El Marqués de Comillas* (fig. C.11), bound for New York City. The ship stops in Havana, where John de Menil meets them.

June 10 The reunited family arrives in New York. Later, in Houston, they meet up with extended family already settled there: Dominique's sister Annette Doll and her family, and her cousin Pierre Schlumberger and his family.

John de Menil becomes president of Schlumberger Overseas (Middle and Far East) and Schlumberger Surenco (Latin America), which is based in Caracas. Because the war makes travel to East Asia problematic, he divides his time among Caracas and Maracaibo, Venezuela, and Trinidad (fig. C.8).

John and Dominique de Menil travel to South America, staying mainly in Venezuela, on Schlumberger business. Expecting to be back within a few weeks, they remain abroad for much longer. While in Venezuela, the couple meet French intellectual and Spanish Civil War veteran Jean Malaquais (born Vladimir Malacki), a friend of André Breton's and other Surrealists. Malaquais's wife, Galy, paints Dominique's portrait. Through Malaquais, the de Menils contribute funds to

anti-Franco Spanish refugees and provide support to the widow of Leon Trotsky (fig. C.9). In Caracas, Dominique also raises funds for the Free French forces by designing furniture (stools, mirrors, and tables) and table linens, embroidered by native women, and selling them in a shop she opens called La France. During a stay in Trinidad, she designs several liturgical vessels, which are crafted by a local silversmith (fig. C.10).

In Argentina, John and Dominique de Menil meet Pierre Verger, a French ethnographer and photographer writing a book on Peruvian folklore; later they fund its publication. They encounter Verger again in 1946 in Bahia, Brazil, where he is working with Father François de l'Espinay, a French priest studying Candomblé, an Afro-Brazilian religion with roots in Yoruba Orisha ritual. They later support de l'Espinay's stay and research.

1943

John and Dominique de Menil visit the painter Armando Reverón, who maintains an "outsider" existence in Macuto, Venezuela. John takes photographs of the artist at his primitive beach compound, and later the couple buys several works from him.

1944

The de Menils return to Houston, where they settle permanently while maintaining residences in New York City and Paris.

1945

While on a business trip in New York, John de Menil purchases Paul Cézanne's watercolor *Montagne (Mountain)*, ca. 1895, for $300 from the Valentine Dudensing Gallery. He is guided in this, the couple's most significant acquisition to date, by Father Couturier. The priest had arrived in New York in 1939 to deliver Lenten sermons and remained there as an exile throughout the war. During his stay, he reconnected with the de Menils,

introducing them to the work of exiled artists, particularly Fernand Léger, and to the galleries and museums in the city.

April 12 Francois, younger son of John and Dominique de Menil, is born in Houston.

1946

New York art dealer Alexander Iolas establishes Hugo Gallery with Donna Maria Hugo. The gallery, located on 55th Street, becomes renowned for its Surrealist exhibitions. In 1953 Iolas relocates the gallery to 57th Street and renames it the Alexander Iolas Gallery. He eventually opens galleries in Paris, Geneva, and Rome. He becomes one of the de Menils' closest art advisors. Over a thirty-year period, they purchase hundreds of works and receive others as gifts from him, with a special focus on the art of Max Ernst and René Magritte.

1947

John de Menil begins his lifelong involvement with various art museums at the Museum of Fine Arts, Houston (est. 1924). He joins the Accessions Committee and later serves on the board, while both he and Dominique de Menil participate in various other committees.

The de Menils help to establish the Houston Players, a theatrical group that performs live in the River Oaks Theatre. They invite director/actor Eddie Dowling and actor Robert Emmett, among others, to become part of the ensemble.

June 13 Philippa (later Fariha), youngest daughter of John and Dominique de Menil, is born in Houston.

1948

On the recommendation of New York artist Mary Callery, the de Menils commission Philip Johnson to design their home in Briarwood in the River Oaks area of Houston. It is one of the architect's earliest commissions.

Fig. C.6
Dominique de Menil, Paris, ca. 1930

Fig. C.7
John de Menil, Bucharest, ca. 1939

Fig. C.8
John de Menil, Trinidad, 1942

Fig. C.9
Walter Ketley, Vsevolod (Esteban) Volkov, Dominique de Menil, Galy and Jean Malaquais, and Natalia Sedova Trotsky, Coyoacán, Mexico City, 1944

Fig. C.10
Monstrance designed by Dominique de Menil in Trinidad, 1942. The Menil Collection, Houston

Fig. C.11 *opposite bottom*
Postcard of *El Marqués de Comillas*, the passenger ship Dominique de Menil and her three children take to Havana, Cuba, in the summer of 1941

Completed in 1951, the house is one of the earliest examples of International Style architecture in the Southwest (fig. C.12). Following this introduction to Texas, Johnson later designs buildings in Dallas, Fort Worth, and Houston. He also completes several houses for de Menil friends and for Dominique's sister, Sylvie Boissonnas, and her husband, Eric, during the 1950s.

May 21 The Contemporary Arts Association of Houston (CAA) is chartered, funded by membership dues and run by volunteers. John de Menil is elected to the board on July 15 and becomes chairman in 1950. (CAA's first building, which opens in 1949, is called the Contemporary Arts Museum; the organization officially adopts that name in 2003.)

October 31 The first Contemporary Arts Association (CAA) exhibition, "This Is Contemporary Art," opens. Lacking a building of its own, the CAA installs the exhibition at the Museum of Fine Arts, Houston.

1949

In New York, the de Menils purchase from Alexander Iolas their first painting by the Surrealist Victor Brauner, *Deuxième et dernière intégration*, 1945. From now until Brauner's death in 1966, they regularly acquire his paintings, visit his studio when they travel to Paris, and promote his art in the United States. The Menil Collection holds forty-eight works by the artist.

The de Menils begin to donate funds to the Museum of Modern Art, New York (est. 1929), to purchase art, including paintings by Victor Brauner, René Magritte, and Roberto Matta.

The de Menils engage New York couturier Charles James, who had created several garments for Dominique de Menil, to advise on the interior and to design some of the furniture for their new home, including a chaise lounge, loveseat, and sofa (fig. C.13). He chooses a striking palette of paint colors and fabrics for the upholstery, draperies, and wall coverings, particularly

for the interiors of closets and small spaces, much like the often vivid, unexpected colors he selects for the linings of his clothes designs. In 1957 the de Menils give the Brooklyn Museum of Art funds to purchase a collection of original dresses by James.

November The Contemporary Arts Association's first building opens at 302 Dallas Street, an A-frame structure designed by Fred McKie and Karl Kamrath, who were inspired by Frank Lloyd Wright's Arizona studio, Taliesin West. When CAA loses its lease in 1954, it moves the building to a site near the Texas Medical Center off Holcombe Boulevard, rented for one dollar a year from the Prudential Insurance Co. During a nighttime parade of artists and supporters, the disassembled building is moved in two sections to its new location.

1950

Hugo V. Neuhaus, the local architect for Philip Johnson on the construction of the de Menils' house, introduces

architect Howard Barnstone to John and Dominique de Menil at a dinner party. Barnstone develops an immediate rapport with the couple, and in 1952 they engage him and Preston Bolton to handle mechanical alterations and ongoing maintenance of their Houston home. In 1954 Bolton & Barnstone design renovations for the de Menils' New York residence on East 80th Street.

1951

The de Menils accept an invitation to serve on the Social Arts Committee of the University of St. Thomas. This is the first formal engagement they have with the liberal arts school, established in 1947 and administered by Basilian priests.

February 4 "Vincent van Gogh," the first exhibition organized by John and Dominique de Menil, opens at the Contemporary Arts Museum (fig. C.16). With the help of the CAA's Exhibition Committee, the de Menils secure loans of twenty-four well-known Van Gogh works from major collections, including *Dr. Gachet*. The de Menils travel to New York by train to personally pick up and then later return the painting to the lender, Werner Kramarsky. An illustrated catalogue accompanies the exhibition, which is attended by over six thousand visitors in its first week. In support of the de Menils' effort, Mr. and Mrs. John Hay Whitney donate Van Gogh's *The Novel Reader*, 1888, to CAA. (In 1954–55 the museum deaccessioned it along with its entire small permanent collection.)

October Invited to Houston by the de Menils, Alexander Calder oversees the installation of "Calder–Miró: Exhibition of Paintings and Sculpture" at the Contemporary Arts Museum.

1952

January 13 "Max Ernst" opens at the Contemporary Arts Museum. Organized by the de Menils, the exhibition is Ernst's first solo museum show in the United

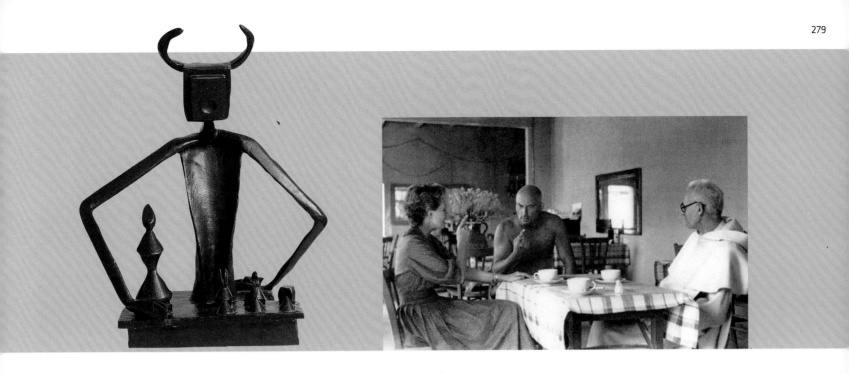

States. The artist contributes an original drawing for the catalogue's cover. Ernst and his wife, artist Dorothea Tanning, drive to Houston from Sedona, Arizona, in a station wagon crowded with paintings (and two dogs). During the week in Houston, Ernst is honored at a dinner given by Ima Hogg at her home Bayou Bend, and he visits Texas Southern University (est. 1947 as Texas State University for Negroes) with Dominique de Menil. There he admires a drawing by John Biggers, chair of the Studio Art Department. The de Menils purchase the drawing for him.

John and Dominique de Menil see a plaster cast of Max Ernst's sculpture *The King Playing with the Queen*, 1944, in artist Robert Motherwell's studio in New York. The couple commissions its casting into bronze, keeping two of the three sculptures for themselves (fig. C.14). Making their first personal donation to a museum, they give the remaining one to the Museum of Modern Art, New York, in 1955. Later they purchase an additional casting and give it to Motherwell in 1972.

Curator Douglas MacAgy, then executive secretary of the New York Museums Committee for UNESCO, working out of an office at the Museum of Modern Art, New York, is invited to assess the practices of the Contemporary Arts Association. Taken ill, he is unable to accept and suggests his wife, Jermayne MacAgy, then assistant director of the California Palace of the Legion of Honor, San Francisco, for the project. The CAA agrees, and after her consultation, Jermayne MacAgy recommends that the museum hire a professional director, a step not taken at this time. She returns to San Francisco but leaves behind a strong, positive, and lasting impression on the de Menils and others.

Summer In France, Father Couturier (fig. C.15) accompanies the de Menils to Catholic churches where he has initiated modernist projects. These projects include the Chapel at the Plateau d'Assy, on which artists Pierre Bonnard, Georges Braque, Henri Matisse, and Georges Rouault had worked. They visit Audincourt, with stained-glass windows by Léger; Varengeville, with stained-glass windows by Braque; the Vence Chapel, designed by Matisse; and the site where Le Corbusier's church at Ronchamp is being constructed. The experience is crucial to developing the de Menils' desire to blend spiritual and religious endeavors with modern artistic and architectural projects. In addition, the trip includes visits to the Musée Picasso in Antibes and Le Corbusier's Unité d'Habitation in Marseille. They also stop at Léger's studio, where the de Menils purchase *Les constructeurs* (*The Builders*), 1951. John de Menil returns to France in November 1953. With daughter Christophe and Father Couturier, he meets Matisse.

1953

December Nina Cullinan, Houston art collector and Contemporary Arts Association board member, funds an addition to the Museum of Fine Arts, Houston, specifying that it be made available to the CAA for exhibitions of contemporary and modern art. The commission is awarded to Ludwig Mies van der Rohe, who designs Cullinan Hall as a vast open space ideal for displaying large-scale contemporary art.

1954

Having heard of plans, never realized, for the de Menils to commission Philip Johnson to design a new parish complex for St. Michael's Catholic Church in Houston, the Basilian Fathers of the University of St. Thomas approach the couple to assist with the school's building program. The de Menils offer to pay for the master plan on the condition that a renowned architect be engaged. Johnson is selected on their advice and proposes an unornamented Miesian-style campus based on Thomas Jefferson's plan of the academic village at the University of Virginia. Johnson completes the plan in 1957.

John de Menil is elected to the board of the Museum of Fine Arts, Houston, where he serves until his death. In 1955 he joins the museum's Executive Committee.

Fig. C.12
De Menils' home under construction, Houston, 1949

Fig. C.13
Dominique de Menil wearing a Charles James gown and seated on a sofa designed by James for the de Menils' home, ca. 1951

Fig. C.14
Max Ernst, *The King Playing with the Queen*, 1944/1954. The Menil Collection, Houston

Fig. C.15
Dominique de Menil, Édouard Trouin (a client of Le Corbusier's), and Father Marie-Alain Couturier, France, ca. 1952

Fig. C.16 *opposite bottom*
Cover of the exhibition catalogue *Vincent van Gogh*, Contemporary Arts Museum Houston, 1951

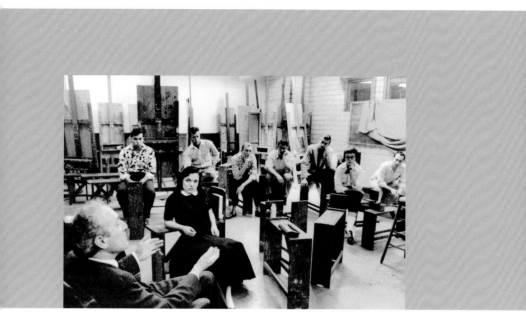

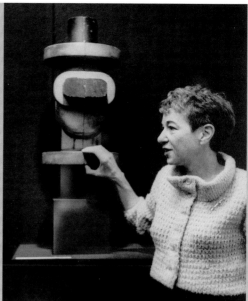

John de Menil begins nearly twenty years of service to the Museum of Modern Art, New York. He joins the museum's International Council, the purpose of which is to encourage cultural exchange between countries by overseeing the American Pavilion at the Venice Biennale and sending exhibitions around the world. (Shows such as "Jackson Pollock 1912–1956," 1958–59, "Mark Rothko," 1961–63, and "Robert Motherwell," 1966, bring American artists to European venues. Others, including "The Photographer's Eye," 1967–73, "From Cézanne Through Picasso: 100 Drawings from the Collection of MoMA," 1971–72, and "Word and Image: A Collection of Posters from the Museum of Modern Art," 1971–75, travel beyond Europe to Asia, Latin America, Australia, and New Zealand.) Later John de Menil serves on various other committees and in 1962 is named a trustee, a position he holds until 1973.

John de Menil commissions Houston architectural partners Preston Bolton and Howard Barnstone to build a series of modernist houses and dormitories in Argentina, Peru, Trinidad, and Venezuela for Schlumberger field engineers and their families, who frequently move from one location to another.

February 9 Father Couturier dies in southern France. He leaves his papers to the Dominican order, which later lends them to the Menil Foundation [see following entry] to be catalogued. From them, the foundation publishes *La veritée blessée*, 1984; *Art sacré* and its English translation, *Sacred Art*, 1989; and *La chapelle de Vence: journal de la creation*, 1993, translated into English in 1999. Couturier's papers are currently at the Bibliothèque du Saulchoir in Paris; a copy resided at Yale University until 2007, when it was moved to the Menil Archives.

March 19 The Menil Foundation Inc., is founded as a nonprofit charitable organization for the "support and advancement of religious, charitable, literary, scientific and educational purposes." The foundation does not begin to acquire art until 1960; the de Menils, however, continue to purchase art for their personal collection.

1955

September Employed on the recommendation of the de Menils, Jermayne MacAgy (fig. C.18) comes to Houston as the first professional director of the Contemporary Arts Association, until then a largely volunteer organization. She will curate a series of groundbreaking exhibitions over the next four years.

1956

John de Menil sits on the American Federation of Arts (AFA) Committee of the Museum of Fine Arts, Houston. Established by an act of Congress in 1909, the AFA promotes visual arts in collaboration with museums.

1957

April 3–6 The annual convention of the American Federation of Arts is held in Houston, an epochal event in the cultural life of the city (fig. C.21). John de Menil,

who is chairman of the Steering Committee, is instrumental in bringing in many key participants, including dealer Sidney Janis, art historians Sid Meyer Schapiro (fig. C.17) and James Johnson Sweeney, and artists Stuart Davis and Marcel Duchamp. The de Menils hire Henri Cartier-Bresson to photograph the convention.

May John de Menil joins the board of the Institute of International Education (IIE), Southern Regional Center, becoming its first campaign chairman. IIE promotes international education by offering scholarships and managing exchange programs worldwide. Wanting to introduce Houston to international students, John de Menil serves the organization in many capacities. As chairman of local and regional committees, he raises large sums of money, hosting events and promoting IIE programs through speaking engagements in cities all over the southern United States and in Latin America. The de Menils also lend artworks for display in its Houston office.

September 5 Jermayne MacAgy curates "Mark Rothko" at the Contemporary Arts Museum. Douglas and Jermayne MacAgy knew Rothko in San Francisco, and the de Menils had acquired two of his paintings in April, after Dominique saw his work at an exhibition at the Sidney Janis Gallery in New York. The CAA exhibition begins the artist's long engagement with Houston, though he never visits the city.

October 23 The inaugural meeting of the University of St. Thomas Arts Council is held to address the absence of a strong art history curriculum in the city and the need for providing public guidance and education in art through outreach in the university and surrounding community. In response, the de Menils offer the nucleus of their private collection to the university on extended loan for teaching purposes in May 1958.

1958

October 3–5 The University of St. Thomas celebrates the opening of Strake Hall and Jones Hall (fig. C.19),

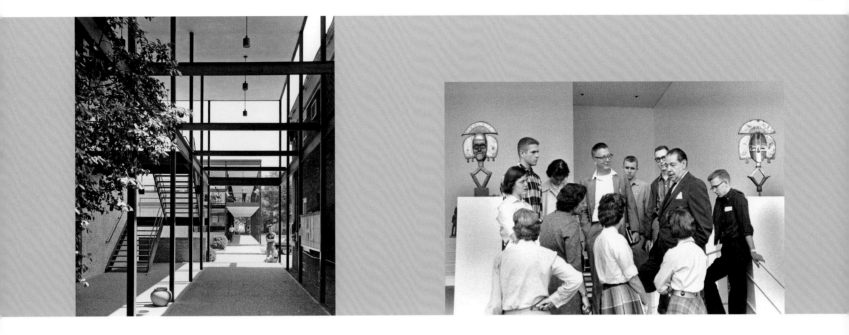

designed by Philip Johnson in association with Preston Bolton and Howard Barnstone. Jones Hall will become the main venue for exhibitions supported by the de Menils at the university.

1959

January When Jermayne MacAgy's contract is not renewed at the Contemporary Arts Association, the de Menils, who have been planning the creation of an art history department at the University of St. Thomas, ask her to join the faculty as its founding chairman. The couple underwrite the department's entire budget, including MacAgy and her staff's salaries. The offices are originally located in Jones Hall, and as the staff grows and an extensive library is formed, the department moves to an adjacent two-story house the interiors of which are redesigned by Bolton & Barnstone. In the fall, MacAgy begins teaching courses for St. Thomas students and for adults outside the university. She also curates exhibitions at St. Thomas and at the Museum of Fine Arts, Houston.

February 26 The Contemporary Arts Association presents "Totems Not Taboo: An Exhibition of Primitive Art," curated by Jermayne MacAgy, in the new Cullinan Hall at the Museum of Fine Arts, Houston. (The title of the exhibition is given by John de Menil, who invented many of the titles of exhibitions in which he was involved.) The first museum display in Houston of African and Oceanic art and art of the Americas, the show draws national acclaim, attracting visitors such as architect Buckminster Fuller and René d'Harnoncourt, director of the Museum of Modern Art, New York. The de Menils arrange for d'Harnoncourt to give students tours of the exhibition (fig. C.20).

Fall Douglas MacAgy, aware of the de Menils' interest in placing contemporary art in the chapel envisioned as part of Philip Johnson's plan for the University of St. Thomas, suggests they visit the New York studio of Mark Rothko. Dominique de Menil visits Rothko to see

the paintings he had completed for, but refused to deliver to, the Four Seasons restaurant in the Seagram Building in Manhattan. She is struck by how appropriate the artist's work is for a religious setting.

1960

The de Menils launch a photographic archive and research project, Image of the Black in Western Art, a systematic investigation of the iconography of Africans and their descendants, to demonstrate the constant presence of Africans in Western history and to examine through Western art both insights and misconceptions about blacks. Art historian Ladislas Bugner, recommended by his professor French scholar André Chastel, is named director of the project in Paris the following year. A Houston office is established in 1973, headed by Karen C. C. Dalton, aided by Geraldine Aramanda. The study culminates in a far-reaching publication project that is still under way (now under the aegis of Harvard University), and numerous artworks related to the project are added to the de Menil collection.

The de Menils ask Houston architects Preston Bolton and Howard Barnstone to add an art storage facility to their Houston residence by extending the west end of the building beyond the carport, but these plans are not carried through. At the same time, the architects design and build separate quarters on the property just southwest of the residence, which are initially used by household staff and later as a small guesthouse.

The de Menils move their New York residence to a townhouse at East 73rd Street. Preston Bolton and Howard Barnstone remodel the interior and, in 1964, design an adjoining paved courtyard garden featuring several Max Ernst sculptures. Like the de Menils' home in Houston, the townhouse serves as a meeting point for artists and writers, including John Cage, Alexander Calder, Merce Cunningham, Jasper Johns, Norman Mailer, Robert Rauschenberg, Meyer Schapiro, Frank Stella, and Andy Warhol, as well as a place to house

Fig. C.17
Meyer Schapiro with students during the American Federation of Arts Convention, Houston, 1957

Fig. C.18
Jermayne MacAgy, Contemporary Arts Museum Houston, 1958

Fig. C.19
Portico from Welder Hall to Jones Hall and Strake Hall, University of St. Thomas, Houston

Fig. C.20
René d'Harnoncourt leading a student tour at the exhibition "Totems Not Taboo," Museum of Fine Arts, Houston, 1959

Fig. C.21 *opposite bottom*
Newsletter for the American Federation of Arts Convention in Houston, 1957

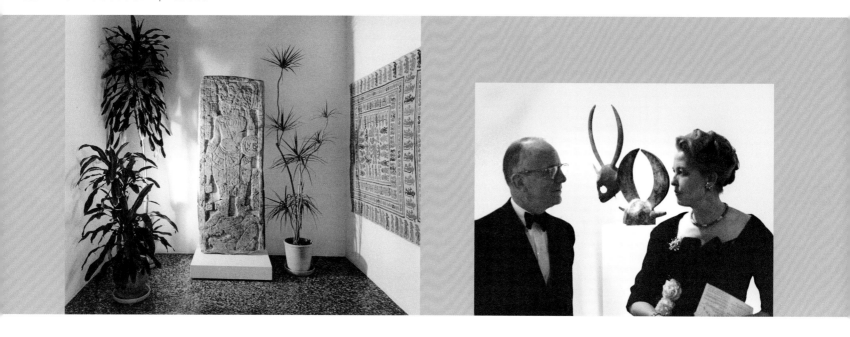

the couple's expanding art collection. Over the years, the de Menils invite University of St. Thomas and Rice University students, such as Susan Barnes, Suzanne Deal Booth, Kathryn Davidson, Fred Hughes, Karl Kilian, Helen Winkler, and Paul Winkler to stay there.

January 9 John de Menil accepts an invitation to become a trustee at the Museum of Primitive Art, New York, a position he holds until his death.

April John and Dominique de Menil inaugurate the Art Loan collection to spur interest in the visual arts among students at the University of St. Thomas. Prints, posters, and reproductions are lent for fifty cents per semester. This is a precursor to such groups as the Print Club and the Art Associates, and to the de Menils' practice of providing long-term loans to organizations such as the Institute of International Education, Rice University, Schlumberger Ltd., and the Texas Medical Center.

October–December Jermayne MacAgy inaugurates a public art appreciation course for adults at the University of St. Thomas. For six weeks on Thursday evenings, she gives illustrated lectures on the art of Africa, the South Pacific, and North, South, and Central America.

1961

James Johnson Sweeney (fig. C.26), who left his position as director of the Solomon R. Guggenheim Museum in New York the previous year, accepts an invitation, initiated by John de Menil, to serve as director of the Museum of Fine Arts, Houston, where he remains until 1967. During his tenure, the de Menils underwrite his salary and housing, as well as important acquisitions for the museum in modern, Greek, and non-Western art.

John de Menil joins the board of trustees at the Amon Carter Museum in Fort Worth. He serves in this position until 1969.

October–November Jermayne MacAgy presents her art appreciation course on the art and culture of the Italian Renaissance at the University of St. Thomas.

1962

The de Menils, through their foundation, begin to amass a small, but fine, group of artworks to form a permanent collection for the University of St. Thomas. In 1968 some of these works are exhibited in "A Young Teaching Collection" at the Museum of Fine Arts, Houston (fig. C.22).

May 1 John and Dominique de Menil become U.S. citizens.

October–November Jermayne MacAgy presents her art appreciation course on the art and culture of Egypt at the University of St. Thomas.

November 21 "The John and Dominique de Menil Collection," an exhibition primarily of non-Western art, opens at the Museum of Primitive Art, New York (fig. C.23). This is the first national venue to feature the de Menils' growing collection.

1963

Jermayne MacAgy and the de Menils visit renowned art historians, including Robert Goldwater, George Heard Hamilton, Meyer Schapiro, and Rudolf Wittkower, to

solicit recommendations for art history faculty for the University of St. Thomas.

February–April Jermayne MacAgy launches a spring series of art appreciation courses for adults, open to the public, at the University of St. Thomas, focusing on the art of Paul Cézanne, El Greco, Giotto, Francisco de Goya, Pablo Picasso, and Rembrandt. In October–November she lectures on Latin American art from pre-Columbian times to the present.

1964

Dominique de Menil personally recruits faculty for the University of St. Thomas Art Department: recent graduate in modern art history William A. Camfield arrives in January, followed in 1965 by Pacific Islands scholar Mino Badner and art historian of antiquities Philip Oliver-Smith, and in 1967 by architectural historian Walter Widrig.

February 18 Jermayne MacAgy dies unexpectedly of diabetic shock at the age of fifty. Dominique de Menil takes over MacAgy's classes and becomes acting chairperson of the University of St. Thomas Art Department. MacAgy leaves her papers to John and Dominique de Menil, now in the Menil Archives, and over 280 artworks, including pieces by Joseph Cornell, Mark Rothko, and Clyfford Still, which are now in the Menil Collection.

March 22 Composer Karl Heinz Stockhausen performs at the University of St. Thomas. Over the years, the de Menils sponsor concerts in Houston by other avant-garde composers, such as John Cage, Morton Feldman, Philip Glass, and Steve Reich.

March–April A new University of St. Thomas spring lecture series begins. Titled "The Art of Collecting," the series includes a tour by John and Dominique de Menil of their home and private collection.

April With Louise Ferrari, assistant to Jermayne MacAgy and later a private dealer, Dominique de Menil visits Mark Rothko in New York to ask him to create paint-

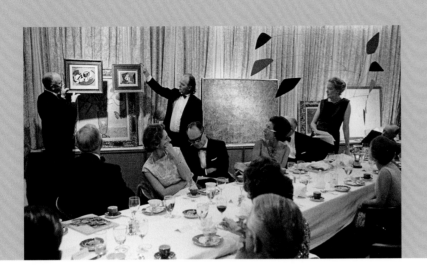

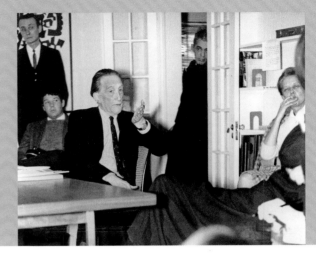

ings for the Catholic chapel she and John plan to build at the University of St. Thomas in MacAgy's memory. The artist accepts the commission, completing the paintings three years later. In December, Philip Johnson is formally engaged as architect for the chapel, with Howard Barnstone and Eugene Aubry acting as local architects. After design conflicts arise between Johnson and Rothko, Johnson excuses himself from the project, and Barnstone and Aubry complete the chapel in 1971.

May 16 "Magritte," curated by Dominique de Menil at the request of Arkansas's Governor Winthrop Rockefeller, opens at the Arkansas Art Center, Little Rock. Many of the works in the exhibition are from the de Menils' and their children's collections.

June 28 At the University of St. Thomas, Dominique de Menil curates "Great Masters for Small Budgets," an exhibition of prints and drawings by, among others, Eduardo Chillida, Jean Dubuffet, Juan Gris, Henri Matisse, and Pablo Picasso. Concurrently, she and John de Menil form the Print Club at St. Thomas. For a five-dollar membership fee (one dollar for students), participants have the opportunity to buy, at cost, prints that Dominique de Menil purchases in shops and galleries in France and New York. After 1969 the club continues to operate at the Rice Museum until 1971.

September 1 John de Menil and Houston investor Aaron J. Farfel establish Art Investments, Ltd. Together they create a plan to stimulate art appreciation, develop awareness, and educate the eye by forming a syndicate, made up of ten members, each of whom invests a specific amount of money for the purchase of artwork from a selection suggested by the de Menils. (According to Farfel's daughter, Lois Stark, the impetus for the program came from a lunch conversation that John de Menil had had with her father in which John said that some Houstonians would think nothing of paying $100,000 for a prize bull but would not pay $1,000 for a work of art.) Twice a year, in a rotating arrangement, members choose a new painting to keep in their homes for six months. The rotation process takes place over dinner at the Ramada Club (fig. C.24). A guest speaker is invited to give a talk—an art historian, an art critic or an artist, but not an art dealer. The partnership dissolves in 1973, at which time the art is auctioned among its members.

September 10 John and Dominique de Menil purchase a bronze casting of Max Ernst's *Capricorn*. Twelve years earlier they had seen a photograph in a *Life* magazine article of the original concrete sculpture, which was located in the artist's garden in Sedona, Arizona. The de Menils asked if the sculpture could be brought to Houston, but its weight and fragile state made that impossible, so they encouraged Ernst to create bronze castings made from a plaster mold.

October 28 Dominique de Menil installs her first University of St. Thomas exhibition, "Constant Companions: An Exhibition of Mythological Animals, Demons and Monsters, Phantasmal Creatures and Various Anatomical Assemblages," in the gallery in Jones Hall. The exhibition evolved from a class Jermayne MacAgy was teaching, which Dominique took over upon MacAgy's death. One of the artists included in the exhibition, Roberto Matta, gives an informal talk to University of St. Thomas students the following March.

December 10 In Paris, John de Menil attends the opening of "Méta Tinguely," an exhibition of Jean Tinguely sculpture, at Iolas Gallery. John purchases the entire exhibition (nine mechanical sculptures), in consultation with James Johnson Sweeney, as a gift to the Museum of Fine Arts, Houston. The works are exhibited there the following spring.

1965

February 24 Marcel Duchamp visits the University of St. Thomas on the occasion of the exhibition of his work, "Not Seen and/or Less Seen of/by Rrose Selavy," at the Museum of Fine Arts, Houston. He gives an informal talk to students and faculty (fig. C.25). Art history student Kathryn Davidson interviews him for the university's newspaper.

Fig. C.22
"A Young Teaching Collection," Museum of Fine Arts, Houston, 1968

Fig. C.23
John and Dominique de Menil at the opening of "The John and Dominique de Menil Collection," Museum of Primitive Art, New York, 1962

Fig. C.24
John de Menil, Jim Love, and Dominique de Menil (*standing*) with Art Investments, Ltd. members evaluating artworks at a dinner party, Ramada Club, Houston, 1965

Fig. C.25
Marcel Duchamp speaking with students and Dominique de Menil (*far right*), University of St. Thomas Art Department, Houston, 1965

Fig. C.26 *opposite bottom*
James Johnson Sweeney and Caroline Wiess Law, Houston, 1967

March–April The University of St. Thomas spring lecture series titled "The History of Architecture" features architect Howard Barnstone; art historian Howard Hibbard; and architectural historians Robert Banner, David Coffin, and John Jacobus.

October–November Mino Badner conducts the University of St. Thomas fall lecture series titled "African Art."

December 17–18 During René Magritte's first trip to the United States, he visits Houston, following the opening of his retrospective at the Museum of Modern Art, New York. Organized by the Art Associates of the University of St. Thomas, his stay includes informal visits with students and faculty and a memorable trip to a rodeo in Simonton, Texas.

1966

John and Dominique de Menil underwrite the publication of *The Galveston That Was*, a chronicle of the city's disappearing architectural treasures, by Howard Barnstone. At John's suggestion, Henri Cartier-Bresson joins Ezra Stoller as photographers for the project. The book helps revive historical preservation efforts in Galveston.

March–May The University of St. Thomas spring lecture series titled "Rome in the Renaissance," features art historians James Beck, Milton Lewine, Donald Posner, and Rudolf Wittkower; architectural historian David Coffin; and collector Janos Scholz.

April 22 John de Menil incorporates a private foundation, Horizon Two Thousand. Its mission is to aid the underprivileged and uneducated throughout the world by furnishing multilingual educational motion pictures that teach literacy and trade skills. Its primary project is to produce Roberto Rossellini's twelve-hour television series, *Lotta dell'uomo per la sua sopravvivenza* (*Man's Struggle for His Survival*), 1967–69, completed segments of which premiere at the University of St. Thomas on November 21, 1968. The foundation

becomes inactive with John de Menil's death in 1973 and is formally dissolved in June 1977.

September On the University of St. Thomas campus, the de Menils sponsor the Special Training Institute on Problems of School Desegregation. Created for teachers and staff of the Houston Independent School District, the program is designed to improve the concepts, attitudes, and understanding of desegregation in elementary and secondary schools. The program continues through January 1968.

October–November The University of St. Thomas fall lecture series titled "Modern Art: A Century of Revolution and Evolution," features art historian William A. Camfield and curators Henry Geldzahler, and Robert Rosenblum.

1967

February–March The University of St. Thomas spring lecture series features artist and critic Brian O'Doherty, composer Morton Feldman (fig. C.27), and curator Eleanor Sayre.

May John and Dominique de Menil assist University of St. Thomas professors Philip Oliver-Smith and Walter Widrig in establishing the Houston Society of the Archaeological Institute of America. The Menil Foundation also joins backers of the archaeological dig opened by Oliver-Smith and Widrig in 1976 at the Via Gabina Villas site in Latium near Rome (fig. C.28).

May 17 Unrest on the campus of Houston's traditionally black campus Texas Southern University results in a violent encounter between students and police. The conflict leads to the accidental death of a police officer and the prosecution of five students. John de Menil pays the students' legal fees and for transportation of their supporters to the trial's venue in Victoria, 125 miles southwest of Houston. The students were ultimately acquitted of all charges.

June The Catholic Church, asked to install a Vatican Pavilion at HemisFair '68 in San Antonio, commissions the University of St. Thomas Art Department to organize an exhibition of religious art by living artists. John and Dominique de Menil assume the curatorial duties. Among those who respond positively to the de Menils' invitation are Robert Indiana, Roberto Matta, Tony Smith, and Andy Warhol; plans are also made to exhibit the recently completed chapel paintings by Mark Rothko for the first time as an ensemble in a sequestered octagonal space. Although the project collapses, two commissions go forward: Indiana's *Love Cross*, 1968 (The Menil Collection, Houston), and Warhol's film *Sunset*, 1967.

June John and Dominique de Menil persuade medievalist Gerald O'Grady, former Rice University faculty member, to organize a media studies program for the University of St. Thomas and the Houston public, focusing on the impact of radio, television, and film on society. O'Grady becomes the director, instituting an ambitious roster of undergraduate courses, continuing education for adults, and screenings and talks for schoolchildren. Named the Media Center, the institution will later become part of Rice University.

June 3 The de Menils host a benefit for the Merce Cunningham Foundation at Philip Johnson's Glass House in New Canaan, Connecticut. There, Andy Warhol meets Fred Hughes, a former art history student of Dominique's at the University of St. Thomas. Hughes will become Warhol's lifelong business manager and confidant and will encourage the de Menils to expand their collection of the artist's work.

October In Houston, a fundraiser for Martin Luther King Jr. is planned by aide Andrew Young, Texas legislator Curtis Graves, and Houstonian Reverend William Lawson. The agency hired to sell tickets is harassed by death threats and a smoke bomb and stops promoting the event. The organizers, fearing that the auditorium will be empty and they will lose money, begin giving away tickets in order to fill the seats. On the day before

the concert, John de Menil sends a check to the organizers to cover the cost of the tickets and all expenses.

October 19 "Visionary Architects" opens at the University of St. Thomas. Originally curated by Jean-Claude Lemagny in France and organized by Dominique de Menil in the United States, the exhibition and catalogue mark a new plateau in scholarly achievements for de Menil projects, reviving interest in the forgotten eighteenth- and nineteenth-century French architects Étienne-Louis Boullée (fig. C.29), Claude Nicolas Ledoux, and Jean-Jacques Lequeu. At Dominique de Menil's request, architect Louis Kahn contributes a poem as a foreword to the catalogue. In connection with the show, the fall lecture series features art historians Jacques de Caso and Robert Rosenblum and architects Buckminster Fuller and Louis Kahn.

1968

March 6 Artist Claes Oldenburg gives an informal talk to University of St. Thomas students.

March 9 Film director Jean-Luc Godard visits Houston to present his film *La Chinoise* at the University of St. Thomas (fig. C.30). The infamous Welder Hall screening is canceled abruptly when the temporary projection equipment destroys part of the director's film print.

March–April In connection with "Look Back: An Exhibition of Cubist Paintings and Sculptures from the Menil Family Collection," the University of St. Thomas presents its spring lecture series, "The World Beyond Cubism," featuring art historians Robert Goldwater, George Heard Hamilton, Fred Licht, and Leo Steinberg.

April Experimental filmmaker Stan VanDerBeek becomes the University of St. Thomas Media Center's first artist-in-residence.

May 3–4 In an event organized by the University of St. Thomas Media Center, Andy Warhol, accompanied by Paul Morrissey and Viva, visits the university to screen his films, including ninety minutes of the twenty-five-hour ★★★★ (*Four Stars*) and the premiere of *Imitation of Christ*, both 1967. Two months later, on June 3, Warhol is shot and nearly killed by author Valerie Solanas at his studio in New York. The de Menils help assemble a medical team to assist in his recovery.

Summer Norman Mailer stays at the de Menil residence in Houston while he works on a book about the space program, *Of a Fire on the Moon*, 1970. The following year, John de Menil has a minor part in Mailer's film *Maidstone*, playing a foreign agent similar to his real-life role in World War II.

August At the de Menils' invitation, classicist Thomas McEvilley joins the University of St. Thomas faculty.

October 18–20 The Media Center at the University of St. Thomas sponsors Houston's first film conference at the Shamrock Hilton Hotel. Participants include classics historian William Arrowsmith and director of the American Film Institute George Stevens Jr.

October 28 Art historian Douglas Cooper gives a lecture on Pablo Picasso and the ballet *Parade*, for which Picasso designed the sets and costumes.

November 21 Opening at the University of St. Thomas, a tribute exhibition titled "Jermayne MacAgy: A Life Illustrated by an Exhibition," includes MacAgy's personal art collection and is curated by Dominique de Menil. A serial portrait of MacAgy by Andy Warhol is commissioned for the exhibition.

November 23 The de Menils propose to move the Art Department and Media Center at the University of St. Thomas to Rice University. Tensions had begun to arise in 1967 as the de Menils' ecumenical vision for the university and the cutting-edge nature of some of their presentations clashed with the more traditional goals of the Basilian clergy, who administer the school.

November–December As part of the University of St. Thomas's fall lecture series titled "Art Collecting," John and Dominique de Menil give the lecture "The Delight and Dilemma of Collecting," which expresses their

Fig. C.27
Louise Ferrari and Morton Feldman, Houston, 1967

Fig. C.28
Via Gabina Villas archeological site, Latium, Italy, 1978

Fig. C.29
Étienne-Louis Boullée, *Newton's Cenotaph*, 1784. From "Visionary Architects," University of St. Thomas, Houston, 1967

Fig. C.30
Jean-Luc Godard with Dominique de Menil, Houston, 1968

philosophy, motivation, and personal approach to collecting art. Other speakers in the series are art historians Daniel Biebuyck, Richard F. Brown, and Daniel Robbins.

November–December Gerald O'Grady organizes "The Film Revolution," a series in which filmmakers Scott Bartlett, Al and David Maysles, Jan Neméc, Roberto Rossellini, Melvin Van Peebles, and Andy Warhol screen and discuss their work at the University of St. Thomas.

December An agreement between Rice University, the University of St. Thomas, and the de Menils is reached: the art history faculty, the exhibition program, the art and slide libraries, and the Media Center are transferred to Rice in fall 1969, and an exchange program of art courses is established between the two schools. The Menil Foundation reacquires the art that had been donated to St. Thomas in exchange for property it owns adjacent to the school (which constitutes parts of the present-day campus). The de Menils establish the Institute for the Arts to administer the publication and exhibition programs at Rice.

As the de Menils begin to hire staff to work on their personal art collection and initiatives of the Menil Foundation, they commission Howard Barnstone and Eugene Aubry to convert two bays of their carport into an office (fig. C.31). Called the "collection room," the office is used to process and catalogue art, staffed initially by researcher Virginia Camfield and curator Kathryn Davidson, who are later joined by administrative curator Mary Jane Victor and collections assistant Mary Kadish. When John de Menil retires from Schlumberger in 1969, Elsian Cozens becomes his personal assistant, setting up an office within the residence. Upon John's death, Cozens becomes Dominique de Menil's personal assistant, a position she holds until Dominique's death in 1997.

1969
The Menil Foundation begins its sponsorship of, and direct involvement in, the catalogues raisonnés of René Magritte by David Sylvester and Sarah Whitfield

(fig. C.32) and of Max Ernst by Werner Spies and Sigrid and Günter Metken. The projects continue over several decades.

January 17 "Images by Light," an early photography exhibition in Houston, opens at the University of St. Thomas. Curated by John Szarkowski, the show features more than one hundred photographs from the daguerreotype to the present, on loan from the Museum of Modern Art, New York. In conjunction with the exhibition, Geoff Winningham organizes "Photography" at the University of St. Thomas, a series featuring lectures by curators Peter Bunnell, Nathan Lyons, and John Szarkowski and photographers Robert Frank, Arthur Siegel, Frederick Sommer, and Jerry N. Uelsmann.

February A temporary building to serve as the Rice Museum is built. Designed by Howard Barnstone and Eugene Aubry, it is nicknamed the "Art Barn" for its its corrugated tin construction; it is followed by an adjacent same-sized "tin shed" building a year later, which houses the school's Media Center. Although conceived as temporary structures, both remain on the Rice University campus. The Rice Museum is now the Glasscock School of Continuing Studies, and the Media Center building houses the Department of Visual and Dramatic Arts.

February–April Gerald O'Grady organizes the "Visiting Director Series," in which Shirley Clarke, Francis Ford Coppola, and George Lucas come to screen and discuss their films at the University of St. Thomas.

March 25 "The Machine as Seen at the End of the Mechanical Age," the inaugural exhibition in the Rice Museum, opens. Organized by Pontus Hulten (fig. C.35) for the Museum of Modern Art, New York, the provocative exhibition features a replica of Marcel Duchamp's *The Bride Stripped Bare by Her Bachelors, Even* (*The Large Glass*), 1915–23, and Ed Kienholz's *Back Seat Dodge '38*, 1964, as well as kinetic sculptures Jean Tinguely created specifically for the Rice venue. The building includes a circular entrance wall designed to enclose,

outdoors, a replica of the model for Vladimir Tatlin's *Monument for the Third International*, 1920. Thirty thousand visitors see the exhibition.

April The Institute for the Arts brings a traveling exhibition from the Museum of Modern Art, New York, of full-scale wood maquettes of six Tony Smith sculptures to Rice University, where the works are installed in front of Hamman Hall. In May John de Menil commissions the metal fabrication of five of these sculptures: *The Snake Is Out*, 1962; *The Elevens Are Up*, 1963; *Marriage*, 1965; and *New Piece* and *Spitball*, both 1966. The fabrication is completed in 1974, and in 1976 the works are installed on Menil Foundation properties neighboring the Rothko Chapel (fig. C.33). For the opening of the Menil Collection in 1987, several of the works are installed in various outdoor locations on the museum campus. In 2006 *The Elevens Are Up* and *New Piece*, joined by *Wall*, 1964 (a work donated by the artist's widow, Jane Smith, in honor of Dominique de Menil), are installed as a group on the Menil campus in a green space on Loretto Street adjoining Richmond Hall.

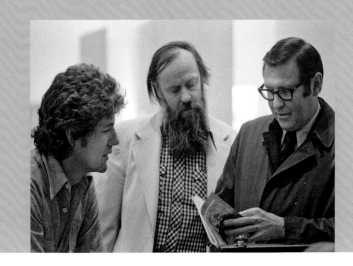

May–August As a response to the April assassination of Martin Luther King Jr., the de Menils offer Barnett Newman's *Broken Obelisk*, 1963–67, as a partial gift to the City of Houston, with the provision that it be dedicated to the civil rights leader. The city declines the gift. In response, John de Menil criticizes the city, suggesting they install a plaque with the sculpture inscribed with the Biblical quotation "Forgive them for they know not what they do." The de Menils purchase the piece, and ultimately install it in a reflecting pool outside the Rothko Chapel.

June The University of St. Thomas formally divests itself of its connection with the planned chapel and its Mark Rothko paintings. The de Menils consider other locations, and after plans fall through to place it in the Texas Medical Center as part of the Institute of Religion and Human Development, they build it on land they own adjacent to the St. Thomas campus and rededicate it as a space for ecumenical worship. The chapel, which is completed in 1971, is transferred to the Institute of Religion and Human Development, which runs it until 1972, at which time it is established as an autonomous entity known as the Rothko Chapel.

October 29 In conjunction with the Rhode Island School of Design, where John de Menil is a trustee, the Rice Museum presents "Raid the Icebox 1 with Andy Warhol: An Exhibition Selected from the Storage Vaults of the Museum of Art, Rhode Island School of Design [RISD]." Warhol curates and installs the show and attends the opening. The idea for the exhibition originated when John de Menil was visiting the RISD museum and discovered the richness of objects held in storage (he invented the title for the exhibition). He suggested that an important contemporary artist curate an exhibition from the holdings and proposed Warhol. The exhibition is an early example of artist interventions within museum collections. In later years, a number of contemporary artists create related exhibitions based on the Menil Collection's holdings.

1970
Interested in providing opportunities in higher education for African Americans, John de Menil contacts Granville Sawyer, the president of Texas Southern University. He is told about a student and campus activist, Mickey Leland. The de Menils contact him and begin what becomes a long and gratifying friendship. Over the years, they support many of his endeavors, and Leland becomes a close advisor and voice for the black community within the Menil Foundation, serving on its board.

Beginning now and into 1976, Roberto Rossellini frequently travels from Rome to Houston. He stays at the de Menils' home and, encouraged by John, works with Rice faculty members on a project to introduce the visual language of film into scientific education. He contracts with Italian television (RAI) to direct *Science*, a series of ten one-hour programs on which he collaborates with Rice University scientists. While a script is written and published, the project is never completed, but *Rice University*, 1971, two fifty-minute films of rough footage, is assembled. During this period, Rossellini directs his famous historical films *Socrates*, 1971, *The Age of Medici*, 1972, *Blaise Pascal*, 1972, *Descartes*, 1973, *Year One*, 1974, and *The Messiah*, 1975. He also writes and publishes scripts for historical documentaries on the American Revolution and the Industrial Revolution.

January 14 The Rice University Media Center opens with James Blue leading the Film Department (fig. C.34), Geoff Winningham as head of the Photography Department, and filmmaker Bruce Baillie as a visiting artist. Entirely funded by the de Menils, the flexible, state-of-the-art facility includes an auditorium, a projection room with Super-8, 16mm, and 35mm equipment, editing and production rooms, animating facilities, and professionally equipped darkrooms. Seeking to attract both liberal arts and science students, the Media Center hosts a wide-ranging series of repertory films, documentaries, and independent short films. Innovative prototype equipment linking Super-8 film with synchronous sound is developed and along with the use

Fig. C.31
Collection room in the de Menils' home, ca. 1971

Fig. C.32
Cover of *René Magritte Catalogue Raisonné*, vol. 2, 1993

Fig. C.33
Tony Smith, *The Snake Is Out*, 1962. The Menil Collection, Houston. Installed beside the Menil Foundation office, Branard Street, Houston, 1975

Fig. C.34
James Blue, Colin Young, and Gerald O'Grady, Rice Media Center, Rice University, Houston, 1971

Fig. C.35 *opposite bottom*
Pontus Hulten and Dominique de Menil, 1968

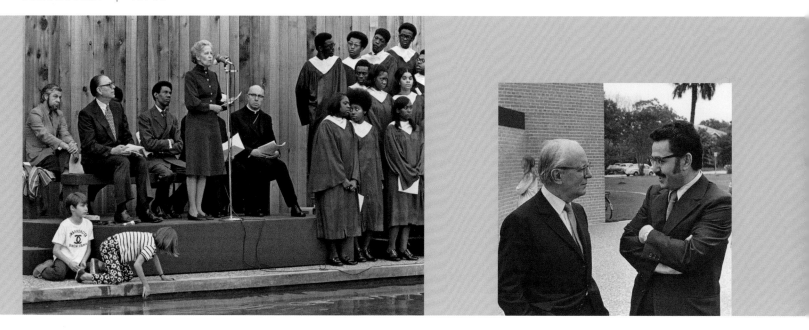

of the earliest portable videotape devices, the center is at the forefront of a movement to make media more accessible to the public.

January 21–24 Composer La Monte Young and light artist Marion Zazeela set up a continuous, around-the-clock sound and light environment, titled *Dream House*, in the Rice Museum.

January–May James Blue organizes a "Spring Film-makers Series" at the Rice Media Center, in which film-makers Bernardo Bertolucci, James McBride, Adolfas Mekas, and Roberto Rossellini, among others, come to screen and discuss their films. Visiting film scholar Colin Young conducts a "Spring Film Form Series" in which he screens and discusses the work of foreign film directors.

February The de Menils attend the exhibition "four 'monuments' to V. Tatlin 1964–1969 from Dan Flavin" at the Leo Castelli Gallery in New York. Deeply impressed, they purchase all of the works in the exhibition. In 2003, the sculptures are installed as a group in Richmond Hall on the Menil campus.

March 16–19 Art historian Leo Steinberg presents a series of lectures titled "Michelangelo Problems or Our Problems with Michelangelo" at Rice University.

April 3 Sponsored by the de Menils, poet, writer, and activist LeRoi Jones (Amiri Baraka) speaks at Texas Southern University.

May Scholar Leon Siroto is contracted to research and catalogue the entire African collection. He prepares texts on hundreds of objects over nearly two decades.

May 14 Expanding the international scope of the de Menils' exhibition program and collection, "Max Ernst: Inside the Sight" opens at Kunsthalle, Hamburg. A retrospective of Ernst's career drawn almost entirely from the de Menils' and their children's holdings, the show travels for several years to sixteen other venues throughout Europe and the United States, appearing at the Rice Museum in 1973.

May 26 Geoff Winningham prepares a detailed memo-randum to Dominique de Menil, providing a list of six-teen established photographers and ten younger ones. While the de Menils had a small collection of photography prior to 1970, they begin acquiring works by many of the artists recommended by Winningham, which spurs the growth of the collection.

Summer John and Dominique de Menil visit the Long Island, New York, studio of Willem De Kooning. Their daughter Christophe introduced her parents to De Kooning, whom she had met in 1963 while work-ing with photographer Hans Namuth on a film about the artist. During the de Menils' visit, photographed by their daughter Adelaide de Menil, the couple notices a small abstract oil painting in progress, *Untitled*, 1970, and reserve it, acquiring it in 1971.

September 10 "Conversations with the Dead" opens at Rice Museum, the culmination of Danny Lyon's proj-ect photographing life inside the Texas state prisons (1967–69). Six years later, the photographs are used as evidence by the U.S. Justice Department in a lawsuit against the prison system. The de Menils met Lyon while he was working on the project, and their interest in the subject later leads them to sponsor curator James Harithas's 1973 exhibition "From Within: Selected Works by Artists and Inmates" at Rice Museum featur-ing art by New York State maximum-security pris-oners. After John de Menil's death, Dominique de Menil periodically assists Lyon's photographic and film proj-ects as well as purchases almost two dozen artworks by prison artists, such as Henry Ray Clark, Frank Jones, and Billy McCune.

October–December In connection with the exhibition "Ten Centuries That Shaped the West: Greek and Roman Art in Texas Collections," Rice presents the fall lecture series, "The Greek and Roman World," featuring art historians Otto Brendel, Alfred Frazer, George M.A. Hanfmann, and Frank Snowden.

November 17–19 Art historian and curator Charles Sterling conducts a lecture series on French fifteenth-century painters at Rice University.

November 20–21 As part of a film festival touring the United States, the Rice Media Center shows the work of African filmmakers. The de Menils' interest in the nascent field of African film leads them, after consult-ing with friend and collaborator Roberto Rossellini, to give financial support to Moustapha Alassane from Niger, one of the filmmakers who comes to the Media Center, and the Nigerian filmmaker Ola Balogun, both of whom are at the beginnings of their important careers. The de Menils acquire some of their films.

1971

Film scholar Colin Young of the National Film School in London, formerly chair of UCLA's Department of Theater Arts and head of its highly respected film school, advises the de Menils on media matters. The filmmaking faculty at the Rice Media Center includes documentarians James Blue, David Hancock, David MacDougall, and Mark McCarty. Along with Geoff Winningham, Eve Sonneman teaches photography.

February 4 "Some American History" opens at the Rice Museum. Conceived by artist Larry Rivers, this con-troversial exhibition about black history includes com-missioned works by Rivers and African American artists Ellsworth Ausby, Frank Bowling, Peter Bradley, Daniel LaRue Johnson, Joe Overstreet, and William Williams. These pieces are now in the Menil Collection.

February 27–28 The Rothko Chapel (fig. C.40) is dedi-cated in opening ceremonies attended by members of the Christian faith—Baptist, Catholic, Greek Ortho-dox, Protestant Episcopal, and United Methodist— as well as the Islamic and Jewish faiths (figs. C.36–37). Barnett Newman's *Broken Obelisk*, 1963–67, installed in the adjacent reflecting pool, is dedicated in honor of Dr. Martin Luther King Jr.

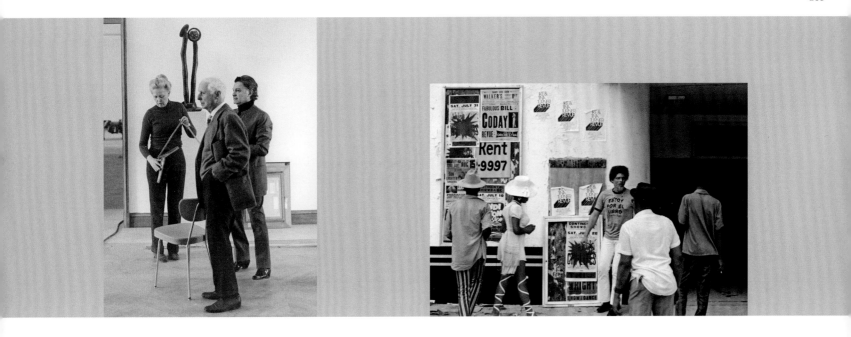

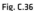

February–March Art critic Rosamond Bernier conducts the "Paris Masters" lecture series at Rice, which concludes with a concert performance by pianists Arthur Gold and Robert Fizdale.

March Houston Independent School District's program Volunteers in Public Schools initiates "Art to Schools," funded by the Institute for the Arts and managed by staff and docents at the Rice Museum. For five years, the program provides to public schools free art slideshow presentations given by docents, accompanied by examples of original works from the de Menils' collection.

April 2 "Max Ernst: Inside the Sight" opens at Les Salles de l'Orangerie in Paris (fig. C.38). Organized by the Institute for the Arts at Rice University and curated by Dominique de Menil, the show marks Ernst's eightieth year. It travels extensively in Germany, France, and the United States. It opens at the Rice Museum in February 1973, with the artist and his wife, Dorothea Tanning, in attendance. Francois de Menil films the Rice installation, which is made into a completed film by him and his son John in 2008.

June 21 John de Menil is introduced to Deloyd Parker, founder of SHAPE (Self-Help for African People through Education), a community center in Houston's Third Ward. Impressed by Parker's determination and independence, the de Menils begin a long-lasting commitment to SHAPE, providing substantial and wide-ranging funding through 1988.

August 22 "The De Luxe Show," an exhibition of contemporary abstract art, opens at the De Luxe Theater, a remodeled movie house in Houston's historically African American Fifth Ward. The exhibition—financed by the de Menils, curated by artist Peter Bradley, and coordinated by civil rights activist Mickey Leland (fig. C.39)—is one of the first in the country to racially integrate contemporary artists. Artists Sam Gilliam and Kenneth Noland install the show with Menil Foundation exhibition assistant Helen Winkler. Critic Clement Greenberg travels from New York to see and write about the show. Over one thousand people from all parts of Houston visit on opening day. Young people from the neighborhood assist at the opening and work as guards and caretakers of the De Luxe during the run of the exhibition.

October To solicit international participation in the Rothko Chapel's activities, John and Dominique de Menil begin travels to Abidjan-Bouaké (Côte d'Ivoire), Beirut, Cairo, Delhi, Lagos, Madras, Nigeria, Paris, Rome (fig. C.41), and Tehran, meeting and talking with

Fig. C.36
Dominique de Menil speaking at the dedication of the Rothko Chapel, Houston, 1971

Fig. C.37
John de Menil and Ibrahim Yazdi, president of the Islamic Society of Greater Houston, at the dedication of the Rothko Chapel, Houston, 1971

Fig. C.38
Dominique de Menil, Max Ernst, and Alexander Iolas installing "Max Ernst: Inside the Sight," Les Salles de l'Orangerie, Paris, 1971

Fig. C.39
Mickey Leland (*center*) preparing for "The De Luxe Show," De Luxe Theater, Houston, 1971

Fig. C.40 *bottom*
Rothko Chapel, Houston

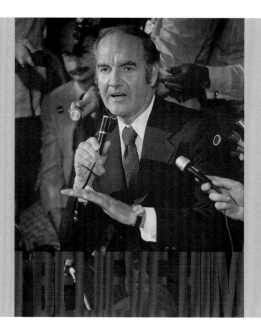

Buddhist, Christian, Hindu, Islamic, and Jewish spiritual leaders. During the trip, which continues to the following spring, they meet Lebanese activist Nabila Drooby, who becomes the director of the Rothko Chapel and is instrumental in developing the series of important international colloquia held there in ensuing years to address global political, sociological, and religious issues. The de Menils also meet and befriend Youakim Moubarac, a Lebanese Maronite theologian, and André Scrima, a Romanian priest, both of whom participate in the first colloquium at the chapel.

1972

Simone Swan becomes the founding executive vice president of the Menil Foundation, a position she holds until 1977. At her recommendation, Harris Rosenstein, an editor at *Art News*, is named director of the Institute for the Arts in November, establishing a stronger link to New York avant-garde artists, such as Brice Marden and David Novros. Rosenstein later continues as publications director at the Menil Foundation.

February–March The Rice Media Center hosts "John Whitney: Toward a New Film Language." Computer graphics pioneer Whitney shows and discusses his abstract computer-generated images.

April The Black Arts Center, operated by Hope Development, Inc., opens the Black Arts Gallery in the De Luxe Theater. The de Menils, taking a behind-the-scenes role, work with local black leaders, providing operating funds and collaborating on the exhibition "Joe Overstreet," which opens there and at the Rice Museum in May. The following year, the de Menils lend significant works from their collection to "Tribal Art of Africa," an exhibition curated by them, with texts written by Leon Siroto and Alvia J. Wardlaw. The four-week-long event attracts busloads of students from the Fifth Ward and neighboring communities. A selected group of objects from the exhibition remain on view at the De Luxe for two years.

April 9 Morton Feldman's composition "The Rothko Chapel," commissioned by the de Menils, premieres at the chapel in a performance by the Corpus Christi Symphony, accompanied by members of the Houston Symphony Chorale.

October Sponsored by John and Dominique de Menil, Dan Flavin designs and produces a poster for George McGovern's presidential campaign (fig. C.42). Always politically active and outspoken, the de Menils correspond with elected officials and contribute funds at the local, state, and national levels. Their support is often linked to African American candidates, civil rights, and promotion of the arts. They vigorously support numerous local and national Democratic Party politicians, including Sheila Jackson Lee, Mickey Leland, Barbara Jordan, Jesse Jackson, and Jimmy Carter.

October 5 Dan Flavin attends the opening of "cornered fluorescent light from Dan Flavin," a group of site-specific works he created for Rice Museum.

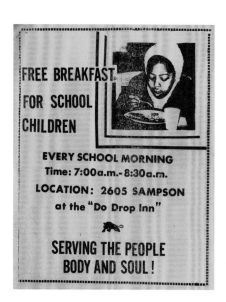

November 7 Menil Foundation trustee Mickey Leland is elected to the Texas House of Representatives, and six years later, to the U. S. House of Representatives, where he serves for over ten years, focusing much of his efforts on health, hunger, and poverty. In 1989 Leland dies in a plane crash in Ethiopia during a relief mission.

November 22 The de Menils engage Louis Kahn to begin preliminary designs for a museum complex on land adjacent to the Rothko Chapel. This is the earliest indication of the de Menils' desire to house their collection in Houston's Montrose neighborhood, its present location. Kahn creates drawings February–October 1973, but the project ends with his death in March 1974.

December Adding another dimension to the Image of the Black in Western Art project, Adelaide de Menil Carpenter and her husband, anthropologist Edmund Carpenter, donate to the Menil Foundation over 2,000 artifacts from American and European popular culture of the nineteenth and twentieth centuries, most depicting black people in demeaning, stereotypical roles. From 1973 to 1999, the Carpenters continue to add significantly to this collection.

1973

January The Menil Foundation provides yearlong funding for the Free Breakfast for School Children program operated by the Black Panther Party in Houston (fig. C.45). The following month, the foundation supplies groceries for distribution by the Black Panthers at a rally supporting James Aaron, a convicted party leader believed to be a victim of racist police policies.

January 4 The Menil Foundation establishes the Committee for Upgrading Black Scholars (CUBS), a college-scholarship program for Houston-area high school students. To keep the decision-making within the community, CUBS is administered by an all-black committee, including Texas State Representative Mickey Leland. The de Menils also support African Americans already in college, including Yale University student

Sylvia Ardyn Boone, who later becomes the first tenured African American woman on the Yale University faculty.

February–October Artists Lynda Benglis and Peter Plagens; art historians Rosamond Bernier, Theodore Reff, and Leo Steinberg; and curators Peter Bunnell, Henry Geldzahler, and John Szarkowski; and film historian František Daniel give lectures at Rice University.

June 1 John de Menil dies of cancer at the age of sixty-nine. His funeral at St Anne's Catholic Church is attended by a diverse cross-section of Houston's art, religious, and business communities as well as other local residents. Following a letter he prepared specifying the details of his funeral, John is buried in a simple wood coffin transported to the church in a Volkswagen van. The funeral director is black, and music by Bob Dylan is played, including "Blowin' in the Wind," "The Times They Are A-Changin'," "The Ballad of Hollis Brown," and "With God On Our Side," because, as John wrote, "All my life I've been, mind and marrow, on the side of the underdog."

July 22–30 The Rothko Chapel hosts its first colloquium, "Traditional Modes of Contemplation and Action," organized by Yusuf Ibish of the American University, Beirut, whom both John and Dominique de Menil met in October 1971. Long-planned by the de Menils, Dominique chairs the event, which brings together spiritual leaders, scholars, and musicians from Africa, Europe, the Middle East, North America, and Asia to discuss the issues of interreligious cooperation and understanding.

Howard Barnstone renovates a bungalow on Branard Street at Mulberry Street into an office for the Menil Foundation. This accelerates a policy begun at the University of St. Thomas of adapting nearby homes as residences and offices with a twofold objective: acting as a stimulus to the then-deteriorating Montrose area while preserving the pedestrian scale of the neighborhood (fig. C.44). Initially in connection with their involvement with the university, John and Dominique

de Menil had acquired land in the neighborhood over the years. By the mid-1970s, the Menil Foundation owns seventy-one lots, including those occupied by the Rothko Chapel and its bungalow office.

October 19 "Gray Is the Color: An Exhibition of Grisaille Painting, XIIIth–XXth Centuries" opens at the Rice Museum. Partly in response to this exhibition, Howard Barnstone suggests that the exteriors of property owned by the Menil Foundation in the Montrose residential area be painted gray. Architect Renzo Piano later adopts a similar gray for the museum's exterior. To this day, the Menil campus is identifiable by its matching gray buildings.

December 8–9 The Rothko Chapel hosts its second colloquium, "Human Rights / Human Reality." Inspired by Dom Hélder Câmara, Archbishop of Olinda and Recife, Brazil (fig. C.43), the colloquium is planned to coincide with the twenty-fifth anniversary of the United Nations Universal Declaration of Human Rights. It features a small panel of leaders in religion and science, including Dom Hélder; scientists John Calhoun, Joel Elkes, and Jonas Salk; and professor and former mayor of Florence Giorgio La Pira, who discuss the connection between human rights and social and economic reality.

1974

February–October Art historians Douglas Fraser, Irving Lavin, and Robert Rosenblum; poets John Ashbery and Kenward Elmslie; and sculptor Richard van Buren give lectures at Rice University.

March 8 Dominique de Menil joins the Acquisitions Committee of the Centre Georges Pompidou, Musée National d'Art Moderne, Paris, one of only two private collectors recruited to the committee. She begins to work with Pontus Hulten, its founding director and one of her longtime acquaintances, to introduce American contemporary artists to France's national collection, becoming the president of the Georges Pompidou Art and Culture Foundation in 1977.

Fig. C.41
Pope Paul VI with Dominique and John de Menil, Vatican City, 1971

Fig. C.42
George McGovern poster designed by Dan Flavin, 1972

Fig. C.43
Dominique de Menil and Dom Hélder Câmara at the Rothko Chapel, Houston, 1973

Fig. C.44
Menil Foundation bungalows on Branard Street, Houston

Fig. C.45 *opposite bottom*
Black Panther flyer advertising a free breakfast program for schoolchildren, Houston, 1973

Dia Art Foundation is formed by Philippa de Menil (who, after converting to Sufi Islam in 1979, changes her name to Fariha), art dealer Heiner Friedrich, and Helen Winkler, a former student at the University of St. Thomas and onetime assistant to John and Dominique de Menil. Dia focuses on collecting in depth the work of a select group of contemporary artists, including Walter De Maria, Dan Flavin, Donald Judd, and Michael Heizer, and assisting them in realizing and maintaining large-scale projects.

April The Menil Foundation acquires an archival set of 385 black-and-white photographs by Henri Cartier-Bresson, selected by the artist as being representative of his best works. Sets are subsequently acquired by the Bibliothèque nationale in Paris, the Victoria and Albert Museum in London, and the Osaka University of Arts in Japan. On May 9, "Henri Cartier-Bresson Archive Photos" opens at the Rice Museum.

Dominique de Menil begins to work with Howard Barnstone on plans for an administrative office and separate conference center (for future Rothko Chapel symposia) to go on the east side of Mulberry Street and an "art storage building" on the south side of Branard Street. She puts the plans aside in 1977 while she rethinks the project.

December 7 At a concert organized by the Institute for the Arts at Rice University, Philip Glass and Ensemble performs in its entirety *Music in Twelve Parts*, Glass's new four-hour composition at the Museum of Fine Arts, Houston.

1975

January The Menil Foundation begins financially supporting Texas Southern University's Suburban Teacher Education Program (STEP), which provides training to black student teachers in preparation for working in suburban schools.

October 23 "Form and Freedom: A Dialogue on Northwest Coast Indian Art" opens at the Rice Museum (fig. C.47). The exhibition features work from John and Dominique de Menil's collection as well as from the collections of Christophe de Menil, Adelaide de Menil, anthropologist Edmund Carpenter, and former de Menil son-in-law and anthropologist Francesco Pellizzi. The accompanying catalogue, edited by Edmund Carpenter, includes a dialogue by two contemporary Northwest Coast artists, Bill Holm and Bill Reid, who discuss the featured works from two very different points of view. Holm gives a lecture in connection with the exhibition. "Out of the Silence: Photographs by Adelaide de Menil" also opens at Rice Museum. The exhibition of photographs of Pacific Northwest art is curated by Dominique de Menil.

December 4 Art historian Sheldon Nodelman gives a lecture at Rice University in connection with the exhibition "Marden, Novros, Rothko: Painting in the Age of Actuality," held earlier in the year at Rice. In 1997 the Menil Collection publishes Nodelman's groundbreaking study on the Rothko Chapel paintings.

1976
March–November Art historians Martin Eidelberg, William Fagg, Suzi Gablik, and Antonio Santos and film scholar Thierry Kuntzel give lectures at Rice University.

June–July Dominique de Menil travels with Howard Barnstone, Harris Rosenstein, and Mary Jane Victor to look at new museum architecture in Buffalo, Cleveland, Pittsburgh, Portland, Seattle, and Vancouver. Kathryn Davidson also studies museum design during travels to institutions in Chicago, New York, and San Francisco.

1977
January 31 The Centre Georges Pompidou, Paris, opens (fig. C.46). The inaugural exhibition features art given by Dominique de Menil, including Jackson Pollock's

The Deep, 1953 (donated by Dominique along with the de Menils' children in 1976 in memory of John de Menil), as well as works by Claes Oldenburg, Larry Rivers, and Andy Warhol. Also included in the exhibition are works given by her sons, Georges and Francois, and works on loan from the John and Dominique de Menil collection. Later, Dominique becomes one of the founders of the Georges Pompidou Art and Culture Foundation, now the Centre Pompidou Foundation, to facilitate cultural exchange between France and America, primarily through acquisitions for the Pompidou. Led by her, the foundation successfully encourages important donations by major collectors. It is now headquartered in Los Angeles.

February 3–5 The Rothko Chapel hosts its third colloquium, "Toward a New Strategy for Development," to discuss concrete approaches to the problem of the growing gap between rich and poor nations throughout the world. Led by Nobel Prize–winning economist Albert Hirschmann, the panel includes distinguished development economists and social scientists, some from developing countries including Bangladesh, Brazil, and India.

April 12 "Frederick Baldwin, Wendy Watriss: Photographs from Grimes County, Texas" opens at Rice Museum. The photographs, created over a two-year period, record events in the lives of the local people, who are of African, German, Mexican, and Polish descent. In 1983 Baldwin and Watriss establish Fotofest in Houston, the first international biennial devoted exclusively to photography, which continues today.

May With financial support from Dominique de Menil, Southwest Alternate Media Project (SWAMP) is established by James Blue, Brian Huberman, and Edward Hugetz to provide a wider community with access to film and video production. First housed on the future site of the Menil Collection building and now residing nearby on the Menil campus, SWAMP continues to promote the creation and appreciation of independent film in Texas.

1978

October 15–22 The Whirling Dervishes of Konya, Turkey, perform at Rice University, the Rothko Chapel, and the University of Houston. Talat Sait Halam, poet, critic, and literary scholar, lectures at Rice in connection with these performances.

1979

The Menil Foundation renews its commitments to Rice for five more years. However, in 1981 Dominique de Menil makes it clear that, with the development of her own independent museum, the foundation will no longer be housed at Rice after 1984.

May Dominique de Menil commissions Howard Barnstone to create additional architectural studies for a building in which to house her art collection. Working with Ant Farm architect Doug Michels, Barnstone designs a large building facing the 3900 block of Mulberry Street. This and his other designs are eventually abandoned, but the planning process proves useful in establishing the future museum's architectural program.

May–June Philosopher Ileana Marcoulesco becomes a consultant to the Rothko Chapel, working on colloquia, discussions, and publications. She begins teaching at the University of St. Thomas in the fall and in 1981 establishes the International Circle for Research in Philosophy, a study center and library housed in a neighborhood bungalow. In 1983 the center launches the journal *Krisis*.

A master's program in art history is established at Rice University with substantial support from Dominique de Menil, including a fellowship named for Jermayne MacAgy. Bertrand Davezac, a French specialist in early medieval art, joins the program's faculty. His appointment encourages de Menil's increased interest in art of that period, and he later joins the Menil Collection as a curator.

September 18–19 HH the 14th Dalai Lama visits the Rothko Chapel and meets with scientists and religious leaders.

November 10 "The Image of the Black in Western Art," an exhibition of photographs curated by Karen C. C. Dalton of works reproduced in the publication of the same name, opens at the Houston Public Library. It is circulated nationally by the Smithsonian Institution Traveling Exhibition Service (SITES) in 1979–88.

1980

August Paul Winkler, a former University of St. Thomas student who had assisted with the de Menils' exhibitions at St. Thomas and Rice University, leaves his position as assistant director of the Museum of International Folk Art, Santa Fe, to assist Dominique de Menil with her plans to build a museum for the collection.

September 5 "Jim Love Up to Now: A Selection" opens at the Rice Museum (fig. C.48). Love, an assemblage sculptor, had worked also for the Contemporary Arts Association and then for the Menil Foundation from 1956 until his death in 2005. The de Menils were strong supporters of his art, and the Menil Collection now holds sixty works.

October 1 Dominique de Menil engages contemporary art curator Walter Hopps (fig. C.49) as a consultant to provide advice on cataloguing and upgrading the modern art in the collection and to help plan for the museum. She was introduced to Hopps in the mid-1970s by her daughter Christophe de Menil, Pontus Hulten, and others (John de Menil had met Hopps in the late 1960s).

November 18–28 Dominique de Menil, Paul Winkler, and architectural designer Glenn Heim go to Paris to meet Renzo Piano, whom Pontus Hulten introduced to de Menil, to discuss the prospect of his designing a building for the collection. Immediately after the meeting, de Menil engages Piano as the museum's architect.

Fig. C.46
Centre Georges Pompidou, Paris

Fig. C.47
Anthropomorphic Mask, Nuu-chah-nulth (Nootka people), British Columbia, collected 1778 by Captain James Cook. The Menil Collection, Houston. From "Form and Freedom: A Dialogue on Northwest Coast Indian Art," Rice Museum, Rice University, 1975

Fig. C. 48
"Jim Love Up to Now: A Selection," Rice Museum, Rice University, Houston, 1980

Fig. C.49
Renzo Piano and Walter Hopps, Houston, 1987

A few days later, de Menil and Heim visit the Kibbutz of Ein Harod in Israel with Piano. The art museum there, designed by Samuel Bickels, is one inspiration for the natural lighting of the Menil Collection.

1981

January 19–22 Renzo Piano makes the first of several visits to Houston this year. In early April, Dominique de Menil, Paul Winkler, and Walter Hopps meet with him in his Genoa studio.

Walter Hopps is named director of the Menil Collection, a position he holds until 1989, at which time he is named consulting curator. He continues in this role until his death in 2005. Paul Winkler is named assistant director of the Menil Collection. He serves as acting director in 1989–90 and as director in 1991–99.

March 15 "Security in Byzantium: Locking, Sealing, Weighing," a long-planned exhibition of Byzantine objects purchased in the mid-1960s, opens at the Rice Museum. Scholars Gary Vikan and John Nesbitt curate the show, based on research begun by the late scholar Marvin C. Ross. Vikan and Nesbitt conduct a seminar at Rice University in conjunction with the exhibition.

March 21 "Transfixed by Light," the first major exhibition from the Menil photography collection opens at the Rice Museum. Scholar and curator Beaumont Newhall selects the seventy-five images for the show and gives a talk in conjunction with the exhibition.

June 20 Recipients from Argentina, Chile, Côte d'Ivoire, El Salvador, Italy, the Mohawk Nation, South Africa, the Soviet Union, and the United States are honored with the first Rothko Chapel Awards for Commitment to Truth and Freedom, established by the chapel on its tenth anniversary as a reaffirmation of its mission. This award is given twice more in 1986 and in 1991.

October 2 Forty-five years after Dominique de Menil attends Father Yves Congar's lectures on ecumenism, she continues her commitment to his teachings. In recognition of his legacy as a key participant in the Vatican II council, over the next twenty years the Menil Foundation and the Rothko Chapel cover half the cost of a multimillion-dollar project to study the writings of Pope John XXIII and the continuing impact of Vatican II. This project is headed by Giuseppe Alberigo, president of the Istituto per le Scienze Religiose, and his associate Alberto Melloni.

October 16 The first major exhibition from the Menil print collection, "Reading Prints: A Selection of 16th- to Early 19th-Century Prints from the Menil Collection," opens at Rice Museum. The exhibition is curated by Richard S. Field, with research assistance by Kathryn Davidson and Elizabeth Glassman. Field gives a lecture in conjunction with the exhibition.

October 21–25 The Rothko Chapel hosts its fourth colloquium, "Islam: Spiritual Message and Quest for Justice," which brings together distinguished Muslims from all parts of the Islamic world, representing a wide variety of geographical regions, scholarly disciplines, opinions, and viewpoints, for a free and open discussion of many aspects of Islam. It is organized by UNESCO official Najmuddin Bammate.

December 2 Speaking at Rice University, Dominique de Menil announces her plans to build a permanent museum for the de Menils' collection, designed by Renzo Piano, with engineer Peter Rice and local associate architect Richard Fitzgerald (fig. C.50). The building is to be placed in Houston on land owned by the Menil Foundation near the Rothko Chapel. In preparing the site, several bungalows are sold, moved, or relocated elsewhere on Menil property, in an attempt to preserve as many as possible. Construction begins in February 1983.

1982

February 5 As part of Dominique de Menil's efforts begun in the mid-1970s to introduce American audiences to contemporary French artists, "Yves Klein: A Retrospective" opens at the Rice Museum, then travels to Chicago, New York, and Paris. Though considerable help comes from Paris, it is primarily organized by Walter Hopps and Thomas McEvilley, who gives a lecture in conjunction with the exhibition.

March Long-time friend and Menil Foundation board member Miles Glaser becomes the foundation's vice president and chief financial officer, positions he holds until 1999.

November 15 Walter Hopps and artist William Christenberry give a lecture in conjunction with the exhibition "William Christenberry: Southern Views" at the Rice Museum (fig. C.51).

1983

Houston architect Anthony Frederick continues the program of Howard Barnstone, renovating neighborhood bungalows into Menil offices. The foundation acquires Richmond Hall in December 1984. Later Frederick oversees its renovation into an exhibition space, which opens in 1987.

February–April Historians Regina A. Perry and William Ferris speak at Rice University in connection with the exhibition "Black Folk Art in America 1930–1980." In addition, blues guitarist James "Son Ford" Thomas gives a concert, and the Ensemble (later the Ensemble Theatre) performs James Weldon Johnson's *God's Trombone: Seven Negro Sermons in Verse*.

June Bertrand Davezac is contacted about the possible acquisition of a disassembled group of Byzantine frescoes. Dominique de Menil, Davezac, Walter Hopps, and Elsian Cozens, fly to Munich to examine the works. They later determine that the frescoes have been exported illegally and that the rightful owner is the Holy Archbishopric of Cyprus. In a landmark agreement, de Menil ransoms the frescoes and funds their conservation and restoration, and in turn, the Holy Archbishopric of Cyprus permits the works to remain in Houston on a long-term loan.

June/November While the museum is under construction, portions of the collection travel: "Five Surrealists from the Menil Collection" opens at the National Gallery of Art, Washington, D.C., on June 17; and "The First Show: Painting and Sculpture from Eight Collections 1940–1980," the inaugural exhibition of the Museum of Contemporary Art, Los Angeles, opens on November 18.

October 28–30 The Rothko Chapel hosts its fifth colloquium, "Ethnicities and Nations: Processes of Interethnic Relations in Latin America, Southeast Asia, and the Pacific," which brings together an international group of anthropologists and other scholars to reflect on questions of identity and to examine the pressures placed on traditional ethnic communities by modern nation-state models of government (fig. C.52). Participants include, among others, anthropologists Remo Guidieri, Francesco Pellizzi, and Stanley J. Tambiah.

1984

April 17 "La rime et la raison: Les collections Ménil (Houston–New York)" opens at the Galeries Nationales du Grand Palais in Paris, the first time a private art collection is exhibited in a state-run French museum (fig. C.53). Curated by Walter Hopps and French curator Jean-Yves Mock with the assistance of Dominique de Menil, the exhibition shows over six hundred works from the de Menil family collections in a kind of dress rehearsal for the opening of the Menil Collection in 1987. French artist Jean-Pierre Raynaud creates a Menil-commissioned architectural installation for the entryway, displaying four objects emblematic of the strengths of the collections: a Paleolithic reindeer sculpture from southwestern France; a reliquary, ca. 500 CE, from Serbia; a seventeenth-century monolith from Nigeria; and Yves-Klein's *La couronne* (*The Crown*), ca. 1960.

April 18 In tandem with "La rime et la raison," "Dons de la famille de Ménil au Musée National d'Art Moderne,"

featuring donations from the de Menil family, opens at the Centre Pompidou, Paris. Dominique de Menil makes her last donation of art to the Centre Pompidou, giving the museum Joán Miró's painting *Blue II*, 1961.

July 13 Dominique de Menil is awarded the French Legion of Honor by French President François Mitterand.

November 16 Walter Hopps lectures in connection with the exhibition "Edward and Nancy Reddin Kienholz: The Art Show" held at the Rice Museum.

1985

March 15 Yanni Petsopoulos, a London-based specialist in the cultures of the eastern Mediterranean and Middle East, encourages Dominique de Menil to meet with Eric Bradley, one of the foremost private collectors of Byzantine icons, after a plan to place his collection in the British Museum falls through. Impressed by his holdings and supported by Bertrand Davezac, she acquires fifty-eight icons.

May 3 Continuing the exhibition of works from the collection while the museum building is under construction, "Cinquante ans de dessins américains: 1930–1980" ("Fifty Years of American Drawing: 1930–1980") at L'École nationale supérieure des Beaux-Arts, Paris, includes many works from the Menil Foundation. Curated by Walter Hopps with art historian Neil Printz, the show travels to Städelschen Kunstinstitut, Frankfurt, as "Amerikanische Zeichnungen, 1930–1980." A reduced version, "27 Ways of Looking at American Drawing," opened at the Rice Museum earlier in the year.

May 10 Final arrangements for a separation of the Menil Foundation from Rice are concluded. The de Menil slide collection and a substantial part of the art library are given to Rice, and Dominique de Menil continues to support the master's program in art history, some professorial salaries, the excavation in Latium, and a grant for a scholar in religious studies.

Fig. C.50
Peter Rice, Renzo Piano, Shunji Ishida, and Lois and Georges de Menil viewing the museum model, Menil Foundation, Houston, 1982

Fig. C.51
The Klan Room, 1962–82, from "William Christenberry: Southern Views," Rice Museum, Rice University, Houston, 1982

Fig. C.52
"Ethnicities and Nations," a colloquium held at the Rothko Chapel, Houston, 1983

Fig. C.53
Entrance to "La rime et la raison: Les collections Ménil (Houston–New York)," Grand Palais, Paris, 1984

1986

On the advice of her daughter Christophe, Dominique de Menil engages Mexican architect Luis Barragán, with his partner Raúl Ferrera, to design a guesthouse to be built adjacent to the planned museum. His only commission outside of Mexico, the design is completed but never executed. The drawings and models subsequently enter the Menil Collection.

March 19 Dominique de Menil and President Jimmy Carter establish the Carter-Menil Human Rights Foundation to promote human rights throughout the world. The foundation awards a $100,000 prize to organizations or individuals for their commitment to human rights. Archbishop Desmond Tutu gives the keynote speech at the first ceremony held at the Rothko Chapel, on December 10; awardees are Yuri Orlov of the Soviet Union and Grupo de Apoyo Mutuo of Guatemala. The awards are given annually from 1986 to 1992 and once more in 1994.

March 24 The Rice Museum closes. The final exhibition, "The Indelible Image: Photographs of War, 1846 to the Present," opened on February 6 as part of FotoFest.

June Dominique de Menil receives the Presidential Medal of Arts in Washington, D.C., from President Ronald Reagan.

October The Menil Collection and the Dia Center for the Arts reach an agreement in which a substantial portion of Dia's collection will be on a five-year, renewable loan to the Menil Collection. Although this arrangement is temporary, works of many artists associated with Dia—including John Chamberlain, Walter De Maria, Michael Heizer, and Cy Twombly—gradually become a new focus for the Menil Collection.

December 10 The Oscar Romero Award is established by the Rothko Chapel to honor El Salvadoran Archbishop Oscar Arnulfo Romero, who was assassinated while saying mass in 1980 after speaking out against torture and the El Salvadoran army's violation of human rights. The first recipient is Bishop Leonidas Proaño

Villalba of Ecuador. The award is given annually through 1997, and then biannually beginning in 2003.

1987

June 3–7 Dedication ceremonies and opening events are held at the Menil Collection (fig. C.55). Dominique de Menil commissioned two musical compositions for the occasion: a fanfare by French composer Pierre Boulez to announce the opening; and a mass by American composer Richard Landry, which is performed at the Rothko Chapel. The festivities are attended by an international roster of dignitaries and members of the art world, including Leo Castelli, John Chamberlain, Henry Geldzahler, Dennis Hopper, Pontus Hulten, Philip Johnson, Danielle (Mrs. Francois) Mitterand, I. M. Pei, Claude (Mrs. Georges) Pompidou, Robert Rauschenberg, Dorothea Tanning, and David Whitney. Along with the installations of the permanent collection, temporary exhibitions include "John Chamberlain" (fig. C.54) and "Ben L. Culwell: Adrenalin Hour" in the main building and "Warhol Shadows" in Richmond Hall. The new building (fig. C.59) has an expansive front lawn with a large park to the east and other green

spaces, which contain outdoor sculptures by Mark di Suvero, Michael Heizer, and Tony Smith.

October 12–31 The Southwest Alternate Media Project (SWAMP), the Rice Media Center, and the Italian Ministry of Tourism and Performing Arts hold a conference, "A Tribute to Roberto Rossellini in Recognition of the Contributions of Dominique and John de Menil to the Media Arts." Six Italian and three American scholars present papers.

1988

February 10 "Texas Art," a group showcase of Texas artists, opens in Richmond Hall, curated by Neil Printz, Alison de Lima Greene, and Marilyn Zeitlin. Works by several of the artists in the exhibition become part of the permanent collection, and three of the artists, Mel Chin, Ben L. Culwell, and Michael Tracy, have had or will have solo shows at the Menil Collection.

April 21 A panel of speakers, including artist and curator Ecke Bonk, William A. Camfield, Walter Hopps, and curator Carlton Lake convene to discuss the exhibition "Marcel Duchamp/Fountain" at the Menil Collection.

October 1 Dominique de Menil provides early funding and rehearsal space in the Menil Collection for Da Camera Society (later Da Camera of Houston), a chamber music organization led by Sergiu Luca, which performs many of its inaugural concerts at the museum. Over the years, the organization presents a broad spectrum of music (fig. C.56), from classical to jazz to avant-garde; pianist Sarah Rothenberg, artistic director beginning in 1994, regularly designs concerts related to Menil exhibitions to this day.

October 21 "Andy Warhol: Death and Disasters" opens at the Menil Collection a year and a half after the artist's death. Curated by Walter Hopps and Neil Printz (later the principal author of the Warhol catalogue raisonné), this first in-depth look at violence in Warhol's oeuvre draws on many Dia-owned works on long-term loan to the museum. Also included in the exhibition are three *Electric Chair* paintings owned by the Menil.

October 30 Long-time friend and supporter Louisa Sarofim is elected to the Menil Foundation board of trustees. In 1997 she is chosen by Dominique de Menil to be her successor as chairman and president, positions she assumes in early 1998, soon after de Menil's death. For the next ten years, Sarofim's strong leadership and vision sustain and build on John and Dominique de Menil's legacy. Adding her own imprint to the museum, she donates significant works of art by Jay DeFeo, Robert Gober (fig. C.57), Hans Hofmann, Ellsworth Kelly, Morris Louis, Bruce Nauman, Claes Oldenburg, Robert Rauschenberg, and Mark Rothko. While remaining foundation chairman, she retires as president in May 2008 and is named a life trustee.

October–November Several exhibitions of pre-twentieth-century art reflecting areas in which the de Menils collected open at the Menil Collection. They include "Selected Prints by Callot, Della Bella, and Goya," "Winslow Homer's Images of Blacks: The Civil War and Reconstruction Years," "Spirituality in the Christian East: Greek, Slavic, and Russian Icons from The Menil Collection," and "The Sarofim Collection of Coptic Art."

1989

Writers in the Schools (WITS), originally headquartered at the University of Houston and now an independent organization, begins an affiliation with the Menil Collection, in which schoolchildren visit the museum to directly experience and write about art (fig. C.58).

Major exhibitions organized by the Menil Collection this year include works by Max Ernst, Jasper Johns, and René Magritte, artists to whom John and Dominique de Menil had made a long-term commitment. Also shown this year are works by Robert Rauschenberg and Cy Twombly, whom Dominique de Menil came to know and support after her husband's death.

June 22 Conservator Laurence J. Morrocco gives a talk about his work conserving the thirteenth-century Byzantine frescoes on loan to the Menil Foundation.

September/December Lectures are given by Walter Hopps and scholar Francis M. Naumann in connection with the exhibition "Perpetual Motif: The Art of Man Ray" at the Menil Collection.

1990

April Through the efforts of Chief Conservator Carol Mancusi-Ungaro, the Menil Collection is awarded a grant by the Andrew W. Mellon Foundation to create a postgraduate fellowship in the museum's Conservation Department. The grant also endows a program for visiting conservators, and funds an artists documentation program in which contemporary artists discuss the conservation of their works. In 1996, the Mellon Foundation contributes toward an endowment that permanently funds the postgraduate fellowship and two full-time conservator positions.

April 5 Dancer and choreographer Trisha Brown; professor of theater and dance Roger Copeland; and curator and writer Klaus Kertess present a panel discussion at the Menil Collection on the nature of collaboration between dance and the visual arts.

Fig. C.54
Walter Hopps and John Chamberlain installing "John Chamberlain" at the Menil Collection, Houston, 1987

Fig. C.55
Crowd at the preview opening of the Menil Collection, Houston, 1987

Fig. C.56
Enso String Quartet, presented by Da Camera of Houston, at the Menil Collection, Houston, 2007

Fig. C.57
Robert Gober, *Untitled*, 1999–2000. The Menil Collection, Houston, Gift of Louisa Stude Sarofim

Fig. C.58
Students at the Menil Collection participating in the Writers in the Schools (WITS) program, Houston, 2009

Fig. C.59 *opposite bottom*
The Menil Collection, Houston

May 7–9 Art historian Leo Steinberg delivers the Margarett Root Brown and Alice Pratt Brown Lectures titled "Women Sacred and Profane: Three Wayward Talks" at the Museum of Fine Arts, Houston, a series co-organized by the Menil Collection.

June 28 "Joseph Beuys: Works from the Dia Art Foundation" opens at the Menil Collection. It is another major exhibition derived from the long-term loan arrangement between the two institutions.

1991
January 12–15 The Rothko Chapel hosts its sixth colloquium, "Christianity and Churches on the Eve of Vatican II," organized by Giuseppe Alberigo and Alberto Melloni of the Istituto per le Scienze Religiose, in which thirty-four priests, scholars, and theologians who participated in Vatican II gather in an effort to document that historical event.

June 15 "Robert Rauschenberg: The Early 1950s," a major exhibition of the artist's little-known early work, opens at the Corcoran Gallery of Art in Washington, D.C. The exhibition, curated by Walter Hopps and organized by the Menil Collection, opens in Houston in September, and travels to Chicago, San Francisco, and New York.

October–January 1992 A series of lectures in conjunction with the exhibition "François de Nomé: Theatre of Light and Destruction" feature curator J. Patrice Marandel, art historians Mary Ann Caws and Lois Parkinson Zamora, and writer Carlos Fuentes.

December 8 Nelson Mandela (fig. C.60) gives a keynote address celebrating the tenth anniversary of the Rothko Chapel Awards for Commitment to Truth and Freedom.

December 10 An unveiling ceremony is held for Michael Heizer's sculpture *Charmstone*, newly installed near the front entrance to the museum. It is accompanied by a brass plaque created by the sculptor honoring the founding benefactors of the museum's endowment.

1992
February 12 Art historian Leo Steinberg delivers the Margarett Root Brown and Alice Pratt Brown Lectures titled "The Devil His Due: Michelangelo's *Creation of Adam*," at the Museum of Fine Arts, Houston. It is co-organized by the Menil Collection.

December 19 "Magritte," a major retrospective of one of the key artists collected by the de Menils, opens at the Menil Collection. Curated by David Sylvester, Sarah Whitfield, and Paul Winkler, the exhibition travels to Chicago, London, and New York.

1993
May 28 "Max Ernst: Dada and the Dawn of Surrealism," opens at the Menil Collection. Curated by William A. Camfield, Susan Davidson, Walter Hopps, and Werner Spies, it is an early exploration of the connection between the two art movements. The exhibition travels to New York and Chicago.

October 22 Dominique de Menil receives the Hadrian Award from the World Monuments Fund. The annual award is given to international leaders who have advanced the preservation of world art and architecture.

1994
January–April In conjunction with "Rolywholyover: A Circus," an evolving exhibition composed by John Cage and held at the Menil Collection, twelve events, including readings, radio broadcasts, and sound performances, are scheduled at different cultural venues in Houston, including the Menil Collection; Lawndale Arts Center; Museum of Fine Arts, Houston; Pacifica Radio; and University of Houston.

May 18 The Carter-Menil Human Rights Foundation presents its final award to the Norwegian Institute of Applied Social Science, a group that facilitated the historic Israeli-Palestinian agreement. Dominique de Menil donates Tony Smith's arch-shaped sculpture *Marriage*

to the people of Norway to be installed on a hill overlooking the Oslo harbor.

September 9 "Franz Kline: Black & White, 1950–1961," guest curated by David Whitney with Walter Hopps and Susan Davidson, opens at the Menil Collection (fig. C.61). It travels to New York and Chicago. Whitney, a longtime Menil trustee, later bequeaths important works to the Menil Collection, including art by Jasper Johns, Ken Price, Robert Rauschenberg, and Andy Warhol, archival documentation about these artists, and his personal art library.

The Image of the Black in Western Art photographic archives and research and publication project move to Harvard University under the management of director and curator Karen C. C. Dalton. They become part of a larger research center on black studies, the W. E. B. Du Bois Institute for African and African American Research, under director Henry Louis Gates Jr.

1995
February 10 The Cy Twombly Gallery opens (fig. C.62). The satellite exhibition space designed by Renzo Piano, which houses over thirty paintings and sculptures by Twombly, is a collaboration between the Menil Collection, the Dia Art Foundation, and the artist. In conjunction with the opening, the exhibition "Cy Twombly: A Retrospective," curated by Kirk Varnedoe, Paul Winkler, and Cy Twombly, is presented at the Menil Collection; Da Camera presents a concert and discussion with Sarah Rothenberg and John Ashbery; and Richard Howard gives the lecture titled "C. P. Cavafy: A Modern Poet."

July 13–20 Curators Nan Rosenthal and Susan Hapgood, artist Allan Kaprow, and art historian William A. Camfield participate in the lecture series, "Neo-Dada: Redefining Art, 1958–1962," co-sponsored by the Menil Collection and the Contemporary Arts Museum Houston.

1996

February 16 The Menil Collection opens "Jasper Johns: The Sculptures," serving as the only American venue for the exhibition (fig. C.64). Organized by the Centre for the Study of Sculpture at the Henry Moore Institute in Leeds, England, and curated by Fred Orton, it is the first show devoted exclusively to the artist's sculpture.

March 5 In conjunction with the exhibition "Eve Arnold: In Retrospect," at the Menil, a documentary film about the artist by Beeban Kidron is shown, followed by a discussion with Arnold and curators Roy Flukinger and April Rapier. In the 1950s and 1960s, Arnold had often visited Houston in order to photograph de Menil events.

December 13 "Mark Rothko: The Chapel Commission" opens at the Menil Collection on the twenty-fifth anniversary of the Rothko Chapel. Curated by David Anfam and Carol Mancusi-Ungaro, the exhibition includes a series of works related to the chapel paintings and other never previously exhibited alternate chapel panels.

1997

February 8 The Byzantine Fresco Chapel opens. Built to contain the restored apse and dome frescoes on loan

from the Holy Archbisphoric of Cyprus, the chapel is consecrated as an Eastern Orthodox worship space on September 15. Architect Francois de Menil, the de Menils' youngest son, was commissioned to design the building (fig. C.63), a technically complex structure that provides an interior glass and steel interpretation of the original Cypriot chapel.

April 23 A gala dinner celebrates the tenth anniversary of the opening of the Menil Collection.

Fall Marking what is to be her last exhibition, Dominique de Menil assists curator Jacques de Caso with "The Drawing Speaks: Works by Théophile Bra," a series of apocalyptic and mystical drawings by the nineteenth-century visionary French artist. The exhibition opens on December 12.

December 31 Dominique de Menil dies at the age of eighty-nine.

1998

February 13 Walter Hopps and Susan Davidson serve as guest curators for the Solomon R. Guggenheim Museum's "Robert Rauschenberg: A Retrospective." As one of the last projects Dominique de Menil supported, the vast exhibition is shown at three Houston venues: the Contemporary Arts Museum Houston, the Museum of Fine Arts, Houston, and the Menil Collection, art institutions Dominique and John de Menil helped to build. On May 7, Leo Steinberg gives the lecture "Encounters with Rauschenberg" at the Museum of Fine Arts, Houston.

November 18 The Dan Flavin Installation at Richmond Hall opens. It is Dominique de Menil's final commission and one of Flavin's last projects (he completed the designs just two days before his death). Since 1972, de Menil had envisioned a space dedicated to the artist's signature light installations; Richmond Hall contains three works created specifically for the building.

Fig. C.60
Nelson Mandela and Dominique de Menil touring the galleries in the Menil Collection, Houston, 1991

Fig. C.61
"Franz Kline: Black & White, 1950–1961," The Menil Collection, Houston, 1994

Fig. C.62
Cy Twombly in front of *Untitled*, 1967, in the Cy Twombly Gallery, The Menil Collection, Houston, 1995

Fig. C.63
The Byzantine Fresco Chapel, Houston

Fig. C.64 *bottom*
Dominique de Menil, Jasper Johns, and Francesco Pellizzi, during "Jasper Johns: The Sculptures," The Menil Collection, Houston, 1996

Exhibition History

Compiled by GERALDINE ARAMANDA
and SEAN NESSELRODE

This history includes exhibitions organized by John and Dominique de Menil or in which the de Menils were involved, and all others presented at the Menil Collection to date. Shows brought to Houston from other venues indicate the originating institution. Exhibitions with an accompanying catalogue are designated with the word "Catalogue" in their listings. Catalogue titles are the same as exhibition titles unless otherwise noted. The French spelling of Menil (Ménil) was occasionally used in exhibition titles and publications.

Vincent van Gogh
February 4–25, 1951
Location: Contemporary Arts Museum Houston
Curators: John and Dominique de Menil
Catalogue: Vincent van Gogh: Catalogue of a Loan Exhibition at the Contemporary Arts Museum of Houston

Calder–Miró: Exhibition of Paintings and Sculpture
October 14–November 4, 1951
Artists: Alexander Calder and Joán Miró
Location: Contemporary Arts Museum Houston
Catalogue

Interiors 1952: Beauty Within Reach of Hand and Budget
November 25–December 30, 1951
Location: Contemporary Arts Museum Houston
Curator: Dominique de Menil and F. Carrington Weems
Catalogue

Max Ernst
January 13–February 3, 1952
Location: Contemporary Arts Museum Houston
Curators: John and Dominique de Menil
Catalogue

Large Scale Paintings I
October–November 1955
Artists: Georges Braque, Victor Brauner, José De Rivera, Jean Dubuffet, Georges Mathieu, Roberto Matta, Joán Miró, George Ludwig Mueller, and Jackson Pollock
Location: Music Hall, Houston
Curator: Jermayne MacAgy

Contemporary European Tapestry
October 28–November 27, 1955
Artists: Eva Anttila, Gina Berganini, Renata Bonfanti, Michel Cadoret, Giuseppe Capogrossi, Geoffrey Clark,

Gordon Cook, Carl Crodel, Ronald Cruickshank, Ann-Mari Forsberg, Cornelia Forster, Lissy Funk, Irma Goecke, Fritz Griebel, Lars Gynning, Lidia Innocenti, Elizabeth Kadow, Ida Kerkovius, Ali Koroma, Louis Le Brocquy, Jean Lurcat, Edna Martin, Kaisa Melaton, Barbo Nilsson, Mario Prassinos, Charles Pulsford, Antonello Rossi, Hannah Ryggen, Ursula Schimer, Greta Schodi, Johanna Shidio, Martha Taipale, Woty Werner, Sofia Widen, Fritz Winter, and Karl Wollerman
Location: Contemporary Arts Museum Houston
Curator: Leila McConnell
Catalogue

Exhibit of Original Medieval Religious Statues & Paintings
December 4–15, 1957
Third annual exhibition of religious art (first and second held in December of 1955 and 1956, respectively)
Location: Administrative Building, University of St. Thomas, Houston
Curators: Jermayne MacAgy and John and Dominique de Menil

A Child's World
December 10, 1955–January 1, 1956
Interactive exhibition of forty-one items of play equipment provided by toy stores and manufacturers
Location: Contemporary Arts Museum Houston
Curators: Campbell and Marilyn Geeslin
Catalogue

The Family of Man
January 28–February 16, 1956
Artists: Approximately 250 photographers from 69 countries
Location: Contemporary Arts Museum Houston
Curator: Edward Steichen
Organizer: The Museum of Modern Art, New York
Catalogue

Shadow and Substance: The Shadow Theater of Montmartre and Modern Art
March 3–April 1, 1956
Artists: Giacomo Balla, Pierre Bonnard, Jules Chéret, Stuart Davis, Edgar Degas, Maurice Denis, Jean Louis Forain, Paul Gauguin, Henri Gabriel Ibels, Fernand Léger, Henri Matisse, Georges Méliès, Edvard Munch, Jackson Pollock, Odilon Redon, Lotte Reiniger, Ker-Xavier Roussel, Georges Seurat, Ben Shahn, Théophile Alexandre Steinlen, Léopold Survage, Henri de Toulouse-Lautrec, Félix Vallotton, and Edouard Vuillard
Location: Contemporary Arts Museum Houston
Curator: Ellen Sharp
Catalogue

Fig. 25.1
"Raid the Icebox 1 with Andy Warhol,"
Rice Museum, Rice University, Houston, 1969

Contemporary Calligraphers: John Marin, Mark Tobey, Morris Graves
April 12–May 13, 1956
Artists: Morris Graves, John Marin, Mark Tobey, and a selection of Asian calligraphers, Han (206 BC–AD 220) to modern
Location: Contemporary Arts Museum Houston
Curators: Robert H. Wilson and Loraine Gonzalez
Catalogue

Contemporary German Graphics
May 24–June 17, 1956
Artists: Karl Bianga, Johanne Blueschke, Kurt Bunge, Otto Eglau, Anneliese Everts, Fritz Grasshoff, Urd von Hentig, Gerhard Hintschich, Gerhard Hoehme, Wolf Hoffmann, Herbert Kaufmann, Carl-Heinz Kliemann, Gertrud Koehler, Ottokar Koeppen, Rudolf Kuegler, Hans Metz, Hermann Ober, Charlotte Schmidt, Susanne Schoenberger, Johanna Schuetz-Wolff, Willi Titze, Emil Wachter, Heinrich Wilthelm, and Paul Wunderlich
Location: Contemporary Arts Museum Houston
Curator: Henri V. Gadbois
Catalogue

Modern Textiles and Ornamental Arts of India
August 24–September 16, 1956
Location: Contemporary Arts Museum Houston
Catalogue

Art Rental Collection
September 27–October 21, 1956
Artists: Sybil Allenson, Carma Anderson, James Boynton, Marbury Brown, Vivian Buchanan, Lucie Cadigan, Lowell Collins, Bill Condon, Bene Conway, Carol Crow, Robin Curtin, Mildred Dixon, Margaret Webb Dreyer, Nique Eberman, Frank Freed, Georgia Fruhling, Marian Hettner Grunbau, Lillian Clark Hamilton, Doris Harrop, Hazel Hatfield, R. Hawkins, Sally and Jane Howard, Emily Jane Japhet, Edith Kirk, Charlotte Kraft, Kay Kuntz, Charmin Lanier, Leon Little, Jim Love, Paul Maxwell, Leila McConnell, Eva McMurrey, Herbert Mears, Helen Momeike-Wisniewski, Gladys Moses, Mary O'Hare, Mauno Oittinen, Norma R. Ory, David G. Parsons, Anna Belle Peck, Martha Alexander Roche, Frances Taylor Royston, Gwen G. Ryan, Alice Sayers, E. M. Schiwetz, Pearl E. Sewell, George Shackelford, Victor Shifreen, Mary Ellen Shipnes, Frances Skinner, Chester Snowden, Bonnie Wilder Sparks, John D. Sparks, Stella Sullivan, V. J. Tate, D. J. Taylor, Henry C. Thompson, Frances Thornton, Mary Lib Vick, Marjorie von Rosenberg, and Jewel Denny Yarbrough
Location: Contemporary Arts Museum Houston
Catalogue

Large Scale Paintings II
October 30–November 5, 1956
Artists: William Baziotes, Max Ernst, Esteban Francis, Sam Francis, Arshile Gorky, Adolph Gottlieb, Hans Hofmann, Franz Kline, Ad Reinhardt, Theodoros Stamos, and Bradley Walker Tomlin
Location: Music Hall, Houston
Curator: Jermayne MacAgy
Catalogue

Let's Face It: An Exhibition of Contemporary Portraits
November 8–December 2, 1956
Artists: Ivan Le Lorraine Albright, Milton Avery, Max Beckmann, Hans Belling, Bill Bomar, Alexander Brook, Bernard Buffet, Vincent Canadé, Bruno Cassinari, Emma Lu Davis, Charles Despiau, Otto Dix, Cornelis van Dongen, Katherine Dreier, Raoul Dufy, Lucian Freud, Robert Gwathmey, Frida Kahlo, Leon Kroll, Julian Levi, Hal Lotterman, Marino Marini, Marthe Rakine, Dickson Reeder, Carlos Orozco Romero, Georges Rouault, Concetta Scaravaglione, Simkha Simkhovitch, David Alfaro Siqueiros, Eugene Speicher, Pavel Tchelitchew, Tebo (Angel Torres Jaramillo), Bror Utter, Franklin Watkins, and Andrew Wyeth
Location: Contemporary Arts Museum Houston
Curator: Jermayne MacAgy
Catalogue

MMS: Monumentality in Modern Sculpture
December 13, 1956–January 13, 1957
Artists: Kenneth Armitage, Jean (Hans) Arp, Ernst Barlach, Wolfgang Behl, Mary Callery, José De Rivera, Edgar Degas, Dorothy Dehner, Max Ernst, Pericle Fazzini, Alberto Giacometti, Joseph Glasco, Julio Gonzalez, Paul Grunland, Adaline Kent, Jacques Lipchitz, Man Ray, Marguerite, Ezio Martinelli, Henri Matisse, Mirko (Mirko Balsadella), Henry Moore, L. E. J. Rhodes, Auguste Rodin, David Smith, Jack Squire, Emmanuel Viviano, and works from Africa, Boeotia, China, Italy, Greece, New Guinea, New Zealand, Persia, Philippine Islands, Mexico, and South Central Europe
Location: Contemporary Arts Museum Houston
Curators: Jermayne MacAgy and John M. Steel
Catalogue

The Magical Worlds of Redon, Klee, Baziotes
January 24–February 17, 1957
Artists: William Baziotes, Paul Klee, and Odilon Redon
Location: Contemporary Arts Museum Houston
Curators: Eleanor Kempner Freed and Ellen Sharp
Catalogue

The Sphere of Mondrian
February 27–March 24, 1957
Artists: Josef Albers, Ilya Bolotowsky, Burgoyne Diller, César Domela, Adolf Richard Fleischmann, Naum Gabo, Fritz Glarner, Sidney Gordin, Jean Gorin, Harry Holzman, Vilmos Huszár, František Kupka, El Lissitzky, Albert Manchak, John McLaughlin, László Moholy-Nagy, Piet Mondrian, Ben Nicholson, Irene Rice Pereira, George Rickey, Joaquín Torres-García, Georges Vantongerloo, Charmion Von Wiegand, Robert Jay Wolff, and John Xceron
Location: Contemporary Arts Museum Houston
Curators: Carol Straus and Jermayne MacAgy
Catalogue

Pacemakers
April 4–28, 1957
Artists: Jeremy Radcliffe Anderson, Forrest Bess, James Boynton, Robert Cremean, Joseph Goto, Walter Egel Kuhlman, John Levee, Raymond Parker, Peter Shoemaker, Hassel Smith, Evelyn Statsinger, Robert Sterling, Pat Trivigno, Charles Williams, and Emerson Woelffer
Location: Contemporary Arts Museum Houston
Curator: Jermayne MacAgy
Catalogue

Yard Art
May 10–June 2, 1957
Artists: Bart Bradford, Jack Daft, Frank Dolejska, Garden Lamps Inc., Jane Howard, Sally Howard, Ruth Laird, Charles Lawrence, Jim Love, Joe Pereira, and Lari Wester
Location: Contemporary Arts Museum Houston
Curator: L. G. Marsters
Catalogue

Post All Bills: Contemporary Posters
June 21–July 14, 1957
Location: Contemporary Arts Museum Houston
Catalogue

Recent Contemporary Acquisitions in Houston
July 25–August 25, 1957
Artists: David Adickes, Leonid Berman, Forrest Bess, Arbit Blatas, James Boynton, Bernard Buffet, Jean Busquets, Mary Callery, Bruno Caruso, Marc Chagall, Enrique Climent, Dana Cole, Jean-Yves Commère, Joseph Cornell, Jean Dubuffet, Enrique Echeverría, Max Ernst, Hamilton Fraser, Ruth Gikow, Joseph Glasco, Morris Graves, Marcel Gromaire, William Austin Kienbusch, Louis Le Brocquy, Fernand Léger, Marino Marini, Marcello Mascherini, André Masson, Antonio Music, A. Pagliacci, Raymond Parker, Joseph Pollet, Jeanne Reynal, Charles H. Royer, F. R. Sisson, Hassel Smith, Rufino Tamayo, Dorothea Tanning, Charles Umlauf, and Claude Venard

Location: Contemporary Arts Museum Houston
Curators: Jermayne MacAgy, assisted by Sandra Helen
 Meyer
Catalogue

Mark Rothko
September 5–October 6, 1957
Location: Contemporary Arts Museum Houston
Curator: Jermayne MacAgy
Catalogue

Irons in the Fire: An Exhibition of Metal Sculpture
October 17–December 1, 1957
Artists: Calvin Albert, Oliver Andrews, Harry Bertoia,
Reg Butler, Lynn Chadwick, Martin Craig, Robert
Cronbach, Lindsey Decker, Herbert Ferber, Ray Fink,
Jean Follett, Kahlil Gibran, Julio Gonzalez, Sidney
Gordin, Joseph Goto, David Hare, Richard Hunt, Ibram
Lassaw, Richard Lippold, Seymour Lipton, Ezio Marti-
nelli, Keith Monroe, Katherine Nash, Manolo Pascual,
Blanche Phillips, Bernhard Rosenthal, Theodore Roszak,
David Smith, Richard Stankiewicz, David Tolerton, and
Hans Uhlmann
Location: Contemporary Arts Museum Houston
Curators: Ralph A. Anderson Jr. and Jermayne MacAgy
Catalogue

The Great, Past and Present
October 28–November 5, 1957
Artists: Aristide Maillol and Mirko (Mirko Balsadella),
exhibited with works from Germany, Greece, India, Italy,
Mexico, North America, the South Pacific, and Thailand
Location: Music Hall, Houston
Curator: Jermayne MacAgy
Catalogue

Art Rental Collection
December 8–29, 1957
Artists: Ella Aydam, Marjorie Boaz Beach, James
Boynton, Marbury H. Brown, Vivian Buchanan, Lowell
Collins, Bill Condon, Bene Conway, Mary Franklin
Cunningham, Robin Curtis, Henri Gadbois, Doris Harrop,
Virginia P. Hartman, Hazel Hatfield, Jane Howard, W. A.
Jones, Charmin S. Lanier, Jim Love, Paul Maxwell, Eva
McMurrey, Herbert H. Mears, Marc Moldawer, F. B. E.
Montgomery, Mauno Oittinen, Anna Belle Peck, Thyra
Rodberg, Frances Taylor Royston, Gwen Ryan, Chester
Snowden, Marjorie Spencer, Richard Gordon Stout,
D. J. Taylor, and Karol Winegardner
Location: Contemporary Arts Museum Houston
Catalogue

The Disquieting Muse: Surrealism
January 9–February 16, 1958
Artists: Giuseppe Arcimboldi, Hans Bellmer, Wolfgang
Hieronymus von Bömmel, Hieronymus Bosch, Benigno
Bossi, René Boyvin, Victor Brauner, Rodolphe Bresdin,
Pieter Brueghel, Leonora Carrington, J. C. Center,
Giorgio de Chirico, Hans Collaert, Joseph Cornell,
Currier and Ives, Salvador Dalí, Paul Delvaux, Marcel
Duchamp, Max Ernst, Louis Fernandez, Frans Floris,
Henry Fuseli, Arshile Gorky, J. J. Granville, John Haberle,
Cyrus W. King, Nicolas de Larmessin I, Reny Lohner,
René Magritte, Man Ray, John Martin, André Masson,
Roberto Matta, Joán Miró, Giovanni Elia Morghen,
Walter Tandy Murch, Francis Picabia, Jean Pillement,

Giovanni Battista Piranesi, Odilon Redon, Kay Sage,
school of Fountainbleau, Kurt Seligmann, I. A. Stokhman,
Yves Tanguy, Dorothea Tanning, Enea Vico, Hans Vrede-
man de Vries, Isaak Vroomans, and unknown artists
Location: Contemporary Arts Museum Houston
Curator: Jermayne MacAgy and Kathryn Swenson
Catalogue

Films: 1948–1958
January 15–February 15, 1958
Artists: Ray Ashley, René Clair, Jean Cocteau, Jules
Dassin, Vittorio De Sica, Morris Engel, Federico Fellini,
Fernandel, Anthony Kimmis, Akira Kurosawa, Ruth
Orkin, UPA, and S. S. Vasan
Location: Contemporary Arts Museum Houston
Curators: Herbert William and Susan Linnstaedter
Catalogue

Collage International: From Picasso to the Present
February 27–April 6, 1958
Artists: Robert Adams, Jean (Hans) Arp, Georges Braque,
J. Goldsborough Bruff, Alberto Burri, Austin Cooper,
Joseph Cornell, Stuart Davis, Sonia Delaunay-Terk,
Arthur Garfield Dove, Victor Dubreuil, George Dunbar,
Ronnie Elliott, Max Ernst, Adolf Richard Fleischmann,
Sue Fuller, Ilse Getz, Bruce Gilchrist, Julio Girona,
Balcomb Greene, Hannah Höch, James Hull, Angelo
Ippolito, Jasper Johns, Guy Johnson, Ida Karskaya,
Henri Laurens, Karl Mann, Conrad Marca-Relli, John
Marin, Henri Matisse, Elizabeth McFadden, Walter
Meigs, Joán Miró, László Moholy-Nagy, Ben Nicholson,
Pablo Picasso, Robert Rauschenberg, Judith Rothschild,
Anne Ryan, Kurt Schwitters, Gino Severini, Joseph
Stella, Dorothy Sturm, Léopold Survage, Esteban
Vicente, Charmion Von Wiegand, and Betty Voorh
Location: Contemporary Arts Museum Houston
Curator: Jermayne MacAgy and Robert H. Wilson
Catalogue

The Common Denominator:
Modern Design 3500 B.C.–1958 A.D.
April 17–June 1, 1958
Location: Contemporary Arts Museum Houston
Curators: Herbert Wells and Jermayne MacAgy
Catalogue

Modern Abstract Japanese Calligraphy
June 26–August 1958
Artists: Kinryu Asami, Sabro Hasegawa, Fumio Ikeda
(Suijo), Shunran Kagawa, Shiho Kanzaki, Ryusho
Kobayashi, Gaun Mochida, Kiyoshi Morita (Shiryu),
Sogyo Nagato, Mokushi Nakamura, Gaboku Ogawa,
Gakayu Osawa, Tadashi Sato, Toko Shinoda, Miyoko
Suzuki, Seijo Taguchi, and Sokyu Ueda
Location: Contemporary Arts Museum Houston
Curators: Mildred Constantine and Jermayne MacAgy
Catalogue

The Trojan Horse: The Art of the Machine
September 25–November 9, 1958
Artists: Constantin Brancusi, Guillaume Duchoul, Duke
of Orleans Ferdinand Philippe, Max Ernst, Oliver Evans,
Domenico Florentino, Cecil Hickerson, Pierre Jacquet-
Droz, Leonardo da Vinci, Roberto Matta, Kasimir
Medunetsky, Robert Michel, Francis Picabia, Augustino
Ramelli, Georges Ribemont-Dessaignes, Morton

Livingston Schamberg, Saul Steinberg, Hedda Sterne,
Diego Ufano, Robert Valturin, Vegece, and Walter A. Wood
Location: Contemporary Arts Museum Houston
Curators: Jim Love and Jermayne MacAgy
Catalogue

Islands Beyond: An Exhibition of
Ecclesiastical Sculpture and Modern Paintings
October 2–19, 1958
Artists: Josef Albers, James Boynton, Jean Dubuffet, Max
Ernst, Jean Fautrier, Esteban Francis, Philip Guston,
Timothy Hennessy, Paul Klee, Fernand Léger, Jim Love,
René Magritte, Georges Mathieu, Roberto Matta, Jeanne
Reynal, Mark Rothko, Kurt Schwitters, Hassel Smith,
Nicolas de Staël, Clyfford Still, Rufino Tamayo, and
Mark Tobey
Location: Jones Hall Fine Arts Gallery, University of
 St. Thomas, Houston
Curator: Jermayne MacAgy
Catalogue

Personal Contacts: A Decade of
Contemporary Drawings, 1948–1958
November 20, 1958–January 4, 1959
Artists: Harold Altman, Leonard Baskin, Max Beckmann,
Peter Blume, Louise Bourgeois, Georges Braque, Victor
Brauner, James Brooks, Carlyle Brown, Paul Cadmus,
John Cage, Charles Cajori, Lawrence Calcagno, Kenneth
Callahan, Eduardo Chillida, Edward Corbett, Stuart Davis,
Willem De Kooning, Jean Dubuffet, Jimmy Ernst, Gray
Foy, Alberto Giacometti, Edward Giobbi, Joseph Glasco,
Adolph Gottlieb, John Graham, Morris Graves, Balcomb
Greene, Étienne Hajdu, Hans Hofmann, John Hultberg,
Jasper Johns, Leon Kelly, Henry Koerner, Yasuo Kuniyoshi,
Wifredo Lam, Ibram Lassaw, John Levee, Jacques Lipchitz,
René Magritte, Conrad Marca-Relli, John Marin, Ezio
Martinelli, Georges Mathieu, Henri Matisse, Roberto
Matta, Henri Michaux, Hans Moller, Robert Motherwell,
Bernard Perlin, Pablo Picasso, Jackson Pollock, Abraham
Rattner, Theodore Roszak, Gordon Russell, William Scott,
Ben Shahn, David Smith, Pierre Soulages, Theodoros
Stamos, Walter Stein, Saul Steinberg, Peter Takal, Pavel
Tchelitchew, Mark Tobey, Jack Tworkov, and Max Weber
Location: Contemporary Arts Museum Houston
Curators: James Boynton and Jermayne MacAgy
Catalogue

Totems Not Taboo: An Exhibition of Primitive Art
February 26–April 23, 1959
Artists: Constantin Brancusi, Henri Laurens, Jacques
Lipchitz, Amedeo Modigliani, and Pablo Picasso, with
works from Africa, Central America, North American,
South America, and the South Pacific
Location: Cullinan Hall, The Museum of Fine Arts,
 Houston
Curator: Jermayne MacAgy
Catalogue

Ten Years of Houston Architecture
March 6–April 1959
Artists: Donald Barthelme & Associates, Bolton &
Barnstone, Cowell & Neuhaus, William R. Jenkins &
Associates, Burdette Keeland Jr., McKie & Kamrath, and
Neuhaus and Taylor, with Clyde Jackson, Philip Johnson
Associates, Ludwig Mies van der Rohe, and Swenson and
Linnstaedter

Location: Contemporary Arts Museum Houston
Curators: Howard Barnstone and Burdette Keeland Jr.
Catalogue

The Romantic Agony: From Goya to de Kooning
April 23–May 31, 1959
Artists: Francis Bacon, Hyman Bloom, Alberto Burri,
Alexander Calder, Willem De Kooning, Jean Dubuffet,
Théodore Géricault, Alberto Giacometti, Arshile Gorky,
Francisco de Goya, Hans Hofmann, Franz Kline, Käthe
Kollwitz, Jacques Lipchitz, Alessandro Magnasco,
Roberto Matta, Joán Miró, Reuben Nakian, Louise
Nevelson, Emil Nolde, Jackson Pollock, Germaine
Richier, Georges Rouault, Chaïm Soutine, and Wols
(Alfred Otto Wolfgang Schulze)
Location: Contemporary Arts Museum Houston
Curators: Marc Moldawer and Jermayne MacAgy
Catalogue

The Visage of Culture: A Telescopic Survey of Art from the Cave Man to the Present
November 6–December 31, 1959
Artists: Andrea da Firenze, Georges Braque, Paul
Cézanne, Guidoccio Cozzarelli, Edgar Degas, Eugène
Delacroix, Cosme Dumonstier, Jean-Honoré Fragonard,
Giovanni da Bologna, Vincent van Gogh, Francisco
de Goya, Jean Baptiste Lemoyne, Jacques Lipchitz, Piet
Mondrian, Pablo Picasso, Nicolas Poussin, Pierre-Auguste
Renoir, Hans Rottenhammer, Georges Rouault, and
works from Prehistoric, Ancient, Early Christian,
Byzantine, Romanesque, and Gothic eras
Location: Jones Hall Fine Arts Gallery, University of
St. Thomas, Houston
Curator: Jermayne MacAgy
Catalogue

The Lively Arts of the Renaissance
January 15–February 21, 1960
Artists: Tiziano Aspetti, Thomas Bampton, Giovanni
Bernardi, Bertoldo di Giovanni, Giovanni Boldù, Johann
Theodor de Bry, Michelangelo Buonarroti, Benvenuto
Cellini, Antonio Cigognara, Pieter Coecke van Aelst,
Donato di Leonardo, Niccolo Fiorentino, Orazi Fontana,
Francesco di Giorgio Martini, Giacomo Franco, Giovanni
Antonio da Brescia, Giovanni da Bologna, Thomas
Heard, Francesco Laurana, Leonardo da Vinci, Filippino
Lippi, Kunz Lochner, Matteo de'Pasti, Maffeo Olivieri,
Perugino (Pietro Perugino), Pierino da Vinci, Pisanello
(Antonio di Puccio Pisano Pisanello), Antonio del
Pollaiuolo, Andrea Riccio, Giancristoforo Romano
[Giovanni Cristoforo Romano], Francesco da Sangallo,
Jacopo Sansovino, Carol Schmidt, Severo da Ravenna,
Silvestro dell' Aquila, Sperandio Savelli, Giovanni
Francesco Susini, Alessandro Vittoria, and unknown
artists
Location: Cullinan Hall, The Museum of Fine Arts,
Houston
Curator: Jermayne MacAgy
Catalogue

Wind, Land and Stars: An Exhibition of Landscape Art from the Fifteenth to the Twentieth Century
March 17–April 25, 1960
Artists: Milton Avery, Sergio Castro, Paul Cézanne,
Giorgio de Chirico, John Constable, Gustave Courbet,
Stuart Davis, Jean Dubuffet, Max Ernst, Jean Fautrier,

Lyonel Feininger, Gentile da Fabriano, Vincent van
Gogh, Morris Graves, Giacomo Guardi, David Hare,
Johan Barthold Jongkind, Ernst Ludwig Kirchner, Paul
Klee, Fernand Léger, Leonid, René Magritte, John Marin,
Henri Matisse, Giovanni Pannini, Hubert Robert,
Georges Rouault, Jacob van Ruisdael, Alfred Sisley,
Chaïm Soutine, Nicolas de Staël, Yves Tanguy, Maurice
de Vlaminck, Edouard Vuillard, and Andrew Wyeth
Location: Jones Hall Fine Arts Gallery, University of
St. Thomas, Houston
Curator: Jermayne MacAgy
Catalogue

Paul Klee
April 19–May 22, 1960
Location: The Museum of Fine Arts, Houston
Curator: Jermayne MacAgy and Committee on
Modern Art, The Museum of Fine Arts, Houston
Catalogue

From Gauguin to Gorky
October 20–December 11, 1960
Artists: Pierre Bonnard, Georges Braque, Paul Cézanne,
Marc Chagall, Giorgio de Chirico, Gustave Courbet,
Stuart Davis, Edgar Degas, André Derain, Arthur
Garfield Dove, Raoul Dufy, Ignace Henri Jean Theodore
Fantin-Latour, Paul Gauguin, Vincent van Gogh, Arshile
Gorky, Juan Gris, Vassily Kandinsky, Ernst Ludwig
Kirchner, Paul Klee, Fernand Léger, Édouard Manet,
Henri Matisse, Joán Miró, Amedeo Modigliani, Piet
Mondrian, Claude Monet, Pablo Picasso, Camille
Pissarro, Odilon Redon, Pierre-Auguste Renoir, Georges
Rouault, Henri Rousseau, Chaïm Soutine, Maurice
Utrillo, Suzanne Valadon, and Maurice de Vlaminck
Location: Cullinan Hall, The Museum of Fine Arts,
Houston
Curators: Jermayne MacAgy and Committee on
Modern Art, The Museum of Fine Arts, Houston
Catalogue: From Gauguin to Gorky in Cullinan Hall

Persona Grata: An Exhibition of Masks from 1200 B.C. to the Present
November 3–December 11, 1960
Artists: Karel Appel, Wladislaw Theodore Benda, Victor
Brauner, Giorgio de Chirico, Honoré Daumier, Julio
De Diego, Max Ernst, Giovanni Domenico Ferretti, Pietro
Longhi, Paul Klee, René Magritte, Joán Miró, Tanya Moisei-
witsch, Emil Nolde, Pablo Picasso, Margaret Severn, and
unattributed or commercially produced works
Location: Jones Hall Fine Arts Gallery, University of St.
Thomas, Houston
Curator: Jermayne MacAgy
Catalogue

René Magritte in America
February 2–March 1, 1961
Location: The Museum of Fine Arts, Houston
Curator: Douglas MacAgy
Catalogue

Desiderio's Cathedral
March 19–April 30, 1961
Artists: Jacopo del Casentino, François de Nomé,
Bartolomé Ordóñez, Francisco de Zurbarán, and works
of the thirteenth to sixteenth centuries from England,
France, Germany, and Italy

Location: Jones Hall Fine Arts Gallery, University of
St. Thomas, Houston
Curator: Jermayne MacAgy
Catalogue

American Folk Art
September 28–November 15, 1961
Artists: Alexander Boudrou, George Caitlin, Joseph H.
Davis, Deborah Goldsmith, Matilda A. Haviland, Joseph
Headley, Edward Hicks, Betsy B. Lathrop, Reuben Low
Reed, Joseph Remick, Samuel Robb, William Schimmel,
Catherine Townsend Warner, and unattributed works
from the Williamsburg Collection
Location: Jones Hall Fine Arts Gallery, University of
St. Thomas, Houston
Curator: Jermayne MacAgy
*Catalogue: American Folk Art from Houston Collections
presented by The Fine Arts Department, University of
St. Thomas*

The Age of the Thousand Flowers: An Exhibition of Works by Artists Past and Present
March 9–April 30, 1962
Artists: André Bauchant, Ferdinand Bauer, Forrest Bess,
Pierre Bonnard, Eugène Louis Boudin, Georges Braque,
Victor Brauner, Alexander Calder, Marc Chagall, Georg
Dionysius Ehret, Max Ernst, Ignace Henri Jean Theodore
Fantin-Latour, Jean Fautrier, Francesco Fieravino,
Robert Furber, Fede Galizia, Morris Graves, Paul Klee,
Fernand Léger, John Lindley, Jim Love, Loren MacIver,
René Magritte, Master of the Legend of Saint Lucy, Henri
Matisse, Piet Mondrian, Jean-Baptiste Monnoyer, Francis
Picabia, Pablo Picasso, Odilon Redon, Pierre-Auguste
Renoir, Georges Rouault, Stéphanie Félicité du Crest de
Saint-Aubin, Jean Schlumberger, Florine Stettheimer,
Takis (Panayiotis Vassilakis), A. Teixeira, Robert John
Thornton, Gaspar Peeter de Verbruggen the Younger,
and Simon Verelst
Location: Jones Hall Fine Arts Gallery, University of
St. Thomas, Houston
Curator: Jermayne MacAgy
Catalogue

Other Voices: An Exhibition of Artifacts of Religious and Supernatural Beliefs of Other Cultures
October 25–December 16, 1962
Artists: Victor Brauner, with unattributed works by
indigenous artists
Location: Jones Hall Fine Arts Gallery, University of
St. Thomas, Houston
Curator: Jermayne MacAgy
Catalogue

The John and Dominique de Menil Collection
November 21, 1962–February 1, 1963
Artists: Works from indigenous cultures of Africa,
France, Greece, Iran, North America, Siberia, South
America, Spain, and Syria
Location: Museum of Primitive Art, New York
Curator: Douglas Newton
Catalogue

Art Has Many Facets: The Artistic Fascination with the Cube

March 23–May 12, 1963

Artists: Henri Georges Adam, Josef Albers, Juan de Arfe, Ernesto Barreda, Billy Al Bengston, Jeanne Boillot, Dusti Bonge, Giovanni Battista Bracelli, Victor Brauner, Eduardo Chillida, Genevieve Claisse, Hugo Rodolfo Demarco, Dominique de Menil, Burgoyne Diller, (Louis Charles) Dupain de Montesson, Albrecht Dürer, Richard Faralla, Alberto Giacometti, Fritz Glarner, Juan Gris, (Nicolas) Grollier de Servière, Augustin Hirschvogel, Hendrik Hondius the Elder, Klaus Ihlenfeld, S. Jacobs, Wenzel Jamnitzer, Edme Jeaurat, Alfred Jensen, Mathurin Jousse, Lyman Kipp, Paul Klee, Harold Krisel, Nicolas de Larmessin I, Henri Laurens, Fernand Léger, Julio Le Parc, Denver Lindley Jr., Jacques Lipchitz, Richard Lippold, Jim Love, René Magritte, Albert Manchak, Richard Mortensen, Walter Tandy Murch, Louise Nevelson, Jean François Niceron, Ben Nicholson, George Ortman, Josef Peeters, Emilio Pettoruti, (Paul) Pfinzing Von Henfenfeld, Pablo Picasso, Ioh. Isacio Pontano, Andrea Puteo, Odilon Redon, James Rosati, Henryk Stazewski, Saul Steinberg, Luis Tomasello, Anne Truitt, Victor Vasarely, Sidney Wolfson, Norman Zammitt, and unknown artists

Location: Jones Hall Fine Arts Gallery, University of St. Thomas, Houston

Curator: Jermayne MacAgy

Catalogue

Sculpture: Cycladic and Haniwa

October 25, 1963–January 18, 1964

Location: Jones Hall Fine Arts Gallery, University of St. Thomas, Houston

Curator: Jermayne MacAgy

Catalogue

Out of This World: An Exhibition of Fantastic Landscapes from the Renaissance to the Present

March 20–May 3, 1964

Artists: Lazzaro Bastiani, André Bauchant, John Baxter, Auguste De Beaurepaire, Eugene Berman, Albert Blakelock, Peter Blume, Camille Bombois, Victor Brauner, Rodolphe Bresdin, M. Cambry, Jean-Francois Chopard, Fabrizio Clerici, Brian Connelly, Joseph Cornell, Currier and Ives, Dorothy Dehner, Gustave Doré, Jean Dubuffet, Max Ernst, Yolande Fievre, Esteve Francés, Eugene Gabritschewsky, John Haberle, Maerten van Heemskerck, Victor Hugo, Guy Johnson, Paul Klee, Jacqueline Lamba, Jacques Moreau Le Maréchal, Stanislao Lepri, Jean Lurcat, René Magritte, John Martin, Roberto Matta, Matthieu Merian, Henri Michaux, Joán Miró, Anton Mirou, Joos de Momper, Claude Monet, Adolphe Joseph Monticelli, Gustave Moreau, Walter Tandy Murch, Costantino Nivola, Sidney Nolan, François de Nomé, J. F. Picard, Cornelis van Poelenburgh, Marie-Anne Poniatowska, Richard Pousette-Dart, Odilon Redon, Jacob Savery, Shōkadō Shōjō, Joseph Stella, Yves Tanguy, Antoni Tàpies, Mark Tobey, Rombout van Troyen, Joseph Mallord William Turner, Maurice de Vlaminck, and works from Europe, Italy, and Spain

Location: Jones Hall Fine Arts Gallery, University of St. Thomas, Houston

Curator: Jermayne MacAgy

Catalogue

Magritte

May 16–June 28, 1964

Artist: René Magritte

Location: Arkansas Art Center, Little Rock

Curator: Dominique de Menil

Catalogue: Magritte: An Exhibition Prepared by the Art Department of the University of St. Thomas, Houston, Texas

Great Masters for Small Budgets

June 28–September 30, 1964

Artists: Jean (Hans) Arp, Georges Braque, Eduardo Chillida, Jean Dubuffet, Max Ernst, Alberto Giacometti, Juan Gris, Fernand Léger, Henri Matisse, Joán Miró, and Pablo Picasso

Location: Jones Hall Fine Arts Gallery, University of St. Thomas, Houston

Curator: Dominique de Menil

Constant Companions: An Exhibition of Mythological Animals, Demons and Monsters, Phantasmal Creatures and Various Anatomical Assemblages

October 28, 1964–February 7, 1965

Artists: Ulysses Aldrovandus, Jost Amman, Francis Bacon, Christian Bérard, Louis Boulanger, Louise Bourgeois, Victor Brauner, Rodolphe Bresdin, Pieter Brueghel the Elder, François Chaveau, Jean Cocteau, William Nelson Copley, John William Smith Cox, Dado (Miodrag Djurie Dado), Salvador Dalí, C. David, Eugène Delacroix, Etienne Delaune, Jean Dubuffet, Jacques Androuet Du Cerceau, Guillaume Dupaix, Albrecht Dürer, Jean Duvet, Max Ernst, Louis Fernandez, John Fischer, Eugene Gabritschewsky, Conrad Gessner, Hendrick Goltzius, Francisco de Goya, Reinhoud d'Haese, Alfred Louis Vigny Jacomin, Abbas Joachim, Athanasius Kircher, Paul Klee, Joseph A. Kurhajec, Wifredo Lam, Octave Landuyt, Fortunio Licetus, Lucas van Leyden, Conrad Lycosthenes, Maestro del Drago, René Magritte, Robert Mallary, Andrea Mantegna, Roberto Matta, James Metcalf, Henri Michaux, Mirko (Mirko Balsadella) Joán Miró, Gustave Moreau, Alfred de Musset & P. J. Stahl, Giovanni Orlandi, Ovid, Ambroise Paré, Pablo Picasso, Odilon Redon, Andrea Riccio, Giulio Romano (Giulio Pippi), Salvator Rosa, Giovanni Jacopo Rossi, Niki de Saint-Phalle, Daniel Schellinks, Martin Schongauer, P. Gasparus Schottus, Kurt Seligmann, Saul Steinberg, Graham Sutherland, Takis (Panayiotis Vassilakis), Yves Tanguy, Dorothea Tanning, Antonio Tempesta, Edward Topsell, J. P. Valeriano, Enea Vico, and Unica Zurn

Location: Jones Hall Fine Arts Gallery, University of St. Thomas, Houston

Curator: Dominique de Menil

Catalogue

Unromantic Agony

April 4–30, 1965

Artists: Christian Bérard, Mary Callery, Jean Fautrier, Louis Fernandez, Jasper Johns, Guy Johnson, Paul Klee, Jim Love, René Magritte, Robert Mallary, Leopoldo Méndez, Pablo Picasso, Giovanni Battista Piranesi, José Guadalupe Posada, Robert Rauschenberg, Georges Rouault, Henri de Toulouse-Lautrec, Juan Alonzo Villabrille y Ron, Andy Warhol, and unattributed works and books by Samuel Clarke, John Foxe, and Philip Limborch

Location: Jones Hall Fine Arts Gallery, University of St. Thomas, Houston

Curator: Dominique de Menil

Catalogue

Through the Porthole

July 3–October 3, 1965

Artists: G. Candida Babuino, E. Bouché, Joseph Cornell, Paul Delvaux, George W. Grover, R. Jacobson, Charles Euphrasie Kuwasseg, Jim Love, Rafael Moreno, Emile Oberkampf, Armando Reverón, Julius Stockfleth, Yannis Tsarouchis, Louis Vivin, and unknown artists; books exhibited by P. D. Boilat, Castillan, Sir John Chardin, Marie-Gabriel-Florent-Auguste Choiseul-Gouffier, John Churchill, Charles Cordier, William Daniell, Denham Dixon, William Hemsley Emory, Charles A. Goodrich, Sir Thomas Herbert, Peter Heylyn, Athanasius Kircher, François Leguat, Jeronymo Lobo, Henry Maundrell, Francis Moore, John Nieuhoff, Adam Olearius, William Patterson, Philip Quarl, Sir Paul Rycaut, Thomas Salmon, L. Sitgreaves, Charles Sigisbert Sonnini, Henry Swinburne, Balthazar Tellez, and Walausna

Location: Jones Hall Fine Arts Gallery, University of St. Thomas, Houston

Curator: Dominique de Menil

Catalogue

Humble Treasures: An Exhibition of Tribal Art from Negro Africa

October 15, 1965–February 20, 1966

Location: Jones Hall Fine Arts Gallery, University of St. Thomas, Houston

Curator: Dominique de Menil

Catalogue

Builders and Humanists: The Renaissance Popes as Patrons of the Arts

March 24–May 22, 1966

Artists: Nicolaus van Aelst, Alessandro Algardi, Bartolomeo Ammanati, Augustin-Charles d'Aviler, Nicolas Beatrizet, Bernardo Bellotto, Gian Lorenzo Bernini, Giulio Bonasone, follower of Michelangelo Buonarroti, Luca Cambiaso, Bernardino Campi, Caradosso (Christoforo Foppa), replica of Caravaggio (Michelangelo Merisi da Caravaggio), Annibale Carracci, Lodovico Carracci, Giacomo Cavedone, Benvenuto Cellini, Cerano (Giovanni Battista Crespi), Giuseppe Cesari, Giulio Clovio, Charles Cochin, Cristoforo di Geremia, Lievin Cruyl, Giovanni Daudine, Stefano Della Bella, Marco Dente, Domenichino (Domenico Zampieri), Giovanni Antonio Dosio, Etienne Duperac, Hermann Egger, Giovanni Battista Falda, Ambrogio Giovanni Figino, Antonio Gentili, Giorgio Ghisi, Girolamo da Carpi, Giulio Romano (Giulio Pippi), Athanasius Kircher, Antoine Lafréry, Giovanni Lanfranco, Ottavio Mario Leoni, Etienne Frederic Lignon, Pirro Ligorio, Peter van Lint, Lysippus the Younger, Carlo Maratti, Battista dell'Angelo del Moro, Agostino Musi, Girolamo Muziano, Giovanni Battista Nolli, Giovanni Francesco Penni, Giovanni Battista Piranesi, Marcantonio Raimondi, Raphael (Raffaello Sanzio da Urbino), Giancristoforo Romano (Giovanni Cristoforo Romano), Martino Rota, Andrea Sacchi, Antonio Salamanca, Francesco Salviati, Girolamo Siciolante, Israël Silvestre, Alessandro Specchi, manner of Antonio Tempesta, Pellegrino Tibaldi, follower of Titian (Tiziano Vecellio), Joseph Mallord

William Turner, Giuseppe Vasi, Enea Vico, circle of Vignola, Anthonis van den Wyngaerde, Federico Zuccaro, Taddeo Zuccaro, and a selection of architectural drawings and books
Location: Jones Hall Fine Arts Gallery, University of
St. Thomas, Houston
Curator: Dominique de Menil
Catalogue

Made of Iron

September 29, 1966–January 3, 1967
Artists: Alexander Calder, César (César Baldaccini), John Chamberlain, Eduardo Chillida, François Clouet, José De Rivera, Roy Fridge, Julio Gonzalez, David Hayes, Rudolf Hoflehner, Robert Jacobsen, Frank Koralewsky, Fernand Léger, Georges Liautaud, Jim Love, Ezio Martinelli, Jean Louis Ernest Meissonier, Antonio Maria Monti, Robert Muller, Claes Oldenburg, Michelangelo Pistoletto, George Rickey, Julius Schmidt, David Smith, Francesco Somaini, Takis (Panayiotis Vassilakis), Jean Tinguely, unknown artists, and a selection of books and engravings
Location: Jones Hall Fine Arts Gallery, University of
St. Thomas, Houston
Curator: Dominique de Menil
Catalogue

19th- and 20th-Century Posters

January 13–February 28, 1967
Artists: Richard Joseph Anuskiewicz, Edward Avedisian, V. Bergé, Pierre Bonnard, Georges Braque, Victor Brauner, Marc Chagall, Alfred Choubrac, Jean Dubuffet, Henri A. Ferguson, Alberto Giacometti, Nicholas Krushenick, Fernand Léger, Roy Lichtenstein, Richard Lindner, Henri Matisse, Joán Miró, Alphonse Mucha, Pablo Picasso, Robert Rauschenberg, Paul Sémant, Pierre Soulages, Henri de Toulouse-Lautrec, Raoul Ubac, Andy Warhol, Wes Wilson, and unknown artists
Location: Jones Hall Fine Arts Gallery, University of
St. Thomas, Houston
Curator: Dominique de Menil
Catalogue

Six Painters: Mondrian, De Kooning, Guston, Kline, Pollock and Rothko

February 23–April 15, 1967
Artists: Willem De Kooning, Philip Guston, Franz Kline, Piet Mondrian, Jackson Pollock, and Mark Rothko
Location: Jones Hall Fine Arts Gallery, University of
St. Thomas, Houston
Curator: Dominique de Menil
Catalogue

Mixed Masters: An Exhibition Showing the Various Media Used by Contemporary Artists

May 19–September 18, 1967
Artists: Arman (Armand Fernandez), Richard Artschwager, Pol Bury, William Nelson Copley, John Fischer, Al Hansen, Richard Hogle, Robert Indiana, Roy Lichtenstein, Jim Love, Claes Oldenburg, Martial Raysse, Niki de Saint-Phalle, Lucas Samaras, George Segal, Takis (Panayiotis Vassilakis), Wayne Thiebaud, John Van Saun, and Andy Warhol
Location: Jones Hall Fine Arts Gallery, University of
St. Thomas, Houston
Curator: Dominique de Menil
Catalogue

Visionary Architects: Boullée, Ledoux, Lequeu

October 19, 1967–January 3, 1968
Artists: François Barbier, François-Joseph Bélanger, Jacques Charles Bonnard, Étienne-Louis Boullée, Pierre-Jules Delépine, Louis Jean Desprez, Pierre-François-Léonard Fontaine, Jean Joseph Pascal Gay, Larseneur, Claude-Nicolas Ledoux, Jean-Jacques Lequeu, Charles Percier, Jean-Nicolas Sobre, Jean-Jacques Tardieu, Louis-Alexandre Trouard, Antoine Laurent Thomas Vaudoyer, François Verly, and Joseph-Marie Vien
Location: Jones Hall Fine Arts Gallery, University of
St. Thomas, Houston
Curators: Jean-Claude Lemagny and Dominique de Menil
Catalogue

Light and Vision: Photographs from the Beginning Classes at the Media Center

ca. 1968
Artists: Nancy Brennan, Victor Durant, Jacqueline Frank, Harry Golightly, Dale Illig, John Jackson, Peter Kelly, John Kelsey, Laura Kennerly, Steve Leary, Linda Lee, Christa Levine, Margaret Lewis, Rodney Marionneaux, William Mebane, Lili Milani, Goran Milutinovic, Velda Myers, Bernard Pendergraft, John Pratt, Dan Samuels, William Stevens, Herman Suit, Janis Todd, and Dan Yates
Location: Media Center, University of St. Thomas,
Houston
Curator: Geoff Winningham
Catalogue

Early Chinese Art and the Pacific Basin: A Photographic Exhibition

February 2–25, 1968
Location: Jones Hall Fine Arts Gallery, University of
St. Thomas, Houston
Curator: Douglas Fraser
Organizer: Department of Art History and Archaeology,
Columbia University, New York
Catalogue

Look Back: An Exhibition of Cubist Paintings and Sculptures from the Menil Family Collection

March 13–September 13, 1968
Artists: Georges Braque, Paul Cézanne, Juan Gris, Henri Laurens, Fernand Léger, Jacques Lipchitz, and Pablo Picasso
Location: Jones Hall Fine Arts Gallery, University of
St. Thomas, Houston
Curator: Dominique de Menil
Catalogue

Exhibition of De Menil Paintings & Sculptures

September 8–October 6, 1968
Artists: Jean (Hans) Arp, Lee Bontecou, Victor Brauner, Alexander Calder, Chryssa (Varda Chryssa), William Copley, Jean Dubuffet, Max Ernst, Jasper Johns, Paul Klee, Wifredo Lam, Fernand Léger, René Magritte, Roberto Matta, Henri Michaux, Louise Nevelson, Claes Oldenburg, Francis Picabia, Robert Rauschenberg, Martial Raysse, Georges Rouault, Niki de Saint-Phalle, George Segal, Takis (Panayiotis Vassilakis), Jean Tinguely, Andy Warhol, and Jack Youngerman
Location: Witte Museum, San Antonio
Curator: Martha Utterback

A Young Teaching Collection

November 7, 1968–January 12, 1969
Artists: Arman (Armand Fernandez), Erik Borja, Georges Braque, Pol Bury, Guglielmo Caccia, Alexander Calder, Théodore Chassériau, Christo and Jeanne-Claude, Eugène Delacroix, Anthony van Dyck, Nicolás Enriquez, Max Ernst, Battista Franco, Arshile Gorky, Jacopo del Casentino, Paul Klee, Yves Klein, Wifredo Lam, copy after Charles Lebrun, Pirro Ligorio, Jim Love, Alessandro Magnasco, René Magritte, Albert Manchak, Roberto Matta, Claes Oldenburg, Giovanni Francesco Penni, Pablo Picasso, Michelangelo Pistoletto, follower of Rembrandt van Rijn, Larry Rivers, George Romney, Niki de Saint-Phalle, Lucas Samaras, Saul Steinberg, Takis (Panayiotis Vassilakis), Wayne Thiebaud, Jean Tinguely, Andy Warhol, Thomas Wyck, and unknown artists
Location: The Museum of Fine Arts, Houston
Curator: Dominique de Menil
Catalogue

Jermayne MacAgy: A Life Illustrated by an Exhibition

November 21, 1968–January 5, 1969
Artists: Josef Albers, Gertrude Barnstone, William Baziotes, Hans Bellmer, Forrest Bess, Jack Boynton, Victor Brauner, Joseph Cornell, follower of Gustave Courbet, Max Ernst, Charles Houghton Howard, Guy Johnson, Walter Egel Kuhlman, Agapito Labios, Jim Love, Henri Matisse, Roberto Matta, Joán Miró, Marc Moldawer, Pablo Picasso, Mark Rothko, Peter Shoemaker, Hassel Smith, Clyfford Still, Richard Gordon Stout, Andy Warhol, and unknown artists
Location: Jones Hall Fine Arts Gallery, University of
St. Thomas, Houston
Curator: Dominique de Menil
Catalogue

Images by Light

January 17–March 2, 1969
Artists: Robert Adamson, Manuel Alvarez Bravo, Eugène Atget, E. J. Bellocq, Bisson Frères (Louis August and Auguste-Rosalie), Brassaï (Gyula Halász), Julia Margaret Cameron, Michael Ciavolino, Alvin Langdon Coburn, Imogene Cunningham, Harold Eugene Edgerton, Peter Henry Emerson, Frederick Henry Evans, Alexander Gardner, William A. Garnett, Arnold Genthe, Mario Giacomelli, Ernst Haas, Josiah Johnson Hawes, David Martin Heath, David Octavius Hill, Irwin Klein, George Krause, Jacques Henri Charles au Lartigue, Russell Lee, Man Ray, Adolf de Meyer, Tina Modotti, László Moholy-Nagy, Barbara Morgan, Wright Morris, Eadweard Muybridge, Paul Outerbridge, Irving Penn, August Sander, Naomi Savage, Christian Schad, Charles Sheeler, Arthur S. Siegel, Aaron Siskind, W. Eugene Smith, Frederick Sommer, Albert Sands Southworth, Edward Jean Steichen, Ralph Steiner, Alfred Stieglitz, Paul Strand, Weegee (Arthur Fellig), Brett Weston, Edward Weston, and Clarence Hudson White
Location: Jones Hall Fine Arts Gallery, University of
St. Thomas, Houston
Curator: John Szarkowski

The Machine as Seen at the End of the Mechanical Age
March 25–May 18, 1969
Artists: John William Anthes, Giacomo Balla, Hans Bellmer, Per Biorn, Umberto Boccioni, James Boydell, Giovanni Battista Bracelli, Victor Brauner, Robert Breer, Ettore Bugatti, Alexander Calder, César (César Baldaccini), Charles Chaplin, Colin Chapman, Giorgio de Chirico, George Cruikshank, Nicolas-Joseph Cugnot, Honoré Daumier, Robert Delaunay, Marcel Duchamp, Raymond Duchamp-Villon, Jean Dupuy, school of Albrecht Dürer, Ed van der Elsken, Jacob Epstein, Max Ernst, Alexandre Exter, Ray Farhner, Lyonel Feininger, Richard Fraenkel, R. Buckminster Fuller, Naum Gabo, Alberto Giacometti, Rube Goldberg, Natalia Goncharova, Anthony Granatelli, Georg Grosz, Hans Haacke, Leon D. Harmon, Hilary Harris, Raoul Hausmann, Hannah Höch, Winslow Homer, Pierre Jacquet-Droz, Edward Kienholz, Tracy S. Kinsel, Konrad Klapheck, Paul Klee, Billy Klüver, Kenneth C. Knowlton, Jacques Henri Charles au Lartigue, Camille Lefèbvre, Fernand Léger, Leonardo da Vinci, Wyndham Lewis, El Lissitzky, Lumière Brothers, James Macaulay, René Magritte, Kazimir Malevich, Man Ray, Jules Etienne Marey, Ralph Martel, Eric Martin, Roberto Matta, Theodore Maurisset, Winsor McCay, Georges Méliès, László Moholy-Nagy, Filippo Morgen, Bruno Munari, Eadweard Muybridge, Alphonse de Neuville, Claes Oldenburg, Nam June Paik, Robin Parkinson, Ennemond Alexandre Petitot, Francis Picabia, Kristofer Polhem, Liubov Popova, Jeffrey Raskin, Robert Rauschenberg, W. Read, Georges Ribemont-Dessaignes, Simon Ritter von Stampfer, Richard Stankiewicz, Joseph Stella, Takis (Panayiotis Vassilakis), Vladimir Tatlin, Jean Tinguely, Mark Tobey, Henri de Toulouse-Lautrec, Richard Trevithick, Wen-Ying Tsai, Frank Turner, Aleksandr Aleksandrovich Vesnin, W. L. Walton, La Monte Young, Lucy Jackson Young, Niels O. Young, and Marian Zazeela
Location: Rice Museum, Rice University, Houston
Curator: Karl Gunnar Pontus Hulten
Organizer: The Museum of Modern Art, New York
Catalogue

Tony Smith
April 21–May 28, 1969
Location: Rice University, Houston
Curator: Renée Sabatello Neu

The Sky Is the Limit
May 7–June 30, 1969
Artists: Iain Baxter, Alexander Calder, Christo and Jeanne-Claude, Joseph Cornell, Charles August Albert Dellschau, Max Ernst, R. Buckminster Fuller, Hans Haacke, Gerald Laing, Stanley Landsman, Roy Lichtenstein, René Magritte, John Martin, Roberto Matta, Leila McConnell, Bruce Nauman, Georgia O'Keeffe, Odilon Redon, Mark Rothko, Matija Skurjeni, Yves Tanguy, Polygnotos Vagis, Philip Van Brunt, and Andy Warhol
Location: Jones Hall Fine Arts Gallery, University of St. Thomas, Houston
Curator: Paul Winkler

An Exhibition of African Art
May 8–12, 1969
Location: Texas Southern University, Houston

Raid the Icebox 1 with Andy Warhol: An Exhibition Selected from the Storage Vaults of the Museum of Art, Rhode Island School of Design
October 29, 1969–January 4, 1970
Artists: Alessandro Algardi, Giuseppe Baldrighi, Frank W. Benson, Luca Cambiaso, Albert-Ernest Carrier-Belleuse, Paul Cézanne, Alonzo Chappel, William Merritt Chase, Arthur B. Davies, Herman Decker, Edgar Degas, Guy Pène Du Bois, Christoffer Wilhelm Eckersberg, Lyonel Feininger, Jean Louis Forain, Jan Gossaert, Robert Henri, John F. Kensett, Wifredo Lam, Marie Laurencin, Silvestro Lega, James S. Lincoln, Eduardo Macentyre, Isaac de Moucheron, Joseph Paelinck, Maxfield Parrish, Bartolomeo Passarotti, Matthew William Peters, Francesco Primaticcio, Waldemar Raemisch, Guido Reni, Diego Rivera, Hubert Robert, Auguste Rodin, Henri Rousseau, John Singer Sargent, Georges Seurat, Charles Sheeler, Smith of Connecticut, Florine Stettheimer, James Jacques Joseph Tissot, Henri de Toulouse-Lautrec, Alonso Miguel de Tovar, Antonio González Velázquez, James McNeill Whistler, and unknown artists
Location: Rice Museum, Rice University, Houston
Curators: Dominique de Menil and Andy Warhol
Catalogue

Seventeenth-Century Dutch Masters from the Metropolitan Museum of Art
January 18–March 1, 1970
Artists: Jan Abrahamsz Beerstraten, Nicolaes Berchem, Abraham Bloemaert, Ferdinand Bol, Jan Both, Peeter Bout, Paul Bril, Willem Pietersz Buytewech, Leendert van der Cooghen, Isaac van Duynen, Allart van Everdingen, Simon Wynhoutsz Frisius, Jacques de Gheyn the Elder, Hendrick Goltzius, Hendrick Goudt, Frans Hals, C. Hellemans, Bartholomeus van der Helst, Pieter de Hooch, Ludolf de Jongh, Thomas de Keyser, Jan Lievens, Aert van der Neer, Adriaen van Ostade, Jürgen Ovens, Paulus Potter, Rembrandt van Rijn, Geertruydt Roghman, Roelant Roghman, Jacob van Ruisdael, Rachel Ruysch, Salomon van Ruysdael, Cornelis Saftleven, Herman Saftleven, Jan Steen, Ernst Stuven, Michael Sweerts, Adriaen van de Velde, Esaias van de Velde, and Jan van de Velde
Location: Rice Museum, Rice University, Houston
Curators: Peter Selz, with the curators of The Metropolitan Museum of Art, New York
Organizer: The Metropolitan Museum of Art, New York

La Monte Young and Marian Zazeela: Dream House
January 21–24, 1970
Location: Rice Museum, Rice University, Houston
Curator: Dominique de Menil

25 Photographs by Aaron Siskind from George Eastman House Collection
March 1–20, 1970
Location: Rice Media Center, Rice University, Houston

The Highway
March 12–May 18, 1970
Artists: William Allen, Allan D'Arcangelo, Robert Alan Bechtle, Billy Al Bengston, Aaron Bohrod, Tom Brozovich, John Chamberlain, Thomas Chimes, Christo and Jeanne-Claude, Mike Cooper, Robert Cottingham, Ralston Crawford, Stuart Davis, Richard Estes, Walker Evans, Ralph Goings, Art Himsl, Frederic Hobbs, Edward Hopper, Douglas Huebler, Robert Indiana, Gerald Laing, Daniel Lang, Dorothea Lange, N.E. Thing Co. Ltd. (Iain Baxter, President), Claes Oldenburg, Gerhard Richter, James Rosenquist, Edward Ruscha, John Salt, Salvatore Scarpitta, Jason Seley, Niles Spencer, Joseph Stella, Wayne Thiebaud, Mark Tobey, Ernest Trova, Andy Warhol, Tom Wesselmann, Young Electric Sign Company, and unknown artists
Location: Rice Museum, Rice University, Houston
Curator: Stephen S. Prokopoff
Organizers: Institute of Contemporary Art, University of Pennsylvania, Philadelphia, in collaboration with Institute for the Arts, Rice University, Houston, and Akron Art Institute
Catalogue

Surrealism: Surrealist Paintings from The D. and J. de Menil Collection, Houston, Texas
March 29–May 3, 1970
Artists: Victor Brauner, Giorgio de Chirico, Max Ernst, Wifredo Lam, René Magritte, Man Ray, Roberto Matta, and Yves Tanguy
Location: University Art Museum, University of Texas, Austin
Curator: Donald B. Goodall

Claes Oldenburg
April 13–19, 1970
Location: Rice Museum, Rice University, Houston
Curator: Dominique de Menil

Conversations with the Dead: An Exhibition of Photographs of Prison Life by Danny Lyon, with the Letters and Drawings of Billy McCune #122054
September 10–October 11, 1970
Location: Rice Museum, Rice University, Houston
Curator: Dominique de Menil
Catalogue

Ten Centuries That Shaped the West: Greek and Roman Art in Texas Collections
October 15, 1970–January 3, 1971
Location: Rice Museum, Rice University, Houston
Curator: Dominique de Menil

Pol Bury
January 25–March 7, 1971
Location: Rice Media Center, Rice University, Houston
Curator: Brenda Richardson
Organizers: University Art Museum, University of California at Berkeley, and Solomon R. Guggenheim Museum, New York
Catalogue

Some American History
February 4–April 25, 1971
Artists: Ellsworth Ausby, Frank Bowling, Peter Bradley, Daniel laRue Johnson, Joe Overstreet, Larry Rivers, and William Williams
Location: Rice Museum, Rice University, Houston
Curator: Dominique de Menil
Catalogue

For Children
May 22–August 29, 1971
Artists: Arman (Armand Fernandez), Victor Brauner, Alexander Calder, Giorgio de Chirico, William Nelson Copley, Joseph Cornell, Jean Dubuffet, Yolande Fievre, Lucio Fontana, Étienne Hajdu, Al Hansen, Joseph A. Kurhajec, Jim Love, René Magritte, David Parsons, Pablo Picasso, Martial Raysse, Nicolas de Staël, Saul Steinberg, Takis (Panayiotis Vassilakis), and Polygnotos Vagis
Location: Rice Museum, Rice University, Houston
Curator: Dominique de Menil

The De Luxe Show
August 22–September 12, 1971
Artists: Walter Darby Bannard, Peter Bradley, Anthony Caro, Dan Christensen, Edward Clark, Frank Davis, Sam Gilliam, Robert Gordon, Richard Hunt, Virginia Jaramillo, Daniel Johnson, Craig Kauffman, Alvin Loving, Kenneth Noland, Jules Olitski, Larry Poons, Michael Steiner, William Williams, and James Wolfe
Location: De Luxe Theater, Houston
Curator: Peter Bradley
Catalogue

Tamarind: A Renaissance of Lithography
September 1–30, 1971
Artists: Rodolfo Abularach, Clinton Adams, Anni Albers, John Altoon, Garo Antreasian, Ruth Asawa, Herbert Bayer, Billy Al Bengston, James Boynton, Paul Brach, William Brice, Salvador Bru, Rafael Canogar, Vija Celmins, Robert Cremean, William R. Crutchfield, José Luis Cuevas, Richard Diebenkorn, Burban Dogancay, Jules Engel, Sam Francis, Antonio Frasconi, Gego (Gertrudis Goldschmidt), Paul Harris, Robert Hensen, John Hunter, Richard Hunter, Masuo Ikeda, Alfred Jensen, Ynez John-ston, Allen Jones, John Paul Jones, Matsumi Kanemitsu, Nicholas Krushenick, Jacob Landau, Rico Lebrun, John Levee, Frank Lobdell, Maryan S. Maryan, James McGarrell, Eleanore Mikus, Carl Morris, Ed Moses, Lee Mullican, Louise Nevelson, Nathan Oliveria, George Ortman, Robert Andrew Parker, Henry C. Pearson, William Pettet, Otto Piene, Gio Pomodoro, Kenneth Price, Jesse Reichek, Seymour Rosofsky, Edward Ruscha, Miriam Schapiro, Karl Schrag, Aubrey Schwartz, Irene Siegel, Leon Polk Smith, Hedda Sterne, James Strombotne, Peter Takal, Rufino Tamayo, Walasse Ting, Hugh Townley, June Wayne, Hugo Weber, H. C. Westermann, Charles White, Emerson Woelffer, Dick Wray, Adja Yunkers, and Norman Zammitt
Location: Rice Media Center, Rice University, Houston
Organizers: Tamarind Lithography Workshop, Albu-querque, circulated by the International Exhibitions Foundation, Washington, D.C.
Catalogue

Selection from the Ménil Collection
September 24, 1971–April 30, 1972
Artists: Jean (Hans) Arp, Georges Braque, Victor Brauner, Paul Cézanne, Théodore Chasseriau, Giorgio de Chirico, Chryssa (Varda Chryssa), François Clouet, Willem De Kooning, Eugène Delacroix, Gustave Doré, Jean Dubuffet, Anthony van Dyck, Lucio Fontana, Pietro Francavilla, Alberto Giacometti, Giambologna (Giovanni da Bologna), Vincent van Gogh, Robert Indiana, Jacopo del Casentino, Jasper Johns, Paul Klee, Yves Klein, Franz Kline, Wifredo Lam, workshop of Charles Lebrun, Fernand Léger, Alessandro Magnasco, René Magritte,

Henri Matisse, Roberto Matta, Joán Miró, Piet Mondrian, Robert Motherwell, François de Nomé, Claes Olden-burg, Giovanni Francesco Penni, Pablo Picasso, Ad Reinhardt, Rembrandt van Rijn, George Romney, Georges Rouault, Antonio Saura, George Segal, David Smith, Nicolas de Staël, Theodoros Stamos, Clyfford Still, Takis (Panayiotis Vassilakis), Rufino Tamayo, Jean Tinguely, Andy Warhol, Wols (Alfred Otto Wolfgang Schulze), Francisco Zurbaran, and unknown artists
Location: Rice Museum, Rice University, Houston
Curator: Dominique de Menil
Catalogue

Photography by Eve Sonneman
January 16–February 15, 1972
Location: Rice Media Center, Rice University, Houston

Photographs by Herb Lotz
February 15–March 10, 1972
Location: Rice Media Center, Rice University, Houston

Photographs by Garry Winogrand
March 15–April 10, 1972
Location: Rice Media Center, Rice University, Houston

The Work of Venturi & Rauch
April 15–May 15, 1972
Artists: Robert Venturi and John K. Rauch
Location: Rice Media Center, Rice University, Houston
Catalogue

Joe Overstreet
May 14–July 30, 1972; August 15–September 30, 1972
Locations: Rice Museum, Rice University, Houston;
 De Luxe Theater, Black Arts Center, Houston
Curator: Joe Overstreet
Catalogue

Posters
August 28–September 15, 1972
Artists: Richard Avedon, Victor Brauner, Pieter Brueghel, R. L. Haeberle, Raoul Hausmann, Michael Heizer, M. Jirleiy, Jasper Johns, Yves Klein, Lalannes, Fernand Léger, René Magritte, Man Ray, Henri Matisse, Joán Miró, Claes Olden-burg, Francis Picabia, Pablo Picasso, Martial Raysse, Lucas Samaras, Andy Warhol, and William Williams
Location: Rice Museum, Rice University, Houston

Photo-Portraits by Gerard Malanga
September 9–October 28, 1972
Location: Rice Media Center, Rice University, Houston
Curator: Ian Glennie
Catalogue

cornered fluorescent light from Dan Flavin
October 5–November 26, 1972
An auxiliary group of drawings selected by Flavin from Menil holdings was shown in the adjacent Print Room.
Artists: Dan Flavin, with Paul Cézanne, John Chamber-lain, Giorgio de Chirico, Vincent van Gogh, Juan Gris, Paul Klee, Franz Kline, Henri Laurens, Fernand Léger, Man Ray, Henri Matisse, Amedeo Modigliani, Claes Olden-burg, Pablo Picasso, Robert Rauschenberg, Auguste Rodin, Andy Warhol, and Wols (Alfred Otto Wolfgang Schultze)
Location: Rice Museum, Rice University, Houston
Curators: Dan Flavin and Dominique de Menil

The Navajo Blanket
December 5, 1972–January 15, 1973
Location: Rice Museum, Rice University, Houston
Curator: Mary Hunt Kahlenberg and Anthony Berlant
Organizer: Los Angeles County Museum of Art
Catalogue

Bark Paintings
January 16–28, 1973
Artists: Ticuna Indians of the upper Amazon
Location: Rice Museum, Rice University, Houston
Curator: David Paris

Max Ernst: Illustrated Books, Writings, Periodicals, Exhibition Catalogs, Dada and Surrealist Memorabilia: Collection of Marvin Watson, Jr., Houston
February 7–May 20, 1973
Location: Rice Museum, Rice University, Houston
Curator: Dominique de Menil
Catalogue

Max Ernst: Inside the Sight
February 7–June 17, 1973
Location: Rice Museum, Rice University, Houston
Curator: Dominique de Menil
Catalogue

Tribal Art of Africa
April 22–May 20, 1973
Location: Black Arts Gallery, De Luxe Theater, Houston
Curators: John and Dominique de Menil

From Within: Selected Works by the Artists/ Inmates of New York State Correctional Facility at Auburn (Maximum Security)
September 16–October 7, 1973
Artists: James Evans, Joel Gaines, Justino Galarza, Armondo Hernandez (Mondo), Bernard Lawyer, Ron Lonbardi, John McCluney, Michael Joseph Nero, Juan Alberto Cruz Nieves, Alfredo Ortiz, Rolin W. Robinson (Sabu), Alfred Rodríguez, Daniel Rogers, Otis Scott, Richard Simmons, John Henry Smith, Joseph Stevens, Eugene Thomas (Alahumba), Ralph Thompson (Akili Nali), Herman B. Ward, and Ronald Warford
Location: Rice Museum, Rice University, Houston
Curator: James Harithas
Organizer: Everson Museum of Art, Syracuse
Catalogue

Gray Is the Color: An Exhibition of Grisaille Painting, XIIIth–XXth Centuries
October 19, 1973–January 16, 1974
Artists: Josef Albers, Richard Artschwager, John Baeder, Louis Léopold Boilly, François Boucher, Victor Brauner, Francis B. Carpenter, Eugène Carrière, José del Castillo, Pierre Jacques Cazes, Théodore Chassériau, Donato Creti, Jean Joseph Delvigne, Giacinto Diana, Gustave Doré, Anthony van Dyck, Thomas Cowperthwait Eakins, Max Ernst, Jean Fautrier, Louis Fernandez, Jean-Léon Gérôme, Alberto Giacometti, Giulio Romano (Giulio Pippi), Jean-Urbain Guerin, Claude-Guy Hallé, Maerten van Heemskerck, Philippe Auguste Hennequin, Robert Indiana, workshop of Jean-Auguste-Dominique Ingres, Jasper Johns, Carlo Labruzzi, Fernand Léger, François Lemoyne, Jean Limousin, René Magritte, Man Ray, Andrea Mantegna, Reginald Marsh, Master of 1402,

Andrea Michieli, Jan Miense Molenaer, Francesco Monti, Gustave Moreau, François de Nomé, Pierre Nouailher, Francesco Parmigianino (Girolamo Francesco Maria Mazzola), Bernard Picart, Pablo Picasso, Giovanni Battista Pittoni, Frans Pourbus the Elder, Odilon Redon, Frederic Remington, Marco Ricci, James Rosenquist, Georges Rouault, Peter Paul Rubens, Jean de Saint-Igny, Adam van Salm, Daniel Seghers, Théophile Alexandre Steinlen, Frank Stella, Hedda Sterne, H. E. Tidmarsh, Giovanni Battista Tiepolo, Giovanni Domenico Tiepolo, Mark Tobey, Louis Tocqué, Gillis van Valckenborch, Quentin Varin, Victor Vasarely, François-Xavier Vispré, Andy Warhol, John Willenbecher, and Jacob de Wit
Location: Rice Museum, Rice University, Houston
Curator: Dominique de Menil
Catalogue

Homage to Picasso
February 8–April 28, 1974
Artist: Pablo Picasso
Location: Rice Museum, Rice University, Houston
Curator: Dominique de Menil

Richard Van Buren: Outdoor Sculpture
April 21–August 31, 1974
Location: Rice University, Houston

Henri Cartier-Bresson Archive Photos
May 9–September 15, 1974
Location: Rice Museum, Rice University, Houston
Curator: Sandra Curtis

African Art as Philosophy: A Photographic Exhibition
October 8, 1974–January 5, 1975
Location: Rice Museum, Rice University, Houston
Curators: Douglas Fraser and Mino Badner
Organizer: Department of Art History and Archaeology, Columbia University, New York
Catalogue

Wayne Thiebaud
January 13–February 15, 1975
Location: 429 Sewall Hall, Rice University, Houston
Curator: Susan Barnes

Antwerp's Golden Age: The Metropolis of the West in the 16th and 17th Centuries
February 8–March 23, 1975
Artists: Anonymous Antwerp Master, Hendrik van Balen I, Hendrik Jansen Barrefelt, Coenraet Bloc, Joannes Bochius, Boetius Adams Bolswert, Schelte Bolswert, Gaspar Bouttats, Paul Bril, Jan Brueghel the Elder, Pieter Brueghel the Younger, Abraham de Bruyn, Hieronymus Cock, Mathys Cock, Gaspar de Crayer, Anthony van Dyck, Egidius Everaerts, Petrus Apianus-Gemma Frisius, Jan Fyt, Philip Galle, Hubertus Goltzius, Lodovico Guicciardini, Joris Hoefnagel, Franz Hogenberg, Wenceslaus Hollar, Melchisedech Hoorn, Frans Huys, Christoffel Jegher, Gerard de Jode, Jacob Jonghelinck, Jacob Jordaens, Olivier de La Marche, Hans Liefrinck, Justus Lipsius, Mathias Lobelius, Ludolphus a Saxonia, Guilielmus Lyndewode, Cornelis Massys, Gerardus Mercator, Jan Mollyns, Joos de Momper, Jan van Montfort, Abraham Ortelius, Pauwels van Overbeke, Bonaventura Peeters, Andries Pevernage, Christophe Plantin, Paulus Pontius, Erasmus Quellinus, Peter Paul Rubens,

Cornelis Schut, Sebastiano Serlio, Frans Snyders, Famianus Strada, Sylvester of Paris, Hans Symoens, David Teniers the Younger, Andre Thevet, Theodor van Thulden, Otto van Veen, Abraham Verhoeven, Maarten de Vos, Paul de Vos, Lucas Vorsterman, Hans Vredeman de Vries, Anton Wierix, Hieronymus Wierix, and Jan Wierix
Location: Rice Museum, Rice University, Houston
Organizers: City of Antwerp and Belgian Ministry of Flemish Culture, circulated by Smithsonian Institution, Washington, D.C.
Catalogue

The Hindu Pantheon: Miniature Paintings and Small Bronzes from India in the Collection of Dr. and Mrs. Wayne E. Begley
April 3–May 4, 1975
Location: Rice Museum, Rice University, Houston
Curators: Dominique de Menil and Wayne E. Begley
Catalogue

Marden, Novros, Rothko: Painting in the Age of Actuality
April 18–June 15, 1975
Artists: Brice Marden, David Novros, and Mark Rothko
Location: Rice Museum and Sewall Gallery, Rice University, Houston
Catalogue

Terminal Iron Works: Photographs of David Smith by Dan Budnik from 1962 and 1963
June 5–July 6, 1975
Location: Rice Museum, Rice University, Houston
Organizer: University Art Gallery, State University of New York at Albany
Catalogue

Three Centuries of French Posters
July 10–August 31, 1975
Location: Rice Museum, Rice University, Houston
Curator: Geneviève Picon
Organizers: Musée des Arts Décoratifs, Paris, co-sponsored by the Association Française d'Action Artistique, Paris
Catalogue

Kilim Rugs from Turkey
August 19–September 14, 1975
Location: Rice Museum, Rice University, Houston
Curator: Dale Eldred

Visions, Dreams, and Fantasy in 16th- to 20th-Century Prints
August 19–September 14, 1975
Artists: Enrico Baj, Hans Bellmer, Victor Brauner, François Chaveau, Dado (Miodrag Djurie Dado), Salvador Dalí, Gustave Doré, Albrecht Dürer, James Ensor, Max Ernst, Leonor Fini, J. J. Granville, Stanley William Hayter, Pieter van der Heyden, Wifredo Lam, Man Ray, John Martin, André Masson, Roberto Matta, Joán Miró, Henry Bonaventure Monnier, Giovanni Battista Piranesi, Marcantonio Raimondi, Rembrandt van Rijn, and Hans Vredeman de Vries
Location: Rice Museum, Rice University, Houston
Organizers: Bibliothèque Nationale, Paris, circulated by Association Française d'Action Artistique, Paris, and Cultural Services of the French Embassy

Catalogue: Surrealist Prints from Dürer to Dalí: Onirisme et fantastique dans la gravure, du XVIe siècle à nos jours

Form and Freedom: A Dialogue on Northwest Coast Indian Art
October 23, 1975–January 25, 1976
Location: Rice Museum, Rice University, Houston
Curator: Dominique de Menil
Organizers: Institute for the Arts, Rice University, Houston, with The Metropolitan Museum of Art, New York
Catalogue

Out of the Silence: Photographs by Adelaide de Menil
October 23, 1975–January 25, 1976
Location: Rice Museum, Rice University, Houston
Curator: Dominique de Menil
Organizer: Amon Carter Museum, Fort Worth
Catalogue

Art Nouveau: Belgium, France
March 26–June 27, 1976
Artists: Edmond Francois Aman-Jean, Emile André, Jane Atché, Bapst et Falize, Aubrey Vincent Beardsley, Edmond Becker, Emile Berchmans, Henri Berge, Émile Bernard, Joseph-Antoine Bernard, Paul Berthon, Louis Bigaux, Alexandre Bigot, Marcel Bing, William Blake, Boch Frères Kéramis, Pierre Bonnard, Lucien Bonvallet, Frédéric Boucheron, Firmin Bouisset, Eugène Bourgouin, Maurice Bouval, Félix Bracquemond, Jules-Paul Brateau, Phillipe Joseph Brocard, Carlo Bugatti, François Rupert Carabin, Cardeilhac, Eugène Carrière, Jean Carriès, Louis Chalon, Ernest Chaplet, Alexandre-Louis-Marie Charpentier, Joseph Chéret, Jules Chéret, Christofle, Edward Colonna, Gisberg Combaz, Omer Coppens, Arthur Craco, Walter Crane, Adolphe Crespin, Victor Creten, Cristallerie de Pantin, Cristallerie Schneider, Henri Cros, Adrien Pierre Dalpayrat, Albert Louis Dammouse, Edouard Alexandre Dammouse, Auguste and Antonin Daum, Théodore Deck, François-Emile Décorchemont, Emile Decoueur, Auguste Delaherche, Jean Delville, Maurice Denis, Alphonse Derain, Georges Despret, Charles Desrosiers, Emile Diffloth, Taxile Doat, August Donnay, Fernand Dubois, Maurice Dufrène, Jean Dunand, Otto Eckmann, James Ensor, Henri Evenepoel, Jean-Jacques Feuchère, Eugène Feuillâtre, Georges de Feure, Alfred William Finch, Arthur Foäche, Paul Follot, George Fouquet, Paul Frey, Eugène Gaillard, Lucien Gaillard, Emile Gallé, Antoni Gaudí, Paul Gauguin, Lucien Gautrait, GDA (Gérard Dufraisseix Abbot), Paul Grandhomme and Alfred Garnier, Eugène Grasset, Henri Gray, Emile Grittel, Jacques Gruber, William H. Grueby, Maurice-Gustave Guerchet, Hector Guimard, Charles Édouard Haviland, Georges Hoentschel, Josef Hoffmann, Katsushika Hokusai, Paul Jenneney, Fernand Khnopff, Charles Korschann, Edmond Lachenal, Georges Lacombe, René Lalique, Abel Landry, Raoul François Larche, Léon Ledru, Legras et Cie, Georges Lemmen, Marcel Lenoir, Lucien Lévy-Dhurmer, Luigi Loir, Charles Rennie Mackintosh, Arthur Heygate Mackmurdo, Aristide Maillol, Louis Majorelle, Manufacture de Sèvres, Edgard Maxence, Franz Melchers, André Methey, Henri Georges Jean Isidore Meunier, Eugène Michel, George Minne, Gustave Moreau, William Morris, Joseph and Pierre Mougin, Alphonse Mucha, Emile Müller, Henri Eugène Nocq, Manuel Orazi, Armand Point, Privat-Livemont,

Victor Prouvé, Paul Elie Ranson, Armand Rassenfosse, Maurice Réalier-Dumas, Odilon Redon, Aloïs Reinitzer, Georges de Ribaucourt, Charles Ricketts, Richard Riemerschmid, Théodore Rivière, Pierre Roche, Auguste Rodin, Dante Gabriel Rossetti, Eugène Rousseau, Victor Rousseau, Hélène de Rudder, Théo van Rysselberghe, Léonard Sarluis, Carlos Schwabe, Pierre Selmersheim, Gustave Serrurier-Bovy, Charles van der Stappen, Fernand Thesmar, Henri Thiriet, Victor Thonet, Louis Comfort Tiffany, Georges Tonnellier, Jan Toorop, Henri de Toulouse-Lautrec, Fernand Toussaint, Adolphe Truffier, University City Pottery, Val Saint Lambert, Anna Marie Valentien, Félix Vallotton, Artus Van Briggle, Maurice Pillard Verneuil, Paul and Henri Vever, James Vibert, Charles Francis Annesley Voysey, Edouard Vuillard, Amalric Walter, and Philippe Wolfers
Location: Rice Museum, Rice University, Houston
Curator: Dominique de Menil
Organizers: Institute for the Arts, Rice University, Houston, and The Art Institute of Chicago
Catalogue

The Graphic Art of Francisco Goya
September 1–October 17, 1976
Location: Rice Museum, Rice University, Houston
Curator: David W. Steadman
Organizer: Montgomery Art Center, Pomona College, Claremont
Catalogue: The Graphic Art of Francisco Goya from the Norton Simon Foundation, the Norton Simon, Inc. Museum of Art and the Pomona College Collections

Secret Affinities: Words and Images by René Magritte
October 1, 1976–June 19, 1977
Location: Rice Museum, Rice University, Houston
Curator: Dominique de Menil
Catalogue

Grass
January 25–March 13, 1977
Artists: Chikuensai Azuma, Mrs. Thomas Benrimo, Cecilia Dingle, Mrs. Phyl Dover, Carol Gross, Doris Johnson, Mrs. Kae Jung Kwak, Larry Pierson, Sally Victor, and works from Africa, Austria, Borneo, Burma, China, Czechoslovakia, Denmark, England, Ethiopia, Europe, Finland, France, Germany, India, Indonesia, Iran, Ireland, Israel, Italy, Japan, Korea, Madagascar, Mauritius, Mexico, Morocco, New Guinea, New Hebrides, Nubia, Pakistan, Philippines, Poland, Rhodesia, Russia, Solomon Islands, South America, Spain, Sumatra, Surinam, Sweden, Switzerland, Thailand, Tibet, and the United States
Location: Rice Museum, Rice University, Houston
Curator: Mary Hunt Kahlenberg
Organizer: Los Angeles County Museum of Art
Catalogue

Frederick Baldwin, Wendy Watriss: Photographs from Grimes County, Texas
April 12–June 19, 1977
Location: Rice Museum, Rice University, Houston
Curators: Frederick Baldwin and Wendy Watriss
Catalogue

Joseph Cornell
September 16–December 31, 1977
Location: Rice Museum, Rice University, Houston
Curator: Dominique de Menil

The I at Play: A Selection from the Menil Collection
September 16–December 31, 1977
Artists: Berenice Abbott, H. Anderson, J. Archer, H. Ashby, Eugène Atget, F. W. N. Bayley, Anne Beck, M. Belin, Bernard, Sarah Bernhardt, Joh. and Corn. Blaeu, Benigno Bossi, Brassaï (Gyula Halász), E. Adveno Brooke, E. Brown Jr., E. Caffand, Harry Callahan, studio of Alfred S. Campbell, Friedrich Campe, J. Chapman, A. Coquart, Walter Crane, Croifey, Jules David, Charles August Albert Dellschau, Diderot & d'Alembert, Joh. Gabriell Doppelmajero, Gustave Doré, Jacques Androuet Du Cerceau, H. Duru, John Fiesche, Ch. Geoffroy, Conrad Gessner, J. Grandville, H. C. F. Gray, E. Guerin, Harrison, William Hogarth, Johann Baptista Homann, François Gerard Jollain, Clarence John Laughlin, LeMercier, Jean Le Pautre, Emile Levy, George W. Lewis, H. Hondiuis Leyde, William Home Lizars, Martinet, Master L. G., Antoine Maurin, Nicholas Eustache Maurin, Jean Midolle, William Milne, Miss Zara, Mutlow, Francesco Panini, J. Pass, Adam Perelle, Hendrik Pola, L. Pousthomis, Reinier and Josua Atiens, Caesare Ripa, Von Hermann Schran & Co., Stoddard, Daniel Stoopendaal, Èdouard Traviés, Amédée Varin, Giovanni Volpato, Hans Vredeman de Vries, J. W., R. D. Williamson, J. Wood, and works from England, Europe, France, Germany, Italy, The Netherlands, Romania, Switzerland, and the United States
Location: Rice Museum, Rice University, Houston
Curator: Dominique de Menil

Visions of Courtly India: The Archer Collection of Pahari Miniatures
February 4–March 19, 1978
Location: Rice Museum, Rice University, Houston
Curator: W. G. (William George) Archer
Organizer: International Exhibitions Foundation, Washington, D.C.
Catalogue

Art Survey: The Real Thing
February 4–March 19, 1978
Artists: Larry Bell, Christo and Jeanne-Claude, Willem De Kooning, Jim Dine, Jean Dubuffet, Marcel Duchamp, Max Ernst, Dan Flavin, Arshile Gorky, Richard Hamilton, Jasper Johns, Vassily Kandinsky, Franz Kline, Joseph Kosuth, Roy Lichtenstein, Richard Lindner, Henri Matisse, Claes Oldenburg, Dennis Oppenheim, Pablo Picasso, Jackson Pollock, Robert Rauschenberg, James Rosenquist, Edward Ruscha, Mark Rothko, Lucas Samaras, George Segal, David Smith, Robert Smithson, Frank Stella, Takis (Panayiotis Vassilakis), Wayne Thiebaud, Jean Tinguely, Andy Warhol, and Greek, Late Antique, Early Christian, Baroque, and Rococo art
Location: Rice Museum, Rice University, Houston
Curator: Dominique de Menil

Léger, Our Contemporary
April 14–June 11, 1978
Artist: Fernand Léger
Location: Rice Museum, Rice University, Houston
Curator: Dominique de Menil
Catalogue

Embroidery Through the Ages
October 13, 1978–January 7, 1979
Artists: Cristóbal Balenciaga, Maison M. Bisson, Callot Soeurs, Christian Dior, Georges Doeuillet, Jacques Doucet, Jacques Fath, Madame Gaufrés, Hubert de Givenchy, Jeanne Lanvin, Mainbocher (Main Rousseau Bocher), Atelier Martine, Milon the Elder, Jeanne Paquin, Paul Poiret, Ernest Randnitz, A. A. Rateaux, Rébé (René Begué), John Redfern, C. Rossigneux, Yves Saint Laurent, Elsa Schiaparelli, Madeleine Vionnet, Charles Frederick Worth, and unknown artists
Location: Rice Museum, Rice University, Houston
Curators: Nadine Gasc, with Liliane Schildge, Mariette Sfez, Micheline Viseux, and Marie-Noële de Gary
Organizers: Musée des Arts Décoratifs, Paris, with Cooper-Hewitt, National Design Museum, New York
Catalogue

Michelangelo Pistoletto: Mirror-Works
February 16–April 15, 1979
Location: Rice Museum, Rice University, Houston
Curators: Heidi Rentería and Michelangelo Pistoletto
Catalogue: Michelangelo Pistoletto: Mirror-Works, Creative Collaborations, Furniture Environments

Franz Kline: The Color Abstractions, 1947–1961
May 4–July 1, 1979
Location: Rice Museum, Rice University, Houston
Curator: Laughlin Phillips
Organizer: The Phillips Collection, Washington, D.C.
Catalogue

Meanwhile…American Works 1947–61 from the Menil Collection
May 4–July 1, 1979
Artists: Josef Albers, Lee Bontecou, Jack Boynton, Alexander Calder, Gene Charlton, Willem De Kooning, William Giles, Jasper Johns, Guy Johnson, Franz Kline, Walter Egel Kuhlman, Richard Lindner, Albert Manchak, Elizabeth McFadden, Louise Nevelson, Robert Rauschenberg, Ad Reinhardt, Jeanne Reynal, Larry Rivers, Mark Rothko, Anne Ryan, Peter Shoemaker, David Smith, Hassel Smith, Saul Steinberg, and Clyfford Still
Location: Rice Museum, Rice University, Houston
Curator: Dominique de Menil

CPLY: Reflection on a Past Life
September 7–November 11, 1979
Artist: William Nelson Copley
Location: Rice Museum, Rice University, Houston
Curators: Dominique de Menil and Heidi Rentería
Catalogue: CPLY: Reflection on a Past Life: An exhibition of William Nelson Copley's Recent Mirror Pieces and Earlier Paintings and Drawings in Houston Collections, Rice Museum

Crosscurrents: French and Italian Neoclassical Drawings and Prints from the Cooper-Hewitt Museum
September 28–November 11, 1979
Artists: copy after Giocondo Albertolli, Jacques Denis Antoine and workshop, Mario Asprucci the Younger, Giuseppe Barberi, Antonio Basoli, François-Joseph Bélanger, Pietro Belli, Vincenzo Brenna and Franciszek Smuglewicz, Pietro Camporese the Younger, Gilles Paul Cauvet, Charles Michel-Ange Challe, copy after Charles Louis Clérisseau, Tommaso Conca, Jean Charles

Delafosse, Louis Jean Desprez, Hippolyte François Joseph Equennez, Auguste Pierre Sainte Marie Famin, Gaetano Frizzati, Felice Giani, Richard de Lalonde, Jean Jacques François Lebarbier the Elder, circle of Claude-Nicolas Ledoux, Jean Laurent Legeay, Louis-Joseph Le Lorrain, circle of Jean-Jacques Lequeu, Giuseppe Locatelli, Victor Louis, Jean-Baptise Marechal, Angelo Mezzetti, Flaminio Innocenzi Minozzi, Jean Guillaume Moitte, Pierre Louis Moreau-Desproux, Charles Normand, Pierre-Adrien Pâris, follower of Charles Percier, Firmin Perlin, Jean Baptiste Marie Pierre, Giovanni Battista Piranesi, Planier, circle of Leopold Pollack, Jean Louis Prieur the Younger, Giacomo Quarenghi, Luigi Righetti, François Romain, Luigi Rossini, André Jacques Roubo, Jean-Sinéon Rousseau de la Rottière, Antonio Sarti, Louis Gustave Taraval, Mauro Antonio Tesi, Angelo Toselli, Charles de Wailly, and unknown artists
Location: Rice Museum, Rice University, Houston
Curators: Elaine Evans Dee and Catherine Bernard
Organizers: Cooper-Hewitt, National Design Museum, New York, circulated by Smithsonian Institution Traveling Exhibition Service (SITES), Washington, D.C.
Catalogue

The Image of the Black in Western Art
November 10, 1979–January 12, 1980
Location: Central Library, Julia Ideson Building, Houston Public Library, Houston
Curators: Dominique de Menil, Ladislas Bugner, and Karen C. C. Dalton

Day and Night: Works from the Menil Foundation Collection
December 14, 1979–March 2, 1980
Artists: Giorgio de Chirico, Max Ernst, Jean Fautrier, Louis Fernandez, Francisco de Goya, René Magritte, John Martin, Jan Müller, François de Nomé, Pablo Picasso, Martial Raysse, Odilon Redon, Rembrandt van Rijn, Josef Šímá, Rombout van Troyen, Polygnotos Vagis, Gillis van Valckenborch, and unknown artists
Location: Rice Museum, Rice University, Houston
Curator: Dominique de Menil

Alvar Aalto: 1898–1976
March 28–June 1, 1980
Location: Rice Museum, Rice University, Houston
Curators: Antonio de Souza Santos and Peter Papademetriou
Organizer: Museum of Finnish Architecture, Helsinki
Catalogue

Jim Love Up to Now: A Selection
September 5–November 16, 1980
Location: Rice Museum, Rice University, Houston
Curator: Heidi Rentería
Catalogue

Sculpture of Black Africa:
The Gus Nicholson Collection
December 12, 1980–February 22, 1981
Location: Rice Museum, Rice University, Houston
Curator: Dominique de Menil

Roman Opalka 1965/1–Infinity. 16 Details
December 19, 1980–February 22, 1981
Location: Rice Museum, Rice University, Houston
Curator: Dominique de Menil
Organizer: John Weber Gallery, New York
Catalogue

Security in Byzantium: Locking, Sealing, Weighing
March 15–May 24, 1981
Location: Rice Museum, Rice University, Houston
Curators: Gary Vikan and John Nesbitt
Catalogue

Transfixed by Light: Photographs from the Menil Collection: Selected by Beaumont Newhall
March 21–May 24, 1981
Artists: Ansel Adams, Eugène Atget, Brassaï (Gyula Halász), Harry Callahan, Paul Caponigro, Henri Cartier-Bresson, Edward Sheriff Curtis, Frederick Henry Evans, L. Blaine Hickey, Lewis Wickes Hine, Gertrude Käsebier, André Kertész, Clarence John Laughlin, Danny Lyon, Man Ray, Richard Misrach, Nadar (Félix Nadar), Hans Namuth, Beaumont Newhall, Arnold Newman, Aaron Siskind, W. Eugene Smith, Edward Jean Steichen, and James Van Der Zee
Location: Rice Museum, Rice University, Houston
Curators: Dominique de Menil, Beaumont Newhall, Kathryn Davidson, and Elizabeth Glassman
Catalogue

Reading Prints: A Selection of 16th- to Early 19th-Century Prints from the Menil Collection
October 16–December 31, 1981
Artists: Master A. F. Altmann, Francois Androit (Handeroit), Michael Baurenfeind, Nicolas Beatrizet, Hans Sebald Beham, Johann Georg Bodenehr, Giulio Bonasone, Natale Bonifazio, Abraham Bosse, Giovanni Botero, Constant Bourgeois, Ambrogio Brambilla, Hans Burgkmair, Jacques Callot, José de Casanova, Hendrik Causé, Lucas Cranach the Elder, Thomas Cross the Elder, Cornelis Gerritsz Decker, Etienne Delaune, Stefano Della Bella, François Desprez, Wendel Dietterlin, Jacques Androuet Du Cerceau the Elder, Etienne Dupérac, Albrecht Dürer, Giovanni Battista Falda, Giovanni Battista Ferrari, Johann Bernhard Fischer von Erlach, Albert Flamen, Philip Galle, Francisco de Goya, Pieter van der Heyden, Wenzel Jamnitzer, Jean Jollat, Jacques Lagniet, Nicolas de Larmessin II, André Le Nôtre, Lucas van Leyden, Conrad Lycosthenes, Master H. H., Master MTR, Master of the Die, Jean Midolle, Jan Müller, Jean François Niceron, Giovanni Ottaviani, Juan Palomina, Ambroise Paré, Crispijn de Passe the Younger, Gabriel Perelle, Giovanni Battista Piranesi, Stefano Pozzi, Andrea Pozzo, Marcantonio Raimondi, Rembrandt van Rijn, Humphry Repton, Jan Sadeler the Elder, Israël Silvestre, Pieter Stevens and Philip van Gunst, Antonio Tempesta, Philippe Thomassin, Giuseppe Vasi, Antoine Vérard, Enea Vico, Jacopo da Vignola, Juan de Vingles, Hans Vredeman de Vries, and Mathis Zündt
Location: Rice Museum, Rice University, Houston
Curators: Richard S. Field, Dominique de Menil, Elizabeth Glassman, and Kathryn Davidson
Catalogue

Yves Klein 1928–1962: A Retrospective
February 5–May 2, 1982
Location: Rice Museum, Rice University, Houston
Curator: Dominique de Menil
Catalogue

William Christenberry: Southern Views
September 24–December 31, 1982
Location: Rice Museum, Rice University, Houston
Curators: Dominique de Menil and Walter Hopps
Catalogue

Recent Acquisitions: The Menil Collection
January 8–30, 1983
Artists: Billy Al Bengston, Oleksandr Bohomazov, Pierre Bonnard, Mary Corse, Thomas Couture, Jim Dine, Gustave Doré, Cornelis de Heem, George Inness Jr., Ivan Klyun, attributed to Godfrey Kneller, Mikhail Larionov, El Lissitzky, Robert Mangold, László Moholy-Nagy, Giacomo Nani, Michelangelo Pistoletto, Robert Rauschenberg, Jean-Pierre Raynaud, Marco Ricci, attributed to Henri Rousseau, Kurt Schwitters, George Smith, Cy Twombly, and Andy Warhol
Location: Rice Museum, Rice University, Houston
Curators: Dominique de Menil and Walter Hopps

The Art of Metal in Africa
February 4–April 10, 1983
Location: Sewall Gallery, Rice University, Houston
Curator: Marie-Thérèse Brincard
Organizer: African American Institute, New York
Catalogue

Black Folk Art in America 1930–1980
March 4–May 15, 1983
Artists: Jesse Aaron, Steve Ashby, David Butler, Ulysses Davis, William Dawson, Sam Doyle, William Edmondson, Sister Gertrude Morgan, Leslie Payne, Elijah Pierce, Nellie Mae Rowe, James "Son Ford" Thomas, Mose Tolliver, Bill Traylor, Inez Nathaniel Walker, George White, George Williams, Luster Willis, and Joseph E. Yoakum
Location: Rice Museum, Rice University, Houston
Curators: John Beardsley and Jane Livingston
Organizer: Corcoran Gallery of Art, Washington, D.C.
Catalogue

Five Surrealists from the Menil Collection
June 17–September 28, 1983
Artists: Victor Brauner, Giorgio de Chirico, Max Ernst, René Magritte, and Yves Tanguy
Location: National Gallery of Art, Washington, D.C.
Curators: Dominique de Menil, Walter Hopps, and David Sylvester
Catalogue

Tibet, the Sacred Realm: Photographs 1880–1950
September 23–December 31, 1983
Artists: Jacques Bacot, Charles Suydam Cutting, Alexandra David-Néel, Brooke Dolan II, Heinrich Harrer, Sven Anders Hedin, R. F. Johnson and Hoffman, Sonam Wangfel Laden-La, Roderick A. MacLeod, Henri d'Orléans, Joseph Francis Charles Rock, George N. Roerich, Albert L. Shelton, George Sherriff, Frederick Spencer-Chapman, George Taylor, Ilya Tolstoy, G. Ts. Tsybikoff, Leslie Weir, John Claude White, and Alexander F. R. Wollaston

Location: Rice Museum, Rice University, Houston
Curator: Michael E. Hoffman
Organizer: Alfred Stieglitz Center, Philadelphia Museum of Art
Catalogue

La rime et la raison: Les collections Ménil (Houston–New York)
April 17–July 30, 1984
Artists: Carl Andre, Giuseppe Arcimboldi, Arman (Armand Fernandez), Jean (Hans) Arp, Richard Artschwager, Larry Bell, Christian Bérard, Forrest Bess, Georges Braque, Victor Brauner, André Breton, Pol Bury, Alexander Calder, Henri Cartier-Bresson, Paul Cézanne, John Chamberlain, Eduardo Chillida, Giorgio de Chirico, Christo and Jeanne-Claude, Chryssa (Varda Chryssa), François Clouet, Ettore Colla, William Nelson Copley, Joseph Cornell, Stuart Davis, Willem De Kooning, Walter De Maria, Jim Dine, Jean Dubuffet, Marcel Duchamp, Max Ernst, Walker Evans, Jean Fautrier, Louis Fernandez, Francesco Fieravino, Dan Flavin, Lucio Fontana, Alberto Giacometti, Arshile Gorky, Juan Gris, Jasper Johns, Donald Judd, Leon Kelly, Paul Klee, Yves Klein, Franz Kline, Ivan Klyun, Wifredo Lam, Henri Laurens, Fernand Léger, Mathieu Le Nain, El Lissitzky, Jim Love, Christian Luycks, René Magritte, Kazimir Malevich, Robert Mangold, Man Ray, Brice Marden, Henri Matisse, Roberto Matta, Henri Michaux, Joán Miró, Piet Mondrian, Robert Morris, Robert Motherwell, Barnett Newman, François de Nomé, Claes Oldenburg, Francis Picabia, Pablo Picasso, Michelangelo Pistoletto, Jackson Pollock, Robert Rauschenberg, Jean-Pierre Raynaud, Martial Raysse, Ad Reinhardt, Marco Ricci, Larry Rivers, James Rosenquist, Mark Rothko, Georges Rouault, Edward Ruscha, Robert Ryman, Joseph Sacco, Niki de Saint-Phalle, Adriaan van Salm, Antonio Saura, Kurt Schwitters, George Segal, David Smith, Frank Stella, Clyfford Still, Takis (Panayiotis Vassilakis), Yves Tanguy, Dorothea Tanning, Wayne Thiebaud, Jean Tinguely, Rombout van Troyen, Cy Twombly, Dirk Valkenborch, François-Xavier Vispré, Andy Warhol, Wols (Alfred Otto Wolfgang Schulze), and Tomás Yepes
Location: Galeries nationales du Grand Palais, Paris
Curators: Walter Hopps and Jean-Yves Mock
Catalogue

Edward and Nancy Reddin Kienholz: The Art Show
November 11, 1984–January 13, 1985
Location: Rice Museum, Rice University, Houston
Curators: Walter Hopps and Neil Printz
Catalogue: The Art Show, 1963–1977: Edward Kienholz, Nancy Reddin Kienholz

27 Ways of Looking at American Drawing
February 26–April 7, 1985
Artists: Christo and Jeanne-Claude, Arthur Garfield Dove, Robert Gordy, Arshile Gorky, Hans Hofmann, Richard Jackson, Donald Judd, Franz Kline, Man Ray, Brice Marden, Robert Motherwell, Walter Tandy Murch, Jim Nutt, Claes Oldenburg, Jackson Pollock, Robert Rauschenberg, Larry Rivers, Mark Rothko, Carroll Sockwell, Saul Steinberg, Mark Tobey, James Turrell, Cy Twombly, and Robert Wilson
Location: Rice Museum, Rice University, Houston
Curators: Walter Hopps and Neil Printz

Cinquante ans de dessins américains: 1930–1980; Amerikanische Zeichnungen, 1930–1980
May 3–July 13, 1985; November 28, 1985–January 26, 1986
Artists: John Altoon, Lee Bontecou, Federico Castellon, Vija Celmins, John Chamberlain, Christo and Jeanne-Claude, William Nelson Copley, Joseph Cornell, Ben L. Culwell, Stuart Davis, Willem De Kooning, Richard Diebenkorn, Jim Dine, Mark Di Suvero, Arthur Garfield Dove, Dan Flavin, Sam Francis, Robert Gordy, Arshile Gorky, Philip Guston, Michael Heizer, Hans Hofmann, Edward Hopper, Richard Jackson, Jasper Johns, Donald Judd, Ellsworth Kelly, Edward Kienholz, Franz Kline, Gaston Lachaise, Sol LeWitt, Roy Lichtenstein, Frank Lobdell, Man Ray, Brice Marden, Agnes Martin, Robert Morris, Robert Motherwell, Walter Tandy Murch, Reuben Nakian, Bruce Nauman, Barnett Newman, Jim Nutt, Georgia O'Keeffe, Philip Pearlstein, Jackson Pollock, Robert Rauschenberg, Larry Rivers, James Rosenquist, Mark Rothko, Edward Ruscha, Kurt Seligmann, David Smith, Robert Smithson, Carroll Sockwell, Saul Steinberg, Frank Stella, Clyfford Still, Myron Stedman Stout, Dorothea Tanning, Wayne Thiebaud, Mark Tobey, Anne Truitt, James Turrell, Cy Twombly, Andy Warhol, H. C. Westermann, William T. Wiley, and Robert Wilson
Locations: École nationale supérieure des Beaux-Arts, Paris; Städtische Galerie im Städelschen Kunstinstitut, Frankfurt am Main
Curators: Walter Hopps and Neil Printz
Catalogues

The Indelible Image: Photographs of War, 1846 to the Present [FotoFest]
February 6–March 24, 1986
Artists: Max Alpert, François Aubert, Dmitri Baltermants, Micha Bar-Am, George N. Barnard, Sidney Jackson Bartholomew, Felice Beato, William Abraham Bell, Margaret Bourke-White, Mathew B. Brady, Stephen R. Brown, W. G. Brunk, John Burke, Larry Burrows, Agustín Víctor Casasola, Chim (David Seymour), Edward Clark, Kelso Daly, Thomas Daniel, Jack Delano, Raymond Depardon, Emmanuel Evzerikhin, Roger Fenton, Barrett Gallagher, John C. H. Grabill, Ed Grazda, Philip Jones Griffiths, Alain Guillo, James Henry Hare, Himes, Lewis Wickes Hine, Hayakawa Hiroshi, Hanns Hubmann, Charles Fenno Jacobs, Kimura Kenichi, Dmitri Kessel, Eugene Khaldey, Manfred Kreiner, Constance Stuart Larrabee, Gustave Le Gray, Catherine Leroy, Royan M. Linn, James Lloyd, Harry Mattison, Don McCullin, James L. McGarrigle, Susan Meiselas, Hansel Mieth, Lee Miller, Arthur S. Mole, Carl Mydans, James Nachtwey, Timothy O'Sullivan, Joseph J. Pennell, Gilles Peress, James Pickerell, Lt. Reid, Eugene Richards, Stephen Shames, Suzuki Shinichi, Leif Skoogfors, W. Eugene Smith, Wilfred Dudley Smithers, Chris Steele-Perkins, Wolf Strache, Sergei Strunnikov, R. Sullivan, Reinhold Thiele, John D. Thomas, and Shōmei Tomatsu
Location: Rice Museum, Rice University, Houston
Curators: Frances Lindley Fralin, Jane Livingston, Kathryn Davidson, and Elizabeth Glassman
Organizer: Corcoran Gallery of Art, Washington, D.C.
Catalogue

A Brokerage of Desire
July 11–August 16, 1986; April 15–May 24, 1987
Artists: Alan Belcher, Gretchen Bender, Anne Doran, Jeff Koons, Peter Nagy, and Haim Steinbach
Locations: Otis Art Institute, Parsons School of Design, Los Angeles; Centre Georges Pompidou, Musée national d'art moderne, Paris
Curators: Howard Halle and Walter Hopps
Catalogue: Carte blanche: Les courtiers du désir

John Chamberlain
June 7, 1987–April 3, 1988
Location: The Menil Collection, Houston
Curator: Walter Hopps
Catalogue: Sculpture: John Chamberlain, 1970s & 1980s

Ben L. Culwell: Adrenalin Hour
June 7–November 29, 1987
Location: The Menil Collection, Houston
Curators: Walter Hopps and Kathryn Davidson
Catalogue: Adrenalin Hour: The South Pacific, World War II

Warhol Shadows
June 7, 1987–January 31, 1988
Artist: Andy Warhol
Location: Richmond Hall, The Menil Collection, Houston
Curators: Neil Printz and Walter Hopps
Catalogue

Genesi di un Progetto: Piano's Rehabilitation of Palladio's Basilica at Vicenza
October 13–November 1, 1987
Artist: Renzo Piano
Location: The Menil Collection, Houston
Curator: Paul Winkler

Marcel Duchamp / Fountain
December 24, 1987–October 2, 1988
Artists: Marcel Duchamp, Robert M. Kulicke, Peter Nagy, Bert Stern, and Alfred Stieglitz
Location: The Menil Collection, Houston
Curators: William Camfield and Walter Hopps
Catalogue

Texas Art: An Exhibition Selected from The Menil Collection, The Museum of Fine Arts, Houston, and Trustees' Collections of the Contemporary Arts Museum Houston
February 10–May 15, 1988
Artists: John Alexander, David Bates, Forrest Bess, Derek Boshier, Jack Boynton, Mel Chin, Ben L. Culwell, Jeff Delude, Chuck Dugan, Vernon Fisher, Roy Fridge, Joseph Glasco, Bert Long, Jim Love, Ken Luce, David McManaway, Melissa Miller, Gael Stack, Earl Staley, Richard Gordon Stout, James Surls, Michael Tracy, Bob Wade, and Dick Wray
Location: Richmond Hall, The Menil Collection, Houston
Curators: Neil Printz, Alison de Lima Greene, and Marilyn Zeitlin
Catalogue

Men's Lives
March 2–May 1, 1988
Artists: Dan Budnik, Adelaide de Menil, Martine Franck, Jean Gaumy, Evelyn Hofer, Lynn Johnson, Koug Kuntz, Danny Lyon, and Gilles Peress
Location: The Menil Collection, Houston
Catalogue: Men's Lives: The Surfmen and Baymen of the South Fork

Photographs: Henri Cartier-Bresson, Walker Evans
[FotoFest]
March 2–May 8, 1988
Location: The Menil Collection, Houston
Curator: Walter Hopps

David Salle
May 20–September 4, 1988
Location: The Menil Collection, Houston
Curators: Walter Hopps and David Salle

Robert Longo
May 20–September 24, 1988
Location: The Menil Collection, Houston
Curators: Walter Hopps and Robert Longo

Richard Jackson: Installations 1970–1988
July 21, 1988–January 14, 1990
Location: Richmond Hall, The Menil Collection, Houston
Curators: Walter Hopps and Neil Printz

Andy Warhol: Death and Disasters
October 21, 1988–January 8, 1989
Location: The Menil Collection, Houston
Curators: Walter Hopps and Neil Printz
Catalogue

Selected Prints by Callot, Della Bella, and Goya
October 21, 1988–April 2, 1989
Artists: Jacques Callot, Stefano Della Bella, and Francisco de Goya
Location: The Menil Collection, Houston
Curators: Walter Hopps and Kathryn Davidson

Winslow Homer's Images of Blacks: The Civil War and Reconstruction Years
October 22, 1988–January 8, 1989
Artists: Winslow Homer, with Solomon Eytinge Jr., C. E. F. Hillen, Thomas Nast, William Ludwell Sheppard, and unknown artists
Location: The Menil Collection, Houston
Curators: Peter H. Wood and Karen C. C. Dalton
Catalogue

Spirituality in the Christian East: Greek, Slavic, and Russian Icons from The Menil Collection
November 12, 1988–June 4, 1989
Location: The Menil Collection, Houston
Curator: Bertrand Davezac
Catalogue

The Sarofim Collection of Coptic Art
November 12, 1988–February 28, 1989
Location: The Menil Collection, Houston
Curator: Paul Winkler

René Magritte: Late Works
January 27–June 4, 1989
Location: The Menil Collection, Houston
Curator: Dominique de Menil

Terminal Privileges: Michael Tracy
February 24–May 14, 1989
Location: The Menil Collection, Houston
Curator: Edward Leffingwell
Organizer: P.S. 1, The Institute for Art and Urban Resources, Inc., New York
Catalogue: Terminal Privileges=Privilegios Terminales: Michael Tracy

Works on Paper by Jasper Johns, Robert Rauschenberg, and Larry Rivers
April 14, 1989–February 4, 1990
Location: The Menil Collection, Houston
Curator: Walter Hopps

Blinky Palermo: To The People of New York City
June 7–August 13, 1989
Location: The Menil Collection, Houston
Curator: Paul Winkler
Organizer: Dia Art Foundation, New York
Catalogue

Perpetual Motif: The Art of Man Ray
June 28–September 17, 1989
Location: The Menil Collection, Houston
Curator: Merry Foresta
Organizer: National Museum of American Art, Smithsonian Institution, Washington, D.C.
Catalogue

Cy Twombly
September 7, 1989–March 11, 1990
Location: The Menil Collection, Houston
Curator: Paul Winkler
Catalogue

Max Ernst: Selections from The Menil Family Collections
October 27, 1989–October 28, 1990
Location: The Menil Collection, Houston
Curator: Walter Hopps

Marc Riboud: Photographs at Home and Abroad
[FotoFest]
February 15–March 25, 1990
Location: The Menil Collection, Houston
Organizer: International Center of Photography, New York
Catalogue

Jay DeFeo: Works on Paper 1951–1989
April 5–May 27, 1990
Location: The Menil Collection, Houston
Curator: Sidra Stich
Organizer: University Art Museum, University of California at Berkeley
Catalogue

The Birth of Venus: Neolithic & Chalcolithic Antiquities from Cyprus
April 27–September 16, 1990
Location: The Menil Collection, Houston
Curator: Walter Hopps
Organizers: The J. Paul Getty Museum, Malibu, and the Menil Collection, Houston
Catalogue: Cyprus Before the Bronze Age: Art of the Chalcolithic Period

Joseph Beuys: Works from the Dia Art Foundation
June 28, 1990–January 6, 1991
Location: The Menil Collection, Houston
Curator: Paul Winkler

Josef Albers
September 27, 1990–January 27, 1991
Location: The Menil Collection, Houston
Curator: Walter Hopps

James Reaben
December 1, 1990–January 20, 1991
Location: The Menil Collection, Houston
Curators: Paul Winkler and William Steen

Jean-Pierre Raynaud
January 26–March 10, 1991
Location: The Menil Collection, Houston
Curator: Alfred Pacquement
Catalogue

Dan Flavin: Three "monuments" for V. Tatlin
February 6–May 5, 1991
Location: The Menil Collection, Houston
Curator: Walter Hopps

Texas Selections from the Menil Collection: A Tribute to the University of Texas Medical Branch Centennial Celebration
March 9–April 21, 1991
Artists: Forrest Bess, Bob Camblin, Henri Cartier-Bresson, Gene Charlton, Mel Chin, Henry Ray Clark, Ben L. Culwell, Charles August Albert Dellschau, Vanzant Driver, Carter Ernst, Roy Fridge, Ernest C. Hewitt, Guy Johnson, Frank Jones, Paul Kittelson, Jim Love, Danny Lyon, Billy McCune, David McManaway, John Peters, James Reaben, William Steen, Richard Gordon Stout, Johnnie Swearingen, Michael Tracy, and Bob Wade
Location: Galveston Art Center, Galveston
Curator: Clint Willour

Viewpoints: Mel Chin
April 28–August 25, 1991
Location: The Menil Collection, Houston
Curator: Paul Winkler
Organizer: Walker Art Center, Minneapolis
Catalogue

Mark Rothko
May 9–June 30, 1991
Location: The Menil Collection, Houston
Curator: Paul Winkler

Object & Image: Recent Art from The Menil Collection
July 31–October 6, 1991
Artists: Gretchen Bender, Anne Doran, Howard Halle, Donald Lipski, Peter Nagy, Cindy Sherman, Haim Steinbach, and Lew Thomas
Location: The Menil Collection, Houston
Curator: Walter Hopps

Robert Rauschenberg: The Early 1950s
September 27, 1991–January 5, 1992
Location: The Menil Collection, Houston
Curators: Walter Hopps, Neil Printz, and Susan Davidson
Catalogue

François de Nomé: Theatre of Light and Destruction
October 17, 1991–January 12, 1992
Location: The Menil Collection, Houston
Curator: Bertrand Davezac
Catalogue: François de Nomé: Mysteries of a Seventeenth-Century Neapolitan Painter

Arnulf Rainer: Young Cross
January 31–April 26, 1992
Location: The Menil Collection, Houston
Curator: Franz Dahlem
Catalogue

Photographs by Constantin Brancusi [FotoFest]
March 20–June 28, 1992
Location: The Menil Collection, Houston
Curator: Walter Hopps
Organizer: Didier Imbert Fine Art, Paris
Catalogue: Brancusi Photo Reflexion

Tadao Ando
March 20–May 24, 1992
Location: Richmond Hall, The Menil Collection, Houston
Curator: Stuart Wrede
Organizer: The Museum of Modern Art, New York
Catalogue

Ken Price
May 21–August 23, 1992
Location: The Menil Collection, Houston
Curator: David Whitney
Organizer: Walker Art Center, Minneapolis
Catalogue

Six Artists
May 29–September 20, 1992
Artists: John Chamberlain, Willem De Kooning, Yves Klein, Brice Marden, Jean Tinguely, and Andy Warhol
Location: The Menil Collection, Houston
Curators: Walter Hopps and Paul Winkler

Sixteenth- and Seventeenth-Century Prints from the Menil Collection
July 24–September 13, 1992
Artists: Leonhard Beck, Hans Burgkmair, Jacques Callot, Lucas Cranach the Elder, Albrecht Dürer, Lucas van Leyden, and Ippolito Salviani
Location: The Menil Collection, Houston
Curator: Bertrand Davezac

Contemporary Art from the Marcia Simon Weisman Collection
September 25, 1992–January 10, 1993
Artists: Don Bachardy, Larry Bell, Billy Al Bengston, Joseph Cornell, Willem De Kooning, Richard Diebenkorn, Sam Francis, Alberto Giacometti, Joe Goode, Arshile Gorky, Robert Graham, Philip Guston, Jasper Johns, Franz Kline, Roy Lichtenstein, Kazimir Malevich, Henri Matisse, Joán Miró, Ed Moses, Barnett Newman, Claes Oldenburg, Richard Pettibone, Jackson Pollock, Mel Ramos, Mark Rothko, Edward Ruscha, Clyfford Still, and Andy Warhol
Location: The Menil Collection, Houston
Curator: Walter Hopps

Brice Marden: Cold Mountain
October 2–November 29, 1992
Location: The Menil Collection, Houston
Curators: Gary Garrels and Paul Winkler
Organizers: Dia Center for the Arts, New York, Walker Art Center, Minneapolis, and The Menil Collection, Houston
Catalogue

Magritte
December 19, 1992–February 21, 1993
Artist: René Magritte
Location: The Menil Collection, Houston
Curators: David Sylvester, Sarah Whitfield, and Paul Winkler
Organizers: South Bank Centre, London, in collaboration with The Metropolitan Museum of Art, New York, The Art Institute of Chicago, and The Menil Collection, Houston
Catalogue

A Renaissance Installation of Tapestries, Objects, Paintings
January 28, 1993–February 6, 1994
Location: The Menil Collection, Houston
Curator: Bertrand Davezac

Jean-Michel Basquiat
March 12–May 9, 1993
Location: The Menil Collection, Houston
Curators: Richard Marshall and Walter Hopps
Organizer: Whitney Museum of American Art, New York
Catalogue

Renzo Piano Building Workshop: Selected Projects
March 12–May 30, 1993
Location: Richmond Hall, The Menil Collection, Houston
Curators: Drexel Turner, Paul Winkler, and Peter Buchanan
Organizers: Renzo Piano Building Workshop, Genoa, for Architectural League of New York and Italian Cultural Institute
Catalogue

Max Ernst: Dada and the Dawn of Surrealism
May 28–August 29, 1993
Location: The Menil Collection, Houston
Curators: William Camfield, Walter Hopps, Susan Davidson, and Werner Spies

Andy Warhol Portraits
September 24–December 19, 1993
Location: The Menil Collection, Houston
Curator: Paul Winkler

Art of the Persian Courts: Selections from the Art and History Trust Collection
September 24, 1993–January 16, 1994
Location: The Menil Collection, Houston
Curator: Abolala Soudavar
Organizer: Los Angeles County Museum of Art
Catalogue

Rolywholyover: A Circus for Museum by John Cage
January 14–April 2, 1994
Artists: John Cage, with Stephen Addiss, Aeschylus, Anni Albers, Josef Albers, Charles Amirkhanian, William Anastasi, David Antin, Antonin Artaud, Robert Ashley, Milton Babbitt, Matsuo Bash, Stephen Bastian, Julian Beck, L. C. Beckett, David Behrman, Cathy Berberian, Luciano Berio, Leonard Bernstein, Wendell Berry, Joseph Beuys, Bonnie Bird, Robert R. Bliss, Pierre Boulez, Dove Bradshaw, Stan Brakhage, George Brecht, William Brooks, Carolyn Brown, Earle Brown, Kathan Brown, Norman O. Brown, Richard Buhlig, William S. Burroughs, Joseph Campbell, Elliott Carter, Daniel Charles, Remy Charlip, Gloria Cheng, Daitokuji Chuho, Ananda Kentish Coomaraswamy, Joseph Cornell, Philip Corner, Henry Cowell, Lowell Cross, Andrew Culver, E. E. Cummings, Merce Cunningham, Alvin Curran, Mell Daniel, Emile de Antonio, Elaine De Kooning, Willem De Kooning, Maya Deren, Dean Drummond, Jean Dubuffet, Marcel Duchamp, Meister Eckhart, Alison Edwards, T. S. Eliot, Max Ernst, Lyonel Feininger, Morton Feldman, Robert Filliou, Oskar Fischinger, Syvilla Fort, Betty Freeman, R. Buckminster Fuller, Jon Gibson, Allen Ginsberg, Malcolm Goldstein, Arshile Gorky, Morris Graves, Peter Greenaway, Mineko Grimmer, Richard Hamilton, Al Hansen, Lou Harrison, Dick Higgins, Lejaren Hiller, Alan Hovhaness, Earl Howard, Fred Hoyle, Huang Po, Toshi Ichiyanagi, Inzan, Charles Ives, Alexei Jawlensky, Jasper Johns, James Joyce, Mauricio Kagel, Allan Kaprow, Ellsworth Kelly, Mary Jean Kenton, Paul Klee, Yves Klein, Franz Kline, Alison Knowles, Hirokazu Kosaka, Richard Kostelanetz, Takehisa Kosugi, Irwin Kremen, Shigeko Kubota, Kusan, Joan La Barbara, Sol LeWitt, Richard Lippold, Joan Logue, Henning Lohner, Lois Long, members of the Los Angeles Philharmonic, Alvin Lucier, George Maciunas, Jackson Mac Low, Judith Malina, Kazimir Malevich, Man Ray, Tom Marioni, Marx Brothers, Jackie Matisse, Marshall McLuhan, Larry Miller, Joán Miró, László Moholy-Nagy, Piet Mondrian, Robert Motherwell, Gordon Mumma, Conlon Nancarrow, Nantembo, János Négyesy, Louise Nevelson, New Century Players, Barnett Newman, Isamu Noguchi, Pauline Oliveros, Charles Olson, Yoko Ono, Nam June Paik, Harry Partch, Kenneth Patchen, Octavio Paz, Ezra Pound, Sri Ramakrishna, Ranzan, Robert Rauschenberg, Ad Reinhardt, Repercussion Unit, Mary Caroline Richards, Hans Richter, Jim Rosenberg, David Rosenboom, Mark Rothko, Carl Ruggles, Luigi Russolo, Robert Ryman, Erik Satie, Frank Schaeffer, Arnold Schoenberg, Fanny Schoening, Michael Silver, Marsha Skinner, Ellsworth Snyder, Edward Jean Steichen, Gertrude Stein, Karlheinz Stockhausen, Carl Stone, Grete Sultan, Daisetz T. Suzuki, Yuji Takahashi,

Tōru Takemitsu, Margaret Leng Tan, Dorothea Tanning, James Tenney, Virgil Thomson, Henry David Thoreau, Jean Tinguely, Mark Tobey, David Tudor, Cy Twombly, Stan VanDerBeek, Edgard Varèse, Anton Webern, Adolph Weiss, Edward Weston, Walt Whitman, Ludwig Wittgenstein, Christian Wolff, La Monte Young, and Paul Zukofsky
Location: The Menil Collection, Houston
Curator: Julie Lazar
Organizer: The Museum of Contemporary Art, Los Angeles
Catalogue: Rolywholyover: A Circus

**A Piece of the Moon World:
Paul Klee in Texas Collections**
March 9–June 5, 1994
Location: The Menil Collection, Houston
Curators: Susan Davidson, Paul Winkler, and Dominique de Menil
Catalogue

The New Generation: Contemporary Photography from Cuba [Fotofest]
March 24–April 17, 1994
Artists: Pedro Abascal, Juan Carlos Alom, Max Orlando Baños, Mario Díaz, Carlos Garaicoa, Katia García Fayat, Carlos Mayol, Humberto Mayol, Eduardo Muñoz, José Ney, René Peña, Marta María Pérez, Manuel Piña, Rigoberto Romero, and Alfredo Sarabia
Location: Richmond Hall, The Menil Collection, Houston
Curators: Wendy Watriss and Frederick Baldwin

African Zion: The Sacred Art of Ethiopia
April 28–July 31, 1994
Location: The Menil Collection, Houston
Curators: Paul Winkler and Deborah Velders
Organizers: InterCultura, Fort Worth, and The Walters Art Gallery, Baltimore, in association with the Institute of Ethiopian Studies, Addis Ababa
Catalogue

Photographs by Dimitrius Kyriazis
April 28–July 31, 1994
Location: The Menil Collection, Houston
Curators: Paul Winkler and Deborah Velders

Some American Drawings
July 22–October 16, 1994
Artists: Walter De Maria, Donald Judd, Sol LeWitt, Agnes Martin, Claes Oldenburg, Larry Rivers, Edward Ruscha, Saul Steinberg, Andy Warhol, and Robert Wilson
Location: The Menil Collection, Houston
Curator: Paul Winkler

Franz Kline: Black & White, 1950–1961
September 9–November 27, 1994
Location: The Menil Collection, Houston
Curators: David Whitney, Susan Davidson, and Walter Hopps
Catalogue

**Masterpieces of Bolivian Colonial Art:
16th to 18th Century**
October 26, 1994–January 8, 1995
Location: The Menil Collection, Houston
Catalogue: Bolivian Masterpieces: Colonial Painting

Henri Cartier-Bresson: Photographs of Houston, 1957 [FotoFest]
November 10–December 11, 1994
Location: The Menil Collection, Houston
Curator: Lauri Nelson

Sherrie Levine: Newborn
December 9, 1994–January 15, 1995
Location: The Menil Collection, Houston
Organizer: Philadelphia Museum of Art
Catalogue

Cy Twombly: A Retrospective
February 12–March 19, 1995
Location: Cy Twombly Gallery, The Menil Collection, Houston
Curators: Kirk Varnedoe
Organizer: The Museum of Modern Art, New York
Catalogue

Defining Space
May 24–September 24, 1995
Artists: James Lee Byars, John Chamberlain, Walter De Maria, Dan Flavin, Alberto Giacometti, Yves Klein, Bruce Nauman, Louise Nevelson, Blinky Palermo, David Smith, Takis (Panayiotis Vassilakis), Cy Twombly, and works from Africa, Egypt, Iberia, and Greece
Location: The Menil Collection, Houston
Curator: Paul Winkler

William Christenberry
July 12–August 27, 1995
Location: The Menil Collection, Houston
Curator: Paul Winkler

Greek Culture Exhibition
August 10–September 29, 1995
Location: Central Library, Julia Ideson Building, Houston Public Library, Houston
Curator: Bertrand Davezac

**Tibet: The Pure Realm; Zanskar and Tibet:
Photographs by Richard Gere**
September 8–October 22, 1995
Location: The Menil Collection, Houston
Curators: William Steen and Paul Winkler

Tsakli: Tibetan Ritual Paintings
September 8–October 22, 1995
Location: The Menil Collection, Houston
Curators: William Steen and Paul Winkler

Edward Kienholz, 1954–1962
October 20, 1995–January 14, 1996
Location: The Menil Collection, Houston
Curator: Walter Hopps
Catalogue

Jasper Johns: The Sculptures
February 16–March 31, 1996
Location: The Menil Collection, Houston
Curator: Fred Orton
Organizer: Centre for the Study of Sculpture, The Henry Moore Institute, Leeds
Catalogue

Eve Arnold: In Retrospect [FotoFest]
March 1–April 28, 1996
Location: The Menil Collection, Houston
Curators: Roy Flukinger, April Rapier, and Paul Winkler
Organizer: Harry Ransom Humanities Research Center, University of Texas at Austin
Catalogue: Keepsakes: The Photography of Eve Arnold in Retrospect

Kurdistan: In the Shadow of History [FotoFest]
March 1–April 28, 1996
Location: Richmond Hall, The Menil Collection, Houston
Curators: Susan Meiselas, Charles Merewether, and Wendy Watriss
Catalogue

**Greek Icons After the Fall of Constantinople:
Selections from the Roger Cabal Collection**
March 15–June 2, 1996
Location: The Menil Collection, Houston
Curator: Bertrand Davezac
Catalogue

Georges Rouault: The Inner Light
April 26–August 25, 1996
Location: The Menil Collection, Houston
Curators: Dominique de Menil and Ileana Marcoulesco
Catalogue

Louis Fernandez
July 20, 1996–January 5, 1997
Location: The Menil Collection, Houston
Curators: Dominique de Menil and Ileana Marcoulesco

**Objects & Images: The Art of Assemblage in
The Menil Collection**
September 25–December 1, 1996
Artists: Gretchen Bender, Anne Doran, Howard Halle, Donald Lipski, Peter Nagy, Cindy Sherman, and Haim Steinbach
Location: The Menil Collection, Houston
Curator: Walter Hopps

Mark Rothko: The Chapel Commission
December 13, 1996–March 30, 1997
Location: The Menil Collection, Houston
Curators: David Anfam, Carol Mancusi-Ungaro, Paul Winkler, and Susan Davidson
Catalogue

**Georges Braque: Menil / Schlumberger
Family Collections**
April 25–November 30, 1997
Location: The Menil Collection, Houston
Curator: Paul Winkler

Braque: The Late Works
April 30–August 31, 1997
Artist: Georges Braque
Location: The Menil Collection, Houston
Curators: John Golding and Simonetta Fraquelli
Organizers: Royal Academy of Arts, London, in association with The Menil Collection, Houston
Catalogue

Joseph Cornell
October 3, 1997–January 4, 1998
Location: The Menil Collection, Houston
Curator: Paul Winkler

The Drawing Speaks: Works by Théophile Bra
December 12, 1997–March 29, 1998
Location: The Menil Collection, Houston
Curator: Jacques de Caso
Catalogue: The Drawing Speaks: Théophile Bra:
 Works 1826–1855
 (*Le Dessin Parle: Théophile Bra: Oeuvres 1826–1855*)

Robert Rauschenberg: A Retrospective
February 13–May 17, 1998
Location: The Menil Collection, Houston
Curators: Walter Hopps and Susan Davidson
Organizers: Solomon R. Guggenheim Museum, New York
Catalogue

Local Heroes [FotoFest]
February 27–March 29, 1998
Artists: Ben DeSoto, George Hixson, and John Lee
Location: The Menil Collection, Houston
Curator: Mark Flood

Mid-Century Drawings from the Collection
April 22–October 4, 1998
Artists: Max Ernst, Arshile Gorky, René Magritte, Man
Ray, Roberto Matta, Meret Oppenheim, Mark Rothko,
and Yves Tanguy
Location: The Menil Collection, Houston

**In and Out: Naive, Folk, and Self-Taught Artists
from the Collection**
June 12–October 11, 1998
Artists: Felipe Archuleta, Eddie Arning, André Bauchant,
David Butler, Henry Darger, Charles August Albert
Dellschau, Howard Finster, Odelia A. Hurd, Frank Jones,
Horace Pippin, I. E. Reiquer, Henri Rousseau, Johnnie
Swearingen, Bill Traylor, and unknown artists
Location: The Menil Collection, Houston
Curator: Paul Winkler

René Magritte
August 4, 1998–January 15, 1999
Location: State Hermitage Museum, St. Petersburg, and
 Pushkin State Museum of Fine Arts, Moscow
Curators: David Sylvester and Paul Winkler
Catalogue

**The Elusive City: Photographs of Houston
by Paul Hester**
October 16, 1998–January 3, 1999
Location: The Menil Collection, Houston
Organizer: Rice Design Alliance, Houston
Catalogue

Dan Flavin / Donald Judd: Aspects of Color
November 20, 1998–January 24, 1999
Location: The Menil Collection, Houston
Curator: Marianne Stockebrand and Paul Winkler

**Utopia Observed: A Photographic Portrait
of Joseph Cornell by Harry Roseman**
January 29–April 4, 1999

Location: The Menil Collection, Houston
Curator: Susan Davidson

Joseph Cornell / Marcel Duchamp . . . in resonance
January 29–May 16, 1999
Location: The Menil Collection, Houston
Curators: Walter Hopps, Ecke Bonk, Lynda Roscoe
 Hartigan, Susan Davidson, and Ann Temkin
Organizers: Philadelphia Museum of Art and The Menil
 Collection, Houston
Catalogue

**room, an installation by Lars Lerup
and Sohela Farokhi**
March 19–June 6, 1999
Location: The Menil Collection, Houston
Catalogue

William Eggleston Photographs: Then and Now
May 28–September 12, 1999
Location: The Menil Collection, Houston
Curator: Walter Hopps
Catalogue: The Hasselblad Award 1998: William Eggleston

**17 Contemporaries: Artists from America, Italy, and
Mexico — The Eighties**
June 11–August 15, 1999
Artists: Dan Asher, Jean-Michel Basquiat, Bill Beckly,
Mike Bidlo, Saint Clair Cemin, Sandro Chia, Francesco
Clemente, George Condo, Chuck Connelly, Julio Galán,
Jonathan Lasker, Mimmo Paladino, Ira Richer, David
Salle, Julian Schnabel, Ray Smith, and German Venegas
Location: The Menil Collection, Houston
Curator: Paul Winkler

Sam Francis: Paintings 1947–1990
September 10, 1999–January 2, 2000
Location: The Menil Collection, Houston
Curator: William C. Agee
Organizer: The Museum of Contemporary Art,
 Los Angeles
Catalogue

Remembering Saul Steinberg
September 24–November 28, 1999
Location: The Menil Collection, Houston
Curator: Walter Hopps

Byzantion in Texas: Images and Objects
December 17, 1999–February 27, 2000
Location: The Menil Collection, Houston
Curator: Bertrand Davezac

Willem De Kooning: In Process
January 28–March 12, 2000
Location: The Menil Collection
Curator: Klaus Kertess
Organizer: Museum of Art, Fort Lauderdale
Catalogue

**John Chamberlain Sculpture: Selections from
The Menil Collection and the Dia Art Foundation**
January 28–April 2, 2000
Location: The Menil Collection, Houston
Curators: Susan Davidson and Walter Hopps

Lunar Landscapes: Unmanned Space Photography
[FotoFest]
March 10–June 4, 2000
Location: The Menil Collection, Houston
Curator: Susan Davidson

**Spirits of the Water: Native Art Collected on
Expeditions to Alaska and British Columbia, 1774–1910**
May 5–August 13, 2000
Location: The Menil Collection, Houston
Curators: Paz Cabello, Alberto Costa Romero de Tejado,
 and Susan Davidson
Organizer: Fundación "la Caixa," Barcelona
Catalogue

Sharon Kopriva: Work 1986–1998
June 9–August 20, 2000
Location: The Menil Collection, Houston
Curator: Walter Hopps
Catalogue

**From Above: Photographs of Houston by
Alex S. MacLean**
September 7, 2000–January 7, 2001
Location: The Menil Collection, Houston
Curators: Susan Davidson and William F. Stern

Cy Twombly: The Sculpture
September 20, 2000–January 7, 2001
Location: The Menil Collection, Houston
Curators: Katharina Schmidt and Paul Winkler
Organizers: Kunstmuseum Basel and The Menil
 Collection, Houston
Catalogue: Cy Twombly: Die Skulptur (Cy Twombly:
 The Sculpture)

Pop Art: U.S. / U.K. Connections, 1956–1966
January 26–May 13, 2001
Artists: Allan D'Arcangelo, Clive Barker, Billy Al
Bengston, Peter Blake, Derek Boshier, Pauline Boty,
Patrick Caulfield, Jim Dine, Rosalyn Drexler, Joe Goode,
Richard Hamilton, Phillip Hefferton, David Hockney,
Robert Indiana, Allen Jones, Edward Kienholz, R. B. Kitaj,
Gerald Laing, Roy Lichtenstein, Claes Oldenburg,
Eduardo Luigi Paolozzi, Peter Phillips, Mel Ramos,
James Rosenquist, Edward Ruscha, Ben Talbert, Joseph
Tilson, Andy Warhol, John Wesley, and Tom
Wesselmann
Location: The Menil Collection, Houston
Curators: David E. Brauer and Jim Edwards
Catalogue

Postmodern Americans: A Selection
January 26–May 13, 2001
Artists: Gretchen Bender, Anne Doran, Mark Flood,
Howard Halle, William Harvey, Rachel Hecker, Sherrie
Levine, Robert Longo, Manuel (Suzanne Bloom and Ed
Hill), Michael McCall, John McIntosh, Jack Pierson,
Rachel Ranta, Cindy Sherman, Alexis Smith, Al Souza,
Haim Steinbach, Lew Thomas, and Robert Williams
Location: The Menil Collection, Houston
Curator: Walter Hopps

The Exquisite Corpse
June 1–September 9, 2001
Artists: Victor Brauner, André Breton, Thérèse Caen, Salvador Dalí, Oscar Domínguez, Nusch Éluard, Paul Éluard, Esteve Francés, Jacques Hérold, Georges Hugnet, Germaine Hugnet, Valentine Hugo, Jacqueline Lamba, Man Ray, André Masson, Anne "Pajarito" Matta, Roberto Matta, Joán Miró, Max Morise, Gordon Onslow-Ford, Benjamin Péret, Robert Rius, Jeannette Tanguy, Yves Tanguy, Tristan Tzara, Raoul Ubac, Remedios Varo, and unknown artist
Location: The Menil Collection, Houston
Curator: Susan Davidson

Yves Tanguy Retrospective
June 1–September 30, 2001
Location: The Menil Collection, Houston
Curator: Susan Davidson
Organizer: Staatsgalerie Stuttgart
Catalogue: Yves Tanguy and Surrealism

Mineko Grimmer: Remembering Plato
September 26, 2001–February 3, 2002
Location: The Menil Collection, Houston
Curator: Ned Rifkin

Victor Brauner: Surrealist Hieroglyphs
October 26, 2001–January 6, 2002
Location: The Menil Collection, Houston
Curator: Susan Davidson
Catalogue

Agnes Martin: The Nineties and Beyond
February 1–May 26, 2002
Location: The Menil Collection, Houston
Curator: Ned Rifkin
Catalogue

Vik Muniz: Model Pictures [FotoFest]
February 22–June 9, 2002
Location: The Menil Collection, Houston
Curator: Matthew Drutt
Catalogue

Old Master Drawings: Selections from The Menil Collection
June 26–September 8, 2002
Artists: Edmé Bouchardon, attributed to Guglielmo Caccia, Luca Cambiaso, attributed to Giuseppe Cesari, Claude Louis Chatelet, Giovanni Daudine, Gottfried Eichler the Younger, circle of Giulio Romano, attributed to Jan Hackaert, Raymond Lafage, attributed to Pirro Ligorio, Alessandro Magnasco, Giulio or Alfonso Parigi, Francesco Parmigianino (Girolamo Francesco Maria Mazzola), attributed to Gabriel Perelle and Jean Lepantre, Vincenzo dal Re, Rembrandt van Rijn, Jean Restout, George Romney, Antonio Tempesta, and works from France and Italy
Location: The Menil Collection, Houston
Curator: Susan Davidson

Anna Gaskell: half life
September 27, 2002–January 12, 2003
Location: The Menil Collection, Houston
Curator: Matthew Drutt
Catalogue

H. C. Westermann
October 4, 2002–January 5, 2003
Location: The Menil Collection, Houston
Curators: Lynne Warren and Michael Rooks
Organizer: Museum of Contemporary Art, Chicago
Catalogue

Donald Judd: Early Work 1955–1968
January 31–April 27, 2003
Location: The Menil Collection, Houston
Curator: Thomas Kellein
Organizers: Kunsthalle Bielefeld and The Menil Collection, Houston
Catalogue: Donald Judd: 1955–1968

Jasper Johns: Drawings
January 31–May 4, 2003
Location: The Menil Collection, Houston
Curator: Mark Rosenthal
Catalogue

Sanctuaries: The Last Works of John Hejduk. Selections from the John Hejduk Archive at the Canadian Centre for Architecture, Montreal & The Menil Collection, Houston
May 7–August 31, 2003
Location: The Menil Collection, Houston
Curator: K. Michael Hays
Organizers: Whitney Museum of American Art, New York, in association with Harvard University Graduate School of Design, Cambridge, and The Menil Collection, Houston
Catalogue

James Rosenquist: A Retrospective
May 17–August 17, 2003
Location: The Menil Collection, Houston
Curators: Walter Hopps and Sarah Bancroft
Organizer: Solomon R. Guggenheim Museum, New York
Catalogue

Roberto Matta: Cosmic Terrains. Selections from The Menil Collection
June 6–September 4, 2003
Location: The Menil Collection, Houston
Curator: Matthew Drutt

In Pursuit of the Absolute
September 17, 2003–February 29, 2004
Artists: Walter De Maria, Donald Judd, Yves Klein, Sol LeWitt, Brice Marden, Agnes Martin, Barnett Newman, Jackson Pollock, Ad Reinhardt, Mark Rothko, Robert Ryman, Frank Stella, and Clyfford Still
Location: The Menil Collection, Houston
Curator: Matthew Drutt

Jonathan Monk: Square Circles Squares
October 3, 2003–January 11, 2004
Location: The Menil Collection, Houston
Curator: Matthew Drutt

Kazimir Malevich: Suprematism
October 3, 2003–January 11, 2004
Location: The Menil Collection, Houston
Curator: Matthew Drutt
Organizers: Solomon R. Guggenheim Foundation, New York, and The Menil Collection, Houston
Catalogue

Tabletki: Russian Icons from The Menil Collection
October 3, 2003–January 25, 2004
Location: The Menil Collection, Houston
Curator: Matthew Drutt

Luis Barragán: An Unbuilt House for the Menil
February 11–May 30, 2004
Artists: Luis Barragán and Raúl Ferrera
Location: The Menil Collection, Houston
Curator: Matthew Drutt

Arshile Gorky: A Retrospective of Drawings
March 5–May 9, 2004
Location: The Menil Collection, Houston
Curators: Janie C. Lee and Melvin P. Lader
Organizer: Whitney Museum of American Art, New York
Catalogue

Luisa Lambri: Locations [FotoFest]
March 19–June 27, 2004
Location: The Menil Collection, Houston
Curator: Matthew Drutt
Catalogue

Olafur Eliasson: Photographs
May 26–September 5, 2004
Location: The Menil Collection, Houston
Curator: Matthew Drutt
Catalogue

Earthworks: Land Art at the Menil
June 9–August 15, 2004
Artists: Michael Heizer, Peter Hutchinson, Dennis Oppenheim, Robert Smithson, and James Turrell
Location: The Menil Collection, Houston
Curators: Matthew Drutt and Susan Braeuer

Old Masters: Selections from The Menil Collection
July 14–September 12, 2004
Artists: Abraham Bloemaert, Hans Burgkmair, Luca Cambiaso, attributed to Bernardo Cavallino, François Clouet, Lucas Cranach the Elder, Aelbert Cuyp, Albrecht Dürer, workshop of Charles Le Brun, Lucas van Leyden, after Giovanni Francesco Penni, Rembrandt van Rijn, Adriaan van Salm, Nicolaas Verkolje, and unknown artists
Location: The Menil Collection, Houston
Curator: Josef Helfenstein

Contortion and Distortion: Post-War European Art from The Menil Collection
September 22, 2004–January 9, 2005
Artists: Roberto Crippa, Jean Dubuffet, Jean Fautrier, Lucio Fontana, Alberto Giacometti, Yves Klein, Michelangelo Pistoletto, Niki de Saint-Phalle, and Jean Tinguely
Location: The Menil Collection, Houston
Curator: Matthew Drutt

Joseph Beuys: Actions, Vitrines, Environments
October 8, 2004–January 2, 2005
Location: The Menil Collection, Houston
Curator: Mark Rosenthal
Organizers: The Menil Collection, Houston, in
collaboration with Tate Modern, London
Catalogue

Deep Wells and Reflecting Pools
January 21–April 17, 2005
Artists: Jean-Baptiste Carpeaux, Jacques Charles, George
Dawe, Jean Pierre Duprey, Sir Jacob Epstein, David
Claypool Johnston, Charles-Philibert Lasteyrie (after
Wailly & Werner), Gabriel Mathias, David Mossey, Sir
Joshua Reynolds, Larry Rivers, attributed to Thomas
Rowlandson, Shields & Yarnell, Marcel Antoine Verdier,
François André Vincent, Wedgwood, Williamson &
Puryear, and unknown artists
Location: The Menil Collection, Houston
Curators: David McGee and Matthew Drutt

Romuald Hazoumé: La bouche du roi
January 29–June 12, 2005
Location: The Menil Collection, Houston
Curators: Matthew Drutt and Romuald Hazoumé
Catalogue

Ellsworth Kelly: Tablet
February 11–May 8, 2005
Location: The Menil Collection, Houston
Curator: Matthew Drutt

Cy Twombly: Fifty Years of Works on Paper
May 27–September 4, 2005
Location: The Menil Collection, Houston
Curator: Julie Sylvester
Organizers: State Hermitage Museum, St. Petersburg,
coordinated by Whitney Museum of American Art,
New York
Catalogue

**David McManaway and Friends: Jim Love and Roy
Fridge with Additional Works Donated by William Hill**
June 10–September 18, 2005
Artists: Roy Fridge, David Gibson, Lucas Johnson,
Jim Love, David McManaway, and Forrest Prince
Location: The Menil Collection, Houston
Curator: Walter Hopps

**Bill Traylor, William Edmondson and
the Modernist Impulse**
July 22–October 2, 2005
Artists: Bill Traylor and William Edmondson, with
photographs of the artists at work by Louise Dahl-Wolfe,
Charles Shannon, and Edward Weston
Location: The Menil Collection, Houston
Curator: Josef Helfenstein
Organizer: Kranert Art Museum and Kinkead Pavilion,
University of Illinois, Urbana-Champaign
Catalogue

Sand Mandala: The Sacred Tour
September 17–23, 2005
Location: The Menil Collection, Houston
Curator: Josef Helfenstein

The Surreal Calder
September 30, 2005–January 8, 2006
Artists: Alexander Calder, Max Ernst, René Magritte,
Joán Miró, Pablo Picasso, and Yves Tanguy
Location: The Menil Collection, Houston
Curator: Mark Rosenthal
Catalogue

**Convulsive Beauty:
Selections from The Menil Collection**
October 5, 2005–February 5, 2006
Artists: Hans Bellmer, Federico Castellon, Marcel
Duchamp, Max Ernst, Robert Gober, Jim Love, René
Magritte, and unknown artists
Location: The Menil Collection, Houston
Curator: Josef Helfenstein

Robert Gober: The Meat Wagon
October 28, 2005–January 22, 2006
Artists: Edgar Degas, Eugène Delacroix, William
Eggleston, Lucio Fontana, Robert Gober, Guerrilla Art
Action Group, Charles Houghton Howard, Charles
James, Roger de La Fresnaye, René Magritte, Henri
Matisse, Piet Mondrian, Joshua Mann Pailet, Michel-
angelo Pistoletto, Mark Rothko, Georges Rouault, Tony
Smith, François-Xavier Vispré, Andy Warhol, and works
from Egypt, Europe, North America, and South America
Location: The Menil Collection, Houston
Curator: Robert Gober and Matthew Drutt
Catalogue

Eva Hesse Drawing
February 3–April 23, 2006
Location: The Menil Collection, Houston
Curators: Catherine de Zegher and Elisabeth Sussman
Organizers: The Drawing Center, New York, and
The Menil Collection, Houston
Catalogue

Insistent Objects: David Levinthal's Blackface
[FotoFest]
March 17–May 7, 2006
Location: The Menil Collection, Houston
Curator: Kristina Van Dyke
Catalogue: David Levinthal: Blackface

William Christenberry
March 17–May 7, 2006
Location: The Menil Collection, Houston
Curator: Clare Elliott

**West Coast Abstract Expressionist Art:
Selections from The Menil Collection**
March 31–July 9, 2006
Artists: Edward Dugmore, Sonia Gechtoff, James Kelly,
Walter Egel Kuhlman, and Clyfford Still
Location: The Menil Collection, Houston
Curator: Clare Elliott

Frank Stella 1958
May 26–August 20, 2006
Location: The Menil Collection, Houston
Curators: Harry Cooper and Megan R. Luke
Organizer: Arthur M. Sackler Museum, Harvard
University, Cambridge
Catalogue

**Chance Encounters: The Formation of the de Menil's
African Collection**
May 26–September 10, 2006
Artists: Francis Bacon, Victor Brauner, James Lee Byars,
Jean-Baptiste Carpeaux, Chryssa (Varda Chryssa), Bruce
Conner, Joseph Cornell, Jay DeFeo, Max Ernst, Louis
Fernandez, Lucio Fontana, Yves Klein, Robert Rauschen-
berg, Andy Warhol, Roman works, and works from
Africa, British Columbia, Melanesia, and Polynesia
Location: The Menil Collection, Houston
Curator: Kristina Van Dyke

Color and Line: Selections from The Menil Collection
July 21–October 22, 2006
Artists: Yves Klein, Brice Marden, John McLaughlin,
Kenneth Noland, Frederick Lane Sandback, and
Frank Stella
Location: The Menil Collection, Houston
Curator: Brooke Stroud

The Imagery of Chess Revisited
September 8, 2006–January 7, 2007
Artists: Xenia Cage, Alexander Calder, Julio De Diego,
Marcel Duchamp, Max Ernst, Richard Filipowski, Josef
Hartwig, Herman Miller Furniture Catalogue, Antonín
Heythum, Carol Janeway, Leon Kelly, Stefi Kiesler, Julien
Levy, Man Ray, Roberto Matta, Isamu Noguchi, Kay Sage,
Kurt Seligmann, Muriel Streeter, Yves Tanguy, and
Dorothea Tanning
Location: The Menil Collection, Houston
Curator: Larry List
Organizer: The Noguchi Museum, New York
Catalogue

Klee and America
October 6, 2006–January 28, 2007
Artist: Paul Klee
Location: The Menil Collection, Houston
Curator: Josef Helfenstein
Catalogue

**Contemporary Conversations: David Novros
and The Menil Collection**
November 3, 2006–March 4, 2007
Location: The Menil Collection, Houston
Curator: Josef Helfenstein

**Everyday People: 20th-Century Photography
from The Menil Collection**
January 26–April 29, 2007
Artists: Eve Arnold, Gertrude Duby Blom, Brassaï (Gyula
Halász), Larry Burrows, Emil Cadoo, Henri Cartier-
Bresson, Scott Michael Coburn, Bruce L. Davidson,
Walker Evans, Robert Frank, Ira Friedlander, Danny
Lyon, Joshua Mann Pailet, Gordon Parks, Ogden
Robertson, W. Eugene Smith, Eve Sonneman, James
Van Der Zee, and Shawn Walker
Location: The Menil Collection, Houston
Curator: Franklin Sirmans

Robert Rauschenberg: Cardboards and Related Pieces
February 23–May 13, 2007
Location: The Menil Collection, Houston
Curator: Josef Helfenstein
Catalogue

Andy Warhol: Three Houston Women
March 16–August 26, 2007
Location: The Menil Collection, Houston
Curator: Brooke Stroud

The David Whitney Bequest
May 11–August 12, 2007
Artists: Vija Celmins, Jasper Johns, Roy Lichtenstein, Brice Marden, Claes Oldenburg, Ken Price, Robert Rauschenberg, Cy Twombly, Andy Warhol, and Steve Wolfe
Location: The Menil Collection, Houston
Curator: Franklin Sirmans

A Modern Patronage: de Menil Gifts to American and European Museums
June 8–September 16, 2007
Artists: Lee Bontecou, Christo and Jeanne Claude, Max Ernst, René Magritte, Man Ray, Claes Oldenburg, Jackson Pollock, Larry Rivers, Mark Rothko, Jean Tinguely, Andy Warhol, Wols (Alfred Otto Wolfgang Schulze), and works from Africa and Mexico
Location: The Menil Collection, Houston
Curator: Josef Helfenstein
Catalogue

Lessons from Below: Otabenga Jones & Associates
September 14–December 9, 2007
Artists: Brandt and Scheible, John Brathwaite, Emil Cadoo, Alexander Calder, Henri Cartier-Bresson, Barbara Chase-Riboud, Henry Ray Clark, Joseph Cornell, Roy DeCarava, George Deem, Charles August Albert Dellschau, Walter De Maria, Sir Jacob Epstein, Mariano José María Bernardo Fortuny y Carbó, Léonard Foujita, Ronald Hartgrove, Ellsworth Kelly, Paul Klee, Helen Levitt, Llanta, Edward Orme & Denton, Joe Overstreet, Wolfgang Paalen, Richard Pettibone, Yves Tanguy, James Van Der Zee, Wand, Andy Warhol, Williamson & Puryear, and works from Africa and North American Indians
Location: The Menil Collection, Houston
Curators: Otabenga Jones & Associates, Franklin Sirmans, and Michelle White
Catalogue

A Rose Has No Teeth: Bruce Nauman in the 1960s
October 25, 2007–January 13, 2008
Location: The Menil Collection, Houston
Curator: Constance Lewallen
Organizer: University Art Museum, University of California at Berkeley
Catalogue

Contemporary Conversations: Robert Ryman, 1976
November 9, 2007–February 17, 2008
Location: The Menil Collection, Houston
Curator: Franklin Sirmans

Vivid Vernacular: William Christenberry, William Eggleston, and Walker Evans [FotoFest]
January 11–April 20, 2008
Location: The Menil Collection, Houston
Curator: Clare Elliott

How Artists Draw: Toward the Menil Drawing Institute and Study Center
February 15–May 18, 2008
Artists: Lee Bontecou, Georges Braque, Victor Brauner, André Breton, Marcel Broodthaers, Vija Celmins, Paul Cézanne, John Chamberlain, Christo and Jeanne-Claude, Chuck Close, Willem De Kooning, Jean Dubuffet, Marcel Duchamp, Max Ernst, Robert Gober, Vincent van Gogh, Arshile Gorky, John Graham, Juan Gris, Raoul Hausmann, Michael Heizer, Jacques Hérold, Jasper Johns, Donald Judd, Ellsworth Kelly, Paul Klee, Yves Klein, Franz Kline, Lee Krasner, Fernand Léger, Sol LeWitt, Roy Lichtenstein, René Magritte, Man Ray, Brice Marden, Agnes Martin, Roberto Matta, Bruce Nauman, Barnett Newman, Georgia O'Keeffe, Claes Oldenburg, Francis Picabia, Pablo Picasso, Jackson Pollock, Robert Rauschenberg, Odilon Redon, Mark Rothko, Robert Ryman, Frederick Lane Sandback, Kurt Schwitters, Richard Serra, Georges Seurat, Frank Stella, Yves Tanguy, and Cy Twombly
Location: The Menil Collection, Houston
Curator: Bernice Rose

form, color, illumination: Suzan Frecon painting
March 7–May 11, 2008
Location: The Menil Collection, Houston
Curator: Josef Helfenstein
Organizers: The Menil Collection, Houston, and Kunstmuseum Bern

Max Neuhaus: Circumscription Drawings
May 3–August 10, 2008
Location: The Menil Collection, Houston
Curator: Josef Helfenstein

Sterne & Steinberg: Critics Within
May 23–August 17, 2008
Artists: Hedda Sterne and Saul Steinberg
Location: The Menil Collection, Houston
Curator: Sarah Eckhardt

NeoHooDoo: Art for a Forgotten Faith
June 27–September 21, 2008
Artists: Terry Adkins, Janine Antoni, Radcliffe Bailey, Jean-Michel Basquiat, José Bedia Valdés, Rebecca Belmore, Sanford Biggers, Tania Bruguera, James Lee Byars, John Cage, María Magdalena Campos-Pons, William Cordova, Jimmie Durham, Regina Galindo, Robert Gober, Felix Gonzalez-Torres, David Hammons, Michael Joo, Brian Jungen, Kcho (Alexis Leyva Machado), Marepe (Marcos Reis Peixoto), Ana Mendieta, Amalia Mesa-Bains, Pepón Osorio, Adrian Piper, Ernesto Pujol, Dario Robleto, Betye Saar, Doris Salcedo, Gary Simmons, George Smith, Michael Tracy, and Nari Ward
Location: The Menil Collection, Houston
Curator: Franklin Sirmans
Organizers: The Menil Collection, Houston, and P.S. 1 Contemporary Art Center, New York
Catalogue

Imaginary Spaces: Selections from The Menil Collection
August 22, 2008–March 1, 2009
Artists: Vija Celmins, Giorgio de Chirico, Christo and Jeanne-Claude, Joseph Cornell, Hermann Finsterlin, Michael Heizer, John Quentin Hejduk, Edward Kienholz, René Magritte, Man Ray, Roberto Matta,

Giovanni Battista Piranesi, Robert Rauschenberg, Robert Smithson, James Turrell, and unknown artist
Location: The Menil Collection, Houston
Curator: Michelle White

Art and Power in Central African Savanna
September 26, 2008–January 4, 2009
Location: The Menil Collection, Houston
Curators: Constantine Petridis
Organizer: The Cleveland Museum of Art

Max Ernst in the Garden of the Nymph Ancolie
October 31, 2008–February 15, 2009
Location: The Menil Collection, Houston
Curators: Josef Helfenstein and Annja Müller-Alsbach
Organizers: The Menil Collection, Houston, and Museum Tinguely, Basel

Face Off: A Selection of Old Masters and Others from The Menil Collection
February 6–April 26, 2009
Artists: Francis Bacon, Christian Bérard, Abraham Bloemaert, Victor Brauner, Denys Calvaert, François Clouet, Aelbert Cuyp, Honoré Daumier, Marlene Dumas, Jean Pierre Duprey, William Eggleston, Louis Fernandez, Léonard Foujita, Francisco de Goya, Jean-Baptiste Greuze, attributed to Godfrey Kneller, Lucas van Leyden, René Magritte, circle of Bartolomeo Passarotti, Rembrandt van Rijn, Sir Joshua Reynolds, Larry Rivers, Georges Rouault, Henry Ossawa Tanner, Nicolaas Verkolje, and works from Egypt, Flanders, France, Mexico, Peru, and Spain
Location: The Menil Collection, Houston
Curator: Franklin Sirmans

Contemporary Conversations: John Chamberlain, American Tableau
March 20–August 2, 2009
Location: The Menil Collection, Houston
Curator: Franklin Sirmans

Marlene Dumas: Measuring Your Own Grave
March 27–June 21, 2009
Location: The Menil Collection, Houston
Curators: Connie Butler
Organizers: The Museum of Contemporary Art, Los Angeles, in association with The Museum of Modern Art, New York

Drawings on Site: Claes Oldenburg and Coosje van Bruggen
May 9–October 11, 2009
Location: The Menil Collection, Houston
Curator: Bernice Rose

Body in Fragments
August 21, 2009–February 28, 2010
Artists: Eugène Delacroix, Marcel Duchamp, Robert Gober, Nancy Grossman, Charles James, Jasper Johns, Edward Kienholz, Yves Klein, Roy Lichtenstein, René Magritte, Michelangelo Pistoletto, Robert Rauschenberg, James Rosenquist, Henri Rousseau, Susan Weil, Roman and Byzantine works, and works from Africa, Egypt, England, France, Germany, and Syria
Location: The Menil Collection, Houston
Curator: Kristina Van Dyke

Joaquín Torres-García: Constructing Abstraction with Wood
September 25, 2009–January 3, 2010
Location: The Menil Collection, Houston
Curators: Mari Carmen Ramírez and Josef Helfenstein
Organizers: The Menil Collection, Houston, in
 association with The Museum of Fine Arts, Houston
Catalogue

Cy Twombly: Treatise on the Veil
October 30, 2009–February 14, 2010
Location: The Menil Collection, Houston
Curators: Bernice Rose and Michelle White

Maurizio Cattelan
February 12–August 15, 2010
Artists: Maurizio Cattelan, with Giovanni Anselmo,
Alighiero Boetti, James Lee Byars, Lucio Fontana, Jasper
Johns, Robert Morris, Bruce Nauman, Giuseppe Penone,
Michelangelo Pistoletto, Robert Rauschenberg, Cy
Twombly, and Andy Warhol
Location: The Menil Collection, Houston
Curators: Maurizio Cattelan and Franklin Sirmans
Catalogue: Maurizio Cattelan: Is There Life Before Death?

Leaps into the Void: Documents of Nouveau Realist Performance [FotoFest]
March 19–August 8, 2010
Artists: Arman (Armand Fernandez), Christo and
Jeanne-Claude, Francois de Menil, János Kender, Yves
Klein, Martial Raysse, Mimmo Rotella, Niki de Saint-
Phalle, Harry Shunk, and Jean Tinguely
Location: The Menil Collection, Houston
Curator: Michelle White

Steve Wolfe on Paper
April 2–July 25, 2010
Location: The Menil Collection, Houston
Curators: Carter Foster and Franklin Sirmans
Organizers: Whitney Museum of American Art,
 New York, and The Menil Collection, Houston
Catalogue

Objects of Devotion
August 13–October 31, 2010
Location: The Menil Collection, Houston
Curator: Kristina Van Dyke

Earth Paint Paper Wood: Recent Acquisitions
August 27–November 28, 2010
Location: The Menil Collection, Houston
Curators: Clare Elliott

Kurt Schwitters: Color and Collage
October 22, 2010–January 30, 2011
Location: The Menil Collection, Houston
Curators: Isabel Schulz and Josef Helfenstein
Catalogue

Vija Celmins: Television and Disaster, 1964–1966
November 19, 2010–February 20, 2011
Location: The Menil Collection, Houston
Curators: Franklin Sirmans and Michelle White
Organizers: The Menil Collection, Houston, and
 Los Angeles County Museum of Art
Catalogue

Tony Smith: Drawings
December 17, 2010–April 3, 2011
Location: The Menil Collection, Houston
Curator: Bernice Rose

Selections from the Menil Archives Film and Media Collection

Compiled by GERALDINE ARAMANDA,
LISA BARKLEY, and DON QUAINTANCE

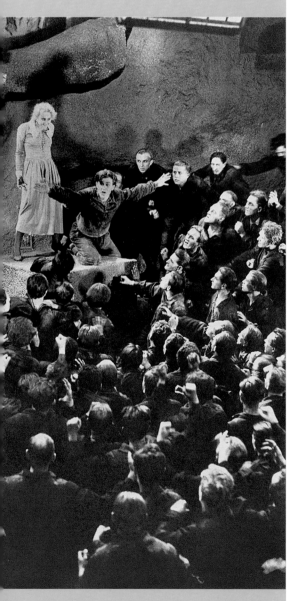

Fig. 26.1
Film still from Fritz Lang's *Metropolis*, 1927

The Menil Archives Film and Media Collection is an expansive library of film, video, and audio material begun by John and Dominique de Menil in the late 1960s with the establishment of the Media Center at the University of St. Thomas, Houston. Reflecting the de Menils' eclectic tastes and diverse interests, the film archive includes a range of documentary, experimental, and independently produced works.

The de Menils were fascinated by the artistic possibilities of film, as evidenced by their collections of early technical and cinematic experiments from the Cinémathèque Française archive and of documentaries on avant-garde art practices and performance, including the complete collection of films by Francois de Menil. Their collection of politically oriented cinema produced within and about developing nations, often supported by the de Menils in collaboration with filmmakers such as Roberto Rossellini and Danny Lyon, exemplifies their enthusiasm for film's ability to educate and effect social change. There are also examples in various media on the de Menils and their projects including sound and visual documentation of exhibition installations, public programs, Rothko Chapel colloquiums, and private interviews and discussions.

EARLY EXPERIMENTAL, FICTIONAL, AND DOCUMENTARY CINEMA

Alberini, Filoteo. *La presa di Roma (20 settembre 1870)*, 1905. 16mm film (excerpt).

Andréani, Henri. *MacBeth*, 1911. 16mm film (excerpt).

———. *Moïse sauvé des eaux*, 1911. 16mm film (excerpt).

Blom, August. *Ved faengslets port*, 1911. 16mm film (excerpt).

Booth, W. R. *When the Devil Drives*, 1907. 16mm film (excerpt).

Borgnetto, Luigi Romano. *La caduta di Troia*, 1910. 16mm film (excerpt).

Bourgeois, Gérard. *Victimes de l'alcoolisme*, 1911. 16mm film (excerpt).

Bragaglia, Anton Giulio. *Thaïs*, 1916. 16mm film (excerpt).

Bull, Lucien, and Pierre Nogues. *Ultra cinema de Bull et Nogues*, ca. 1900. 16mm film (excerpt).

Buñuel, Luis. *L'age d'or*, 1930. VHS.

Calmettes, André. *La dame aux camélias*, 1911. 16mm film (excerpt).

Calmettes, André, and Charles Le Bargy. *L'assassinat du duc de Guise*, 1908. 16mm film (excerpt).

———. *Le retour d'Ulysse*, 1909. 16mm film (excerpt).

Caserini, Mario. *Dante e Beatrice*, 1912. 16mm film (excerpt).

Clair, René. *Les deux timides*, 1928. 16mm film (excerpt).

———. *Entr'acte*, 1924. 16mm film (excerpt).

Cohl, Émile. *Les joyeux microbes*, 1909. 16mm film (excerpt).

———. *Mobilier fidèle (Automatic Moving Company)*, *Up the Flue*, *Fantasmagorie (Metamorphosis)*, and *Loïe Fuller*, 1908–19. 16mm film.

Curtis, Edward S. *In the Land of the War Canoes*, 1914. 16mm film.

Deed, André. *Boireau domestique*, 1912. 16mm film (excerpt).

———. *Cretinetti e le donne*, 1910. 16mm film (excerpt).

Delluc, Louis. *La femme de nulle part*, 1922. 16mm film (excerpt).

Dovzhenko, Aleksandr. *Arsenal*, 1929. 16mm film (excerpt).

Dreyer, Carl Theodor. *La passion de Jeanne d'Arc*, 1928. 16mm film (excerpt).

———. *Prästänkan*, aka *The Parson's Widow* and *La quatrième alliance de Dame Marguerite*, 1920. 16mm film (excerpt).

Dulac, Germaine. *La coquille et le clergyman*, 1928. 16mm film (excerpt).

———. *La souriante Madame Beudet*, 1923. 16mm film (excerpt).

Eggeling, Viking. *Symphonie diagonale*, 1924. 16mm (excerpt).

Eisenstein, Sergei M. *Bronenosets Potyomkin*, 1925. 16mm film (excerpt).

———. *Oktyabr*, 1928. 16mm film (excerpt).

———. *Staroye i novoye*, 1929. 16mm film (excerpt).

Epstein, Jean. *Coeur fidèle*, 1923. 16mm film.

———. *Finis terrae*, 1929. 16mm film (excerpt).

Farkas, Nicolas. *Variétés*, 1935. 16mm film (excerpt).

Feuillade, Louis. *Juve contre Fantômas*, 1913. 16mm film (excerpt).

———. *Le proscrit*, 1912. 16mm film (excerpt).

———. *Le thé chez la concierge*, 1907. 16mm film (excerpt).

———. *Les vampires*, 1915. 16mm (excerpt).

Fitzhamon, Lewin. *Rescued by Rover*, 1905. 16mm film.

Flaherty, Robert. *Nanook of the North*, 1922. VHS.

Galeen, Henrik. *Der Student von Prag*, 1926. 16mm film (excerpt).

Gance, Abel. *La dixième symphonie*, 1918. 16mm film (excerpt).

———. *Napoléon*, 1927. 16mm film (excerpt).

———. *La roue*, 1923. 16mm film (excerpt).

Gasnier, Louis. *Les débuts d'un patineur*, 1907. 16mm film (excerpt).

Janssen, Pierre Jules César. *Paysage de Venus devant le soleil*, 1874. 16mm film (excerpt).

Kuleshov, Lev. *Neobychainye priklyucheniya mistera: Vesta v strane bolshevikov*, 1924. 16mm film (excerpt).

L'Herbier, Marcel. *L'homme du large*, 1920. 16mm film (excerpt).

Lang, Fritz. *Metropolis*, 1927. 16mm film (excerpt).

———. *Der müde Tod*, 1921. 16mm film (excerpt).

———. *Die Nibelungen: Siegfried*, 1924. 16mm film (excerpt).

Léger, Fernand, and Dudley Murphy. *Ballet mécanique*, 1924. 16mm film (excerpt).

Linder, Max. *Max est distrait*, 1910. 16mm film.

———. *Max victime de quinquina*, 1911. 16mm film (excerpt).

———. *Première sortie d'un collégien*, 1905. 16mm film (excerpt).

Lorentz, Pare. *The Plow That Broke the Plains*, 1936. 16mm film.

Lubitsch, Ernst. *Madame DuBarry*, 1919. 16mm film (excerpt).

Lumière, Auguste. *Melbourne*, 1896. 16mm film (excerpt).

Lumière, Louis. *Arrivée d'un train à Battery Place*, 1896. 16mm film.

———. *L'arroseur arrosé*, 1895. 16mm film.

———. *L'assassinat du duc de Guise*, 1897. 16mm film.

———. *Les bains de Diane à Milan*, 1896. 16mm film (excerpt).

———. *Bocal aux poissons-rouges*, 1895. 16mm film.

———. *La charcuterie mécanique*, 1895. 16mm film.

———. *Charpentier et cartonnier*, 1895. 16mm film.

———. *Le concert*, 1895. 16mm film.

———. *Couronnement du Tzar*, 1896. 16mm film.

———. *Course en sacs*, 1895. 16mm film.

———. *La défense du drapeau*, 1897. 16mm film.

———. *Le déjeuner du chat*, 1895. 16mm film.

———. *Enfants aux jouets*, 1895. 16mm film.

———. *Grand Café*, 1895. 16mm film.

———. *Jean qui pleure et Jean qui rit*, 1897. 16mm film.

———. *Jeanne d'Arc*, 1898–99. 16mm film.

———. *Labourage*, 1895. 16mm film.

———. *Panorama d'Amberieu*, 1895. 16mm film.

———. *Panorama de la place St. Marc à Venise*, 1895. 16mm film.

———. *Panoramique sur les côtes anglaises*, 1895. 16mm film (excerpt).

———. *Rocher de la Vierge*, 1895. 16mm film.

Man Ray. *Le retour à la raison*, 1923. 16mm film (excerpt).

Marey, Étienne-Jules. *Chronophotographies de Marey*, 1888. 16mm film (excerpt).

Melford, George. *East of Borneo*, 1931. VHS (Hollywood film used as source material for Joseph Cornell's films *Angel*, 1957; *Aviary*, 1955; and *Rose Hobart*, 1936).

Méliès, Georges. *L'affaire Dreyfus*, 1899. 16mm film (excerpt).

———. *Après le bal–Le tub*, 1897. 16mm film (excerpt).

———. *Aquarium aux poissons d'or*, 1904. 16mm film.

———. *Barbe-bleue*, 1901. 16mm film (excerpt).

———. *Le brahmane et papillon*, aka *La chrysalide et le papillon d'or*, 1901. 16mm (excerpt).

———. *Escamotage d'une dame au théâtre Robert Houdin*, 1896. 16mm film (excerpt).

———. *L'homme à la tête de caoutchouc*, 1901. 16mm film (excerpt).

———. *Le magicien*, 1898. 16mm film (excerpt).

———. *La mort de Jules César*, 1907. 16mm film (excerpt).

———. *Le voyage dans la lune*, 1902. 16mm film (excerpt).

———. *Nouvelles luttes extravagantes*, 1899–1900. 16mm film (excerpt).

———. *Le palais des mille et une nuits*, 1905. 16mm film (excerpt).

Milano Films. *Lydia*, 1910. 16mm film (excerpt).

———. *Odette*, ca. 1915. 16mm film (excerpt).

Mottershaw, Frank. *The Life of Charles Peace*, 1905. 16mm film (excerpt).

Murnau, F. W. *Der letzte Mann*, 1924. 16mm film.

———. *Nosferatu, eine Symphonie des Grauens*, 1922. 16mm film (excerpt).

Nonguet, Lucien. *Dix femmes pour un mari*, 1905. 16mm film (excerpt).

———. *Les petits vagabonds*, 1905. 16mm film (excerpt).

Pabst, Georg Wilhelm. *Die Büchse der Pandora*, 1929. 16mm film (excerpt).

———. *Die freudlose Gasse*, 1925. 16mm film (excerpt).

Pastrone, Giovanni. *Cabiria*, 1914. 16mm film (excerpt).

Perret, Léonce. *La dentellière*, 1913. 16mm film (excerpt).

Pick, Lupu. *Sylvester*, 1924. 16mm film (excerpt).

Protazanov, Yakov. *Aelita*, 1924. 16mm film (excerpt).

Pudovkin, Vsevolod. *Konets Sankt-Peterburga*, 1927. 16mm film (excerpt).

Robison, Arthur. *Le montreur d'ombres*, 1923. 16mm film (excerpt).

Ruttmann, Walter. *Berlin: Die Sinfonie der Großstadt*, 1927. 16mm film (excerpt).

Sjöström, Victor. *Dödskyssen*, 1916. 16mm film.

———. *Körkarlen*, 1921. 16mm film (excerpt).

Skladanowsky, Max. *Vue de Max Skladanowsky*, ca. 1895. Five 16mm films on two reels.

Stiller, Mauritz. *Herr Arnes pengar*, 1919. 16mm film (excerpt).

Velle, Gaston. *Voyage autour d'une étoile*, 1906. 16mm film (excerpt).

Vertov, Dziga. *Chelovek s kino-apparatom*, 1929. 16mm film (excerpt).

———. *Odinnadtsatyy*, 1928. 16mm film (excerpt).

Williamson, James. *Fire!*, 1901. 16mm film (excerpt).

Zecca, Ferdinand. *Ce que je vois de mon sixième*, 1901. 16mm film (excerpt).

———. *Histoire d'une crime*, 1901. 16mm film (excerpt).

———. *Les victimes de l'alcoolisme*, 1902. 16mm film (excerpt).

TWENTIETH-CENTURY INDEPENDENT AND EXPERIMENTAL CINEMA

Baillie, Bruce. *All My Life*, 1970. 16mm film.

———. *Tung*, 1970. 16mm film.

———. *Valentin de las Sierras*, 1970. 16mm film.

Beeson, Constance. *Unfolding*, 1969. 16mm film.

Blier, Bertrand. *Hitler, connais pas*, 1963. 16mm film.

Colomb de Daunant, Denys. *Dream of Wild Horses*, 1970. 16mm film.

Connor, Bruce. *A Movie*, 1958. 16mm film.

Copley, William N., and Viola Stephan. *Even If You Are Unhappy*, 1978. Beta video cassette.

Cornell, Joseph. Compilation of *Angel*, 1957; *Aviary*, 1955; and *Rose Hobart*, 1936.

Cornell, Joseph, and Lawrence Jordan. *Cornell*, 1965; *Cotillion*; *Jack's Dream*; and *Thimble Theater*, 1930–68. VHS.

De Maria, Walter. *Hardcore*, 1969. 16mm film.

Eames, Charles and Ray. *Powers of Ten*, 1968. 16mm film.

Emshwiller, Ed. *George Dumpson's Place*, 1964–65. 16mm film.

Fridge, Roy. *Concert Tonight*, 1963. 16mm film.

———. *Plugs*, n.d. 16mm film.

———. *Reflections of St. Bambola*, 1968. 16mm film.

———. *Roy Fridge Film Anthology: Concert Tonight, Drumbreak, A Gathering of the Species, Hearts and Arrows, Reflections of St. Bambola*, and *Injun*, 1959–71. VHS.

———. *Roy Fridge Films: Abacus, Drumbreak, A Gathering of the Species, Concert Tonight, Hearts and Arrows, Reflections of St. Bambola*, and *Jomo*, 1959–71. VHS.

———. *Roy Fridge Films: Injun, Reflections of St. Bambola, Hearts and Arrows, Concert Tonight*, and *Injun* raw footage, 1963–71. DVD.

———. *Roy Fridge Films: Reflections of St. Bambola, Hearts and Arrows, Concert Tonight, Abacus, Drumbreak*, and *A Gathering of the Species*, 1959–71. DVD.

Goldman, Peter Emanuel. *Wheel of Ashes*, 1968. 16mm film.

McLaren, Norman. *Pas de deux*, 1967. 16mm film.

Oldenburg, Claes. *Claes Oldenburg: "Happenings" / Ray Gun Theater—1962*, 1962. VHS.

Pennell, Eagle. *The King of Texas*, 2007, and *A Hell of a Note*, 1977. DVD.

———. *The Long Road* (soundtrack of *The Whole Shootin' Match*, 1978, and *The King of Texas*, 2007). CD.

———. *The Whole Shootin' Match*, 1978. DVD.

Rickey, George. *Philly Film*, ca. 1980. 16mm film.

VanDerBeek, Stan. *Oh*, 1968. 16mm film.

CONTEMPORARY FICTION AND DOCUMENTARY FILM

Alassane, Moustapha. *Le retour d'un aventurier*, 1972. 16mm film.

Almendros, Néstor, and Orlando Jiménez Leal. *Mauvaise conduite*, 1984. 35mm film.

Ballantyne, Tanya. *The Things I Cannot Change*, 1966. 16mm film.

Balogun, Ola. *Alpha*, 1973. 16mm film.

———. *In the Beginning*, 1973. 16mm film.

Barrios, Jaime. *El Bloque*, 1972. 16mm film.

Bondi, Claudio. *Roberto Rossellini: Sognando la scienza* (documentary), 1997. VHS [PAL].

Chandler, John. *Slavery: The Black Man and the Man*, 1970. 16mm film.

Danska, Herbert. *Right On!*, 1971. 16mm film.

de Menil, Francois. *Hon*, 1966. Documentary about the deconstruction of the the the sculptural installation by Niki de Saint-Phalle, Jean Tinguely, and Per Olof Ultved. 16mm film.

———. *Niki de Saint-Phalle*, 1982. Documentary about the artist. 16mm film.

———. *North Star: Mark di Suvero*, 1977. Documentary about the artist with music by Philip Glass. 16mm film.

———. *Tinguely: A Kinetic Cosmos*, 1981. Documentary about the artist. 16mm film.

Diegues, Carlos. *Ganga Zumba*, 1963. 16mm film.

Gibaud, Marcel. *La vie de Jésus*, 1952. 16mm film. (excerpt).

Goulet, Pierre-Marie. *Djerrahi*, 1978. 16mm film.

Koenig, Wolf. *The Lonely Boy*, 1962. 16mm film.

Huberman, Brian, and Ed Hugetz. *Who Will Stand with the 4th Ward?*, 1984. Beta video cassette.

Lyon, Danny. *Born to Film*, 1982. VHS.

———. *Born to Film*, 1982, and *Two Fathers*, 2005. DVD.

———. *Dear Mark*, 1981. VHS.

———. *Five Days*, 2004. DVD.

———. *Little Boy*, 1977. 16mm film.

———. *Media Man*, 1994. VHS.

———. *Murderers*, 2006. DVD.

———. *Los niños abandonados*, 1975. 16mm film.

———. *El otro lado*, 1978. VHS.

———. *Soc. Sci. 127*, 1969. 16mm film.

———. *Willie*, Parts I and II, 1985. VHS.

Mallon, Jean. *Ductus, ou la formation de l'alphabet moderne* (formerly *Écriture*), 1976. 16mm film.

McDougall, David. *Nawi*, 1971. 16mm film.

Ortiz, Ralph [Raphael Montañez]. *People Are Chicken*, ca. 1965. 16mm film.

Rossellini, Roberto. *Blaise Pascal*, 1972. 35mm film.

———. *Intervista a Salvador Allende: La forza e la ragione* (Roberto Rossellini interviews Salvador Allende), 1971–73. 16mm film.

———. *La lotta dell'uomo per la sua sopravvivenza*, 1970. 35mm film.

———. *Science* (Rice University Public Relations Film), 1973. 16mm film.

———. *Viaggio in Italia*, 1954. 16mm film.

Tomkowitz, Paul. *Street Railway Switchman*, 1953. 16mm film.

Tyson, Thom. *Excuse Me America*, 1978. Documentary on Dom Hélder Câmera. 16mm film.

MENIL-RELATED MATERIAL

DOCUMENTARY FILMS AND OTHER MEDIA

American Federation of Arts. American Federation of Arts Convention, Houston, 1957. 17¼-inch magnetic tapes.

Associated Arts Workshop, ca. 1955. Documentary footage of the opening of Jermayne MacAgy–curated exhibition at the California Palace Legion of Honor, San Francisco. 16mm film.

Baker, Adam. Installation of Cy Twombly's *Treatise on the Veil (Second Version)* at the Menil Collection, 2010. A time-lapse documentation of stretching and hanging the monumental canvas. DVD.

Black Arts Center, De Luxe Theater, Houston, ca. 1972. ¼-inch magnetic tape.

Broken Obelisk, 1970. Installation of Barnett Newman's sculpture at the Rothko Chapel. VHS.

de Menil, Francois. *For Children*, 1971. Documentary about the exhibition, filmed by William Colville. 16mm film.

———. *Jean Tinguely in Motion*, 1969. Documentary about the making of *Water Machine #14* for the exhibition "The Machine as Seen at the End of the Mechanical Age," filmed by William Colville. 16mm film.

———. *The Machine*, 1969. Documentary about the exhibition "The Machine as Seen at the End of the Mechanical Age," filmed by William Colville. 16mm film.

———. *The Party*, 1972. Footage from a film in progress about two events at the de Menil townhouse in New York. 16mm film.

———. *Rothko Chapel* (long and short versions), 1972. Documentary featuring interviews with John and Dominique de Menil and with chapel visitors, the architectural space and the Mark Rothko paintings, and scenes from some early performances and events, filmed by Francois de Menil and Adam Hollander, music by Morton Feldman. 16mm film.

———. *A Young Teaching Collection*, 1968. Documentary of exhibition opening including interviews with Dominique de Menil and museum visitors, filmed by William Colville. 16mm film.

de Menil, Francois, and John de Menil. *Max Ernst Hanging*, 2008. Documentary about the exhibition "Max Ernst: Inside the Sight," from footage filmed by Francois de Menil in 1973. DVD.

Dominique de Menil funeral, 1998. Documentary footage. VHS.

Dominique de Menil memorial mass presented by the Carter Center and Habitat for Humanity, 1998. Documentary footage. VHS.

Edward and Nancy Reddin Kienholz: The Art Show, 1985. Documentary footage of the exhibition. ¾-inch U-matic cassette.

Fujisankei Communications International, Inc. and ACA Recording Studios. Cy Twombly Gallery, 1994. Unedited footage. VHS.

HH the 14th Dalai Lama's visit to the Rothko Chapel, 1979. ¼-inch magnetic tapes.

Houston PBS–Channel 8. *A Tribute to Dominique de Menil*, 1997. VHS.

Interiors 1952: Beauty within Reach of Hand and Budget, 1951. Documentary about the exhibition narrated by Dominique de Menil. 16mm film.

KPFT-FM Pacifica Radio. *The Rothko Chapel*, 1973. Radio documentary on the commission, completion, and dedication of chapel. Audio cassette.

Larry Rivers: Some American History, 1971. Unedited documentary footage of the exhibition opening. 16mm film.

Mendel, Pierre. *Constant Companions*, 1964. Documentary about the exhibition. 35mm film.

Origins of the Rothko Chapel, 1990. Conversation with Dominique de Menil and Tom Shannon. Audio cassette.

Out of the Silence, 1972. Narration by William Reid of text written to accompany the exhibition. ¼-inch magnetic tape.

Roberto Rossellini: 10 Years (video record of a conference at Rice Menia Center), 1987. ¾-inch U-matic cassette.

Rothko Chapel paintings, 1971. Documentary footage on the installation of Mark Rothko's paintings in the chapel. Super 8mm film.

Schlumberger Limited. *The Innovative Spirit: A Schlumberger History*, 1997. VHS.

Sims, Tom, and Laurie McDonald, with Southwest Alternate Media Project (SWAMP). *Jim Love Up to Now*, 1980. Unedited documentary footage of the exhibition. ¾-inch U-matic cassette.

Southwest Alternate Media Project (SWAMP). *Security in Byzantium—Locking, Sealing, Weighing*, 1981. Video of exhibition. ¾-inch U-matic cassette.

INTERVIEWS

These privately or publicly conducted interviews and oral histories discuss Menil research and projects.

Davezac, Bertrand, Dominique de Menil, Walter Hopps, and Paul Winkler. Conversation at de Menil home about the creation of the Menil Collection, 1983. Audio cassette.

de Menil, Dominique. "Désir des arts: La rime et la raison 1ere et 2eme partie and inauguration expo Grand Palais," 1984. Interview. VHS [PAL].

———. Interview by Adelaide de Menil, 1993. Audio cassette.

———. Interview by David Snell, 1971. Audio cassette.

———. Interview by Deborah Velders about Fernand Léger, 1992. Audio cassette.

———. Interview by Deborah Velders about Victor Brauner, 1992. Audio cassette.

———. Interview by Paul Winkler and Carol Mancusi-Ungaro, 1995. Video 8 cassette.

———. "Relative Values: Keeping up with the Medici," 1991. Interview for the BBC. VHS.

de Menil, Dominique, and Philippe Verdier. Discussion, 1978. Audio cassette.

de Menil, Francois. "Passport Texas: Byzantine Frescoes," 2007. Interview by Stacee Hawkins about the Byzantine Fresco Chapel for *Stafford Texas Weekly News*. DVD.

de Menil, John. Interview at the Dallas Art Museum, 1969. ¼-inch magnetic tape.

———. Interview by David Snell, 1971. Audio cassette.

———. Interview for KPOL AM radio, 1968. ¼-inch magnetic tape.

Fosdick, Helen Winkler, and A. C. Conrad. "Roberto Rossellini: Sognando la Scienza," 1997. Interview by Claudio Bondi about Rossellini's collaborations with the de Menils and scientists at Rice University. VHS [PAL].

Hopps, Walter. Interview by Geraldine Aramanda about the history of the recovery of the Byzantine frescoes taken from Lysi, Cyprus, 2004. Menil Archives Oral History Project. CD.

———. "The de Menils: The Last of the Great Collections," 1988. Interview by Joyce Gay. VHS.

Iolas, Alexander. Interview by Dominique de Menil, 1977. Audio cassette.

Love, Jim. Interview by Dominique de Menil, 1980. Audio cassette.

Love, Jim, and Helen Winkler. Interview by Geraldine Aramanda about Jermayne MacAgy, 2003. Menil Archives Oral History Project. Audio cassette.

"Souvenirs," 1984–85. Eighty-two relatives, friends, and associates of John de Menil interviewed by Adelaide de Menil Carpenter. 16mm films and ¼-inch magnetic tapes.

Tinguely, Jean. Interview by Dominique de Menil, 1980. Audio cassette.

LECTURES, CONVERSATIONS, PANELS

Bugner, Ladislas, and Dominique de Menil. "The Image of the Black in Western Art, Vol II," ca. 1979. Conversation organized by the Menil Foundation, Inc. Audio cassette.

Bugner, Ladislas, Dominique de Menil, David Sylvester, and Avram Udovitch. "Conversation with Dominique de Menil, Ladislas Bugner, and Avram Udovitch about Blacks in the Middle Ages" and "Discussion with David Sylvester and Dominique de Menil on Monochrome Art," both 1977. Audio cassette.

Dalton, Karen C. C., Bertrand Davezac, and Dominique de Menil. "The Image of the Black in Western Art," 1980. Talk organized by the Menil Foundation, Inc. CD.

de Menil, Adelaide. "Past Times as Pastimes," 1999. Lecture. Audio cassette.

de Menil, Dominique, and John de Menil. "The Art of Collecting: The Delight and Dilemma of Collecting," 1964. Lecture at the University of St. Thomas, Houston. Audio cassette.

de Menil, Dominique, Francesco Pellizzi, and Leon Siroto. "Leon Siroto, Francesco Pellizzi, and Dominique de Menil Discussion on African Art," 1979. Conversation organized by the Menil Foundation, Inc. Audio cassette.

de Menil, Dominique, Helénè Lassalle, and Charles Sterling. "Conversation between Charles Sterling, Helénè Lassalle, and Dominique de Menil: Launay," 1980. Audio cassette.

Fox, Stephen, Ben Koush, and William Neuhaus. "3363 Seminar: Hugo Neuhaus, Menil Modernism, and Houston," 2009. Illustrated talk. 16gb SDHC card.

Jiménez, Carlos. "Luis Barragán at the Menil Collection," 2004. Conversation with Marco Bracamontes. Audio cassette.

Johnson, Philip. "Philip Johnson Talk at 3363 San Felipe," 1999. VHS.

Longoria, Rafael. "Luis Barragán at the Menil Collection," 2004. Conversation with Marco Bracamontes. Audio cassette.

Pacquement, Alfred. "Dynamism Is Contagious: The de Menils & the Centre Pompidou," 2007. Lecture. Mini DV.

Piano, Renzo. "Since the Menil Collection," 2007. Lecture. Digital video cassette.

ARTISTS DOCUMENTATION PROGRAM

This ongoing series of conversations with contemporary artists addresses the condition and conservation of their works. Access to the video interviews is limited; however, a selection will be made available online in 2011 at www.menil.org.

THE ARTIST'S EYE SERIES

This ongoing series invites Houston artists to lead a public gallery talk discussing a significant work or artist in the Menil Collection or on temporary display in the museum. A complete and current listing of DVDs is available at www.menil.org.

ROTHKO CHAPEL: AWARD CEREMONIES, COLLOQUIUMS, AND EVENTS

First Rothko Chapel Colloquium, memorial prayer service, 1973. ¾-inch U-matic cassette.

"Human Rights / Human Reality," 1973, proceedings of second Rothko Chapel Colloquium. ¾-inch U-matic cassette.

Second Rothko Chapel Awards for Commitment to Truth and Freedom, first Oscar Romero Award, and first Carter-Menil Human Rights Prizes, presentation of awards, December 10, 1986. VHS.

Third Rothko Chapel Awards for Commitment to Truth and Freedom, fourth Oscar Romero Award, and sixth Carter-Menil Human Rights Prizes, dinner for recipients and presenters, December 7, 1991. Filmed by Access TV. VHS.

Third Rothko Chapel Awards for Commitment to Truth and Freedom, fourth Oscar Romero Award, a Special Rothko Chapel Award, and sixth Carter-Menil Human Rights Prizes, presentation of awards, December 8, 1991. VHS.

"Toward a New Strategy for Development," proceedings of third Rothko Chapel Colloquium, 1977. ¼-inch magnetic tape.

"Traditional Modes of Contemplation and Action," proceedings of first Rothko Chapel Colloquium, 1973. ½-inch helical scan tape.

Selected Bibliography

Compiled by SEAN NESSELRODE

While entries are arranged under primary subject matter headings, they may contain material pertinent to other sections.

ART

"Adaptive Use: Renovated Movie Theater Brings Fine Art to a Depressed Neighborhood." *Interiors* 131 (January 1972): 12.

Aston, Dore "The Rothko Chapel in Houston." *Studio International* 181 (June 1971): 274–5.

Barnes, Susan J. *The Rothko Chapel: An Act of Faith.* Houston: Rothko Chapel, 1989.

Battcock, Gregory. "'A Young Teaching Collection': From Art to Idea." *Art Journal* 28, no. 4 (Summer 1969): 406–10.

Billot, Marcel. "Les archives Marie-Alain Couturier à la Menil Foundation." *Art Libraries Journal* 15, no. 2 (1990): 33–36.

Brennan, Marcia, Alfred Pacquement, and Ann Temkin. *A Modern Patronage: de Menil Gifts to American and European Museums.* Introduction by Josef Helfenstein. Houston: Menil Foundation; New Haven and London: Yale University Press, 2007.

Colpitt, Frances. "Outtakes from the Chapel." *Art in America* 85 (June 1997): 98–99.

Couturier, Marie-Alain, Henri Matisse, and Louis-Bertrand Rayssiguier. *La chapelle de Vence: Journal d'une création.* Paris: Cerf; Genève: Albert Skira, 1993. Translated by Michael Taylor as *The Vence Chapel: The Archive of a Creation* (Houston: Menil Foundation; Milano: Skira, 1993).

Davis, George. "The De Luxe Show." *Art and Artists* 6 (February 1972): 36–37.

de Menil, Dominique. "Les coups de foudre de Mme de Ménil." Interview by Pierre André Boutag and Philippe Collin. *Le point*, no. 604, April 16, 1984, 74–75.

———. Interview. In *The First Show: Painting and Sculpture from Eight Collections, 1940–1980*, edited by Julia Brown and Bridget Johnson, 35–50. Los Angeles: Museum of Contemporary Art; New York: Arts Publisher, 1983.

———. "La rime et la raison: Le choc des mondes." Interview by Anne-Marie Bénézech. *Arts d'Afrique noire* 51 (Autumn 1984): 33–37.

Elliott, Clare. *Art Spaces: The Menil Collection.* London: Scala, 2007.

Eynatten, K. C., Kate Hutchins, and Don Quaintance, eds. *Image of the Not-Seen: Search for Understanding.* The Rothko Chapel Art Series. Houston: Rothko Chapel, 2007.

Herbert, Lynn M. "Seeing Was Believing: Installations of Jermayne MacAgy and James Johnson Sweeney." *Cite* 40 (Winter 1997/1998): 30–33.

Holmes, Ann, and Patricia C. Johnson. Articles in Zest section "The Menil Opens." *Houston Chronicle*, June 7, 1987.

Jodidio, Philip. "Inauguration Menil." *Connaissance des arts*, no. 424 (June 1987): 88–91.

Johnston, Marguerite. "The Institute for the Arts Comes to Rice." *Rice University Review* 6 (Summer 1971): 6–11.

Lampe, Mary M. "Swamp Roots: The Origins of Southwest Alternate Media Project and the Development of a Texas Film Community." In *A Closer Look: Hidden Histories*, edited by Helen de Michiel and Kathy High, 42–53. San Francisco: National Alliance for Media Arts and Culture, 2005.

Mancusi-Ungaro, Carol. "Embracing Humility in the Shadow of the Artist." In *Personal Viewpoints: Thoughts About Paintings Conservation*, edited by Mark Leonard, 83–94. Los Angeles: Getty Conservation Institute, 2003.

Mancusi-Ungaro, Carol, and Pia Gottschaller. "The Rothko Chapel: Reflectance, Reflection, and Restoration." *Zeitschrift für Kunsttechnologie und Konservierung* 2, no. 2 (2002): 215–24.

Mark Rothko: The Chapel Commission. Exhibition catalogue. Texts by David Anfam, Carol Mancusi-Ungaro, and Paul Winkler. Houston: Menil Collection, 1996.

The Menil Collection: A Selection from the Paleolithic to the Modern Era. New York: Abrams, 1987. Rev. ed., 1997.

Nodelman, Sheldon. *The Rothko Chapel Paintings: Origins, Structure, Meaning.* Austin: University of Texas Press; Houston: Menil Collection, 1997.

O'Doherty, Brian. "'The Rothko Chapel." *Art in America* 61 (January–February 1973): 14–16, 18, 20.

Papanikolas, Theresa. "A Deliberate Accident: Magritte in the Collection of John and Dominique de Menil." In *Magritte and Contemporary Art: The Treachery of Images*, introduction by Stephanie Barron, exhibition catalogue, 87–93. Los Angeles: Los Angeles County Museum of Art, 2006.

Paz, Octavio. "The Cy Twombly Gallery at the Menil Collection: A Conversation." Interview by John Harvey. *RES* 28 (Autumn 1995): 180–83.

La rime et la raison: Les collections Ménil (Houston–New York). Exhibition catalogue. Paris: Galeries nationales du Grand Palais, 1984.

Smart, Pamela. "Art of Transport." *Southern Review* 33, no. 3 (2000): 292–307.

———. "Possession: Intimate Artifice at The Menil Collection." *Modernism / Modernity* 13, no. 1 (January 2006): 19–39.

———. "Sacred Modern: The Ethnography of an Art Museum." PhD diss., Rice University, 1997.

———. *Sacred Modern: Faith, Activism, and Aesthetics in the Menil Collection.* Austin: University of Texas Press, 2010.

"Une vie, un musée." *Arts d'Afrique noire*, no. 63 (August 1987): 43.

Van Dyke, Kristina. *African Art from The Menil Collection.* Houston: Menil Foundation; New Haven and London: Yale University Press, 2008.

———. "Chance Encounters: The Formation of the de Menils' African Collection." *Tribal Art (San Francisco, Calif.)* 10, no. 4 (Summer 2006): 68–71.

———. "The Menil Collection: Houston, Texas." *African Arts* 40, no. 3 (Autumn 2007): 36–49.

Wood, Peter H., and Karen C. C. Dalton. *Winslow Homer's Images of Blacks: The Civil War and Reconstruction Years.* Houston: Menil Foundation; Austin: University of Texas Press, 1988.

A Young Teaching Collection. Introduction by Walter Widrig. Exhibition catalogue. Houston: Museum of Fine Arts, Houston, 1968.

ARCHITECTURE

"Art Collection and Home of the John de Menils in Houston's River Oaks." *Interiors* 123 (November 1963): 84–91.

"Artistic Designs: A Marriage of Divergent Styles." In *The Grand Homes of Texas*, edited by Ann Richardson, 15–25. Austin: Texas Monthly Press, 1982.

Asensio Cerver, Francisco. "The Menil Collection and Cy Twombly Annex." In *The Architecture of Museums*, translated by Mark Lodge, 32–41. New York: Hearst Books, 1997.

Banham, Reyner. "In the Neighborhood of Art." *Art in America* 75 (June 1987): 124–29.

Barnstone, Howard, with Burdette Keeland. *Ten Years of Houston Architecture.* Houston: Contemporary Arts Museum, 1959.

Bernier, Rosamond. "A Gift of Vision." *House and Garden* 159 (July 1987): 120–29, 180.

Bland, Kathleen. "Glass House Builder Expands on Ideas." *Houston Post,* January 11, 1950.

Bloch-Champfort, Guy. "La Menil Collection, un musée au campus." *Connaissance des arts*, no. 670 (April 2009): 120–25.

Buchanan, Peter. "Cy Twombly Pavilion." In *Renzo Piano Building Workshop: Complete Works,* vol. 1, 165. London: Phaidon Press, 1993.

———. "The Menil Collection." In *Renzo Piano Building Workshop: Complete Works,* vol. 1, 140–64. London: Phaidon Press, 1993.

Davey, Peter. "Menil Museum." *Architectural Review* 181 (March 1987): 36–42.

Farelly, E. M. "Piano Practice: Picking Up the Pieces (and Running with Them)." *Architectural Review* 181 (March 1987): 32–35.

Filler, Martin. "The Real Menil." *The Magazine Antiques* 174, no. 3 (September 2008): 78–85.

Germany, Lisa, and Grant Mudford. "De Menil House, Houston, 1949." In *Great Houses of Texas*, 142–151. New York: Abrams, 2008.

Giovannini, Joseph. "Modern Reliquary: In a New Houston Museum, Francois de Menil Crafts an Authentic Setting for Two Byzantine Frescoes." *Architecture* 86 (April 1997): 68–75.

Glancey, Jonathan. "A Homely Gallery: De Menil Collection of African Art, Houston." *The Architect* 94 (September 1987): 38–43.

Guazzoni, Edoardo, and Ermanno Ranzani. "Museo Menil, Houston." *Domus*, no. 685 (July/August 1987): 32–43.

Hay, David. "De Menil Reborn." *Metropolis* (August/September 2004): 98–101.

Ingersoll, Richard. "Pianissimo: The Very Quiet Menil Collection." *Texas Architect* 37 (May/June 1987): 40–47.

Ishida, Shunji. "Toward an Invisible Light." Translated by William R. Tingey. *A+U 206* (November 1987): 64–74.

Jenkins, Stover, and David Mohney. "Mr. and Mrs. John de Menil House, 1949–50." In *The Houses of Philip Johnson*, 55–59. New York: Abbeville Press, 2001.

Lemann, Nicholas. "The Architects." *Texas Monthly*, April 1982, 143–46.

Loud, Patricia Cummings. "Louis I. Kahn as Museum Designer." In *The Art Museums of Louis I. Kahn*, 245–72. Durham, N.C.: Duke University Press and Duke University Museum of Art, 1989.

"Machine Shop for Art." *Architectural Forum* 131 (July/ August 1969): 96.

McAuliffe, Mary. "The Erasure of the Canopy: Spatial Definition at the Menil Museum." *Crit 19* (Winter 1987): 32–37.

"The Menil Collection Museum." *A+U 206* (November 1987): 42–61.

Middleton, William. "A House That Rattled Texas Windows." *New York Times*, June 3, 2004.

Mitchell, Charles Dee. "Twombly's Tempietto." *Art in America* 83 (February 1995): 47.

"Modern Day Medici." Interview with Dominique de Menil. *Architecture* 86 (April 1997): 49–53.

Moorhead, Gerald. "Softly Piano." *Texas Architect* 45 (July/August 1995): 62.

"Padiglione Cy Twombly, Menil Collection, Houston." *Casabella* 62, no. 656 (May 1998): 72–73.

Pastier, John. "Simplicity of Form, Ingenuity in the Use of Daylight." *Architecture* 76 (May 1987): 84–91.

"Piano and Fitzgerald Architects: De Menil Collection, Houston." *GA Document*, no. 19 (1988): 20–31.

Piano, Renzo. *Menil: The Menil Collection / Renzo Piano.* Genoa: Fondazione Renzo Piano, 2007.

———. "Museo de Menil, Houston, 1981–86." In *Renzo Piano, Progetti e Architetture 1987–1994*, 16–29. Milan: Electa, 1994.

"Project Design Data." *A+U 206* (November 1987): 88–90.

Quaintance, Don. "Hanging at Dominique's and Mark's Place." *ArtLies* 27 (Summer 2000): 6–9.

Shkapich, Kim, and Susan de Menil, eds. *Sanctuary: The Spirit in/of Architecture.* Houston: Byzantine Fresco Foundation, 2004.

Slessor, Catherine. "Out of This World." *Architectural Review* 203 (May 1998): 82–85. On the Byzantine Fresco Chapel.

Stein, Karen D. "Art House: Cy Twombly Gallery, The Menil Collection, Houston, Texas." *Architectural Record* 183 (May 1995): 78–83.

Stern, William F. "The Twombly Gallery and the Making of Place." *Cite 34* (Spring 1996): 16–19.

Sweeney, James Johnson. "Collectors' House: The de Menils' Affair with Art." *Vogue*, April 1, 1966, 184–93, 199–200.

Welch, Frank D. *Philip Johnson and Texas*, chapter 1, 36–75. Austin: University of Texas Press, 2000.

Wolf, Eric M. "The Menil Collection." In *American Art Museum Architecture: Documents and Design*, 42–71. New York and London: W. W. Norton, 2010.

ACTIVISM

Butterfield, Jan. "The Deluxe Show." *Texas Observer*, September 24, 1971.

The Carter-Menil Human Rights Prize. Booklet. Atlanta, Houston, and Paris: The Carter-Menil Human Rights Foundation, 1986.

"Council Accepts Gift Sculpture." *Houston Chronicle*, May 28, 1969.

"Council Turns to Moon in King Sculpture Issue." *Houston Chronicle*, August 21, 1969.

"Donor of Obelisk Sculpture Sees It as King Memorial." *Houston Post*, June 4, 1969.

Ferretti, Fred. "Houston Getting a Sculpture After All." *New York Times*, August 26, 1969.

Freed, Eleanor. "The 'Obelisk' Finds a Home at Long Last." *Houston Post*, August 31, 1969.

Hobdy, D. J. "Institute of Religion Accepts Controversial 'Broken Obelisk.'" *Houston Chronicle*, August 26, 1969.

Holmes, Ann. "City May Be Given Celebrated Sculpture." *Houston Chronicle*, May 2, 1969.

———. "Heroic Storm Centers, Those Public Sculptures." *Houston Chronicle*, August 10, 1969.

"An Obelisk for Houston." *Houston Post*, August 27, 1969.

Richard, Paul. "Woe Follows the Obelisk." *Washington Post*, August 25, 1969.

The Rothko Chapel Awards for Commitment to Truth and Freedom. Booklet. Statement by Dominique de Menil. Houston: Rothko Chapel, 1986.

"Sculpture Acceptable to City—but Quote?" *Houston Post,* May 29, 1969.

"Why Not Dedicate Art to King, De Menil Asks City Council." *Houston Chronicle,* August 20, 1969.

BIOGRAPHY

Albee, Edward. "Mrs. de Menil's Liquor Closet." *Nest* (Fall 2001): 194–201. Reprinted in Edward Albee, *Stretching My Mind* (New York: Carroll & Graf, 2005), 215–17.

Barnes, Susan J. "Dominique de Menil: 'A Double Passion.'" *ARTnews* 97 (March 1998): 66.

Brettell, Richard R., and C. D. Dickerson. "Private Collecting Without Restraints of Culture or Period." In *From the Private Collections of Texas: European Art, Ancient to Modern,* exhibition catalogue, 67–72. Fort Worth: Kimbell Art Museum, 2009.

Browning, Dominique. "What I Admire I Must Possess." *Texas Monthly,* April 1983, 141–47, 192–209.

Brutvan, Cheryl A. "The MacAgy Years." In *In Our Time: Houston's Contemporary Arts Museum, 1948–1982,* 22–31. Exhibition catalogue. Houston: Contemporary Arts Museum, 1982.

Camfield, William A. "Dominique de Menil, 1908–1997." *Cite* 40 (Winter 1997/1998): 10–11.

Colpitt, Frances. "Dominique de Menil, 1908–1997." *Art in America* 86 (February 1998): 120.

Davidson, John. "Dominique de Menil." *House and Garden* 155 (March 1983): 10–12.

de Menil, Dominique. "Dans les jardins de Houston: Rencontre avec Dominique de Ménil." Interview. *Le Monde,* April 12, 1984.

"Dominique de Menil 1908–1997." *Southwest Alternate Media Project Media Bulletin* (Winter/Spring 1998): 2–3.

Feldman, Morton. "Obituary for John de Menil." *Art in America* (November/December 1973).

Freed, Eleanor. "Dominique de Menil: Rare Vision in the Arts." *Texas Humanist* 7, no. 1 (September/October 1984): 42–46.

———. "John de Menil, Man with a Mission." *Houston Post,* June 10, 1973.

Glueck, Grace. "Art Benefactors Shift Their Field." *New York Times,* December 19, 1968.

———. "The de Menil Family: The Medici of Modern Art." *New York Times Magazine,* May 18, 1986, 28–46, 66, 106, 113.

Holmes, Ann. "Dominique de Menil: From *Jeune Fille* to 'Renaissance Woman.'" *Art News* 82 (January 1983): 80–85.

———. "Dominique de Menil: A New Kind of Patroness in a Changing Art Scene." *Houston Chronicle,* May 26, 1968.

———. "A Law Unto Themselves: John and Dominique de Menil." *The ARTgallery Magazine* 8 (May 1970): 34–36.

Hopps, Walter. "Encountering the de Menils." In *good,* edited by Toni Beauchamp and Polly Koch, 103–107. Houston: Masterpiece Lithography, 2000.

Hugetz, Edward, and Brian Huberman. "The Memory of Rossellini in Texas." In *Roberto Rossellini,* 107–15. Rome: Edizione Ente Autonomo Gestione Cinema, 1987. Published by the Ministero del Turismo e della Spettacolo for the multimedia project "Rossellini in Texas," October 1987.

Johnston, Marguerite. "The de Menils: They Made Houston a More Beautiful Place in Which to Live." *Houston Post,* Today section, January 9–12, 1977. Four-part series.

Kilian, Karl. "Flashback to the Sixties: University of St. Thomas." *Cite* 35 (Fall 1996): 22–23.

Lewis, Anne S. "What Dominique de Menil Wrought." *Wall Street Journal,* June 9–10, 2007.

Middlebrook, Ellen. "Jean de Menil's Inspiration for Study Came Late." *Houston Post,* September 22, 1957.

Morrison, Harriet. "They Live with Art and Love It." *New York Herald Tribune,* May 6, 1959.

Muse, Vance. "Dominique de Menil." *Veranda* 21, no. 6 (October 2007): 98–104, 244.

———. "Life Well Lived Dept.: Philip Johnson and other friends take their leave of a singular patroness." *The New Yorker,* January 26, 1998, 29.

Nelson, Lauri. "Cartier-Bresson in Houston, 1957." *Cite* 33 (Fall 1995/Winter 1996): 27–31.

O'Neil, John. "Beginnings: Personal Notes About Art at Rice University (1965–1970)." *Rice Sallyport* (Fall 2005): 37–41.

Pugh, Clifford. "De Menil Laid to Rest with Elegant Simplicity." *Houston Chronicle,* January 4, 1998.

Riboud, Marc. "Adieu a Dominique de Menil." *Connaissance des arts,* no. 547 (February 1998): 24.

Schlumberger, Anne Gruner. *The Schlumberger Adventure.* New York: Arco, 1982.

Tomkins, Calvin. "The Benefactor" (profile of Dominique de Menil). *The New Yorker,* June 8, 1998, 52–67.

———. "A Touch for the Now" (profile of Walter Hopps). *The New Yorker,* July 29, 1991, 33–57.

Viladas, Pilar. "They Did It Their Way." *New York Times Magazine,* October 10, 1999, 85–94.

MENIL RESEARCH PUBLICATIONS

Bugner, Ladislas, ed. *The Image of the Black in Western Art.* 4 vols. New York: William Morrow; Houston: Menil Foundation; Cambridge, Mass. and London: Belknap Press of Harvard University Press, 1976–.

Carr, Annemarie Weyl, and Laurence J. Morrocco. *A Byzantine Masterpiece Recovered, the Thirteenth-Century Murals of Lysi, Cyprus.* Austin: University of Texas Press, 1991.

Couturier, Marie-Alain. *Art sacré: Textes choisis par Dominique de Menil et Pie Duployé.* Houston: Menil Foundation, 1983. Translated by Granger Ryan as *Sacred Art: Texts Selected by Dominique de Menil and Pie Duployé* (Austin: University of Texas Press; Houston: Menil Foundation, 1989).

Guidieri, Remo, Francesco Pellizzi, and Stanley J. Tambiah, eds. *Ethnicities and Nations: Processes of Interethnic Relations in Latin America, South East Asia, and the Pacific.* Houston: Rothko Chapel; Austin: University of Texas Press, 1988.

Ibish, Yusuf, and Ileana Marcoulesco, eds. *Contemplation and Action in World Religions: Selected Papers from the Rothko Chapel Colloquium.* Houston: Rothko Chapel; Seattle: University of Washington Press, 1978.

Ibish, Yusuf, and Peter Lamborn Wilson, eds. *Traditional Modes of Contemplation and Action.* Tehran: Imperial Iranian Academy of Philosophy, 1977.

Karageorghis, Vassos. *Blacks in Ancient Cypriot Art.* Houston: Menil Foundation, 1988.

Suckale-Redlefsen, Gude, with Robert Suckale. *Mauritius, der heilige Mohr.* Houston: Menil Foundation; München: Schnell & Steiner, 1987.

Spies, Werner. *Max Ernst, Oeuvre-Katalog.* 7 vols. Houston: Menil Foundation; Köln: Verlag M. DuMont Schauberg, 1975–2007.

Sylvester, David, and Sarah Whitfield. *René Magritte: Catalogue Raisonné.* 5 vols. Houston: Menil Foundation, 1992–97.

WRITINGS OF JOHN AND DOMINIQUE DE MENIL

de Menil, Dominique. "About Yves Klein" and "About the Exhibition." In *Yves Klein 1928–1962: A Retrospective*, exhibition catalogue, 7–9. Houston: Rice Museum, 1982.

———. Acknowledgments and Foreword. In *Six Painters: Mondrian, de Kooning, Guston, Kline, Pollock and Rothko*, exhibition catalogue, 8–9. Houston: University of St. Thomas, 1967.

———. "Acknowledgments and Perspectives." In *The Image of the Black in Western Art*, Vol. 1, *From the Pharaohs to the Fall of the Roman Empire*, ix–xi.

———. "Avant-propos." In *Carte blanche: Le courtiers du désir*, exhibition catalogue. Paris: Centre Georges Pompidou, 1986.

———. "Avant-propos." In *Cinquante ans de dessins américains: 1930–1980*, exhibition catalogue, 9. Paris: École nationale supérieure des Beaux-Arts, 1985.

———. "Biographical Note." In Couturier, *Sacred Art*, 157–59.

———. "Constant Companions." In *Constant Companions: An Exhibition of Mythological Animals, Demons and Monsters, Phantasmal Creatures and Various Anatomical Assemblages*, exhibition catalogue. Houston: University of St. Thomas, 1964.

———. Foreword. In *Builders and Humanists: The Renaissance Popes as Patrons of the Arts*, exhibition catalogue, 26–27. Houston: University of St. Thomas, 1966.

———. Foreword. *Georges Rouault: The Inner Light*, exhibition catalogue. Houston: Menil Collection, 1996.

———. Foreword. In *Gray Is the Color: An Exhibition of Grisaille Painting, XIIIth–XXth Centuries*, exhibition catalogue, 9–11. Houston: Rice Museum, 1973.

———. Foreword. In *The John and Dominique de Menil Collection*, exhibition catalogue. New York: Museum of Primitive Art, 1962.

———. Foreword. In *Max Ernst: Illustrated Books, Writings, Periodicals, Exhibition Catalogues, Dada and Surrealist Memorabilia: Collection of Marvin Watson, Jr., Houston*, exhibition catalogue. Houston: Rice Museum, 1973.

———. Foreword. In *The Menil Collection: A Selection from the Paleolithic to the Modern Era*, 7–8.

———. Foreword. In Nodelman, *The Rothko Chapel Paintings*, 9.

———. Foreword. *A Piece of the Moon World: Paul Klee in Texas Collections*, exhibition catalogue, 7. Houston: Menil Collection, 1994.

———. Foreword. In *Raid the Icebox 1 with Andy Warhol: An Exhibition Selected from the Storage Vaults of the Museum of Art, Rhode Island School of Design*, exhibition catalogue, 5. Houston: Rice Museum, 1969.

———. Foreword. In *Selection from the Ménil Collection*, exhibition catalogue. Houston: Rice Museum, 1971.

———. Foreword. In *Transfixed by Light: Photographs from the Menil Collection: Selected by Beaumont Newhall*, exhibition catalogue. Houston: Rice Museum, 1981.

———. Foreword. In *Visionary Architects: Boullée, Ledoux, Lequeu*, exhibition catalogue, 11–12. Houston: University of St. Thomas, 1967.

———. Foreword. In *A Young Teaching Collection*, exhibition catalogue, 10.

———. "Humble Treasures." In *Humble Treasures: An Exhibition of Tribal Art from Negro Africa*, exhibition catalogue. Houston: University of St. Thomas, 1965.

———. "Impressions américaines en France." *L'art sacré* 7–8 (March–April 1953): 1–32.

———. "Jermayne MacAgy." In *Jermayne MacAgy: A Life Illustrated by an Exhibition*, exhibition catalogue, 10–12. Houston: University of St. Thomas, 1968.

———. "Jermayne MacAgy." In *Out of This World: An Exhibition of Fantastic Landscapes from the Renaissance to the Present*, exhibition catalogue. Houston: University of St. Thomas, 1964.

———. "Jim Love Up to Now." In *Jim Love Up to Now: A Selection*, exhibition catalogue, 14–21. Houston: Rice Museum, 1980.

———. "La rime et la raison." In *La rime et la raison*, exhibition catalogue, 11–12.

———. "Léger, Our Contemporary." In *Léger, Our Contemporary*, exhibition catalogue, 6–7. Houston: Rice Museum, 1978.

———. "Matisse et Rothko." In Couturier, Matisse, and Rayssiguier, *La chapelle de Vence*, 5–6. Translated by Michael Taylor as "Matisse and Rothko" in Couturier, Matisse, and Rayssiguier, *The Vence Chapel*.

———. "The Menil Collection and Museum." *A+U 206* (November 1987): 62–63.

———. "New Art Center, New Possibilities." *Institute for the Arts, Rice University, Houston Newsletter No. 1* (Winter 1969).

———. "Pour laisser parler le Père Couturier." In Couturier, *Art Sacré*, 9. Translated by Granger Ryan as "To Recapture the Voice of Père Couturier" in Couturier, *Sacred Art*, 9.

———. Preface. In Barnes, *The Rothko Chapel*, 7–9.

———. Preface. In *The Drawing Speaks: Works by Théophile Bra*, exhibition catalogue. Houston: Menil Collection, 1997.

———. "Regards blancs sur l'africain." *Le nouvel observateur*, April 13–19, 1984, 90.

———. "The Rothko Chapel." *Art Journal* 30, no. 3 (Spring 1971): 249–51.

———. *The Rothko Chapel: Writings on Art and the Threshold of the Divine*. Edited by Polly Koch, Diane Lovejoy, and Frances Carter Stephens. Forewords by Fariha de Menil and Christopher Rothko, and introduction by Emilee Dawn Whitehurst. Houston: Rothko Chapel, 2010.

———. "A Statement." In *The Rothko Chapel Awards*, 5.

———. "Ten Centuries That Shaped the West." In Herbert Hoffman, *Ten Centuries That Shaped the West: Greek and Roman Art in Texas Collections*, exhibition catalogue, ix–xix. Houston: Rice Museum, 1970.

———. "Through the Porthole." In *Through the Porthole*, exhibition catalogue, 20. Houston: University of St. Thomas, 1965.

———. "Unromantic Agony." In *Unromantic Agony*, exhibition catalogue. Houston: University of St. Thomas, 1965.

———. "Vagaries about the Cube and the Sphere." In *Art Has Many Facets: The Artistic Fascination with the Cube*, exhibition catalogue. Houston: University of St. Thomas, 1963.

de Menil, Dominique, and Jean Schlumberger. *Conrad Schlumberger, sa vie, son oeuvre*. Paris: Editions hors commerce, 1949. Reprinted in Jean Schlumberger, *Oeuvres*, vol. 5 (Paris: Gallimard, 1960), 260–81.

de Menil, John. "A Provincial Town." In *Houston: Text by Houstonians*, 127–29. Marrero, La.: Hope Haven Press, 1949.

de Menil, John and Dominique. "Regard sur le passé." In *Collection de Menil: Oeuvres Cubistes*, exhibition catalogue. Rouen, France: Musée des beaux arts, 1970.

Schlumberger (de Menil), Dominique. "Courrier de Berlin." *Le revue du cinéma* 2, no. 8 (March 1930): 60.

———. "Les divers procédés du film parlant." *Le revue du cinéma* 2, no. 9 (April 1930): 43–52.

Index

Note: Numbers in bold refer to pages with illustrations. Artworks (in italics) and solo exhibitions (within quotation marks) are listed under the artist's name. Group exhibitions appear under the name of the presentation venue.

PHOTOGRAPHY AND DOCUMENT CREDITS

Materials from the Menil Collection are listed under the four different locations where they are housed.

Menil Archives

back cover (middle right), p. 247, figs. 2.3, 2.13, 3.1, 4.9, 8.11, 13.5, 14.8, 14.24, 14.29, 14.40, 15.16, 21.1, 21.2, 26.1, C.32, C.39, C.45, C.64
Courtesy of the American Federation of Arts, fig. C.21
Annie Amante, fig. 14.39
Eve Arnold, figs. 2.5, 2.14, 4.8, 15.8, C.18, C.20, C.27
Frederick Baldwin and Wendy Watriss, fig. 6.6
Courtesy of the Barnett Newman Foundation, New York, fig. 14.35
Jennifer Binder, courtesy of the Byzantine Fresco Chapel, fig. 13.12
John Bintliff, fig. C.30
Bill Brain, courtesy of Roger Wells, fig. C.33
Courtesy of the Contemporary Arts Museum Houston, fig. C.16
David Crossley, figs. 14.37, C.43, C.50, C.60; courtesy of the Rothko Chapel, figs. 7.3, 7.4, 8.5, C.52; courtesy of the Renzo Piano Building Workshop, figs. 16.2, 17.5
Crossley and Pogue, Houston, fig. C.49
Courtesy of Dan Flavin, Ltd., fig. 14.13
A. de Menil, back cover (top), pp. 16–17, 116–17; figs. 4.14, 10.17, 10.18, 14.30, C.23
John de Menil, fig. C.12
Estate of Jim Love, fig. 14.23
Courtesy the Estate of Robert Rauschenberg, fig. 14.38
Anthony Frederick, fig. C.55
Alexandre Georges, fig. 15.7
Larry Gilbert, fig 1.1
Splash Goodie, pp. 90–91
Glenn Heim, figs. 10.1, C.31
Paul Hester, figs. 2.8, 4.24, 18.2, 22.8, C.48, C.51, C.61
Hester + Hardaway, frontispiece; fig. 20.1
Hickey-Robertson, Houston, pp. 46–47, 168–69; figs. 2.6, 2.11, 2.12, 4.1, 4.12, 4.16–4.20, 4.22, 4.23, 6.5, 8.1, 8.6–8.10, 8.12, 12.7, 14.14, 14.25, 14.52, 15.12, 15.13, 16.3, 17.9, 22.6, 22.7, 25.1, C.19, C.22, C.24, C.26, C.29, C.35; courtesy of the Rothko Chapel, back cover (middle left), figs. 11.7, 11.10, 22.4, C.36, C.37
Courtesy of the *Houston Post*, fig. 15.4
Jacqueline Hyde, fig. 3.7
Shunji Ishida, courtesy of the Renzo Piano Building Workshop, figs. 2.16, 16.1
Balthazar Korab, figs. 4.2, 15.3, 15.5, 20.3
Rodney Marionneaux, fig. 4.13
Maurice Miller, figs. 4.6, 4.10; courtesy of the Contemporary Arts Museum Houston, fig. 4.7
Andre Morain, figs. 14.10, C.38
Laurence Morrocco, fig. 13.2
Courtesy of Michelangelo Pistoletto; Luhring Augustine, New York; and Galleria Christian Stein, Milan, fig. 14.36
By kind permission of PJAR Architects, fig. 14.22
Don Quaintance, figs. 15.1, 15.19, 22.5, C.44; courtesy of the Rothko Chapel, fig. C.40
Father Leonard C. Quinlan, figs. 4.15, C.25
Courtesy of the Renzo Piano Building Workshop, figs. 17.7, 17.8, 18.5–18.7
Marc Riboud, figs. 15.18, C.53
Text courtesy of Kate Rothko Prizel and Christopher Rothko, fig. 14.42
Schlueter, Houston, fig. 12.9

John Lee Simons, pp. 272–73, figs. 2.1, 6.8, 12.8, 15.15, 22.2, C.34
Warren Skaaren, front cover, figs. 6.1, 14.41
William Steen, figs. 20.6, C.54
Fred Stein, New York, by kind permission of PJAR Architects, fig. 14.21
Mike Stude, fig. 16.4
Taylor and Dull, fig. 15.11
Courtesy of Wayne Thiebaud, fig. 14.47
Courtesy of Cy Twombly, fig. 18.4
Paul Winkler, fig. C.59

De Menil Family Papers, Menil Archives

figs. 6.11, 7.2, 14.6, 19.1, 22.3, C.1–C.3, C.6, C.8, C.11
Dominique de Menil, fig. C.7
John de Menil, figs. C.4, C.15
Foto-Excelsior, M. Gerie, fig. 2.2
Hickey-Robertson, courtesy of the Rothko Chapel, Houston, fig. 7.1
By kind permission of PJAR Architects, fig. 14.20
Pontificia Fotografia, photograph by G. Felici, fig. C.41
Marc Riboud, fig. C.5
F. Wilbur Seiders, fig. C.13

The Menil Collection, Houston

Henri Cartier-Bresson, figs. 2.4, 4.4, 4.5, 14.5, C.17
William Christenberry, courtesy of Hemphill Fine Arts, fig. 10.16
A. C. Cooper, London, figs. 10.13, 10.14
Allan Finkelman, fig. 10.3
Rick Gardner, Houston, fig. 20.4
Paul Hester, Houston, fig. 14.16; courtesy of the Byzantine Fresco Chapel, figs. 13.6, 13.11
Hester + Hardaway, Houston, figs. 3.5, 10.2, 10.7, 14.46, 14.51, 14.53, 17.12, C.42; courtesy of Lucas Samaras and Pace Gallery, fig. 14.44
Hickey-Robertson, Houston, back cover (bottom left), pp. 196–97, figs. 2.15, 3.4, 8.3, 10.4–10.6, 10.8–10.12, 10.15, 12.1, 12.10–12.12, 14.12, 14.18, 14.31, 14.33, 15.17, 18.1, 18.8–18.13, 20.2, 20.7, 22.1, 22.9, C.14, C.47, C.62; courtesy of the Barnett Newman Foundation, New York, fig. 3.6; courtesy of the Rothko Chapel and the Barnett Newman Foundation, New York, fig. 11.8; courtesy of Glenn Heim, fig. 14.16
George Hixson, figs. 12.3–12.6, 14.3
Mary Kadish, courtesy of the Niki Charitable Art Foundation, fig. 14.49
Danny Lyon, courtesy of Edwynn Houk Gallery, fig. 6.7
Courtesy of Matthew Marks Gallery, fig. C.57
Joshua Mann Pailet, fig. 20.5
By kind permission of PJAR Architects, courtesy of the Rothko Chapel, figs. 11.5, 11.6
Don Quaintance, fig. 14.28
F. Wilbur Seiders, fig. C.10
Janet Woodard, Houston, fig. 8.4; courtesy of the Louis I. Kahn Collection, University of Pennsylvania and the Pennsylvania Historical and Museum Commission, fig. 15.14

Menil Object Files

figs. 14.1, 14.4, 14.7, 14.9, 14.11, 14.17, 14.27, 14.32, 14.45, 14.50
Writing courtesy of Glenn Heim, fig. 14.15
Writing courtesy of Jasper Johns, fig. 14.19
Writing courtesy of Danny Lyon, fig. 14.26

Additional Sources

Anthony Allison, courtesy of the Rothko Chapel, figs. 7.7, 7.8
Courtesy of the Archiepiscopal Museum, Nicosia, Cyprus, fig. 13.10
Archives de la Province Dominicaine de France, fig. 2.9
Courtesy of Gertrude Barnstone, fig. 15.10
Richard Bryant, courtesy of the Renzo Piano Building Workshop, fig. 17.1
Gerald L. Carr, figs. 13.7, 13.8
Christopher Cascio, courtesy of Da Camera of Houston, fig. C.56
Courtesy of Mel Chin, fig. 23.1
Courtesy of Dan Flavin, Ltd., fig. 12.13
Lucien Debretagne, fig. 15.2
Thomas Dix, courtesy of Fondation Beyeler, fig. 17.3
Florida Center for Instructional Technology (FCIT) at the University of South Florida, fig. 18.3
Harvard Art Museum, Fogg Museum, Harvard University, Imaging Department, fig. 11.4
Courtesy of *The Herald*, Texas Southern University, Houston, fig. 8.2
George Hixson, Houston, fig. 2.7
Richard Ingersoll, fig. 17.11
Courtesy of Nancy James, fig. 15.6
Billy Jim, courtesy of Dan Flavin, Ltd.; Dia Arts Foundation; and David Zwirner, New York, fig. 12.2
Courtesy of the Jim Scarbrough Family, fig. 14.2
From *La revue du cinéma*, figs. 6.9, 6.10
Courtesy of LeBaron's Fine Art, Sacramento, California, fig. 14.48
Courtesy of Leisure Time Features, fig. 6.4
Mishkan LeOmanut, courtesy of the Museum of Art, Ein Harod, Israel, fig. 17.4
Alexander Liberman, Alexander Liberman Photographic Collection & Archive Research Library, the Getty Research Institute, Los Angeles, California (2000.R.19), fig. 11.1
John Edward Linden, fig. 17.10
Courtesy of Lippincott, Inc., North Haven, Connecticut, and the Barnett Newman Foundation, New York, fig. 14.34
Courtesy of Elisabeth Malaquais, fig. C.9
Frank Martin, fig. 5.1
Stephanie Maze / Corbis, fig. 7.6
Courtesy of Benoit Mortiz, fig. 11.2
Courtesy of the the Museum of Fine Arts, Houston, figs. 4.11, 15.9
Hans Namuth, courtesy of the Center for Creative Photography, University of Arizona, fig. 14.43
Courtesy of Norman Mailer Licensing, fig. 6.3
H. Del Omo, courtesy of the Réunion des Musées Nationaux / Art Resource, New York, fig. 19.2
Courtesy of Deloyd Parker, fig. 9.1
A. Reeve, courtesy of the National Gallery of Scotland, fig. 7.5
F. Wilbur Seiders, courtesy of the Contemporary Arts Museum Houston, fig. 4.3

COPYRIGHT NOTICES

Contributors

Suzanne Deal Booth was a student at Rice University in 1975 when she was first employed by Dominique de Menil, with whom she continued to work for many years. She is founder and director of Friends of Heritage Preservation, a nonprofit organization dedicated to the recognition, preservation, and conservation of artistic and cultural heritage. She currently serves on the boards of Rice University, the Institute of Fine Arts at New York University, the Los Angeles County Museum of Art, and several other arts organizations.

William A. Camfield is a scholar who joined the Art Department at the University of St. Thomas in 1964. In 1969 he moved with the de Menils to Rice University, where he taught until his retirement in 2002. His publications include *Francis Picabia: His Art, Life, and Times* (Princeton University Press, 1979), *Marcel Duchamp, Fountain* (The Menil Collection, 1989), *Max Ernst: Dada and the Dawn of Surrealism* (Prestel, 1993), and *More Than a Constructive Hobby: The Paintings of Frank Freed* (The Museum of Fine Arts, Houston, 1996). In support of his work on the catalogue raisonné of Francis Picabia, he was awarded Mellon Emeritus Fellowships in 2005 and 2006, and fellowships from the Dedalus Foundation in 2007 and 2009.

Annemarie Weyl Carr is University Distinguished Professor Emerita of Art History at Southern Methodist University. Her books include *A Byzantine Masterpiece Recovered: The Thirteenth-Century Murals of Lysi* (University of Texas Press and The Menil Collection, 1991). She concentrates in her work on the Byzantine, Crusader, and early modern murals and icons of Cyprus and the eastern Mediterranean Levant.

Mel Chin is a conceptual artist based in North Carolina. He worked as a preparator at the Rice Museum in 1983. Chin has exhibited at venues including the Hirshhorn Museum and Sculpture Garden, Washington, D.C.; the Menil Collection, Houston; the Museum of Contemporary Art, Los Angeles; the Museum of Modern Art, New York; and Whitney Museum of American Art, New York. He has received numerous awards including those from the National Endowment for the Arts, the Pollock/Krasner Foundation, and the Joan Mitchell Foundation.

Bertrand Davezac is a scholar of early medieval art. He was a member of the faculty of Rice University's graduate program in art history in 1979–93 and served as curator of the Menil Collection in 1979–2000. He has written several publications on Byzantine and early medieval art, including *L'icône, objet d'art ou objet de culte?* (Éditions du Cerf, 2001), *Greek Icons After the Fall of Constantinople: Selections from the Roger Cabal Collection* (The Menil Collection, 1996), and *Luz del icono: colección Roger Cabal* (Antiguo Colegio de San Ildefonso, 1997).

Christophe de Menil is the eldest of John and Dominique de Menil's five children. She is a renowned jewelry and fashion designer as well as a patron of the arts. She created costume designs for the artist and theater director Robert Wilson for twenty years.

Clare Elliott is assistant curator at the Menil Collection, specializing in modern and contemporary art. She has also worked at the Contemporary Arts Museum Houston; the Museum of Fine Arts, Houston; the Williams College Museum of Art; and the Clark Art Institute in Williamstown, Massachusetts. She is the author of *Art Spaces: The Menil Collection* (Scala, 2007).

Stephen Fox is a Fellow of the Anchorage Foundation of Texas.

Pia Gottschaller is a paintings conservator and fine arts program associate at Deutsche Akademie Rom Villa Massimo in Rome. She assisted with the restoration and conservation of the Rothko Chapel paintings as a Mellon Fellow at the Menil Collection in 1998–2000. She is the author of *Palermo: Inside His Images* (Siegl, 2004), *The Act of Creating Space: Lucio Fontana* (Siegl, 2008), and several essays on technical art history.

Walter Hopps co-founded the Ferus Gallery, Los Angeles, in 1957 and served as director of the Pasadena Art Museum in 1962–67, curating shows that included the first Marcel Duchamp retrospective in 1963. He later served as director of the Corcoran Gallery of Art, Washington, D.C., and as curator of twentieth-century art at the National Collection of Fine Arts (now the Smithsonian American Art Museum), Washington, D.C. In 1980 he became director of the Menil Foundation and was founding director of the Menil Collection. He was named consulting curator of twentieth-century art at the Menil in 1989, a position he held until his death in 2005.

Richard Ingersoll is professor of architecture at Syracuse University in Florence. He taught architectural history at Rice University in 1986–96. He was editor-in-chief of *Design Book Review* in 1983–98, and he continues to write criticism for numerous periodicals. His recent publications include *World Architecture: A Critical Mosaic, 1900–2000, Vol. 1: Canada and the United States* (Springer, 1999), and *Sprawltown: Looking for the City on Its Edges* (Princeton Architectural Press, 2006).

Thomas McEvilley taught classics at the University of St. Thomas before becoming professor of art history at Rice University in 1969, where he taught until 2004. He is a former contributing editor of *Artforum* magazine. His publications include *The Exile's Return: Toward a Redefinition of Painting for the Post-modern Era* (Cambridge University Press, 1993), *Sculpture in the Age of Doubt* (Allworth Press, 1999), and *The Triumph of Anti-Art: Conceptual and Performance Art in the Formation of Post-modernism* (McPherson & Co., 2005).

Gerald O'Grady was founder and director of the Media Center at the University of St. Thomas and later of the Center for Media Study at the State University of New York at Buffalo, where he taught until his retirement in 1994. Fourteen of his essays were published in *Buffalo Heads: Media Study, Media Practice, Media Pioneers, 1973–1990* (MIT Press, 2008).

Deloyd Parker is founder and executive director of SHAPE (Self-Help for African People through Education), a community center established in 1969 in Houston's Third Ward. Parker has traveled around the world sharing SHAPE's philosophy of strengthening families and communities, and in 2000 he began a partnership with the Gambian government, which led to the opening of a SHAPE center in that country.

Francesco Pellizzi is associate of Middle American Ethnology at the Peabody Museum of Archaeology and Ethnology, Harvard University. Co-founder and editor of the journal *RES: Anthropology and Aesthetics*, he also founded and edited the book series Res Monographs in Anthropology and Aesthetics for Cambridge University Press (1986–98). He has been chair of the University Seminar on the Arts of Africa, Oceania, and the Americas at Columbia University since 2005. He served on the board of the Rothko Chapel in 1975–2005 and the board of the Menil Foundation in 1977–2005. He was editorial coordinator of the multivolume project the Image of the Black in Western Art in 1991–2003.

Renzo Piano is a renowned Italian architect who has been awarded the Pritzker Architecture Prize, the AIA Gold Medal, the Kyoto Prize, and the Sonning Prize. Among his many international design projects are the Centre Georges Pompidou, Paris, completed 1977; the Menil Collection, Houston, completed 1987; the Fondation Beyeler, Basel-Riehen, Switzerland, completed 1997; the New York Times Building, New York, completed 2007; and the Modern Art wing of the Art Institute of Chicago, completed 2009.

Pamela G. Smart is assistant professor of anthropology and art history at Binghamton University, specializing in museum studies and the anthropology of art and aesthetics. She completed a doctorate in anthropology at Rice University in 1997. In fall 2010 the University of Texas Press will publish her book *Sacred Modern: Faith, Activism, and Aesthetics in the Menil Collection.*

Simone Swan ran a public information firm addressing cultural, institutional, and environmental issues prior to joining the Menil Foundation as founding executive vice president in 1972, remaining there through 1977. In 1998 she established the Adobe Alliance in the Big Bend region of Texas, a nonprofit organization promoting low-cost, sustainable housing using earth architecture. She currently serves on the board of trustees of the Adobe Association of the Southwest.

Dorothea Tanning is an artist and author. She and her husband, Max Ernst, were close friends of John and Dominique de Menil's. In recent years Tanning has focused on writing poetry, which has appeared in *The New Yorker*, *The Yale Review*, *The Antioch Review*, and *The New Republic*. Her memoir, *Between Lives: An Artist and Her World* (W. W. Norton, 2001), is a model of the genre. Her visual art is in the collections of the Menil Collection, Houston; the Museum of Modern Art, New York; the Philadelphia Museum of Art; and the Tate Modern, London.

Kristina Van Dyke is curator for collections and research at the Menil Collection and a scholar of African art, specializing in the art of Mali. She received her master's degree in art history from Williams College and a doctorate in African art history from Harvard University. She is the author of *African Art from The Menil Collection* (The Menil Collection, 2008).

Alvia J. Wardlaw is professor of art history at Texas Southern University and director/curator of the University Museum at Texas Southern University. A historian of African American art, she was curator at the Museum of Fine Arts, Houston in 1995–2009. In 1973 she wrote the accompanying essay for the de Menils' exhibition "Tribal Art of Africa," held in Houston's De Luxe Theater. Her publications include *The Art of John Biggers: View from the Upper Room* (Museum of Fine Arts, Houston and Abrams, 1995) and *The Quilts of Gee's Bend: Masterpieces from a Lost Place* (Tinwood Books, 2002).

Paul Winkler first assisted John and Dominique de Menil when he was a student at the University of St. Thomas. He served as assistant director of the Museum of International Folk Art, Santa Fe, in 1975–80, returning to Houston in 1980 to oversee the design and construction of the Menil Collection. He became assistant director of the Menil in 1989 and was director in 1991–99.

Copy Editor: Polly Koch
Editorial Assistant: Sarah Robinson
Publications Interns: Sean Nesselrode and Nancy O'Connor
Proofreader: Jane McAllister, McLean, Virginia
Indexer: Becky Hornyak
Designer: Don Quaintance, Public Address Design, Houston
Design/Production Assistant: Elizabeth Frizzell

Typography: Klavika (display) and Berkeley (text)
Paper: GardaMatt
Printing, reproductions, binding: Conti Tipocolor, Florence, Italy

Published by
Menil Foundation, Inc.
1511 Branard Street
Houston, Texas 77006

© 2010 Menil Foundation, Inc., Houston

"Memoranda: John and Dominique de Menil" © 2010 Thomas McEvilley

Artists' and photographers' copyrights appear on page 339.

Distributed by
Yale University Press
P.O. Box 209040
302 Temple Street
New Haven, Connecticut 06520-9040
www.yalebooks.com

ISBN 978-0-300-12377-7
Library of Congress Control Number: 2010926780

Printed in Italy